the passionate camera

The Passionate Camera brings together over fifty artists, scholars, and critics to document and celebrate the explosive growth in independent and radical photographic work over the past decade. The essays range from conventional scholarly writing to personalized memoir, short fiction, and self-interview.

The authors present provocative queer readings of photographs from diverse historical archives, investigate critical approaches to the photographing of outlawed desire, and document militant activism, conservative backlash, and the effects of triumphant consumer capitalism.

The Passionate Camera provides both a history of queer and sex-radical photography and a showcase for many of the most exciting and innovative contemporary artists and photographers, whose work has been inspired by militancy and mourning in the wake of AIDS and bolstered by the growth of queer studies.

Illustrated with nearly two hundred black and white and color plates, *The Passionate Camera* features work from artists as diverse as Ajamu, Rotimi Fani-Kayode, Felix Gonzalez-Torres, Sunil Gupta, Lyle Ashton Harris, Glenn Ligon, Yasumasa Morimura, Catherine Opie, Hanh Thi Pham, and John O'Reilly. Gathering these works together for the first time in a critical, lucid, and accessible context, *The Passionate Camera* is a preeminent source on queer and sex-radical photography at the end of the twentieth century.

Essays by: Kaucyila Brooke, Michael Anton Budd, David Deitcher, Linda Dittmar, Mark Alice Durant, Paul B. Franklin, Lyle Ashton Harris, Thomas Allen Harris, David Joselit, Liz Kotz, Catherine Lord, Richard Meyer, José Esteban Muñoz, Mary Patten, Erica Rand, Mark A. Reid, Mysoon Rizk, James Smalls, Alisa Solomon, Elizabeth Stephens, Thomas Waugh.

Deborah Bright is an associate professor of photography and art history at the Rhode Island School of Design. A practising artist, she has written widely on photography and cultural issues for a number of publications.

the passionate camera

photography and bodies of desire

edited by deborah bright

london and new york

First published 1998
by Routledge
11 New Fetter Lane, London EC4P 4EE

Simultaneously published in the USA and Canada
by Routledge
29 West 35th Street, New York, NY 10001

Selection and editorial matter © 1998 Deborah Bright
Individual chapters © 1998 individual contributors

Typeset in Bembo by Keystroke, Jacaranda Lodge, Wolverhampton
Printed and bound in Great Britain by Butler and Tanner Ltd, Frome and London

British Library Cataloguing in Publication Data
A catalogue record for this book is available from the British Library

Library of Congress Cataloging in Publication Data
The Passionate Camera: Photography and bodies of desire / edited by
 Deborah Bright.
 Includes bibliographical references and index.
 1. Photography—Moral and ethical aspects. 2. Photography,
 Erotic—Moral and ethical aspects. 3. Sexuality in art.
 4. Homosexuality in art. I. Bright, Deborah.
 TR183.P27 1998
 778.9′28—dc21 98-12079

ISBN 0–415–14581–3 (hbk)
ISBN 0–415–14582–1 (pbk)

contents

portfolio

three **calculated exposures in risky conditions**

contributors

writers

Deborah Bright is an artist and writer whose photo works have been exhibited internationally and whose essays and works have been published in *Afterimage, Exposure, Art Journal, Views, WhiteWalls,* the *Michigan Quarterly Review,* and in Jean Fraser and Tessa Boffin, eds, *Stolen Glances* (Pandora, 1991) and Diane Neumaier, ed., *Reframings: New American Feminist Photographies* (Temple, 1995). She is associate professor of photography and art history at the Rhode Island School of Design.

Kaucyila Brooke is an artist who produces photo and text narratives for installation and publication and works in video art. She lives in Los Angeles and teaches in the Photography Program at Cal Arts.

Michael Anton Budd is the author of *The Sculpture Machine: Physical Culture and Body Politics in the Age of Empire* (Macmillan/NYU, 1997). He has taught history and cultural politics at the College of Wooster, the Rhode Island School of Design, University of Rhode Island, and Rutgers University where he received his Ph.D. in modern history. He teaches history and comparative civilizations at Bradford College, Massachusetts.

David Deitcher is an art historian and critic whose essays have appeared in the *Village Voice, Artforum, Art in America, Frieze* and *Parkett.* He is editor of *The Question of Equality: Lesbian and Gay Politics in America Since Stonewall* (Scribner, 1995), and is author of the forthcoming *Dear Comrades: Male Friendship and American Photography, 1840–1914.* He teaches art and critical theory at the Cooper Union for the Advancement of Science and Art.

Linda Dittmar is co-editor of *From Hanoi to Hollywood: The Vietnam War in American Film* (Rutgers, 1990) and *Multiple Voices in Feminist Film Criticism* (Minnesota, 1994). She is professor of English at the University of Massachusetts, Boston.

Mark Alice Durant is an artist, writer and assistant professor in the Department of Art Media Studies at Syracuse University. His photographs, installations and performances have been presented internationally, and he is the author of *McDermott and McGough: A History of Photography* (Arena Editions, 1998).

Paul B. Franklin is co-editor of *Field Work: Sites in Literary and Cultural Studies* (Routledge, 1996). He is a doctoral candidate in the Department of Fine Arts at Harvard University.

Lyle Ashton Harris is a New York and Los Angeles-based photographer whose work has been shown at the Guggenheim Museum, the Whitney Museum of American Art, and the New Museum for Contemporary Art. He is represented by Jack Tilton Gallery, New York.

Thomas Allen Harris is a media artist whose films and videotapes, including *Splash, Black Body, Heaven, Earth & Hell,* and *All In the Family,* have been shown at the American Film Institute, the

Berlin International Film Festival, and the New York Film Festival. He teaches at the University of California, San Diego.

David Joselit is the author of *Infinite Regress: Marcel Duchamp, 1910–1943* (MIT, 1998) and his essays on queer visuality have appeared in *Art in America*, *Robert Mapplethorpe: The Perfect Moment*, and *Gay and Lesbian Studies in Art History*. He is assistant professor in the Department of Art History at the University of California, Irvine.

Liz Kotz lives in New York and writes on film, video, and visual arts. She is completing a dissertation at Columbia University on models of language in 1960s American art.

Catherine Lord is a writer and curator of the exhibitions *Pervert*, *Gender, fucked*, and *Trash*. She teaches in the Department of Studio Art and Women's Studies at the University of California, Irvine.

Richard Meyer is assistant professor of modern and contemporary art at the University of Southern California. His book *Outlaw Representation: Censorship and Homosxuality in American Art, 1934–1994*, will be published by Oxford University Press in its *Ideologies of Desire* series.

José Esteban Muñoz is the author of *Disidentifications: Race, Sex and Visual Culture* (Minnesota, 1998), and co-editor of *Everynight Life: Culture and Dance in Latin/o America* (Duke, 1997) and *Pop Out: Queer Warhol* (Duke, 1996). He teaches in the Department of Performance Studies at the Tisch School of the Arts at New York University and is completing a manuscript on haunted texts, the world-making properties of minoritarian memory, and the materiality of performance.

Mary Patten is a visual artist, video maker, educator, and long-time community and political activist. Her videos and installations have been widely exhibited, most recently in *Discord/Sabotage of Realities* at the Kunstverein and at the Kunsthaus in Hamburg. From 1993 to 1995, she edited *WhiteWalls: A Journal of Language and Art*, and was a founding member of ACT UP/Chicago and the ACT UP Women's Caucus. She teaches in the Video Department of the School of the Art Institute of Chicago.

Erica Rand teaches in the Art Department at Bates College. She is the author of *Barbie's Queer Accessories* (Duke, 1995) and of articles in journals including *Genders*, *Art Journal*, *Eighteenth-Century Studies*, and *Radical Teacher*.

Mark A. Reid is the author of *PostNegritude Visual and Literary Culture* (SUNY, 1997), and *Redefining Black Film* (California, 1993); editor of *Spike Lee's "Do the Right Thing,"* co-editor of *le Cinema Noir Americain*, and is an editorial board member of *Cinema Journal*, *Jump Cut*, and *Wide Angle*. He is associate professor of English and Film at the University of Florida.

Mysoon Rizk recently completed a doctorate in art history at the University of Illinois, Urbana-Champaign. She served as archivist for the Estate of David Wojnarowicz and is currently editing the catalogue for the artist's forthcoming exhibition at the New Museum of Contemporary Art.

James Smalls is completing *Esclave, Nègre, Noir: The Black Presence in French Art from 1789 to 1870* (California, forthcoming). He is assistant professor of art history at Rutgers University where he teaches the interrelatedness of race, gender, and queer sexualities in nineteenth-century modern art and in twentieth-century African American art.

Alisa Solomon is a staff writer for the *Village Voice* and is the author of *Re-Dressing the Canon: Essays on Theater and Gender* (Routledge, 1997). She is associate professor of English at Baruch College–CUNY and of English and Theater at the CUNY Graduate Center.

Elizabeth Stephens is a San Francisco-based multimedia artist. She produces photo, video and sculptural installations that address technology, lesbian desire and notions of community. She teaches in the Studio Art Department at the University of California, Santa Cruz.

Thomas Waugh is the author of *Hard to Imagine: Gay Male Eroticism in Photography and Film From Their Beginnings to Stonewall* (Columbia, 1996). He is professor of Film Studies at Concordia University, Montreal, where he has also taught queer studies and an interdisciplinary course on AIDS.

artists

Laura Aguilar lives and works in Rosemead, California. She received the 1995 James D. Phelan Art Award in photography and her work has been included in the exhibitions, *In a Different Light*, *Bad Girls*, and *Sexual Politics: Judy Chicago's "Dinner Party" in Feminist Art History*.

Ajamu is a London-based photographer whose practice investigates the role of the image in the *mise en scène* of sexuality, desire, and fantasy from the diasporic perspective of a black queer subject.

Stephen Andrews is an artist living and working in Toronto, Canada. He is represented in New York by Lombard Freid Fine Arts.

Robert Blanchon lives in Los Angeles and wants to move back to New York.

Kaucyila Brooke is an artist who produces photo and text narratives for installation and publication and works in video art. She lives in Los Angeles and teaches in the Photography Program at Cal Arts.

Jeffery Byrd is a photographer and performance artist whose work has been widely exhibited and published in the USA. He has taught at the University of Alabama and Oberlin College and is currently an associate professor at the University of Northern Iowa.

Tammy Rae Carland is a photographer and video artist. She has exhibited her photographs internationally and her video works include *Odd Girl Out*, *Lady (out)laws and Faggot Wannabes* and *The Indiana Tapes*. She also produces zines, including *I (heart) Amy Carter* and *Jailhouse Turnout*.

Jill Casid and **María DeGuzmán** have been working together as SPIR: Conceptual Photography since 1991 to produce narrative photo-tableaux and text sequences which they call *chromo-crypto-dramas*. Their work has been exhibited at the Institute of Contemporary Art, Boston, the *galeria del progreso*, Madrid, Pulse Art, New York, Watershed Media Centre, Bristol, and at Harvard University where both are Ph.D. candidates.

Gaye Chan was born in Hong Kong and emigrated to the US when she was twelve. She received her MFA degree from the San Francisco Art Institute and is associate professor of photography at the University of Hawaii. She has been an exhibiting visual artist since 1979.

Lawrence Chua is the author of the novel *Crush* (Grove Press) and editor of the anthology, *Collapsing New Buildings* (Kaya). His writing appears in various anthologies and publications, including *Rolling Stone*, the *Village Voice*, the *Nation* and *Vibe*. http://home.earthlink.net/elchino.

Darren P. Clark is a photographer and film-maker from Tucson, Arizona. His work can be found in the Center for Creative Photography's Artists Book Collection. His hobbies include long moonlight walks and animal husbandry.

Terrence Facey is a London-based photographer of West Indian descent. Informed by extensive travels in Jamaica and Cuba, his photographs investigate diverse historical issues affecting black people living in Britain, particularly the sexual politics and cultural representations of inter-racial sex and relationships.

Rotimi Fani-Kayode was a London-based Nigerian photographer. A monograph on his work, *Black Male/White Male*, was published the year before his death in 1989, and his photographs were included in the 1996 Solomon R. Guggenheim Museum survey, *In/Sight: African Photographers, 1940 to the Present*. His estate is administered by Autograph, London.

Robert Flynt is a New York-based artist who has exhibited at the Witkin Gallery, New York, the Craig Krull Gallery, Santa Monica, and the G. Gibson Gallery, Seattle. His monograph *Compound Fracture* was published in 1996 by Twin Palms Press.

Tomàs Gaspar has lived in New York since 1980 and studied photography with Nan Goldin. He derives his work from his personal visual diary of friends and is currently represented by MBM Gallery, New York.

Ken Gonzales-Day lives in Los Angeles and is associate professor at Scripps College. He has exhibited his work at White Columns and Christinerose Gallery in New York, Hallwalls, Buffalo, the New Museum of Contemporary Art, New York, the Los Angeles Center for Photographic Studies, and the New Orleans Contemporary Art Center.

Felix Gonzalez-Torres was a New York-based artist and member of Group Material. He was honored shortly before his death in 1996 with a retrospective survey at the Solomon R. Guggenheim Museum and his work has been shown at the Museum of Modern Art, New York, the Museum of Contemporary Art, Los Angeles, and the Hirshhorn Museum and Sculpture Garden, Washington, DC. His estate is administered by Andrea Rosen Gallery, New York.

Sunil Gupta is a London-based photographer, artist and curator. His work has been exhibited internationally, including solo shows at Bedford Hill Gallery, London, Portfolio, Edinburgh, YYZ, Toronto, and the Contemporary Art Gallery, Vancouver. He edited *Disrupted Borders* (1993), *An Economy of Signs* (1990) and, with Tessa Boffin, *Ecstatic Antibodies: Resisting AIDS Mythology* (1990).

Rita Hammond teaches art history and photography at Cazenovia College, New York, where she lives and has her studio. She was awarded a New York Foundation for the Arts Fellowship in 1995.

Lyle Ashton Harris is a New York and Los Angeles-based photographer whose work has been shown at the Guggenheim Museum, the Whitney Museum of American Art, and the New Museum for Contemporary Art. He is represented by Jack Tilton Gallery, New York.

Thomas Allen Harris is a media artist whose films and videotapes, including *Splash*, *Black Body*, *Heaven, Earth & Hell*, and *All In the Family*, have been shown at the American Film Institute, the Berlin International Film Festival, and the New York Film Festival. He teaches at the University of California, San Diego.

Bill Jacobson is a New York-based photographer whose work has been exhibited at the Grey Art Gallery, New York, the Princeton University Art Museum, the San Francisco Art Institute, and the Photographer's Gallery, London. He is represented by Julie Saul Gallery, New York. "My pictures function as a metaphor for the way the mind works; simultaneously collecting images while letting others go, fading in the way that memories fade . . . "

Deborah Kass is a New York-based artist whose work has been shown at Jose Friere Fine Art, New York, Barbara Krakow Gallery, Boston, fiction/nonfiction, New York, and was included in *Too Jewish? Challenging Traditional Identities*, at The Jewish Museum, New York.

Andrew Kim is a Korean American artist living and working in Los Angeles's Little Tokyo district. He received his MFA from Cal Arts and is now making art with digital imagery on computers.

Nina Levitt is a Canadian artist currently trying to make a living after completing her MFA at the University of Illinois at Chicago. Over the past decade her photo-based work has been included in numerous exhibitions in Canada, the United States and the United Kingdom, including *Critical Details*, *Found Missing*, *Drag City*, *100 Years of Homosexuality*, *Fag-o-sites*, *Dress Codes*, *Stolen Glances*, *The Zone of Conventional Practice & Other Real Stories*, and *Sight Specific: Lesbians & Representation*.

Glenn Ligon is a New York-based artist whose work has been exhibited at the Whitney Museum of American Art, the Hirshhorn Museum and Sculpture Garden, Washington, DC, and the San Francisco Art Institute. His work is represented by Max Protetch Gallery, New York.

Yasumasa Morimura lives and works in Osaka, Japan. His works have been exhibited at the Guggenheim Museum, New York, the Museum of Fine Arts, Boston, and the Institute of Contemporary Art, Boston. He is represented in New York by Luhring Augustine Gallery.

Mark Morrisroe was a New York-based artist who died in 1989. His photographs were featured in the 1995 *Boston School* exhibition, and his estate is administered by the Pat Hearn Gallery, New York.

Catherine Opie lives and works in Los Angeles. Her work has been exhibited at Jay Gorney

Fine Art, New York, and the Whitney Museum of American Art, and is represented by Regen Projects, Los Angeles.

John O'Reilly lives and works in Worcester, Massachusetts. His work has been exhibited at the Whitney Museum of American Art and is represented by Howard Yezerski Gallery, Boston, and by Julie Saul Gallery, New York.

Ria Pacquée lives and works in Antwerp, Belgium. Her serial photographic works were featured in the exhibition *Dress Codes* at the Institute of Contemporary Art, Boston.

Paul Pfeiffer is an artist living in New York where he teaches at the Parsons School of Design. Recent exhibitions include *Pervert*, *In a Different Light*, and *Memories of Overdevelopment*. He was a Fulbright Fellow in 1994–95 and resident artist at the Bronx Museum of Art in 1997.

Hanh Thi Pham is a Vietnamese American artist who lives and works in the Los Angeles area. Her work was included in the exhibitions *Asia/America: Identities in Contemporary Asian American Art* (traveling exhibition), *Picturing Asia America: Communities, Culture, Difference*, and *Strange Fruits*.

J. John Priola was born in Denver, Colorado, and currently lives and works in the San Francisco Bay area. He has worked with photography for the past fifteen years in various forms from installation to series, and is represented by Fraenkel Gallery, San Francisco.

Chuck Samuels is a Canadian artist/photographer who lives and works in Montréal.

Joe Smoke is a Los Angeles-based artist who currently works as Fund Raising Coordinator for the Gay & Lesbian Center in Los Angeles. His *Decorator Home* series addresses issues of "queering space, changing closets, and remodeling the nation."

Linn Underhill lives in upstate New York and teaches photography at Colgate University.

Suara Welitoff lives and works in Cambridge, Massachusetts, and is represented by Bernard Toale Gallery, Boston.

carole s. vance

foreword

The Passionate Camera explores the diverse and contradictory passions surrounding sexuality and
photographic imagery with brave and critical intelligence.

The past decade has made it painfully obvious that visual depictions of sexuality can be used to
stir and mobilize furious political and cultural campaigns, including in the USA the sustained
attack on the National Endowment for the Arts (NEA), persistent efforts to block frank public
health education about safer sex, and attempts to reinstate the link between minority sexualities,
disease, and loathing.

At the beginning, the campaign against the NEA might have seemed an impulsive, irrational,
and quixotic assault, given the small number of NEA-funded projects to which conservative and
fundamentalist groups objected (all consisting of photography or performance art). The specter of
legislators denouncing art exhibits they had never seen or ripping up photographic catalogues on
the Senate floor suggested surrealistic moments from the yet-to-be-made video *The Marx Brothers
Meet Foucault*. Despite these farcical moments, the conservative campaign used sexual images
cleverly and strategically as both the target of the attack and the mechanism to foment a
large-scale and persistent sexual panic. The panic raged on for a number of years, exploiting the
slippage between terms like "erotic," "sexual," "pornographic," and "obscene," to eventually and
successfully mainstream the previously extremist convention that all erotic depictions were, by
definition, obscene, or at the very least, dangerous and unbearably controversial.

Sex panics are politics by other means, and the recent campaigns against and through sexual
imagery achieved significant and disturbing results. Long-standing efforts to defund and reduce
the scope of the NEA, largely unsuccessful during the Reagan presidency when framed in terms
of cost-cutting and populism, achieved new success through the strategy of "add sex and stir." In
addition, the endlessly circulated image of the fuming taxpayer, outraged at the use of public
monies for allegedly offensive art, suggested there was a singular and uniform standard of public
taste. Amid growing gender and sexual nonconformity, this sleight of hand erased actual diversity
and real taxpayers, substituting the fiction that all citizens shared the same sexual subjectivity. In
public debates, the sexual image underwent similar consolidation, with its meaning framed as

obvious, stable, and literally read. Sexual images, however, are slippery in more ways than one. They are highly context-dependent, subject to multiple readings, and always in play with the viewer's sensibility and life history. This war on culture attempted not only to remove funding and resources, but to shrink visibility, language, and memory.

This project to narrow and poison the ability of artists – and all citizens – to explore and consider sexually unconventional and queer imagery is paradoxically a testament to the recent proliferation and vigor of such images, as well as the social movements that make possible visual exploration and dissent. The fallout of campaigns against sexual imagery is similarly mixed, producing resistance as well as the intended retraction.

This collection provides a staging ground for diverse visual and critical explorations of passion in all its messy complexity – appetite, desire, hunger, love, lust, fervor, intensity, emotion, and yearning. The passions evoked and interrogated are multiple, not singular, and situated in regard to their historical and cultural contexts.

The project of visualizing passions, for bodies, persons, meanings, and communities, is a vital artistic and political venture. In the face of political campaigns that aim to make sexuality and sexual exploration less visible, and therefore less imaginable, accessible, and legitimate, this book offers a complex and compelling demonstration of what is to be gained (and lost) in political and cultural struggles over the sexual image.

carole s. vance
school of public health and department of anthropology
columbia university, new york

acknowledgments

A book such as this is a labor of love and would not have been possible without the generosity and
support of many, only some of whom I can thank here. I am indebted to Diane Neumaier,
who first encouraged me to edit a special issue of the journal of the Society for Photographic
Education, *exposure*, addressing contemporary issues in photography and sexuality; a project
which became the germ of this book. My thanks, also, to a number of colleagues and friends
whose wise counsel was indispensable to my gathering information about contributors and
artists and thinking through ideas about how to frame significant issues of queer photographic
practice today, especially Doug Ischar, Kaucyila Brooke, Richard Meyer, Margo Machida,
David Deitcher, Mary Patten, and Liz Kotz. Thanks also to Carole S. Vance, Julia Ballerini,
Catherine Lord, Erica Rand, and members of my photo reading group (Judy Black, Eleanor
Hight, Patricia Johnston, Anne McCauley) for offering suggestions and comments on my
introductory essay.

Those whose friendship, collegiality, and good humor sustained me during the years I worked
on *The Passionate Camera* include Amanda Berry, Jennifer Gonzales, Geeta Patel, Kath Weston,
Lia Gangitano, Esther Parada, Paul Franklin, Harmony Hammond, Diane O'Donoghue, Robert
Rindler, James Connors, Susan Stewart, Tee Corinne, Barbara Hammer, S. A. Bachman, Sarah
Hart, Ann Fessler, Paul Franklin, Michael Budd, Scott Cook, Mary Ann Nilsson, Alan Helms,
Elizabeth Grossman, Baruch Kirschenbaum, Beth Stephens, and E. G. Crichton.

I am following in the footsteps of others who have published pioneering books theorizing and
situating gay, lesbian and other queer practices in photography and am in their debt, most
notably: Simon Watney, whose book *Policing Desire: Pornography, AIDS, and the Media* (1987) was
immensely influential on my own thinking around sexual politics and photographic practice;
Douglas Crimp, whose important edited volume, *AIDS: Cultural Analysis/Cultural Activism*
(1987), and his book with Adam Rolston, *AIDS Demo/Graphics* (1990), were crucial texts in
theorizing media images around the epidemic and radical responses to them; the late Tessa Boffin
and Jean Fraser, whose co-edited collection of essays and images, *Stolen Glances* (1990), was a
landmark critical study of photography by and about lesbians; Emmanuel Cooper, whose

illustrated surveys, *The Sexual Perspective* (1994 rev.) and *Fully Exposed* (1995), contributed much to historicizing queer visual art and male nude photography, and the Canadian collective Kiss & Tell (Susan Stewart, Persimmon Blackbridge, Lizard Jones), for their series of provocative projects, *Drawing the Line* (1991), *True Inversions* (1993), and *Her Tongue on My Theory* (1994), which complicated and expanded readings of photographs by and about women's outlaw desires.

The *Passionate Camera* was assisted through various forms of institutional support, including a production grant from the Rhode Island School of Design Faculty Development Fund and the granting of a year's sabbatical leave. As a 1995–96 fellow at the Mary Ingraham Bunting Institute of Radcliffe College, I gained invaluable insights and support from Robin Becker, Carrie Mae Weems, Lorraine O'Grady, and Linda Roach, and enjoyed the good spirits and research assistance of my junior partner, Alena J. Williams. My students keep me in touch with "stuff that really matters" and the need for lucid thinking and writing, and I thank my colleagues in the art history and photography departments at RISD, not only for enthusiastically supporting my research and professional activities, but for providing me with a rich and interdisciplinary intellectual life for which I'm immensely grateful.

I would like to acknowledge by name, and with immense gratitude, those who responded to my desperate fund-raising pleas and made donations to help purchase reproduction rights for some of the photographs used in the essays: S. A. Bachman, Robin Becker, Jill S. Beppu, Pat Berman, Judy Black, Laura Blacklow, Gay S. Block, Leslie Bostrum, Linda Brooks, Jeffery Byrd, Sherman Clarke, Tee A. Corinne, George Creamer, Douglas Crimp, Pamela DeMarris, Damien Dibona, Linda Dittmar, Elsa Dorfman, Renee Eason, Joan Fitzsimmons, Nancy Floyd, Nancy Gonchar, Barbara Hammer, Harmony Hammond, Jean Hardisty, Henry Horenstein, Dorothy Imagire, David Joselit, Robert Kelley, Angela Kelly, Catherine Lord, Joanne Lukitsh, Sallie McCorkle, James R. Meadows, Suzette Min, Frank Noelker, Diane O'Donoghue, Linda Olstein, Esther Parada, Jan Paris, William Parker, Geeta Patel, Julie Pell, Barbara Schulman, JoAnne Seador, Julie Smith, Judith Tannenbaum, Jim Van Buskirk, Ruth Wallen, Carrie Mae Weems, Jane Wenger, Deborah Willis-Kennedy, and Joseph Young.

My editor at Routledge, Rebecca Barden, has been enormously helpful and encouraging throughout this long process, from beginning to end, and I am grateful for her forbearance with this first-time author/editor. Rebecca's commitment to publishing important work in visual culture and criticism, a sadly neglected area in queer studies, cannot be acknowledged enough.

My deepest gratitude is to Linda Dittmar, my partner in everything, whose generosity and critical intelligence had much to do with the success of the entire undertaking, not just her own contribution to it. With good grace, she shared in the woes of missed deadlines, computer traffic-jams, unavailable photographs, mounting debts, design compromises, and more than a few episodes of editorial insomnia. Her love, wisdom, and encouragement were always there when I needed them.

Finally, but above all, my thanks to the fifty-seven (at last count!) contributors to *The Passionate Camera* for their generous and enthusiastic support for the project and willingness to put in the necessary effort to make it happen.

Some of the essays collected here have appeared elsewhere in other forms. I am grateful to those who gave me permission to republish them in this volume.

Kaucyila Brooke's essay, "Roundabout," and Mark Alice Durant's essay, "Lost (and Found) in The Masquerade: The Photographs of Pierre Molinier," initially appeared in somewhat different versions in *exposure*, vol. 29, nos 2/3, 1994.

Michael Anton Budd's essay, "Every Man a Hero," is a revised and expanded chapter from his book *The Sculpture Machine: Physical Culture and Body Politics in the Age of Empire*, London and New York, Macmillan and New York University Press, 1996.

David Joselit's essay, "Mark Morrisroe's Photographic Masquerade," was originally written for the exhibition catalogue, *Boston School*, ed. Lia Gangitano, Boston, The Institute of Contemporary Art, 1995.

Richard Meyer's revised essay, "Rock Hudson's Body," appeared originally in Diana Fuss, ed., *Inside/Out: Lesbian Theories, Gay Theories*, New York and London, Routledge, 1991.

Mark A. Reid's revised essay, "Postnegritude Reappropriation and the Black Male Nude: The Photography of Rotimi Fani-Kayode," appeared in *Wide Angle*, vol. 14, no. 2, April 1992.

James Smalls's essay, "Public Face, Private Thoughts: Fetish, Interracialism, and the Homoerotic in Carl Van Vechten's Photographs," appeared in *Genders*, no. 25, 1997.

Alisa Solomon's "Not Just a Passing Fancy: Notes on Butch" appeared originally in *Theatre*, vol. 24, no. 2, 1993, and is included in her book *Redressing the Canon: Essay on Theater and Gender*, London and New York, Routledge, 1997.

Thomas Waugh's essay, "Posing and Performance," is a revised excerpt from a chapter in his book *Hard to Imagine: Gay Male Eroticism in Photography and Film from their Beginnings to Stonewall*, New York, Columbia University Press, 1996.

Ria Pacquée, from *The Inferno* (Amsterdam, 1995). Courtesy the artist

deborah bright

pictures, perverts, and politics

Decadent or liberating? Elitist or profoundly democratic? Trendy fashion statement or lasting revolution?
Over the past decade, photographs explicitly contesting normative representations of sexuality and
desire have stirred passionate public debate within and without the art world. Whether it
concerned photographs of erotic subcultures, gay men and lesbians, transgendered and transsexual
subjects, sex workers, preadolescent children, or provocatively posed teenagers in fashion spreads,
these two-dimensional constructions on paper and film became, willy nilly, protagonists in what
right-wing populist and ex-presidential candidate Patrick Buchanan termed "the war for
America's culture." The social instabilities produced by the collapse of the Soviet Union, a
changing domestic economy and the political ascendancy of social and religious conservatives in
the 1980s created a climate ripe for scapegoating – not of the policies that promoted local
disinvestment and the rapid redistribution of wealth, but of the corrupting "enemies within":
immigrants, those on public assistance, young unemployed black men, unwed mothers, and gay
men and lesbians who had gained significant political visibility since the late 1960s and who were
making slow and fitful progress toward fuller recognition of their civil rights.

While the poor, urban blacks, and immigrants could be "managed" through punitive
legislation, incarceration, and the roll-back of affirmative action, sexual dissent – most clearly
articulated by educated middle-class feminists and queers – was assailed at the symbolic level
through the repeated public invocation of "traditional family values," organized media assaults on
"political correctness" and "victim politics," and highly publicized political attacks on publicly
funded art (particularly by women and queers) with sexual content. The name of Jesse Helms,
Republican southern senator and flag-bearer for the Christian right, became synonymous with
calls for national legislation to protect "the vast middle-American population" from the kind of
"patently offensive collection of homo-erotic pornography and sexually explicit nudes of
children" being financed by the National Endowment for the Arts.

What was it about photographs of sexually charged subjects that made them so vulnerable to
accusations of "pornography" and "obscenity" – as though these qualities were self-evident and
inhered in the images, and not in the eyes of the beholder?[1] Why did the stakes seem so high

1

where photographs were concerned? The dearth of critical and historical perspectives on photography's agency in the social construction of sexuality (in favor of appeals to "common sense" and "knowing pornography when I see it") that characterized so much of the emotionally polarized debate over the NEA and other censorship scandals indicated the urgent need for a book like *The Passionate Camera*. As editor, I sought to assemble a thoughtful and accessible collection of essays and works exploring a range of historical and contemporary photographic practices which challenge and disrupt the dominant social consensus around sexuality and its representations.

However, my intention for *The Passionate Camera* was not only to respond to political attacks. Another, more positive impetus for producing this book was to document and celebrate what conservatives and religious fundamentalists so fervently wish to suppress: the explosive growth of independent photographic works since the mid-1980s by a critical mass of artists and cultural producers who openly challenge the sexual status quo. This grassroots production was fostered, to a significant degree, by the atmosphere of militance and extreme urgency that accompanied the AIDS pandemic.

Many AIDS activists were members of the arts community which had been devastated by the epidemic. As public censorship accelerated and as social conservatives enacted punitive cultural legislation – exemplified in Britain by the passage in 1988 of Section 28 of the Local Government Act which prohibited state funding for cultural works "promoting homosexuality" or "the acceptability of homosexuality as a pretended family relationship" – a number of artists chose to put their cultural production in the service of an activist politics. They also challenged (less successfully) the prevailing myth that works of art should address only what is "transcendent" and "universal" – that is, disengaged from immediate social struggle. What could be more universal, AIDS activists demanded, than survival itself? As Douglas Crimp put it, "We don't need to transcend the epidemic: we need to end it."

AIDS activism's imperative to historicize and critique the dominant sex–gender system that produces and polices (even as it is produced and policed by) homophobic categories of "normality" and "deviance," and to strategize effective political and cultural resistances to it, gave added impetus to the growth industry within the academy of what has come to be called "queer studies" – a wide-ranging, energetic, cross-disciplinary critique of heteronormativity and its effects. Radical revisions of histories and theories of gender and sexuality by Michel Foucault, Jeffrey Weeks, Gayle Rubin, Monique Wittig, Eve Kosofsky Sedgwick, Teresa De Lauretis, and Judith Butler had an enormous impact on the work of younger artists by the mid-1980s, particularly those emerging from MFA programs in more progressive departments and art schools. Queer production is young: many of the contributors to *The Passionate Camera* are in their twenties and thirties.

Confronted with the imperative to act and show solidarity in the face of conservative attacks on artistic expression, the integrity of museum curatorship, the National Endowments, and academic freedom, historically conservative disciplines such as art history cautiously opened their conferences, symposia and publications to queer perspectives. An active gay and lesbian caucus organized within the College Art Association in 1990 to promote awareness of queer issues and activism among arts professionals. As I write this, the mail brings the latest copy of the organization's academic quarterly, *Art Journal* – a special theme issue on "the Gay and Lesbian Presence in Art." A decade ago, this could not have happened.[2]

a queer book, indeed

If the *Art Journal*'s use of the phrase "gay and lesbian" has an old-fashioned ring to it, it is because in the USA that formula has, since the early 1990s, been largely superseded by the term "queer." Though they are often used interchangeably, they are not the same. The older terms, gay and lesbian, embody two polarities: one between the biological sexes, men and women; the other between hetero- and homosexuality as mutually exclusive modes of erotic object choice. The term "queer," on the other hand, connotes a radical assault on both of these naturalized sex–gender binaries. It embodies the notion of a society where, unlike our own, intimate and social relations among consenting adults can be sustained without being socially regulated either by genital anatomical differences and the power hierarchies ascribed to them, or by the public classification – with real legal and material consequences – of private acts into categories of "normality" and "deviance" in relation to their putative reproductive function. In other words, "queer" points to how all of us might live and love, regardless of how our bodies are marked. The short-lived radical action group Queer Nation branched off from ACT UP in 1990 to promote this utopian "national" consciousness and resist a compulsory, "totalizing" heterosexuality and its minoritizing discourses through street visibility actions and guerrilla media zaps.

While queer critiques ideally encompass the complicating of sexuality by gender, race, ethnicity, and class, nonetheless they often erase these distinctions and share with "gay and lesbian" a worldview that is implicitly white, affluent, and male – the universal subject by default. Furthermore, misapplications of queer theory, particularly misreadings of the writings of Butler and Marjorie Garber, have fostered a misconception of gender identity as voluntarily (even playfully) chosen by a pre-existing autonomous subject, instead of that subject's being itself constituted, named, and made intelligible through historically contingent and instrumental categories such as gender, race, ethnicity, and class.

Shadowing the pronounced shift to the right in the larger political arena, the radical anti-assimilationist critiques of the black, feminist, and gay liberation movements of the late 1960s and early 1970s have given way to a civil libertarian "gay rights" agenda focused more on obtaining the right to conform to societal norms than on profoundly transforming them.[3] The largest gay and lesbian lobbying groups, such as the Human Rights Campaign Fund, have concentrated their organizing efforts on removing the lingering barriers to full citizenship (for those who are already white and middle-class) such as openly serving in the military, winning legal recognition for same-sex unions, changing child custody and adoption laws, and securing the range of social and economic benefits now granted to straight married couples. It was partly their well-developed sense of entitlement to the services and benefits of the state and society that galvanized the fury and militance of AIDS activism among middle-class white gay men; government officials and the media were treating them like "others," like pariahs who were expendable.

Those other Others (queers among them), including urban blacks, the working poor, and non-white immigrants, have more compelling and urgent political battles to fight in a period of manufactured scarcity and shrinking access to adequate healthcare, education, and employment. This may partly account for the present scarcity, relative to works by middle-class whites, of writings and works by blacks, Latinos, Asians, Native Americans, and working-class queers of any race that foreground compulsory heterosexuality as a subject to be interrogated and troubled. When the dominant society has systematically deprived a community or racial group of valorized and dignified symbolic images of basic social identities and relations such as healthy young manhood and womanhood, and strong family life (and, in fact, has pathologized and demonized

these groups' social formations and representations) their participation in queer struggle will necessarily look very different from that of those whose racial and class identities have been institutionalized as the gendered and sexualized ideal to which all must aspire.[4] For example, it is precisely because blacks of both sexes were, and continue to be, violently and sexually objectified by whites that their relationship to sexual dissent is complicated both within and without their communities in ways hegemonic queer politics has mostly failed to account for. Afro-Caribbean author Makeda Silvera hints at these blindspots in her essay "Man Royal and Sodomites":

The presence of an "out" Afro-Caribbean lesbian in our community is dealt with by suspicion and fear from both men and our heterosexual Black sisters . . . The one privilege within our group is heterosexual . . . There is the danger of being physically "disciplined" for speaking as a woman-identified-woman. And what of our white lesbian sisters and their community? . . . We remain outsiders in these groups, without images or political voices that echo our own. We know too clearly that, as non-white lesbians in this country, we are politically and socially at the very bottom of the heap. Denial of such differences robs us of our true visibility.[5]

Mindful of these histories of cultural erasure, *The Passionate Camera* remains strategically queer in its agendas. It is a collection of writings and works which, taken as a whole, trouble the power-ridden normativities of gender and sexuality and their photographic representations across historical contexts, classes, and cultures within western industrial democracies. While the works and essays predominantly address same-sex expressions and desires, *The Passionate Camera* also includes (and seeks to make links among) works and writings about desires and expressions not so easily classified by modern or postmodern terminologies; about emphatically, even hysterically, "straight" practices in photography that can be read against the grain; about the complications and contradictions of production and reception across national, ethnic, and class lines; about practices that insist on the liberatory power of reclaiming and recontextualizing sexist, classist, and racist images as objects of desire; and about the processes of censorship and state repression which strike at sex-dissident women across all classes and orientations, as much as they target gay men.

what mrs grundy saw

This brings us back to the question of why *The Passionate Camera* is primarily concerned with photographs rather than with other representational media such as paintings, drawings, films, or videotapes. Certainly, my aim as editor was not to grant any unique aesthetic status to photographs as objects or even to claim any special pre-eminence for them as a mass communications medium; television outstripped photojournalism forty years ago in terms of market reach. Rather, I am interested in looking at photographs because they tend to get into trouble.

Photography, whether commercial, consumer, or artistic, has always had a vexed relationship to the depiction of sexually charged subjects, though what has been considered taboo has changed over time. Though he pursued his hobby in a pre-Freudian era when children (as long as they were white and middle-class) were considered sexually innocent, author and photographic enthusiast Lewis Carroll betrayed his fear of social censure when he remarked of the intimate portraits he made of friends' children: "I *wish* I dared dispense with *all* costume. Naked children are so perfectly pure and lovely; but Mrs Grundy would be furious – it would never do."[6]

Accounts of the recent battles among image-producers and anti-porn crusaders show that little has changed in 120 years, despite a rising standard of consumption and the loosening of social and sexual prohibitions this has brought. Mrs Grundy is still busy. In recent years, widespread

publicity around child abuse and child pornography has coalesced with toxic stereotypes of homosexuals as child-predators to produce a moral panic. Robert Mapplethorpe's photographs of two young children of personal friends – a naked boy frolicking on a chair and a toddler unselfconsciously lifting the hem of her dress to reveal her pubis – were branded by Helms and his allies as irrefutable "child obscenity."

Photographs are easy targets for scandal because they are what semioticians term "open signs." They masquerade as compelling evidence of the real, while obscuring their status as (always already) mediated representations. As a result, they are assigned a credibility and persuasiveness that inspires belief. By contrast, paintings and drawings make their status as fabricated objects plain – it's understood that they are constructions, not transparent chemical imprints of the visible. Unlike documentary films or television programs, which can also be understood as direct transcriptions of reality, photographs are often viewed as isolated autonomous images, not as frames propelled in time by an edited narrative or sequence which mediates their reception in relatively controlled ways.[7] And even if a photograph initially appears in a specific viewing context such as an advertisement, family photo album, or history book, it is easily extracted from that matrix and re-presented in other contexts for other purposes. Many a teenager's bedroom displays arrangements of images culled from sources as diverse as sports, rock, and fashion magazines to family snaps and greeting cards; all are reactivated as emblems of a particular individual's fantasies and pleasures.

Depending on the viewing context and a viewer's given psychic and social predispositions, any number of meanings can be made from any photograph, both consciously and unconsciously (as advertisers know so well). Meaning is not sealed by the frame of the image. In photographic education and criticism, however, formalist methodologies dominated interpretative discourse until the early 1980s.[8] Photographic signification was reduced to whatever could be extracted from a close reading of the image's structure – its framing, vantage point, detail, and so on – while modes and contexts of production and reception (e.g. Mrs Grundy) were disregarded. The critical revolution produced by various postmodern and deconstructionist critiques – from semiotics to psychoanalysis (via film theory) to postcolonial, feminist, and neo-marxist critiques – revolutionized photographic art practice and pedagogy even as it had already transformed literature and film studies by the late 1970s.

These new critiques would soon prove their mettle in theorizing, unmasking, and combating the misrepresentations and distorted public images (and the dominant social agendas they served) that suddenly engulfed gay men, lesbians, and others in the wake of AIDS. Trained art historians and critics such as Craig Owens, Douglas Crimp, Simon Watney, and Jan Zita Grover brought sophisticated visual analyses to bear on how mass-media and art photographs constructed bigoted stereotypes of diseased homosexual bodies bearing the stigmata (lesions, emaciation) of their shame and depravity. After ACT UP/New York formed, artist affinity groups such as Gran Fury produced brilliant graphics for the various media "zaps" and street demos ACT UP organized.

manufacturing a moral panic

The political objective of conservative politicians and religious leaders who launched the 1989 attack on separate NEA-funded exhibitions of photographs by Robert Mapplethorpe and Andres Serrano was to halt federal funding of non-profit cultural production, including independent scholarship and public television, as well as the arts. This was ideological warfare masquerading as deficit cutting, for the funds at stake were insignificant in the context of the entire federal budget. In fact, as business patrons and arts lobbyists tirelessly pointed out, the arts were a proven growth

industry in terms of dollars and jobs generated in the service sector. Rather, conservatives accurately perceived that the National Endowments for the Arts and Humanities were liberal Great Society programs invested in promoting limited forms of cultural democracy in the wake of violent racial unrest in the early 1960s. For all of its inherent bureaucratic diffidence, the NEA and its state arts agencies had fostered the growth of community-based art and art criticism during the 1970s and 1980s, providing diverse, grassroots, and even oppositional voices with the modest means to survive and build an audience base outside the profit-driven arts and entertainment marketplaces.

Nurtured by NEA-funded alternative spaces such as Franklin Furnace and Artists Space in New York, Los Angeles Contemporary Exhibitions (LACE), New Langton Arts and Camerawork in San Francisco, Randolph Street Gallery in Chicago, Nexus in Atlanta, the Visual Studies Workshop in Rochester, Mobius in Boston, Diverse Works in Houston, and Film In The Cities in Minneapolis–St Paul, and publicized through (formerly) NEA-funded organs such as *Afterimage*, *Heresies*, *Artpaper*, *New Art Examiner*, *High Performance*, *Framework*, *Views*, *exposure*, *Nueva Luz*, *New Observations*, *Camerawork*, *Shift*, and *Art Papers*, images and works exploring new constructions and visions of sexuality and gender were produced, exhibited, and publicized, along with works by other socially and historically marginalized groups, including blacks, Asians, Native Americans, Latinos, sex workers, feminists, labor activists, and inner-city youth. It would be precisely these non-profit organizations that would bear the brunt of the funding cuts.[9]

Robert Mapplethorpe's posthumous retrospective, *The Perfect Moment*, which included a portfolio of small images of posed subjects from New York's gay male leather and s/m subcultures, was indeed "the perfect moment" for the right to escalate a public attack on NEA-funded photography exhibits that had begun several months earlier when the Reverend Donald Wildmon's American Family Association bombarded Congress with mass mailings about Andres Serrano's image *Piss Christ*. As feminist anthropologist Carole S. Vance pointed out, fundamentalist leaders and right-wing politicians had perfected an effective strategy at the symbolic level to both mobilize their own grassroots and simultaneously immobilize their opponents.[10] By singling out individual photographs – whether of a crucifix immersed in urine or of a leatherman pissing in another man's mouth – and isolating them from their contexts, conservatives could impute to these images whatever nefarious meanings and motives they wished, thereby framing the artists' supporters as defenders of "filth." Furthermore, by portraying art museums and the National Endowment as elitist purveyors of anti-Americanism and perversity, the right fanned the durable flames of class resentment among their lower middle-class and working-class base whose livelihoods and families had been hardest hit by global economic changes.

In the USA, no work can be deemed legally obscene if, taken as a whole, it can be shown to possess "literary, artistic, political or scientific merit."[11] But, intimidated by the mobilization of what appeared to be mass outrage and fearing for their remaining federal funding, museum administrators, Endowment officials, the press, and other public-opinion leaders could not bring themselves to defend Mapplethorpe's photographs publicly – nor the works of other queer and sex-radical artists who were under attack such as David Wojnarowicz, Karen Finley, Tim Miller, John Fleck, and Holly Hughes (and later, photographers Barbara DeGenevieve and Merry Alpern) – as having "artistic merit" *precisely because* they artfully disrupted normalized assumptions about the nature of sexual desire. In 1990, Congress enacted legislation (upheld by the Supreme Court in a ruling eight years later) requiring the Endowment to take into account "general standards of decency" in awarding grants. Local acts of illegal situational censorship proliferated and, more

insidiously, these scandals and their attendant press accelerated self-censoring among art professionals and institutions which backed off from controversial subjects rather than risk adverse publicity.

resisting normality

It became clear, then, that bodies of criticism needed to be developed that would anchor and contextualize visual expressions of sexual dissent as an important democratic tradition with long subversive histories of their own, often linked to other narratives of social struggle. Feminists had already pioneered this terrain with their potent challenges to dominant social constructions of gender and the family, the latter institution privileged in the modern industrial state with socializing children into acceptable roles and traditionally maintaining a patriarchal sexual and economic order. As declining male wages after the 1960s necessitated two-earner families to maintain a middle-class living standard, the old bargain of female economic dependency in exchange for male honor and protection became increasingly untenable.

New sexual and reproductive freedom brought by advanced birth control technologies, and increased educational and economic opportunities for middle-class women in the still-expanding economy of the 1960s, brought changes in both the symbolic and material realms as women fought to wrest control of their images, their bodies, and their productive and reproductive labor in both public and private life. Feminist consciousness-raising, boycotts, and direct action had a marked impact on public representations of white middle-class women in US consumer advertising. No longer did they seem wholly obsessed with spotless glassware or with catching and keeping Prince Charming in their Maidenform bras.[12]

On the other hand, images of women's bodies have remained objects of intense and painful contention among feminists. The "porn wars" of the late 1970s and 1980s pitted those women who explored sexual subjects and eroticism as a necessary intervention in a territory historically reserved for male commerce and privilege against those who believed that any sexualized images of women's bodies, without exception, promoted misogyny and violence against women. For radical anti-porn feminists, anything that one woman found offensive in an image could be construed as contributing to the subordination of all women and would therefore be prosecutable under the kinds of legal reforms advocated by feminist lawyer Catharine MacKinnon and writer/activist Andrea Dworkin. The stakes were raised in the porn wars in 1984 when MacKinnon allied herself with religious conservatives to promote the enactment of such laws in Indianapolis and Minneapolis.

The assumption of women's universal victimhood in relation to sexual images (and sexual desire itself) galvanized a countervailing feminist activism, spearheaded by progressive heterosexual feminists such as Ellen Willis, Dierdre English, and Paula Webster, who were also joined by Pat Califia and other urban lesbians who, along with gay men, were enjoying a renaissance of sexual visibility in the wake of the women's and gay liberation movements. In 1981, a San Francisco-based lesbian-feminist s/m support group, SAMOIS, published *Coming to Power*, a daring anthology of writings, drawings, and photographs exploring s/m fantasy and lesbian leather culture. The book unleashed a storm of protest by anti-porn feminists who saw in the pictures of bare-breasted, leather-clad women sporting whips, handcuffs, and collars terrifying phantasms of male-identified violence. That same year, the Heresies Collective in New York published its famous Sex Issue as a protest against anti-porn organizing among feminists, and, in 1982, over eight hundred women attended a scholarly conference exploring female sexuality at Barnard while Women Against Pornography led noisy and disruptive demonstrations outside.

The first independent commercial porn magazine by and for lesbians, *On Our Backs*, was founded by Debi Sundahl in 1984 and was emblematic of this militant defiance of cultural feminist "correctness." Even the magazine's name was an unsisterly jab at the scrupulously feminist *off our backs*. Fantasy images by photographers such as Honey Lee Cottrell and Morgan Gwenwald of seduction scenes, girl-gang sex, sculpted bodies, pierced labia and nipples, leather and lace, and eager fingers, fists, tongues, and dildos filled each issue, accompanied by short erotic fiction pieces. Ever mindful of its grassroots mission, *On Our Backs* sponsored erotic photography contests for readers. Other lesbian porn magazines such as *Bad Attitude* and *Outrageous Women* followed, and lesbian porn videotape production flourished. Books such as *Caught Looking*, published by the Feminist Anti-Censorship Task Force (FACT) in 1986, insisted on women's right to sexual and erotic agency, including both producing and consuming pornography. In its pages, *Caught Looking* presented a photographic smorgasbord of polysexuality: women and men arousing themselves and each other in every way imaginable, from all periods in photographed history. By showing such a wide-ranging selection of porn, *Caught Looking* sought both to demystify it and to demonstrate that it wasn't the instrumentally misogynistic product anti-porn feminists described. Rather, it catered to an array of nuanced fantasies and desires, utterly disrespectful of gender conventions.

Rejecting cultural feminism's desexualized ideal of "woman-identified" sisterhood, pro-sex dykes (as they often called themselves) promoted an assertively sexual stance, often looking for inspiration to gay male sexual subcultures with their bars and sex clubs, eroticized codes of dress, explicit pornographies and inventive use of sex toys and props. In a decade of sexual backlash, this was a defiantly *political* agenda and melded well with AIDS activism's militant pro-sex message. With the founding of ACT UP in 1987, women activists appropriated countercultural emblems from both punk and working-class drag to signify their solidarity with the movement and its in-your-face militancy: black leather jackets, boots, tattoos, T-shirts with buttons and stickers, and bandannas. Side-by-side with gay men – an historically unprecedented coalition – AIDS-activist dykes advocated an explicit politics of "safe sex" and lots of it in the face of loud public abstinence campaigns, gay bashing, and sex-phobic scare-mongering in the press.

Among younger "gen-X dykes and fags" in their teens and early twenties, who shared no history with older feminist sex debates and showed little patience for them, a lively grassroots cultural production flourished in the form of videos and zines: cheaply produced homemade magazines that had sprung from the "do-it-yourself" ethos of punk rock fanzines of the early 1980s. Zines were extremely small-scale and catered to queer subcultures including ethnic and racial groups, aficionados of specialized erotic tastes/techniques, fans of particular cult/camp icons from popular culture, religious survivors – in short, anyone with access to a word processor, a photocopier, and a dissatisfaction with what mainstream gay and lesbian periodicals such as *The Advocate*, *Genre*, *On Our Backs*, *Out*, *Poz*, *Ten Percent*, *Girlfriends*, and *Deneuve/Curve* had to offer. Names like *JDs*, *Cunt*, *Bimbox*, *Girljock*, *Bamboo Girl*, *Fierce Vagina*, *Anything That Moves*, *Whorezine*, *Jailhouse Turnout*, *Frighten the Horses*, and *Bitch Nation*, made explicit the anti-(gay/feminist)-establishment sexual politics of zine culture. Zines exhibited all of the spunk, black humor, and youthful brio of their Dada and surrealist predecessors. Local alternative, gay, and feminist bookstores carried the little publications, and distribution networks formed. By 1991, the first international conference of queer zines, "Spew," was held at Randolph Street Gallery in Chicago and in 1996, New York's New Museum acknowledged the phenomenon in its interactive exhibition *alt. youth. media*.

Another manifestation of the new sexual militancy after the mid-1980s was lesbians' embracing of their own outlaw histories of early twentieth-century sexual inversion ("mannish"

cross-dressing lesbians exemplified by Stephen Gordon in Radclyffe Hall's 1928 novel *The Well of Loneliness*) and working-class "butch femme" subcultures which had flourished in urban bars during the "dark ages" between the Second World War and Stonewall. Such gender-role identification had been scorned by many middle-class lesbian feminists during the preceding decade as male-identified and anti-feminist. This condescending and judgmental attitude had effectively excluded and alienated an older generation of lesbians from the women's and gay liberation movements. As working-class femme writer Joan Nestle so eloquently lamented, feminists who rejected butches' and femmes' hard-won dignity (often at the end of a fist or policeman's club) had little to offer them.

The 1993 publication of *Stone Butch Blues*, Leslie Feinberg's fictionalized autobiography of a motorcycle-riding, working-class, "passing" pre-Stonewall butch, made the author an overnight celebrity on the lesbian culture circuit. The fantasy image of the young lean leather-jacketed, tattooed outlaw, having her strap-on fondled by her "tarted-up" girlfriend, was already being played out in the photographs of Gwenwald, Cottrell, Della Grace, and Jill Posener, among others. A dazzling selection of suit-and-tied, buzz-cut, booted, biker-jacketed, muscled, cigarette-dragging and dildo-wearing butches can be enjoyed in the recent publication *Nothing But the Girl: The Blatant Lesbian Image* (1996), edited by Susie Bright and Posener.[13] However, the "butch femme" revival elided the social and psychological roots of those choices, including their class origins (i.e., the economic options available to working-class and poor women), and their significance in securing a longed-for coherence between a deeply-felt "authentic" gender identity and its physical embodiment. For Leslie Feinberg, Doris Lunden, Marion Paull, and others, passing as a man in a society that equated gender with anatomy – and allocated resources and privileges on that basis – was not a playful semiotic subversion of an oppressive regulatory regime, but a necessary survival strategy within it.

Inevitably in consumer capitalism, when subcultural styles catch on among white middle-class youth, it means big business, especially if their countercultural "look" can be skimmed off from its politics with a minimum of fuss. The new sexual attitude had an enormous impact in the arena of fashion and retail in the early 1990s, particularly among young educated childless white women enjoying their unprecedented "post-feminist" economic mobility. In May 1993, *New York* magazine announced "lesbian chic" with butch pop idol k. d. lang on its cover, noting the new visibility of lesbians among the political, entertainment, and sports elites. Bill Clinton's first election produced a euphoria among queers who had campaigned hard for his victory and hoped for relief from conservative dominance in national government. After taking office in 1993, Clinton appointed Roberta Achtenberg, an open lesbian, as Assistant Secretary of Housing and Urban Development and, in one of his first presidential actions, tried to lift the ban on gay men and lesbians openly serving in the military. Although this initiative was ultimately defeated by the Pentagon and its conservative allies in Congress, the attempt demonstrated the new access gay and lesbian lobbyists enjoyed at the beginning of Clinton's presidency.

In the professional sports and entertainment worlds, tennis champion Martina Navratilova and former Olympic diver Greg Louganis went public with their same-sex orientations while lang made an even splashier appearance on the August 1993 cover of *Vanity Fair*, lathered up for a shave by teddy-clad super-model Cindy Crawford. *Cosmopolitan* magazine, that bible of "sex and the single girl," featured a lead article on "Being a Gay Woman in the 90's" in the November issue, while movies and television sit-coms cautiously began to incorporate sympathetic lesbian characters into their story-lines. Throughout the early 1990s, teen idol Madonna flamboyantly advertised her switch-hitting ways and brought queer subcultural styles to the shopping mall. But as Danae Clark and others have pointed out, such appropriations of queer signs effectively

"de-gays" them and transforms them into safe consumer style choices any woman, queer or straight, might make.[14]

Lacking alternative (non-profit) forms of visible association available to other groups such as kinship systems, churches, social-service clubs, and educational institutions, community-building by middle-class metropolitan gay men and, to a lesser extent, lesbians has been largely mediated by consumption: clubs and bars, gyms, restaurants, periodicals, literature, phone-sex lines, tours and resorts, merchandise, and social services. If anti-censorship feminism and AIDS activism provided the motive force for many middle-class women's explorations and assertions of sexual agency in the late 1980s, middle-class white gay men were fighting to retain their two-decades-old gains in visibility and economic power within the gentrifying urban enclaves they had colonized for themselves in the Castro, the South End, Newtown, West Hollywood, and the West and East Villages – a visibility and power that the AIDS epidemic and the intensifying conservative backlash threatened to erode.

Inspired by the feminist and Black Power movements of the 1960s, a militant gay liberation movement had insisted upon public visibility by "coming out" and standing up to police predation and brutality, most notoriously in the 1969 Stonewall riots, the mythicized touchstone of gay liberation. The post-Stonewall image of the proud, vigorously masculine gay white man in his late twenties – typified by the clone look of the late 1970s and whose manifold sartorial symbols were catalogued by San Francisco photographer Hal Fischer in his small self-published book *Gay Semiotics* (1977)[15] – affirmed male homosexuality as virile, legitimate, and healthy, as opposed to effeminate, deviant, and pathological. It was only in 1973, after all, that the American Psychiatric Association – over the objections of numerous clinicians – had removed homosexuality from its list of mental disorders.

Historically, male homosocial and sexual institutions and communities had evolved quite apart from those of women, reflecting the dichotomous spatial arrangements of gender in industrial societies: bourgeois women were defined in relation to (the unpaid labor of) marriage and family while men occupied the public sphere of wage labor outside the home. Men migrated to urban centers where there were jobs and where institutions existed that fostered "the life" – a "queer" life lived parallel to and undetected by most heterosexuals. Being forced to hide their desires from families, fellow workers, neighbors, and police did not mean gay men were invisible to each other. In his excellent study *Gay New York*, historian George Chauncey charts the highly complex spatialities of urban homosexual male commerce and visibility (even across class and race lines) from the 1890s to the 1940s: the saloons, speakeasies, bars, cafeterias, drag balls, bathhouses, parks, and clubs.[16] Here men could meet other men for companionship and sex and resist (to varying degrees) pressures of social conformity in the years before formal political organizing emerged. Chauncey's study reconstructs a multifaceted gay world that existed with a surprising amount of openness in New York until the 1930s when a cultural backlash spawned by the Depression produced stringent new laws aimed at suppressing public visibility of homosexuality in entertainment, employment, and social life. The postwar Red Scare with its publicized purges, witchhunts, and linking of homosexuality to pathology and communism constructed the deep closets where most hid their queer lives between 1945 and 1970.

Photographs depicting or hinting at lived men's and women's transgressive desires in the years before Stonewall have become precious relics, treasured and woven into the narratives queers have constructed about their suppressed histories. From the anonymous tintypes, cartes-de-visite and snapshots found in thrift shops and flea markets to the hellenistic romps of Baron Wilhelm von Gloeden and campy "Christs" of F. Holland Day, to the "glamour generation" fashion photographers of the 1920s, to the beefcake "pin-ups" in physique magazines, images suggesting

eroticized male–male relations from photography's beginnings to gay liberation have been lovingly excavated, published, and written about.

On the other hand, lesbian or "sapphic" photographs were almost exclusively produced by men as a staple fantasy of straight porn. As "normal women" were not believed (permitted) to be interested in sex outside of marriage and reproduction, no self-identified erotic image commerces by and for women developed until the 1970s, within the context of feminism. In her introduction to *Nothing But the Girl*, Susie Bright remarks that, when she came out as a lesbian in 1974, the only book of contemporary erotic photographs of women together she could find was David Hamilton's *Sisters*, a male fashion photographer's dewy images of long-haired blonds in romantic poses. "Lesbians might like to laugh or deny it now," Bright writes, "but this book graced many a 1970s dyke bedroom, often accompanied by the matching posters on the wall."[17] The longing and labor to reconstruct a usable photographic past where women could look at and photograph each other with desire characterizes a number of the contributions by lesbians to *The Passionate Camera*.

The same holds true for non-white men and women whose desires and bodily image heritages are also marked and shaped by historical subordination. As among lesbians, the pornography debates opened a wedge between white and black gay men, the former defending porn with libertarian arguments privileging the individual consumer and his right to sexual pleasure, while the latter's relationship to porn, as Kobena Mercer points out in his discussions of Mapplethorpe, is one of extreme ambivalence. As R. W. Connell has remarked: "To treat one's body as a private possession (the basis of the discourse of sexual rights within a capitalist society) is to refuse the issue of inequality among owners."[18] Nonetheless, pornography was one of the few sites where eroticized photographs of black men's bodies were visible to other black men as well as to whites. These images frequently evoked an enduring repertoire of colonial-slavery stereotypes ranging from the primitive super-stud to the exotic feminized "house boy," stereotypes used to justify white supremacy. Though fully aware of the oppressive dimensions of these staged representations, Mercer writes: "we are fascinated, we still want to look, even if we cannot find the images we want to see."[19] The active making of alternative meanings and exploiting the slippages of pornographic conventions to recode readings of black queer desire marks the works of a number of artists such as Lyle Ashton Harris, Glenn Ligon, Ajamu, Terrence Facey, Danny Tisdale, and Rotimi Fani-Kayode, and film-makers such as Isaac Julien and the late Marlon Riggs.

While the Greco-Roman male nude enjoyed privileged status as the emblem of the European masculine ideal since the Renaissance, its "nakedness" (to invoke Sir Kenneth Clark's problematic distinction) was taboo – nakedness being understood as eroticized and therefore sexually vulnerable. The erect penis was understood in western culture to be the *echt* sign of penetrating male dominance over women and lesser males, yet it could signify its governing power only by remaining hidden. Its invisibility, or, more accurately, its latent presence, signaled the sublimation of the passions by the intellect (indicating superior civilization) while simultaneously constructing a visible erotics of "others," scrupulously documented in criminal, medical, ethnographic, and pornographic archives. The fantasmatic projection of outsized genitals on to men and women of African descent is symptomatic. By the same token, priapic visibility – or its tantalizing promise evident in telltale bulges – made male desire "seeable" to homosexual men in a world that severely regulated and punished transgressions of male homosociality. Gay male pornography is nothing if not a visual encyclopedia of the aesthetics of penile and testicular presentation.

Eve Kosofsky Sedgwick has argued that the homosocial bonds of male domination are constituted, in part, by the repudiation of erotic bonds among men. It was precisely the ability to project that eroticism on to others – women, blacks, and homosexual men – that guaranteed the

masculine identity and superior status of (ostensibly heterosexual) white men. In the 1970s, when white feminist artists such as Judy Dater, Jackie Livingston, and Sylvia Sleigh sought to realign gender relations symbolically through representation, one of the most popular tactics was to make paintings and photographs of supine naked men – their flaccid penises visibly cradled against their thighs. The effect was not exactly earth-shattering and did nothing to change real-world power relations, but the art-historical gesture was clear enough.

In his book *Fully Exposed: The Male Nude in Photography*, Emmanuel Cooper recounts the critical reactions in the art press, ranging from disdain to outright hostility, which greeted the 1978 photographic exhibition *The Male Nude* at Marcuse Pfeifer Gallery in New York.[20] Only six years later, hunky young white boys clad only in their form-fitting Calvins (and lovingly posed and lit by fashion photographer Bruce Weber) appealed overtly to gay male consumers in mainstream print and billboard advertising. Despite a full-fledged moral panic, fine-art monographs of Mapplethorpe, Weber, Duane Michals, Arthur Tress, and Herb Ritts sell briskly in upscale bookstores, and major museum retrospectives are not uncommon. But it would be a mistake to read such class-restricted commerces as signs of real progress in social toleration. White middle-class queers may be welcomed by advertisers as a niche market, but they are still not regarded as full citizens in the eyes of the law.

As demonstrated in the highly politicized debates over gays in the military, "gay marriage" laws, and organized efforts to repeal local antidiscrimination statutes, changing a few class-specific images in the media is not the same as changing legalized bigotry and institutionalized ignorance. Only collective political action will accomplish this, action across a broad range of alliances and with a full consciousness of our own differences of privilege and struggle. As Rosemary Hennessy reminds us, "Redressing gay invisibility by promoting images of a seamlessly middle-class gay consumer or by inviting us to see queer identities only in terms of style, textuality, or performative play helps produce imaginary gay/queer subjects that keep invisible the divisions of wealth and labor that these images and knowledges depend on."[21] Ensconced in our privileged sanctuaries of the academy and art studio where we can create contingent visual illusions of a fully habitable world, it's easy to forget how little has changed; how contained and "boxed in" our discourse is; how few lives we actually touch; how much fear of our "difference" and all that it represents still remains. While celebrating the vigorous growth of queer scholarship and photographic production over the past decade, I realize with a chill that *The Passionate Camera* could well become its memorial should the economic climate worsen and the repressive public tolerance we now labor under further dissipates.

an overview of the essays

The Passionate Camera is divided into three sections of essays, separated by two portfolio inserts of photographs. The essays represent a range of styles and genres of writing, from conventional scholarly contributions to more personalized forms, including memoir, short fiction, and self-interview. This heterogeneity reflects the necessary inventiveness of new queer cultural production and criticism where the enforced silences, gaps, and elisions of history demand the overt deployment of a certain imaginative labor of reconstruction and reinvention on the part of artists and writers working with this material. But all were selected and organized to enhance the ways in which the individual contributions enrich and reflect each other and create a complex and rich critical framework for the photographic works featured in the portfolio sections. As I commissioned and assembled the essays, three distinct clusters emerged: roughly, those essays addressing various photographies from the (pre-Stonewall) past; practices and expressions from the

more recent past and present; and, finally, case studies where photographs played a key role in larger political and cultural debates around sexual dissent and queer visibility.

The first section of essays, "Trouble in the Archive," features provocative queer readings of photographs from diverse historical archives, including antique studio portraits, physical culture photographs, fashion and dance photography, art photographs, and personal pornography. In his essay, "Looking at a Photograph, Looking for a History," David Deitcher reads an anonymous mid-nineteenth-century studio portrait of two men, a brilliant demonstration of the kind of imaginative retrieval and historical reconstruction necessary for making such artifacts mean and creating a usable queer past. Michael Anton Budd's essay, "Every Man a Hero: Sculpting the Homoerotic in Physical Culture Photography," looks at photographs of male bodies from the late nineteenth-century physical culture movement, particularly the ways in which pose artists such as Eugen Sandow crossed class lines from the music-hall stage to physical culture entrepreneurship by constructing an eroticized "national" male body that was useful to a growing middle-class consumer economy in the age of imperialism.

In "Posing and Performance: Glamour and Desire in Homoerotic Photography, 1920–1945," Thomas Waugh discusses the "glamour generation" of studio photographers, culturati, dancers, and actors who formed tight social circles in New York and Europe during the interwar years. Photographers such as Hoymingen-Huene, Horst, and George Platt Lynes produced a new homoerotically inflected visual pleasure in photography of the male body in fashion, advertising, entertainment, and the performing arts – an eroticism suppressed when war mobilization demanded a more "manly" iconography. In his carefully argued essay which follows, art historian James Smalls focuses on photographs by one of the "glamour generation's" inner circle, Carl Van Vechten. Well known as a public patron of the Harlem Renaissance and portraitist of black celebrities, Van Vechten's privately posed studio images of interracial couples and black male nudes betray the complex and contradictory psychosexual character of the racial and sexual fetishization of black men's bodies among elite urban white gay men in the waning days of colonialism. Smalls shows how Van Vechten's photographs are sites of intersubjective regimes of power and desire that are fluid and multiple, producing spaces, as well, for black gay male and interracial erotic desire to manifest itself in a world where few such representations exist or are unilaterally dismissed as inherently racist and exploitative.

French surrealism provided the fertile ground for the two photographers discussed in the essays by photographers Kaucyila Brooke and Mark Alice Durant. Brassaï (Gyula Halasz) was emphatically "straight," prowling the sexual underground of night-time Paris with his camera, while Pierre Molinier, who came to the surrealist scene after the Second World War, was too "bent" even for André Breton who expelled him from surrealist circles for the flagrance of his blasphemous perversity. In his essay, "Lost (and Found) in a Masquerade," Durant investigates the elaborate autoerotic world Molinier constructed in his provincial studio, populated by anatomically fantastic hybrids who gratified their creator's manifold desires for release from the limitations of the highly regulated bourgeois Catholic body. Brooke takes us on a more autobiographical journey, romancing Brassaï's tuxedoed butches and coifed femmes across time and the complicated "roundabouts" of her own efforts to photograph and represent lesbian desire. Transgressing the voyeuristic distance which surrounds these photographs, Brooke reimagines Brassaï's scenes through her own desiring lens, refusing Berenice Abbott's anguished admonition that such things must remain not only unspeakable but unimaginable. Catherine Lord's short fiction piece, "Her Garden in Winter," echoes Deitcher's opening essay and provides a fitting closure to the section with its meditation on a found snapshot of one woman, photographed by another.

The second section, "Inverted Views and Dissident Desires," investigates more recent works and critical approaches to photographing outlaw desires since Stonewall. In 1971, photographer Larry Clark published his instant photo classic, *Tulsa*, followed in a little over a decade by *Teenage Lust*. Both books represented a quasi-autobiographical return to a highly sexed, white-trash "bad boy" adolescence the photographer idealized. In his provocative reading of Clark's *oeuvre*, "Rough Boy Trade: Queer Desire/Straight Identity in the Photography of Larry Clark," José Esteban Muñoz sees Clark as actively policing the border between *wanting to be* and *wanting to have*, but failing to stanch its homoerotic leakages. Even the presence of females in the photographed scenes fails to contain successfully the photographer's voyeuristic fascination with the straight boys he photographs and their homosocial "outlaw" rituals. It's not that Clark is a repressed homosexual, Muñoz reminds us, but that his "desiring lens" with which he photographs this "trade" subverts the seamless spectacle of heterosexuality the pictures promise to deliver.

David Wojnarowicz did not find his queer desires mirrored in post-Stonewall gay liberation when he set out in 1978 to make his first completed artwork, a photographic documentation of his fictitious *Rimbaud in New York*. As Mysoon Rizk shows in her study of this little-known series, "Constructing Histories," this former hustler and talented street kid used his fabricated Rimbaud to create for himself a usable model for his budding identity as a queer artist-poet. In his essay, "Mark Morrisroe's Photographic Masquerade," David Joselit brings a more traditional formalist analysis to bear on the photographs of another kid hustler-turned-artist, the late Mark Morrisroe. Joselit traces Morrisroe's deployment of sandwiched negatives, disruptions of figure–ground relationships, and surface markings as analogous to the artist's efforts to "write a new life" for himself as a masquerader across gendered and corporeal boundaries, including the limits of his own impending mortality.

Liz Kotz steps back and takes a longer view of Morrisroe's generation of art photographers, clustered around Nan Goldin, who have been promoted in a number of recent exhibitions and catalogues as practitioners of a new kind of "intimate" documentary photography. The images are seen as mirroring the artist's autobiography rather than neutrally presenting a selection of visual facts as in canonical modernist documentary. Besides Morrisroe and Goldin, this group includes US photographers Jack Pierson, David Armstrong, and Philip-Lorca diCorcia and European photographers Richard Billingham and Wolfgang Tillmans. In her essay, "Aesthetics of 'Intimacy,'" Kotz focuses on the works of Morrisroe, Goldin, and Pierson, analyzing what happens to that promised moment of private disclosure when these photographs are transformed into ubiquitous public commodities, photographic *punctums* available wholesale. Furthermore, what are the implications for queer politics of the largely uncritical embrace of this kind of work and its constructed discourse of the private?

In "Postnegritude Reappropriation and the Black Male Nude," film scholar Mark A. Reid discusses the work of another photographer tragically taken by AIDS: Nigerian-born, US-educated, and London-based Rotimi Fani-Kayode. Rotimi's upbringing as heir to a Yoruba dynasty, and the acknowledgment of his own queer desires in exile, presented seemingly irreconcilable choices. As Reid shows, however, Rotimi refused these dichotomous "either-ors," and created a vibrant living embodiment (in both senses) of his hybrid sexual and diasporic identity as a post-independence Afro-British queer.

The digitized multiple self-portraits of Yasumasa Morimura, a Japanese artist whose works have received significant exposure in the West, present another kind of post-national hybrid queer identity, at once post-Japanese and post-European. Morimura appropriates his image referents from contexts as canonical as kabuki theater and western art history to the latest international icons of popular entertainment and fashion. As Paul Franklin elucidates in his essay, "Orienting

the Asian Male Body in the Photography of Yasumasa Morimura," beyond mere po-mo camping and dragging up for the camera, Morimura puts his fingers (quite literally) on the dark underside of white, Asian, and queer sexism and racism. As an out and proud "sissy boy" himself, Franklin identifies in his essay with Morimura's swishy strategies of seduction and refusal.

In their edited conversation "Black Widow," brothers and independent artists Lyle Ashton Harris and Thomas Allen Harris investigate the complex autobiographical and political contexts that informed two of their collaborative photographic projects, *Brotherhood, Crossroads, Etcetera* and *Orisha Studies*. Both projects, as well as their independent works, follow in the tradition of African American art and literature which has been a process of giving shape to public selves that "protest the degradation of their ethnic group by the multiple forms of American racism." Drawing from personal histories played out in the political spaces between Black Power and black nationalism, and invoking ancient African cosmologies as well as Judeo-Christian myths, the Harris brothers create complex allegories invoking public and private desires, including the deeply taboo desires of black men and brothers for each other.

Theater critic Alisa Solomon gives a complex and politically savvy reading of the iconography of lesbian "butch" in her essay, "Not Just a Passing Fancy: Notes on Butch." With humor and acuity, Solomon pokes holes in notions of gender-play as value-free (e.g. "lesbian chic") and grounds the power of the butch image in its disruptive and transgressive effects in terms of its intended audience. Butches address their butchness to women, thereby exposing the artifice of masculinity (and male power) itself. It is that repeated taunt, "Hey, whadda you? A boy or a girl?", that signals the destabilization of gender categories; a destabilization which provokes the severest violence by those desperate to maintain them and the promise of power they guarantee.

In her photo-essay which follows, "Looking-class Heroes: Dykes on Bikes Cruising Calendar Girls," artist Elizabeth Stephens recuperates the leather-clad "biker dyke" image for an erotic fantasy life rooted in her own white rural girlhood. Using her camera, she evokes the world of "Tool Girls" – the scantily clad pin-up models who adorned the tool sales calendars in her father's machine shop and whose images were denied to her as objects of sexual fantasy by the homosocial rules of the male blue-collar workplace. In revenge, Stephens claims for herself the envied machismo of the outlaw Harley biker who never rides the "bitch pad," cruising the streets and making pictures of her perfect calendar girl. Closing the section, Catherine Lord revisits another remembered site of transgressive butchness in her short story "Looking for My Museum." Reinvoking a time when feminism erased working-class bar culture from the lesbian map, Lord gives us a loving portrait of Marion, the last stone butch at the Riv.

The third section, "Calculated Exposures in Risky Conditions," goes beyond questions of individual or subcultural expressive art practice to analyze the photographic production of sexual difference (or sameness) within the larger contexts of triumphant consumer capitalism, two decades of rolling conservative backlash (now focused on the repeal and prohibition of local anti-discrimination laws), and the burn-out, fragmentation and co-optation of organized militant activism. It is easy to mistake the profusion of queer image-making and theorizing such as that exhibited in the previous selections of essays and photographs for real progress in social transformation. This last group of essays is intended as a corrective to that perception. In fact, it becomes painfully clear that the new "queer visibility" we are celebrating has been achieved largely for the minority of queers already privileged by society and at the expense of the majority who are not. It has also come at the price of uncoupling queer politics from other struggles for social and economic justice, as has been noted by more than a few critics on the left who are discomfited by the paradox of the emergence of middle-class queer media visibility precisely at

deborah bright

the moment of conservatism's triumphant dismantling of the national welfare state and programs to increase access to economic opportunities for women and nonwhite men.

Linda Dittmar explores this contradictory economy of queer visibility for lesbians in her essay "The Straight Goods: Lesbian Chic and Identity Capital on a Not-so-queer Planet." Tracing the publicized phenomenon of "lesbian chic" in mainstream straight media and fashion photography, Dittmar demonstrates how fashion's photographic repackaging of conventional signifiers of strength and assertiveness in a man's world subtly functions to contain the threat of the new prominence of high-powered professional white women, including lesbians, in the corporate, political, and entertainment worlds by the early 1990s. Images showing suave sophisticates sporting short haircuts, pinstripes, neckties, and cufflinks erase not only most real-life lesbians who are not affluent and assimilated into corporate upward mobility, but lesbians' countercultural histories and political agency as well. Even lesbian-targeted magazines such as *Curve* and *Girlfriends*, while eschewing the corporate chic of mainstream "gay window" fashion, suture personal happiness to more modest consumption in a rosy world of whiteness (or light tan) that needs no changing.

In "Rock Hudson's Body," Richard Meyer looks at the movie and fanzine construction of the screen idol's star body in publicity photos from the 1940s and 1950s. Hudson's body was imaged as large to overflowing, yet gentle, playful, and open to a heterosexual female gaze in ways that most male romantic leads never allowed. Hudson's stardom was established on his roles in women's melodramas where he played the wholesome "hygienic" and domesticated counterpart to the untamed wildness and machismo of James Dean, Marlon Brando, and John Wayne. Hudson's homosexuality became public knowledge in 1985 owing to his illness from AIDS, and photos of the ailing star appeared in the press alongside his old movie stills. Such photographic "evidence" was intended by the press to map the physical signs of disease on to the "corrupting" effects of homosexuality itself. But Hudson's outing as a homosexual also exposed the actor's consummate skill at publicly performing heterosexual masculinity in his movie roles and, in the process, unmasked masculinity itself as an act – a revelation for which the dying Hudson was reviled by the media.

Erica Rand and Mary Patten, veterans of numerous activist campaigns around women's issues, AIDS organizing, and anti-discrimination law repeal efforts, recount the painful lessons learned in the field about how images of queers and queer activism are displaced, erased, and disappeared, not only by a homophobic culture but even by gays themselves and their sympathizers who are afraid of alienating mainstream society. Rand's in-depth discussion in her essay, "The Passionate Activist and the Political Camera," of conflicts over images – first among dyke activists and then between such groups and community organizers who took charge of media publicity during anti-repeal campaigns in Maine – shows how perceived divisions between local activists and outsiders (including academics), queers and straight working-class voters, grassroots organizers and "political professionals," impeded coalition-building and left no foundation for further organizing for progressive change, once the election was over. Leaders of the "Maine Won't Discriminate" campaign ran print and television ads that kept visually identifiable queers out of sight, rather than directly confronting the distorted stereotypes of gays used in right-wing propaganda such as the notorious videotape *The Gay Agenda*. Rand points out that such "de-gaying" strategies backfire – as they did in Lewiston's local referendum – because they do nothing to counter the negative images of queers already ingrained in public consciousness. Rand reflects on the limitations of grand media strategies altogether in producing real political change, arguing instead for increased sensitivity by organizers to local conditions and the development of situational strategies to address them.

In "The Thrill is Gone," a moving "post-mortem" on her years on the frontlines of ACT UP/Chicago and its women's caucus, Mary Patten re-reads photographs produced in the context of militant AIDS activism, discussing the effectiveness of such image interventions and their subsequent migrations from context to context: from street demos to campaigns to free political prisoners; from documents of angry blood-stained clashes with police to magazine ads. Recognizing the futility of claiming fixed ownership of photographic images and their meanings, Patten sees their appropriations as symptomatic of the ways in which capitalism co-opts social revolution and turns it into style. In her concluding reflections on the political costs of queer visibility, Patten reminds us that progressive social activism doesn't stop when the cameras are switched off.

In her third short story, "The Family Jewels," which closes this final section, Catherine Lord evokes the isolation of growing up in a family which kept photographs of itself, photographs which mirrored back private secrets and public lies and kept her narrator from recognizing, and recognizing herself in, some painfully longed-for truths.

the photographs

Two color portfolio sections, along with several independent and serial works interspersed among the essays, feature works by thirty-eight artists, mostly from the US, along with the United Kingdom (4), Canada (3), Belgium (1), and Japan (1). All of the works were produced between 1988 and 1996. This selection was made after three years of active soliciting for slides and information through exhibitions, photography and art publications, institutional and personal networks, as well as by searching through magazines, newsletters, exhibition announcements, and conference proceedings. *The Passionate Camera*'s bias toward the alternative (non-profit) US queer art/media scene reflects my own context of practice; this is the milieu I know and whose political struggles and critical debates I actively engage in as an artist, teacher, and critic. Despite the predictable predominance of works from urban California and New York where there are the largest queer communities, I received numerous queries and slides from geographically dispersed locales in the USA, Canada, and United Kingdom, signifying the large diffusion of interest in queer critiques and practices.

Although personal biases inform any editorial project – how can they not? – I placed a priority on finding works by independent visual artists who identified as such in relation to the marketplace, as opposed to professional fashion and advertising photographers, freelance photojournalists, professional pornographers, or documentarians of the sexual underground and its subcultures. I looked for works which put visual markers of sexual desire – including erotic fantasies, bodies and genders – under radical interrogation from the inside. I expressly avoided the quasi-documentary strategies typically seen in European publications from B. Taschen and Edition Stemmle (widely available in both queer and mainstream bookstores) which put on voyeuristic display their subjects' glamour, exoticism, or abject sexual freakiness. I sought works which showed a consciousness of their (and their makers') compound positionings within a complex productive web of embodied material and social conditions such as racial and ethnic difference, national heritage, and economic class, as well as current struggles around contested signs of health and illness, normality and deviance, personal desire and its organized regulation. Finally, I selected works which took visual pleasure – that "radical kinaesthetic jolt" – seriously as part of their strategic program.

Regrettably, space and production constraints were daunting and many deserving works could not be included. I felt the loss particularly keenly in relation to conceptual and multimedia works

which use photographs in an expanded viewing context, works by important queer practitioners such as Nancy Davenport, Doug Ischar, Silvia Malagrino, Shani Mootoo, Connie Samaras, Susan Stewart, and Michael Yamamoto. I opted for coverage over depth, trying to represent a range of page-friendly and provocative works by many artists rather than presenting extended bodies of works by a few. Some of the artists agreed to extract photographic fragments from larger contexts, but this was not a sacrifice everyone was willing, or able, to make. Other artists were unwilling to show earlier works, or were not sufficiently satisfied with works in progress to release them for publication. While a number of these photographs have achieved recognition in the art marketplace, many others are too idiosyncratic, complicated, or content-loaded to pass themselves off as "universal human expressions." On the other hand, this is not a book that cultural conservatives will easily ignore, for not only does it bring together a critical mass of contemporary sex-radical images, but it surrounds them with a serious and articulate body of writing that anchors them, illuminates them, and grants them the legitimating historical frameworks they deserve.

notes

1 The terms were often used interchangeably, though "obscenity" is a legal term, requiring the meeting of exceedingly stringent criteria (see note 11 below), while "pornography" is an entirely subjective "hot-button" term, more useful for hurling against images one fears or finds disgusting than for explaining anything about what those images depict, for whom they were intended, or how they might be interpreted. As used in this essay, the term "pornography" will denote (unjudgmentally) images and materials produced primarily for the purpose of sexual arousal.

2 This assimilation of radical movements of sexual resistance into the halls of academe has not been greeted with universal joy. Many see it as the first step toward co-optation and containment by the ruling political center as situational "street politics" are transformed (deadened) into "discourse" with its metatheories, specializations, and abstractions. See Lauren Berlant and Michael Warner, "What Does Queer Theory Teach Us about X?" *PMLA*, May 1995, p. 343. In a closely argued and lucid essay, Rosemary Hennessy pinpoints the ways in which queer visibility has been a mixed success for pushing forward a radical social critique. See her "Queer Visibility in Commodity Culture," *Cultural Critique*, no. 29, Winter 1994–95, pp. 31–76.

3 See Barbara Smith, "Where's the Revolution?" *The Nation*, 5 July 1993, pp. 12–16, for an impassioned critique of the 1990s lesbian and gay movement's ideological and practical abandonment of its earlier alliances with feminist, left, and black progressives in favor of pursuing an "assimilationist 'civil rights' agenda" . . . "despite the fact that the majority of 'queers' are people of color, female or working class."

4 Barbara Smith, "Homophobia: Why Bring It Up?" in Henry Abelove *et al.*, *The Lesbian and Gay Studies Reader*, New York and London, Routledge, 1993. Also see Cherrie Moraga and Gloria Anzaldua, eds, *This Bridge Called My Back: Writings by Radical Women of Color*, New York, Kitchen Table: Women of Color Press, 1981, 1983.

5 Makeda Silvera, "Man Royal and Sodomites: Some Thoughts on Afro-Caribbean Lesbians," in Lynne Fernie, ed., *Sight Specific: Lesbians and Representation* (exhibition catalogue), Toronto, A Space, 1988, pp. 36–43.

6 Helmut Gernsheim, *Lewis Carroll, Photographer*, New York, Dover, 1969, p. 21.

7 See Laura Mulvey, "Magnificent Obsession," *Parachute*, March/April/May 1986, p. 7, for a useful capsule comparison of the interpretive operations of cinema and photography.

8 See Jan Zita Grover, "The Subject of Photography in the American Academy," *Screen*, vol. 27, no. 5, September–October 1986, pp. 38–48.

9 It should be noted that cultural conservatives had tried to defund the Endowments eight years earlier, at the

beginning of Ronald Reagan's first term in office, but had been beaten back by a coalition of business and arts lobbyists and their congressional allies. The only bones thrown to the right at that time were the elimination of fellowships for art criticism and, tellingly, documentary photography projects. Both categories were attacked for having a "marxist" bias.

10 Carole S. Vance, "The War on Culture," *Art in America*, September 1989, pp. 39–43.

11 "According to what has come to be known as the 'three prongs' of the Miller [vs California] standard, work can be found obscene only when it meets *all three* of the following criteria stated in the ruling: 1) the average person, applying contemporary community standards, would find that the work, taken as a whole, appeals to prurient interest; 2) the work depicts or describes, in a patently offensive way, sexual conduct specified by statute, and 3) the work, taken as a whole, lacks serious literary, artistic, political, or scientific value." From Carole S. Vance, "Misunderstanding Obscenity," *Art in America*, May 1990.

12 This is not to imply that public images of bourgeois white women are no longer problematic. Far from it, as ongoing critiques of the fashion, film/television, advertising, entertainment, cosmetics, and diet industries indicate. A woman still can't be too blonde, affluent, young, or thin.

13 Susie Bright and Jill Posener, eds., *Nothing But the Girl: The Blatant Lesbian Image*, New York, Freedom Editions, and London, Wellington House, 1996. Also see SAMOIS, ed., *Coming to Power: Writings and Graphics on Lesbian S/M*, Boston, Alyson Publications, 1981; Gon Buurman, *Poseuses, Vrouwen-portretten/Portraits of Women*, Amsterdam, Schorer Foundation, the Gay and Lesbian Advisory Organization in Amsterdam, 1987; Della Grace, *Love Bites*, London, GMP, 1991; and Lily Burana, Roxxie and Linnea Due, eds, *Dagger: On Butch Women*, Pittsburgh and San Francisco, Cleis Press, 1994.

14 See Danae Clark, "Commodity Lesbianism," in *The Lesbian and Gay Studies Reader*, p. 186.

15 Hal Fischer, *Gay Semiotics: A Photographic Study of Visual Coding Among Homosexual Men*, Hal Fischer, 1977.

16 George Chauncey, *Gay New York: Gender, Urban Culture, and the Making of the Gay Male World, 1890–1940*, New York, Basic Books, 1994.

17 Bright and Posener, *Nothing But the Girl*, p. 6. As Bright also acknowledges later in the book, "In the beginning, there was Tee . . ." The sensual art photographs of Tee A. Corinne were first published around this time (1974), and Corinne's images, like Barbara Hammer's independent films, were crucial pioneering works of lesbian erotic expression in a West Coast countercultural feminist context. Corinne's traveling slide shows of lesbian imageries from history and the present educated a whole generation of dykes in the 1970s and 1980s, and her solarized photograph of two nude lesbians cradled in a passionate embrace, "Sinister Wisdom," quickly replaced David Hamilton's unconvincing version on those bedroom walls.

18 R. W. Connell, "Democracies of Pleasure: Thoughts on the Goals of Radical Sexual Politics," in Linda Nicholson and Steven Seidman, eds, *Social Postmodernism: Beyond Identity Politics*, Cambridge University Press, 1995, p. 392.

19 Kobena Mercer and Isaac Julien, "True Confessions," in Thelma Golden, ed., *Black Male: Representations of Masculinity in Contemporary Art*, New York, The Whitney Museum of American Art, 1994, p. 194.

20 Emmanuel Cooper, *Fully Exposed: The Male Nude in Photography*, London, Routledge, 1995, p. 183.

21 Hennessy, "Queer Visibility," p. 69.

trouble in the archive

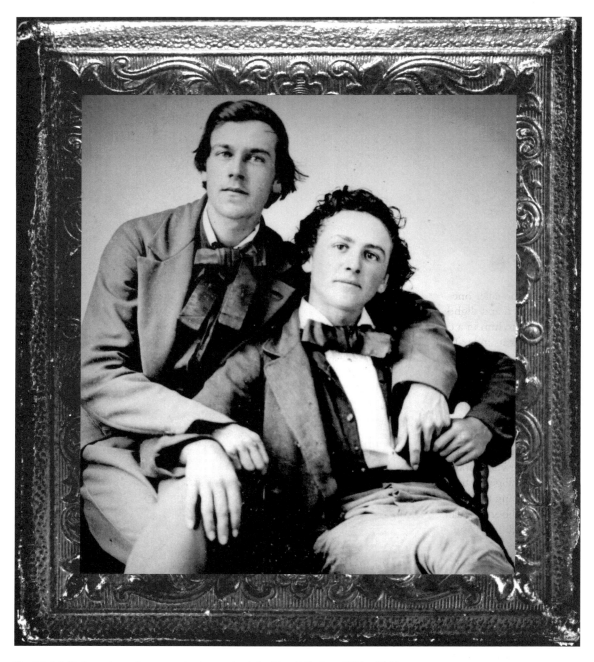

Figs 1.1–1.4 Photographer unknown, ambrotype, n.d., sixth plate. Collection of Brian Wallis

david deitcher

looking at a photograph, looking for a history

One man, the taller one, has eyes as clear as ice but not so cold. He sits on a wooden stool, inclining to his left and slightly forward to drape a lanky arm around the neck of his friend who sits below and before him in a cane-seated chair. This leaves his hand hanging rather low against the torso of his mate, its index finger aligned with his comrade's groin in a way that I'm inclined to read rather deliberately, as if to say: "You know what we're about." Casually crossed legs sheathed to the knees in riding boots obscure all but a few suggestive folds at his breeches' buttoned fly. This seated man has taken the third finger and pinkie of his companion's suspended hand inside his own as he looks at the camera with disarming directness.

The two men look so relaxed, so comfortable together; especially the seated one who projects such poise in the shelter of his friend's accommodating body. It's hard to tell – old photographs like this ambrotype concentrate such a wealth of detail into such small objects – but his eyes look somewhat darker and softer. This much I plainly see: he wears his wavy hair pushed back from an "intelligent" brow. His right forearm rests easy between his friend's crossed thighs, his hand cupping the contour of the knee that is raised. There, his pinkie deviates ever so slightly from its neighbors – a dainty departure that nonetheless is consistent with the overall attitude of both men, which is urbane, sophisticated, even patrician.

Who are these two men, looking out across time from the other side of a sliver of glass? I am powerfully drawn to them, as I am to this old photograph and to others that share its most salient feature: the registration of physical affection between men from long ago. There are many reasons for this attraction, some straightforward (though not simple) like the mildly erotic pleasure I derive from looking at old pictures of men touching men. Others are more obscure, having to do with how very long ago they lived and died. But above all, their appeal centers on the possibility that these pictures offer evidence of a past that is hard to find; and that, once found, may be even harder to bear. For all too often, the historic traces of same-sex love consist of entries in police records and court documents, or stigmatizing evaluations by physicians, psychologists, and criminologists. Thus the history of gay desire has been written by individuals and institutions whose purpose has been to snuff it out.

Reflecting on his research into the gay history of nineteenth-century London, British author Neil Bartlett was prompted to ask: "Do we view it with dismay, since it is a record of sorrow, of powerlessness, a record of lives wrecked? Or is it possible to read even these texts, written as they were by journalists, policemen and court clerks, with delight, as precious traces of dangerous, pleasurable, complicated gay lives?[1] Being drawn in this way to the past is a sign of longing: for the self-validation that results from having a history to refer to; for a sense of connection to others – past and present – whose experience mirrors your own. Inasmuch as photographs like this lack supporting documentation, they are powerless to communicate anything more than *this is how they looked on that day when they sat for the photographer.* Immersed in their appearance, I am ignorant of any tragedy that might have befallen these men, or of any crime they may have committed. Uncertain of anything that ever actually transpired between them, I am free to imagine whatever I please. With neither caption nor context to anchor this object, I am left to wonder: By what hazardous, indirect route did this uncanny image, encased in morocco and burgundy velvet, find its way to my desk where it arouses curiosity about the details of the world it so vividly pictures, and desire for whatever it all represents.

Have I said in so many words how elegant these men look in their nicely tailored sack coats? Though both men wear vests, only that of the fellow in the foreground is visible. Its brass buttons are mostly unfastened to reveal a white shirt beneath, its standing collar offset by a substantial cravat. Of the taller man's vest and shirt I discern barely a hint, because the forward inclination

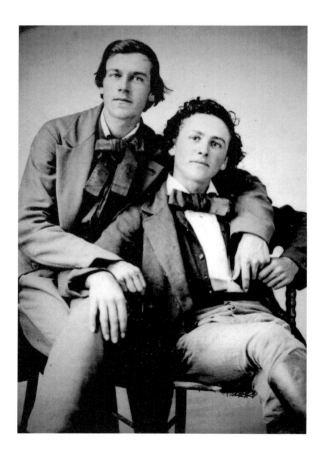

and inward curve of his body have combined with the more abundant folds of his generously bowed tie to conceal these garments. And when was it that these men might actually have dressed for the photographer? The style of their clothes suggests the 1850s, which corresponds with the early years in the relatively brief life of the ambrotype.[2] The sense of leisurely style that both men exude is supported by their hands, which look soft though manly in their mass. Fingernails as immaculate and carefully trimmed as these rule out manual labor. Neither wears a ring nor any other item of jewelry, yet clearly theirs was not a Spartan life. Did they have money at birth? or did they earn whatever money they have? Were they businessmen? Shopkeepers? Poets or journalists? Did they read Melville, Hawthorne, Emerson, Whitman?

I am drawn to the men in this photograph because their pose strikes me as courageous, even defiant. And yet this may only be projection on my part – a measure of how much I would like to find gay desire reflected in an artifact from the pre-gay past. From everything I read about the times in which they lived, courage and defiance may not then have been essential to striking such a tender pose, at least not if what went on between these men can comfortably be considered within the context of "romantic friendship." Ever since 1975, when feminist historian Caroll Smith-Rosenberg explored the documentatary evidence of intimate friendships between nineteenth-century women, that term has been used to denote the demonstrably affectionate same-sex relationships between men as well as between women which flourished throughout much of that century. Smith-Rosenberg's purpose – and her achievement – was to have interpreted romantic friendship within the context of its Victorian social circumstances, rather than from a twentieth-century psychosocial perspective which would have distorted its meaning. Rather than proceed from our "dichotomized universe of deviance and normality, genitality and platonic love," which would have been "alien to the emotions and attitudes of the nineteenth century," Smith-Rosenberg analyzed these passionate attachments within the context of segregated male and female social spheres which she attributed to "rigid gender-role differentiation within the family and within society as a whole."[3] To this suggestive account of segregated male and female social worlds, other historians have since added such effects of industrialization as the rise of wage labor and the increasing pressure on men to live and labor apart from women and families in urban and frontier situations that fostered not just romantic friendship but sexual same-sex relations.[4]

The journal of Albert Dodd, a Yale student during the late 1830s, provides evidence of the kind of passionate attachments that arose between privileged men within the university's all-male preserve. On 4 February 1837, Dodd wrote in his journal about his love for a young man named John: "I regard, I esteem, I love him more than all the rest," he claimed, thereby alluding to others – male and female, as it happens – who had also attracted his devoted attention.[5] Attempting to sort out his feelings, Dodd added, "it is not friendship merely which I feel for him, or it is friendship of the strongest kind. It is a heart-felt, a manly, a pure, deep, and fervent love." That this intense young man regarded such heartfelt, manly love as "pure" would strike the "dichotomized" twentieth-century observer as more noteworthy than it would have one of Dodd's contemporaries. Nor was his invocation of purity necessarily made in guilty denial of a more deeply rooted culpability. Dodd's evaluation of his fervent attachment to John reflects the prestige then widely accorded such relationships as a result of the cult of friendship, which originated in the latter half of the eighteenth century and persisted throughout much of the nineteenth. This cult inspired a wide range of literary expressions, extending from essays such as Emerson's "Friendship" to Melville's alternately voluptuous and agitated same-sex fictional scenarios, or Walt Whitman's tireless advocacy of "manly affection," whether in ardent poems or

more sober prose in which he prescribed "comradeship" as a tonic alternative to the vulgar materialism of American life. Albert Dodd's feelings for John are merely the unbridled (and hackneyed) expression of emotions that Whitman redeemed as upright in *Democratic Vistas* where they materialize as "threads of manly friendship, fond and loving, pure and sweet, strong and lifelong . . . "[6]

At different times throughout the nineteenth century, and for different reasons, classically educated American and British men were also inclined to exalt their romantic same-sex attachments with ennobling and chastening references to Plato and Aristotle, Damon and Pythias, Achilles and Patroclus.[7] At the height of the Victorian cult of friendship, passionate same-sex affection between social equals was also viewed as pure in contrast with its complement between men and women. Notwithstanding the religious sanctification of marriage, the love of man and wife could not aspire to the immaculate spirituality of same-sex romance, in part because of the instrumentality implicit in procreative sex; in part because such love was tainted by cravings that Victorians found too easily assimilable to the instinctual drives of the animal kingdom.

Same-sex romantic friendship could be cherished as pure despite the fact that fervent emotion could, and often did, correspond with physical intimacy. After Albert Dodd found a responsive object of his affections in Anthony Halsey (his entreaties to John fell on deaf ears), he noted the ensuing raptures in his journal: "Often too he shared my pillow – or I his, and how sweet to sleep with him, to hold his beloved form in my embrace, to have his arms about my neck, to imprint upon his face sweet kisses!" As Smith-Rosenberg foresaw, the twentieth-century inclination to classify human intimacies in terms either of a normal or deviant sexuality has made it difficult for historians to come to terms with the meaning of more fluid affections. The tenacity of this either/or reflex is discernible when, for example, Peter Gay generalizes that in most instances the "embraces and kisses one friend bestowed on the other remained mere epistolary effusions."[8] The naturalized projection on to the past of our dichotomized view of intimacy also has surfaced in the deployment of the word "innocent" to describe the emotions and activities of romantic friends, in and out of bed, thereby implying the guilt of more knowing relations.[9]

Not that historians haven't gone to considerable lengths to acknowledge that some romantic friendships occurred between men and between women whose desires would always have been found "guilty." In exploring the limits of the physical intimacies that occurred within the historical context of socially sanctioned same-sex love, a certain elasticity has been adopted. This seems merely prudent, considering how impossible it is to ascertain precisely what went on in bed between Dodd and Halsey, between Daniel Webster and Hervey Bingham, or between the young storekeeper from New Salem, Illinois, named Joshua Speed, and Abraham Lincoln, with whom he shared his bed – let alone what went on in beds and on city streets between other men (or women) who, like the amorous couple in this photograph, never did document their sexual activities in words that have survived.[10] In this context, it is still startling to read Smith-Rosenberg's conclusion that the sanction granted romantic friendship endowed Victorians with greater freedom to traverse the affective spectrum between "committed heterosexuality" and "uncompromising homosexuality" than would be available during the supposedly more liberal twentieth century.[11] What constellation of mitigating social circumstances made possible this Victorian sanction? And what might all this have meant to those less innocent contemporaries at what had always been viewed as the wrong end of the affective spectrum who, even without permission, would have desired same-sex intimacy?

Throughout much of the nineteenth century the construction and maintenance of romantic friendship as pure could find support in the tacit understanding of love and lust as different things. Before Freud proposed the sex drive as the universal motive force in human life, love could be

regarded as other than eros. This meant that romantic friends could enjoy considerable latitude in the emotional and physical expression of their affections. According to gay historian Jonathan Ned Katz, "The secure belief in the idea of a nonsexual 'passion' made possible the unself-conscious, unembarrassed expression of same-sex attraction, clearly including a sensual component."[12]

There were, of course, certain kinds of physical contact that never ceased to be condemned throughout the nineteenth century. In addition to the distinction between passionate love and lust, the survival of romantic friendship also depended upon the exclusion of "sodomy" from public life and discourse. Although at different moments throughout the nineteenth-century United States "sodomy" denoted different forms of forbidden behavior, during most of the century this religiously freighted term referred not only to anal sex between men, but also to "various nonprocreative sexual acts, including masturbation and oral sex."[13] It also proved advantageous to romantic friendship that bourgeois power and influence achieved hegemonic political, economic, and social influence in the United States and throughout much of Europe during the middle of the nineteenth century. Not only did the attendant rise of wage labor and the continued segregation of the sexes, races, and classes make romantic friendship possible, it was also consistent with bourgeois style – "a mixture," according to Peter Gay's formulation, "of delicate euphemisms and wide-eyed candor" – that sodomy would remain so far beyond the pale of acceptable middle-class behavior and polite discussion that it could barely enter language. Thus, "the abominable and revolting crime," or "the crime that cannot be named." Paradoxically, the most repressive aspects of bourgeois discretion yielded liberal dividends for romantic friends and fellow travelers. "Behind the sheltering facade of discretion many nineteenth-century male and female homosexuals, defining their own forbidden ways of loving, enjoyed a privileged space of impunity for their unorthodox amorous arrangements."[14]

In 1989, social historian Anthony Rotundo expressed an increasingly popular view among his colleagues when he observed: "The single most revealing fact about middle-class attitudes toward homosexuality in the 1800s is that there was no such term."[15] Much has been made of this constructionist view of homosexuality as a historically contingent term – a modern classification that only gradually acquired its name and meaning at the confluence of a number of institutionalized discourses during the last quarter of the nineteenth century. The understanding of homosexuality and heterosexuality as barely century-old social constructions should not, however, obscure the reality that the activities most intimately associated with the former were widely condemned and harshly punished since well before the dawn of modernity.[16]

As homosexuality became an increasingly prominent topic of public discussion, and object of legislative initiative and medical and psychological examination, the bourgeois inclination to disavow such behavior – attributing it instead to dissolute aristocrats, foreigners, and atavistic members of the working class – became untenable. And if scandal in the ranks of the middle class could no longer be denied, then the sinner would have to be punished. Thus the modern demonization of same-sex love found its culminating public instance during the spring of 1895 in the sensationally reported trials and subsequent imprisonment of Oscar Wilde – a man whose wit and superior attitude had already supplied the most powerful classes in Great Britain with ample reason to take offense.

In this context, the passage of such laws as Britain's 1885 Labouchère Amendment to the Criminal Law Amendment Act assumes both special and emblematic meaning.[17] Unlike previous legislation, which had outlawed "sodomy and buggery" – regardless of the sex of whomever was caught in the act – the Labouchère Amendment cast a finer net over a more narrowly delineated segment of the population as it criminalized "any male person" who commits "any act of gross indecency with another male person."[18] As it prohibited *all* acts that men might engage in

together, including many that previously were practiced with impunity by "romantic friends," the new law contributed to the social construction of the homosexual as criminal. Within the context of other discursive developments that were also heightening the homosexual's public profile, the chilling effect of this legislation proved sufficiently pronounced to take on cultural dimensions. For example, the increasingly pronounced (not to say desperate) inclination to turn to the classical past for an "apologia of a fateful inheritance" was not the only means by which the prominent homosexual British writer John Addington Symonds sought to legitimize his sexual needs, which now more than ever he had reason to regard as shameful. In 1890, Symonds turned for cultural validation to that erstwhile champion of urban cruising and manly love, Walt Whitman, whose famous disavowal is not the only proof of the bard's growing sense of guilt as the century, and his life, were drawing to a close.[19]

Even as modern legislation like the Labouchère Amendment constructed the homosexual as criminal, doctors and practitioners in the burgeoning social sciences, in sexology and psychology were defining same-sexers as atavistic, deviant, and pathological in opposition to the emerging heterosexual norm.[20] As a result of this convergence of overlapping institutional and disciplinary developments, a wide range of emotions and behaviors between men, which previously were cherished within the context of romantic friendship, were increasingly identified with crime and sexual "perversion." Throughout much of the nineteenth century, social relations forged by industrialized capitalism had combined with traditional gender assignments to segregate the sexes, races and classes, and to foster same-sex romantic friendship. Toward century's end, the modern institutional and disciplinary "innovations" helped advance a more restrictive heterosexuality as the social norm. As a result, it became necessary to ensure that the still intense, libidinally charged

relations between men that still electrified the homosocial hubs of exclusively male learning and labor would not only *not* be construed as "homosexual," but would now spark an incendiary homophobia as well, as if to clinch the matter. And, as Eve Sedgwick has demonstrated, this institution of homophobia within the context of homosocial male bonding was more than coincidental to the consolidation of male power and privilege at a time when women were contesting that birthright.[21]

Many photographs like this have survived to demonstrate both the prevalence of such intimate friendships between men and how commonplace it was for them to commemorate their affections with a visit to the local photographer. In their popularity and commemorative sentimentality, these pictures anticipate the ritualistic function and social meaning of the self-produced snapshot which became increasingly common after 1880. Corresponding with the rise and fall of the romantic friendships they document, this photographic sub-genre of the portrait extends from the dawn of the photographic era until, near century's end, the tender pose was variously toned down, de-sentimentalized, reassigned among specific types of men, or to men in certain contextualizing circumstances that could effect the construction of certain meanings. These photographs of more or less intimate same-sex relationships therefore document the historical mutability of friendship, masculinity, and sexuality. As the century draws to a close, and same-sex attachment and physical contact become objects of increased scrutiny, two men reckless enough to be caught sharing such a tender moment before the camera might well have found their masculinity and their probity in doubt. There were, however, circumstantial exceptions. Men photographed within each other's arms at military encampments, or posing warmly as athletic team competitors, or sharing a smoke in the sanctuary of an all-male private club could rely upon the power of such framing circumstances to warrant, if not quite prove, that their bonds were acceptably "homosocial," rather than scandalously homosexual.

In this context, it is interesting to consider the late nineteenth-century naming and stigmatization of the homosexual in relation to the invention of the self-produced snapshot with which it corresponds historically. Insofar as the technology that made possible self-made photographs circumvented the public scrutiny implicit in a visit to the commercial photography studio, it also made possible the proliferation of private, potentially "anti-social" images such as pornography. This suggests a photographic and technological rationale for a "panoptic" disciplinary regime that polices desire not so much through the unwieldy imposition of brute force but through the infinitely more subtle and cost-effective process of defining normative sexuality.[22]

Looking at this much older picture, I am inclined to imagine, for a variety of reasons, that these men took full advantage of the special dispensation granted in their day to romantic friendship. In such moments of possibly anti-historical reverie, I see them as lovers who enjoyed then-unmentionable sexual acts, and who, whenever necessary, dissimulated skillfully as "romantic friends" to avoid exposure and punishment as the sodomites I (want to) believe they were. The beautiful thing about such photographs is that no one can tell me otherwise; at least not based on the evidence – or lack of evidence – the photographs provide. In this way these vivid artifacts exist in and out of history.

Is this picture and the tradition it exemplifies representative of a time when same-sex love was freer and less fraught than it later became? Do such photographs provide evidence of a time when impassioned ties between men (and between women) were taken for granted – or, perhaps more precisely, taken *as* granted? Is this one among many surviving shards from a past that, from a certain perspective, looks positively Arcadian inasmuch as – given a certain discretion – the intimate relations it pictures, and others it only implies, were for some time spared the

all-encompassing suspicion and scorn that would later be heaped upon them? But what kind of Arcadia is it that brackets off as "unspeakable" some of the most intimate forms of human contact? Might such pictures simply reflect the prevalence in the nineteenth century of loving feelings between men? Can love between men ever be "simple" which corresponds historically with the consolidation of power between them? Such questions suggest that in order to take pleasure in looking at these artifacts, it helps to retain a certain ignorance about the reality they picture. Only then is it possible to learn something quite different; something that, to the gay observer, is no less important: what might these pictures *represent*?

Photographs like this offer evidence of a great many things, but of precisely what I'm not now prepared to say. I don't know, and probably never will know, who the men in this picture are, and on one level that suits me fine. Neither am I inclined to dwell on the social and cultural preconditions for their portrait, if considering those details will undermine other satisfactions that uncertainty keeps alive. My pleasure centers principally on the appearance of these men and on the object that contains their likeness. My relation to both is therefore akin to flirtation. It parallels the sense of limitless possibility that depends on not knowing very much more about a man than is suggested by his presence; and on deferring the moment of defining the nature of an erotic relationship which may be sexual but cannot be fixed as committed. Desire thrives on the suggestion, on the possible, just as surely as it shrinks from the light of a deeper familiarity and the more static circumstances of commitment. British psychoanalyst Adam Phillips has written of flirtation that it "sustains the life of desire." Similarly, my desire to sustain a relationship with this photograph that, like flirtation, embraces uncertainty is "a way of cultivating wishes, of playing for time."[23]

Why should I want the meaning of this intimate and ambiguous pose to be limited by the constraints of a well-documented history? Why indeed, since the empirically anchored, historical understanding is bound to disrupt the satisfying sense of connection that I know I can sustain to these men under the more speculative terms of a less grounded, imaginary association. In one of the "Calamus" poems in *Leaves of Grass*, Walt Whitman describes his anxiety in believing or trusting in people or things, knowing how easily his faith in them could be undermined. "Of the Terrible Doubt of Appearances" also addresses the misgivings that arise at the thought of relinquishing such uncertain trust (which Whitman will not do) for a more easily verifiable intelligence that insists "we may be deluded." There is something metaphysical about Whitman's suspended disbelief, which merely acknowledges the impossibility of living in a state of permanent disillusionment. Though well aware of the likelihood that "reliance and hope are but speculations after all," the poet chooses the life-affirming metaphysical shelter afforded by the imaginary. A parallel sense of anxiety attends the decision to bracket off whatever "history" may have to say about these photographs in order to explore what they represent from this decidedly interested perspective; knowing, as Whitman did, that any single viewpoint can only offer knowledge that is contingent.

May-be seeming to me what they are (as doubtless they
 indeed but seem) as from my present point of view,
 and might prove (as of course they would) nought of
 what they appear, or nought anyhow, from entirely
 changed points of view.[24]

They have no names, no "proper" names, and this attracts me to them more, not less. Still, I examine every millimeter of the case that contains their likeness in search of names: their names, or the name of the photographer who took their picture, the studio in which they posed, the city in which they lived. Part of me wants to know where and when they lived, what happened to them, how they made a living, how and when they died. Part of me would like to know if one, or the other, or both were survived by wives and children. But another part of me would rather never know. Perhaps I should explain, though this requires history – of a certain kind.

Even the thought that these men might have married and raised children is dismaying to me. The naturalized identification of marriage and parenting with heterosexuality has so often been used to deny the queer past – and so often gay men and lesbians have been coerced into acquiescing in this conspiracy of self-denial. Given how commonplace it has been for same-sexers to lead double lives, and the force of the terror that has fueled this masquerade, universal heterosexuality seems a more convenient than fitting conclusion to draw from the matrimonial glut. Sometimes the use of marriage and/or parenthood to certify heterosexuality yields results that border on the comical. As a young boy I remember that my mother worshipped Leonard Bernstein. One night at the dinner table, where peace rarely prevailed, she was holding forth on the subject of the charismatic conductor when, out of nowhere, my presumably jealous and competitive father pronounced her beloved Lenny a fag. To this outrage my mother responded that Bernstein was – thank you very much – a happily married father. A silent smirk momentarily disturbed the symmetry of my father's face. He needed say no more since my mother's defense of her idol had struck him as the non-sequitur it was.

Dismay, under any circumstances, is a powerful and troubling emotion, one that leaves a sense of depletion and powerlessness in its wake. But what does it mean to experience dismay in

reflecting upon the historical probability that the men in photographs like this one may well have married and reproduced? The feeling surfaces as if in acknowledgment that same-sexers have been coerced into living as straight people and had little choice but to assist in expunging their deviant desires from the historical record. But to the extent that dismay is also a form of abjection, it therefore suggests deeper roots than mere frustration in the search for signs of that past. I feel the disabling effects of dismay when, for example, I read a historical account of romantic friendship between men that concludes that these relationships terminated in marriage and adulthood – the two, inevitably, being equal. Anthony Rotundo drew this conclusion in his study of a number of documented romantic friendships between men. He reasoned that it was during the interregnum between boyhood and manhood that such relationships flourished. In romantic friendship, Rotundo observed, nineteenth-century youths could find a substitute for the "emotional nurture provided most often in boyhood by a mother," or the "worldy counsel" supplied by a father, or "a rehearsal for marriage."

Defining adulthood and maturity in terms of marriage and successful adaptation to the harshly competitive, male-dominated nineteenth-century workplace, Rotundo is implying the arrested development of any man who married but nonetheless sustained his romantic same-sex friendship; to say nothing of those other men who never married but participated in illicit same-sex relations. This view is consistent, of course, with the view of homosexuals as psychologically arrested narcissists who have failed to navigate the Oedipal shoals successfully – a painfully familiar scenario upheld by homophobic vulgarizers of Freud's problematic etiology of homosexual object choice.[25] Dismay – at the absence of history where history should be; at the intractability and apparent logic of the homophobic mindset – may therefore be rage turned inward, partly in fear of the annihilating force of that violent emotion; partly in frustration at being intimidated at the thought of the real and imagined destructive power that has almost succeeded in supplanting the queer past with the popular myth that no such past exists. Dismay of this kind is a self-fulfilling sense of one's own powerlessness.

The anonymity of the individuals on both sides of the camera has guaranteed that this photograph and others like it would be consigned to the margins of cultural as well as historical perception. Doubtless contributing to this result was the systematic suppression from the historical record of any document of same-sex love that was not at the same time a testament to its ruinous consequences. Considering this climate of repression, is it any wonder that the identities of men who posed together so long ago with forthright and tender affection failed to survive? Inasmuch as such photographs cannot be related to any identifiable photographer or sitter, the historians, critics, museum curators, photography connoisseurs and collectors who are in a position to ascribe historical importance, cultural value or aesthetic merit to these objects effectively abandoned them. As a result, they have circulated for decades in the limbo of flea markets, down-scale antique stores, photo fairs and auctions. There, tenacious, usually gay hobbyists and collectors with a taste for the "buddy picture" (as one aficionado dubbed this subgenre) as well as for antique photographs of cross-dressers and vintage homoerotica, rescue them from oblivion. Anonymity also ensures that collectors need not pay very much for these objects of their desire, not even for photographs as beautiful and rare as the ambrotype before me.

Anonymity disqualifies such pictures from consideration in terms of institutionalized discourses that might otherwise transport them from the ephemeral space of the artifact to the realm of the eternal work of art. As anonymously created photographs of nameless sitters, they have no place within an *oeuvre*. They play no supporting role within the familiar scenario of artistic development from anxious influence to the consolidation of a signature style. Nor can they be fetishized for

their connection to the biographical details of a life, be it the photographer's or the sitter's; but neither, by the same token, can the meaning of these objects be exhausted as the illustration of a personal experience.

As for me, I am most attached to the orphaned picture – to the castoff that lies unnoticed at the weekend flea market amid the indignity of unsorted elastic-bound stacks of other tintypes, cartes-de-visite, and postcards. To them I feel something beyond exhilaration in having discovered photographic evidence of historic same-sex intimacy in an era of possibly more fluid relations. I identify with the weathered object. In its scuff marks and dents, I see the signs of age, and more. I see the stigmata of their abandonment and mistreatment as so much discarded junk. To be drawn so empathetically to such objects suggests a decidedly sentimental relation to the past.

Like most photographs, this old likeness conveys a vivid sensation of the presence of its sitters who died so long ago. Pleasure in looking at them can therefore entail a certain morbidity as well, which results, in part, from certain characteristics of photography that Roland Barthes, among other writers, has noted. Looking at this object, I am aware of how long ago light registered its uncanny impression in the emulsion-coated surface as it probed the living bodies of these men in their space and time at the instant of exposure. Just as the passage of time stripped these men of their identities, so exposure to light, which brought their image into being and now makes them visible, is causing them to fade from view. Are some individuals more susceptible than others to interacting with photographs in this way?

The knowledge that no children of my own will survive to remember me contributes to this morbid predisposition; as does the suspicion that among my eight nieces and nephews, some will forget me too. Who among them, I wonder, will neglect to tell their children about their queer uncle David who went away to live with a man without raising children? As I look at the image of these forgotten men, I fear I can glimpse my future in the past. I can only guess how many other gay men would find themselves drawn to such dark reflection upon these objects. Now more than ever.

There are, to be sure, other emotions that describe gay men's relations to the past; but I suspect that they supplement, rather than negate, the sentimental. There is the libidinally charged delight in looking at the style of these men and others, and being struck by its radical dissimilarity from today's masculine ideal. To judge from the photographic evidence, there was so much more invention about the way men put themselves together. Notwithstanding the legibility of codified fashions among borderline dandies like the men in this picture, other men in other pictures were responding inventively to the more varied circumstances of nineteenth-century life in urban, rural, and frontier settings. American men with disparate economic means at their disposal evolved styles of dress and modes of comportment that, in retrospect, seem strikingly original. But this is too distanced, too abstract a way of looking, which depends too much on the knowledge that so many of their styles have been codified, copied and reified by today's purveyors of masculine American style, from Hollywood to Marlboro to Ralph Lauren.

In looking at old pictures of men together, I also find myself attracted to a far broader range of physical types than is the case today: to skinny men with odd, angular faces; to men with crudely cut, heavily pomaded, or just plain greasy hair; to unshaven men and to men who sport extravagant sideburns, handlebar mustaches, or full shaggy beards. It would be hard to exaggerate the contrast between the men in these pictures and today's masculine ideal of chiseled features and the gym-crafted bodies suggesting armor, not flesh; imagined as if in cybernetic resistance to the plague.

Still more remote from morbidity and sentimentality are defiant feelings which tragedy, past

and present, can also provoke. Defiance is implicit in the act of historical reclamation, and brings pleasure and persistence to the search for evidence of a past that may well be strewn with the debris of lives wrecked by antiquated injunctions, or disfigured by more modern technologies for regulating desire. Resistance compels the queer historian to unearth precious traces of that past, and to disseminate them in the form of previously untold stories of men and women, some of whom succeeded as others failed to live with and act upon their forbidden love. Through such acts of recuperation, the queer historian helps to ensure the continued availability of that past as a source of validation and connection for more or less isolated individuals in the future.

A more measured defiance also informs the salvage of these vernacular photographs, which the majority culture has found unworthy of preservation and study, consideration and care. As the gay man lavishes attention upon these discarded photographs, he parallels the oppositional, queer rehabilitation of officially disparaged culture known as Camp. The fact that these photographs can only perpetuate uncertainty regarding precisely what they picture in no way detracts from the significance of their recovery. From a queer perspective, this self-imposed horizon of historical knowledge has a salutary effect, as it rejects the hubris that so often motivates more elaborately legitimated attempts at historical reclamation.[26] Nor should the importance of this modest salvage operation be denied on the basis of its more speculative (and therefore depreciated) historical method. Central to that speculative method is the self-validating faith in the potential for personal desires to lead to the disclosure of public truths.

In a not unrelated context Audre Lorde once wrote, "the master's tools will never dismantle the master's house." Similarly, queer men and women are justified in maintaining a certain skepticism regarding the historian's positivistic and empirical method, and may therefore be inclined to attend to the quirks of individual and collective appetites and enthusiasms, permitting them to guide archival research. Unable to be certain of which among these photographs actually constitutes the discarded traces of historic queer love, they all become symbolic of the mutability of same-sex affection, of masculinity, male sexuality, and the limits of same-sex intimacy as homosocial relations between men transmuted into homophobic ones. It is, then, not only the fact that these photographs show men touching men that so engages my attention. It is their symbolic appeal as historical and cultural objects that simultaneously exist outside history and culture. Perpetuating uncertainty, these images mirror an epistemological constant of queer history: the persistence of the closet. In such ways, the photograph before me goes well beyond the literalness of depiction to suggest the more complex condition of allegorical likeness.

notes

1 Neil Bartlett, *Who Was That Man? A Present for Mr Oscar Wilde*, London, Serpent's Tail, 1985, p. 129.

2 On American fashions of the 1850s, see Joan Severa, *Dressed for the Photographer: Ordinary Americans & Fashion, 1840–1900*, Kent, Ohio, Kent State University Press, 1995, pp. 84–184. In 1854, a Bostonian, James Ambrose Cutting, patented this collodion-based process which, like the tintype (invented two years later), was a less expensive alternative to the daguerreotype. It was the more durable tintype that proliferated throughout the rest of the nineteenth century, whereas the more fragile (glass) ambrotype's popularity extended only into the 1860s. See William Crawford, *The Keepers of Light: A History & Working Guide to Early Photographic Processes*, Dobbs Ferry, NY, Morgan & Morgan, 1979, pp. 43–4.

3 For this and subsequent quotations, see Caroll Smith-Rosenberg, "The Female World of Love and Ritual: Relations Between Women in Nineteenth-century America," in *Disorderly Conduct: Visions of Gender in Victorian America*, New York, Alfred A. Knopf, 1985, pp. 53–76. Among other contributions to the literature

on this subject are: John D'Emilio and Estelle B. Freedman, *Intimate Matters: A History of Sexuality in America*, New York, Harper & Row, 1988; Lillian Faderman, *Surpassing the Love of Men: Romantic Friendship and Love Between Women from the Renaissance to the Present*, New York, William Morrow and Co., 1981; Peter Gay, *The Tender Passion, The Bourgeois Experience: Victoria to Freud*, vol. II, New York, Oxford University Press, 1986; Jonathan Ned Katz, *Gay American History: Lesbians and Gay Men in the USA*, New York, Thomas Crowell, 1976, and *The Invention of Heterosexuality*, New York, Dutton Books, 1995; Michael Lynch, "'Here is Adhesiveness': From Friendship to Homosexuality," *Victorian Studies*, Autumn 1985, pp. 67–96; Anthony Rotundo, "Romantic Friendship: Male Intimacy and Middle-class Youth in the Northern United States, 1800–1900," *Journal of Social History*, 1989, pp. 1–25.

4 "Wage labor, the ability to live apart from families, and the sociability of the separate sexual spheres had fostered romantic, spiritual, homoerotic and sexual unions." See D'Emilio and Freedman, *Intimate Matters*, p. 129.

5 The Journal of Albert Dodd resides among the Albert Dodd Papers, Yale University Library, Manuscript and Archives. The source for my quotations from it is Gay, *The Tender Passion*, pp. 206–11.

6 Whitman, quoted in D'Emilio and Freedman, *Intimate Matters*, p. 127.

7 Addressing the later nineteenth-century tendency to hellenize references to same-sex love by advocates of aestheticism and/or homosexuals, Peter Gay has noted: "To assimilate modern homosexual affairs to the exalted classical heritage was to borrow from its dignity, to claim a kind of historic rightness. The device was transparent, but no less popular for all that." Gay, *The Tender Passion*, p. 238.

8 Ibid., p. 210.

9 Determined to pin down the ultimate meaning of young Daniel Webster's letter to his "Dearly Beloved" Hervey Bingham, in which Webster conjured a future in which "we will yoke together again; your little bed is just wide enough," Rotundo concludes: "That playful statement may have been made *in total innocence*. The most useful means of understanding Webster's suggestion, though, is one that recognizes bed partners as a common custom of the time, even as it concedes more intimate possibilities for two men who sleep together" (italics added). I am not as concerned with the accuracy or inaccuracy of Rotundo's statement, nor even with his methodology, but with the compulsion to make sense of these nineteenth-century facts in terms of twentieth-century dichotomies. Rotundo, "Romantic Friendship," pp. 3–4, 11.

10 Among the scarce documentation which proves that what went on in bed between American men in the nineteenth century could well have been genital sex is one letter from 1862, which includes the following: "I feel some inclination to learn whether you yet sleep in your Shirt-tail, and whether you yet have the extravagant delight of poking and punching a writhing Bedfellow with your long fleshen pole – the exquisite touches of which I have often had the honor of feeling?" See Martin Duberman, "'Writhing Bedfellows' in Antebellum South Carolina: Historical Interpretation and the Politics of Evidence," in Duberman, ed., *About Time: Exploring the Gay Past*, New York, Meridian Books 1991, p. 5.

11 Smith-Rosenberg, "The Female World," p. 76.

12 Katz, *Gay American History*, p. 673.

13 D'Emilio and Freedman, *Intimate Matters*, p. 122.

14 Gay, *The Tender Passion*, p. 205

15 Rotundo, "Romantic Friendship," p. 9.

16 On the execution of homosexuals, whether by public incineration (hence, "faggot") or by hanging, which British law prescribed from 1533 and well into the era of Wordsworth, Coleridge, Byron, Shelly, and Keats, see Louis Crompton, *Byron and Greek Love: Homophobia in 19th Century England*, Berkeley, University of California Press, 1985, pp. 12–62.

17 Though the photograph that prompts these ruminations is in all likelihood (though not certainly) American, I discuss this pivotal British law because no federal statutes exist during the nineteenth or for that matter the twentieth century in the United States, where such laws have been left for individual states to decide. Thus

in *Bowers* v. *Hardwick* (1986), the Supreme Court affirmed states' rights to maintain sodomy statutes. In accordance with religious injunctions, sodomy was outlawed throughout the nineteenth century in many states. Significantly, it was only at the end of the nineteenth century that New York outlawed "consenting to sodomy" – a broader application targeting the person as much as the act. By that time, "the homosexual" had been identified by American, as well as European, practitioners of medicine. See D'Emilio and Freedman, *Intimate Matters*, pp. 122–3.

18 Labouchère Amendment quoted in Jeffrey Weeks, *Coming Out: Homosexual Politics in Britain from the Nineteenth Century to the Present*, London and New York, Quartet Book Ltd, 1977, p. 14.

19 Regarding Symonds's "apologia," and his appeal to Whitman, see Gay, *The Tender Passion*, pp. 248, 228–9. For Whitman's distress at his "diseased, feverish, disproportionate adhesiveness," see David S. Reynolds, *Walt Whitman's America*, New York, Alfred A. Knopf, Inc., 1995, p. 250.

20 Of the legislative initiatives related to same-sex male sexuality which swept Prussia, Great Britain, and Denmark, Peter Gay has observed: "Indeed, lessening the stringency of penalties against sodomy and related offenses only increased the inclination of authorities to prosecute and of juries to convict." Gay, *The Tender Passion*, p. 220ff.

21 Eve Kosofsky Sedgwick, *Between Men: English Literature and Male Homosocial Desire*, New York, Columbia University Press, 1985.

22 Many thanks to Deborah Bright for alerting me to the historical correspondence between the popularization of the snapshot and the historical construction of normative heterosexuality.

23 Adam Phillips, *On Flirtation: Psychoanalytic Essays on the Uncommitted Life*, Cambridge, Mass., 1994, pp. xvii, xix. Many thanks to Julie Ault for bringing this book to my attention.

24 "Of the Terrible Doubt of Appearances," in Walt Whitman, *Leaves of Grass*, New York, The Modern Library, 1993, p. 152.

25 See Rotundo, "Romantic Friendship," p. 14. For an enlightening discussion of male homosexuality as viewed by Freud and his followers, see Kenneth Lewes, *The Psychoanalytic Theory of Male Homosexuality*, New York, Simon and Schuster, 1988.

26 Perhaps the most spectacular demonstration of such historical hubris is the corporate-sponsored "restoration" of the Sistine Chapel in Rome. I am not interested in whether or not this Herculean effort has "restored" Michelangelo's frescos to anything approaching their condition in the artist's day. That does not seem a question that anyone lacking a time machine can reasonably hope to answer. Far more interesting is the underlying attitude that modern technologies can somehow cleanse the material consequences of a half-millennium and the accompanying idea that this is a *historical* thing to do – as if the Renaissance could be made more immediate to the conditions of life at the end of the twentieth century. That this rehabilitation has occurred during Pope John Paul II's reassertion of papal authority, with funding from a Japanese film company, speaks volumes about the relationship between such spectacular acts of historical and cultural reclamation and the institutions that find such actions desirable.

Nina Levitt, *Submerged (for Alice Austen)*, 1991–92, monochrome color photographs, 24 × 30 and 40 × 30 in. Courtesy the artist

chapter two
michael anton budd

every man a hero
sculpting the homoerotic in physical culture photography

To be Greek one should have no clothes: to be mediaeval one should have no body: to be modern one should have no soul.

Oscar Wilde[1]

Click, link, click, link . . . deeper . . . into my cyber relationship with guys I'll never meet or who are likely dead. I like the dead ones. Dead porno stars are the hottest. They can't talk anymore, so the iconization is total.

Thomas Wooley

Souls and naked bodies; the icon versus the living. As Montaigne conceived it, such dichotomies suggest the *petite morte* of all thought and imagination as somehow outside the flesh. Of course, the body that is closest to being a true icon is the cadaver, and to be self-consciously human is to be alienated from simply being a corpse. In this sense, the living body is always a stranger; an evolving process that needs to be conjured up as statuesque form through the imagination. The mnemonic technology of photography has both mediated and enabled the modern condition of a more deeply divided body and self. To be sure, being gay today would be very different without a social and cultural framework for circulating and valuing photographic images. But just as photography cannot be addressed as mere technology, contemporary homoeroticism cannot be reduced to a purely spectral phenomenon.[2]

Around a century ago, photography began to expand as a mass medium. The once strictly elite connoisseurship of the male body was engulfed by a mass market of photographic images that appealed to many tastes including men who desired other men. The emergence of sexual practice as social identity went hand-in-hand with the advent of modern photographic consciousness and

capitalist consumer culture. It was within the interstices of commercially based systems of masculinization that certain aspects of gay association and identity began to flourish. Indeed, it was no accident that new movements based on male–male association such as physical culture – the fitness craze of the day – and Scouting followed in the wake of homosexual panic provoked by the Oscar Wilde trials.

Though Wilde may have compared a runner's leg to a Greek elegy, today's ever more complex visual lexicons have all but supplanted the plain poetics of words. The mind–body division is as old as thought itself but western individualism and technology have given its trajectory a particular character, especially in the nineteenth century. Long before photography and industrial capitalism that stimulated its invention, sculpture, perspective painting, and printing had similarly fixed bodies in time, space, and memory as concrete objects. As both Roland Barthes and Susan Sontag note, however, photographs – like death masks – are different from such precursors because they bear actual traces of the real. Today, advertisements, holiday snapshots, official portraits, mug shots, pornographic videos and Magnetic Resonance Imaging all assist us in imagining our own bodies as well as those of others. In many ways, such traces of the real have become our most important cultural talismans, the idols upon which our fears and desires are fastened and in which wanting and not wanting are reified. In fact, if we accept today's media hype at face value, we live in a never-never land of forecasted desire, in a suspended animation of virtual but not actual being. Image-making technologies appear to be our only means of creating ourselves in "real time." The most topical example of this is found on the byways of the information superhighway.

On the Internet, sex cruisers can post, send, and receive pictures. Porn – mostly digitized versions of conventional video and magazine fodder – proliferates. In cyberspace, desires can be traded in a shorthand of erotic images and anonymous conversations; genders and sexual roles can

Fig. 2.1 "Patrick," website download, 1996. Courtesy the author

Fig. 2.2 "Tom," scanned video capture, 1996. Courtesy the author

be donned and discarded like clothing. Nude torsos, with or without faces and genitals, can be sent out for inspection in hopes of "hooking up" (Figs 2.1, 2.2). Like our bodies themselves, these latest communications technologies seem to be linking us up, while simultaneously casting us adrift and alone into the void of the datum-plane. Isolation and connection; manufactured bodies instead of real ones; this is all new. Or is it? The erotic body as commodity fetish is certainly in the ether. Perhaps this is where "the body" always is, or has been. Wherever it actually resides, the material conditions that make the dispersal, fragmentation, and memorialization of the body possible have changed dramatically over the past century.

In order to understand the communities of desire that launch naked torsos such as "Patrick" and "Tom" into cyberspace, we need to step back to another defining moment in the expansion of communication, to the birth of the photographically illustrated mass magazine. The 1890s represented the birth of modern consumer consciousness. During that decade, the space of individual identity formation began to be colonized by sellers of products and services within a mass culture that allowed men and women to compare themselves, "invidiously" as Weblen thought, to one another and to ideal images. The problem for sellers was how to turn such comparisons into profit. A framework was needed for circulating and valuing images, both a visual language and a space in which viewers could come together. One such new spatial and visual framework was to be found within the spread of popular gymnasia, sporting leagues, and mass circulation health and fitness magazines.

As a metaphor for sculpting the self and the body, photography played a major role in making the abstracted body into a more tangible commodity or circulating good. Within an age less inundated by manufactured representations, the realism of the photograph and other

reproductions seemed at first a kind of antidote to the swirl of life's complexities as they were mirrored within the expanding print media of the *fin de siècle*. The standard of mimesis available to early photographers included painting and its classical antecedent, statuary. The late art historian Craig Owens observed that neoclassicism in the form of the idealized body tends to be reasserted at times of cultural fragmentation and political crisis. The reliance on a sculptural body in the age of photography was also due to the abundance of statuary and monuments made possible by the invention of industrial processes for making cheaper metal-cast images. Ideal sculptural images, both old and newly modeled, or photographically reproduced, quickly assumed a new importance as evidence of the desired static self, representative of a stable history and a clearly concrete present. The new technologies of the photograph and cinema were thus readily taken up as devices for ordering or classicizing mass bodies. In this regard, the technology of the camera was a literal sculpting machine that clearly manifested the Victorian tension between tradition and modernity.

At the end of the century, fitness and exercise were just beginning to be popularly known by the catch phrase "physical culture." Physical culture implied an ideological and commercial cultivating of the body and can be distinguished from earlier Victorian patent medicines, therapeutic water cures, and athletic revivals by virtue of the numbers it reached and its greater appeal across class lines. The movement came to encompass a broad range of phenomena relating to popular fitness, and persisted into the 1960s as a designation for gay-coded muscular posing magazines. It emerged as a mass medium when music-hall strong men made the shift from performing as classical body icons (sold first in postcard form) to acting as fitness entrepreneurs and magazine publishers. The first and most important of such figures was German-born Eugen Sandow, a contemporary of Oscar Wilde. The Marquis of Queensberry, Wilde's adversary, judged Sandow's physique competitions, as did Sir Arthur Conan Doyle, who even went so far as to write a preface to a Sandow publication. Many ideas similar to Sandow's concerning social and health reform were eventually enacted as part of the British welfare state and it was noted that he influenced most of the young men of the Edwardian generation.

In terms of the creation of a homoerotic community of desire, Sandow as icon is less important than his pioneering of physique competitions that linked consumers to one another through self-photography and contest displays. As late as 1866 in Britain, it was possible for a man to be prosecuted for "indecency" because he had shown his legs while "race-running."[3] By the end of the century, physical culture had assisted in making legitimate representations of nearly nude male bodies more common within a growing mass media. As a mass good, of course, corporeal images were not simply creatures of the state, commercial interests, or doctors. Pictures of bodies not only constituted disciplinary ideals, but were also focal points for amorphous and unique individual desires. On the surface, physical culture media attempted to bridge the distance between national and individual aspirations. Underneath, individual needs were always the focus, since the nation, apart from its palpable public institutions, existed as a more ephemeral imaginary than one's own body. In this regard, physical culture helped reconstruct dominant and subversive images of the body.

Inciting needs and desires expressed in living bodies was the physical culture media's bread and butter. Presumably, needs that improved health and strength also promoted the well-being of the nation and empire. But images of neoclassically posed male physiques clearly possessed a value beyond the building of better citizen-soldiers. In some ways it is all too easy for us today to read physical culture magazines as both crassly commercial and implicitly gay-coded. Whether there was intended homoerotic content in the physical culture press or not, it could not be acknowledged at the time. Wilde's prosecution in 1895 illustrated that the late Victorian body

remained constrained by tightening moral codes even as it became an ever more present focal point of consumerism. The Bradlaugh case, the Parnell divorce, and the Sir Hector MacDonald scandal were all examples of institutional and judicial responses to the sexual body as a social danger. More specifically, the Wilde trials foregrounded two opposing ideas of the gendered and sexualized self. In the end, the "rule-bound violence" of aggressive British masculinity triumphed. Wilde's loss in the highly conventional arena of British justice was a win for a progressively masculinized society that was embracing institutionalized sport wholeheartedly. And yet, the same society that gave rise to mass sport continued to harbor spaces in which male–male love could be legitimized, if not always easily indulged.

Certainly, Wilde was not alone in his attraction to a combined modern/ancient aesthetic of bodily freedom. The interest in antiquity was enjoyed by many who did not share his passion for Oxford undergraduates or working-class youths. As Charles Kains-Jackson, Lord Alfred Douglas's friend and fellow homosexual activist, argued, England no longer needed to concern herself with "population" now that the country was "militarily stable." In an article in the Spring 1894 edition of *The Artist and Journal of Home Culture*, Kains-Jackson reasoned that a real civilization might then flower, producing a "new chivalry" founded upon a spiritual and intellectual foundation of male love.[4] Like many physical culture writers, he linked the romanticized martial life with bodily fitness. Kains-Jackson was alert to the predisposition of his special audience and that of late nineteenth-century British society in general, which was easily seduced by romanticized chivalric as well as classical analogies. His very use of the chivalric metaphor emphasized the continuing power of martial imagery in the construction of both an imperial mythos and his own particular eroticism. In this regard, Kains-Jackson illustrates how physique photographs of strong men posing as Greek statues, and a variety of other male bodies in the physical culture press, could be read as both erotic and inspiring imperial imagery.

As Wilde's trial illustrated, any new chivalric or martial model, insofar as it allowed men to take any pleasure in their own bodies or in homosocial activities in general, was destined to develop along rather circumscribed and conventional lines. Nonetheless, the emphasis on embodied maleness within a romanticized framework of martial skill served both to support and to undercut the contradictory rationales that lay behind racist, ethnocentric, and gender paradigms. Although less visible, the same was true of sexuality. The male body was beautiful, good, and heroic. Each of these was a quality that could also be eroticized. More importantly, the fact that they could be de-eroticized provided a rationale for nurturing and concealing individual desires that were socially inappropriate, if not illegal.

By the end of the century, hard labor in Reading Gaol had become a presumably more humane punishment for the sexually deviant than the Regency hangman's rope. But the definition of sexual misconduct among males had widened to include more than mere genital contact. Of course, the precise sins of the "degenerate" could not be discussed or portrayed in any detail. Indeed, they could only be prosecuted within a framework of body politics that revolved around veiled readings of the body that distinguished the heroic from the erotic as well as the complex realm of homosocial Victorian friendship from its dreaded antithesis. Wilde's own thoughts on the tractability of language, style, and the bodily pose were proved correct even as they were employed against him. He was depicted in court and in the press as the embodiment of "gross indecency," in opposition to the implied innocence of the "boys," "lads," and "youths" he was accused of corrupting.[5] In the end, he was convicted as much for his ideas and impudence in the face of authority as he was for his "immoral" practices.

Wilde's American tour in 1882 illustrates some of the conditions that allowed for the admiration of the male body while the actual sexual act between men was being actively

persecuted. His posing as the aesthete on stage and in the press in association with a tour of Gilbert and Sullivan's *Patience* had the commercial purpose of attracting audiences for the operetta. A decade later on his own tour, Eugen Sandow also entered the marketplace as a posing subject under Florenz Ziegfeld's management. Side by side, photographic depictions of a nearly nude Sandow and a fully clothed Wilde, both photographed by Napoleon Sarony of New York, revealed two very different creatures indeed. Anxieties over the line dividing the sexes or the normal from the perverse were subsumed in such new forms of representation that supported various interpretive visions of the natural past, such as the weakness of the effeminate dandy versus the apparent power and historical weight of neoclassical sculpture imitated by the music-hall strong man.

Both were engaged in the same commercial activity of selling a photographically manufactured self. But Wilde's body was hidden beneath clothes and Sandow's was undressed for all to see. In further comparing the two, however, a reversal takes place in which the nearly nude Sandow stands as the more opaque figure while the pallid and lank young Wilde, fully dressed and in lace cuffs, appears as the more transparent. Sandow asserted himself as the epitome of modern embodied manliness while Wilde resolutely refused to conform to any normal idea of embodied masculinity. Rather than subverting or violating middle-class sensibilities, Sandow's pose represented an aesthetic philosophy more firmly grounded in an ideology of male power expressed in physical beauty, muscular strength, and proportion. Wilde physically and intellectually challenged the simplistic logic of such an ideology.

Sandow's own adolescent conversion to health and fitness, as retold again and again in various forms, illustrated the pervasive use of antique imagery in reproducing the image of the heroic.

our family physician . . . told my father that if he did not take me to Italy for the winter I would never survive it such a weakling I was as a child . . . Well, I went to Italy, and there my eyes were opened. The Greek and Roman statues I saw there inspired me with envy and admiration. I became morally and mentally awakened.[6]

As he told the tale, he emphasized the importance of "mental culture first, physical afterwards." In fact, the real commodity he sold in his magazine was not technique, training, or mental culture, but rather a more amorphous satisfaction of desire, an answer to the "envy and admiration" he himself professed to have experienced on that first visit to Italy. Certainly, many of his contemporaries would have understood the similar "stormy emotion" also experienced by the young Viscount Esher upon visiting the sculpture gallery of the Louvre.[7] Pointedly, the world of physical culture overlapped with that of elite lovers of boys and ancient statuary.

The music halls where Sandow originally performed were also frequented by male as well as female prostitutes.[8] From early in his career he traveled not only at the shadowy fringes of the music hall and circus, but also in the dubious realm of the artist and the model. Often working-class or foreign, artists' models played an important role in constructing both heroic and erotic imagery in the traditional arts and in photography. In a rare physical culture article authored by a woman, Mrs Frank Elliot illustrated a common objectification of the foreign male body:

With regard to male models the regular studio type of young man is often Italian. Italians are as a rule more picturesque and plastic than the average English model. Although the latter may be found seriously cultivating his muscular system at the halleturnberein [*sic*].[9]

Sandow began his career as just such a plastic foreign body. Apart from his first visit as a boy, his formative experience in the realm of bodily representation also took place in Italy, a traditionally well-known site of homoerotic imagery and transgressive sexual practice. Before his first trip to America, the young Sandow was "picked up" in Venice by Sir Aubrey Hunt, an English painter (Fig. 2.3).[10] In another version of the visit to Rome he asked his father "why our modern race had nothing to show in physical development like those lusty men of olden time? Had the race deteriorated, or were the figures before him only . . . ideal creations of god-like men?" His father replied that the race had suffered from "sordid habits" and "fashionable indulgences." In this telling, the historicized body was presented as a nexus of individual desires and national health. Again, Sandow carefully situated himself as chaste in his identification with antique images of male power and his appreciation of their bodily beauty and perfection. But the stories of his visit to Italy can still be read as tales of his "coming out" as an admirer of the male physique if not an actual aficionado of male eroticism. He was himself certainly admired and his picture collected by others. But his own admiration of the masculine body was presented as distinct from the increasingly taboo physical act of men loving men, just as European and national bodies were de-sexualized and shorn of erotic potential while retaining their power as symbols of white male dominance. In this sense, the

Fig. 2.3 Sir Aubrey Hunt, *Eugen Sandow*, c. 1880s. Courtesy David Chapman

very denial of the erotic was proof of the extent to which elite discourse held authority over the definition of the body.

The question is not so much one of how same-sex relations between men became criminalized in the period but rather how other male pleasures like those encouraged in physical culture were at the same time asserted as legitimate. This dichotomy is underscored by the fact that stage displays of women in tights and shorter skirts remained the subject of debate in newspaper letter columns in the mid-1890s.[11] Many were more horrified to hear about the female prostitutes trolling the five-shilling public promenades of the theaters than about male poseurs. Certainly, there was more being revealed in the music halls than women's legs! When the question of renewing the alcohol license of the Palace Theater of Varieties came up before the Licensing Committee in the winter of 1894, the propriety of a female act entitled the "Living Pictures" was raised. These new *poses plastiques* used body make-up to give the impression of stone sculpture. They were known for their use of semi-nude women who, except for their heavy white make-up, were sometimes bare-breasted. George Bernard Shaw, among others, commented how strange it was that women were not as equally debased by the sight of unclothed male athletes as men presumably were by undressed women.[12] One self-appointed critic of the licentious music halls, Mrs Ormiston Chant, claimed that "men would refuse to exhibit their bodies nightly in this way."[13] As Sandow and others demonstrated nightly, this was not so.

As the display of the unclothed male body became more common within certain constraints, publishing photographs or artistic reproductions of partially clothed women's bodies remained prosecutable. Indeed, physical culture pictures may have become much more popular as sexual imagery as a result of the earlier 1870s and 1880s crackdown on the British trade in "obscene" photographs.[14] Physical culture was never successful in its attempts to diversify its readership to include significant numbers of women. That images of physical culture girls were more often used to attract male readers points also to the homoerotic potential of the magazines. Whatever the publisher's intent, the rationale of a liberating health regimen allowed for the display of women's bodies that could always be viewed with more suspicion than those of men. Physical culturists treated female bodies simultaneously as mechanisms of male power and as fleshly objects of desire. In general, women and children were seen to be in more need of exercise in a strictly scientific or practical reproductive sense. Obviously, the request for photographs of physical culture children and the publication of pictures of semi-nude young girls also had the potential for appealing to prurient tastes. What could not be acknowledged with any decorum was the possibility that unsheathed body images of Sandow and his competitors might be just as erotic as popular cigarette card pictures of alluring female dancers.

Images of the "weaker sex" were not the only available depictions of women. Sandow had female competitors and imitators both in print and on the stage. Strong and beautiful as she might have been, the female music-hall weight lifter wore her body in the wrong way. In effect, she became a cross-dresser by wearing her body in a traditional male style (Fig. 2.4). Such a transgression could be softened only by presenting her as a comic or sexual figure. In sharp contrast, pictures of boxers or soldiers in military postcard series depicted men instrumentally as heroic and active in a manner that de-emphasized possible erotic readings. Exceptions in this period would be Baron von Gloeden's images of nude boys posed in neoclassical settings. Even these, however, when compared to his depictions of women, indicate the presumption of a dominant male gaze within which boys and women are crucially constructed as "non-men."[15]

In the context of a divide between the heroic and the erotic, the first of Sandow's "Great Competitions" was introduced in the initial issues of his magazine in the late 1890s. The contest aimed to attract readers and students for mail-order instruction, provide the magazine with

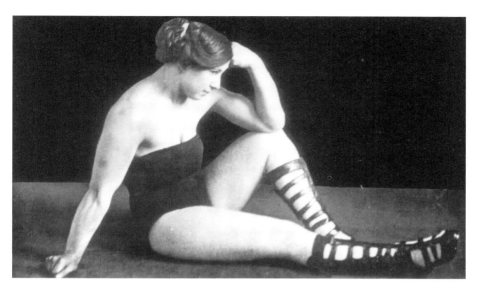

Fig. 2.4 Photographer unknown, *Athelda*, female strength performer, c. 1890s. Courtesy David Chapman

photographs to publish, and create general publicity for Sandow's gymnasia and other enterprises. The means of taking and reproducing photographs was quickly improving. In general, the creation of a seemingly concrete and absolute objective perspective quite outside of bodily experience had contributed to a clearer standard of physical normality. As in the Victorian post-mortem portrait, photography made the objective stance of the pathologist available to all. From such a seductive superior standpoint, the corporeal could be analyzed and judged in new ways and presumably reshaped. For the physical culture entrepreneur, the problem (as always) was one of how to incite legitimately desires and bodily needs that created or corresponded to the purchasing wants of individual consumers. One solution was to ask readers to photograph their own bodies in heroic statuesque poses and sell back to them a kind of petrified commodity of the self made whole.

The contest response provides a look at the genesis of the modern male body image as a participatory process. Pictures were sent in from all over Britain. Some contributors posed formally in ways that strong men did on cheap postcards. Most men stood frontally to the camera with their arms crossed across their chests (Fig. 2.5). Some wore moustaches; haircuts were universally short. Most subjects appear to be in their twenties, a few are middle aged. Some are skinny, others are brawny, or tattooed. A few wore singlets, though most were bare-chested. Sandow selected the photographs for publication "haphazardly from a number," and kept a "monster album" of all photographs sent to him at his headquarters. From these he hoped to create a "Book of Beauty … such has rarely glorified the world."[16] The eventual group of "splendidly proportioned men" (over 150 made it to the semi-finals) was judged by a classically trained sculptor, Sir Charles B. Lawes, and the medically trained Conan Doyle. While the correspondent for the *Times* noted that the development of some of the men seemed "abnormal,"[17] the entire process of the competition served to support the authority of a normalizing rhetoric by presenting concrete ideals of maleness. It did so by combining specular aesthetics and the pleasure of looking with the comfortable validation of one's body being "right" rather than degenerate or "wrong." Later, pictures of the winners were sold as a package. Clearly,

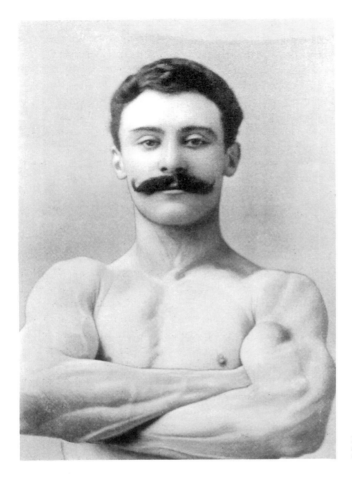

Fig. 2.5 Martinus Sievking, Sandow's companion and
accompanist, in a typical physical culture pose.
Courtesy David Chapman

there was a market for men who liked to look at such pictures. Which brings up the question of
who bought such collections of the "splendidly proportioned" and why? In any event, the
willingness of readers to submit them was indicative of a marginally successful effort to construct
physical culture and its language of the pose as an act of self-definition.

In sponsoring such contests, physical culture media imitated the earlier subscription ploys of
Lord Northcliffe and others in the mass dailies. More importantly, the addition of the
self-revealing photograph created a space for male display and self-definition somewhat apart from
actual gymnasia or swimming baths. As the success of its photo competitions indicates, physical
culture offered men an attractive means of expressing their public gendered, if not private sexual,
identity. Alongside the confessional and "parliamentary" forms of advice and letters columns, the
contests presaged a range of later publications that would cater to the vicarious tendencies of
twentieth-century mass readerships. As traditional voices of moral authority weakened, physical
culture commerce provided an alternative language in both print and photographic form. In
letters and advice sections, publishers' replies were sometimes printed elliptically without the
actual queries that had inspired them. In this way the body and its attributes, the presumed central
object of discussion, were displaced. Thus, we have "New Reader" being advised "Bathe in the

open by all means," and "H. Lewis" being told that "A book on Artistic anatomy would suit you. We shall publish a series of anatomical photographs next month." Other intriguing responses include that to "E.L.": "you can see it privately if you make application," or to "Depressed": "My dear boy, letters like yours give me the heartache. Be a man, say to yourself 'never again,' and stick to it."

Apart from the coded expression of illicit desires in public print, men were presumably attracted to physical culture's visual template as a guide to be more manly. Within physical culture's architecture of words, photographs, diagrams, contests, and leagues, men could act upon "innate" martial and associational desires. For men, the solidity of the heroic naked body as a common and concrete experience served to mask the specificity of pleasures and desires within it. But the commodification of the heroic male body as a kind of fashionable attire could also complicate important social distinctions. The elemental differences in approaching masculine and "other" bodies did not break along strictly genital lines of feminine versus masculine identity, or manliness versus unmanliness. For example, the industrial civilization frequently blamed for the effeminization of men could also be erected as a final bastion separating "primitives" from the civilized neo-primitives who read the physical culture press.

Ultimately, even the strong beautiful male could wear his body in the wrong manner. In 1905, when F. W. Haslam, a professor of classics, spoke before a physical culture society in Canterbury, New Zealand, he argued against the failure to link citizenship with military duty and bodily fitness, scornfully noting that its lamentable results included the tendency for public gymnasia to be taken over by time wasters, "professional athletes, pretty boys and their friends, who made their exercises a cloak for immoral practices."[18] His allusion to this aspect of gym life reads as a common example of homosexual panic from the period. As a classicist, Haslam was no doubt aware of the "unspeakable" sexual practices of the Greeks, and was at pains to remind his listeners that the rise and fall of such ancient civilizations provided an important lesson for contemporary physical culturists. The open-ended possibilities of the naked body's interpretation meant that Haslam had a point. To argue that the admiration of the body had to remain pure demonstrated some knowledge or belief in its potentially impure reception. The centrality of dynamics of repression and liberation to Victorian processes of desire meant, of course, that the unspeakable would at the very least continue to be whispered. Despite the ongoing institutionalization of the delineation between the homosexual and the heterosexual, the spectral processes of the era of the sculpture machine foreground the inherent difficulty of socially constructed categories of sexuality being mutually exclusive and strictly binary. Physical culture photographs notwithstanding, the views of Haslam and others indicated that physical culture media were that much more important for men who desired simple comradeship or sexual pleasures focused upon other men.

Legal repression worked on one level, but an upper- and middle-class-dominated demi-monde of homosexual practices did not disappear in the wake of Wilde's conviction. Consciously or not, physical culture media catered to the over-arching pornographic gaze of consumerism as well as an elite penchant for sexually crossing the class divide. In an otherwise repressive atmosphere, the very importance of male power, symbolized by physical culture posing, permitted a greater expression of male affection and admiration of the masculine body. Classifieds, letters columns, photo contests and the homosocial character of such publications provided a space for a variety of men to enjoy and imagine other men's bodies; to communicate, and even meet one another. Indeed, by the middle of the twentieth century, physique publications were being avidly cross-read by men who had begun to identify themselves primarily according to their sexual activities. In this sense, fitness magazines took a major step toward the creation of a homosexual subculture based on something more than overt prostitution or chance encounters in public places.[19]

Quite apart from Haslam, the founder of Scouting, Robert Baden Powell, serves as a different example of late Victorian erotic expression and repression.[20] In particular, he provides some clues about how physical culture as sexual imagery may have fitted into the lives of some of its readers. Baden Powell's love of the empire's far-flung places was about not only the "flannel shirt life," but also the greater opportunities to take part in a male culture that prized and displayed the body regularly. He held an "emotional and aesthetic affinity" for the "well-muscled males who were taming nature in these remote places."[21] His attitude toward the body in general was keyed toward the typical pattern of physical culture gender differentiation. Emphasizing "clean manliness" in an unpublished draft article titled "A Dirty Age," he condemned the depiction of female anatomy. He considered the tenth Scout law to be the most important, "A Scout is clean in thought and word and deed," and was especially concerned with "keeping the racial member clean."

Much like Sandow and Wilde, Baden Powell displayed a genius for marketing himself as a successful author, publicist, and entrepreneur. In addition to selling the ethos of imperialism, he was also an "invisible spectator" or consumer of male photographic erotica. He made special trips to see A. H. Tod's collection of photographs of nude boys at Charterhouse and his appreciation for nude imagery extended to the spectacle of actual nude young men bathing in public.[22] Watching bathers had long been a London pastime. Earlier, Francis Galton had "often watched crowds bathe . . . in the Serpentine" and complained of the the relative lack of such opportunities to compare his countrymen in the nude.[23] In Baden Powell's lifetime, such public opportunities diminished as the body became a focal point of movements like Scouting and physical culture.

To be young and male was to be exempt, in Baden Powell's canon, from the usual tyranny of social distinctions. His love for the ambiguity or "betweenness" of boyhood was linked to his own experience of adulthood wherein work and the need to earn an income took precedence over frolic and play. The uniformed hero of Mafeking in the Boer War, like the proto-military Boy Scout, provided refuge in his assertion of the big lie, that of an overarching and bodily indexed manliness within which specific desires, including homoerotic ones, might be kept secret. In this regard, Sandow's body was also a kind of uniform, as well as its own mask and mediator. It acted as a greater metaphorical body that could be mistaken by thousands of others for their own, and in which specific individual desires might be diffused within the experience of a physique somehow anterior to its socially determined existence and being.

Sandow's career in Britain began with his presentation as "in between." His first stage appearance was as the preferred object of desire for both Wilde and Baden Powell, the "ephebe," positioned in the state bordering youth and full adulthood. Acquiring a moustache, Sandow soon proceeded to occupy the role of the "mature athlete," a relatively new image of male eroticism compared to the dominant Victorian objectification of the youthful adolescent as epitomized in von Gloeden's photographs.[24] The mature athlete was different from the boy-Ganymede and yet similar in the poseur's willingness to become vulnerable to the camera's eye. The heroism of youth was that of vulnerability associated with innocence. The heroic stance of the mature strong man was characterized by control; the exertion of power and the promise of mastery. In the assertion of a neoclassically inspired muscular aesthetic, particular notions of beauty and sexual positioning were sublimely and causally linked with an abstracted and still palpable exercise of male power. But these were never hard and fast ideas and relations. Individuals who fantasized physical encounters with such images could make them into objects of possession as well as icons of potential domination. A given subject might desire, in fact, to possess the mature strong man master or be dominated by the adolescent youth. Another might find equivalent pleasure in

imitation; assuming either or both bodily costumes in fantasies or actual enactments of same-gender and opposite-gender sexual encounters.

The apparent control of the body, as well as who did the looking and why, were all critical questions. There was perhaps nothing more obvious than the weakness of the woman in her "underthings" or the languor of the over-dressed and dandified poet-aesthete when compared to the strength of the well-muscled and naked male. But such distinctions between men, women, and effeminate men were fundamentally reliant on the assumption that different poses by men, women, and inverts reflected their inner desires and fundamental constitutions. The strategic juxtaposition of certain types of men – those with exemplary muscles – with representations of the self-conscious powerlessness of the effeminate underscored such assumptions. Images of strong or degenerate men and exotic women were read within a world that believed in the premise of male superiority. In fact, neither the belief in male primacy nor the ideals of male and female representation conformed very closely to people's actual lives. The weedy degenerate clerk, unfit for military service, who was the presumed client of the physical culture huckster, made for an interesting contrast to the growing numbers of "New Women" who energetically played sports at school, avidly rode bicycles, campaigned for the vote, and who, in short, were making a hash of traditional representational distinctions. Meanwhile, there were guardsmen and others who conformed publicly to archetypes of masculinity even as they sold themselves as prostitutes or enjoyed sexual relations with their male comrades.[25]

For men who desired other men, playing the double game was enabled and encouraged by dominant presumptions about the legibility of the body's surface. As a public iconization of the real, photography gave a new sheen and opaqueness to that surface. Like the novel, photographs were intensely personal and intimate. A blizzard of images could be taken into individual consciousness and experience and be interpreted in ways that did not validate the dominant visual order. A large part of the success of physical culture was its assertion of the male body as heroic rather than erotic; in the depiction of bodies as under control rather than out of control. But underneath or rather outside the frame of the photographically controlled body there was always the threat or promise of its opposite. In some cases, certainly, the presence of the erotic beyond the frame was more obvious. In one of several physical culture articles, eugenicist Francis Hutchinson described his sixteen-year pursuit of measuring and photographing a large number of young men in the nude. In his arguments for nude male physical culture, Hutchinson proposed the mass production of live body casts to be displayed in gyms and museums, and the circulation of books of honor containing photographs of the very best bodies.[26] Obviously, Hutchinson liked to look and wanted to see more. But exemplary images of bodies could be made to mean many different things; scrapbook images and casts of bodies such as Sandow's (Figs 2.6, 2.7) could be sexually charged or not depending on the viewer's disposition. The need for qualifying text and/or fig leaves underscored the potential for reading any body image erotically. This is not to say that any body was always naturally erotic beneath the scrim of cultural disavowal, but rather that erotic readings of the body were as legitimate as heroic ones for either gender.

In photographic practice, physical culture magazines provided space for a readership of men who at least desired to look at or compare themselves with other men. Whether physical culturists intended it or not, men like Baden Powell, Edmund Gosse, Viscount Esher, J. A. Symonds, and significant numbers of others were very likely to have read these published illustrations and photographs as homoerotic. In this context, the treatment of the male genitals presented an interesting problem for physical culture photography. The bowdlerizing of the phallus with a fig leaf was already a familiar practice in Victorian photographs of ancient statuary. In profile views, of course, the penis could be retouched out with little effort. But by the early twentieth century,

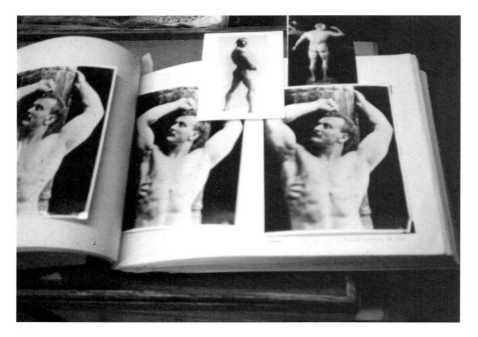

Fig 2.6 Scrapbook of photographs of Sandow, n.d. Courtesy the author

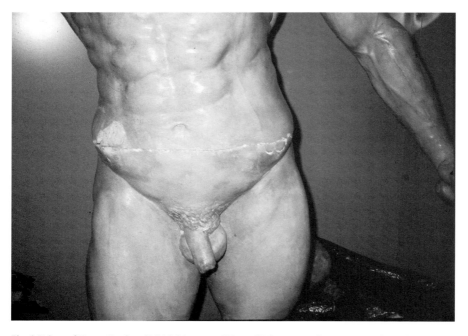

Fig. 2.7 Cast of Eugen Sandow, British Museum of Natural History, London. Courtesy the author

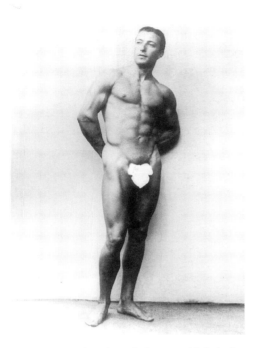

Fig. 2.8 Arax, *Male Nude* (Emile Bonnet) with fig leaf removed, n.d. Courtesy David Chapman

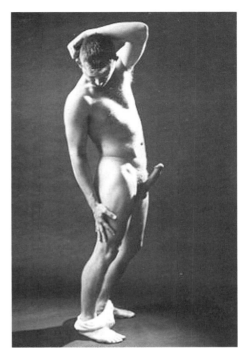

Fig. 2.9 David (Dazie) Edwards, "Buck," website download, 1997. Courtesy the Estate of David Edwards

the photographic emasculation effected in the frontal pose by the fig-leaf-as-g-string was not so easily repaired as it was in antique statues! (Fig. 2.8). As much as it attempted to deny the erotic, the multiply erased crotch called attention to what was missing, giving the erotic dreamer a different space in which to maneuver than that provided in pornography by the explicit erection.

Such practices from a century ago that aimed to reorder mass bodies were avowedly repressive in many cases, and unexpectedly liberating in others. In the flesh and in the physical culture photograph, bodies and desires were always re-read and at best only temporarily constrained or controlled. In their variety and complexity, the images of a century ago constitute traces of a dimly imagined future encompassing our own contemporary commercial aesthetic that continues to separate and fuse the heroic with the erotic. Now, as then, the heroic is a handy way of erasing and concealing our individual lack of self-control and actual political power. It is here that we find the basis for our present-day love affair with the free-wheeling virtual body. From the video fighters in Mortal Kombat to the clean-shaven body of the well-muscled porn god, the animation of the statuesque has become commonplace (Fig. 2.9). Indeed, the concern with bodily control through the photographic assertion of the heroic continues to underscore the body's elusiveness as an ideological construct in both its gendered definition and in the conflation of social identity with sexual practice.

In this context, some have posited that we are now beyond the body, in a post-corporeal as well as postmodern age. This is a provocative but dangerous notion. That we can problematize the self and body through language or play with disembodiedness in cyberspace does not release

us from the corporeal. Certainly the present hypereality of the 3-D virtual image lessens the symbolic power of the sculptural. But rather than inhabiting a post-corporeal age, we are in many ways still part of an era of the body that began with the diffusion of photo-illustrated media one hundred years ago. Even with new graphic and information technologies, prosthetics, and alterations, bodies remain our *modus operandi*; the things that connect us and separate us from one another. However or from whatever point we survey the political landscape and imagine ourselves – whether it be in terms of class, gender, ethnic or sexual identity – we must still contend with our bodily differences and commonalties. In this sense, critical histories of bodies, or what Sontag calls an "ecology of real things," cannot be disconnected from histories of photographic objects. Whether we are moving toward greater toleration of bodily difference or not, physical culture photographs remind us that our most concrete lodestar of existence, the body, can be made to mean many things. The crucial question remains: by what processes are its meanings decided? As a metaphor for sculpting the self and the body, photography holds part of the answer and continues to make decisive contributions to a contemporary male eroticism still shadowed by a heroic/erotic pose between life, death and desire.

notes

1 Richard Ellmann, *Oscar Wilde*, New York, Knopf, 1988, pp. 183, 39.

2 *Cyber*: "Web Talk: Being an Occasional Odyssey through the Internet," *Village Voice*, 1 October 1996.

3 John Hargreaves, *Sport, Power and Culture: A Social and Historical Analysis of Popular Sports in Britain*, New York, St Martin's, 1986, p. 51.

4 Charles Kains-Jackson, "The New Chivalry," *The Artist and Journal of Home Culture*, April 1894, in Regina Gagnier, *Idylls of the Marketplace: Oscar Wilde and the Victorian Public*, Stanford University Press, 1986, p. 160.

5 Ed Cohen, *Talk on the Wilde Side: Toward a Genealogy of a Discourse on Male Sexualities*, New York and London, Routledge, 1993, p. 195.

6 "Sandow interviewed in America," *Sandow's Magazine*, vol. 8, January 1902, pp. 56–8.

7 James Lees-Milne, *The Enigmatic Edwardian: The Life of Reginald, 2nd Viscount Esher*, London, Sidgwick and Jackson, 1988, p. 35.

8 Jeffrey Weeks, *Coming Out: Homosexual Politics in Britain, from the Nineteenth Century to the Present*, London, Quartet, 1977, p. 37; and *Sex, Politics and Society: The Regulation of Sexuality Since 1800*, London, Longman, 1981, p. 113; also, Ronald K. Hyam, *Empire and Sexuality: The British Experience*, Manchester University Press, 1990, pp. 67–9.

9 "Some Types of Artist's Models," *Sandow's Magazine*, vol. 15, no. 106, July 13, 1905, pp. 90–2.

10 The meeting with Aubrey Hunt of the Royal Academy occurred as Sandow emerged from the sea at the Lido in Venice. Afterwards, he engaged him to model for a painting of the Roman gladiatorial games. David Chapman, *Sandow the Magnificent*, Urbana and Chicago, University of Illinois Press, 1994, pp. 19–20.

11 These were subsequently debated at the Licensing Committee meetings of the London County Council. Geoffrey Stokes, *In the Nineties*, University of Chicago Press, 1989, p. 56.

12 See Arthur Symons in the *New Review*, November 1894, pp. 461–70; and George Bernard Shaw, *Our Theaters in the Nineties*, vol. 1, p. 86, as quoted in Stokes, *In the Nineties*, p. 79. Shaw decried "false decency" that made people ashamed of their bodies. See Ben Maddow, "Nude in a Social Landscape," in Constance Sullivan, ed., *Nude Photographs: 1850–1980*, New York, Harper, 1980. p. 187.

13 Geoffrey Stokes, *In the Nineties*, p. 79, as quoted from D. F. Cheshire, *Music Hall in Britain*, Newton Abbot, David & Charles, 1974, p. 41.

14 Britain not only sold cloth to the world, but was a major exporter of nude erotic photographs. See Hyam, *Empire and Sexuality*, pp. 3ff., 20.

15 Ulrich Pohlmann, *Wilhelm von Gloeden: Sehnsucht nach Arkadien*, Berlin, Nishen Verlag, 1987.

16 *Sandow's Magazine*, vol. 4, 1901, p. 475.

17 "Physical Culture Display," *The Times*, London, 16 September 1901, p. 7.

18 F. W. Haslam, "The Greek Ideal: Duty and Beauty," lecture reprinted in *Sandow's Magazine*, no. 103, 22 June 1905, pp. 636–9.

19 Weeks, *Sex, Politics and Society*, pp. 108–17.

20 Tim Jeal, *The Boy-Man, The Life of Lord Baden Powell*, New York, Morrow, 1990, p. 39.

21 Baden Powell admired the bodies and strength of "men who are men" (thus assuming a great many men who are not men) in Canada, Norway, Australia, South Africa, and among the hillsmen of Kashmir – also the "well-built naked wonderfully made bodies" of men washing together during the Great War.

22 Baden Powell, diary reference, 1919: "Tod's photographs of naked boys and trees etc. Excellent." Tod was housemaster at Charterhouse, Baden Powell's alma mater. In a later letter to Tod, BP broaches the possibility that he "might get a further look at those wonderful photographs of yours?" At the same time, Henry Scott Tuke's large paintings of naked boys were being hung in the Royal Academy. Tuke was gay, as were many of his patrons, but "his pictures were art and therefore safe from censure." In 1934, BP railed against the police ban on boys swimming nude in the Serpentine. In a similar tone, he advised Scoutmasters to encourage "self-expression, instead of disciplining . . . by police methods of repression." From *The Scouter*, 1934, p. 262. All quotes from Jeal, *The Boy-Man*, pp. 90–3.

23 *Sandow's Magazine*, October 1903, pp. 167–9.

24 On the "ephebe," versus the "he-man" mediated by the invisible consumer, and the "desiring body of the gay producer-spectator" rarely visible within the camera frame, see Thomas Waugh, "The Third Body: Patterns in the Construction of the Subject in Gay Male Narrative Film," in Martha Gever *et al.*, eds, *Queer Looks: Perspectives on Lesbian and Gay Film and Video*, New York and London, Routledge, 1993, pp. 141–2.

25 On guardsmen as male prostitutes and the class complexities of male sexuality, see Weeks, *Sex, Politics and Society*, pp. 112–14.

26 *Sandow's Magazine*, no. 1, July 1898, p. 5.

chapter three
thomas waugh

posing and performance
glamour and desire in homoerotic art photography, 1920–1945

Dear Hugh,
Antony's tender, wistful, nostalgic, poetic, mystical, heartbreaking Jardin aux Lilas knocked me over again last night and I wept at its beauty! . . . It is by far the best thing I have seen *you* do and you are magnificent in it: exactly right [charming, romantic, tragic, & with just a dash of diablerie. Incredibly handsome, of course] (or better!) . . .

About Thursday morning. If it is sunny and nothing has happened to you in the meantime, I will stop for you in front of the Windsor about 11.10 AM. It would be nice if you could be downstairs. At any rate we won't have much time. [I will bring Juante *with me*]. Bring your kit with makeup and red pants etc . . . Love and congratulations to you both,

Carlo.

I am printing you and Juante (June 8) today. Some of these will startle anybody!
Carl Van Vechten to ballet dancer Hugh Laing, 1940[1] (Fig. 3.1)

The glamour generation of art photographers emerged from the First World War to come of age during the era of jazz, cinema, and Art Deco, as well as the Weimar Republic and the Great Depression. This generation's veils – of the decorative and applied arts, of stylized melancholy, of high Bohemian camp, in short, of *glamour* – set a tone radically different from the intense eroticism of previous generations epitomized by Wilhelm von Gloeden and F. Holland Day.

The moniker "glamour" may seem trite, even harsh, as a defining label for the networks of young men who undertook their photographic careers in the 1920s and 1930s, but it is one many of them might have relished. I would not want to exaggerate the historical coherence of these loose networks I refer to as a generation, yet certain social and cultural moorings they held in

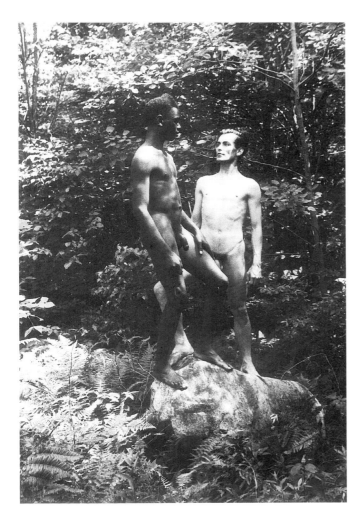

Fig. 3.1 Carl Van Vechten, *Hugh Laing and Juante Meadows*, 1940. Yale Collection of American Literature, Beinecke Rare Book & Manuscript Library, Yale University, New Haven. Courtesy Estate of Carl Van Vechten, Joseph Solomon Executor

common, along with certain aesthetic and erotic interests, make the label "glamour" fit them nicely.

John Berger has defined glamour as a specifically modern phenomenon, emerging within a culture that was increasingly visual and "specularized." He calls glamour "the happiness of being envied," a commodity manufactured by the publicity industry in a society "stopped half way" in the movement toward "democracy." Glamorous day-dreams compensate for social powerlessness and economic deprivation. Etymologically connected to magic, and dictionary-defined as "delusive or alluring beauty or charm" (*OED*), glamour seems to connote also the contradictory mix of intimate identification and unfulfillable voyeurism that I have argued elsewhere is a basis of homoerotic spectatorship. Glamour implies the "envy" – or I would argue, the "desire" – of the spectator, a hybrid of starfucking and projection. It also implies the visual pleasure of the perfectly lit, eroticized body, all summed up in Van Vechten's excessive gush of adjectives to his dancer model.[2] The glamour generation of gay male photographers worked their magic constructions of both the male and female body for the most part commercially within the prototype image industries that were consolidating in Europe and America during the interwar

thomas waugh

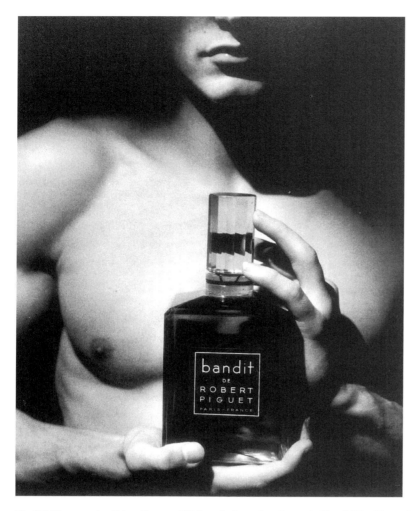

Fig. 3.2 Glamour advertising. Raymond Voinquel, planned perfume ad, "Bandit" by Piguet, Paris, 1940. Courtesy the artist

years: fashion, journalism, advertising (Fig. 3.2), show business and the performing arts, celebrity portraiture, and the motion picture industry, a new sector that had virtually invented glamour itself.

Profiles of the most visible practitioners in Europe and the United States point to two largely intersecting networks and a sprinkling of more isolated figures dominating the gay cultural orbits within this period's photographic worlds. The first is a club of gay image-makers who were at some point in their lives affiliated with the international fashion bible *Vogue*, or its rival, *Harper's Bazaar*. George Hoyningen-Huene (1900–68), the Baltic baron whose family had fled the Russian Revolution, was the presiding genius at Paris *Vogue* from 1926 to 1935 and a mentor for many figures in the glamour networks. His German protégé and lover, Horst P. Horst (born 1906), would later inherit his mantle as international dean of fashion photography and eventually became a society portraitist. The couple were occasional weekend guests at the country home of the foremost Englishman in international *Voguerie*, the prolific Cecil Beaton

60

(1904–80). The gay fashion circuit also included Herbert List (1903–75), scion of a Hamburg merchant family and one of the intellectuals of the group, who moved through the fashion world of Paris en route to Italy and Greece before his wartime return to Germany. Yet another European was Raymond Voinquel (1912–94), who worked in the French film industry from the 1930s to 1970, chiefly as a glamour studio photographer, with directors such as Marcel Carné and Jean Cocteau.

Two New Yorkers on the edges of the *Vogue* web specialized in performing arts photography. Carl Van Vechten (1880–1964), the Europhile elder of the entire network, for whom photography came as a third career after music and dance criticism and novels, is most famously remembered as the downtown white patron of the Harlem Renaissance and connoisseur of its aspiring writers and its drag balls. But he also included hundreds of white culturati and Parisian socialites as his sitters.[3] His sometime house guest, the Hungarian-born fencing champion Nickolas Muray (1892–1965), crafted luminous male nudes out of his work in the interwar New York theatrical and society circuits.[4] Finally, a younger New Yorker, George Platt Lynes (1907–55), whose dimensions we are only now beginning to fathom,[5] would eventually repudiate his considerable fashion livelihood, though he owed more to his 1930s enthronement on the *haute* level of *couture* than he might have liked to admit.

In fact, not *everyone* worked for *Vogue*. A second 1930s cadre, as multidisciplinary as their fashion friends, identified more directly with the fine arts and literary milieus. High priest of this group was the Frenchman Jean Cocteau (1889–1963), whose prominence in theatre, film, and letters would eventually get him into the Académie Française (despite his brilliance in erotic drawings and unsigned erotic narrative). The network also included another mentor figure, Pavel Tchelitchew (1898–1957), émigré Russian painter and stage designer who presided alternately as lover to and mother superior of the entire network. American hangers-on ranged from artist Paul Cadmus (born 1904) and his sometime lover Jared French (1905–87), both figurative painters bucking the new abstractionist orthodoxy in the New York art world (French was also a set and costume designer), to Charles Henri Ford (born 1910), the surrealist poet from Mississippi who experimented with visuals and editing literary magazines as well. Many other handsome young gay American writers hobnobbed on the Paris circuit at the time, such as men of letters Glenway Wescott (1901–87) and Sam Steward (1909–93).

On the whole, this highly interconnected transatlantic web of gay intelligentsia and denizens of high bohemia shared what seems to have been a gay distrust of the growing influence of more rigorously abstract and puritanical modes of high modernism. And it was mutual. Modernist theorist Clement Greenberg's attack on Tchelitchew, dubbed "neo-romantic," echoed the contemptuous tenor of surrealist kingpin André Breton's earlier and more famous tirade about Cocteau and other queers in general.[6] By and large, such image-makers were better integrated, both socially and artistically, with the eclectic gay cultural networks of Europe and New York than with the modernist vanguards, largely straight, of their own disciplines.

Moving in privileged social circles and smart vocational ghettos where homosexual lifestyles were the norm and where homosexual style and creativity were prized, both the fashion and the fine arts circles of the glamour generation lived openly gay lives on the whole – perhaps more so than any other generation before Stonewall.[7] They displayed a palpable ease and comfort in their sexual identities, and in erotic work that reflected those identities. In this they were closer in spirit to Oscar Wilde and other turn-of-the-century aesthetes than to the conflicted sensibilities that were to emerge after the Second World War. Sometimes the fashion network and the fine arts network would intersect at the much sought-after European "at homes" of Stephen Tennant, Coco Chanel, or Gertrude Stein, in Cocteau's opium-clouded hotel rooms,

at the Manhattan salons of Van Vechten and the discreet Lincoln Kirstein, or at the Upper East Side apartment Lynes shared with his lovers *à trois*, Wescott and Monroe Wheeler of the Museum of Modern Art. Many cocktails were consumed and lovers shared. To contemporary eyes the intersecting circles seemed inbred and incestuous: Beaton attended a New York party in the late 1930s chez Ford, Parker Tyler, and Tchelitchew, at which a principal topic of conversation was whether marxism had deformed their friends W. H. Auden and Christopher Isherwood or whether Auden and Isherwood had deformed marxism.[8] No wonder one disgruntled poet on the edges of the circle, gay himself, would widely circulate a denunciation of the homosexual "cult" in the arts.[9]

Despite a wide range of individual interests within the glamour networks, from Beaton's queens (real ones) to List's metaphysics to Van Vechten's passion for Harlem, one can generalize about the erotic imagery that emerged in that it was usually more peripheral to the artists'

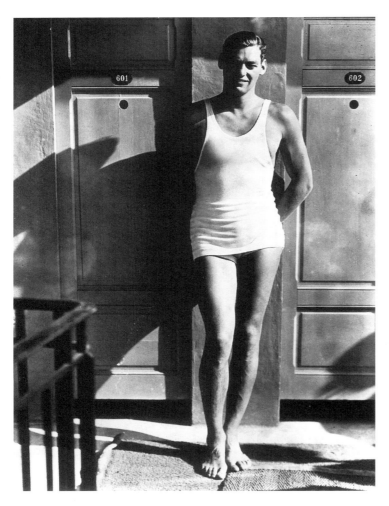

Fig. 3.3. George Hoyningen-Huene, *Johnny Weissmuller*, **1930. Frederick R. Koch Collection, Harvard Theatre Collection, Cambridge, Massachusetts**

vocations than its obsessive core. (And, until recently, mainstream critical myopia banished it even beyond the periphery.) At most, the eroticism of the glamour artists filled inconspicuous but coherent corners of their public *oeuvre*, situated on a continuum with it stylistically and thematically. Thus Hoyningen-Huene's famous beefcake shot of swimmer Johnny Weissmuller pictured him standing as if on a Paris runway rather than in the shipboard poolside sunlight (Fig. 3.3) Such erotic work deployed, either consciously or unconsciously, the vocabulary of their vocation, the fastidiously constructed studio-based universe of fantasy that was common to their work as chroniclers of society, show business, and fashion.

Two other generalizations can be made about the glamour image-makers, both the flaunters and the more private men. First, they were an urban crowd, infected with a romanticism – whether expressionist or constructivist, surrealist or Art Deco – that was in tune with the pulsating life of Paris, New York, London, Moscow, and Berlin. Their element was the artifice of the studio where the dazzling perfection of electric light matched the cosmopolitan rhythm of the industrial metropolis.

Finally, the imaging of the female body was the bread and butter for many of them – all except List were known as prolific and sensitive delineators of women. Their talent for depicting women drew on their homoerotic sensibilities in two ways. First, they transcended the gendered object choice through a sensuality of fabric, make-up, pose, and gesture, or alternatively through visual caresses of famous, often androgynous, faces. Also, these artists articulated what I refer to elsewhere as the "diva syndrome," in which an identification with a larger-than-life female subjectivity inside a heterosexual narrative framework is homoeroticized specifically in its shared male object choice. Here, homoeroticism arises not from the representation of homosexuality per se, but in the eroticization of the male object of desire, where heterosexual women and gay men are either accomplices, rivals, or stand-ins for each other.

In short, even when the erotic work was largely unpublished during the active career of the artist, as with Lynes, Voinquel, and Van Vechten, or when the artist himself seems to have considered it a "frivolous" sideline to his more serious "artistic" work, as was perhaps the case with List, or when the artist was even unaware of its presence within his work, as may have been the case with Beaton and Muray, the continuum between private images of desire and public images of glamour is fundamental. Glimpses at four principal genres of the erotic production of the glamour generation will illuminate these dynamics.

the portrait as erotic genre

The interconnectedness of the glamour milieu becomes legible in one special genre of this generation's erotic image-making, the portrait. Membership in these networks involved photographing – and being photographed by – everyone else. Mentor figures like Stein, Cocteau, and Tchelitchew were obsessively photographed again and again.[10] Beaton, for whom being photographed was the ultimate pleasure, sat for Lynes, Huene, Van Vechten, and Horst. It was the latter who posed the Englishman as the generation's idol (and Beaton's future lover) Greta Garbo (in her androgynous role as *Queen Christina*). Dandy, narcissist, and frequent on-camera cross-dresser, Beaton photographed himself repeatedly, often in the overripe getups that seemed to inform his erotic sensibility. He also found the time for all his friends, including the fellow artist and designer Rex Whistler camping it up on a rocky seashore in a tatty leopardskin, like a superannuated von Gloeden model; the moody and slender (but butch) Platt Lynes (also Huene's subject); and the dashing couple Horst and Huene, who immortalized each other several times as well (Fig. 3.4). Huene was caught also by List and by Van Vechten, who in turn provided portraits of every

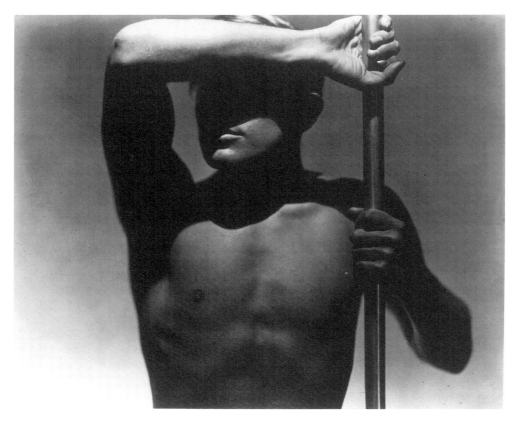

Fig. 3.4 The lover's image. George Hoyningen-Huene, *Horst*, c. 1931. Frederick R. Koch Collection, Harvard Theatre Collection, Cambridge, Massachusetts

cultural icon and fresh new face of his day, including Muray (who naturally photographed him back), Beaton, Cadmus and French, and Ford. Tchelitchew posed most tenderly for Huene, whose hand affectionately enters the frame, and most dramatically for Beaton, who caught him painting Beaton's own life-long elusive passion, Peter Watkins, in a work where the ocular circuits of unspoken desire are busy indeed.

Lynes dramatized his portraits even more in a subgenre he himself may have invented, the portrait of the (gay) artist as a character in a narrative dream tableau. His straight sitters were usually placed in bare or abstract settings or with the tools of their trade, whereas, for gay sitters, sexual identity and biographical hints were usually visualized as erotic fantasy. Lynes's familiar surrealist-flavored 1939 images of Isherwood are a case in point: in one image (Fig. 3.5), the fully clothed writer looks at the camera past a foreground male nude figure, head cropped and genitals dodged out. In another, Isherwood poses in front of a rear-projected reclining nude whose face and genitals are fully in view.[11] Does the dichotomy of these alternative portraits express a visual artist's envy of the writer's forthrightness? Or was Lynes evoking a tension between sexual compulsion and repression that few of the glamour artists seemed to feel outwardly, least of all Isherwood, but which was increasingly an anxiety for the photographer? Or does it simply express the pragmatic necessity of public and private versions of the same portrait?

One very particular category of the portrait appeals to the privileged knowledge of the spectator and to the gay historian's unfairly denigrated role as gossip – the lover's portrait. Huene and Horst were not the only ones to capture their lovers on film. The sometime lovers Ford and Tchelitchew also portrayed each other, photochemically and in ink and wash, respectively. As for Lynes's relationships, his portraits of his doomed wartime lover George Tichenor are deservedly admired, but he also photographed his sometime lovers, Wescott and Wheeler, with more affectionate and less dramatic effect. A further subgenre can also be identified, the "trick portrait," in which the consummation of fleeting lust and the short intense encounter are transformed into a permanent trophy. The promiscuous Lynes may not have been its inventor but he has turned out to be the first within the glamour milieu to have left behind so much documentation.[12] The subgenre is probably much more extensive than we shall ever know, and has much more developed counterparts in the commercial domain of licit physique photography and, one assumes, in illicit photography.

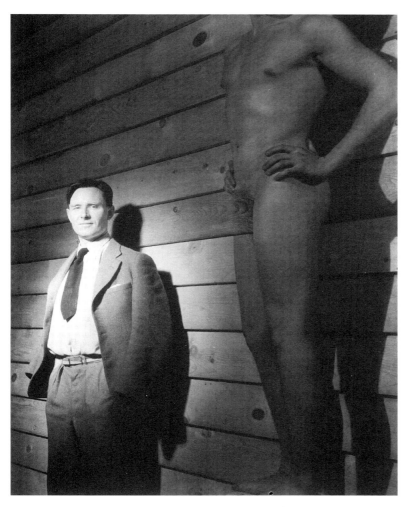

Fig. 3.5 George Platt Lynes, *Christopher Isherwood*, c. 1939. Courtesy estate of George Platt Lynes

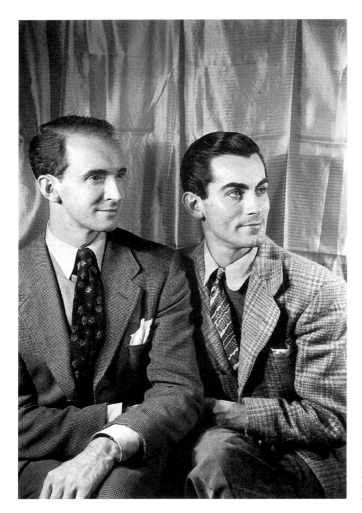

Fig. 3.6 Carl Van Vechten, *Hugh Laing and Antony Tudor*, ballet stars, 1940. Yale Collection of American Literature, Beinecke Rare Book & Manuscript Library, Yale University, New Haven. Courtesy of Carl Van Vechten, Joseph Solomon Executor

This *ronde* of musical portraits provides documentation of subcultural history, communicating a discreet creative camaraderie intensified by both elite status and social marginality. To me, the portraits of this generation – aside from the sexual relationships they so often articulated, the question of who slept with whom, or who would have liked to – often transmit an electricity of erotic kinship, guarded but palpable. One of the quietest and, for me, most eloquent homoerotic portraits came from Van Vechten. A dapper and fully dressed Hugh Laing (1911–88), Van Vechten's favorite dancer model of the late 1930s, poses smilingly with his lover, the pioneering choreographer Antony Tudor (1908–87), who was less than public about his sexual orientation (Fig. 3.6). Here is not only a variation of Lynes's gay-artist-as-sexual-subject genre, focusing on the creative partnership that was the sensation of the New York stage, but also a tender and knowing visual tribute to a couple invisibly touching hands, and an epitome of the private–public tension of glamour iconography. The application of 1930s glamour codes to personal projections and homages, sexual dialogues and secrets, networkings and seductions, led to a cumulative self-portrait of this cosmopolitan generation of artists and intellectuals, a collective register of coded desire.

performing arts photography

If Van Vechten, Muray and Lynes were the official New York chroniclers of the theatre and dance (and occasionally opera) scene, and Cocteau in his playwright hat was the *enfant prodigue* of the Paris stage, almost everyone else in the glamour networks had some kind of connection to the stage as well. A good many, for example, were full-time or part-time designers for the theatre, dance, or cinema (Beaton, Cadmus, French, Huene, Tchelitchew, Voinquel, and, of course, Cocteau). Theatricality may well be an essential component of a transhistorical "gay sensibility," as Jack Babuscio and others have argued,[13] but the stage was also, like the fashion world, another particularly gay vocational ghetto in the pre-Stonewall landscape. The ballet especially, unlike fashion, often constituted a male representational universe, with its top-billed male dancers extending athletic masculinity towards grace and sensitivity. Codes of propriety were strictly enforced but allowed a broader latitude for the expression of homoerotic sensibilities than almost any other cultural setting. Performance segments re-enacted in the photographer's studio refracted this universe into a glimpse of a homoerotic utopia, both single studies and group choreographies, both flowing narrative and frozen presentation.

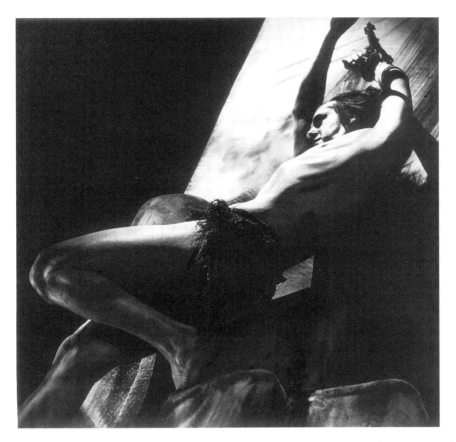

Fig. 3.7 George Hyningen-Huene, *Ted Shawn*, Promethean gay dance star, c. 1931. Performing Arts Collection, New York Public Library at Lincoln Center

The performing arts also offered the ladies-wear specialists like Lynes and Huene a legitimizing gander at beefcake: for example, the latter's several takes on the popular Russian ballet star Serge Lifar, a well-known protégé of Diaghilev whose brooding intensity was also photographed by Lynes and Beaton. Muray's nudes of stars of modern dance, such as Hubert Stowitts, were magazine sensations of the 1920s, and his tribute to New York's groundbreaking modernist, gay-identified dancer-choreographer Ted Shawn[14] (1891–1972) came to the attention of the sharp-eyed Beaton.[15] Shawn was also photographed in action by Huene (Fig. 3.7), and was the favorite of another more unassuming gay dance photographer, John Lindquist (1890–1980), a Boston department store cashier who devoted every weekend year after year to documenting Shawn's legendary all-male dance troupe.

Inevitably, some of the glamour photographs of men in tights transgressed the codes of decency, but the sexually explicit photos were private complements to a public *oeuvre*, as with this well-filled image from the later revival of the ultra-gay 1930s dance hit, *Filling Station* (Fig. 3.8). The Van Vechten tableaux of Laing and Meadows, of which an outdoors variant is shown above (Fig. 3.1), present the same gestural vocabulary as the photographer's public dance photography, differing only in the unpublishable same-sex/different-race nudity.

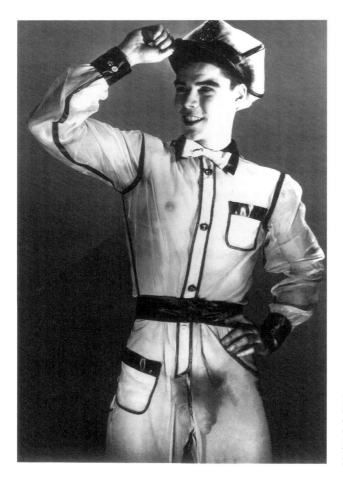

Fig. 3.8 George Platt Lynes, Offstage at the *Filling Station*, gelatin silver print, 1951–52. Paul Cadmus designed the see-through overalls, and other contributors to this ultra-gay ballet, first mounted in 1936, included Virgil Thomson and Lincoln Kirstein. **University of Iowa Museum of Art, gift of Charles Renslow. Courtesy Estate of George Platt Lynes**

Finally, the performing arts influence is palpable in the glamour generation's sense of the masculine object of desire and of the male body in particular. Dancers, whether Lifar, Stowitts, or Laing, figures of grace, elegance, and control, had a corresponding presence in the commercial physique iconography of the period. Certainly the most famous physique model of the 1930s and in fact one of Lynes's earliest male nudes, Tony Sansone, could well have been a dancer with his modest bulk and lithe curves.[16] Even when the dancers' roles were filled in by the photographers' non-athletic young companions and fellow intellectuals – from Cadmus's narrative photographs of writer Donald Windham (born 1920)[17] to Lynes's and Beaton's mid-1930s nudes and portraits of Cocteau's boyfriend Marcel Khill (1912–40) – the Art Deco ideal of streamlined, non-muscular beauty prevails, the ambiguous synthesis of fairy and trade: Orpheus not Hercules.

The dancer figure adored by the glamour sensibility also had a social connotation: if not the aristocratic ease of Beaton models, then at least a kind of ethereal disengagement from the everyday world, a refusal of the increasingly important social documentary culture leading up to the Second World War. In short, the dancer body operated as an abstraction. Otherwise, the war seems a dividing line between the idealized dancer and the resurgent type of the musclebound body builder, Sansone and Khill nudged aside by Mr America. Lynes's later interest in the richly signifying social bodies of trade and working-class young men in general, anchored in the everyday social reality of tattoos, ashtrays, and ripped T-shirts, stolid poses and sullen stares, would become a further alternative to the dancer. But for the time being, at the end of the interwar period, Lynes and his cohorts were still haunted by the graceful figure of Orpheus.

myth as erotic narrative

The performing arts work fostered the germ of another important erotic genre of the day, that legacy from von Gloeden and Holland Day: the mytho-narrative tableau. During the Depression, the classical no longer had the currency in western popular culture that it did even for von Gloeden's audience: now most classical references referred ironically to earlier artistic appropriations, or else engaged in transforming mythological clichés into a stripped-down, frankly elemental sexual modernity, charged by popularizations of Freud's own appropriations of mythological narrative. Lynes began work in the late 1930s with mythological themes such as those that Cocteau had been churning out on the Paris stage ever since the 1920s and that had been popular in the New York modern dance scene even longer.

One untitled tableau, seemingly inspired by a neoclassical sculpture of a fatal lovers' spat between Hercules and his companion Lichas, shows a gigantic model, face hidden by a gleaming helmet but genitals flaunted at the lens, carrying an upside-down ephebe on his back. One of Lynes's better-known images from the *Cyclops* series offers equally frank play with the idea of the huge eye syperimposed on the awakening model's heart. The mythological pretext was not only a format for storytelling or a question of, as Wescott put it, depicting "the handsomest young men and women of the day more or less naked in sumptuous fancy-dress."[18] It was also a matter of the restoration of the sexual and specifically the homosexual to the bowdlerized heritage of European culture. Lynes's Hercules and Cyclops allowed for a relatively safe confrontation with taboo images and with Freudian- and surrealist-inspired conceits of voyeurism, abjection, and "perverse" desire. Laurel crowns and pan pipes were on their way out, while adult carnality, prurience, and pain were in.

The mythological figure of Narcissus, another classical homoerotic icon, was perhaps closer to surrealist inspiration than Hercules. Beaton, Voinquel, and Lynes, as well as Cocteau and

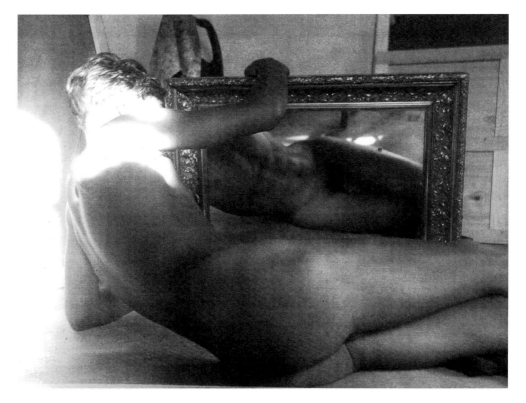

Fig. 3.9 Updating mythologies. Charles Henri Ford, *Narcissus*, c. 1936. Courtesy the artist

several other gay film-makers of this generation, all had their go at the self-absorbed dreamer. Cocteau's obsessively recurring Narcissus figures, the horny poet kissing his reflections, were derived from the artist's memories of youthful voyeurism as recounted in his *Livre blanc*. As Richard Dyer has explained, the loose association between homosexuality and narcissism was also a way for popular culture of the time to deal with the gay problematic of sameness and difference.[19] Usually, traditional feminine iconography of the mirror is appropriated for the purpose, often with a twist as in this boudoir Narcissus by Ford where the mirror reflects the model's genitals not his face (Fig. 3.9). Another remarkable update of Narcissus for the 1930s is a bedroom photo by Ford, who orchestrated a close-up self-portrait in full jerk-off arousal before the mirror, using the everyday vocabulary of checked shirt and hard-on to turn the mythic hero into the phallic self.[20]

A less culturally specific narrative aesthetic arose out of surrealist pop culture of the 1930s and is exemplified in the enigmatic narrative tableaux by the PAJAMA group formed by Cadmus, French, and the latter's eventual wife, Margaret. Although Cadmus's and the Frenches' images echo Lynes' studio precision of choreography and gesture, their sense of dreamlike erotic tension is heightened by their un-Lynesian *plein air* locations, many of them in what were then emerging as the gay resorts of Fire Island and Provincetown. Rather than the respectable cultural markers of Christian or Greek mythology, these narratives employ the archetypal connotations of shore, sea, and sky, often caught in far vistas. Biographical connotations hover nearby, however, especially in the presence on and off camera of Margaret French. She appears either as a heterosexual option

within a bisexual scenario, or as a kind of feminine eye enacting a voyeuristic relationship with the male couple. Some of Voinquel's *plein air* male nudes – titans on the shore, in the stadium, or on horseback – published only late in his career, achieve a similar magic of archetypal erotic narrative.[21]

the exotic: photographers abroad

Despite the prevalence in glamour imagery of the controlled studio aesthetic of the fashion world, the PAJAMA trio were not the only photographers to continue von Gloeden's and Day's tradition of outdoors sunlit imagery. The others who did, however, pursued that *fin-de-siècle* fascination with more distant lands than Fire Island. List was the major photographer of this generation to prefer natural light to the studio, initially adapting his aesthetic concerns to the adolescent erotics of sunshine and calisthetics on northern beaches. He then went south and spent the rest of his career intermittently in sensuous idylls in the Mediterranean and the Caribbean. Increasingly, he would echo less the nordic nudists of his youth than classical models and pictures, with languid figures and compositions melding ancient homoerotic traditions to the exotic lusts of the gay tourist. The Mediterranean somehow brought out the most deeply and sensuously erotic in his sensibility, and some of his intense classical iconography showed little sign of the ironic and surrealist updates of laurel wreaths wrought by his transatlantic friends (Fig. 3.10).

Like List, the glamour generation was mostly northern European by origin, by temporary choice, or by affinity (especially the Americans!). Urban exiles, expatriates, or refugees themselves, the glamour photographers had at first seemed uninterested in the orientalist iconography that had

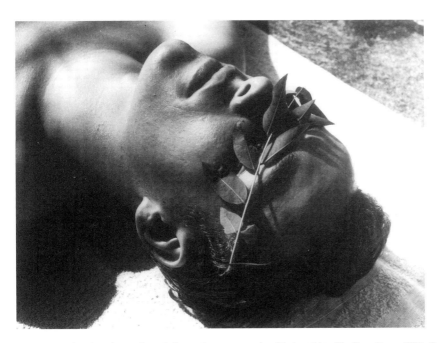

Fig. 3.10 Ancient laurel wreaths and the modern gay traveler. Herbert List, *The Hero, Greece*, 1936. Courtesy estate of Herbert List and Max Scheler

fascinated von Gloeden and Holland Day. Many of the interwar gay artists seemed too caught up in the cosmopolitan culture of the modern metropolis to eroticize the Other and were decidedly half-hearted about romantic escapes to Elsewheres, whether the Mediterranean, Arcadia or Uptown.

The New Yorkers of the glamour network were a case apart. Their exoticization of African American performers and dancers provide a stepping stone between the nineteenth century and the full-blown exoticism of Mapplethorpe's black nudes forty years later – and a canvas almost as troubled as Mapplethorpe's. On the one hand, Muray's idealized portraits of actor-athlete Paul Robeson (Fig. 3.11) and other nonwhite performers of the New York stage fits the classical orientalizing mold. Yet, in the following decade, Lynes's ensemble of dancers in Stein's *Four Saints in Three Acts* (1934) seems, in retrospect, to reflect uncomfortable political realities more frankly: the three teenaged black dancers pose nude, reclining alongside a clothed and upright white choreographer who touches them paternally.[22] As for Van Vechten, his public work focused on the florescence of urban black culture, both as a portraitist and as a documentarist of black dancers in mainstream and specialized troupes, providing invaluable public visibility to such outfits as the American Negro Ballet. His codes of documentary inclusiveness, however disenfranchising and patronizing they now seem, were consistent with liberal ideology of the day. But his private images pushed such codes to their limits, both the interracial same-sex configurations exemplified in the Laing–Meadows duo (Fig. 3.1) and above all a series confronting a tense and trouserless young black dancer (1942). One of the latter images reveals documentary edges (a striped T-shirt anticipates Lynes's rough trade portraits of the 1950s) and all the fetishization of class, race, and sexual dynamics that Muray's discreet rear view and soft focus dissimulated (a clenched fist and awkward snarl seem to guard the exposed genitals). Here, and in Van Vechten's mannerist embroidering of the African American body in other private nudes – with hyperbolic African props and jewelry and the like – the contradictions of depicting the Other "startle" in ways the photographer clearly did not mean in his note to Laing. Private desire, as ever, simply brought such contradictions to the surface.

White Americans' domestic exoticism aside, the approaching war seemed to swing the focus of the increasingly uprooted Europeans of the glamour networks towards the erotics of the Other. At first, exile had been a self-chosen pilgrimage or affectation, with Paris attracting US expatriates as diverse as Ford and Van Vechten, and New York and Tangiers drawing Europeans such as Beaton and Horst. Soon the irreversible political crisis in Europe not only nudged List towards the Mediterranean but pointed Tchelitchew, Horst, and Huene (as well as Auden and Isherwood, of course) toward American residency. Disillusionment with the increasing pressures of the fashion industry also played its part in the growing diaspora: Huene suddenly abandoned the vocation that had made him famous for a series of photographic travel book projects exploring afresh the old landscapes of Greece, Syria, Mexico, Egypt, and the sub-Sahara. The last-named landscape is the only peopled one in this phase of Huene's work and provided one of glamour photography's strongest statements of exotic fantasy. Black Africa confronted the fashion photographer with social realities he had previously only abstracted (his infelicitous African male caryatids decorating *Vogue* layouts in 1934,[23] blatantly racist even by the standards of the day). But of the social reality he witnessed in sub-Saharan Africa, caught in palpably carnal images of tribal dancers or nude teenagers running along the Nile, Huene tends to evacuate social meaning, preferring to ascribe to his subjects, almost enviously, an amalgam of narcissism and trance, in terms relentlessly Eurocentric (and misogynist):

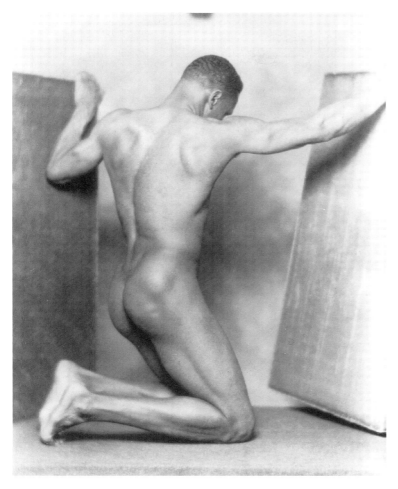

Fig. 3.11 Orientalizing mold. Nickolas Muray, *Paul Robeson*, c. 1926. George Eastman House

I find myself in the presence of a most beautiful youth. He is broad-shouldered and slender with the simple formation of a body found in early Greek sculpture, a faint smile, an expression of ecstatic beatitude on his motionless face . . . In one hand he holds a mirror into which he gazes in rapture, oblivious of the battling, surging crowd. His look seems to go beyond his own reflected image, beyond into nothingness. A woman comes up to the youth and puts some betel in his mouth. Next to him stands a female dancer who seems the living incarnation of all evil and baseness personified. The drums beat steadily, the flautist joins in, but the young deity keeps staring through the looking-glass into infinity, with the same static smile which seems to be part of his features.[24]

> Voinquel's own beefcake tour of the emerging postcolonial world would take place in the 1950s, but Huene's pilgrimage had been in many ways the swansong of gay colonial complicity and a final impoverishment of the nineteenth-century homophile search for the homosocial ideal in non-European cultures.[25]

73

glamour at war

In many ways Huene's disillusionment was prophetic. Sophisticated and worldly-wise, the glamour image-makers cultivated an aristocratic indifference to the geopolitical volcano that would soon erupt: "blind to the looming catastrophes," as List's biographer Günter Metken would put it.[26] In an era when the engaged documentary of the Popular Front was in ascendancy, the glamour generation had retreated as far as possible from the conflicting and gritty demands of a world wracked by violence, hatred, and hunger. Auden and Isherwood had been mobilized in the anti-fascist struggle and its documentary aesthetic, but this queer left contingent was decidedly a fringe element.

Once war broke out, politics would push gay artists like Voinquel, List, and Cocteau even further back into mythological history, but throughout the English-speaking Allied regions things were different. Beaton would soon be transformed (temporarily) from a dilettante into a roving

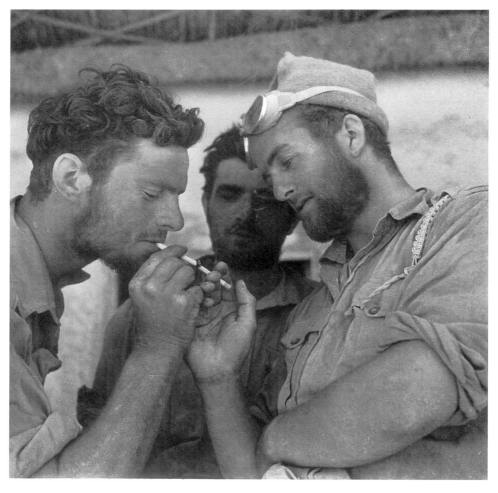

Fig. 3.12 Wartime male bonding. Cecil Beaton, untitled photograph, c. 1943, Imperial War Museum, London

documentarist of the Allied effort. His new calling was as an official morale-boosting portraitist in the encampments of Africa and Asia. This did not prevent him from catching a few "sexual glances inferred in his photographs of servicemen" of course,[27] and the tactile homosociality of a cigarette-lighting ritual within the North African campaign (Fig. 3.12), nor did he shrink from giving the orientalist sensibility a new impetus in his images of more exotic allies, of Kurds and Bedouins who returned his gaze.

But the emerging generation of gay photographers caught up in the war were not all imperial emissaries. Their images were the intimate journeywork of ordinary young homosexuals caught up in both a global crisis and large societal shifts, where wartime mobilizations brought new visibility to same-sex communities of feeling both inside and outside the military.[28] In this context, the portrait genre was re-energized as an icon of homosocial camaraderie and also of homoerotic bonding. Lynes's wartime diary of erotic desire, separation, and loss (in his studies of the Tichenor brothers) should be seen in this light. More upbeat are portraits by the young Minor White (1908–76) (Fig. 3.13) of his fellow GIs, chaste images of his squadron buddies. They testify

Fig 3.13 Minor White, *Dan DeBoie*, 1942. Courtesy the Minor White Archive, Princeton University, © 1989 by The Trustees of Princeton University. All rights reserved

just as eloquently as their equivalents within the busy commercial and illicit homoerotic strata to the younger generation's encounter with identity, desire and collectivity in the wartime environment.

In summary, the shelter of elite vocational ghettos and the generic ambiguities of portraits, performers, mythic narratives and exotic fantasies all allowed the osmosis of homoerotic desire back and forth between the private domain and public image-making. If the glamour photographers' erotic works sometimes hinted at an uneasy relationship between private erotic expression and a public cultural vocation (as they did most tellingly in Van Vechten, List, and Lynes), it was a gentle divergence that hardly rippled the surface of their work. With this sophisticated indifference to the discrepancy between public codes and private fantasies, Cocteau's myth of the tormented and tragic gay Orpheus was a stereotype that fits awkwardly on the work of the glamour networks. The war somehow hastened the time when eroticism would become a deeply problematic core of artistic vision rather than a ripple among easefully stylized margins, untroubled surfaces, or elegantly lit corners. Only after weathering a second world war and facing a chilly new climate of sexual and political instability would an older tested generation of artists

collectively produce a sustained body of erotic imagery, an epochal expression of gay desire that went beyond "charming, romantic, tragic, & with just a dash of diablerie. Incredibly handsome, of course."

notes

This edited excerpt from my *Hard to Imagine: Gay Male Eroticism in Photography and Film from their Beginnings to Stonewall*, New York, Columbia University Press, 1996, should be read in the context of my basic argument, that eroticism lies at the heart of gay male visual expression in photography and film during the one hundred years or so of my period, and of my basic methodological principle, namely that gay male discourses within the sanctified realm of high art cannot be viewed in isolation from contemporaneous currents in commercial and popular art, illicit or "pornographic" art, nor from visual regimes within science, politics, and law. The present excerpt, however, limits itself to photographers in the interwar period working within the infrastructures and discourses of high art, regardless of whether individual works can be considered public or private. The author wishes to thank Concordia University and the Canada Council for funding this article in part, and Columbia University Press for allowing its publication in the present volume.

1 Bruce Kellner, ed., *Letters of Carl Van Vechten*, New Haven and London, Yale University Press, 1987, pp. 172–3. Text in square brackets is incorporated in the appropriate places from the letter-writer's footnotes. Van Vechten's letter concerns ongoing duo nude photo sessions between Laing and African American dancer Juante Meadows. The Thursday nudes were taken uncharacteristically in a forest setting on the Connecticut estate of the photographer's well-heeled friends and included among other things a rather excessive St Sebastian pose by Meadows.

2 John Berger, *Ways of Seeing*, Harmondsworth, Penguin, 1972, pp. 132–49.

3 For a summary of gay and lesbian currents within New York African American culture of the 1920s, see Eric Garber, "A Spectacle in Color: The Lesbian and Gay Subculture of Jazz Age Harlem," in Martin Bauml Duberman, Martha Vicinus, and George Chauncey, Jr, eds, *Hidden from History: Reclaiming the Gay and Lesbian Past*, New York, New American Library, 1989, pp. 318–31.

4 Muray left a widow and two children at his death and it is not known if his sexual and social practice matched the homoerotic sensibility of his many male nudes, taken mostly within the performing arts milieu.

5 The main entrants in the considerable Lynes industry are Jack Woody, *George Platt Lynes, Photographs 1931–1955*, Pasadena, Twelvetrees Press, 1981; Peter Weiermair, ed., *George Platt Lynes*, Berlin, Bruno Gmünder, 1989; James Crump, ed., *George Platt Lynes: Photographs from the Kinsey Institute*, Boston, Bulfinch, 1993.

6 Clement Greenberg, "The Renaissance of the Little Magazine," *Partisan Review*, January–February 1941, pp. 72–6. Greenberg's other target was another member of the gay circle, Christian Bérard (1902–49), also a "neo-romantic" painter as well as the art designer for Cocteau's films. For an account of surrealist homophobia see Edouard Roditi, "The Homophobia of André Breton," *Christopher Street*, no. 113, July 1987, pp. 17–24.

7 George Chauncey's *Gay New York: Gender, Urban Culture, and the Making of the Gay Male World, 1890–1940*, New York, Basic Books, 1994, released after this text was written, makes it clear how New York offered the interwar generations of gay men unprecedented opportunities, spaces, and networks for social visibility. One assumes that London and Paris were similar to New York in this respect, but further research needs to explore how the cultural and social elites, to which the glamour photographers belonged, participated in this visibility.

8 Cecil Beaton, *Cecil Beaton's New York*, Philadelphia and New York, Lippincott, 1938, p. 235.

9 Robert Duncan (1919–88), "The Homosexual in Society" (1944), in Ekbert Faas, *Young Robert Duncan: Portrait of the Poet as Homosexual in Society*, Santa Barbara, Sparrow Press, 1983, pp. 319–22.

10 Cocteau was photographed by Beaton, Horst, Huene, List, Lynes, Van Vechten, and Voinquel; Stein by Beaton, Horst, Lynes, Van Vechten; Tchelitchew by Beaton, Ford, Huene, Lynes, and Van Vechten.

11 The latter 1939 portrait of Isherwood may be found in Allen Ellenzweig, *The Homoerotic Photograph: Male Images from Durieu/Delacroix to Mapplethorpe*, New York, Columbia University Press, 1992, p. 97.

12 James Crump has brought to light Lynes's fascinating correspondence to Bernard Perlman in this regard. See Crump, *George Platt Lynes*, pp. 137–55.

13 Jack Babuscio, "Camp and the Gay Sensibility," in Richard Dyer, ed., *Gays and Film*, 1977, 1980; revised edition New York, Zoetrope, 1984, pp. 40–57.

14 The New York gay party attended by Cecil Beaton included gossip about Ted Shawn being "so exquisite, he drives his automobile with his legs crossed."

15 Cecil Beaton and Gail Buckland, *The Magic Image: The Genius of Photography from 1839 to the Present Day*, London, Weidenfeld and Nicolson, 1975, pp. 202–3.

16 Crump, *George Platt Lynes*, p. 2. Interestingly, Sansone's Svengali, Edwin Townsend, was also a dance photographer, in which hat he frequently documented the performances of gay dance star Ted Shawn and his all-male ensembles.

17 Windham poses in photos on pages 5, 13, 22, 36, and 60 of Jack Woody, ed., *Collaboration: The Photographs of Paul Cadmus, Margaret French and Jared French*, Santa Fe, Twelvetrees Press, 1992, unpaged. Khill appears in Weiermair, *George Platt Lynes*, p. 106 as well as in two 1936 "Male Nudes" (nos 21 and 26) of the touring exhibition (originating at Grey Gallery, New York University, 1993) of the Kinsey Institute's Lynes selection that coincided with the publication of Crump's monograph.

18 Glenway Wescott, "Illustrations of Mythology," *US Camera*, no. 2 (1939). See Woody, *George Platt Lynes*, pp. 61–3.

19 Dyer, *Gays and Film*, p. 67ff.

20 Ford would edit a special issue of his avant-garde literary magazine, *View*, on "Narcissism" in October 1943.

21 Raymond Voinquel, *Photographies 1930-1988*, Paris, Nathan Image, 1988; *Raymond Voinquel*, Paris, Espace Photo Paris/Paris Audiovisuel, 1993.

22 Crump, *George Platt Lynes*, p. 59.

23 William A. Ewing, *The Photographic Art of Hoyningen-Huene*, London, Thames and Hudson, 1986, pp. 41, 109, etc.

24 George Hoyningen-Huene, *African Mirage*, New York, Scribner's, 1938, p. 86.

25 Compare Edward Carpenter, *Intermediate Types Among Primitive Folk: A Study in Social Evolution*, London, 1914; *The Intermediate Sex*, 9th edition, London, 1952.

26 Günter Metken, *Herbert List, Photographs, 1930–1970*, New York, Rizzoli, 1981, p. 11.

27 Stuart Morgan, "Open Secrets: Identity, Persona and Cecil Beaton," in David Mellor, ed., *Cecil Beaton, A Retrospective*, Boston, Little Brown, 1986, pp. 116–17.

28 One index of the new communities of feeling was the gradually emerging network of European gay magazines. Not incidentally, at least three of the glamour photographers would find a new audience in this network. The Swiss magazine *Der Kreis* offered a full-page Huene nude in December 1944. An unattributed sample of Lynes's *Four Saints* material appeared in Amsterdam's *Orgaan en mededelingenblad* in December 1947; a fully attributed selection appeared in *Der Kreis* in July 1950, and Lynes would be the favorite photographer of the Zurich journal until his death. The Dutch *Vriendschap* presented the above List photo (Fig. 3.10) on its cover in May 1950.

james smalls

public face, private thoughts
fetish, interracialism, and the homoerotic in carl van vechten's photographs

The art and literature of the Harlem Renaissance are primarily a black and white affair, whereas the art, fiction, and life of Carl Van Vechten (1880–1964) – perhaps black America's most notorious philanthropist – reveal many shades of gray. In 1932, Van Vechten gave up his career as a novelist of light fiction and became a full-time amateur photographer. He was introduced to the then-new Leica camera by his friend, the noted caricaturist Miguel Covarrubias, who, among other things, satirized Van Vechten's obsession with African American culture in a drawing entitled "A Prediction" in which Van Vechten was showcased with "negroid" facial features. Not long after, *Vanity Fair* took note of Van Vechten's negrophilic tendencies when it derisively declared that he was "getting a heavy tan."

Of all the key players in New York in the years spanning the 1920s until his death in 1964, Carl Van Vechten was perhaps the most well-known and the most influential – easily earning a reputation as a connoisseur and chronicler of Harlem and its black inhabitants through his activities as novelist, music and dance critic, patron of the arts, and photographer. As a powerful catalyst in keeping the "Negro in vogue" for almost five decades, Van Vechten was an essential asset to aspiring African American artists and writers. His acquaintance with influential socialite Mabel Dodge Luhan, and a stint with the *New York Times* as music critic, afforded him access to personalities of the day and gave him ready entrée into the worlds of dance, music, and theater. He was well connected in both the arts and publishing worlds and gave many African American creative artists their first break by introducing them and their work to important whites in key institutional positions – thereby acting as "a kind of midwife to the Harlem Renaissance."[1]

Over a span of more than thirty years, Van Vechten produced thousands of photographs on a variety of subjects. He specialized in portrait photography – in particular, black portrait

photography. These "celebrity" photos were highly conscious portraits of African American artists, writers, and other notables and tackled identity formation as desired by the subject and forged by the photographer. They also helped to reinforce the critical observation that Van Vechten was a collector of rare *objets d'art* and of rare people. In her discussions on photography, Susan Sontag noted that "photography has the power to turn people into objects that can be symbolically possessed."[2] As will become evident throughout the discussion, the act of photography itself was fetishistically critical to Van Vechten's psychological and social definition. Not only was his intention to use photography as an artistic expression of cultural and racial documentation, but he also employed the medium as a means of popular mythmaking about himself in relation to African Americans.

Van Vechten's photographic output is, relatively speaking, rarely discussed in the literature, and few have, to the best of my knowledge, seriously analyzed or critically questioned his negrophilic visualizations in photography. His black celebrity photos were praised by many African Americans, for they assisted in the establishment of blackness as dignified and beautiful within the confines of a bourgeois western art tradition. They were also credited as instrumental in reversing decades of stereotyped black physiognomy by presenting the African American in the most sophisticated dress, manner, and demeanor. As Van Vechten's celebrity photos demonstrate, the African American head became the approved armature around which racial pride and identity were molded. Even though the body is subordinated in these works to focus on physiognomy, the black body and its potential to be hypersexualized was not overlooked by Van Vechten, who eventually found it, embraced it, exploited it, and worshipped it in a series of little-known photographs that I refer to here as his "fetish and fantasy" works.

These highly erotic and provocative photographs were produced in the 1930s and 1940s and focus on the sexually suggestive interrelationship between black and white men either within the artificial confines of the studio or within narrativized fields of nature and culture referenced as "primitive." Never publicly exhibited, these images reveal a more sinister side to Van Vechten's seemingly benevolent social enterprise. Having taken pains to conceal his sexual orientation from public view,[3] Van Vechten himself requested that these photos not be made public until several years after his death. Now freed from their archival invisibility, these images can be critically assessed.

In conjunction with Van Vechten's literary and philanthropic influences, these photographs force the acknowledgment of a fact: that white patronage carried with it a concomitant racial agenda and was motivated by a bias for modernist primitivism that viewed things African and African American as a means through which the patron could enter into what he or she believed was a more authentic relationship with the world.[4] Thus, these works pose a difficult dilemma for today's viewer in that they make one wonder whether the racial and sexual fantasies they manifest should necessarily compromise the credibility and integrity of white patronage. In light of his positive and affirmative deeds and accomplishments as a philanthropist and promoter of African American art and culture, should Van Vechten's "fetish and fantasy" images necessarily disqualify or call into doubt his "public face" of sincerity, credibility, and integrity? Do these visualized "private thoughts" reinforce or undermine racist myths about black sexuality and/or about interracial co-operation? Ultimately, can we trust representation as definitive or absolute evidence of psychic and social realities?

Van Vechten's "fetish and fantasy" photos exemplify the unstable regions in the intersections of psychic preoccupations (fantasies) and social realities. As such, they provoke questions that cannot be answered with a singular *yes* or *no* response. Clearly, this human necessity was marked by Van

Vechten's own race, social status, and sexual orientation. However, my response to and consumption of these photographs are likewise marked, in fairly complex ways, by my own racial designation and sexual preference.

An art historian by training, I have been taught to separate my personal opinions, moral judgments, and fantasies from the interpretation of visual culture. But in looking at these photographs, I realize that my indoctrination into the social history of art and its methodologies has limited my abilities to contend with art production as psychosexual residue. My attempt to grapple here with issues of racial and sexual desire and fantasy in these photographs creates an almost schizophrenic split in my approach to the topic. On the one hand, I want to look at Van Vechten's "fetish and fantasy" images as socially and historically significant works created during a specific time and place in which elements of the primitive and the modern were employed to define, confirm, and promote a constructed self for Van Vechten in relationship to an African American community which was, at the same time, struggling with its own issues of identity. On the other hand, I want to suggest how the "fetish and fantasy" images might operate as products of gay interracial desire and fantasy for myself and for contemporary viewers. To do the latter, I grate against my art historical grain by making no claims to neutral observation in taking my own subject position into account as a gay black man whose principal but not exclusive object of desire is white men. I thus have a personal stake in this inquiry – an emotional involvement that intervenes in my intellectual interest in and interpretation of these photographs.

Interracial representations such as those created by Van Vechten allow for intervention in important contemporary debates centered on the complex interstices of race, homosexuality, and visual culture. This conversation was, for the most part, begun by contemporary cultural theorist Kobena Mercer, whose most recent work on Robert Mapplethorpe's photographs of black male nudes brings into sharper focus the complexities involved in racial and homoerotic relations both inside and outside of representation.[5] Mercer rethought his previous negative reading of Mapplethorpe's work by critically interrogating his own viewership and identification with homoerotic networks of looking. His rethinking of these issues revealed ambivalences and ambiguities in his personal response to such representation. As Mercer had discovered, and as Van Vechten's work helps to clarify, interracial gay relations (in representation and in social reality) involve complex multidirectional exchanges of psychological and emotional needs and desires. Race and racial difference become significant and crucial aspects of exchange.

By asking the question of whether or not Van Vechten's "fetish and fantasy" photographs should adversely compromise his credibility and integrity as patron to black America, I raise the possibility, as did Mercer with Mapplethorpe, that the issues implicit in these images are more complex, ambivalent, textured, and less easily read as "black and white" racist discourse. Unlike Mercer, whose strategy for reassessing Mapplethorpe's imagery was predicated on anger and ambivalence as a black gay male spectator, I approach Van Vechten's "fetish and fantasy" works from the standpoint of surprise, admiration, and delight in their interracial and erotic suggestiveness. I like these photographs. Nevertheless, in this discussion I want to assume that there are implied power relations in gestures of white mastery and black male appropriation and I would care to first read these works as negative exercises in racist dynamics implicating a white male imaginary. In addition, I want to examine how these photographs lay bare the destabilizing function of fetishism, primitivism, and spectatorship in the reception and reading of racialized homoerotic visual imagery. In many ways, this essay continues the conversation started by Mercer, and hopefully will add to it.

the primitive, the fetish, and the racial

In his critical examination of Mapplethorpe's images of black male nudes, Mercer begins by questioning fetishism as a legitimate theoretical paradigm for evaluating racialized representation. He rails against fetishism as an ethnocentric "master discourse" – a discourse that seduces in its conspicuous absence of race. However, in his subsequent reassessment of these images, Mercer recontextualized his previous argument of "erotic objectification and aestheticization of racial difference" by positing an alternative to reading fetishism as a negative characteristic. To do so, Mercer first acknowledged that "fetish" or "fetishistic" carry negative connotations that society has conditioned its members to believe and accept. Thus, inherent in the concept of the fetish and fetishism is a moral position which had informed his earlier reading. In this regard, Mercer acknowledges the usefulness of fetishism as a theoretical tool for "conceptualizing issues of subjectivity and spectatorship in representations of race and ethnicity" while warning against its pitfalls.

In his dissection of Freud's "Fetishism," Whitney Davis similarly stresses the importance of distinguishing fetishism and fetishistic practice from other psychological interests such as obsession, phobia, voyeurism, homosexual longing, mourning, and sadism.[6] Certainly, voyeurism, narcissism, and a focus on modernist technique predominate in a couple of Van Vechten's photographs in which a sole black male subject is used to suggest sexual play (Fig. 4.1). Here the photographer uses the technique of double exposure and the artistic principle of collage to create an illusion in which a black male subject suggests the sexual position "69." The fragmenting, doubling, and serializing of body parts owes much to jazz imagery and to contemporary Cubist explorations of form. Such treatment of the body also implies a certain amount of violence in fetishistic fashioning and looking. But as Mercer learned and as becomes evident with Van Vechten's interracial nudes, this approach is not inherently negative or dehumanizing. Seen as a legitimate means of sexual/racial transgression, Van Vechten's photograph consciously "stages" a sexual act in the guise of modern collage art. It serves to give a visual record to all the taboo things designed to satisfy sexual and artistic urges simultaneously, as well as gratify Van Vechten's need to *épater le bourgeois*.[7]

This image and others like it must have served a particular psychic and social need for Van Vechten, who considered such photos more "artistic" than his better-known black "celebrity" head shots and, as such, more in keeping with his self-identification as a modernist. As an experiment in the visual manifestation of "private thought," this image was fashioned to clarify, justify, or assuage his "public face" status. As a photographic experiment, this and other images underscore his indulgence in sexual and racial fantasies through fetishistic contrivance and voyeuristic posturing. Not only does the element of voyeurism come into play as the subject's limbs confusingly and suggestively intertwine as would body parts in an orgy, but the very act of photographic manipulation in the darkroom and reconfiguration of the male body in the studio are themselves revealing of Van Vechten's apparent need to manipulate and control sexually and, in this case, racially.

Primitivism and fetishism are related events. So too are fetishism, the stereotype, and colonialism. The intricate interworkings of these phenomena cannot be fully unpacked here, but suffice it to say that the stereotype, like the fetish, has negative connotations due to the process of objectification that both entail.[8] Both depend upon a dialogue between "fixity" and "ambivalence" in the ideological construction of otherness. This discourse, in turn, allows for the continuation of colonial fantasy in that black subjects come to stand in as fixed ideas about the nature of sexuality and otherness. The construction of that fantasy is a complex articulation of the

james smalls

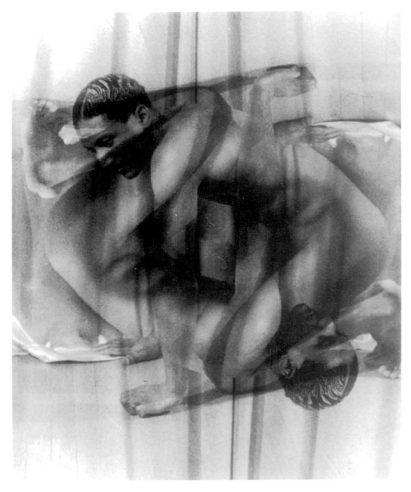

Fig 4.1

Figs 4.1–4.9 Carl Van Vechten, untitled, undated photographs. Courtesy Yale Collection of American Literature, Beinecke Rare Book & Manuscript Library, Yale University, New Haven. Courtesy Estate of Carl Van Vechten, Joseph Solomon Executor

tropes of fetishism by which individuals control and order a mass of complex information so as to project values and beliefs successfully on to objects of desire and fear. All three phenomena – primitivism, fetishism, and colonialism – conspire to constitute "a system of multiple beliefs, an imaginary resolution of a real contradiction."[9]

Van Vechten's "fetish and fantasy" photographs engage in modern primitivist practice by employing two kinds of fetish in a modernist context – the racial or epidermal, and the sexual. As cultural theorist Homi Bhabha has noted, the former aspect of the fetish differs from the latter in that the former can never be hidden as a secret and is significant in the signifying chain of both "negrophobia" and "negrophilia."[10] The "charm" of Van Vechten's "fetish and fantasy" photos is that they successfully confuse philic and phobic attitudes about race for both the spectator and for the master subject in their interracial erotic indulgence. In allowing for a play back and forth of negrophilic/phobic fetishistic tendencies, Van Vechten makes sex (more accurately, homoerotic desire) a prevalent open secret. Because fetishistic representation makes present for the subject

82

what is absent in the real, Van Vechten's photographs can be characterized as visualizations of a masculine fantasy of mastery and control over the "objects" represented and depicted.[11] This is an inherent trait in the problematic aspect of fetishism because it resides in colonizing discourses and as such automatically sets up a negative colonizer/colonized relationship of power.

The stereotype operates much in the same fashion as does the fetish – as a scene or site of fantasy and defense, or as a desire for an originality which is threatened by the difference of race, color, and culture. What complicates the matter is that Van Vechten produced imagery that is both racial and *inter*racial. Both black and white men are subjected to the same negative relationships of power, both are susceptible as "virgin territory to be penetrated and possessed by an all-powerful desire to probe and explore an alien body."[12] Thus, fetishism and the fantasy of mastery are intensified and complicated by a combined interracial and homoerotic investment. So, in discussing Van Vechten's photography in the context of fetishism and fetishistic practice, I distinguish between his "racialized" nudes in which a sole black subject is posed in an artificial studio environment or in a natural setting read as "primitive," and his "interracial" images in which black and white men are similarly contextualized as they interrelate on physical and erotic levels. With both kinds of images, spectatorship and the dynamics of gay male fantasy become critical to deciphering the images' meaning.

Fig. 4.2 shows two male figures – one white and the other black – posed in the studio against a curtain backdrop with arms raised above their heads and bodies in a mirroring *contrapposto* stance. The foregrounded white figure has his back and buttocks exposed to the viewer while the black man opposite him is frontally posed to reveal both his face and penis. Both figures are "feminized" in that their sinuous poses recall those typically associated with women in western art; they are presented as passive objects of desire. In the relationship constructed between the two subjects, however, the white man assumes a more passive role in his vulnerability to anal penetration. A difference in skin color has replaced the "norm" of sexual difference. The black man becomes the phallic counterpart to the anally receptive white man. An erotic fantasy based on desired relations of sexual power and fetishistic practice between the races is set up. This image, like so many others in Van Vechten's interracial series, is not bound by a single fantasy reading of white-over-black power relations. This is particularly true when potential shifting subject positioning and spectatorship are considered – a phenomenon I will discuss later.

Fig. 4.2 is subversive of the usual racial stereotype in that it shows a white man in a position of vulnerability and as the potential object of aggressive fetishistic looking. On the other hand, in several of Van Vechten's racialized nudes, white mastery over the racial other is assumed and pronounced. For example, in a couple of his racialized photographs in which a sole black figure implies a white presence in the gaze, the black man becomes, as a product of white construction, an ethnographic representative of "Africa." In these images, the black figure is scantily swathed in African fabric as a "sign" of his Africanicity. In one photograph, the black subject frontally faces the camera in confrontation with the viewer. His upper torso is heavily draped in African cloth while from the waist down he is shown naked with penis exposed. The black man's African "essence" is reduced to his penis and to a scrap of fabric on which are noticeable African designs. The black man is "ethnicized," sexualized, and objectified as a specimen of study by the photographer. He becomes a sign of a whole range of racial and sexual expectations related to a fixed concept of the primitive.

Van Vechten's compositional placement of black against white in the visual arena facilitates the imaginary projection, acknowledgment, and identification with fantasies about racial and cultural "difference" and the attempted disavowal of that difference. However, the differences are fetishized, objectified, and in some cases presented as serious ethnographic documents of mutual

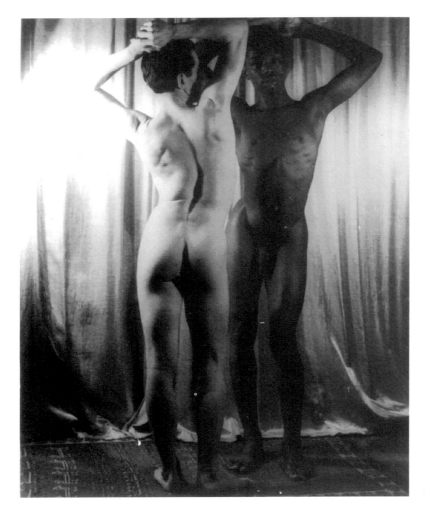

Fig. 4.2

racial and cultural embrace and co-operation. What makes Van Vechten's representation peculiar and particular is that skin is not the principal signifier of fantasy in his interracial images. He perceives all expressions of interracial exchange – be they psychic or social – as fetish. Skin remains, however, a significant element in Van Vechten's work, for the fetish is always experienced in contrasting terms to the white male body, even when that white body is conspicuously absent from the visual frame. Van Vechten's own subject position and interests as white author of the visual text makes this so.[13] In his case, the fantasy of mastery is intensified and complicated by what I perceive as a distinct and deliberate authorial projection into his images.

This projection, in alliance with the racial fetish, the stereotype, and homoerotic desire, assists in the formation and affirmation of a social self predicated on a play between mastery and pleasure as well as on anxiety and defense. By positioning himself as author and voyeur both inside and outside of the visual text, Van Vechten completes a cycle of cathartic union with or repulsive fear of the black man. Thus, the specular effect of these photographs takes on added meaning. On the one hand, Van Vechten projects himself as gallantly embracing black people and, on the other

hand, he privileges himself as a disinterested spectator who witnesses and records blacks embracing their racialized and sexualized selves. Furthermore, Van Vechten cleverly plays with the idea of black and white on multiple levels. On an artistic/photographic level, he uses black-and-white photography to pattern black and white bodies in black and white poses or situations of polarized tension – opposites do indeed attract. The attraction/repulsion aspect of these images is underscored by the black and white patterning of the studio backdrops and erotic tension that charges the figures.[14]

All of Van Vechten's "fetish and fantasy" photos share in common the combination of studio control and artificiality with the spontaneous vision of the snapshot as ethnographic document. The documentary aspect of his working method makes significant connection to the primitive concept of the mask as "a portrait completely on the surface, evident, unequivocal . . . the stereotype . . . being first of all a social, historical product, [containing] more truth than any image claiming to be 'true'; it bears a quantity of meanings that will gradually be revealed."[15] Particularly for Van Vechten, the mask was significant in that it exposed far more than it concealed. Theatrical contrivance and the mask come together and play significant roles in his photograph of a black man displaying an African mask to the viewer. Here, the spectacle of the body is racially, culturally, and sexually coded. The black model dutifully, perhaps even resentfully, displays to the viewer the object of his racial origins while in a pendant photograph (Fig. 4.3) portraying the same model holding the same mask over his genitals, the mask transforms the black subject into a sign and symbol of exotic culture and sexual powers. The black man simultaneously displays and "wears" the mask. The spectacle of the auction block is evoked with the objectifying display of the exposed black body and its cultural correlates (the primitive) scripted onto it. The mask conceals and yet reveals the mysteries of the black man to the spectator. He not only flaunts his essence to the implied privileged observer, but is himself transformed into an ethnographic item of note for the discriminating eye of the "expert." The theatrical backdrop reinforces the stereotype as a tropical floral pattern is used to evoke the "primitive" in nature.

The spectacular exploitation of the black body as sexual object and item of ethnographic curiosity grew out of the historical practice of minstrelsy.[16] In displaying his own mask/penis to the white photographer/spectator, the black man literally becomes a spectacle on a minstrel stage – a black performer in blackface. Not surprisingly, Van Vechten was, in his social life, an avid fan of minstrelsy – defined here as a form of racial entertainment extolling the complications of revealing and hiding "true" identity behind a mask or facade of blackness (hence Covarrubias's caricature of Van Vechten in blackface). The photographer's love of minstrelsy is recounted in an anecdote in which he persuaded the wealthy socialite Mabel Dodge to allow two African American performers to entertain at one of her parties. Dodge recorded that

while an appalling Negress danced before us in white stockings and black buttoned boots, the man strummed a banjo and sang an embarrassing song. They both leered and rolled their suggestive eyes and made me feel first hot and then cold, for I had never been so near this kind of thing before; but Carl rocked with laughter and little shrieks escaped him as he clapped his pretty hands.[17]

Van Vechten's male nude photographs are especially likened to the concept of blackface minstrelsy in their ultimate purpose of displaying and fetishizing the black male body in the frozen spectacle of a combined ethnographic and erotic contemplation. In each image, nudity is a significant requirement marking the black body as icon of study and fantasy. The designation of the black body as performative and spectacular was essential to early twentieth-century modernist practice. Since the mask and minstrelsy often operate within contrived theatrical spaces, it was

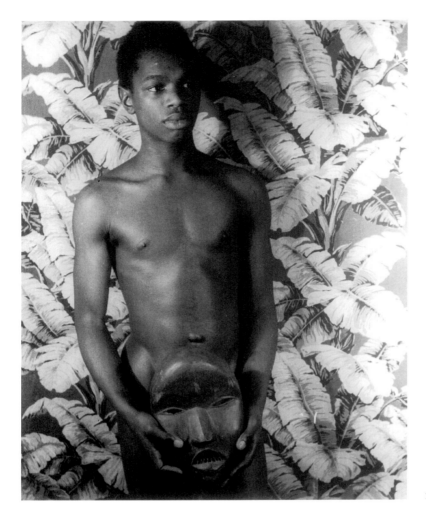

Fig. 4.3

logical that Van Vechten would find both attractive given his penchant for artificiality, the theater, and his passion for collecting people and objects. Houston Baker reminds us that the mask is not only a "thing," but is also a "space of habitation." It is a form that exemplifies the white man's "repressed spirits of sexuality, ludic play, id satisfaction, castration anxiety, and a mirror stage of development."[18] On a Freudian level, the mask is, as a disembodied face, also likened to decapitation and castration. With all of its metaphoric associations with primitivism, fetishism, psychosexual display, and concealment, the mask was a meaningful and useful item and idea to master for both the black and white modern artist.

Playing on the idea of the mask as a sign and process of cathartic union with the other, Van Vechten's fantasy of racial and cultural mastery is coupled with an aspect of voyeuristic spectacle in a rather unusual photograph showing a nude black man beholding an African statuette (Fig. 4.4). The angular positioning of the model's back, arms, buttocks, and legs intentionally mimics and evokes the angular forms of the object he holds. Here, Van Vechten plays on the idea of the photographer's "objective" ethnographic documentary eye contemplating the black man who

holds and contemplates his own primitiveness (i.e., a likeness of his own body). The impression is one of serious ethnographic study and cataloguing of the primitive body. It is also a clear visual statement of physical and cultural possession on the part of the intended spectator. Both black man and statuette are conceived as works of art – acquired, owned, and fashioned to the beholder's desires. In another photograph with the same model set in a dance pose, the figure's nudity and angular form work to evoke a sensual primitiveness in the dance while turning the subject into an object of racial and cultural distinction. The subject has become the very African statuette that he held in the prior photograph.

In both instances, the voyeuristic scrutiny of the photographer's gaze is justified as an aesthetic study of angular form and movement. By viewing the black subject in this manner, Van Vechten could successfully objectify and fetishize the black body and transfer it on to the legitimizing cultural plane of African art and the ethnology of black dance. No doubt, these images satisfied Van Vechten's multiple intentions – they appeased his penchant for collecting and documenting peoples and culture while they allowed for the exercising of his fantasy as voyeur of primitive and

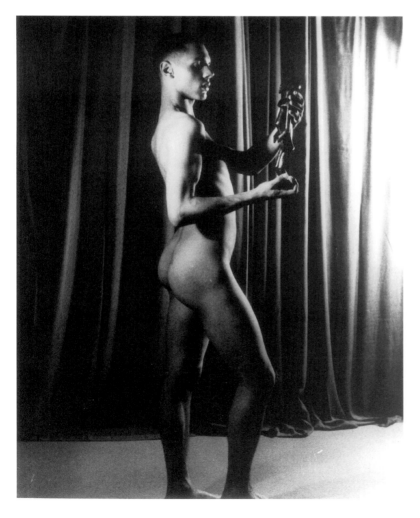

Fig. 4.4

narcissistic practices. Furthermore, as contrived visual displays of homoerotic, interracial, and intercultural activities constructed within highly artificial and controlled spaces, they satisfied his need to collect and document black people in relation to his own specific conception of the black man's ancestral link to Africa.

lure of the primitive and loss of self

In early twentieth-century modernist practice, white engagement with the primitive was viewed as a sign of social and artistic sophistication – a purifying regression through simplification and the satisfaction of primal urges. Africa was, to employ a term used by Michel Leiris, "Edenic" – a conceptualized site of "ritual intoxication" for whites.[19] Indulgence in the primitive was considered as one way to put aside or momentarily suspend one's racial and cultural identity and become "one" with the other. As shall be elaborated more fully below, blacks also partook in the intoxication of the primitive as defined by whites but for altogether different reasons. Taking pleasure in the losing of self in the other served to disrupt historical, spatial, and social oppositions between white and black, self and other, Euroamerica and Africa. As an admirer and patron of African American art and letters, Van Vechten shared in his contemporaries' beliefs that persons of African descent retained many of the elemental, spiritual qualities that white people had lost. The idea of unrestrained and aggressive sexuality – a significant feature of cultural primitivism – is employed by Van Vechten as one aspect of a nostalgic regression heightened by the insularity of the studio. His "fetish and fantasy" imagery underscores the critical and social ambiguity that arises out of an attempt to embrace primitivism as an instrument for disidentification with white, patriarchal, bourgeois society.

According to Hal Foster's elaboration on the underlying dynamics of primitivism, two things occur in its modernist form. On the one hand, there is an explicit desire to break down the cultural oppositions of European and "primitive" culture and nature, as well as the psychic oppositions held to underlie them: active and passive, masculine and feminine, heterosexual and homosexual. On the other hand, there is an insistence on maintaining these oppositions. These conflicts of desire occur because the primitivist seeks both to be "opened up to difference" (i.e., racial, sexual, social, cultural) and to be "fixed in opposition" to the other so as to have mastery over it.[20] In Van Vechten's case, this is most clearly seen in several of his interracial nudes in which the themes of male homosexuality, cannibalism, and acts of physical violence – all of which are homologous events in fetishist and primitivist discourse – are linked.

Most significant for my discussion, however, is the social and psychic function of primitivism for Van Vechten himself. Owing to the secretive nature of the fabrication and circulation of these photographs, I submit that they have more to do with Van Vechten's racial and social crisis as a private individual and public patron than anything else. They also illustrate his dire need to demarcate racial and sexual subject and object and to seek jurisdiction over both. The highly sexualized and racialized aspects of his "fetish and fantasy" photos become simulacra of charms and dangers against the loss of self inscribed in both homoerotic and interracial experience. For example, in a telling photograph from this "loss of self" series, Van Vechten depicts the white man as actively netted by the "primitive" (Fig. 4.5). The white victim, willingly snared as prey, will soon be either abused, sacrificed, or devoured by the black man. The white man seems to be a willing accomplice in his capture, putting up little resistance. Again, I cannot help but read the netted white figure as an authorial projection – that is, as Van Vechten willingly throwing himself into the pig-sty of primitivist activity and taking delight in slopping about in its muck. In order for Van Vechten to enjoy his status as victim of, and lord over, the very object he desires, he "gets

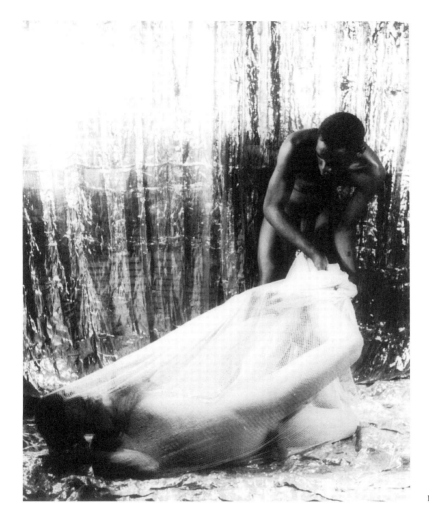

Fig. 4.5

primitive" and partakes in the base pleasures and biological impulses that the black man has to offer.

Of course, this primitivized sadomasochistic ritual of sacrifice is based on a manifestation of "colonial fantasy" in which a rigid set of racial and sexual roles and identities are used to construct scenarios of desire in a way that clearly routes these references to historical legacies of slavery, bondage, lynching, and to the real consequences of white exploration and exploitation of peoples of African descent. This primitivist discourse in Van Vechten's representation, although extreme in its kitsch/camp feel, has close affinities with serious orientalist/exoticist discourse.[21] For instance, a photograph of a black man serving a white man grapes (Fig. 4.6) conveys stereotyped servitude in conjunction with racial distinction, sexual subservience, and implied social hierarchy as does any exotic harem image or story from the nineteenth century. Thus, at first glance it would appear that the ideas behind Van Vechten's "fetish and fantasy" images are not new but are merely a contemporary rehash of old stereotyped racial, sexual, and social fantasy codes used to solidify existing hierarchical structures between the races. If read this way, then these images,

created by Van Vechten as a measure of authorial projection, clearly have negative implications for the gay white male imaginary. However, the interracial character of the works and the potential mobility of spectatorship change all this.

Van Vechten's obsessive fixation on the white man's relationship and proximity to the black male body and the latter's "primitive" rhythms force a decidedly autobiographical note of intersubjective desire and wish-fulfillment on to his photographs. Around 1940, Van Vechten made a series of photographs in which black and white men encounter each other in a natural, jungle-like setting (Fig. 4.7). As visual manifestations of modern colonial discourse, these photos attempt simultaneously to recognize and disavow differences between the races by producing for the white man a deceiving space of encounter, knowledge, and embracing of the primitive through voyeuristic surveillance and incitement of sadomasochistic interplay. In all instances, the white man's encounter with Africa is a desired one, one in which he is a visitor or lost stranger to the black man's "natural" habitat in nature. The white man willingly becomes the docile and passive object of foreplay who deserves and wants to be netted, tied up, sodomized, and

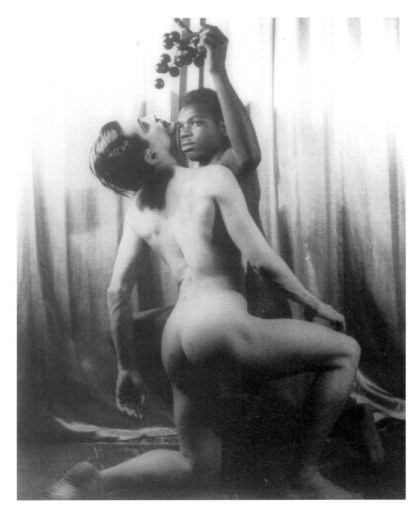

Fig. 4.6

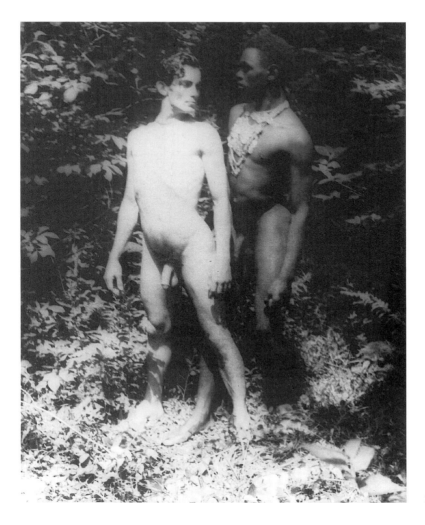

Fig. 4.7

cannibalized. This state of affairs is most explicitly revealed in yet another series of photographs created around the same time as those mentioned above in which themes of sacrifice and ritualized enactments of violence and sexual violation between black and white men are most noteworthy. In these, it is the mystique of the black man's "Africanness" set in contrastive conjunction with a "willing" and receptive white man that operates to signify transgressive sadomasochistic fantasies and desires for both subjects. The implications of sodomy, cannibalism, and sadomasochism become Van Vechten's projections of a particular modern subjectivity on to a constructed interracial primitivism.[22]

Van Vechten's fantasy of becoming one with the other continues with two incredible photographs showing a white man draped over an African drum while in the masochistic "jouissance" of a self-sacrifice to "Africa." In one of the two images, the white man is represented nude, bound at the hands and feet, and draped over an African drum (Fig. 4.8). He is about to be stabbed, disemboweled, and sacrificed by the black man who crouches before him clutching a knife. The floral backdrop attempts to impart a sense of primitivized place. The other photograph

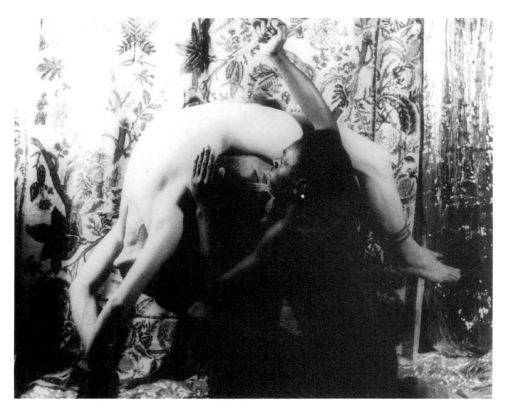

Fig. 4.8

evokes the white man's complete loss of self and willing sacrifice to "Africa" as an ideal. In it, the white man is alone, nude, and uncomfortably splayed over the drum. The plain backdrop and glittery floor material emphasize the artificial and theatrical setting for an offering taking place on an African drum-as-altar. Because he is alone and offered only to the viewer's gaze (initially and intentionally that of Van Vechten himself), the offering of self becomes a private affair (if the idea of authorial projection is accepted) for Van Vechten who desires to be sacrificed on the shrine of Africa, thereby identifying himself as both a captive and martyr.

Van Vechten's loss of self is achieved by pairing contradictory elements of impotence and aggression, passive spectatorship, and acts of cruelty. For the photographer, these images constituted attempted flirtations with boundary dissolution and transcendence – boundaries that most likely tested and affirmed his need to maintain separation, difference, and control over African Americans while convincing himself through artistic reinforcement of complete surrender to them. These contrived fetishistic acts of racial and sexual fantasy not only serve as psychic or fantasmatic reinforcement of Van Vechten's very public social role as a patron and philanthropist of African American art and culture, but function to resolve conflicts of racial difference and homoerotic desire through sadomasochistic wish-fulfillment in his perceived passive surrender and self-sacrifice to black men. In a Freudian sense then, Van Vechten's sacrifice becomes "a symbolic version of cannibalism and a sacred, transcendental version of suicide – a version in which the voluntary destruction or offering of self achieves social significance."[23]

In a curious series of "fetish and fantasy" interracial photographs in which a loss of self thematically predominates, Van Vechten evokes a quasi-ritualistic atmosphere of white worship of and supplication to the black body/penis. In one of these (Fig. 4.9), a white man is shown on his knees with his back to the viewer. He raises both hands as though in supplication before a standing black man who looks down on the white figure while holding a goblet in each hand. The artificiality of the studio environment draws the viewer's attention to the activity taking place between the two figures. The position of the white man and the compositional placement of his head at the black man's crotch suggests fellatio. The setting, props, lighting, and positioning of the figures all give a pious feel to a profane encounter. Again, Van Vechten is working with oppositions to heighten sexual and social fantasy. Interestingly, this photograph clearly relates to Fig. 4.2 in its encoding of a passive/active dynamic in racial division.[24] Clearly, the mechanisms of sadomasochism and sexual/racial fetishistic practice – both being significant dynamics contained within the tradition that paved the way for modernist primitivism – are the operative agents in these and other images created by the photographer.

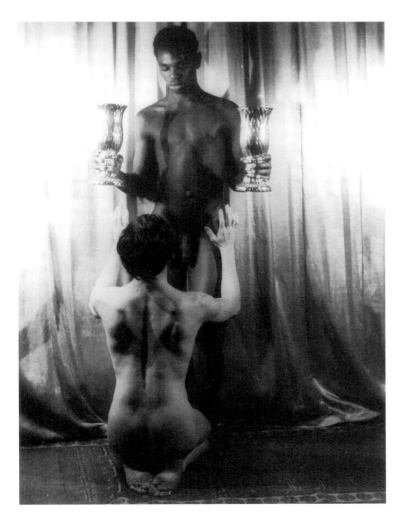

Fig. 4.9

If the potential for authorial projection is kept in mind, the oscillation of the white master subject between sadist and masochist parallels a desired alternation between active and passive positions *vis-à-vis* the black body/penis. This is a dynamic of power that is, in this instance, ascribed to the white master subject. However, owing to the interracial character of these images, the subject-position mobility of the author is also allowed to the viewer, a point I will return to in the following section. For now, I want to reiterate that images like these were extremely significant for defining and maintaining Van Vechten's psychic link to a social life. By focusing in on the homoerotic in racial difference and by placing that fantasy within a highly artificial atmosphere of harmonious solemnity, images such as Fig. 4.9 heighten a sense of white capitulation and racial co-operation that is then transferred by Van Vechten to the social domain. In pushing the theme of utopic interracial harmony in ritualized gestures and contrived settings, Van Vechten's photos succeed at playing upon a conflicting fusion of racial power, fear, and desire by the white master subject. Whereas his earlier novels had manifested a serious moral commentary on the inversion of accepted values, these photographs are more private, playful, and "therapeutic" reveries on the photographer's own transgressive violations of a perceived barrier between himself and the African American community. In his social life, Van Vechten loved to go "slumming" in Harlem and, in fact, bragged that he had started that trend. His "fetish and fantasy" photographs indulge a desire to taste the forbidden fruit of the black man whose "goods," both sexual and cultural, are as tempting and satisfying as the prohibited fruit in Eden (Fig. 4.6).

spectatorship

On one level, Van Vechten's "fetish and fantasy" nudes could be read as modes of representation fashioned to "facilitate the [white] imaginary projection of certain racial and sexual fantasies about the black male body."[25] Yet on another level, they are classic expressions of ambivalence in that they exemplify the fracturing or multiplicity of homoerotic desire and interracialism into complicated psychic, social, and spectatorial emotional effects. They offer the spectator, regardless of race, multiple erotic fantasies from which to choose.[26] I can, if I so desire, identify with the white man's subject and object position, and he with mine. By eliding and replacing the black man with my imaginary self in Fig. 4.9, I can identify as sadist; by doing the same in imagery where the black man is subservient as in Fig. 4.6, I identify as masochist. By not transposing myself at all, I become a voyeur or I can place myself into the scenario as a third person in a *ménage à trois* – all of these "democratic" possibilities can be erotically and fantasmatically stimulating for both subject and object of desire.[27] Unlike Mapplethorpe's imagery, or even that of Van Vechten's contemporary George Platt Lynes, where the element of "where to look" is limited and dictated by the artist, Van Vechten's "fetish and fantasy" photos do not command a "categorical" identity or subject position for the spectator. Such a fluid fantasmatic legitimizes and seriously complicates the relationship of power between white and black men. I am *and* am not "used, laid bare, and overdetermined from without" by white eyes in the realm of fantasy.[28] On the contrary, I find my control of the fantasy to be an important element in further stimulating erotic desire.[29]

Van Vechten's "fetish and fantasy" photographs emphasize ambivalent interracial relations of looking and desiring that often destabilize any subject/object dichotomy in terms of seeing and being seen. Voyeurism, objectification, fetishization, s/m relations – all necessarily come into play if the fantasy is to be maintained. These scenes and their related issues invite the spectator into what Mercer refers to as "those messy spaces in-between . . . binary oppositions . . . that ordinarily

dominate representations of difference." The shifting subject positionings and numerous permutations of racial and homoerotic fantasies elicited from Van Vechten's visual imagery exemplify the complexities of desire in which questions of race, homosexuality, social identity, and power, enter into the psychic and lived relations between black and white men. These kinds of responses cannot be explained solely by theoretical paradigms because the problem with theory is that it tends to be removed from our lived experiences which are based, in significant part, on fantasies and desires – interests that reside in those "messy spaces." As visual manifestations of gay and racial fantasy and desire, Van Vechten's photographs help illuminate and bridge those gaps.

parallel desires

The dialogue between the primitive and the modern in early twentieth-century American culture forced many African American artists and writers to succumb also to fetishistic expectations in their work. Since primitivism and primitive behavior were defined by the dominant culture as a state existing before Christian morality, homosexuality would then be justified in such a context.[30] Despite the individuality and semi-independence that history has ascribed to the African American artist, it was Van Vechten who not only commanded awe and respect from a modest portion of them and others from the African American community in Harlem, but it was he who also single-handedly dictated or coerced the homoeroticizing and sensualizing of the black male body for them.

Whereas white gay artists such as Van Vechten found emotional solace and urgent social significance in mixing erotics with "Africanisms" to inform an avant-garde agenda, for the African American intelligentsia of the early modern period, homosexuality and Africanicity were discontinuous problematics. Homosexuality, either black or white, was a taboo topic dealt with only indirectly. The problem of the gay black relationship to Africa germinated in the work of Alain Locke – African American leader and philosopher of black cultural production from the 1920s to the 1950s. Locke argued for the need for African Americans to study their origins in Africa and to apply what they learned to artistic production. According to David Bergman, "Locke's interest in Africa . . . [was] . . . at least partly motivated by a desire to create a cultural context for black homosexuality."[31] In his writings on African and African American art, Locke himself couched his sexual politics in ambiguous and enigmatic terms. Since gay black men of the early modern era sought legitimation of desire in an African past (as did whites), they easily adopted similar primitive features or ideas in representation. Perhaps this is why it was easy for Van Vechten to dictate a primitivized homosexuality to African American artists.

Unlike the use of the black body by whites to promote a self-conscious vanguardism, the goal of the black artist in the employment of similar primitivist and fetishist tropes was to relocate from the social and artistic margins to a site of mainstream acceptance by the white status quo. That is to say, African American artists were aware of the psychological need of whites for Harlem and for the primitivized black man. To supply what was in demand was not necessarily viewed as a negative thing. As Nathan Huggins has suggested, the indulgence by whites in Harlem as a heart of darkness and in black men as its drumbeats, "provided some black men a positive image of themselves, and, most important, it brought downtown money uptown."[32]

Ironically, in latching on to primitivism and the racial fetish, both blacks and whites used the black body as linkage to a primitive modernism but did so with different objectives. Interestingly, very few African American artists included the black nude body in their work. When they did, they objectified it and fashioned it as an item of consumption to suit contemporary aesthetic or artistic trends such as Art Deco or Cubism. For example, the African American artist and writer

Richard Bruce Nugent, who was also a close acquaintance of Van Vechten, created highly sensualized, stylized, and decorative graphics of black nudes for *Fire!!*, a radical magazine published in 1926 by young African American writers and artists. Nugent concentrated on male figures whose rendering was sexually and sensually provocative. His erotic drawings paralleled his scandalous short story of miscegenation, androgyny, and homoeroticism, "Smoke, Lilies, and Jade." Nugent was an outrageously flamboyant personality whose reputation as a notorious "out" homosexual surprised even Van Vechten himself.[33]

Of all the African American artists who incorporated the racialized and eroticized male nude into their art, the sculptor Richmond Barthé (1901–89) is perhaps the most notable. The major theme of his work was the nude or nearly nude black male figure in the act of the dance. Despite differences in media, Barthé's works are similar to Van Vechten's in their juxtapositioning of racial focus and the sensual worship of the black male physique in motion. Van Vechten and Barthé were not only friends, but the latter is rumored to have shared in Van Vechten's homoerotic interest in and attraction to black men.[34] Barthé and Van Vechten exemplify that ambiguous moment when aspects of the primitive and the modern coexist. But treating the black body in this way is especially problematic for the African American artist, for when the black physique becomes both product and property of the white elite (Barthé's sculptures were praised and purchased by whites), it is transformed into an objectified cultural product whose very "blackness" (an essentialist concept brought about by Locke's New Negro movement and a racialist approach to art) becomes suspect.

While Van Vechten's prominence as patron to the African American community in Harlem helps to explain the parallel desires that some African American male artists may have had for the eroticized and primitivized black male body, his involvement in the New York gay subculture also helped shape how black men were perceived and received in both art and life by elite gay white men.[35] As experimental works in patterning and contrasting arrangements in black-and-white, and as visualized intersubjective reinforcements for a public posture, Van Vechten's interracial male nudes were fashioned "for his eyes only" and for those of his most intimate circle of gay friends and other cultural types who not only had strong interests in primitivist modernism and its connection to the avant garde, but whose penchant for the homoerotic and the racial also made for a "naughty" underground environment of interracial bedfellows. Exactly who slept with whom makes for good gossip but is not important here. Suffice it to say that Van Vechten's "fetish and fantasy" images, as well as interracial images created by his friend and contemporary George Platt Lynes, constitute cultural evidence of a phenomenon in early twentieth-century gay modernist circles in which racial distinction became a significant factor in a homoerotic attraction which may or may not have been mutual for all involved.

Based on my own emotional response to both Van Vechten's and George Platt Lynes's imagery (and not on any "hard" documentary evidence), I suspect that the predominantly white urban gay subculture of the 1930s and 1940s consciously utilized race, racial difference, and the homoerotic as group-defining instruments of power and identification with a cultural avant-garde elite. I have also suggested that many African American men who identified with this white cultural vanguardism were complicit in this self-defining interracialism. Unfortunately, there is no existing documentation that tells us precisely how whites or blacks of Van Vechten's intimate circle responded to his interracial imagery. We do have, however, written evidence of the erotic pleasures taken in interracial representation by George Platt Lynes, whose male nudes parallel Van Vechten's ideas on interracial sexuality.

Lynes and Van Vechten were very close friends and fellow New Yorkers who had met each other in Paris in the 1920s as members of the circle of Gertrude Stein. The careers of both

photographers run parallel in that Lynes's ambition before photography was to become a writer. Also, both started their careers as photographers with portraits of celebrities in the literary, art, and theater worlds. Unlike Van Vechten's, Lynes's homosexuality was public knowledge, especially among the American expatriates in Paris. As a photographer, Lynes was more famous and celebrated than was Van Vechten, whose notoriety rested primarily on his role as patron and philanthropist. Owing to the implicit and explicit social and legal pressures of the period, neither Lynes nor Van Vechten could openly display their intensely homoerotic and interracial photographs. Their public exposure would have proven too shocking for an audience in which homosexuality was taboo and interracial coupling, particularly between the sexes, was suspect. This in turn restricted their circulation to a close circuit of confidants. Nonetheless, both photographers no doubt saw their male nudes as private exercises in modernist practice and as a means of psychically and socially reaffirming their roles as white men in command of aesthetic, racial, and sexual matters. Lynes's fixation on and control over black men and their crotches was indicated in his correspondence with Bernard Perlin: "Tomorrow I've a date with D., that 'wonderful gentle good-looking (super body!) Negro' I [have] inherited." In a subsequent letter, Lynes continued: "The brown boy I inherited is HEAVEN – affectionate and good, beautiful in the lean long muscular way, chocolate and ashes-of-roses, and (you guess where and how) fantastic, wonderful."[36]

Lynes's use of the word "inherited" underscores an enthusiastic desire to collect and possess racial bodies, while his allusion to the black man's phallic endowment points to the stereotype of the hypersexual as an essential component in the description of racial difference for the white master subject. Even though attitudes such as this negatively indict the gay white male imaginary in the exploitation of race and sex, they also speak to the realities of intersubjective fantasies that were enjoyed not only by the white master subject, but also, in many instances, by the eroticized object of desire – the black man. In other words, Lynes's description might be deemed racist and stereotyped, but it is also erotic. Racism and eroticism often work in concert to reinforce each other in fantasy and desire. The fixation on racial stereotypes not only might add considerable pleasure to the object of desire for the subject, but its very status as a taboo can work inadvertently to stimulate attraction for the spectator, regardless of race. As Van Vechten's "fetish and fantasy" works have helped to explain, sadomasochistic currents and subject position mobilities can and do intensify the ambivalence of desire inherent in such encounters. Another more explicit letter from Lynes to Perlin further implicates the white photographer in "negative" yet erotically stimulating pleasures indulged in a voyeuristic approach to the interracial couple:

I asked B. if he'd be willing to pose with D. A little to my surprise he said yes, so I asked D. to come along. He did. I photographed . . . them together in all sorts of close-contact suggestive sentimental sensuous poses . . . D. would have been willing, but I thought B. wouldn't . . . But then . . . everything did happen . . . and the sight of that big black boy screwing that super-naked little white bundle of brawn was one of the finest I've ever seen.[37]

It is the sight of gay sadomasochistic power relations underscored by racial opposition ("big black boy"/"white bundle of brawn") that structures the photographer's enthusiastic and intensely erotic description. Lynes revels in his own spectatorship. More specifically, he makes reference here to a series of art photos in which white and black and all black men engage in sexual foreplay leading up to and including the sex act.[38] Although Van Vechten never made such explicit statements regarding race and sexual attitudes in his correspondences, the chances are good, based upon his "fetish and fantasy" images and prominent status in the gay subculture of New York, that he wholeheartedly shared in Lynes's libidinous interracial fantasies.[39]

The interracial male nudes of Van Vechten and Lynes are significant in that they are evidence, among other things, of these men's erotic use of race and racial difference within a burgeoning gay male subculture in New York spanning the decades from the 1930s to the end of the 1950s – a subculture in which race and racial difference were evidently of primary importance. As Lynes's and Van Vechten's photographs and their exchange between individuals suggest, race and racial distinction were not only significant factors in the power operations within the gay subculture of this period, but also route our attention to the complex avenues of sexual and racial desire of both blacks and whites in erotic fantasy and in social arenas. It is clear that, for Van Vechten, his gay proclivities overlapped with his desperate social attempts to project himself as the "Messiah" of African American culture. He needed concocted images of a harmonious interracialism as a personal vehicle of reinforcement to convince himself that he indeed possessed a level of prestige and power of which he may not have been thoroughly convinced that he actually had. In his social life, Van Vechten desired desperately to be part of black cultural strides, but more often than not encountered walls of resistance and mistrust by many African Americans.[40] He remained an outsider. So, his interracial male nudes operate as modes of fantasy or desire to infiltrate and be accepted by the black man. Also, what these photographs make clear to me is that a distinction must be made between a historical racism that negatively impacts upon the real social lives of individuals, and a psychic racialism, that is, the focus on racial difference and stereotypes in the realm of desire that form the basis of erotic fantasy in representation.

conclusion

By now, it should be obvious why the public has not been allowed to see these "fetish and fantasy" photographs, for they expose the private thoughts and desires of a man who publicly promoted himself as an affirming advocate for African Americans, their creativity, and culture. Without a doubt, racial and gay subtexts and pretexts percolate below the surface of Van Vechten's photographs. In the end, his photographs draw critical attention to the artifice of the forced racial, sexual, and cultural roles and identities ascribed to blacks by whites. They therefore point to a "constructedness" of race and racial difference within a homoeroticized field, thereby reminding us that pleasures can ultimately be political even when left publicly unacknowledged. They can be said to make ambivalent the "political unconscious" of white masculinity as they expose a need to have jurisdiction, claim, and control over black cultural and white subcultural arenas while at the same time hypocritically posturing a semblance of objectivity and enlightened sympathy.

The privileged white pre-Stonewall gay subculture in which individuals like Van Vechten officiated perhaps needed the tropes of black primitivism and the intricate dynamics of fetishism in order to distinguish and empower itself within its own socially stigmatized status as a repressed minority. It was through interracial and homoerotic imagery that gay white males attempted to distinguish themselves by exercising control over the representation of the bodies of others. It was an engagement that could seriously indict Van Vechten and force suspicion and condemnation of his homoerotic and negrophilic motivations and intentions. However, as I have tried to suggest in this essay, Van Vechten's photos are not as simple and clear-cut as they might first appear in their delineations of power relations between blacks and whites. His interracial nude photos underscore the observation that racial and sexual desire are intersubjective constructions that are mobile and fluid. With them, the spectator can constantly transgress identities, positions, and roles. They in fact constitute aspects of interracial gay desires that are as complex, ambivalent, and multiple as was Van Vechten's personality.

Considering the possibilities and potential subject-position mobilities that Van Vechten's works elicit, it may be too hasty and simplistic to dismiss him as a racist and to believe that blacks were merely his helpless victims. These "fetish and fantasy" images force the viewer to acknowledge that the flow of desire and power can be multidirectional. African Americans also can and do exhibit, proclaim, and exercise fantasies of racial domination, phallic endowment, and exploitation. To what extent were African Americans themselves responsible for, or complicit in, their own representation in Van Vechten's images? This is a controversial question, but I believe that it lies at the very heart of fantasy in gay interracial relations. By allowing myself to be fetishized and by reveling in that process from my own subject position as a gay black male spectator, I can also maintain the illusion of co-operation and wrest a certain amount of power and control over the white man. This is not a form a self-hatred or internalized racism, but represents one way in which the black man can use for empowerment a fantasy that may or may not be his own. Such ambivalences of fantasy catalyzed by Van Vechten's interracial representation give a more complex poignancy to the notion of being "in bed with the enemy."

The complexity of the relationships among interracialism, homoeroticism, and fantasy as I have posed them here calls into question the very validity of representation as definitive evidence of social and/or psychic truth. As cultural constructs created from elements of fantasy and social reality in varying proportion, Van Vechten's "fetish and fantasy" photos speak to the very problem of trusting representation as evidence of an author's moral, political, or ideological convictions. Fantasy is just that, and is not reality even though both are usually based on each other. Given Van Vechten's relationship to the straight and gay African American communities and his engagement in modernist primitivism, one must interrogate what pleasures and cultural/political agendas are being played out on all sides.

Van Vechten's fractured complexity as an individual, in addition to his multiple identities as writer, collector, photographer, and philanthropist, make his life, work, and intentions fascinating and rewarding avenues of future investigation and analysis. As an important figure in early twentieth-century modernist thought and practice, Van Vechten lives up to our expectations in that "the woof of his thought is a charming destroyal of all accepted standards, the web of his thinking is a delicate but constructive anarchy."[41] "Web of thinking" and "constructive anarchy" are indeed appropriate descriptions for Van Vechten's brand of modernity, for what his images do if anything are to keep us continually confused and conflicted.

notes

This essay is a shortened version of "Public Face, Private Thoughts: Fetish, Interracialism, and the Homoerotic in Some Photographs by Carl Van Vechten" which appeared in *Genders*, no. 25 (1997). I would like to thank Martin Duberman, Jonathan Weinberg, and Margaret Vendryes for their leads, comments, and insightful revelations about Van Vechten.

1 Nathan Irvin Huggins, *Harlem Renaissance*, London, Oxford University Press, 1971, p. 93.

2 Susan Sontag, *On Photography*, New York, Doubleday/Anchor, 1989, p. 14.

3 There is strong evidence to indicate that Van Vechten's marriage to the actress Fania Marinoff was an arrangement of convenience; see Bruce Kellner, ed., *Letters of Carl Van Vechten*, New Haven, Yale University Press, 1987.

4 For a more apologetic approach to white patronage, see Jeffrey C. Stewart, "Black Modernism and White Patronage," *The International Review of African American Art*, vol. ll, no. 3, 1994, pp. 43–6. Also see David Levering Lewis, *When Harlem Was in Vogue*, New York, Oxford University Press, 1971, and Huggins for

more condemnatory views of white patronage as a negative influence on African American art, artists, and culture.

5 Mercer's essays on Mapplethorpe have appeared in various sources. In 1994, he incorporated them into a single chapter entitled "Reading Racial Fetishism: The Photographs of Robert Mapplethorpe," in his book *Welcome to the Jungle: New Positions in Black Cultural Studies*, New York, Routledge, 1994, pp. 171–219. This is the source I will use throughout this essay. Mercer mentions Van Vechten in his writings, referencing him only as "white photographer of black literati in the Harlem Renaissance." Apparently he was unaware of the photographer's interracial nudes.

6 Whitney Davis, "HomoVision: A Reading of Freud's 'Fetishism,'" *Genders*, no. 15, Winter 1992, pp. 86–118.

7 In his writing as well as his photography, Van Vechten used the black head and body to promote an anti-bourgeois stance inherent in the rebelliousness of early twentieth-century modernism – a position "indulgent of free love, feminism, homosexuality, the mixture of 'high' and 'low' culture, and support of abstraction and Cubism"; see Stewart, "Black Modernism," pp. 43–6.

8 For a highly nuanced discussion of the intermachinations of these phenomena, see Hal Foster, *Recodings: Art, Spectacle, Cultural Politics*, Seattle, Bay Press, 1985; and Homi K. Bhabha, "The Other Question: Stereotype, Discrimination and the Discourse of Colonialism," in *The Location of Culture*, London, Routledge, 1994, pp. 66–84.

9 Foster, *Recodings*, p. 198.

10 On skin fetishism as an articulation of the "ethnic signifier," see Stuart Hall, "Pluralism, Race, and Class in Caribbean Society," in *Race and Class in Post-Colonial Studies*, Paris, UNESCO, 1977, pp. 150–82; also see Victor Burgin, "Photography, Fantasy, Fiction," *Screen*, vol. 26, Spring 1980, reprinted in Victor Burgin, ed., *Thinking Photography*, London, Macmillan, 1982, pp. 177–216; and Bhabha, "The Other Question."

11 Bhabha, "The Other Question," p. 80. This characterization is problematic in many respects. It assumes in its gender specificity that fetishism and fetishistic practice are the exclusive domain of men. It does not allow for the possibility of women as having fantasies of mastery and control.

12 Mercer, *Welcome to the Jungle*, p. 177.

13 For a theoretical perspective on the author as projection, see Michel Foucault, "What Is an Author?" in *Language, Counter-Memory, Practice*, trans. Donald F. Bouchard and Sherry Simon, Oxford, Blackwell, 1977.

14 The idea for using patterned backdrops as environments was borrowed from fine art paintings and became an important signature element in Van Vechten's photographic style; see Kellner, *Letters*, p. 187; also see Keith F. Davis, *The Passionate Observer: Photographs by Carl Van Vechten*, Kansas City, MO, Hallmark Cards, 1993, note 52.

15 From Italo Calvino, *Difficult Loves*, trans. William Weaver, San Diego, Harcourt Brace Jovanovich, 1984, pp. 228–9. Cited in Jefferson Hunter, *Image and Word: The Interaction of Twentieth-century Photographs and Texts*, Cambridge, Mass., Harvard University Press, 1987, p. 115.

16 On the history of minstrelsy see Robert C. Toll, *Blacking Up: The Minstrel Show in Nineteenth Century America*, New York, Oxford University Press, 1974; on the theoretical links between race, the mask, and sexuality, see Eric Lott, *Love and Theft: Blackface Minstrelsy and the American Working Class*, New York, Oxford University Press, 1993.

17 Mabel Dodge Luhan, *Intimate Memories, III*, New York, Harcourt Brace and World, 1936, pp. 79–80.

18 Houston Baker, Jr, *Modernism and the Harlem Renaissance*, Chicago, University of Chicago Press, 1987, p. 17.

19 Marianna Torgovnick, *Gone Primitive: Savage Intellects, Modern Lives*, Chicago, University of Chicago Press, 1990, p. 111.

20 Hal Foster, "Primitive Scenes," *Critical Inquiry*, vol. 20, no. 1, Autumn 1993, pp. 83–5.

21 For more nuanced discussions of colonialism and related orientalist/exoticist practices, see Edward Said, *Orientalism*, New York, Vintage Books, 1979; Homi K. Bhabha, "The Other Question"; James Clifford,

"On Orientalism," *The Predicament of Culture*, Cambridge, Mass., Harvard University Press, 1988; also see Torgovnick, *Gone Primitive*, pp. 252–3, note 17.

22 On these preoccupations in primitivist practice, see Foster, "Primitive Scenes"; also see Homi K. Bhabha, "Interrogating Identity," in *The Location of Culture*, pp. 40–65.

23 Torgovnick, *Gone Primitive*, p. 189.

24 Although difficult to verify, it is very likely that these two photographs, as well as some others, were all shot in the same session.

25 Mercer, *Welcome to the Jungle*, p. 173.

26 It is important to remark that these images were not intended for female spectatorship. Because of this, I consider here only the gay male subject position.

27 This kind of complicated dynamic occurs with straight pornography in which the heterosexual male can transpose himself into lesbian scenes.

28 This was the source of Mercer's initial angry response to Mapplethorpe's black male nudes; see Mercer, *Welcome to the Jungle*, p. 193.

29 In this regard, my own subject position response was reinforced by other African American gay men at the Black Nations/Queer Nations? conference who, upon seeing several of these "fetish and fantasy" photographs, expressed subjective sentiments of an aroused excitement and erotic stimulation that these images stirred in them.

30 Within the discourse of primitivism, homosexuality is often linked with castration and cannibalism; see Torgovnick, *Gone Primitive*.

31 David Bergman, *Gaiety Transfigured: Gay Self-representation in American Literature*, Madison, University of Wisconsin Press, 1991, pp. 176–7.

32 Huggins, *Harlem Renaissance*, p. 90.

33 In one of his letters, Van Vechten wrote: "Also as I went out William Pickens caught my arm to ask me who the 'young man in evening clothes' was. It was Bruce Nugent, of course, with his usual open chest and uncovered ankles. I suppose soon he will be going without trousers"; see Kellner, *Letters*, "Letter to Langston Hughes" (11 May 1927), pp. 95–6. Of course, Van Vechten photographed Nugent, who became one of his "collected" acquaintances.

34 Apparently, Barthé found Van Vechten to be an indispensable ally when he was in need of black male models. This is substantiated by an Easter card dated 21 March 1940, in which Barthé thanked Van Vechten for sending him nude photographs of Allan Juante Meadows – the black model used in most of Van Vechten's "fetish and fantasy" photos. See Van Vechten Collection – Correspondence from Richmond Barthé, Beinecke Library, Yale University.

35 It was especially within the entertainment enclaves of the theater and the dance where a vibrant black and white pre-Stonewall gay subculture emerged and thrived in the 1930s and 1940s. See George Chauncey, *Gay New York*, New York, Basic Books, 1994. [Ed. note: Also see Thomas Waugh's essay in this volume.] We also know that in his role as lord over the "glitterati" of New York, Van Vechten was involved in the life of the black gay community in Harlem. He attended and officiated over many of the drag balls held there such as those at the Rockland Palace Casino and the Savoy; see Bruce Kellner, *Carl Van Vechten and the Irreverent Decades*, Norman, University of Oklahoma Press, 1968, p. 201.

36 Letter from Lynes to Bernard Perlin, 24 October 1952; quoted in James Crump, "Photography As Agency: George Platt Lynes and the Avant-Garde," in *George Platt Lynes, Photographs from the Kinsey Institute*, New York, Bulfinch Press, 1993, p. 152.

37 Ibid., p. 154.

38 To my knowledge, these photographs have never been published and remain in the archives of the Kinsey Institute for Sexual Research.

39 Unfortunately, Van Vechten does not mention Lynes's photographs in any of his copious correspondences.

Nor does Lynes ever mention seeing works by Van Vechten. This does not mean, however, that the exchange never happened. The secretive, underground nature of homoerotic and interracial linkages must have fueled these kinds of exchanges. Also, the private and closeted nature of Van Vechten's visual imagery showing a coupling of homoerotic and interracial desire is consistent with his attempts to fashion and control his public and private persona.

40 Formidable resistance came from W. E. B. DuBois who was the most important and influential leader among the black middle class. DuBois, deeply disturbed and troubled by Van Vechten's salacious novel *Nigger Heaven* (1926), decried any artistic focus on black sexuality. He criticized Van Vechten's approach to black sexuality, labeling the novel a "caricature of half-truths . . . near . . . cheap melodrama."; quoted in *The Crisis*, December 1926. Nathan Huggins points out that Harold Cruse, in his *The Crisis of the Negro Intellectual* (New York, Morrow, 1967, p. 35), believes that blacks and Harlem paid a high price for Van Vechten's patronage. Langston Hughes, James W. Johnson, and Van Vechten's biographers think he gave more than he got; see Huggins, *Harlem Renaissance*, p. 314, note 8.

41 Quoted in preface to Edward Lueders, *Carl Van Vechten*, New York, Twayne, 1965, n.p.

chapter five
mark alice durant

lost (and found) in a masquerade
the photographs of pierre molinier

To be one human creature is to be a legion of mannequins. These mannequins can become
animated according to the choice of the individual creature. When the creature steps into the
mannequin he immediately believes it to be real and alive and as long as he believes this he is
trapped inside the dead image . . . Every individual gives names to his mannequins and nearly all
these names begin with "I am" and are followed by a long stream of lies.

Leonora Carrington[1]

The French artist Pierre Molinier was born in 1900 and died by his own hand in 1976. His death from a
self-inflicted gunshot wound occurred, appropriately, in front of his mirror in the studio where he
performed and photographed his narcissistic rituals of erotic self-transformation. The irony that he
"did" himself in death as he "did" to himself in life is as perversely balanced as the symmetry of
his double-gendered self-portraits that will be the subject of this essay. Molinier lived the
chronological spectrum of the monumental upheavals, atrocities and cultural changes of
twentieth-century Europe. Strangely though, his artworks remained obsessively fixed in their
themes and strategies, always turning inward, away from the chaos of politics, war and culture to
the more individually pliable structures of gender and sexuality. Molinier's investigations,
transgressions and celebrations of the deeply rooted binary systems of western culture –
male/female, homo/heterosexual, old/young, past/present, presence/absence, animate/inanimate
– are remarkably relevant to contemporary discourses on gender, representation, fetishism,
pastiche, eroticism and abjection. The work of modern and contemporary artists as diverse as
F. Holland Day, Hans Bellmer, Brassaï, Hannah Höch, Joel-Peter Witkin, Robert Gober, and
Cindy Sherman can be reinformed in the flickering light of Molinier's backroom transgressions.
Yet this relevance is anchored in Molinier's archaic notions of spiritual and physical transcendence
and tempered by an aesthetic nostalgia with roots in French Symbolism.

mark alice durant

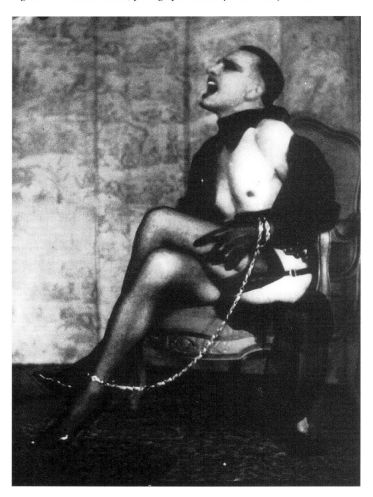

Fig. 5.1 *L'Enchaîné (photographic self-portrait)*, 1966

Until recently, there has been very little written about Molinier in English, and I admit at the outset that the biographical information I have on Molinier is pretty sketchy.[2] My initial encounter with Molinier's photographs occurred in 1983 when I was graduate student at the San Francisco Art Institute. Faculty member Linda Connor loaned me an obscure German-produced catalogue from the early 1970s. It was covered in black linen and embossed with the words, *Pierre Molinier, lui-même* (a reference to the surrealist publication, *le Surréalisme, Même*). I translated the title of Peter Gorsen's accompanying essay as "On Hermaphroditic Surrealism," otherwise, the body of the catalogue text remained opaque. As I do not read German, my information was largely visual, but because Molinier was playing in the "forest of signs" behind the house of western culture, it was not difficult to "read" what he was up to. His images remained impressed on my visual consciousness and it is a testament to their mystery that they resonate beyond the merely semiotic.

The catalogue itself is like an elegant peep show, black taffeta-like pages separate each new image or sequence of images. The first image after the Gorsen essay (Fig. 5.2) depicts a wooden cross grave marker with the name of Molinier himself carved into the wood. In French, the inscription reads: "Here lies a man without morals." In marking his own grave, Molinier displayed his characteristic disdain for the bourgeois sensibility of marking death with flowery words and their attendant proclamations of salvation, heavenly peace, or eternal damnation. Simultaneously, through his fictive death, he called into being one who both is, and is not, himself; he called for his *doppelgänger*. This ritual call of death and transformation at the netherworld between self and other manifests Molinier's precarious straddling of the binary at the center of surrealism's agenda, that of Eros and Thanatos. An early image in the catalogue shows Molinier lying in bed as a corpse, a mannequin's hand on his genitals. In succeeding images the figure arises, as if in a trance, to try on his new guises beyond the quotidian costuming of male and female. Transfixed by these photographs, I felt as though I was looking through a keyhole at the end of a dark hallway, the room within lit dimly, perhaps by candlelight and just out of reach. I felt the thrill of voyeurism, the naughtiness of stumbling on something not meant for my eyes.

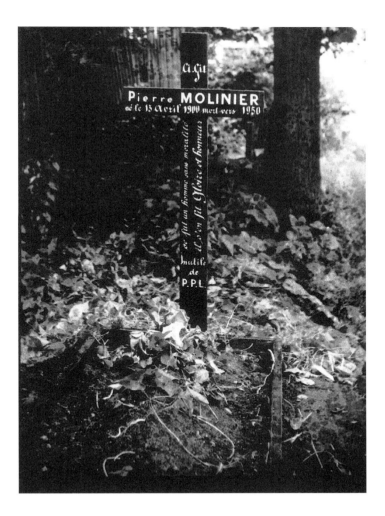

Fig. 5.2 *Fictitious Grave of Pierre Molinier, 1950*

105

In this group of photographs and photomontages, Molinier creates hybrids of male and female, mannequin and human, young and old, phallus and fetish, all dimly glowing and vignetted by an enclosing darkness – delicate bubbles of perversion that float like semiotic mutations in the recesses of the structures that give us our identities.

While still a young man, Molinier's dominant motifs began to take form: androgyny, stockinged legs, high heels and obsessive autoeroticism. He was fond of wearing his mother's and younger sister's stockings and shoes and became a practicing transvestite by the age of eighteen, also (not coincidentally) the year of his sister's death. His sister Julienne was, to Molinier, the perfect embodiment of androgyny with her "masculine features, high cheekbones, large fleshy lips," and her face and long legs were the objects of his passion.[3] As Molinier's self-mythologizing would have it, when alone with Julienne's body lying in wake, he photographed her veiled for burial in her gown and silk stockings. After making the exposure, he climbed upon the corpse, caressed her legs and ejaculated on her stomach. Later, on printing the photograph, he wrote: "My love/Its ending."[4] While determining the truthfulness of Molinier's necrophilic and incestuous anecdote is impossible, it clearly demonstrates the nexus of obsessions and impulses that were to be the cornerstones of the artist's final body of work: sex and death, male and female, blasphemy and travesty, performance and its documentation.

Molinier was essentially a provincial artist. After serving in the French army from 1921 to 1922, he settled in Bordeaux where he lived and worked for most of his life. He considered himself primarily a painter, making photographs for his own erotic pleasure and considering them ancillary to his artistic production. In his early years as an artist, he experimented with previously established styles such as post-impressionism and Symbolism. The influence of Symbolism remains evident in his later paintings and photographs with their evocative sense of melodrama, decadent atmospheres, and the multiple identities and mythological motifs of a private hybrid bestiary. Artists such as Aubrey Beardsley, Gustave Moreau, and Odilon Redon clearly left their impact. Other significant influences included photographic pictorialism such as that practiced by F. Holland Day, the surrealist works of Hans Bellmer, and the Viennese Actionists.

However, I believe it was Molinier's association with an unorthodox version of the fraternal order of Masons that had a profound influence on his aesthetics and provided an outlet for his ritual/performative needs. Masonry, like many semi-secret fraternal organizations that flourished in the nineteenth and early twentieth centuries, was known for its pseudo-mystical symbol systems and invented rituals that allowed men to navigate visual and physical initiations safely in a homosocial structure. In his study on fraternal organizations in the nineteenth-century United States, historian Mark C. Carnes explores some common themes found in the male attraction to secret homosocial organizations:

the themes and symbols of fraternal rituals are often laden with gender and interfamilial associations on which psychoanalytic models depend. Briefly, consider the basic plot of the master mason degree: the master of the lodge "tortured" the initiate, who was naked from the waist up, by pressing the points of a compass against his left and right breasts. The initiate was often "killed" and buried. After various mystical incantations and processes, he was raised to a new life as a master mason.[5]

Falsely claiming ancient and venerable origins in the Crusades or even earlier, these male fraternities served many utilitarian and social functions: as craft or trade organizations; as secular but parallel brotherhoods to religious hierarchies; as political meeting houses, and so forth. What takes these organizations beyond the run-of-the-mill boy's club is the unique and sometimes

campy pastiche of images plundered from the Egyptians, Babylonians, medieval Christianity, and a myriad of other pseudo-historical sources. Combining secret passwords, codes, signals and handshakes, these organizations inadvertently parodied male initiation rituals and attempted to take the power of procreation for men themselves. Molinier makes constant references in his work to the pastiche symbolism of the Masons, often signing his work with Masonic icons such as the compass, and scrawling aphorisms related to his fraternity within his drawings. Molinier's *faux* grave marker and the manner in which his body rematerializes in the morbid photographs that begin the German catalogue give evidence of the "humid back rooms of spirituality" Molinier's imagination occupied.[6] Perhaps these experiences within the secret brotherhood gave Molinier permission to investigate the realms of homoerotic performance, sex, and iconography. Certainly, at the very least they provided a secular alternative to Catholicism in their rich imagery and ritual, so while rebuking the Church by blaspheming its imagery, Molinier was still able to participate in a kind of organized ritual mysticism that Catholicism had provided.

You got your mother in a whirl
she's not sure if you're a boy or a girl.
> David Bowie, *Rebel, Rebel*

I do not think it coincidental that during the period of the late 1960s through the mid-1970s, when Molinier was making his late images, there was a broad resurgence of interest in the Symbolists, accompanied by major European survey exhibitions and the publication of several richly illustrated catalogues. The 1960s counter culture's interest in alternative structures and visionary/hallucinogenic experiences fostered an explosion of symbols and philosophies that combined eastern and western motifs, the exotic with the urban, the political and the mystical. In the post-hippie world of rock and roll, the music and images of such androgynous figures as David Bowie (represented on his *Diamond Dogs* album cover as a chimera), Lou Reed (whose *Transformer* album featured the homo-anthem, *Take a Walk on the Wild Side*), and the New York Dolls (whose proto-punk sensibility fused with transvestism) reigned in the bohemian underground. Even Mick Jagger, rock and roll's most notorious heterosexual, had his bisexual androgynous moment in 1972 in the film *Performance*. If implicit in this turn toward decadent hedonism is the counter culture's failure to create realistic alternative social structures, the new site of rebellion became the sexual self with the assumed fixity of gender positions and sexual orientation coming into question in popular culture as never before.

I search for new perfumes, bigger flowers, unknown pleasures.
> The Chimera to Flaubert's St Anthony[7]

Molinier's mystical, sexual, festishistic kitsch was as hybridized aesthetically and symbolically as the chimera, an important mythological creature inhabiting the world of the Symbolists. The chimera is described as a fire-breathing monster commonly represented with a lion's head, a goat's body, and a serpent's tail; but any grotesque creature of the imagination consisting of vivisected body fragments can play the role. In genetics, a chimera is defined as an organism that is partly male and partly female. As utilized by the Symbolists, the chimera was a kind of guide or gatekeeper to secret worlds associated with sensuality and visions. The chimera stood at the threshold between the historical and the mythological, between the classical and the modern, between the human and the animal, between the mortal and the divine, between the miraculous and the mundane, between science and the imagination. In a widely read book of the early 1970s

about Symbolist art, *Dreamers of Decadence*, Philippe Jullian described a kind of typology of the chimera:

the mystical chimera . . . the female pope of secret religions, surrounded by ambiguous angels, flies towards Wagnerian basilicas; with that she is, she conjures up spirits . . . her sister, the erotic chimera, is a daughter of Baudelaire . . . sad and even cruel in character; once eroticism had become a priestly function . . . it gave as much pain as pleasure.[8]

In fact, all of the themes and motifs of Baudelaire's *Les fleurs du mal* were appropriated and illustrated in the works and personal mannerisms of artists who considered themselves Symbolists: occultism, dandyism, exoticism and, most importantly, eroticism. Decadent exaggeration fusing with an ornate romanticism characterized the thickly atmospheric otherworldliness of Symbolist visions. The model of the artist/bohemian versus the bourgeoisie has a particularly French heritage and was often abetted by a vehement anti-Catholicism. Albert Aurier, an important French critic and contemporary champion of Symbolism, penned this simple allegory which concisely illustrates the blasphemous sensibility of his circle: "an evening came since when I have done nothing but weep, grinding my teeth with insatiable longing, an evening of unforeseen madness . . . the crime of stealing the Madonna's garter."[9] The cult of Christ, the sanctity of the Virgin, and the denial of the carnal that so permeate Roman Catholicism became the targets for the French avant-garde's traditional hostility to the Church.

The ephemeral, diaphanous, and ultimately vague world imaged and inhabited by the Symbolists was revisited in the 1920s by the surrealists. By this time, the artists were armed with new weapons with which to attack the bourgeoisie: the theory of the unconscious (thanks to Freud); irony (thanks to Alfred Jarry); and a new-found faith in the inherently surreal characteristics of photography (thanks to Man Ray). With heroes like the Marquis de Sade, the surrealists invented a kind of black symbolism – more sexual, more predatory, more agressive – which sharpened what Walter Benjamin has called surrealism's "bitter, passionate revolt against Catholicism."[10] In search of "convulsive beauty" (Breton), and "profane illumination" (Benjamin), the surrealists attempted to reconfigure the almost exclusively female body in accordance with an unconscious landscape of repulsion and desire.

The body is like a sentence which invites dissection in order that its true meaning may be reconstituted in an endless series of anagrams.

Hans Bellmer[11]

Hans Bellmer's drawings and photographs of reconfigured dolls are especially relevant as precursors to Molinier's later experiments with transgressive representations. Bellmer describes using a mirror at right angles to the body to create a fragmented symmetry of the body and its reflection, what he called the "third image": "the mirror divides and reproduces at the same time it creates antagonisms, but its movement resolves the contradiction, as a whip does for the top, and goes beyond it to create a third entity."[12] The structural and representational violence that is characteristic of the works of politicized Dada artists of the 1920s such as Hannah Höch, Raoul Hausmann, and John Heartfield – as opposed to the more seamless and softened juxtapositions of surrealism – is present in (fellow German) Bellmer's photographs. The contradictory impulses of montage, that of interruption and reassembly, are both evident in Bellmer's photographs and, later, in Molinier's photomontages. In Bellmer's case, the intrinsic seamlessness of the photographic window and the photographic surface serve to "make real" his puzzle-like

reassemblages of a young girl's body. The presence of the doll is made convincing and palpable by the uninterrupted surface of the photograph. It is as if Bellmer's "dolls" appeared before his camera, were found in the world in this manner, and that the photographer merely documented the encounter. This effect contributes to the hallucinogenic and nightmare-like qualities of the images, like stumbling on the aftermath of a grotesque crime in the dark. Additionally, it gives evidence of what Rosalind Krauss and Jane Livingston describe in their ground-breaking catalogue, *L'Amour Fou*, as "the seeming contradiction between the extravagant productions of the unconscious and the documentary deadpan of the camera."[13] This, for them, is the reason for photography's surprising centrality to the surrealist enterprise.

In her essay "Surrealism: Fetishism's Job," Dawn Ades writes that Bellmer's photographs are haunted by the idea of the "possible body." "Bellmer claims that desire has its point of departure not in the whole, but in the detail. The body fragment isolated and compulsively repeated also points to male anxiety about lack in the Freudian sense of the fetish."[14] While there are certain traits that Bellmer's and Molinier's works have in common, such as the reconfigured body, the mannequin, the seemingly endless duplication of limbs, and the seamless and evidentiary qualities of the photograph, there are some fundamental differences. The most obvious is that, for Bellmer, the subject of his manipulations is the metaphorical body of the young girl. Bellmer assumes the invisible, yet omnipotent, directorial role, twisting and contorting the object of his obsessions in the attempt to visualize the internal landscape of his own desires. As for Molinier, while he enlisted occasional collaborators for some of his images, he himself was the primary subject and object of his desire and control. Since Molinier's photographs were produced by him, of him, and for him, he creates a hermetic trinity of operator, subject and spectator. And it is the intensity, inescapability, and self-implicating characteristics of his later images that would threaten the dominant hetero-masculinity of the surrealist gaze.

In 1955, Molinier contacted André Breton in Paris. Breton was still the ringmaster of the surrealist circle, even as its influence and relevance was in eclipse in the postwar years. Initially, Breton was quite taken with Molinier's daring images. In them, Breton saw a manifestation of his lifelong mantra: "Beauty should be convulsive, or not at all." Breton arranged for Molinier's first Paris exhibition in January 1956. Molinier continued his association with the surrealists until 1965, publishing images and texts in the magazine, *le Surréalism, Même*. In 1964, Breton collaborated with film-maker Raymond Borde on an experimental documentary on Molinier and his works. The film is a kind of tour of Molinier's studio, showing his paintings and drawings worked in a style combining Symbolist affectation with public restroom graffiti: twisting and contorted clusters of stockinged legs, mouths, eyes, vaginal and phallic shapes; a vortex of distorted limbs, nipples and big-lashed eyes, orifices, painted lips parting to show glistening teeth, vaginal wounds opening in flexed thighs and calves – all suspended in a web of fishnet-like patterns. The film opens with the voice of Emmanuelle, a popular French writer of soft-core porn:

I am the one woman and the other, and the third one, the kind of women who kiss themselves, caress themselves, penetrate themselves, split themselves and open themselves up . . . And I am also the one who loves them, while they enjoy showing themselves being naked: I am, therefore, both you and myself, and I am you without knowing who you are.[15]

Molinier's collection of fetish items – mannequins, high heels, veils, and fishnet stockings – are also shown in various tableaux and vignetted still lifes. We see Molinier among his paintings and effects (including his burial cross with a human skull perched at its base), like an eccentric and somewhat sinister uncle attempting to explain his unusual obsessions. A painted sign fills the

frame, its circus-like letters spell out the phrase, "Three Passions – Painting – Girls – And the Gun." This is followed by a sequence of Molinier firing his rather large revolver. Throughout the film a male voice makes ornate proclamations: "Do not leave, one is talking to you. And it is surging from the deepest swirl releasing itself ecstatically on the indefinitely troubled surface, whipped by lashes of water, rippled by furrows of crawling streams of hair." Or, "Rising from the fusion of jewels, amongst which the black opal dominates, the genius of Molinier is to let the woman surge, no longer stricken but striking, to daringly portray her as superb prey." The distant echoes of the Symbolist voice are amplified through the fetishized language of surrealism; sex, dreams, drowning, violence, death and transformation are the bejeweled offerings of Molinier's chimera.

Molinier continued his association with the surrealist group until 1965 when he was to unveil his collage-painting *Oh! Marie . . . Mère de Dieu* in a surrealist exhibition. Evidently he crossed some line even for Breton, who fancied himself as *the* provocateur of the bourgeoisie. The painting depicts Molinier as a hermaphroditic Christ on the cross being sodomized with a dildo by Mary Magdalene. Mary, the Mother of God, is squeezing his nipples and sucking his cock. Molinier later said of this painting,

if I were to be crucified, I would want it the way my Christ is getting it. And I'd love to have a *godemiche* up the old 8-hole, for example. And be sucked on. Then my suffering would be transformed into sensual delight. It's an erotic symbolism, in the sense that pain can be pleasure.[16]

The title itself is a perverse play on a stereotypical orgasmic climax-cry and Breton, a notorious homophobe, never spoke to Molinier again. It is unclear whether Molinier kept his homoerotic inclinations under wraps, so to speak, to remain in Breton's favor, or whether it was a personal and aesthetic revelation that led him to break with the hetero-myopia that so characterized Breton's version of surrealism. But it was at the point of Breton's excommunication that Molinier began his final body of remarkable photographs and photomontages that reach beyond the sometimes kitschy, second-rate post-Symbolist, post-surrealist paintings and drawings that were the primary product of his artistic career.

Cumulatively, Molinier's photographic works display an array of images and objects within his studio: paintings, drawings, collages, fetish objects, *godemiches* (dildos), masks, high heels, stockings, and customized furniture that served as props for his photographic tableaux and erotic performances. I will describe and discuss various items in Molinier's collection of devices in terms of how they served his photographic project. By his own declarations, Molinier wanted to attain a permanent state of multiple perversion. "It often happened that I would come on my stocking-thighs while inserting a dildo into myself, with a beautiful doll's face arranged and made up according to my desires in front of me – *ma foi, j'ai jouie terriblement*."[17] As stated earlier, his photographs supplemented his larger artistic production, but it is clear, in retrospect, that they are the most convincing of his transgressive endeavors; a subtext that reveals itself as a meta-text for the artist. Despite extensive airbrushing and montage techniques, the specificity of the photographed act of autoeroticism produces a self-shattering fantasy – a travesty of manhood, a hybrid of male and female, animate and inanimate – a new creature of simultaneous genders. Molinier's liminal creature, a twentieth-century chimera, stands erect in his high heels at the threshold leading from subversion to submission.

Mon fétiche des jambes (Fig. 5.3) is perhaps the most compressed and reductive image of Molinier's constellations of symbols, objects, and fetishes. In a dramatically vignetted tableau,

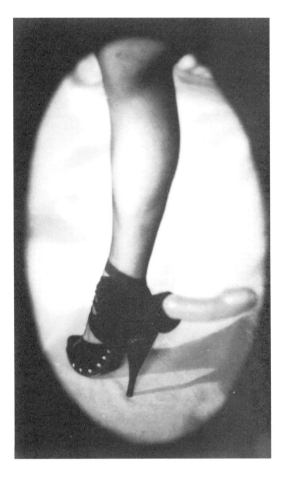

Fig. 5.3 *Mon fétiche des jambes*, 1966

a stockinged leg is shown from the knee down. The foot is wearing an extremely arched
high-heeled shoe that seems to be bound to it by multiple leather straps. Extending from and
attached to the heel is a sleek and erect phallic form, one of the artist's self-constructed *godemiches*.
From compressed silk covered by a prophylactic, Molinier fabricated hundreds of these dildos of
various shapes, sizes, and methods for attachment. In this particular configuration, the *godemiche*
could easily be brought up to the anus simply by fully bending back the knee. Molinier's solution
for attaining true androgyny was to be both the giver and receiver of penetration. For Molinier,
the phallus becomes both symbolically and actively the agent of transformation, a literal and
figurative magic wand.

It must be remembered that these photographs are both documents of sexual actions and erotic
images for future arousal; Molinier is, in effect, performing for himself. The high heel is what
Gorsen calls the "effeminate phallus," it signifies both as the phallus and as the orifice for its
reception.[18] The high heel represents presence and absence, having and lack, a penis and a hollow
space ready to be filled; it is both container and content. With the attached *godemiche*, the high
heel becomes both the real and symbolic phallus. In Rosalind Krauss's discussion of fetishism and
surrealism, she writes: "If fetishism is the substitute of the unnatural for the natural, its logic turns

111

Fig. 5.4 *Pantomime Céleste*, 1967

on the refusal to accept sexual difference." Quoting Freud, she continues, "to put it plainly, the fetish is the substitute for the woman's (mother's) phallus which the little boy once believed in and does not wish to forego."[19] So it is the *godemiche* which is the essential device for Molinier's attempts to create, temporarily at least, that hybrid third gender of his desire.

In his photomontage *Pantomime Céleste* (Fig. 5.4), two figures are inextricably bound together by chains around their necks and ankles, their gender is unclear. They are doubles, twins, short-haired replicas of one another, each wearing enormous high heels, stockings, garter belts, elbow-length gloves and eye masks. One leans over a stool while the other leans away; both stare at the camera, painted lips slightly parted. As usual, an enclosing darkness threatens to obfuscate the image, yet the bodies appear to glow with an unearthly light. Do Molinier's figures represent the "third sex," a reconciled androgyny? Or are they simultaneous signs without resolution, threatening to cancel each other out? In Nan Goldin's book of photographs *The Other Side*, she describes her transvestite and transsexual subjects not as people suffering from "gender dysphoria but rather expressing gender euphoria." She claims that her book is about "new possibilities and transcendence . . . the people in these pictures are truly revolutionary: they are the real winners in the battle of the sexes because they have stepped out of the ring."[20] But this statement makes one wonder: Is it ever possible to step out of the proverbial ring? Does the act of changing gender

roles, or even changing one's sex, allow for a path out of the binary opposition of male/female? Do the chimerical figures of the transvestite, transsexual, hermaphrodite, and androgyne step outside the arena of the male/female binary, or do they serve only as loyal provocateurs – court jesters in the palace of the reigning king and queen? Was it possible for Molinier to shake off gender specificity by his transformations? Do his explicit equations of male/penetrator and female/penetrated coalesce with his desire for a unified sexual being?

The woman shall not wear that which pertaineth unto a man, neither shall a man put on a woman's garments, for all that to do is an abomination unto the Lord thy God.

<div align="right">Deuteronomy 22:5</div>

As is so thoroughly explored in Marjorie Garber's *Vested Interests: Cross-dressing and Cultural Anxiety*, transvestism has a rich and often contradictory history. Sumptuary laws, thought to be divinely ordained, which designate proper and improper clothing according to class, gender, and other stratifications, shift and mutate over time. The blue/pink color coding for male and female children in western culture, for example, reversed itself in the middle of the twentieth century. In earlier years, pink was seen to be a stronger, more masculine, color while blue was seen as dainty and girlish. According to Garber, any transgression of sumptuary law inevitably produces what she calls a "category crisis"; it is an act that, in essence, declares previously immutable and fixed positions and definitions to be permeable and unstable, permitting border crossings that were formerly thought to be unpassable.[21]

For Freud, women's clothes act as transferential objects for transvestites, allowing the male to remember and imagine the phallic mother. In the case of a fetishist like Molinier, various substitutes, such as the high heel, the stockinged leg, the *godemiche*, have been appointed as the focus of his obsessions. "What other men have to woo and make exertions for can be had by the fetishist with no trouble at all."[22] In this way, Molinier is both the seducer and the seduced, the desirous one and the object of that desire; the director, protagonist and antagonist in his proscenium of orgiastic narcissism. The foundational act for Molinier was cross-dressing, although it only begins there. His transgressions become more than a travesty of maleness; they are marked by leakage and excess, blurring and contamination, a parade of illusions where the magician pulls his alternative self out of the hat. Garber makes the observation that the mechanism of substitution, "which is the trigger of transvestic fetishism, is also the very essence of theater: role playing, improvisation, costume and disguise."[23]

The doll was so utterly devoid of imagination that what we imagined for it was inexhaustible.

<div align="right">Rainer Maria Rilke[24]</div>

In *Torso II* (Fig. 5.5), a perfect keyhole effect is created by Molinier's vignetting. A smiling face atop a body of impossible configuration looks at the viewer invitingly. Are the arms lifted in a gesture of surprise or beckoning? Perhaps s/he is the barker for this carnival of sex acts and freak shows. This figure is unashamed, its face a picture of painted innocence, young and girlish – but finally, an impenetrable mask. The torso is contorted or reassembled so that the breasts, buttocks, and face are aligned, overturning one of human anatomy's basic oppositions, that of front and back. A *godemiche* is inserted in the anus, the stockinged legs spread beneath the beatific smile. Gorsen writes, "the most important arena for acts of travesty is the female face . . . ambiguity always arises from self-transformation, from feminizing and rejuvenating an essentially negatively connoted, otherwise male-only face."[25]

long-dead sister. She was also involved with the Viennese Actionists, and in 1969, she re-enacted Molinier's infamous painting, *Oh! Marie . . . Mère de Dieu*, in Herman Nitsch's *31st Action*, having herself crucified and sodomized. Acting out alone or in concert with each other and with dolls, Molinier and Koeck created a series of sexual tableaux and, in a magical transfer of youthful vitality and sensuality as witnessed in the fragmentary icon of the photograph, Molinier was able to create an image of youthful androgyny that was no longer possible in his life.

This transformation could be accomplished only by violating the singular integrity of the body. Utilizing surrealist strategies of defamiliarizing the (usually female) body, Molinier takes the further step of remapping himself. It becomes impossible to discern where his own body begins and ends, what is male and female, what is animate and inanimate. He challenges male heterosexual desire through the disorientation produced by a confusion of signs, Garber's "category crisis." Privately acting out in a hall of mirrors, he deliberately, if temporarily, breaks down the male's coherent relationship to social space. Contradicting a unified gender position, anxiety is produced by the instability, ambivalence and celebratory nature of these images. But questions remain: how is the viewer to position himself or herself in relation to Molinier's

Fig. 5.6 *Lenah-Hanel,* 1968

115

exuberant narcissism? In his self-fucking, he constructs scenes for his own pleasure and self-reflection. The viewer can only gaze at these self-contained pictures and watch in fascinated horror, like a scientist observing replicating cells out of control. The fetishes and chimerical figures proliferate like embryonic Frankenstein's monsters in a womb, a bubble of duplicates, triplicates and quadruplicates – a mutant life form expanding exponentially in a context-less vacuum. Does one fear the contagion of sexual perversion or revel in the euphoria of polymorphous eroticism?

In *Self-portrait with Fetish Items, Chaman I* (Fig. 5.7), Molinier or his surrogate stands erect and alone, a backlit hermaphroditic figure in high heels, stockings, garter belt, corset, necklace and face mask. The shadowy face appears to be smiling, its eyes resembling flickering flames, cat-like and mischievous. Breasts and phallus exuberantly point upward, and the skin that peeks out from behind the silk, lace and fishnet is all aglow with a satanic shimmer. The hybridization of signifiers is clear, the figure literally stands at the threshold, parting the theatrical curtain with an aggressive flourish and without a hint of furtiveness; this image could function as Molinier's manifesto. The aging male body attempts to rejuvenate itself through a shamanistic ritual crossover – not into the

Fig. 5.7 *Self-portrait with Fetish Items, Chaman I*, 1968

feminine, but into the netherworld between male and female. Of equal importance here for the full understanding of Molinier's transformations is that with his pictures he could represent himself, temporarily at least, as a smiling shaman in control of the alchemical formulas that turn dross into gold – in other words, the withering male body into the vital and erect "third being." This youthful figure is the lead character in Molinier's ritual theater of transgression, the master/mistress of ceremonies, the man/woman behind the curtain, the painted puppeteer of "between-ness."

The archaic look of Molinier's photographs is curious, the suspended aura of an earlier time. They suggest F. Holland Day's homoerotic self-portraits as Christ and his soft-focus images of mythical fauns strumming on lutes and prancing around the forest. In Molinier's photographic tableaux there is no hint of contemporary events in France, or the collapse of the colonial empire; even the massive strikes and near revolution of 1968 are not alluded to. What is evoked by the costuming, the vignetting, and even the black-and-whiteness of the images? Weimar Berlin? Or Brassaï's Paris of the 1920s and 1930s – decades characterized by dramatically conflicting ideologies, economic crises, artistic ferment and attendant notions of bourgeois decadence and youthful rebellion? These were the decades of Molinier's young manhood and the glory years of surrealism. But surrealism's attempted psychosexual and aesthetic revolution collapsed in on itself and the social revolutions of Berlin and Moscow were crushed by fascism and totalitarianism. The aging diva, the tragic beauty of the faded drag queen – figures central to homo-camp and homo-noir – also make their influence felt. Within the constellation of sex, youth, conflict, and transgression that motivates Molinier's images is an overwhelming desire to return. Perhaps this is a return to a mythical place, to a past that never was, individually or culturally; a past of sexual euphoria, before sexual bifurcation, before the mirror stage, when the mother still had a phallus and the child existed only for pleasure. Perhaps Molinier's "third gendered" shaman is the healer for the fundamental loss of his sister.

These photographs are nostalgic and claustrophobic by design; one can almost feel the walls closing in, the dark entrapment, and the futility of Molinier's act of travesty. Freud has described the invention of doubling as "a preservation against extinction."[26] The shadow, the mirror's reflection, the photograph and the idea of the immortal soul itself are, finally, significant reminders of death. Molinier's efforts at transgression and his obsessive attempts to rejuvenate himself not only rattle the windows of what Laura Kipnis has called the "prison-house of binary gender role assignment,"[27] but simultaneously call into being the resurrection of his female doppelgänger, blessed or cursed with a Dorian-Gray-like youthfulness. Visually redundant, but hypnotically repeated, Molinier's iconography orbits the twin suns of Eros and Thanatos, the burning brightness of desire and the black hole of extinction. Moliner's chimera, his hermaphrodite, his perfect androgyne, his liminal alter-ego flits in and out of the gates of our various prison-houses and, with each passage, there is a momentary shiver – like the click of the shutter upon release, like the orgasm that is all too brief.

Photographs by nature betoken both an absence and a presence: a moment lost to the past is preserved and resurrected by the resuscitating gaze of the viewer. The photograph exists in the netherworld between the living and the dead, the animate and inanimate, the two- and three-dimensional, the past and present. In this sense the photographer is a shadowy figure. Peter Gorsen writes, "in Molinier's panopticon, though not his alone, the bodies and the dolls and human beings converge onto the paradoxical suspense of 'living corpses.'"[28]

At the end of his life, standing alone in front of his mirror and camera, Molinier created a morphology in the recessed tunnel between his sister and himself, between living skin and the dead artifice of the masquerade. These pictures are not peaceful and quiet, they seem agitated and

unresolved despite their seamlessness, although there is something of the "still life" about them. They have the quality of *natures mortes*, pictures of corpses, visited by a mad cosmetologist stumbling upon the aftermath of a massacre, who – in denial of death – took out his lipstick, blush and eyeliner and gussied up the victims. In the dynamic between performance and documentation, the call and response between grief and desire that echo in his suspended world, Molinier achieves momentary resolution of his sexual and existential crises. But it is the iconicity of photographs in general – be they windows to the sacred or to the profane, to saints or to sinners, to the miraculous or to the diabolical – that can, as in Molinier's case, transform a blasphemous creator into a fervent believer.

notes

1 Leonora Carrington, "My Mother is a Cow," in *The Seventh Horse and Other Stories*, New York, Dutton, 1988.

2 My primary source on Molinier's life is *Pierre Molinier*, with essays by Wayne Baerwaldt, Scott Watson, and Peter Gorsen, Winnipeg: Plug-In Editions, 1993.

3 Ibid., Baerwaldt, p. 11.

4 Ibid.

5 Mark C. Carnes, *Secret Ritual and Manhood in Victorian America*, New Haven, Yale University Press, 1989, p. 12.

6 Walter Benjamin, "Surrealism, the Last Snapshot of the European Intelligentsia," in *Reflections: Essays, Aphorisms, Autobiographical Writings*, New York, Schocken Books, 1986, p. 180.

7 Gustave Flaubert, *The Temptation of Saint Anthony*, Ithaca, Cornell University Press, 1981, p. 223.

8 Philippe Jullian, *Dreamers of Decadence*, New York, Praeger Publishers, 1971, p. 19.

9 Albert Aurier, in Jullian, *Dreamers of Decadence*, p. 244.

10 Benjamin, "Surrealism," p. 179.

11 Hans Bellmer, quoted in *Hans Bellmer*, New York, St Martin's Press, 1972, n.p.

12 Ibid.

13 Rosalind Krauss and Jane Livingston, *L'Amour Fou: Photography and Surrealism*, New York, Abbeville Press, 1985, p. 9.

14 Dawn Ades, "Surrealism: Fetishism's Job," in *Fetishism: Visualizing Power and Desire*, London, South Bank Centre, 1995, p. 81.

15 See illustrated transcript of the film in *Pierre Molinier, Un film de Ray Borde, texte d'André Breton*, Paris, les Presses de l'Imprimerie, 1964.

16 Baerwaldt, in *Pierre Molinier* p. 15. Baerwaldt cites Hanel Koeck in conversation with Molinier.

17 Gorsen, in *Pierre Molinier*, p. 41.

18 Ibid., p. 42.

19 Krauss, *L'Amour Fou*, p. 95.

20 Nan Goldin, *The Other Side*, New York, Scalo Publishers, 1993, p. 8.

21 Marjorie Garber, *Vested Interests: Cross-Dressing and Cultural Anxiety*, London, Routledge, 1992.

22 Sigmund Freud, as quoted in Garber, *Vested Interests*, p. 29.

23 Ibid., p. 29.

24 Rainer Maria Rilke, "Dolls: On the Wax Dolls of Lotte Pritzel," in *Essay on Dolls*, London, Penguin, 1994, p. 32.

25 *Pierre Molinier*, p. 41.

26 Sigmund Freud, "The Uncanny," *The Complete Psychological Works of Sigmund Freud*, vol. 17, Chapel Hill, University of North Carolina Press, 1971, pp. 234–5.

lost (and found) in a masquerade

27 Laura Kipnis, "She-Male Fantasies and the Aesthetics of Pornography," in Pamela Church Gibson and Roma Gibson, eds, *Dirty Looks: Women, Pornography, Power*, London, British Film Institute, 1993, p. 138.
28 *Pierre Molinier*, p. 46.

chapter six
kaucyila brooke

roundabout

For Men
To convince is to conquer without conception.

<div align="right">Walter Benjamin, "One Way Street"[1]</div>

Martin Pawley (Jeffrey Hunter): *You know, it's funny, but last winter when we passed through Fort*
 Wingate, I don't have any recollection of mention of Noyeki Comanche.
Ethan Edwards (John Wayne): *Not so funny when you recollect what Noyeki means.*
Martin Pawley: *What's that?*
Ethan Edwards: *Sorta like round about. Man says he's goin' one place. Means ta go t'other.*

<div align="right">From The Searchers, 1956, directed by John Ford[2]</div>

intersection

We were driving on the left side of the road. Well, you were. I was supposed to be the navigator. It was
your father's car and I was too nervous to drive with all the controls on the left. If the truth be
told – and somewhere I do believe there is some possibility of getting at the truth, however
complicated it may be – I think you were too nervous about letting me drive your father's car.
My job was to anticipate the oncoming roads and turns and to keep us going in the right
direction.

I've always prided myself on my sense of direction. I suppose it would be more accurate to say
that my father always boasted about my navigational skills and his approval, which was disbursed
parsimoniously, convinced me that it must indeed be true. The law of our fathers controls the
chaos of this endless circumference. Perhaps I have transgressed feminine boundaries to activate
this rational order of longitude and latitude. In any new city, I quickly determine landmarks and
know my relationship to the points of the compass. In the American West, where all the cities
I've experienced are organized along north–south and east–west axes, I easily adapt new variables

and plug them into the grid. When we've driven on the right-hand side, I've been astounded that you have been so slow to find our location and our destination. "Didn't anyone teach you how to read a map?" I bark angrily as I pull over to take a look for myself.

Now I find that I can't read the goddamn map and every time we come to a city, we encounter these roundabouts which completely turn me around and make me lose my sense of direction. When I look from the road to the map and back to the road, I discover that the road has exchanged one set of landmarks for another. Each course seems as good as the next and a tyranny of equivalencies rebels against the planned route. Whatever happened to the inner compass I've believed in all these years? I can't find our place on the map and you are getting impatient and I am apologizing to you for every disparaging remark I've ever made about your map-reading skills.

Automobiles enter the roundabout in one direction and circumnavigate until they reach the desired road and exit to the left. Sometimes you get stuck on the inside lane and go round and round until a break in the traffic allows you to move to the outside and exit the circle. Even if your road continues in the same direction, you must enter the circle and follow the traffic around to resume your route. You can't avoid the roundabout; you make a circular digression to continue your journey.

In photography you can never express yourself directly, only through optics, the physical and chemical process.

Brassaï

sidestreet show

Once it was a Navy Town with tattoo parlors, war-based politics, and plenty of hookers and Live Nude Girls. Now it's a resort town with laid-off engineers and defense plant workers. The xenophobia is as strong as ever, only this time the invading forces are not equipped with planes, tanks, and bombs but with brown hands and backs to keep the resort kitchens humming and the businessmen's bed pillows plumped up with "Our Compliments" mints. The threat is still to Our American Way of Life and rapidly changing economic circumstances busily divide the normal from the deviant cultures of the Sometimes-Exotic. Yesterday's curiosities are today's undesirables.

We are walking downtown. Unlike Brassaï and Henry Miller, we are daywalkers.[3] We don't hide ourselves away in the dives of Montparnasse. Of course, we don't even live in Paris and this town certainly lacks a bohemia. But these are "more liberal" times – no one supposes that we are *evil*. After all, it's twenty-five years after Stonewall and I suspect that everyone on the streets knows that we're a force to be reckoned with. I'm a bulldagger and I swagger down the street, hand in jacket pocket, dragging on a cigarette and daring any dick to mess with me. I'm a drag queen, waving my high-heeled shoe as a weapon as I sashay through this reclaimed Navy Town. *We have everyone's respect.*

We are in love.

All afternoon, cars loaded with teenagers have been passing us and heckling. Sometimes their words are garbled, but the sound always makes me jump. Other times, the words "Dykes!" "Lezzies!" or "Queers!" shatter the air as though coming from loudspeakers perched on watchtowers. We are pinned down by their recognition. We are endangered by the study of monsters. We are made visible by the public's interest in nature's curiosities. We want to yell, "This show is over and the monkey is *dead*!" But the car's tail lights are now a block away and we shrug off the interruption of our lovemaking.

Walking up Broadway, away from the postmodern shopping mall and the gentrified district of the renewed Old Town, we approach a neighborhood where street people wander past folk-art galleries and craft shops. Some stores still stand empty from the first exodus to suburban malls and multiplex theaters. We arrive at the window of a specialty coffee shop struggling to survive in the wake of a New World Order that never trickled down to local shopkeepers.

As we near the corner of the shop and glance through the window, we can see the adjacent sidewalk. Two men in tattered clothing approach. I don't notice anything because I'm too intent upon you. But you tug at my elbow. Suddenly, a voice splits the afternoon's perimeter: "I just love women who love women!" The words ricochet off every corner of the intersection. We are no longer ourselves. Our union is refracted and amplified. The sound distorts our bodies. We are remastered and re-recorded for all to hear.

The speaker is a tall, thin black man. He is grinning and staring as he and his companion cross the street in front of us. I pretend to stare at the coffee and tea paraphernalia in the shop window. Again he calls out, "I just love women who love women!" *Perhaps he does*, I think to myself as my lover and I lean against each other and begin to giggle. We have been careful all day. We haven't shared one kiss or long embrace. It is the middle of the afternoon. We are on the street.

The barrier between his body and ours erodes as the words of his fantasy penetrate our experience. His words, which embrace our bodies on the streets, also double for ours in action. We represent lesbian desire. We embody this sexuality which echoes back and forth, from building to building, at the crossroads of his desire and ours. We are collected into his fantasy and this magnification reflects us back to ourselves in a series of looking glasses. We bow to an

audience enjoying the spectacle. We are celebrities. We are larger than life. We are giantesses of sexual deviancy! In an instant we realize that our anonymity may never again serve as a disguise.[4] We are reviled and cringe from the sudden transformation of our experience into a circus of the supranormal.

Of your Paris photographs you, Brassaï, wrote:

I wanted to know what went on inside, behind the walls, behind the facades, in the wings, bars, dives, night clubs, one-night hotels, bordellos, opium dens. I was eager to penetrate this other world, this fringe world, the secret sinister world of mobsters, outcasts, toughs, pimps, whores, addicts, inverts. Rightly or wrongly, I felt at the time that this underground world represented Paris at its least cosmopolitan, at its most alive, its most authentic, that in these colorful faces of its underworld there had been preserved, from age to age, almost without alteration, the folklore of its most remote past.[5]

You were fascinated by, and eager to invade, this other world of the authentic, the alive, and the remote. You knew yourself to be yourself by *not* being those people who lived on the surfaces of your photographs. Spurred by your subjects' suspicion of your intruding lens and curiosity, you aspired to even greater acts of risk and cunning. You were a real man among men as you hunted exotics in the jungles of perversity. Your description of your photographic venture uses the heroic language of colonial conquest. Brassaï, your thirst for secret knowledge propelled you into nocturnal habitats with your net and collecting bag in search of specimens of what you believed was a vanishing race. Stunned by the chloroform of the lens and pinned by the latent image, the inverted became extroverted in the collector's trophy case.

Your photographs of lesbians are found in the chapter titled "Sodom and Gomorrah." According to your account, the lesbian bar, Le Monocle, is "the capital of Gomorrah." There,

all the women were dressed as men, and so totally masculine in appearance that at first glance one thought they were men. Obsessed by their unattainable goal to be men, they wore the most somber uniforms: black tuxedos, as though in mourning for their ideal masculinity . . . and of course their hair – woman's crowning glory, abundant, waved, sweet smelling, curled – had also been sacrificed on Sappho's altar.[6]

Many outsiders assume that butch women want to be what they *cannot*. But this is a projection from a world which maintains sharp boundaries between masculine and feminine. In my world, sexual difference is *the same difference* and the variations are indeterminate. Perhaps it is you, Brassaï, who are obsessed with masculinity. Look at your pictures and see the women whose traces are left there. It is not just an affectation of the dandy's costume; use "Le Monocle" to do some careful viewing.[7] Slow down before you yell from that vehicle. This is hit-and-run photography. An evening in a bar isn't long enough to transform your grab shots into a parallel universe. You aren't cruising slowly enough.

right of way

I am living and working in a desert city of the Southwest. I have been photographing lesbians and women willing to be taken for lesbians. The women in the photographs are posed to reflect my own confusions about the crossroads of power in relationships. This is not self-documentation; it

is self-representation. I tell some of the women to wear butch attire. I tell others to wear dresses. Some have long hair; some wear their hair very short.

I tell them not to smile. They decide to look away. They decide to look into the camera lens. They look at each other. I print these photographs and display them in a closed-off corner of a gallery (Figs 6.1–6.2). I want you to confront them in this confined triangular space. These women are constantly looking at you. When you face them, they're staring over your shoulder. They look at the side of your face. But it is *you* who are looking.

You told me you took your four-year-old son to see my photographs. You thought that I would like to know what he said. You said that he said, "What are all these men doing, Mommy?" You seemed to think that the innocent child was somehow revealing the truth about the meaning of these photographs. You thought that I would like to know the authentic response of a four-year-old boy who lives in a town where Rodeo Day is an official holiday. You said this was evidence that the photographs were essentially about masculinity.

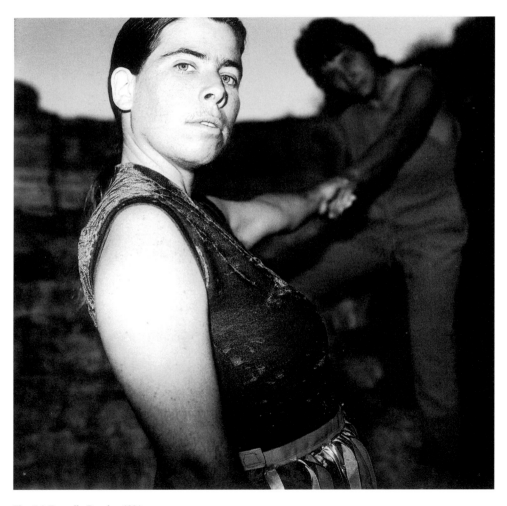

Fig. 6.1 Kaucyila Brooke, 1984

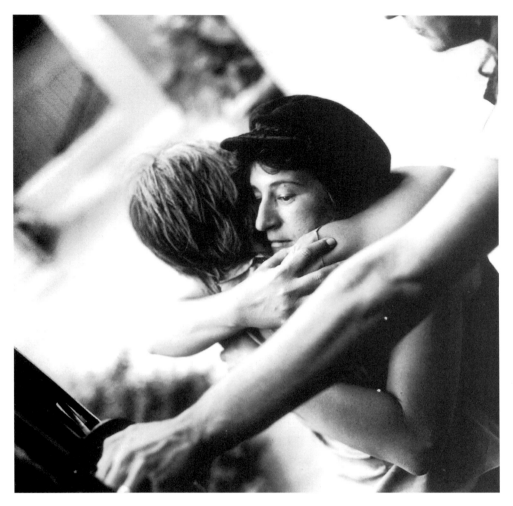

Fig. 6.2 Kaucyila Brooke, 1984

I thought your son's response was evidence that he had no way to catalogue the information in the photographs. I thought that, at four years old, he already had a rigorous education about gender and sexuality. It made me wonder if you had many lesbian friends. I wondered how often you used the word "normal" around him. I wondered how you thought about your own femininity.

midway

I decide to wear a 1950s orange and yellow flowered cotton summer dress – dirndl skirt with a matching fabric belt and a pressed bow at the back. Underneath, I am wearing boys' jockey shorts because they turn me on. It is my Judas Kiss at the shrine I've erected to femininity. You arrive and I am still dressing. You are wearing a crew-necked T-shirt, mustard plaid shorts and a baseball cap. You grab me and pull me to you and I laugh and say we look so

butch–femme. You are excited but say, "Honey, do you mind if we make love later? I just want to get to the fair!"

You hold my hand in the ticket line. I forget to worry about what other people might think. You buy my ticket. "This is a date," you say. I'm in high school. I'm Pat Boone's sister in the film *State Fair* and I'm on a date with Bobby Darin. We walk through the gate and you kiss me. I wonder what the fair-going families think of this display. I see a young Latino couple embrace as the people crowd by and I realize that we are in the falling-in-love sequence of this musical comedy.

The signs promise the biggest, the best, the original, the authentic. I loiter; I savor it all at leisure. "Look at the time!" you say. You want to do everything before the fair closes. I want to photograph the neon. You keep looking at your watch. Finally, you take it off and we wander towards the dancing horses.

We eat corn on the cob. We eat barbecued pork ribs and beans. We look at the industrial product displays. I breathe into your left ear that I love you and the man selling water filters looks as if he's seen it all before. We eat strawberry shortcake. Even though your watch is in my pocket, you start talking about the time. You tell me that you can guess the correct time within five minutes. I challenge you. You are off by half an hour. I don't take a guess. I linger. You want to see the preserves.

We penetrate the Home Crafts Building. The women's clothes are from the 1970s. The little girls' dresses are charming. I tease you and say, "You'll have to get one of those mommy dresses when you have your baby." And you don't say you won't. I imagine you pregnant in the denim smock dress displayed in the glass case.

We turn the corner and admire the hand-painted china. "Look at this one! Look at that one with the apple blossoms, isn't it sweet?" I kiss your neck because you exclaim over the delicately shaded peaches. You turn to me and put your tongue in my mouth. A security guard approaches and says, "You know if you two want to keep that up we have a room reserved for you at the Holiday Inn." I feel you stiffen and you ask her to repeat herself. From where I'm standing I can see the twinkle in her eye. She says, "We don't allow that kind of thing around here," and you look insulted until you catch her wink. Your laughter betrays your apprehension. She tells us it's her standard joke for lovers at the fair and tells us about her job. At first, we think she's a dyke but then she makes sure to mention her husband. She tells us not to miss the candy castle in the next room. We move on to the cakes, pies, and preserves.

Outside we hear the fireworks. "C'mon!" you say and reach for my hand. "We've got to make it to the ferris wheel!" Holding hands, we start running. We get lost. We stop and reorient ourselves and head for the Midway. Dashing past rows of games and rides, the ferris wheel signals to us with its rotating neon lights. We are whirling in our own private cab and the lights from the fair spread out from our revolving perspective. Every time I turn to kiss your lips I see shimmering halos. I never close my eyes. The fireworks spew their colors over the grandstand, making us the lovers at the center of every all-American romance.

Leaving the fair with your arms around me, and mine around the stuffed tiger you won for me, we go the wrong way. A police car follows us, then passes. We go back the way we came and look for the photo booths. We need one last souvenir. I reapply my lipstick at the mirror outside the machine. You sit on the stool and gesture for me to sit on your lap. I pull the curtain shut and say, "No, wait! We have to plan the sequence." "What do you want to do?" you ask. Thinking you'll be delighted, I lift my dress and flash my jockeys at you and say, "Well, I could lift my dress!" I don't recognize the look on your face. You tug at my dress and, pulling it down, say "Stop! The curtain only goes halfway down!" I surprise myself with my own nonchalance.

We take our pictures and come out of the booth to wait for them to drop into the slot. I wander off to have one last look at bric-a-brac.

When I turn back, I see a tall cop talking to you. There are five other cops standing about twenty-five feet away. I walk back to you and hear you say, "We're just waiting for our pictures and then we'll go." I assume the fair is closing and that the cops are telling everyone it's time to leave. But then you add, "By the front gate." "That's weird," I think to myself. Why do they want to know that? As I approach, the cop walks back to his group of blue uniforms. "What happened?" I ask. You tell me that the cop said he saw "your roommate" lift up her dress in the photo booth and that it was time for us to go. He told you that they didn't want our sort of people at the fair. As we walk towards the main entrance, the hair rises on the back of my neck. I turn my head and see a dark blue police car creeping slowly after us.

wrong way

It wasn't easy to get the artwork across the border. We had to get all kinds of special paperwork from important people and rent a van and drive it across ourselves to avoid extra charges from the shipping company. We crossed our fingers, hoping they wouldn't look inside the crates. Photographs of two naked women in bed together is just the kind of thing that gets confiscated at this border. I am installing an exhibition of photographs and text.

To help pay for my trip, you have arranged a special screening of my collaborative videotape. I stand in front of a large theater, introduce the video, and afterward, answer questions. The subject is lesbians. I am always coming out in front of groups of people. I can't help it; it's part of the work. Some already know and it's not a big deal to them. It's not a big deal to me. It's just something to talk about in relation to classic Hollywood narrative. Where are the lesbians? I want to finesse us into the text and I insist upon it.

We leave the theater together. A big group of us flows out into the street. We walk together in a pack, men and women who are strangers to me. You are the only one I know. I've been staying at your place while I've been working in your city. We go to a local bar. Women are flirting with me. One in particular has taken a fancy to me and she makes me uncomfortable. She is so stiff and awkward around me.

It's Thursday night, which means it's Dyke Night at this bar. We settle into comfortable worn furniture and order our drinks. I am cold from the adrenaline of performing and the crisp northern air. I long to feel the heat of my lover's body pressed against my side as we sit nestled in this cozy room. I answer questions about the video. I listen as women tell me about their work. You are the only fag in the group. The woman who fancies me changes her place to sit near me. I wish my girlfriend were here. We haven't slept together in six nights and I'm lonely.

Someone says there is dancing downstairs. I ask you if you want to dance. We make it on to the dance floor – I, in my skirt and silly hat and you with your leather vest and limp wrist. We swing and turn each other within the mass of moving bodies. My hands are around your neck and yours are around my waist. I can finally let go. I spin and watch the circle of my hand-painted skirt traveling parallel to the floor.

Suddenly, she is in front of me. She's big. Very big. She is a diesel. She is shorter than I but aggressive, and she wedges her belly between us. I can't see you anymore. She yells at me above the music, "You're in the wrong place!" "What?" I say. "You don't belong here!" "Are you asking me if I'm a lesbian?" I twitter, birdlike, thinking that I'll have to produce my credentials once again. I wonder if I have some sort of card in my handbag upstairs. She walks away and you say, "Oh, don't pay any attention to her." Your hands flutter as you speak. I shrug and we

continue dancing and flirting, but we don't touch any more. It's like junior high when the chaperones separated the couples who danced too close. I am reprimanded. I've been caught dancing with a gay man.

She's angrier this time. She shoves her belly at me as if it were some sort of weapon. "Get out! You don't belong here! I told you to get out!" She is intimidating me. It's clear that next time she'll do more than yell. You say, "How weird! But don't let it ruin your good time." But I return to our table upstairs. My adrenaline is pumping and any thought of holding my ground on some vague principle of freedom of dress or choice of dance partners within the lesbian community is clearly impractical at this moment.

At the table everyone apologizes for the dykes in their city. One young bleached, pierced, and tattooed baby leather dyke tells me she didn't think I was a real lesbian when she first saw me and then realized she was being narrow-minded. She is embarrassed that she had misread the codes. She wants to find the diesel dyke and take her to task. I say, "It doesn't matter. Let it go." But she convinces me to take a turn around the bar, just to point her out. I don't see her anywhere. She has disappeared.

secondary roads and major highways

People were very liberated then, perhaps more so than now. They worked hard and they were themselves.

Berenice Abbott

I have left you behind, working for one of the first women to become a federal judge in the Northwest. It is an important job. I have always known that your work is the most important thing to you. You graduated third in your law school class and I know that it was the result of hard work. I was there, remember? You said that you didn't want to have to be so *out*. Law is a conservative profession. Besides, wasn't it enough for the people who knew you personally to know about your private life? You tell me that you want to have a child. I say, "Great! I'd love to do that with you." You say you want to do it with a "biological parent."

I've never been a separatist, but I haven't been around men for about seven years. There are lots of them in graduate school and they reinscribe their heterosexuality as though it is already written. They tell me they could tell from my photographs that I was a gay woman. They say, "We've been calling you 'the gay woman from Seattle.'" I say, "You've got it wrong. I'm 'the *dyke* from *Eugene*.'" Later, when I've belted down a few semesters of postmodern theory, I mutter, "Fucking universalists! My historical specificity doesn't even cross your minds!" They don't hear me. They think I speak some kind of lesbian party line.

I take a lot of baths. It is cold in the desert in the wintertime and this is the only way for me to take the chill off. I masturbate in the tub and imagine the hot water is your body flowing over me. I come, sobbing over the loss of our love. I know that something has changed and ring your number all night long. But you never answer. When I finally reach you, you yell into the phone, "Yes, I do have a new lover! Is that what you wanted to hear?" Were you always such a bitch? Or did you change when you fell out of love with me? There is nothing there for me any more and I stop calling you. It is lonely in graduate school and printing all night in the darkroom keeps the pain at bay. I watch the images appear darkly through the exhausted developer. I mix my own formula and my tears are the secret to the depth of the shadow details. I take a lot of pictures.

My photographs do not celebrate a lesbian utopia. They portray alienation, ambivalence, jealousy, and unfulfilled desires. I assume I am entitled to express my passion. I am the only out

128

lesbian in the graduate art program. Other lesbians keep it to themselves and avoid associating with me for fear of being stigmatized by the straights. They say they don't want to limit the audience for their work. They say they want their work to deal with universal ideas. One tells me she can't be friends with me because she's not as secure about her sexual identity as I am. I wonder whatever gave her that idea.

I hang out with women in what is called "the lesbian community." It's not a place that I call home. There is only one dyke bar in town and it's a country-western dance hall. The women pose for my pictures. They say the big words I use and my high falutin' ideas are boring and elitist. They say this lesbian theory I talk about has nothing to do with their lives.

When I exhibit my photographs at the school gallery, I say that they are about lesbian relationships. Most of my fellow students talk about the way the photographs are installed. One of the professors asks about the narrative implications of the piece. Another asks what kind of people these are because he didn't read the text. Then he expresses surprise that I am a lesbian because he thinks that I'm such a nice person (and such a pretty girl). Finally, the one outspoken feminist on the faculty asks about lesbian representation and a shudder goes through the room.

After seeing them hung on the walls, two of the women in the photographs changed their minds. They say they never gave their permission. They say that the issue is disclosure. They say they don't want to talk about it with me. They say I have ruined their careers and that they and their friends want nothing whatsoever to do with me again. I pin the negatives to their front doors with notes of apology. I am down on my knees. I am devastated. These were the strongest images in the show. I vow never again to photograph anyone without a model release.

I realize that no matter how artificial the pose or the *mise en scène*, photographs are inevitably confused with reality. Or with evidence. I change my work so that the construction is on the surface. Meanwhile, I look for a history of lesbian photographs. I am piecing together closeted lives to produce myself through invisible histories. I think that if I can find the evidence of a lesbian visual language, I will become visible. I inhabit a half-world of projected desires and false conclusions.

I show Berenice Abbott's portraits of Paris lesbians to my professor and say I want to write about the difference in their poses from, say, contemporary portraits of the same women by Abbott's mentor, Man Ray. He says he is unfamiliar with these portraits but that in looking at them, he sees nothing remarkable and that their only interest is in the unusual lives of the subjects. I think that my criteria are different and that he is not acknowledging what he cannot see. These portraits are an anomaly in the canon of photographic history and although they are visible on the printed page, they are unrecognizable. In my isolation, I think I recognize portraits of women who appear self-possessed and men who are sensitive. Some of the women wear suits and ties, and have slicked back their hair. Some of the men sport earrings and hold their wrists limp. The women narrow their gaze to confront the lens and I collapse history and convince myself that the semiotics of the pose in Abbott's portraits correspond to those in mine.

I meet you for a drink after your work-day. I haven't seen you for two years and I'm nervous. I dress carefully, hoping you will notice how hip I look. I sit at an outside table and smoke cigarettes. You arrive and we order, then we search for topics we can talk about. I light another cigarette and you say, "Are you still smoking?" I reply, "Only when I'm nervous." You say, "You ought to quit!" then add that you've got to go home and let the dog out because your girlfriend is away. I convince you to go out to dinner with me because it has been so long since we've seen each other. Reluctantly, you agree. At dinner, I look at your hands holding your glass and remember them touching me. Your face disappears and I remember feeling your fingers inside me. I begin to weep and you say that you certainly haven't missed all of my crying.

I decide to read my paper on Berenice Abbott at a conference. The panel moderator says he is interested, but after my last exhibition experience I am cautious about outing people. I write directly to Abbott, hoping she will like what I've written about her portraits of the 1920s. I identify myself as a photographer and as a lesbian looking for other portraits of lesbians. I tell her

BERENICE ABBOTT

BLANCHARD, MAINE
207 - 997 - 3763

MAILING ADDRESS:
R. D. 1
ABBOT VILLAGE MAINE 04406

June 3 1985

Dear Miss Brooke,

As a very private person, I am wondering what satisfaction it can give you to tarnish my name in such a flagrant and libelous fashion. I am a photographer, not a lesbian. Your assumptions have given me anguish which at my age is surely not healthful. I ask you please not to speak or publish your article as it is. One mistaken statement, totally untrue; namely that I at one time took a picture for Man Ray. It would be outrageous to say so.

Furthermore my grand daughter would be unhappy and I ask you to please spare her that unnecessary embarassment. To what end could that possibly serve?

If some of the photographs you mention are of "interesting" women, it is because they were well known and therefore more often used. I photographed more men than women, to name only a few: Jules Romain Tardieu, Cailloux, Sisley Huddleson, calmette, Joyce etc.

(over)

Sincerely Yours, Berenice Abbott

Fig. 6.3 Letter from Berenice Abbott to the author, 3 June 1985. Courtesy estate of Berenice Abbott/Commerce Graphics Ltd, Inc.

that while I don't say for sure, I suggest that she *might* have been a lesbian and that I discuss why this would or wouldn't be important for reading her photographs. Everyone who knows Abbott warns me that she is a "major closet case," so I tread carefully. I give her a way out, betting and hoping she won't take it. But I'm on a losing streak.

P.S,

I do hope you realize that the assumption that strong women are lesbians (far from true), is one of the greatest smears for the entire "womens liberation movement" especially now with a back lash rearing its ugly head.

And yes, I do thank you for your consideration to show me the work before hand.

B.A,

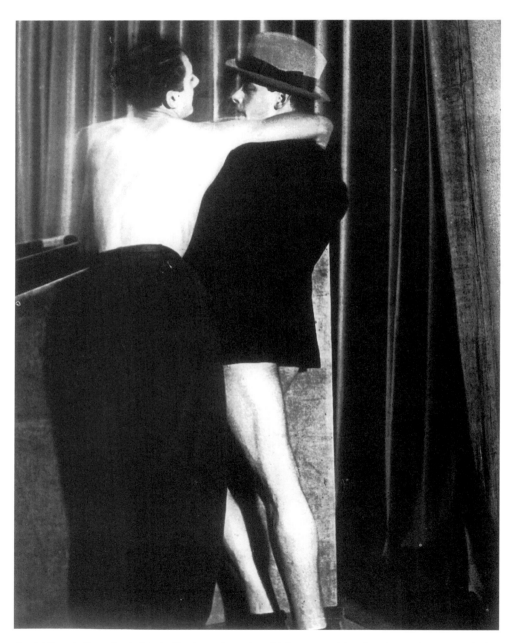

Fig. 6.4 Brassaï, *Young Couple Wearing Two-in-one Suit at the Bal de la Montagne Sainte Geneviève*, c. 1931. Copyright © **Gilberte Brassaï**

dual carriageway

It is the middle of the 1970s and I feel that I have entered the most exciting time in my life. Everything I thought I knew about men, women, sex, nature, and culture has been called into question. The world's dimensions have become charged with erotic anxiety. I cannot remember having ever shifted my thinking this many degrees. The deviations seem endless. I have French-kissed a lesbian.

I have fucked a woman in the center of an open meadow. Later that evening, I am flirting with another woman's woman across the leaping flames of a giant bonfire. I stand in the woods in a line with four other naked women and piss competitively. I never win, but I never lose either. I have fucked more than one woman at a time. I discover that I can have many different kinds of orgasms. I make love with women I don't love. I masturbate with women friends who are also masturbating. I am envious of one friend who can have multiple orgasms by squeezing her thighs together. She has given me detailed instructions, but it has never worked for me.

We are building buildings, changing the language, making culture, and finding out about each other's bodies. I have no idea that we will fall out of fashion or become anyone's embarrassing history. I don't live in the future and I haven't named the present. I think we are living radically. I am not nostalgic about this moment. It is exciting, confusing, and contradictory.

I think we are inventing ourselves. It seems to me that there is no history of us before this moment. Here we are, standing before this curtain, leaning on this table, this counter, this pillar, this post. We are playing. We are frequently dressing up and taking off our clothes. We act out these parts in fields, in back yards, in community halls and bars. Hallowe'en and Valentine's Day are the most important holidays; we are adding new ones all the time.

When I lie in bed and look at you, my top eye sees one view and my bottom eye sees another. In this shifting ground of history, you appear. You are wearing my jacket; I am wearing your trousers. I throw my hip out to the beat of the music, pull my chest close to yours and say, "Hello, Handsome, want to dance?" You give me a cool stare from under the brim of your hat and reply, "Anytime, any place you say, Beautiful."

rear view mirror

I see the road ahead while, in the center of my view, a mirrored rectangle shows me where I've been and what follows after. Like "ambulance" spelled backwards, these photographs are viewed from behind so that they can be brought forward into my future. Who were we then, with our medical assignation of *in*version which explained our *per*version? How did we love each other in our hours after work, those of us who weren't rich like Natalie Barney and Gertrude Stein? How do we look to you now, sitting on your coffee tables or hanging in your galleries?

Night is the only time I can be with the women I love. All day at the office, at the shops, and on the streets, I blend in to protect myself. You will never see me lean against her in the open light of day. You will never see me with my slicked-back hair wearing trousers at the corner newsstand. Or at least you wouldn't know it was me. I'm not foolish enough to get myself arrested; I know there are laws and that those pigs of Paris police like to please the politicians by throwing us in jail. I'm not impressed. But I'm careful.

Tonight is a night like any other night. I'm here at Le Monocle, drinking one of Lulu's "Angel's Lips" cocktails. I love Lulu's drinks. They are never watered down or cut with the cheap stuff as at other bars. It's not just her drinks that I like, though; it's the way she always makes me

kaucyila brooke

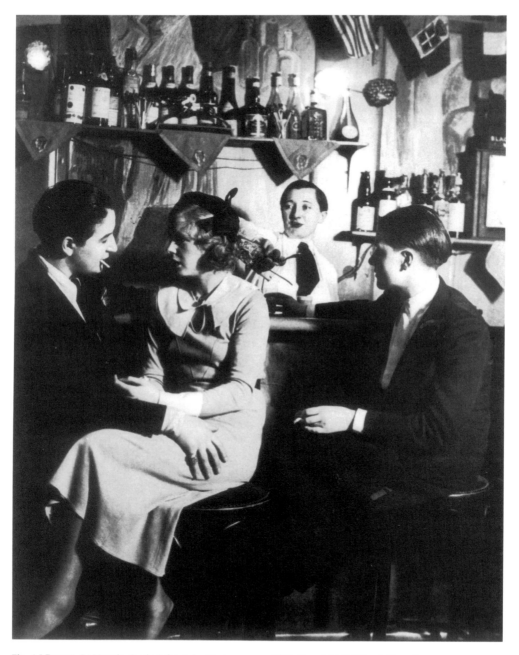

Fig. 6.5 Brassaï, *Le Monocle. On the Left is Lulu, Montparnasse*, c. 1932. Copyright © Gilberte Brassaï

feel welcome as soon as I walk in. I'm never invisible here, not after Lulu's seen me and announced my entrances with, "Hey, look who's here! It's Eugenie!" And we are all here. Well, most of the regulars, that is.

There's Annette, looking up at me over her glass of champagne. She appears to be all alone. Perhaps she'll invite me to sit with her. Perhaps I will invite myself. I like standing next to her table and looking down at her – crowding her – directing my glance her way. I hear she's pretty hot in the sheets and my lips moisten as I picture us writhing together in damp linens. But I'll not rush anything. I've got all night to make it happen.

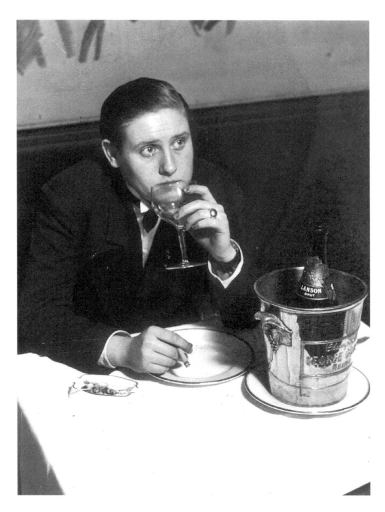

Fig. 6.6 Brassaï, *Young Female Invert, Le Monocle,* **c. 1932. Copyright © Gilberte Brassaï**

And over there, at the bar, is George (or Georgette, we sometimes call her when we're teasing). She looks the dandy this evening, sporting those satin lapels and bow tie, her crisp cuff resting nattily against her thigh, her elbow on the zinc bar. She's so young! Red hair, a breath of freckles blown across the bridge of her nose and baby fat still visible in her cheeks. I remember when she first stumbled in here, awkward and shy. She spent most of the night in a corner staring at the floor, hoping no one would notice her. Now she takes center stage at the bar and casts her gaze wherever, and at whomever, she fancies. Georgette will break our hearts one day as we present ourselves to her, one by one, hoping to catch her attention, wanting to be the one she finally takes home.

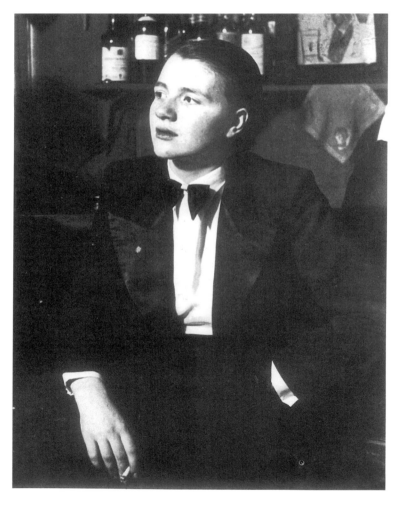

Fig. 6.7 Brassaï, *Young Female Invert, Le Monocle*, c. 1932. Copyright © Gilberte Brassaï

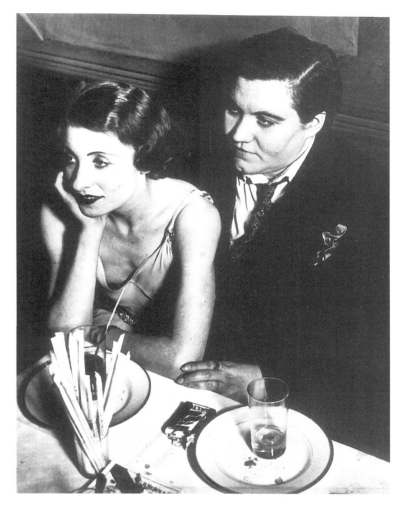

Fig. 6.8 Brassaï, *A Couple at Le Monocle*, c. 1932. Copyright © Gilberte Brassaï

Another table, another couple. I am close enough to see the nicotine stains on her perfectly manicured fingers, resting so lightly on her lover's elbow. I am almost close enough to look down the front of the woman's dress. They don't seem to see me. I like the way they look. She has such full and beautifully shaped eyebrows and the eyeliner around her lids is so dramatic. She looks like a matinée idol. The way the butch's tie is pushed off to the side makes me imagine my hands tugging it loose with delicious abandon and slowly unbuttoning her shirt so that my fingers can explore her breasts, rubbing her nipples until they are hard.

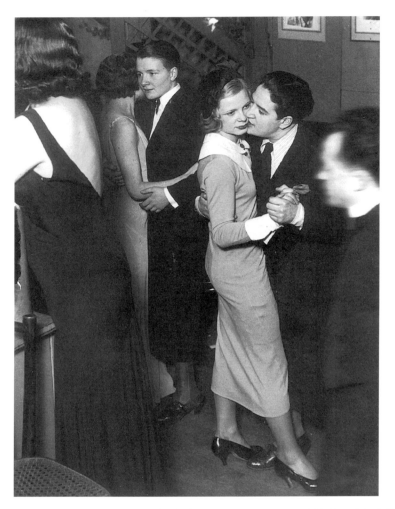

Fig. 6.9 Brassaï, *At Le Monocle, Boulevard Edgar Quinet, Montparnasse*, c. 1933. Copyright © Gilberte Brassaï

I wonder if this is appropriate. What is the mode here? I want to dance with both of them, one at a time, nibbling at the corner of her mouth, pushing my stomach against her crotch. Dare I ask? They've been together such a long time. They are practically an institution in lesbian culture and who am I to break them up now? They've been dancing there together since before I was born – rock solid, unchangeable, and secure in that moment of exposure. They have only just met and are hoping to go home with someone else. Each is pleased to dance with me. It's a bit irregular – the way I look, the way I approach them – but this is a time to break the codes, after all. It is 1933. It is 1993.

notes

Thanks to Jane Cottis, Doug Ischar, Catherine Opie, Connie Samaras, Sally Stein, and Matias Viegener for their helpful comments and encouragement.

1 Walter Benjamin, "One Way Street," in Peter Demetz, ed., *Reflections: Essays, Aphorisms, Autobiographical Writings*, New York, Schocken Books, 1986, p. 63.

2 In this section of *The Searchers*, Wayne's character again demonstrates his encyclopedic knowledge of Comanche language and culture. He makes it clear to his *half-breed* nephew that non-white cultures are duplicitous and unpredictable. Implicating Pawley in this untruth because of his mixed blood maps the logocentrism of white culture. Ironically, Ethan Edwards must also understand another way of thinking in order to track his adversary, Scar (Henry Brandon), chief of the Noyeki Comanche. In the film, one of the multiple metaphors for the title's meaning is a search for another way of understanding difference.

3 For discussion of Brassaï and other surrealist nightwalking activities, see Rosalind Krauss, "Nightwalkers," *Art Journal*, Spring 1981, pp. 33–4. Although Krauss does not refer to nightwalking as a gendered activity, only men are mentioned in this context. In Henry Miller's text "Paris La Nuit," it becomes clear that these ambulatory surveys were in a masculine domain apart from female sex workers and the occasional "wife in tow." *Evergreen Review*, vol. 6, no. 24, May–June 1962, pp. 12–22.

4 For an extensive discussion of the notion of textual splitting, repetition and substitution of the self in literature and, especially, in Brassaï's use of mirrors in his Paris café photographs, see Craig Owens's analysis of *mise en abyme* in his essay "Photography *en abyme*," *October*, no. 5, Summer 1978, pp. 73–88; also see Rosalind Krauss, "Nightwalkers." For an investigation of the complex relationship of the exploitation of human freaks to their attainment of status, fame and fortune at sideshows, see Robert Bogdan, *Freak Show: Presenting Human Oddities for Amusement and Profit*, University of Chicago Press, 1988.

5 Brassaï, *The Secret Paris of the 30's*, trans. Richard Miller, London, Thames and Hudson, 1976, n.p.

6 Ibid.

7 The monocle was part of the effete costume of the era for the male dandy and cross-dressing women and one of the recognizable signs of lesbian culture in Paris. For a more complete discussion, see "Le Monocle de Ma Tante," in Marjorie Garber, *Vested Interests: Cross-Dressing and Cultural Anxiety*, London and New York, Routledge, 1992, pp. 152–5. Also, see Shari Benstock, *Women of the Left Bank: Paris, 1900–1940*, Austin, University of Texas Press, 1986, for descriptions of Paris lesbian society in the early twentieth century.

catherine lord

her garden in winter

For as long as I can remember I've cruised photographs of people. Though there have been exceptions, I've generally been put off by the ones that wanted too shamelessly to be had, like those in museums or on billboards or television or in magazines. Instead, I've looked for the photographs no one wanted, those relegated to the edges, those that have had to be thrown away, or the ones that have become unmoored from their stories, dislodged from the architecture, the furniture, the envelopes and the cases and the frames that kept them in memory. I think nothing of looking carefully at every photograph within view in any house to which I'm invited. I've poked through trash bins to find snapshots I cannot explain to myself. I've taken home beaver shots from the edge of the Westside highway, carefully preserved a color slide of a severed foot found by the railway tracks in Santa Ana. If I have to pay for my habit, I look through junk stores, yard sales, even antique stores. I've leaned to photographs that stretch my dollar, give me as many faces as possible per square inch: family albums and group pictures, school graduating classes, social clubs, church groups, business conventions, in addition to that genre which choreographs thousands in a hot and tedious display of visual nationalism so that someone on high can see a flag, or a bell, or a bird. I can spend hours riffling through boxes and bins and untidy stacks, piles of paper crumbling back into dirt, disintegrating leather, scraps of paper from which all photograph has evaporated save a yellowish shine.

Such photographs I think of privately as the damned of photographic history, the ones that nothing and no one could or would or should have rescued. If photography was a religion, these would be the sinners, the crowds of heathens that no zealot arrived in time to save. Or maybe they are more like the victims of some massive natural disaster, the past sliding out of control into the present. These are the millions too uninteresting or ordinary or just plain ugly to stimulate the acquisitive instincts of any library or museum. They don't signify in history and they don't signify in beauty. They are the souls that have lost their owners, or, literally, their relatives – their kin, their kind, those who anchored their identity in whatever that was that used to be called family. One face before a camera, a couple before a camera, a baby, the

children, a family, the grandparents, the aunt, the house, the horse, the car, a patriarch, a coffin. They have become, in the most literal sense, floating signifiers, exchanged among strangers in flea markets and swap meets so that small entrepreneurs can make a buck, item by inflated item, living off the capital of someone else's memories.

It's dirty work looking through great mounds of the rubble of demolished families to spot the few runaways, who are, of course, skilled at eluding pursuit, at making themselves disappear into the crowd. Sometimes I know I may only be imagining that I've found one of the women who escaped. She is in a group but not of it. She stands apart. She looks back to behind the camera. She looks at another woman, or sits next to her, or simply puts her hand on her arm. She signals, by an item of clothing, a gesture, a stance, or even an entire defiant costume, that she will not stay in her place. Sometimes her picture – too mannish, too loving, too big – has been ripped from a family album. Sometimes her face has been cut entirely out of the photograph, presumably to make the past safe for those who are not like her to imagine their future.

It's easy to get buried looking for the moments I want. It's not even entirely clear what I want by submitting myself to all this, by continually risking myself under the weight of a body in which I have really no more than a polite, even feminine interest. On photography I'm with Roland Barthes, in my own way. I crave surprise. I yearn to be overpowered by something ruthless, inexorable, arrogant. I want to feel something from the image that would go into my heart, pierce me, trouble me, bruise me. It's all in details that are impossible to predict and sound too trivial to name: a hand holding the back of a chair just a little too tightly, or arms crossed over the breasts, or a governess holding steady the pony on which one of her charges is seated, or a hand on the mouth covering bad teeth, or a bandage on a bare foot, a slight moustache, perhaps the straps of a pair of pumps.

I want something to stop me so that I might see truth of a face I could love. I'm the ice princess. I too have looked for the photograph that would produce in me an emotion as certain as memory, from which all other photographs would proceed. Since I must speak in my own way, I falter. She wasn't in any of the albums from my family. I found her by chance in an army town in the desert in one of those shacks where old people turned to leather sell greasy paperbacks and cracked tupperware, along with shoe boxes of postcards, birthday cards, canceled stamps, yellowed envelopes, and collections of white people with red eyes. I paid fifty cents, no haggling, without even looking very carefully, for a snapshot mixed into the muddle. It is a black and white photograph that must have been taken in a working-class district in an American city, probably in the 1940s. She stands outside, the fenced back yard behind her, snowed over so that just the pattern of vegetable rows divides up the white. The outlines and windows of three-decker houses are dimly visible in the background. The photographer must have been standing on the back steps, above her, because she looks up at the camera, her coat open, her skin dark against the starched white collar of her blouse. Her hair is pulled back to the nape of her neck. I think she wears small pearl earrings, though the photograph is too blurry to be certain. Her neck is bare. She stands with her legs slightly apart. Her feet are small, and her thin leather boots are laced all the way up. She looks to be in her thirties. It's getting to be late afternoon, because her shadow skews diagonally out of the frame behind her, along with the shadows of small bare fruit trees, an apple and a pear, I'm almost sure. The stakes for the tomatoes she grows in the summer are clearly visible, as is, at the very back of the yard, a homemade child's swing. She is laughing, blowing a kiss up to her photographer, whose shadow falls on the bare ground in front of her. If I stare, the shape of the shadow is just discernible as that of a woman, dressed in a skirt and wide-brimmed hat, catching the kiss as she looks down into the viewfinder of her camera.

141

I could know this woman, laughing in her garden, with her gentleness that became visible impossibly and all at once when she was still a young girl living with parents that loved her so badly, that is to say, living in a family like all families. This for me could be the photograph at the center of the maze, from which all other photographs would derive, this light-skinned young woman with masses of wavy hair who had come to a cold city in winter from another country where the air was soft and warm, who has passed into another life, and who would continue to dream for years of walking between blue sea and steep green mountains on a beach that narrowed and narrowed until it became too beautiful to bear. I could love this woman in a photograph I will not show because it is the only one I need to possess only for myself. I could have loved her when she was a child, or taken care of her when she was dying, helped her to drink tea with milk from a bowl, as she showed me how to do when I was a child.

portfolio

introduction

This selection of works by contemporary photographers addresses gender, desire, the body, loss, cross-cultural and cross-historical models of queer identity, and photography itself as an instrument of cultural knowledge and authentication. Disrupting and strategically redefining the gestures, codes, and signs of masculinity and femininity have been a central preoccupation of many of these photographers. In her portrait of Angela Scheirl, **Catherine Opie** gives us an opulent, frank and sexy portrait of the young Austrian film-maker in butch-dandy drag, who assesses us with the cool cocky attitude of an adolescent boy. Opie's other photograph is a self-portrait with a stick-figure drawing of two girls holding hands in front of a house, cut into the broad expanse of the photographer's emphatically butch back. The primal wish for the family harmony this drawing so economically maps materializes in the rich red life-blood of the artist who also alludes to a ritualized practice of s/m.

In his digitally composed multiple self-portraits as western pop cultural and art historical icons, Japanese photographer **Yasumasa Morimura** (the subject of Paul Franklin's essay in this volume) shocks us with the persuasiveness of how his Asian body inhabits and queers these paradigms of white western femininity. In *Self Portrait (Actress)/Black Marilyn*, the play becomes an outright scandal. Black British photographer **Ajamu** photographs a black body-builder with his arms raised, displaying to advantage the beautifully sculpted and modeled surfaces of his upper back and arms. An ordinary white bra, its tired elastic indicating repeated use, strains against its hooks to accommodate the model's broad torso. The cultural fetishizing of the black male body and its "monstrous" phallic presence is utterly decoded and undone by this humble scrap of women's intimate apparel and the image is stunningly sexy. In his self-portrait of 1993, Ajamu again references mainstream art photography's established fascination with the black male nude (e.g. Van Vechten, Mapplethorpe), but here the photographer shows us *his* active intervention as both the erotic object of his own gaze and as self-pleasuring subject.

Several artists queer heroic icons from art and photographic history, sabotaging their normative aesthetic and ideological readings. In his untitled image from a large installation work titled *Bone-Grass Boy*, **Ken Gonzales-Day** constructs a fictional scene for his mixed-blood

(Indian/Mexican) narrator, Nepomuceno, who fights in the Mexican–American War in the only battle on what would become US soil. Gonzales-Day photographs himself as the doubled dying hero, romantically displaying his Michelangelesque warrior's body against a painted and photographed backdrop of battlefield dead, the latter appropriated from Timothy O'Sullivan's famous 1863 photograph at Gettysburg. Gonzales-Day's theft of this Civil War icon and his eroticizing and racializing of it plays havoc with official Anglo-American history and overwhelms it with the excessive body of the Native-American/Latino queer.

Robert Blanchon also trains his desiring lens on patriotic icons, in this case, heroic bronze statuary that presides over parks and civic plazas. Angling the camera to frame salient details, Blanchon overtly eroticizes these public monuments to masculine (e)rectitude and virtue. Alexander Hamilton, the architect of US federalism, is shown to have been a man to be "looked up to" for other attributes. By using the camera to show us *what is already there*, Blanchon exposes the policing operations of male homosociality and Christianity that exclude pleasure in such looking and desiring and punish it. **John O'Reilly** uses Polaroid collage to combine diverse literary, artistic, erotic, and historical images that, in their conjuncture, produce richly extended readings of male homoerotic desire. Evoking simultaneously the operatic compositions of baroque art and the abrupt visual dialectics of synthetic Cubism, O'Reilly layers together references to the aesthetics of male homosociality in the worlds of the military, the Catholic Church, Renaissance painting, neoclassical male nudity, and gay pornography.

Jill Casid and **María DeGuzmán**, who collaborate under the name SPIR: Conceptual Photography, take Jacques-Louis David's famous painting of the slain Marat in his bath as their foil for a political statement about AIDS. In David's original, Marat is portrayed with neoclassical restraint as the embodiment (even in death) of the stoic masculine virtues of the proper revolutionary leader. Casid and DeGuzman construct a very different ideal for the 1990s: an emphatically queer hero, hirsute, sporting earrings, nipple clamps, and an orientalized turban with a fall of hair spilling from its folds. In place of Charlotte Corday's petition, he holds an ACT UP poster bearing the message "All People With AIDS Are Innocent."

The nuclear family, the social institution invested with reproducing and safeguarding normative heterosexuality in the succeeding generation, is another important site of intervention by queer artists. Opie's self-portrait described above literalizes the "pain" of family happiness as an ideal etched into our consciousness from earliest childhood. The family is the realm from which queers are expelled, by law and by custom; it is the fundamental site of psychic and social trauma which implicitly links many of the works and writings in this volume. In **Glenn Ligon**'s simulated family photo album, titled *A Feast of Scraps*, snapshots of the artist's own middle-class African American family are interspersed among the pages with found porn photographs of naked black men. Ligon restores to his own version of family history those pictures that were excluded from the official heterosexualized version – the photographs of the faces and the bodies of boys and men he secretly desired. By the same token, he also validates the lives of these anonymous black men by incorporating them into his "family" and its complicated histories. No longer are they outcasts, "scraps" to be used, discarded, and forgotten. **Joe Smoke** also uses found porn photos of men in his *Decorator Home* series, superimposing them in a photocopy machine on to pages cut from model home magazines. The tastefulness and discreet opulence of the decor of upper-class domestic space is rudely violated by cavorting, fisting, fucking men who loll on the little girl's canopied bed, tumble passionately over the sofas, and rub their hard pricks against fine linens. The campy text copy (evoking the limp-wristed stereotype of the gay male interior decorator) is mocked by the obvious virility of Smoke's horny studs.

Other photographs in this section evoke the complex and not altogether namable sensations of loss, memory, and homage that have suffused a number of works in the age of AIDS. It would be far too simplistic and reductive to limit our readings of these works to this singular historical tragedy, but the scope of its devastation haunts many of these expressions, giving them a subtext of melancholy and private grief, even as they bear witness to fierce and insistent survival. **Jeffery Byrd**'s untitled large toned photograph evokes the terrifying tension between desire and risk many gay men must now negotiate in the complex economies of their sex lives. A seated male nude, blindfolded and anchored to his chair, extends his body upward, reaching with his mouth as though to take a bite of some sweet fruit. But instead of pleasure and sustenance, a razorblade awaits. Of his *Interim Couple* series, **Bill Jacobson** writes that they are metaphors, both for the way old photographs fade and for the selective way in which memory itself works, collecting some images while letting others disappear. Jacobson's soft-focus photographs of male couples, often shown embracing or sharing intimate gestures, are doubly loaded. While the "fading away" of the physical body through disease is an obvious reference, these photographs bear witness to the loving presence and commitment of male couples, countering the widespread stereotype of gay men as incapable of sustaining lasting emotional attachments.

Robert Flynt's lush untitled images also evoke the sensuality of single and paired male bodies, using layered references to classical art and other graphic sources such as life-saving and athletic instruction manuals which depict men in intimate physical contact. Photographed under water, Flynt's subjects shimmer, float and dance in intertwined pleasure, as though inhabiting some sun-dappled prelapsarian dreamscape. **J. John Priola**'s beautifully printed and toned photograph, "Hole," from his *Paradise . . . existing evidence* series, is eloquent in its concreteness and simplicity and can be seen in provocative relation to **Darren P. Clark**'s small but brutally direct untitled image from his *Glory Hole* series made the same year.

Suara Welitoff's exquisite and intimately scaled photographs of enigmatic female subjects resist narrative, though many historical references are invoked: portraits of Charcot's hysterics from the Salpetrière, burlesque stage strippers and side-show freaks, Bellocq's portraits of Storyville prostitutes, nineteenth-century porn models – female monsters, one and all – whose undisciplined eroticism threatened bourgeois public order. **Gaye Chan**'s lyrical photograph of one woman's hand bound with adhesive tape to the hand and belly of another is taken from her series, *Angel on Folding Chair*, a visual meditation on the mysteries and emotional complexities of cross-cultural and cross-ethnic histories and desires. "The process of naming, owning and displaying one's desire is the privilege of the individual," Chan writes. The fragile tape that binds the photographed bodies together echoes the photographer's invocation of the contradictions of living between western entitlements to personal pleasure and Chinese obligations of sacrifice and duty.

Catherine Opie, *Angela Hans Scheirl*, 1992, chromogenic print, 20 × 16 in. Courtesy of the artist and Regen Projects, Los Angeles

Catherine Opie, *Self Portrait*, 1993, chromogenic print, 40 × 30 in. Courtesy of the artist and Regen Projects, Los Angeles

149

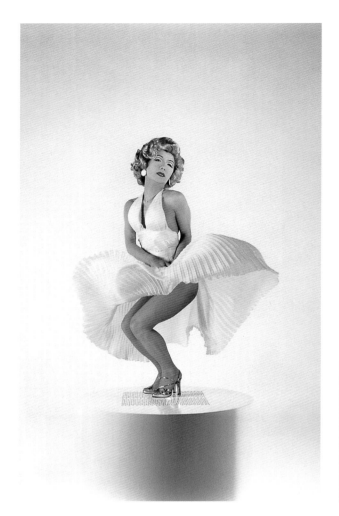

Yasumasa Morimura, *Self Portrait (Actress)/White Marilyn*, 1996, color photograph on canvas, 188 × 90.5 in. Courtesy of the artist and Luhring Augustine Gallery, New York

Yasumasa Morimura, *Self Portrait (Actress)/Black Marilyn*, 1996, color photograph on canvas, 188 × 90.5 in. Courtesy of the artist and Luhring Augustine Gallery, New York

Yasumasa Morimura, *Angels Descending the Stairs*, 1991, color photograph on canvas, 94.5 × 81.25 in. Courtesy of the artist and Luhring Augustine Gallery, New York

Ajamu, *Body Builder in Bra*, 1990, silver gelatin print. Courtesy of the artist

Ajamu, *Self Portrait*, 1993, silver gelatin print. Courtesy of the artist

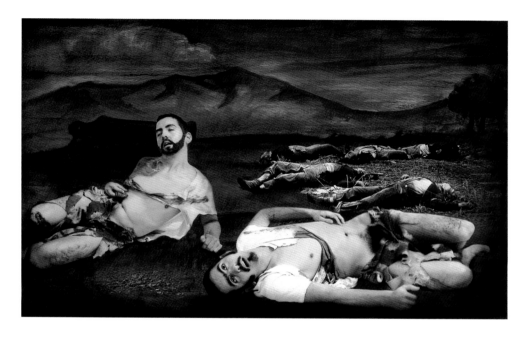

Ken Gonzales-Day, *Untitled No. 7 (Nepomuceno's Battle)*, 1996, chromogenic print from digital negative, 27 × 38 in. Courtesy of the artist

Robert Blanchon, *Untitled (Alexander Hamilton, Boston)*, 1995, chromogenic print, 20 × 20 in. Courtesy of the artist

153

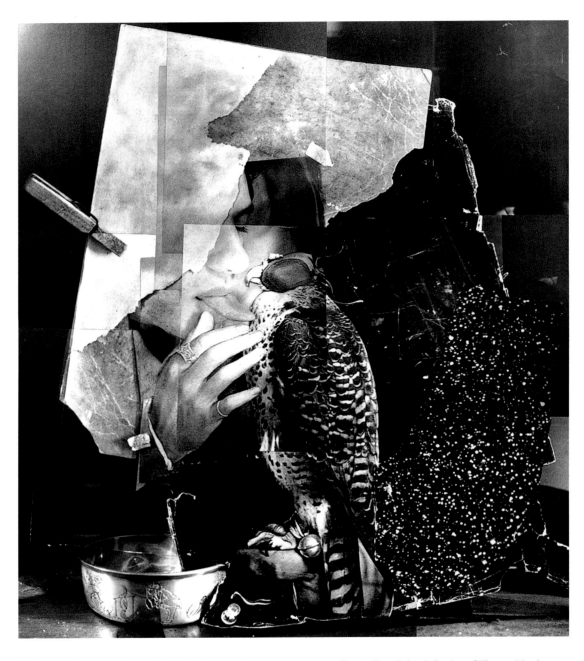

John O'Reilly, "Night" from series *Of Benjamin Britten*, 1993, Polaroid 107 collage, 10⁵⁄₁₆ × 9¼ in. Collection of Thomas Morrissey

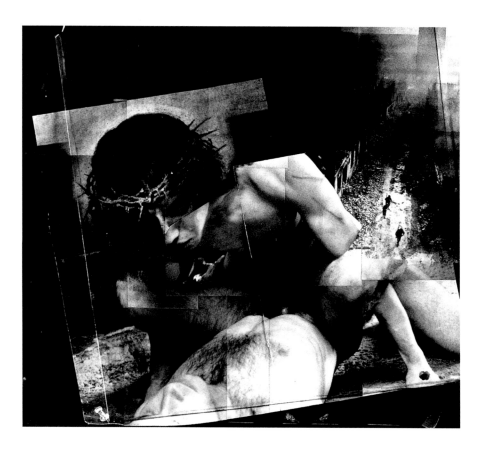

John O'Reilly, "Sgt. Killed in Action, Germany, 1945, Age 22" from *War Series* #29, 1991, Polaroid 107 collage, 11¹⁄₁₆ × 10⅜ in. Collection of John Pijewski

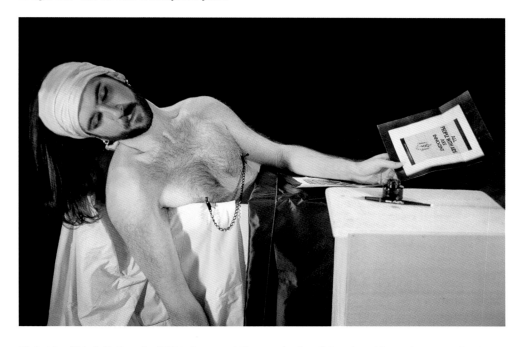

Jill Casid and María DeGuzmán (SPIR): Conceptual Photography, in collaboration with Joseph O'Donnell and Caroline Alyea, *The Death of Marat* (Number 2 in a sequence of 3), 1992, chromogenic print, 11 × 14 in. Courtesy of the artists

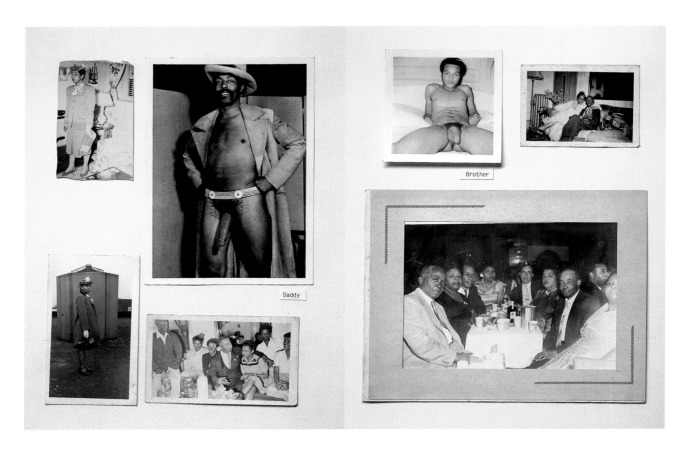

Glenn Ligon, *A Feast of Scraps*, 1995, photo album, photographs, text, 11¼ × 10½ in. each page. Courtesy of the artist and Max Protetch Gallery, New York

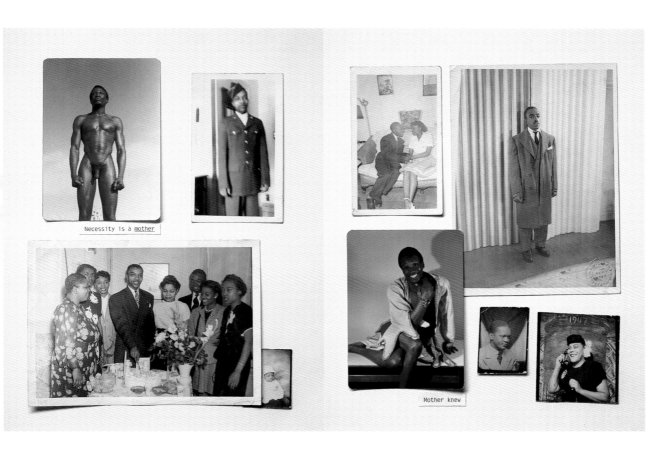

Necessity is a <u>mother</u>

Mother knew

1942

157

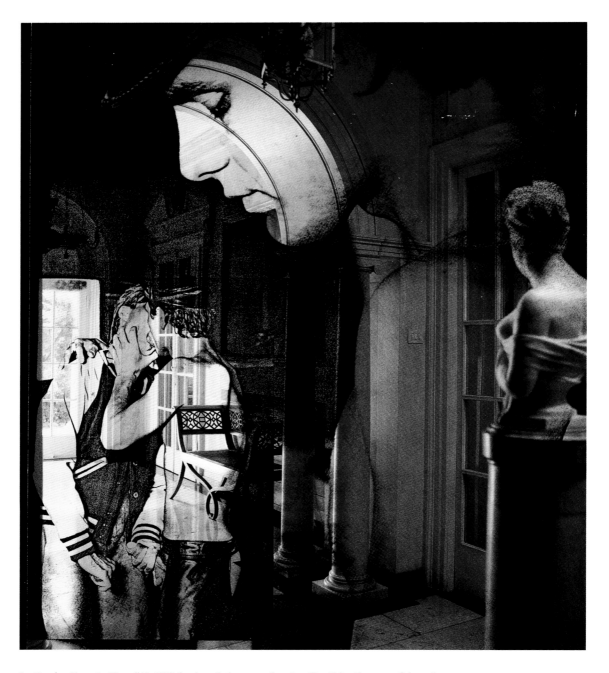

Joe Smoke, *Decorator Home* #43, 1990, laminated chromogenic print, 60 × 47 in. Courtesy of the artist

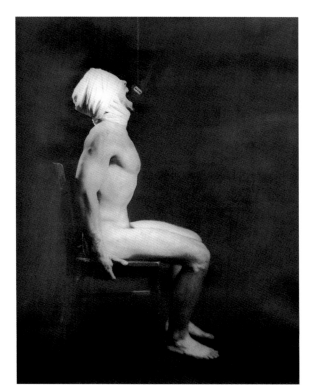

Jeffery Byrd, *Untitled*, 1992, pastel on toned photograph, 34 × 26 in. Courtesy of the artist

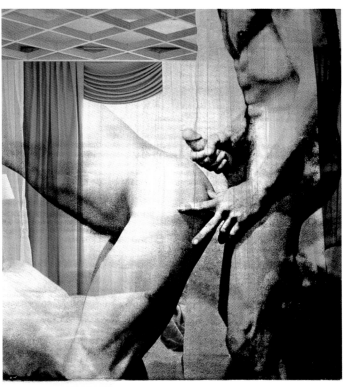

Joe Smoke, *Decorator Home #34*, 1990, dry pigment and watercolor on printed magazine page, 10 × 8 in. Courtesy of the artist

If the living room flirts with the romantic, the bedroom elopes with it

Bill Jacobson, *Interim Couple #1170*, 1994, silver gelatin print, 10×8 in. image on 16×20 in. paper. Courtesy of the artist and Julie Saul Gallery, New York

160

Robert Flynt, *Untitled*, 1994, unique-image chromogenic print, 10 × 8 in. Courtesy of the artist

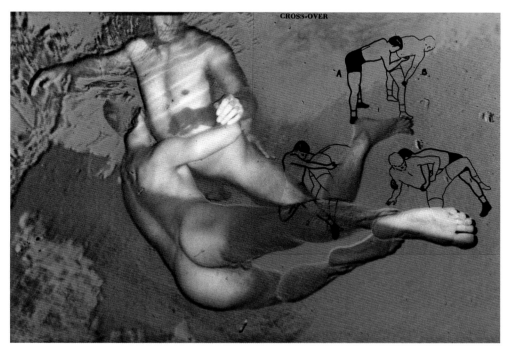

Robert Flynt, *Untitled*, 1993, Cibachrome, 30 × 40 in. Courtesy of the artist

Darren P. Clark, "Untitled" from *Glory Hole* series, 1993, silver gelatin print, 4.25 × 3 in. Courtesy of the artist

J. John Pirola, "Hole" from series *Paradise . . . existing evidence*, 1993, silver gelatin print, 20 × 16 in. Courtesy of the artist and Fraenkel Gallery, San Francisco

162

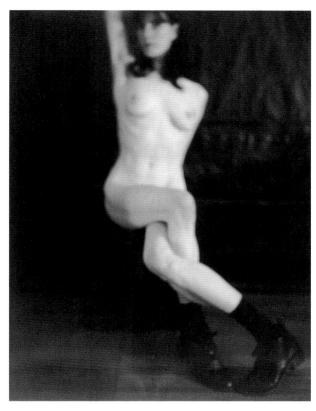

Suara Welitoff, *Untitled*, 1994, silver gelatin contact print, 4.5 × 3.5 in. Courtesy of the artist and Bernard Toale Gallery, Boston

Suara Welitoff, *Untitled*, 1994, Polaroid Type 55 print, 4.5 × 3.5 in. Courtesy of the artist and Bernard Toale Gallery, Boston

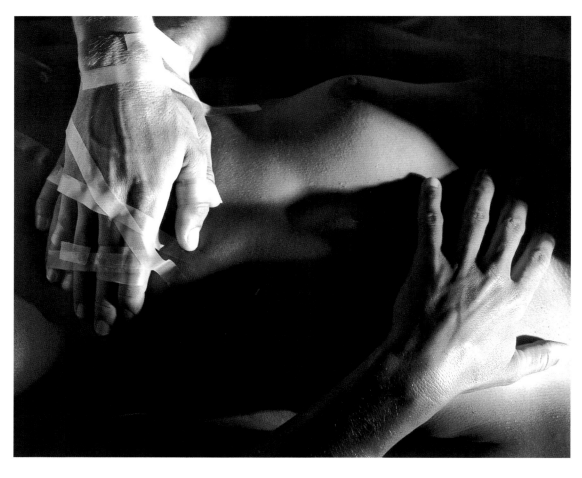

Gaye Chan, "Untitled" from series *Angel on Folding Chair*, 1986–88, silver gelatin print, 16 × 20 in. Courtesy of the artist

part two

inverted views and dissident desires

josé esteban muñoz

rough boy trade
queer desire/straight identity in the photography of larry clark

Editor's note. Larry Clark withheld permission to reproduce his photographs in this volume. Readers are encouraged to seek out these images elsewhere.

Dirty white boys. Gringos. Or gringitos. Snowflakes. When I see Larry Clark's work, especially his three books of photographs, *Tulsa* (1971), *Teenage Lust* (1983), and *The Perfect Childhood* (1995), this is what I think about. The magical mystical white boy. I will indulge this confessional vibe for a few moments longer and explain that these boys hold a place in my psyche. In this recalcitrant psychic space, these boys are as straight as they are white. My attraction to these bodies has everything to do with their unavailability. Besides that, it has something to do with childhood, the moment when one first comes to one's own desire, to feel it as a painful and delicious secret. There is a pull around these images, a beckoning call. Before I learned to value the beauty of other men of color, white boys held my rapt attention. Larry Clark's imagescapes are brimming with these pale and messy boys, these disheveled and numb icons. Thankfully they are now only a component of my desire, one of a few types; but still, the fantasy holds. *I am held*.

I know I'm not the only one for whom this is true. Dirty white boys, straight-acting and *tradey* white boys still hold a central place in the visual imagination of gay men of all colors, all over the world. (The global proportions of this phenomenon have everything to do with the fact that US gay marketing and images dominate iconographies beyond these shores.)[1] Even at this stage in the AIDS pandemic where, in the face of wasting illness, the overdeveloped and pumped-up muscle queen has gained dominance, the image of the lean and lethargic adolescent boy, the "bad boy," retains its appeal. This has to do with the boy's whiteness and his straightness, his ability to tap

into a normative imprint that has a central role in structuring North American (and to some degree global) gay male desire. I see the normative imprint as being akin to what Audre Lorde called the "mythic norm."[2] The mythic norm is a notion of the impenetrable straight white man with money, and a psychic and emotional ideal that people of color, women, the working class, and queers must work against to achieve "self." My addendum to Lorde's work attempts to call attention to the ways in which these normativities often infect the minoritarian subject. *So*, even though one may not be straight, may not be white, and, furthermore, might experience straightness and whiteness as oppressive hegemonic discourses, she or he still might desire these toxic forces.

Clark's photography, especially in *Tulsa* and *Teenage Lust*, captures an aesthetic that has had a vexed and yet central relationship to contemporary gay male culture. This aesthetic is known, in a queer subcultural register, as "trade." Trade has been used in queer lifeworlds to describe tricks and hustlers who commit queer acts yet nonetheless produce a heterosexual identity. In this essay I will use the conceptual and theoretical leverage of trade to unpack the complicated erotic economies of Clark's photographs.

Clark's camera has often been trained on the bodies of nude and semi-nude young white boys in both urban and rural settings. Clark authorizes these expeditions into a culture of "teenage lust" by including written texts that ruminate on his own youth and sexual exploits. The photographer claims heterosexuality, in part through the occasional use of teenage girls in his portraits. Women's bodies function as little more than props in Clark's work. Clark's use of the female body attempts to stave off the specters of homosexual desire that haunt his images. The occasion of Clark's photography will enable a larger rumination about the different ways in which male heterosexuality is haunted by homosexuality and the way in which the pose of trade is central to gay male sexuality.

Think of the "jungle fever" scene in Clark's independent feature film *Kids* (1995) in which an interracial gay male couple is taunted by a flock of Clark's straight boys as they mill around the fountain in Washington Square Park. Up to this point the film has made something of an erotic study of these boys in baggy hip-hop fashions. Queerness has neither been enunciated nor displayed thus far. The boys taunt the queer couple who embody "out" gay desire. At this moment in the narrative the straight boys, the colorful trade that exists at the film's center, need to disarticulate any relationship to queer desire or homosexual identity in an effort to maintain heterosexuality. This scene helps us locate the proximity of queer possibility to straight identity. Clark's lens is committed to maintaining the homoerotic energy that these boys exude. Ironically, the "queer charge" of these images requires the operative fiction of an untainted heterosexual desire. While I have chosen to focus on Clark's earlier and strictly photographic work, I mention this scene because of the way in which it so nicely explicates the relationship between queerness and the heterosexual identities produced in Clark's work. The boys in the park need to sneer at and curse the queer couple in an effort to uncouple themselves from queer desire.

This scene is also important for what it tells gay men about our fascination with "trade." Trade is an intensively choreographed dance. It concerns the establishment of a highly regimented heterosexuality that needs to disavow its relationship to queerness as it fends off queer possibility. The snapping of the shutter that Clark performs, particularly the way in which his prosthetic and mechanical eye captures and holds highly erotic and sexually explicit photos of teenage boys, is the queer act that is central to his project. Everything else that happens prior to, after, alongside and outside of this act is about (re)establishing heterosexuality.

While I will explicate the workings of trade in both queer and straight cultures, I do want to maintain the particularity of trade. I'm not interested in collapsing Clark's work into the category of gay art. This is to say that I have little interest in "gaying" Larry Clark. Instead, I am interested in the way in which this photographer's works invent heterosexuality. In what follows I will read Clark's work through the author's own dictated protocols of the text. I will pursue Clark's text within the grain of his own writings about his images. I will offer a consideration of the artist's work that will elucidate the working and logic of straight white male desirability within queer culture and, conversely, the influence and anxiety that queer formations present to some straight identities.

A very accommodating interviewer once cut to the chase with Clark and asked the following question:

A lot of people see your work as homoerotic, especially the more recent collages and large-scale sequential photos of teenage boys. There are certain gay artists showing now whose work on the surface recalls yours.[3]

The interviewer, noting a similarity that is only "surface," locates the homoeroticism of Clark's project as an unimportant superficial phenomenon. He paves the way for Clark, in his response, to assert that there is something deeper afoot.

I saw that some people might get it that way. They just can't get past that it's teenage boys. Someone I know once showed Allen Ginsberg *Teenage Lust*. Allen looked at the pictures and asked "Is he gay?" and my friend said "No"; Allen said "Wanna bet?" There is that aspect, if you have fifteen year old kids in your pictures with hard-ons, people are going to think that. I never explained why I was interested in those kids, which I'm trying to do now. My wish would be to go back and be that age and be one of those normal kids.

The interviewer proceeds to sum up Clark's last point by asserting, "So the object of desire is to be the kids, not to have them." Clark appreciates this gesture as he closes the subject by replying, "Right, it's to be them."

One is instantly reminded of the lessons that psychoanalysis (especially psychoanalytic queer theories) have taught us about the flimsiness of the *to be* or *to have* binary.[4] In the spirit of reading within the grain of Clark's text I will not rehearse that line of thinking. Clark's autobiographical statements and his work do test out this point. The photographer sometimes presents himself as a sort of late bloomer who missed out on his own adolescence. At different points he describes himself as a born outlaw and a rebellious son. When he does this, he explains the subject matter of his work as being connected to his own wild youth. (He documents his "wildness" in *Teenage Lust* by including his arrest reports, in case the reader doubted his outlaw credentials.) He thus frames what I have called the "queer act" of his photography within either a narrative of heterosexual underdevelopment or one of nostalgia for bad-boy rebellion.

The first two texts I will be considering, *Tulsa* and *Teenage Lust*, are both collector's items: impossibly expensive and very hard to find. They have had a tremendous influence on contemporary North American photographers from Nan Goldin to Jack Pierson. Viewed sequentially, the texts present a developmental thread that is worth tracing. I will follow that thread as well as briefly discussing Clark's most recent book, *The Perfect Childhood*, a text in which themes and energies that animate the two earlier books explode.

169

Tulsa commences with photographs taken by the artist in 1963, when he was twenty years old. The photographic subjects of this book are the artist's young friends. The book's first three images show shirtless boys: two photographs of David Roper and one of Billy Mann. The boys' looks match the rural images that the text's title, *Tulsa*, suggests. At this point, Roper is clean-cut and handsome. His bare-chested shots reveal a crude heart-shaped tattoo on his arm. The next few frames show Roper outdoors with a shotgun in his hand. The artist's lens, from the beginning, is trained on boys. From its first few moments, the book is a study of a regional masculinity. Though seedy, the boys' images are posed at a moment that continues to signify the 1950s visually. These photographs are historically situated at the cusp of the 1960s and the various transformations of style and self-fashioning that accompanied the sexual revolution and the advent of massive youth cultural experimentations with drugs. In these images of regional masculinity, where button-down shirts are stripped off and crew cuts appear to be growing out, we see the advent of a new moment in the history of youth culture.

Before these first few images appear, one of the book's main themes is announced in an autobiographical statement by Clark:

i was born in tulsa oklahoma in 1943. when i was sixteen i started shooting amphetamine. i shot with my friends everyday for three years and then left town but i've gone back through the years. once the needle goes in it never comes out.[5]

The viewer witnesses these slightly clean-cut yet somewhat seedy boys shooting up in the sensationalized shots that follow. Boys are shown in a cluster of four, shooting up and laughing in a backdrop that appears to be a typical 1950s family room, complete with a brick fireplace on whose mantelpiece rest family portraits and a large picture of Jesus Christ. The next page again shows Roper, this time nude in the bathtub, his tongue extended in concentration as he picks out a vein on his arm for the needle. At this stage in the text, women appear. They hold drinks and seem, from their isolated frames, to be spectators of the all-male activity.

After women appear in the text, images of pregnancy and babies follow. The introduction of women into the imagescape calls attention to the boys' status as fuck-ups; they are irresponsible toward their pregnant wives and girlfriends as they shoot up. Women are not at the center of the photographic narrative. They are onlookers, often forlorn and tragic as they watch the men they love destroy themselves.

The book then shifts to 1968. Clark has left Tulsa and returned. Much has changed. This following section is made up of various film strips displayed over the course of four pages. The film strips chronicle veins waiting to be injected, a shady young man in sunglasses driving a car, and a topless and pregnant young wife looking on as her boyfriend shoots up while sitting on their bed. The last strip sums up the role of women in this text. They are the symbols of a decayed moral responsibility, the weighted anchor that holds these boys to the world of heterosexuality. That women are anchors to the world of heterosexual responsibility is important to the mythology of boy trade.

There are also eight film strips of young men, again wearing sunglasses (this time indoors), playing toughs in a mock tough-guy film. This riffing on Hollywood masculinity anticipates the play of embattled straight masculinity that today characterizes the work of Quentin Tarantino. In a world where feminist, raced, and queer discourses threaten the total privilege of white masculinity, both Clark and Tarantino have found refuge in Hollywood's mythology of the tough guy – a character who existed before the advent of rights discourse.

Death is announced as the book's next theme by a page of text that reads, "death is more perfect than life." This, too, is extremely telling in relation to the trade aesthetic. A young shirtless man holding a gun graces the following page whose caption announces, "dead 1970." The man appears to be a grown version of the boyish Billy Mann of the book's second page. The viewer is left to conclude that the boy has been lost to the outlaw life. Trade's aesthetic is a tragic one; the boys who are desired as trade are pasty icons whose desirability is often mediated by the fact that they are fleeting. Either their beauty will fade, or they themselves – living the outlaw life of trade – will be altogether lost to the world.

The good looks that graced Roper and the other young men's adolescence have faded. In the book's next section, the end of trade is represented. The boys who, like Roper, were once trim and pretty, have become grown men who have filled out and no longer possess the gleam of youth. Here one sees some of the only representations of adulthood in Clark's *oeuvre*:[6] men in their thirties sitting by a window smoking; long-haired men playing with guns; a bearded man slumped in a chair. Females return in the text, this time as battered wives and as pregnant women who, though appearing to be near term, dramatically shoot up in a desolate room.

Tulsa once again comes alive in its final pages as it depicts a period when Clark hung out with, as he puts it, "the little brothers and sisters from the neighborhood." One photograph in particular is interesting insofar as it anticipates much of the work that evolves in *Teenage Lust*. Three nude teenagers, two boys and a girl, shoot up in what appears to be one of their bedrooms. The background images include a poster of Lon Chaney as the Wolfman that hangs over a single bed. The room connotes childhood and, more specifically, boyhood. The boy sitting on the bed next to the girl has an erection which is visually aligned with the syringe shooting into her vein. Teenage dick and shooting share the stage. The other boy, who is flaccid, leans over and helps the young woman shoot up. The girl is squarely between the young men, literalizing the title of Eve Kosofsky Sedgwick's second important book, *Between Men*.[7]

In that study, Sedgwick extrapolates Gayle Rubin's work on the male traffic in women.[8] She explains the way in which a homosocial continuum is maintained, in part, through a traffic in women in which women are little more than objects of exchange between men in heteronormative circuits of sociality. The homosocial is often misunderstood as being a paler shade of homosexuality; as what happens before men's affections for one another enter the dimension of the physical. This is incorrect. The homosocial is the originating locus of homophobic violence. Sedgwick's theory of the homosocial maps the ways in which straight men maintain patriarchy's supremacy by subjugating women and attacking queers. Homosociality is certainly charged by same-sex desire, but once those desires become manifest they must be violently disarticulated. (The scene from *Kids* that I discussed earlier, in which the interracial queer couple is harassed by the boys around the fountain, serves as an explication of this violent aspect of trade.) Trade has its own special niche within the homosocial. It is firmly ensconced in the general economy of homosociality – in fact, it is an exaggerated and exemplary instance of it.

The image of the two boys, one with a significant erection, and the girl who "straightens" the scene of their interaction is elaborated and further investigated in *Teenage Lust*. The book is laden with similar images of young (nominally) straight white men and the women who do the representational work of heterosexualizing them or, more accurately, of securing their status as trade. The book announces itself as an "autobiography." Within its first few pages, it offers a much more scattered version of the same "bad boy" self-fashioning that transpires in *Tulsa*. The theme of "teenage lust" proper appears after an image/text proclaims the book's avowed sexual texture:

since i became a photographer i always wanted to turn back the years. always wished i had a camera when i was a boy. fucking in the backseat, gangbanging with the pretty girls all the other girls in the neighborhood hated. the fat girl next door who gave me blow-jobs after school and i treated her mean and told all my pals. we kept count up to about three hundred the times we fucked her in the eighth grade. i got the crabs from babs. albert who said "no, i'm first, she's my sister." once when i fucked after bobby hood (ol' horse dick) i was fucking hair an' air. a little rape.

in 1972 and 73 the kid brothers in the neighborhood took me with them in teen lust scene. it took me back.[9]

The image that accompanies the text shows the figure of a girl who has been ripped out of a group photograph. This is a rare moment in Clark's project, inasmuch as a female nude is featured alone. The fact that this girl accompanies the photographer's misogynist rant positions her as the object of Clark's gang-bang fantasy, the girl who will be but "hair and air" after Clark, Albert (who claims to be her brother), and Bobby Hood (the aforementioned ol' horse dick) rape her. Clark's heterosexual erotics toward women seem to largely exist within a fantasy of group sex where one woman is totally overwhelmed by a cluster of boys/men. The gang-bang fantasy seems like another extreme depiction of the homosocial. Within the homosocial, men "get off" on the notion of collective sexual experiences but do so not by having sex with each other but, instead, by sharing/using the same woman.

In the above passage, Clark explains his fascination with these nude young people as some sort of nostalgic journey back to his own childhood. Once again, the artist is disavowing the "to have" impulse and emphasizing his urge "to be." That the little brothers "took" Clark is one of the explanations the artist gives in accounting for the fetishistic and voyeuristic nature of his project, which is not to say that the artist is apologizing for his voyeurism. Instead, he is normalizing the "queer act" of his photographic work (which I identify as the snapping of the shutter which is, in turn, connected to the desiring lens of his camera) by positioning it within what he sees as a heteronormative frame.

The misogynistic gang-bang script ushers the viewer into the realm of full teen desire. Roland Barthes's keywords, *punctum* and *studium*, are of use when understanding the theatricality of Clark's teenage sex pictures.[10] The visible sex is nominally straight. This is to say that the photograph's *studium* is straight sex. The *punctum*, on the other hand, is that element or component that wounds or pricks the viewer, leaping out from the *studium* and assailing the spectator. In this sequence it is often the boys' bodies or positions that leap out at the viewer. As before, women are not erotic objects in and of themselves; they become eroticized only when the gazes of (often trade) heterosexual men criss-cross each other, mingling together within the act and space of desiring.

The first photograph in this sequence shows three nude teens. Again, the gender composition consists of two males and one female, and what seems to be a third boy's knee is also visible in the frame. The young woman in this picture is positioned similarly to the girl in the photograph from *Tulsa* that I discussed earlier. If one were to follow the artist's directives and look at this work as heterosexual, one would have to include this very particular version of heterosexuality – one in which multiple nude men always surround one woman.

Women are always surrounded in Clark's project. They are encompassed by young male bodies which are calibrated to draw on their presence as an anchor which moors them to heterosexuality. To put it bluntly, Clark's young women are the only thing that keeps these young men from being naked with each other. Michel Foucault, in one of his most frequently

quoted interviews (at least among his queer readers) asserted that we must always labor to "become" homosexual, that the ontology of homosexuality is itself a dangerous fiction:

As far back as I remember, to want boys was to want relations with boys. That has always been important for me. Not necessarily in the form of a couple, but as a matter of existence: how is it possible for men to be together? To live together, to share their time, their meals, their room, their leisure, their grief, their knowledge, their confidences? What is it, to be "naked" among men, outside of institutional relations, family, profession and obligatory camaraderie? It's a desire, an uneasiness, a desire-in-uneasiness that exists among a lot of people.[11]

In much the same way that I literalized the title of Sedgwick's book, I want to call special attention to Foucault's question: "What is it, to be 'naked' among men, outside of institutional relations, family, profession and obligatory camaraderie?" Becoming homosexual for Foucault does not entail being smug in one's identity practice. Rather, it involves this "being naked." Women, in Clark's photographs, are made to stand in for "institutional relations, family, profession and obligatory camaraderie." They maintain heterosexuality while queerness continues to hum in the background. It is thus distressing to consider the ways in which women, who as a class are routinely subjugated within heteronormative culture, are made to stand in for these toxic forces. In the theater of Clark's photographs, women keep trade from literally *becoming* homosexual. Furthermore, they are positioned to re-format and unload the queer energies that abound in both the photographer's images and in his pronounced fascination with young men.

The pages that follow the three-way include a shot of a young woman leaning down and performing oral sex on a long-haired boy. There is the well-known cover image in which a young woman and man recline on a couch together, his penis head emerging from her clenched fist. One of the most theatrical images in the book is also included in this section. In this staged photograph, titled "brother and sister," a young woman is tied on a bed. Though her face is obscured, she does seem to be gagged as well as bound. A long-haired boy has a pistol trained on the girl that runs parallel with his erect penis. The penis and the gun, in a move whose symbolism is so heavy as to vector into the campy, are matched. The final image of this "little brothers" sequence is a collage of shots of male subjects that seem to be from the same series as the images I have been discussing. This collage is a model for Clark's later collage work in *The Perfect Childhood* which includes collages of teen heart-throbs such as Matt Dillon, Corey Haim, and the late River Phoenix. Within all of these pictures, girls again seem to be important to the images' *studiums* but not to their *punctums*. The images are about the "little brothers": their quests, desires, sex, and bodies.

Race has dropped out of my analysis for some time now. I have let this thread drop only to pick it up again at this point. The images I have discussed have featured white bodies. Some of the young men appear to be perhaps Native American. (In the book's written narrative Clark explains that he is part Cherokee.) Yet Native American identity is not indexed in these images in any ways that I can perceive. The boys' bodies, whatever race they might be, function as white-boy trade. While the circuits of identity that constitute heterosexuality and whiteness are tightly intertwined, they are especially in collusion at the site of trade iconicity.

In all of the images I have discussed thus far, the young peoples' skin functions as an alabaster mask of whiteness. Whiteness positions itself as the real and the universal. White trade is the always *almost* unattainable, the lofty ideality. It partially masquerades itself as the nexus of power which is straight white masculinity. I qualify this last assertion with "partially" because trade partially is and isn't straightness, depending on an entire field of variables and contingencies which

are related to issues of spectatorship and reception. Certainly, more often than not, it feels like the *real*. Which is not to say that I am positing an essential or coherent straight white male identity, but I want to gesture to its very *real* material effects.

The ideality of whiteness is abandoned in the book's last section, the striking Times Square teen hustling photographs. This turn in Clark's work is startling to the viewer who has been reading the deferred, displaced, and frustrated queer energies of Clark's text. At this point it becomes very difficult to proceed with the plan of reading Clark within the protocols of his own heterosexuality. Gone are the pregnant girlfriends of *Tulsa* and the young women at the center of potential gang-bangs. The images that fill out this last section are raw and sexual. These boys own their own status as trade and are in no way rendered trade like the "little brothers" of the book's other section. These are boys and young men who have sex for money.

Also gone is the universal white shine. Most of the people photographed in this section appear to be Latinos or very dark Mediterranean boys. The only African American youth appears in a group shot. There is almost no African American presence in Clark's *oeuvre* until *Kids*. Predictably, the young black man who has the most significant role in the film plays the traditional over-sexed and monstrously endowed Negro. Asian American boys, who are positioned as asexual in the cultural economy that reads African Americans as overly sexual, never appear in Clark's work. The swarthy boys who appear in this section wear no porcelain masks. They do not function as ideals at all. They are, in fact, bodies of color for rent.

Clark dedicates a few lines to these youths and his work on 42nd Street at the very end of his exhaustive narrative. He goes to great pains to differentiate himself from the other white men who train their gazes on these young people:

Everything gets old, and . . . But I think the kids don't know that. There's that innocence there. A lot of the 42nd Street pictures are just, are just that. I mean, some of the pictures of the kids when I first met 'em and they were looking at me with those come-on looks, you know, the way they would look at the old men who would come and try to hustle them, the old homosexuals, just with their eyes. I mean I was kind of embarrassed to have some of the pictures of them grabbing theirself 'cause I thought that was maybe too much.[12]

The by now aging photographer seems to be haunted by the specter of the "old homosexual." But if we stick to the letter of Clark's heterosexual assertion, we have a very interesting rendering of embattled white male heterosexuality. This is to say that the artist's straightness depends on the negotiation and management of the queer energies that animate his work.

Queer energies consume *Teenage Lust*'s final component. Many of the boys in this section are younger than the "little brothers" of Oklahoma. The first shot in this series features a rear view of a boy in tight slacks whose broad back is covered with a black T-shirt stenciled with the words "42 BOY'S" in shiny silver characters. His pose, in which his hands converge in front of his body and out of the camera's view, makes it appear as though he is urinating or simply exposing himself on the street. Another image depicts a very young tattooed boy shaking hands with a long-haired street boy. A boy named Angel leans against the railing to the subway steps wearing a derby-style hat. Similar young men stand on the street in different shots. Some of them are smoking. Another boy with an enormous package leans against the facade of a bookstore. One photograph shows a shirtless youth named Bobby, whose fly is open while his semi-erect penis is in clear view. He is smoking what appears to be a joint; his eyes seem to "see" the photographer. His face projects not innocence but knowingness. Bobby looks at the photographer in the way that "old homosexuals" are looked at. If we sympathize with him we can perhaps begin to understand Clark's need to assert his heterosexuality in the face of Bobby's gaze.

It is certainly not a coincidence that once the universalizing discourse of whiteness washes away, the primacy of heteronormativity also begins to be undone. Not being perfect white ideals, the boys in these images are able to inhabit the margins of dominant discourse in ways that the farm-boy trade in Oklahoma is unable to. *Kids* is much less queer than these 42nd Street images. We can only assume that this has a great deal to do with the fact that, while Clark's ensemble of boys was multi-ethnic, his two principal characters in the film, Telly and Casper, are white boys who could have sprung directly from the pages of *Teenage Lust*.

The Perfect Childhood, the catalogue that accompanied a 1995 exhibition of the same name at the Luhring Augustine Gallery in New York, is an almost complete return to the white normativity of *Tulsa* and the first half of *Teenage Lust*. Once again, young white male bodies dominate the work. The images' homoeroticism has been turned up several notches in this text, which opens with shots of a boy on a television talk show. The viewer imagines that the striking blond young man – who appears to be on *Donahue*, *Sally Jesse Raphael*, or some similar show – has committed some horrible crime or has lived the sordid life of a hustler, drug dealer or Satanist. His milky white face screams "bad boy."

From that image we shift to a series of photographs that atomizes the body of a skateboarder. The camera dissects his anatomy, focusing on the scabs on his legs, the sparse hair under his arms and navel, and his naked torso. The boy holds up his skateboard which has a rear-view photograph of a young woman, featuring her genitals. The skateboard is meant to ward off the queer energies that Clark's photographic method accrues. Later in the text, this "beaver shot" talisman is reproduced, independent of the skateboard. The book concludes in the same way it began, with a close and fragmenting examination of the same young skater's body.

Another particularly lengthy photographic sequence features a long-haired blond teenager being felated by an older woman. The blow job spans twenty-nine pictures. The youth's entire body is visible while the woman's head and her hand on his penis are the only visible parts of her body. The variations between the images reproduce the effect of the woman bobbing up and down on the young man's penis. Woman is, once again, a prop that permits the visual exploration of a young man's sexuality and sensuality. While the woman services him, the youth's facial expressions become the center of the photographic narrative. The identificatory locus is intended, at least on the surface, to be the young man's face as he experiences pleasure. But we might also revisit the woman's head which is simply a prop on the level of the photograph's staging, but which also might work as a less direct identificatory site. With its focus on the boy's body and the way in which pleasure is mapped on his face, the sequence presents us with the central conundrum of Clark's photography: is the featured body the body one wants "to be," or the body that one wants "to have?" While the narrative suggests the former, the latter is always set up. But such an identificatory option can only be imagined clandestinely if one were to read the surface of Clark's work, which is to say, if one remained faithful to the protocols of his text.

Newspaper clippings also play a substantial role in *The Perfect Childhood*. The erotics of death and violence always filter through the trade aesthetic. Violence is always present within the logic of trade; it contributes to the soft masochism of this logic and perpetuates the notion that one might be assaulted by this object of desire who cannot be had but who *must* be had. Clark uses his clippings to give his numb icons an aura of danger. The viewer reads many clippings which narrate the stories of boys who kill both of their parents, rape and murder their mothers, or stab and sodomize the paperboy. Pages are devoted to the sensational Pamela Smart/William Flynn case in which a teacher seduced her fifteen-year-old student and had him kill her husband. Newspaper photographs of Smart dancing in her underwear for the boy and a shot of the

innocent and terrified-looking Flynn on the witness stand are repeated at different moments in the text.

One of the more ghastly cases included is that of twin brothers who sodomized a mentally handicapped girl with a baseball bat. Clark uses images of violence against women to transform his boys into savage predators. This dumb brutality was also present in *Kids*. The young men's masculinity (and thus desirability) is established when they beat a young African American senseless. The rougher the trade, the better, for, within the imagination of the straight mind, roughness short-circuits queerness. This is, of course, only partially true since it also plays to the consumer of trade by feeding him soft masochism.

Clark rationalizes the accusations of homoeroticism in his work by mildly castigating himself when, in the interview passage cited earlier, he asserts that "I never explained why I was interested in those kids, which I'm trying to do now." But, as I have demonstrated, Clark is in fact *always* "explaining" his work and its relationship to desire. His written explanations in both *Teenage Lust*'s long narrative and his interviews actually punctuate his images. His explanation is always the same: it's about "being" not "having." Once again I will ask what this might *mean* when one considers such a statement in light of the artist's work.

In closing, I will offer one possible scenario. I will do so by summoning the specter of Henry James. I bring in James via Sedgwick's recent work on queer performativity. In her compelling analysis of the affect of shame and its connection to queer performativity in James's Prefaces, Sedgwick offers a compelling reading of the older author's relationship to his younger self.

The James of the Prefaces revels in the same startling metaphor that animates the present-day literature of the "inner-child": the metaphor that presents one's relation to one's own past as a *relationship*, intersubjective as it is intergenerational. And, it might be added, almost by definition, homoerotic. Often the younger author is present in these Prefaces a figure in himself, but even more frequently the fictions themselves, or character in them, are given his form. One needn't be invested (as pop psychology is) in a normalizing, hygienic teleology of *healing* this relationship.[13]

When we take these formulations into consideration we gain a new vista from which to view Larry Clark's heterosexuality. If we buy Clark's line for heuristic reasons (hoping for new and useful insights on embattled straight white masculinity that might become available if one reads it within the grain), we can see that homoeroticism has not been purged but instead relocated to the self.

By trying to believe Clark's rhetoric that his relation to the boys is about wanting to be and not wanting to have, we discover a strain of queerness that saturates his relationship to his own self. This is not to say that he is a homosexual (latent or otherwise), gay, or queer. He is straight, a player who negotiates the waters of the homosocial with expert ease. He captures the lure and brio of trade in the performance of snapping up his queer images. His finale is always the maneuver of recontextualizing and heterosexualizing that queer moment. This process sometimes distills perfect little numb white trade icons. When the universality of whiteness is displaced, the homosocial component loses cohesion and explicitly queer seams come into view. Clark's heterosexuality remains intact as he continues to cruise himself.

notes

I want to thank Paul Scolieri for his invaluable assistance. I have benefited from Deborah Bright's patience and wisdom.

1 See Chris Berry, *A Bit on the Side*, Sydney, emPress, 1994, for an interesting analysis of the effects of a dominating western gay and lesbian image economy on non-western same-sex desire.

2 Audre Lorde, *Sister Outsider*, Trumansburg, New York, The Crossing Press, 1984.

3 Mike Kelley, "Larry Clark: In Youth Is Pleasure," *Flash Art*, vol. 25, no. 164, May/June 1992, p. 85.

4 See Diana Fuss's *Identification Papers*, New York and London, Routledge, 1995, for a masterful reading of the slippage between desire and identification.

5 Larry Clark, *Tulsa*, New York, Lustrum Press, 197l, n.p.

6 Clark's work, including *Kids* and his more recent photography, is almost exclusively focused on children and young adults. In this way, the artist is something of a twisted Charles Shultz, the cartoonist who created the popular comic strip *Peanuts*, representing a world where adults are noticeably absent and children are the only visible social players.

7 Eve Kosofsky Sedgwick, *Between Men: English Literature and Male Homosocial Desire*, New York, Columbia University Press, 1985.

8 Gayle Rubin, "The Traffic in Women: Notes on the 'Political Economy' of Sex," Rayna R. Reiter, ed., *Toward an Anthropology of Women*, New York, Monthly Review Press, 1975.

9 Larry Clark, *Teenage Lust*, New York, Larry Clark, 1983.

10 Roland Barthes, *Camera Lucida*, New York, Hill and Wang, 1981.

11 Michel Foucault, "Friendship as a Way of Life," in Sylvère Lotringer, ed., *Foucault Live: Collected Interviews, 1961–1984*, trans. John Johnston New York, Semiotext(e), 1996, pp. 308–9.

12 *Teenage Lust*, n. p.

13 Eve Kosofsky Sedgwick, "Queer Performativity: Henry James's *The Art of the Novel*," *Gay and Lesbian Quarterly*, vol. 1, no. 1, 1993.

mysoon rizk

constructing histories

david wojnarowicz's *arthur rimbaud in new york*

In 1978-79, self-taught artist David Wojnarowicz (1954–92) borrowed a broken camera and produced the series of black-and-white photographs *Arthur Rimbaud in New York*. When the Rimbaud series was finally shown in 1990, the artist described it as the first body of work he ever produced.[1] At the time it was made, however, he felt it would be the last work he would ever get a chance to complete.[2]

After years of abuse and family dysfunction, Wojnarowicz spent parts of his youth (ages nine to seventeen) on the streets of New York City as a runaway, child prostitute, and drop-out from the High School of Music and Art. When he finally got off the streets and into a halfway house (with the help of an ex-convict), he saved enough money as a custodial worker to hit the road. He travelled for several years, back and forth between coasts as well as to Canada, Mexico, and France. He worked at a farm on the Canadian border outside Detroit, as a bookstore clerk back in New York, and as an "egg bootlegger" in San Francisco. While freight-hopping or hitching, in bus stations or truck stops, he listened to the stories fellow vagabonds shared, read books, and began writing.[3]

In 1978, after a stay in Paris, Wojnarowicz returned to settle in New York feeling young, broke, and headed for the streets. He was certain he would not survive another stint of homelessness. Moreover, his sense of foreboding grew upon discovering that several close friends were addicted to heroin. The artist became intent on "making and preserving an authentic version of history" that would not just represent but survive him. Inspired by writers such as William Burroughs, Jean Genet, and Arthur Rimbaud, Wojnarowicz initiated the Rimbaud series and other works as documents of his own uneasy survival on society's margins.

The year he left for Paris, Wojnarowicz had taken out a life insurance policy in Rimbaud's name.[4] Preoccupied with mortality and skeptical about Rimbaud's chances, the artist may have envisioned the fatal narrative of the series at this time. The first work to grapple in a sustained way with issues of history, identity, and death, *Arthur Rimbaud in New York* tracked the "locations and

movements" of the artist's life. At the same time, it projected a hypothetical scenario in which an alter-ego, the French Symbolist poet Rimbaud (1854–91), took on the role of doomed protagonist and outlaw.

Appropriating Rimbaud's identity, or at least reviving his spirit, aided the artist not only in retrieving his own childhood memory but also in constructing a new queer identity. He deployed Rimbaud's spirit, however it materialized, as a "device" for recovering the past in the present, or so he later explained:

I didn't see myself as Rimbaud but rather used him as a device to confront my own desires, experiences, biography and to try and touch on those elusive "sites of attraction"; those places that suddenly and unexpectedly revive the smell and traces of former states of body and mind long ago left behind. In the last few months in sifting through my heightening sense of mortality and the calendars of my past, I went into some old cartons and looked at this series. I found many of the negatives damaged or missing indicating that at some point I felt the body of the work was unsuccessful or that it embarrassed me in its naivete. But I was also attracted to the "youth" in the series; the rock n roll do or die abandon of that period of time.[5]

To examine and reconstruct his own life, Wojnarowicz found it helpful to imagine Rimbaud's, to fuse the poet's "identity with modern new york urban activities mostly illegal in nature." By characterizing both himself and Rimbaud in terms of "mostly illegal" activities, Wojnarowicz underscored not only teenage rebelliousness and acts of delinquency they had in common but also the shared experience of growing up queer and outside society.

Even if keyed to personal biography, the locations selected for staging *Arthur Rimbaud in New York* ultimately proved unpredictably rich, with their own idiosyncratic layers of historical information and emotional associations. Despite his close identification with his subject, Wojnarowicz could not access Rimbaud's history – and what he imagined the poet's life might have been like in New York a century later – any more easily than he could his own elusive past. Critically aware of the limitations and artifice of constructing histories, Wojnarowicz pointedly chose not to cast as Rimbaud someone who physically resembled the poet. Instead, he recruited Brian Butterick, a friend and sometimes lover who dabbled with heroin, to wear a cut paper mask adorned with Rimbaud's likeness.

To make the mask, Wojnarowicz relied on a popular and widely known portrait of Rimbaud originally taken by French photographer Etienne Carjat (Fig. 9.1). Carjat had photographed the poet in 1871 when, at age sixteen, he made his infamous debut in Parisian (Parnassian) literary circles. Although Carjat allegedly smashed the original plates in anger at the brash youth (who had knifed him), mechanical reproductions continued to circulate as first the Symbolists, then the surrealists and, more recently, the Beat poets paid homage to Rimbaud's rebellious freedom in life and art. Wojnarowicz's contemporary, rock poet Patti Smith, even thought she saw Rimbaud in New York City – "in the raggedy seats of depots & buses," "smokin cigarettes," and looking like a "leather jacketed street punk angel" and "poet rocker."[6]

Butterick recalled that Wojnarowicz took Rimbaud's portrait from the cover of a 1957 French and English version of *Illuminations*, enlarged it, and cut out just the face. Perhaps he was influenced by the book cover's designer, mail and collage artist Ray Johnson, who had similarly altered Carjat's compelling photograph. Wojnarowicz may have also known of Pablo Picasso's 1960 lithograph of Rimbaud, also derived from Carjat's original and featured on the cover of the 1966 French and English collection of the poet's complete works. It is most tantalizing to speculate that, while in Paris, Wojnarowicz may have seen a poster campaign launched by French

Fig. 9.1 Etienne Carjat, *Portrait of Arthur Rimbaud*, 1871. Courtesy Bibliothèque Nationale de France, Paris

Fluxus artist and Situationist Ernest Pignon-Ernest.[7] Here, Carjat's famous photograph was superimposed on top of Pignon-Ernest's beautifully rendered drawings of a young man's body (Fig. 9.2).

Pignon-Ernest hoped a life-size representation of Rimbaud dressed as a vagabond "in the midst of red and white traffic signs" would foster "new imaginary and real relationships" among the people of Paris.[8] As if responding to Pignon-Ernest's campaign, Wojnarowicz's Rimbaud series attempted to forge such relationships, not only with the poet's image and persona, but with the artist's own identity as well as his "desperate" world. Dressed as a vagabond, Pignon-Ernest's Rimbaud would have struck a deep chord with Wojnarowicz in relation to his own past. Rimbaud's face, pasted on a wall in the midst of a crowded Parisian street of real human faces, could have inspired not only the idea of the outlaw Rimbaud alive in contemporary New York City, but also the choice to signify him by a paper mask.

Wojnarowicz not only recognized the fundamental dynamism of his situation but also the potential for reshaping a troubled past and foreboding future. By fashioning his own network of links to distant points in time and space, he constructed a legacy and genealogy in which Rimbaud served as a spiritual mentor as well as (along with Butterick) the ideal travel companion. They shared parallel experiences and interests, linguistic and poetic precocity, and a willingness to go anywhere and try anything, including pose for a snapshot. Like a saint interceding on behalf of a supplicant, the masked Rimbaud became both a witness to and surrogate for Wojnarowicz's brutal past. As a protective intermediary, the poet gave the artist the psychic distance needed to return to old haunts, revive memories, and connect present to former states of mind. The Rimbaud series enabled Wojnarowicz to engage with "locations and movements" as well as "the rock n roll do or die abandon of that period of time" without losing himself completely in their allure.

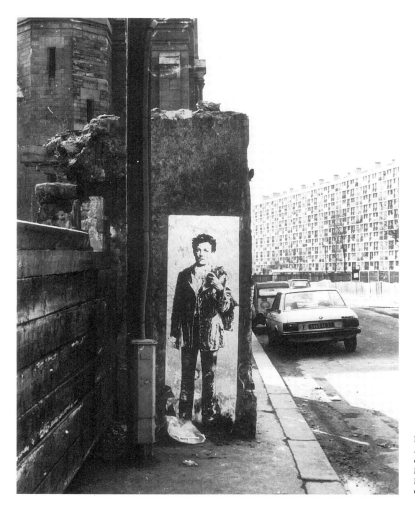

Fig. 9.2 Ernest Pignon-Ernest, *Rimbaud dans Paris*, 1978. Photograph of poster campaign by Philippe Migeat. Courtesy Photographie Musée National d'Art Moderne, Centre Georges Pompidou, Paris

the historical rimbaud

In place of Rimbaud, Wojnarowicz could have made a mask of Tristan Tzara or Marcel Duchamp, in whose names Wojnarowicz had also taken out life insurance policies in 1977. Or he could have used Jean Genet, Yukio Mishima, or William Burroughs, each of whom inspired other works around the same time. Any one of them would have served as a good surrogate protagonist as each made his mark as an outsider, resisting, in Wojnarowicz's words, the "implemented and enforced and legislated social structure." Perhaps what most compelled Wojnarowicz was that while the man Rimbaud survived his youth, the poet Rimbaud did not. By means of the mask, Wojnarowicz reinvoked Rimbaud as the adolescent poet who embarked on his short volatile career when he was just thirteen.

Like Wojnarowicz, Rimbaud came from a broken family, his father having abandoned his mother and four small children. Nevertheless, Rimbaud's life in the French provincial town of Charleville remained relatively stable until July 1870 when the Franco-Prussian War broke out.

The fifteen-year-old Rimbaud had just received top academic honors, but his school closed indefinitely when Germans moved into the region. Determined to run away from home, Rimbaud slipped off during a walk in the country with his mother and sisters, boarded a train to Paris, and got there only to be caught without ticket or fare. He was arrested and imprisoned for a week before being sent back to Charleville.

In February 1871, when the Paris Commune's call to arms reached the provinces, Rimbaud made a second break to the capital with just enough money to get there. He wandered the streets for weeks but was unable to get enlisted or otherwise employed. He ate out of trash bins and slept outdoors "under bridges, in the doorways of houses, [and] in the barges moored along the banks of the river."[9] He sought shelter in military barracks, where he is believed to have been raped by soldiers. Wojnarowicz would have related to Rimbaud's brush with the law, his life on the street, and the confusion brought on by being sexually awakened and molested at the same time.

When the Commune fell in the Spring of 1871, Rimbaud returned to Charleville, where he remained until September. When school finally reopened, he refused to attend, engaging instead in an independent course of study. Part of his days he spent reading and composing innovative poetry, including *Le Bateau Ivre (The Drunken Boat)*. The rest of the time he loitered about, doing his best to scandalize everyone. He stopped washing, wore the same clothes, cultivated lice in his hair (to throw at priests), smoked a pipe turned upside-down, and drank as much beer as he could. Determined to loosen all inhibitions, he hoped to arrive at "the unknown by a derangement of the senses," a delirious state of mind out of which self-knowledge and poetic truths might emerge.[10]

When Rimbaud reached Paris for the third time in September 1871, he was the guest of poet Paul Verlaine who introduced him to the Parnassian poets and took him to Carjat to be photographed. Not yet seventeen, Rimbaud's face is already that of a man twice his age. His tousled hair and skewed bow-tie suggest youthful exuberance which is nevertheless undercut by the gravity of his expression – full of longing, uncertainty, contempt, and world-weariness. By refusing to wash or otherwise ingratiate himself within the bounds of social convention, the upstart poet offended the bourgeois sensibilities of not only his host's family but most of literary Paris. He was expelled from the Verlaine household and homeless for weeks before Verlaine found him accommodations.

For two years, in Paris and London, Rimbaud and Verlaine pursued a tumultuous and scandalous love affair while experimenting heavily with drugs. Rimbaud may have hustled for sex during this time to support his drug habit. On their last day together in a Brussels hotel, Verlaine shot and wounded the nineteen-year-old poet who was trying to leave him. After penning two final and major works, *Une Saison en Enfer (A Season in Hell)* (1873) and *Illuminations* (1872–75), Rimbaud abandoned his poetic experiments at age twenty-one. His long attraction to the sea, his experiences at the London docks, and his facility for learning languages led him to travel for several years, eventually pursuing a trade career in Southern Yemen and Ethiopia before dying prematurely of cancer in Marseilles.

another season in hell

An experiment in the "compression of 'historical time and activity,'" *Arthur Rimbaud in New York* begins with Rimbaud's imaginary arrival by sea at Coney Island (the poet and traveller of 1871–78 reaches America a century later). The series ends with his fatal, albeit fictive, overdose of heroin in an abandoned warehouse on a Hudson River pier. In the twenty-five images documenting his

short life in New York City, Rimbaud visits a fortune teller, rides the subway, hustles in Times Square, eats in a diner, crosses the meat-packing district, and squats in the vacant buildings of the Hudson River piers where more than a third of the series takes place. Moving from one desolate site to another, he smokes cigarettes, drinks beer, reads the paper, jerks off on a mattress, scrawls graffiti, handles a gun, and shoots up.

The first image introduces the protagonist of this abject drama in front of a blank backdrop as if in the style of a passport photograph shown upon arrival to foreign shores (Fig. 9.3). Yet the authority of this official-looking snapshot is undermined by Rimbaud's dangling cigarette, Fruit-of-the-Loom undershirt, and cut-out face. The mask not only prevents the camera from recording the actual features of the anonymous human actor, but it discloses no more than the frozen expression common to FBI mug shots at the post office. Leaning slightly to one side against a bare stucco wall, Rimbaud displays at the outset a resistance to being classified by any authority but his own.

This tough, impassive, Genet-like exterior begins to dissolve as Rimbaud engages with his new environment. Although his expression remains unchanged throughout the series, Rimbaud nevertheless projects a shifting sense of identity in conjunction with each "location" and "movement." The urban landscape often exerts as much of a presence as Rimbaud's solitary figure. Because the mask's gaze remains trained on the camera from frame to frame, addressing the viewer directly, Rimbaud stands apart from his environment, even as he blends into it. At times he recalls the self-conscious tourist, feigning jaded familiarity while having to pose before the requisite sights. Other times, however, his prop-like face and unflinching features, combined with the actor's deliberate pose, seem to correspond and engage actively with surrounding symbolic markers.

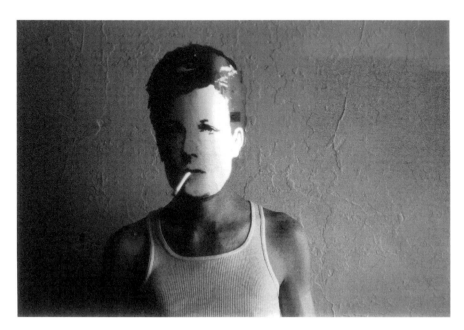

Fig. 9.3

Figs 9.3–9.15 David Wojnarowicz, *Arthur Rimbaud in New York*, silver prints, 1978–79. Courtesy Estate of David Wojnarowicz, New York

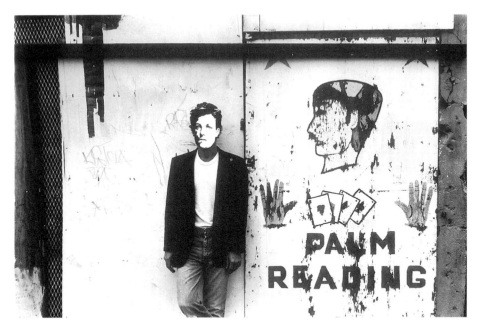

Fig. 9.4

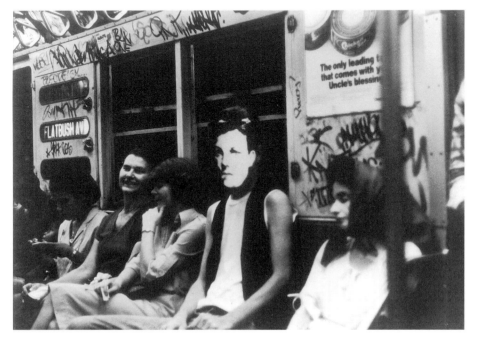

Fig. 9.5

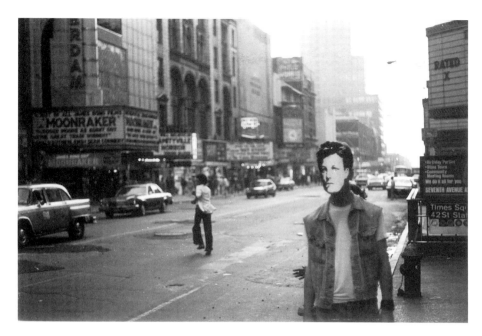

Fig. 9.6

Dressed in a black jacket, T-shirt, and torn jeans in the fifth image of the series, Rimbaud appears at ease in front of a vandalized Coney Island fortune-telling booth (Fig. 9.4). With most of his body visible and his legs crossed, he stands to the left of the closed booth's peeling painted display. Affinities surface between Rimbaud's two-dimensional face and the crude folk-art head painted in profile, looming over a spread of four aces and two open palms. Fixing its serious gaze on the poet, the palm reader's caricatured head resembles Rimbaud's. Its mouth slightly open as if to speak, it seems to offer some portentous revelation while Rimbaud levels his own knowing gaze at the camera before setting off on his New York adventures.

On the subway ride into Manhattan, documented in the sixth image, the theatricality of the Rimbaud series is pressed home (Fig. 9.5). The animated faces and varying moods of the passengers, as well as the graffiti-covered walls of the car, throw into sharp relief the mask's frozen expression, breaking the fictional spell of the narrative. Rimbaud is clearly a prop, his face an uneasy appendage to the human actor whose body is as real and three-dimensional as those around him. In every image in the series, the actor remains in character and performs some apparent action (taking the subway, exploring the piers, injecting the needle), even if these seem like non-actions in relation to the unmasked persons around him.

In the next seven images of the series, for which Wojnarowicz returned to the street scenes of his traumatic adolescence, Rimbaud makes his way through Times Square to hustle his body for money. With a cigarette in one hand and the other in his pocket, the poet seductively loiters under looming bridges, beside a wall, in front of a bar, in the doorway of a porn shop featuring peep shows, or simply along 42nd Street (Fig. 9.6). Rimbaud's impassive pose and masked face call attention not only to Times Square's guarded expressions and spectacular signage but also to its latent sense of volatility caught, in this photograph, between Rimbaud's anchored stance at the right and the receding form and flapping shirt of a young man fleeing across the avenue to the left.

When he prepares, in the thirteenth image, to enter a porn theater, Rimbaud has perhaps caught the eye of a john who will eventually join him inside for sex (Fig. 9.7). Marking the

185

Fig. 9.7

Fig. 9.8

Fig. 9.9

halfway point of the Rimbaud series, this image provides a glimpse of Times Square's glowing neon and flashing lights; its constant traffic; its marquees and admissions booths – all of which are reflected in the curved box office window. Barely noticeable yet centered among these swirling lights and reflections, Rimbaud's shadowy face eerily evokes the desperation, loneliness, and vulnerability of his situation.

Sometimes a john offered the malnourished Wojnarowicz a meal in addition to payment for his services as an underage prostitute. In the fourteenth image of the series, Rimbaud is seated in the back corner booth of a diner across from an unseen companion (Fig. 9.8). In one hand, he clutches hungrily a partially eaten hamburger while his slight build, closed mouth, and masked face allude to chronic hunger despite an insatiable appetite. To Rimbaud's right, an abundant display of decorated cakes and pies behind a glass case entices while simultaneously staying out of reach.

After a detour through the 14th Street meat-packing district, Rimbaud discovers the warehouses of the Hudson River piers where the remainder of the series was shot. These desolate wastelands on the edge of the city served both as pick-up zones for homosexuals and sex-workers as well as places to sell or use drugs. For Wojnarowicz, they were also twentieth-century ruins abandoned to nature, "technological meadows where I could place New York City to my back." In these liminal urban spaces, both Rimbaud and Wojnarowicz explore their personal desires in whatever form impulse demands. Whether drinking, jerking off, pointing a gun, or shooting up, Rimbaud exhibits that "do or die abandon" to which Wojnarowicz found himself drawn.

In the first of the pier photographs, the sixteenth, Rimbaud has located a ratty mattress and stretches out with beer and a found Arabic newspaper (Fig. 9.9). For the first time, he seems to gain a semblance of control over his mind and body as well as respite from sleepless city streets.

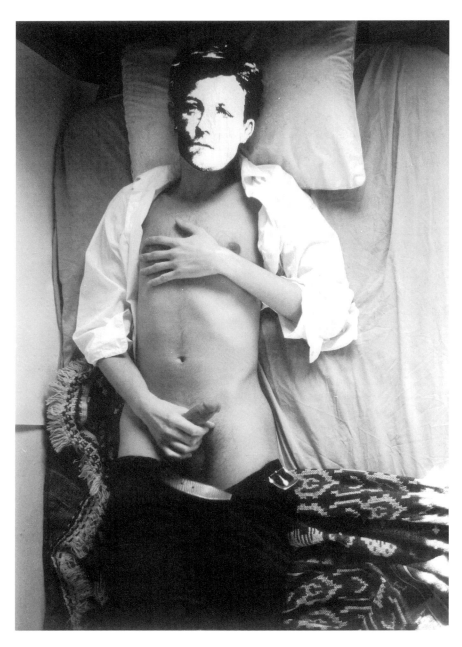

Fig. 9.10

Rimbaud's sense of self-empowerment and the intimacy of Wojnarowicz's close-up shot carry over into the succeeding image in which the masturbating poet attends to his own bodily pleasures and chooses his sexuality for himself (Fig 9.10). Whether he is fantasizing from his ratty quarters in the warehouse, or is simply in a lover's or trick's bed, a clean dress shirt and pants, pillow, sheets, and decorative blanket have miraculously replaced the ragged streetwear and dingy mattress.

The use of the mask reveals the limitations of Rimbaud's control as well as the extent of his alienation from his own body. Indeed, Rimbaud would retain the same expression during orgasm as he would riding the subway, but this is more than just a matter of a prop's artificiality. The mask also alludes to the experience of having to camouflage one's desires from everyone, including one's self; in effect, to submit to invisibility. Wojnarowicz's wish to contest society's abjectification and silencing of sexual outlaws is hinted at by Rimbaud's performative self-determination on the piers.

Just as Rimbaud poses in earlier images alongside the cultural markers of marginal environments such as Coney Island, the subway, Times Square, and a diner, he appears in the final eight images in the derelict spaces of the piers with their own histories of failed capitalist ventures, disinvestment, and alternative habitation by outcasts and squatters. In addition, Wojnarowicz includes his own cultural markers, amplifying the surreal texture of these spaces. From 1978 until they were demolished in 1984, Wojnarowicz continuously revisited these industrial sites and, while documenting them, began to graffiti "word pieces" on their walls in black spray-paint, making references not only to heroin but also to art history, myth, and queer experience.

In the nineteenth image, Wojnarowicz has spray-painted a pair of Chinese characters on the wall, followed by an English word, "DOGFIGHT" (presumably a translation), as well as a sentence demonstrating the word's usage (Fig. 9.11). Rimbaud inclines toward the instructional-looking word piece as if he were teaching it to the camera. His pose makes the rhetorical query, "EX. DID YOU WATCH / THE DOGFIGHT / YESTERDAY / (UNDER MEXICAN SKY)," seem to emerge from his silent lips. The cryptic text calls to mind not only First World War aerial combat and cruel spectator sports, but also notions of immediate televised transmission and live coverage of global spectacles. Its temporal and spatial shake-up of information, along with its merging of factual style with poetic absurdity, resonate with Rimbaud's implausible presence in the cavernous dilapidated warehouse.

Fig. 9.11

Fig. 9.12

Armed with a gun in the next image of the series, Rimbaud acquires a look of grim determination which is enlarged and reinforced by Wojnarowicz's spray-painted caricature of the poet's head on a window behind him (Fig. 9.12). As in the previous image, Rimbaud seems to occupy a didactic role in relation to this symbolic marker, as if his action were meant to manifest or clarify his ghostly double's grimace. Their dual expressions, combined with the weapon, evoke associations not only with the gunshot wound inflicted by Verlaine, but with Wojnarowicz's childhood experiences with a drunken gun-wielding father. Standing in the light and aiming into the darkness presided over by his double, Rimbaud calmly toys with his own potential for violence.

In the twenty-second image, Rimbaud's extended arms invite identification with the framed drawing behind him on the wall, a life-size rear view of a striding male nude with raised arms (Fig. 9.13). Rimbaud's empathic gesture seems to endorse the spray-painted quote from Joseph Beuys, "THE SILENCE / OF MARCEL / DUCHAMP / IS / OVERRATED," which appears behind Rimbaud to the right of the drawing. After all, Rimbaud felt compelled to silence his poetic voice permanently whereas Duchamp kept making art despite his public silence. As for Wojnarowicz, he thought he was about to be mortally silenced just as he was discovering not only his own voice, but its connection to other voices. As a last creative act, the Rimbaud series sought to preserve Wojnarowicz's suppressed history by forging performative ties to related histories of queer rebel artists.

In the twenty-fourth image, Rimbaud poses in a leather jacket – the quintessential symbol of the social and sexual outlaw – next to Wojnarowicz's diagrammatic spray-painting of a male nude figure whose arm is permanently injected by a gigantic syringe (Fig. 9.14). In place of a head, the torso is crowned by a large question mark, implying a confusion or loss of identity or individuality, much as the Rimbaud mask serves to scramble the protagonist's persona. The drawing symbolically correlates such confusion or loss with the experience of drug addiction in which users can lose themselves not only through mental and physical dependence on a narcotic,

Fig. 9.13

Fig. 9.14

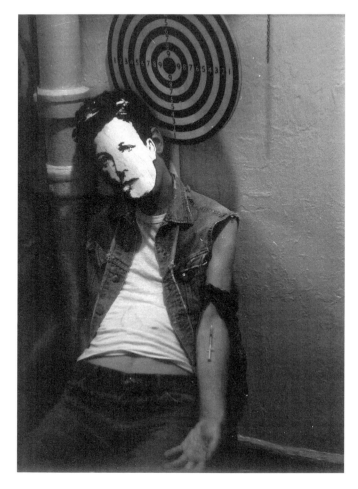

Fig. 9.15

but also through their absorption into social systems of exchange. Their characteristics and behaviors will become statistical abstractions for health care professionals, sociologists, and the criminal justice system, not to mention drug profiteers.

Huddled at the left edge of the twenty-fifth and final image of the series, Rimbaud has injected himself and overdoses while propped up against a wall on which a target is mounted (Fig. 9.15). His masked head appears to have slumped away from the bull's-eye where it initially would have rested. No longer marking Rimbaud as a target, the concentric rings create a halo whose saintly qualities contrast sharply with the harsh reality of the self-martyred body below. Bunched around his chest, the folds of Rimbaud's T-shirt creep indecorously above his jeans, exposing not only his belly but his vulnerability.

With a right arm awkwardly tucked behind his back and his lower body cropped at the thighs, Rimbaud's cramped and ungainly position emphasizes his lack of control. At the vertical center of the photograph, Rimbaud offers a bare and rigid left arm, tied off by a black tourniquet with syringe intact, its contorted palm turned upward as if in supplication. The wall's textured peeling paint that dominates the right half of the frame invokes the backdrop in the first image of the series and invites reflection on the circle of Rimbaud's entire New York journey.

modelling experience

The Rimbaud series was prompted by Wojnarowicz's desire not only to examine the biographical
"locations and movements" which led to his own predicament but also to explore the persistent
beckoning of an outlaw's life in the face of impending self-destruction. The artist was in his
twenties before he discovered role models like Genet, Burroughs, and Rimbaud. Each of these
mentors confirmed for Wojnarowicz "that one could transcend society's hatred of diversity and
loathing of homosexuals." Moreover, each revealed creative strategies for doing so while
demonstrating the value of preserving records of personal experience.

Led by their example, Wojnarowicz sought to make the private public in the form of
"images/writings/objects" that would not only, in his words, "contest state-supported forms of
'history'" but also provide models to people who felt similarly isolated and alienated. For
Wojnarowicz, "an authentic version of history" required "trusting one's own vision and version
of events rather than the government party line as witnessed in the nightly news."[11] Making art
was a way to put one's own otherwise unavailable examples into public circulation "to attract
others with a similar frame of reference."[12]

Wojnarowicz hoped to preserve histories which would otherwise go unrecorded, remain
neglected, or disappear for good from the general record. Such sites as the desolate Hudson River
piers or anonymous Times Square's red-light district alluded to the lived experiences of not only
Wojnarowicz and his fictive Rimbaud, but of countless other outsiders to history, including
queers, juvenile runaways, sex workers, intravenous drug users, and the homeless. Moreover,
locations like the meat-packing district and the subway further characterized the generally
invisible experience of marginality through associations with unsightliness and tawdriness as well
as the mundane, routine, and commonplace.

The Rimbaud series attempted to forge links between Wojnarowicz's experience of social
marginality and that of contemporaries and spiritual predecessors. Through the Rimbaud series,
Wojnarowicz could return to the streets without having to end up on them while he committed
himself to making art instead of hustling or doing drugs – activities now performed (instead of
making art!) by Rimbaud. Such a shifting and scrambling of identity was to become not only a
central strategy of Wojnarowicz's collage aesthetic, but also the conceptual operation at the heart
of his formulation of a spiritual genealogy and vision of history.

Wojnarowicz tried to convey not only the public realities of the urban margins (whether as
broad socioeconomic contexts or particular case histories, both past and present) but also private
experience, including the interplay of individual emotion and imagination. The Rimbaud series
set out to capture such intangible phenomena as memories, dreams, and fantasies while
acknowledging the problematics of apprehending as well as using such ephemera to construct
histories. As if to emphasize the self-conscious fiction of this photographic document,
Wojnarowicz employed a mask to represent the necessarily fantastical notion of bringing
Rimbaud to New York City.

At the same time, the mask effectively modeled the alienation of its protagonists and provided
a compelling symbol for (while drawing the viewer into) the outsider's experience. In addition,
Rimbaud's stiffly posed, stylized re-enactments of diverse activities not only highlighted the
choreographed quality of the series but also illustrated the existential discomfort of being. The
sensation of being a stranger to one's self continually subverted the struggle to locate self-
determination and self-definition. In the face of an irretrievable past, a threatening present, and an
uncertain future, the Rimbaud series laid bare not only the necessity for, but the complications of,
actively constructing a personal history as a defense against multiple levels of silencing.

notes

1 New York writer/drag queen Brian Butterick, with whom Wojnarowicz was involved at this time and who posed as Rimbaud in much of the series, recalls that most of it was shot in a single summer, possibly 1978 (personal interview, New York, 1 December 1995). Wojnarowicz, however, associates the Rimbaud series with 1979; see Wojnarowicz, "Biographical Dateline," in Barry Blinderman, ed., *David Wojnarowicz: Tongues of Flame* (exhibition catalogue), Normal, University Galleries of Illinois State University, 1990. In 1980, selections from the series appeared in *The Soho Weekly News* and the eleventh issue of *Little Caesar*, a Los Angeles literary publication edited by Dennis Cooper. Years later, Wojnarowicz excavated the photographs while preparing for his first retrospective exhibit in Normal, Illinois (January 1990). Although not part of the exhibition, four images of the series were reproduced in the catalogue. Later that year, twenty-five images – the focus of this essay – were featured in a solo exhibition, "In the Garden," at PPOW Gallery, New York (November 1990).

2 David Hirsh, "New York Adventure," *New York Native*, 10:52, issue 398, 3 December 1990, p. 48. In 1978, it should be noted, aside from the Rimbaud series, Wojnarowicz made two photocollages, one in tribute to William Burroughs and the other apotheosizing Jean Genet. That year, with friends, Wojnarowicz also shot a super-8 film called *Heroin* in the abandoned warehouses on the Hudson River piers. In addition, he had begun such writing projects as *Sounds in the Distance*, a version of which appeared unofficially in 1979 before being published in 1982.

3 The most comprehensive overview of Wojnarowicz's history, from 1954 to 1982, remains his own "Biographical Dateline," in Blinderman, *David Wojnarowicz*, pp. 113–18. Equally informative, however, is Wojnarowicz's testimony to parts of this history in court during his 1990 federal lawsuit against the Reverend Donald Wildmon and the American Family Association for harmful misrepresentation of his work. Wojnarowicz was awarded a symbolic dollar for damages and Wildmon was prohibited from further distribution of a defamatory pamphlet aimed at gutting public arts funding which excised fourteen details, including the picture of Rimbaud masturbating, from Wojnarowicz's retrospective catalogue. See David Wojnarowicz, "Affidavit," *David Wojnarowicz* v. *American Family Association and Donald E. Wildmon*, New York 745 F. Supp. 130. SDNY.

4 The life insurance policy is presumably contained in a still-sealed envelope addressed to Arthur Rimbaud in care of Wojnarowicz's address in New York and postmarked 21 March 1977. The Estate of David Wojnarowicz, Item no. P-25-b-1.

5 David Wojnarowicz, unpublished artist's exhibition statement, "David Wojnarowicz: In the Garden," New York, PPOW Gallery, November 1990.

6 Photocopy of untitled poem by Patti Smith, source undetermined, The Estate of David Wojnarowicz, Item no. B-47: M-7-g-3.

7 Pignon-Ernest's poster campaign was brought to my attention by New York artist Gregg Deering.

8 Pignon-Ernest, quoted in Agnès de Gouvion Saint-Cyr, Jean-Claude Lemagny, and Alain Sayag, *20th Century French Photography* (exhibition catalog), Barbican Art Gallery, London, Trefoil Publications Ltd, 1988, p. 129.

9 Enid Starkie, *Arthur Rimbaud*, London, Faber & Faber, 1961, p. 76.

10 Pierre Petitfils, *Rimbaud* trans. Alan Sheridan, Charlottesville, University Press of Virginia, 1987, p. 89.

11 David Wojnarowicz, "Biographical Dateline."

12 David Wojnarowicz, "Post Cards from America: X-Rays from Hell," in Blinderman, *David Wojnarowicz*, p. 108.

david joselit

mark morrisroe's photographic masquerade

Mark Morrisroe is understood as a photographer who, like Nan Goldin or David Armstrong, produced images from his own social milieu. Most accounts of his art are peppered with allusions to "Bohemia" and the "East Village" as though the elusively unsettling nature of his prints accurately reflects or transposes the turbulence of his extraordinary life.[1] Morrisroe's early death from AIDS at the age of thirty in 1989 gives brutal poignancy to such a nostalgic reading of his work; his own disappearance can serve too neatly as an allegory for the disappearance of an entire epoch whose libidinal, stylistic, and aesthetic expressions have themselves been sapped by the same disease that took Morrisroe's life. But if Morrisroe figures in such accounts as a teller of "truth," he is also known as a compulsive liar. His friend Jack Pierson makes this point brilliantly:

Mark lied chronically and w/such abandon, lying doesn't even begin to name the activity. I guess he was trying to write a new life for himself. The weird thing is that his life was already pretty "interesting" and the stories didn't move him up or down the social ladder, they just intensified where he was already to the nth degree.[2]

My purpose in introducing this biographical evidence – which is echoed by all of Morrisroe's close friends and associates – is not to propose a counter-reading of the artist's pictures as a series of deceptions rather than proto-journalistic facts. Instead, I want to insist that "Morrisroe-the-chronicler" is inextricable from "Morrisroe-the-liar." For if, as Pierson suggests, Morrisroe's "lying" was an attempt to "write a new life for himself," then the supposed "truth" of this ongoing life-text is composed of untruths. Put somewhat differently, the *theoretical* significance of Morrisroe's efforts to "write a new life" lies in his recognition that the compulsive and repeated effort to invent and re-invent oneself is fundamentally a form of "lying," or fictionalization, and that "truth" is made up of a succession of lies. As an artist, Morrisroe located this performance of self at the heart of the photographic process. His complex manipulations of the photographic negative – a preoccupation which persisted and developed throughout his career – allowed him a means of transposing truth into lies and lies into truth, or, of "writing a new photograph."

One of Morrisroe's best-known works is a 1986 picture of himself in drag, titled *Sweet Raspberry/Spanish Madonna* (see page 304), which accomplishes a transformation not only in gender but also in nationality – he is a *Spanish* Madonna. Even the term "Madonna" is further bifurcated through its dual allusions to a religious figure of devotion and a gender-bending pop star. Like drag, the act of self-portraiture itself calls attention to a subjective division between s/he who sees and s/he who is transformed into a spectacle to be seen. There is a kind of "lie" encoded in the drama of photographic self-representation; the body of the photographer is transcribed in the photograph, but his or her *position* (the position of the camera) remains outside the image. This multivalent experience of the self unwrapping itself is emblematized in the picture by Morrisroe's face, whose powdered pallor is engulfed in the deep shadows of neck and hair so that it seems to have peeled away from his body. It might therefore be sufficient to locate Morrisroe's efforts to "write a new life" within this complex moment of masquerade – from man to woman, and from photographer to subject – and, indeed, he cross-dressed with some frequency socially, in performances, and in his Warholesque super-8 films.

But Morrisroe's originality as an artist lies in another form of "masquerade" which inheres in the structure of the photograph – the relationship between negative and print. It was exceptional for him to appear cross-dressed in *Sweet Raspberry/Spanish Madonna*, but this extraordinary image shares with most of his pictures a denseness of surface which disrupts the anatomies of its subjects by folding their bodies into deep pools of shadow. It is a paradoxical effect of these works that flesh seems disembodied, but the rich hazy surfaces through which it moves are thick with carnality. This effect is produced through Morrisroe's distinctive practice of sandwiching together color and black and white negatives; a process that creates rich dark shadows and a palpable atmosphere of muted tints. He would make a color photograph first, rephotograph the picture in black and white, and then superimpose the color and black and white negatives in order to make prints, each of which bears the traces of its unique developing process so that no two images produced from the same dyad of negatives look alike. Morrisroe further accentuated the relationship between negative and print by allowing specks of dust, scratches, and fingerprints to emerge in the picture. Even when he did retouch them, he often did so in such a way – like using contrasting colors of retouching paint – as to emphasize the "imperfections" of the negative.

Photographic negatives are presumed to be doubly passive – they are "exposures" of an event on the one hand, and templates for a print on the other – but Morrisroe took great pains to manipulate them, to interrupt their supposedly neutral transmogrification of thing-in-the-world into thing-in-the-picture. Existing between these two positions, the negative is a site where the labor of photographic representation is undertaken, where "identities" are produced. Morrisroe understood better than any artist of his generation that the photographic negative is literally the locus of masquerade. Nowhere is this clearer than in comparing his Polaroid prints, made as casual "sketches" of various poses and attitudes struck playfully by himself and friends, with the more formal c-prints, produced by sandwiching together a color and black and white negative. In the latter, similar and sometimes identical posturings to the banal and often childish attitudes in the Polaroids are invested with a gravity and poignancy through a dense surface haze whose grain is the photograph itself. As Barry Schwabsky aptly commented, this process "conveys a peculiar split in what might be called the inner consistency of the depicted figures: certain people in these photographs . . . seem to escape the ordinary comfortable fleshliness of merely human existence, being compounded instead out of something like the ethereal translucence of angels and the all-too-solid stone of statuary."[3] What Schwabsky calls "a peculiar split in what might be called the inner consistency of the depicted figures" I want to understand as an instance of masquerade or "performativity." It is this split, originating in a dyadic negative and resulting in a visual synthesis

of photographic difference – black and white *and* color – that allows Morrisroe to "write a new life" for the subjects he represents; to open up a space of manipulation and self-invention which transforms the ostensibly "truthful" spontaneity of photography into a meaningful texture of "lies."

Such an understanding of masquerade differs in important ways from that of Cindy Sherman, the most prominent and successful "postmodern" practitioner of performative identity within photography. Sherman's most recent images represent the body as an aggregation of prosthetic parts; a "person," she seems to suggest, is little more than a pile of fetishized limbs. Under the pressure of such anatomical slagheaps – often composed of the crudest sex-shop props – the biological body evaporates, or rather is attenuated into no more than a "ground" for the proliferation of fetishes.[4] Sherman's work exemplifies – though it does not explicitly illustrate or even acknowledge – a recent critical tradition in which experience and, especially, the subversion of gendered identity is understood as a form of masquerade. Mary Ann Doane's now-canonical essay "Film and the Masquerade – Theorising the Female Spectator" exemplifies one important aspect of this tradition. Tracing theories of feminine identity in psychoanalytic theory and popular culture, particularly film, Doane argues that women, on account of the supposed naturalness of femininity and its ideologically conditioned identification *with* nature, are forcibly excluded from signifying themselves, leaving them little choice but to inhabit the identities projected on to them by men. As she puts it, "Too close to herself, entangled in her own enigma, she [Woman] could not step back, could not achieve the necessary distance of a second look."[5]

Achieving such critical distance is a necessary step toward understanding the cultural basis of gender formations. Doane, following the psychoanalyst Joan Riviere,[6] suggests that in its explicit artificiality, masquerade has the capacity to radically de-familiarize and de-naturalize femininity, and thus to create such a critical gap between biological sex and socially-determined gender.[7] Like Cindy Sherman's production of a self composed of strap-on limbs, Doane's vision of a subversive masquerade reveals the constructed and culturally conditioned nature of femininity:

The masquerade, in flaunting femininity, holds it at a distance. Womanliness is a mask which can be worn or removed. The masquerade's resistance to patriarchal positioning would therefore lie in its denial of the production of femininity as closeness, as presence-to-itself, as, precisely, imagistic . . . By destabilising the image, the masquerade confounds this masculine structure of the look.[8]

It is by exaggerating femininity *as a mask* – like Joan Riviere's famous patient who compensated for her assertiveness and success within a masculine professional world by adopting an excessively flirtatious and "girly" persona – that the artificiality of gender codes might be recognized and therefore contested.[9] I want to foreground the phenomenological and implicitly *art-historical* manner in which Doane describes masquerade as a relationship between figure and ground. Her concept of the masquerade, like Sherman's photographs, imagines the *female* body as the ground across which the figure of womanliness, as a "mask which can be worn or removed," produces its spectacle of fetishized *femininity*. The weakness of Doane's formulation is the artificial fixity she attributes to these two terms; the mask is always applied to some presumably more grounded feminine principle which, paradoxically, can be rooted only in the body.

It is Judith Butler who calls attention to the contradiction at the heart of this species of feminist analysis. For if one flees from the myth of a naturalized body by identifying femininity as a cultural mask, and yet one wants to retain the notion of "Woman" at all,[10] then there is little recourse other than returning to a re-essentialized body as the locus of femininity. In order to theorize this catch-22, Butler takes up the metaphor of figure and ground but she does so in such

a way that each term is destabilized; for her, there is not *a* mask applied to *a* body, but rather an array of masks whose complex interplay produces the sensation or experience of an identity. It is worth quoting her discussion of butch–femme lesbian identifications at length in order to capture the force of her dispersal of any fixity in the notions of "figure" and "ground":

Within lesbian contexts, the "identification" with masculinity that appears as butch identity is not a simple assimilation of lesbianism back into the terms of heterosexuality. As one lesbian femme explained, she likes her boys to be girls, meaning that "being a girl" contextualizes and resignifies "masculinity" in a butch identity. As a result, that masculinity, if that it can be called, is always brought into relief against a culturally intelligible "female body." It is precisely this dissonant juxtaposition and the sexual tension that its transgression generates that constitute the object of desire. In other words, the object . . . of lesbian-femme desire is neither some decontextualized female body nor a discrete yet superimposed masculine identity, but the destabilization of both terms as they come into erotic interplay. Similarly, some heterosexual or bisexual women may well prefer that the relation of "figure" to "ground" work in the opposite direction . . . Clearly, this way of thinking about gendered exchanges of desire admits of much greater complexity, for the play of masculine and feminine, as well as the inversion of ground to figure can constitute a highly complex and structured production of desire.[11]

It is Butler's assertion that the "inversion of ground to figure" is highly productive of desire – and perhaps especially conducive to the "transgressive" desires of lesbians and gay men. If we take seriously her choice of this explicitly visual metaphor which, as she can hardly be unaware, has been fundamental to modernist art history, then her conclusion casts Morrisroe's art, as well as his relationship to masquerade, in a highly suggestive light. If, according to Butler, desire and the performance of identity exist at the surface of a body, then that surface functions much like a photograph in which the relationship between "figure" and "ground" is radically mobile. Such a theoretical model does little to explain the prosthetic ballets which characterize Sherman's masquerades, but it does much to illuminate Morrisroe's production of photographic surfaces in which bodies (figures) and their environments (grounds) are in perpetual flux.

In virtually all of Morrisroe's photographs of male and female nudes, the bodies of his subjects are transected by furrows of shadow. An uncanny picture of Janet Massomian (Fig. 10.1) exemplifies this effect. Shot from the side, parts of her anatomy – head, hand, and back – dissolve or almost disappear into the surface murk, while other fragments, such as shoulder, breast, and buttock are irrationally highlighted in their brightness. As in cubist paintings, the presumption of a coherent relationship between a system of shading, or chiaroscuro, and the representation of volume is shattered; light, the motive "force" of photography, loses its function to "write" a picture. Consequently, figure and ground lose their distinctness as each spills on to a single destabilized surface. If we imagine this surface *as a kind of skin*, then it is possible to understand the body, in a vivid metaphor for masquerade, *as a photograph*.[12]

Such an identification of the photographic surface with the topography of the body is accomplished in an untitled image known as *Tattoo* (1988–89). In this work (Fig. 10.2), a section of a man's chest from just under his neck to just below his right nipple occupies the entire expanse of the image. The surface of his body is a field which supports both the gentle curve of two gold chains below the neck and, at the center of the picture, a bird tattoo. But the richness of a shadow across his shoulder and under his breast, as well as the arrestingly artificial orange tone of the image, prevent this field from functioning unambiguously as a "ground"; it seems to engulf the objects upon it rather than receding beneath them. As a

Figs 10.1–10.4 Mark Morrisroe, photographs. Courtesy Pat Hearn Gallery, New York

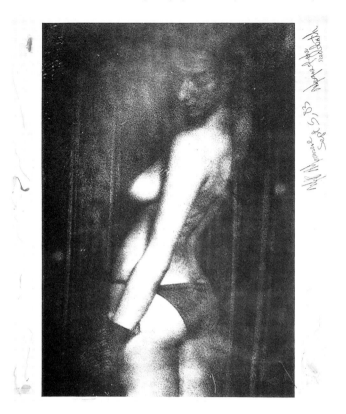

Fig. 10.2 *Untitled (Tattoo)*, c-print, 1988–89

Fig. 10.1 *Janet Massomian*, c-print, 1982

figurative inscription incised under the skin, the tattoo dramatizes this aporia between figure and ground. Moreover, as a culturally-determined form of representation[13] which represents a "natural" creature, the bird evokes the question of nature and culture – of truth and lies – which haunts both the theorization of masquerade and Morrisroe's particular aesthetic voice. In *Tattoo*, the skin functions paradoxically as *both* figure and ground or, more precisely, as a site of their perpetual negotiation.

An analogous knot of contradictions emerges in the photograph of Janet Massomian through the faintly but distinctly legible trace of Morrisroe's fingerprint in the upper left quadrant of the picture. As a residue of its handling by the artist, this imprint functions as a reminder of the negative's otherwise invisible role in producing a print. Not only does this quasi-forensic map of Morrisroe's skin accentuate the fundamental relationship in his work between the surface of a picture and the body's surface, but its explicit allusion to a negative as the locus of aesthetic intervention joins together the two interrelated sites of masquerade in Morrisroe's c-prints – the sandwiched monochrome and color negatives and the collapse between figure and ground which these hybrid exposures produce.

The relationship between negative and print in Morrisroe's photographs might be understood in terms of the relationship between a subject and his or her unconscious. The work of the negative, like the work of the unconscious, is visible in the picture only as a nearly invisible trace

199

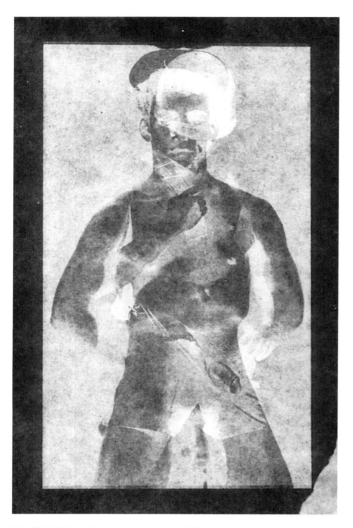

Fig. 10.3 *Military Figure*, sepia tone print, 1986

— like a faint fingerprint — and yet it generates that collapse of "figure" and "ground" which I have associated with masquerade. Such an analogy between photographic process and psychic structure might explain Morrisroe's attraction to the negative as a site of intervention. Indeed, near the end of his life he multiplied his models for exploring the relationship between the ostensibly invisible, or unconscious, negative and its eruption within the print. In one series of pictures from the mid-1980s, for instance, he used bits of paper — candy wrappers, or sheets torn from magazines — as readymade negatives. Often, as in *Military Figure* (1986) (Fig. 10.3), developed from a page of gay pornography, images from the recto and verso of the original are superimposed in the new photograph.[14] The sheet of paper functioning as a "negative" was so thin that when exposed to light during the developing process, images from both sides of the page fused together. Two unrelated bodies join together — not in a "pornographic" embrace — but in the image of a modern gay chimera.

Fig. 10.4 *Untitled (Self Portrait)*, **three dyed x-rays, 1988**

Developed from a "positive" image, the picture manifests those ghostly reversals of dark and light characteristic of a negative and thus places the relationship between negative and positive *en abyme*; the "negative" is a positive print drawn from the mass media, while the positive produced from it looks like a negative. Morrisroe's preoccupation with the relationship between negative and print remains fundamental, but its terms are reversed. Whereas the dyadic negatives composed of a sandwich of color and black-and-white exposures were used to develop representations of subjects who were anatomically intact but dissolving into a grainy surface haze, in *Military Figure*, a single readymade negative results in a hybrid representation composed of two superimposed bodies. In both cases, the picture, as a trace of the interplay between negative and print (or unconscious and self-representation) produces a troubling instability of identity: on the one hand, an implosion, and on the other, a proliferation of "selves."

Perhaps Morrisroe's most poignant exploration of the theoretical significance of the photographic negative occurred in a 1988 series of untitled dyed chest x-rays (Fig. 10.4). If *Military Figure* had used a cultural artifact – pornography – as a negative, these works employ the photographic discourse of medical diagnostics as a means of self-representation. The bitter irony of this transposition of genre from medicine to art is lost on no one who has witnessed the objectification of the seriously ill in the hands of even the most empathic doctors. But if these late works are painfully significant in light of Morrisroe's terminal illness, they have a further theoretical interest in the context of his artistic *oeuvre*.

In presenting the self through a photographic surface representing an organic interior, x-rays suggest a specific problematics of masquerade: the disjunction between the biological operations beneath the skin, and their manifestation, or lack of manifestation, without. Such a split is particularly characteristic of HIV infection and AIDS, whose progress in the body is largely invisible in its early stages. Perhaps the epitome of masquerade among gay men now is not the cliché of the drag queen, but the often intense effort to project or detect health or illness in the bodies of one's self and others. Flooded with acidic color which Kirby Gookin has compared to dyes used for diagnostic tests,[15] Morrisroe's x-rays memorialize this particular performative line between inside and out, health and illness.

One of the last projects Morrisroe undertook was a series of "self-portraits" produced by laying himself down on large sheets of photographic paper unevenly brushed with chemicals. This "performance" – which echoes Yves Klein's human paintbrushes of the late 1950s and early 1960s

and Robert Rauschenberg's *Female Figure (Blueprint)* of 1949, where the contours of a nude's body were exposed directly on to blueprint paper – is a virtual summation of Morrisroe's previous work. For in making a photogram of his own body, he placed himself at the intersection of negative and print, figure and ground. Technically, there is no negative at all in these works and yet the artist's body, in functioning as a template for the developing picture, serves this purpose. Similarly, the image, though certainly *of* this same body, can deliver no more than a blurred profile suggesting its absence. Figure, ground, photograph and negative all collapse around the pivot of the artist's body which is doubly disappearing – from the arena of the photograph, and from life itself through its consumption by AIDS.

The comparison of Morrisroe's work to that of others such as Klein, Rauschenberg (a gay artist who has largely avoided sexuality as an explicit theme in his work), and Cindy Sherman begs a question which has haunted this text. Is it possible, and what interpretive benefits are at stake, in understanding Morrisroe as a gay artist? Unlike the work of Robert Mapplethorpe, whose male nudes typically produce an explicitly homoerotic thematics, or David Wojnarowicz's haunting montaged narratives which explosively juxtapose images of mainstream American life with representations of gay sexuality, "gay subjectivity" is much more elusive in Morrisroe's art. His male nudes, for instance, are hardly more erotically charged than his many images of nude women – one would be hard pressed to prove, without recourse to biographical data, that these images were made by a gay man.

One of the indirect consequences of the demonization of Mapplethorpe's art by the radical right has been his unofficial elevation as a *de facto* exemplar of gay photographic practice. The urgent need to defend his art critically in the face of homophobic assaults has sometimes eclipsed the complexity and breadth of other lesbian and gay photographic practices. Perhaps one way of understanding Morrisroe's position in this field is to invoke the distinction between the labels "lesbian and gay" and "queer" which has emerged in recent years. According to Michael Warner, a fundamental difference between these two appellations is the latter's tendency toward generalization: "it rejects a minoritizing logic of toleration or simple political interest-representation in favor of a more thorough resistance to regimes of the normal."[16]

As Warner, Butler, and others have asserted, the marginal position of queer theorists does not simply equip them to interpret gay and lesbian cultural productions for gay and lesbian communities, or to "translate" them for a straight audience. Rather, the critical distance this marginality allows makes queer theory uniquely capable of describing and challenging *the mainstream itself*. It might therefore be helpful to understand Morrisroe's strategy of masquerade as a "queer" practice. Unlike Mapplethorpe's images of s/m sexual encounters on the one hand, or Sherman's prosthetic figures on the other, Morrisroe evoked an unstable oscillation or collapse between figure and ground, negative and print. The message encoded in his photographs – that a self is produced through an interplay or fusion of masks – does not apply exclusively to lesbians and gay men, but gay men and lesbians undoubtedly experience the contradictions of masquerade more acutely – and often more pleasurably – than heterosexuals. I am arguing, then, that Morrisroe's biography, and particularly his sexual identity, is not the cause of his art, but rather a source of psychic configurations explored within it. If, as Jack Pierson reported, Morrisroe is a chronic liar, the significance of this fact is rooted in his capacity *as an artist* to demonstrate, in truth, that we are all composed of lies.

notes

1 By all accounts, Morrisroe's "hagiography" is chilling. Friends recount that his mother was a prostitute and drug addict and that his father may have been the Boston Strangler; that he ran away from home at thirteen

and was taken in by street hustlers; that he was shot in the back at sixteen, leaving him with a permanent limp. Friends recount his extraordinary cruelty and perversity, alternating with an engaging and unique intelligence. See Pat Hearn, *Mark Morrisroe 1959–1989: A Survey from the Estate*, New York, Pat Hearn Gallery, 1994.

2　Jack Pierson, "[Mark Morrisroe]," *Artforum*, vol. 32, no. 5, January 1994, p. 68.

3　Barry Schwabsky, "Irresponsible Images: The Photographs of Mark Morrisroe," *Print Collector's Newsletter*, May/June 1994, p. 50.

4　Even Sherman's early film stills, centerfold and "fashion"–related series belong to the order of the fetish through their projection of the artist's "identity" into the reified forms of the actress or model.

5　Mary Ann Doane, "Film and the Masquerade – Theorising the Female Spectator," *Screen*, vol. 23, nos 3/4, September/October 1982, pp. 75–6.

6　See Joan Riviere, "Womanliness as Masquerade," in Hendrick M. Ruietenbeck, ed., *Psychoanalysis and Female Sexuality*, New Haven, College and University Press, 1966.

7　It should be noted that Judith Butler's influential work has sought to break down the dichotomy I establish here between a biological sex (female) and a cultural gender (feminine). She demonstrates that even the notion of biological difference is ideologically and socially conditioned. For the moment, though, and particularly in order to comprehend the function masquerade serves in Doane's essay, where the sex/gender dichotomy is still very much in operation, I will allow this somewhat crude binarism to stand. See Judith Butler, *Gender Trouble: Feminism and the Subversion of Identity*, New York, Routledge, 1990.

8　Doane, "Film and the Masquerade," pp. 81–2.

9　It must be stated that such claims on behalf of an exaggerated masquerade or a "flaunted femininity" depend for their efficacy on the masquerade being recognized as a masquerade by women and men. It is unlikely, for instance, that heterosexual men would comprehend any critical distance in a woman's excessive flirtatiousness (and in fact, Riviere's essay, as a case history, makes none of the political claims of Doane's). Even the supposed subversiveness of men dressing as women is quickly recuperated into discourses of homophobia – whether the cross-dressers are straight or gay – and is unlikely to have any positive feminist effect.

10　This provocative question is raised by Butler in her effort to create a geneaology of the category *women*. See Butler, *Gender Trouble*, pp. 1–34.

11　Ibid., p. 123.

12　The psychoanalyst Jacques Lacan makes this point explicitly in his theory of the gaze: "This is the function that is found at the heart of the institution of the subject in the visible. What determines me, at the most profound level, in the visible, is the gaze that is outside. It is through the gaze that I enter light and it is from the gaze that I receive its effects. Hence it comes about that the gaze is the instrument through which light is embodied and through which – if you will allow me to use a word, as I often do, in a fragmented form – I am *photo-graphed*." Jacques Lacan, *The Four Fundamental Concepts of Psycho-Analysis*, ed., Jacques-Alain Miller, trans. Alan Sheridan, New York, W. W. Norton & Co., 1978, p. 106.

13　It needs hardly to be recalled that the tattoo has at least two sets of strong cultural associations: relating to macho military traditions on the one hand, and to the recent widespread subcultural resignifications of these meanings on the other.

14　In 1964, the writer William Burroughs, who often collaborated with the artist Brion Gysin, made at least two photographs using scraps of newspaper as a negative. See Robert A. Sobieszek, *Ports of Entry: William S. Burroughs and the Arts*, Los Angeles, Los Angeles County Museum of Art, and New York, Thames and Hudson, 1996, pp. 34–5.

15　Kirby Gookin, "Mark Morrisroe [exhibition review]," *Artscribe*, March/April 1989, p. 81.

16　Michael Warner, "Introduction," in Michael Warner, ed., *Fear of a Queer Planet: Queer Politics and Social Theory*, Minneapolis, University of Minnesota Press, 1993, p. xxvi.

liz kotz

aesthetics of "intimacy"

After the 1996 Nan Goldin retrospective at the Whitney Museum, the responses of friends I talked to
varied enormously. Some who had lived similar lives during parts of the 1980s – "not that life,
but the next one over," in one's words – appreciated the show. It gave them a sense of
recognition, and an occasion to retrieve a sensation of a world now gone. A writer friend who'd
spent years developing the form to narrate her own chaotic experiences suggested that sometimes
Goldin's images "monumentalize in a way that trashy lives don't." And another, a visual artist,
emerged from the show horrified at the mawkish wall texts and Goldin's forced naivety. She
remarked: "They should have called this show 'Nan Goldin: One Lie After Another.'"

The extremes of these responses tell us something about this kind of work, this loose genre of
personal photography that gets termed "insider" documentary or "subcultural" photography. For
starters, that even those who would seem to be "insiders" can't agree. The critical response, in
both the art and the popular press, was exceptionally uninformative, ranging from the usual
gushing paeans to Goldin's "brutal honesty" and "emotional directness," to the predictable
charges of "exploitation" or bad taste, to not unsurprising praise for her "formal beauty." We
already know all of those terms, and I think we know they're not really adequate. What, then,
might be more useful terms to discuss this work?

At the outset, Goldin's work presents some particular problems: what we're looking at is not
just "work," but something more like a "phenomenon." As anyone who has spent any time in
the visual art world in recent years well knows, a certain kind of work is everywhere: gritty,
quasi-documentary color images of individuals, families, or groupings, presented in an apparently
intimate, unposed manner, shot in an off-kilter, snapshot style, often a bit grainy, unfocused, or
off-color. The subjects are outside the apparent "mainstream" (although they are almost always
white): gay people, transvestites, the drug culture and punk rock, urban bohemians, club kids, an
occasional maladroit family (Figs 11.1–11.2). Some are in distress, but not all. Overtly "marginal"
subjects, they are types of people supposedly "outside" mainstream representation, outside the
dominant culture. And in some senses this work can be viewed as a kind of "self-representation,"
particularly as gay self-representation. By and large, the people shooting the images more-or-less

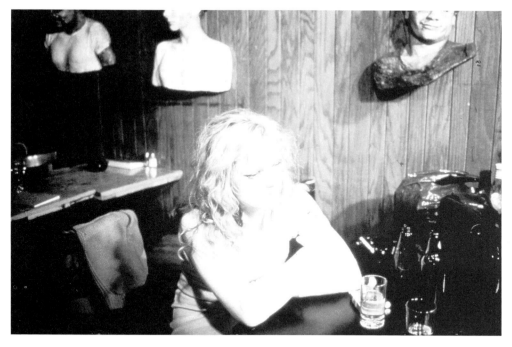

Fig. 11.1 Nan Goldin, *Cookie at Tin Pan Alley, NYC*, 1983. Courtesy Matthew Marks Gallery, New York

belong to the groups they are photographing: that is one of the premises of this kind of work, though exactly what this might mean or do is not totally clear.

Besides Goldin, the photographers we might associate with this loose grouping of work could include Larry Clark, Jack Pierson, Wolfgang Tillmans, Mark Morrisroe, even Richard Billingham. This last is particularly telling, because at first he doesn't seem to fit: a young British art grad who has made a sudden sensation with beautiful, chaotic images of his screwed-up, apparently sub-proletarian family, largely confined within their hideous public housing flat. You can buy his large color coffee-table book at any decent bookstore, right alongside the brand new Jack Pierson book (his third), the new Wolfgang Tillmans (his second), or the recent Nan Goldin/Nobuyoshi Araki collaboration (her fourth).

The fact that this work is so easily available, so lushly produced, so widely commercially circulated, is part of the "phenomenon." Of course, you can't buy Larry Clark's books, at least in the United States, since the most recent one was banned for alleged depiction of underage sexual activity, and the older ones, *Tulsa* and *Teenage Lust*, are long out of print, rare, and quite expensive.[1] Yet on one level access to the "original" images barely matters, since this look has so disseminated throughout the culture, passing over into fashion and advertising. Open almost any fashion magazine, especially British ones, or a recent copy of *Interview*, and you may see its stylistic derivatives: awkwardly posed, garishly lit images for an era of guilty consumption.[2] Of the artists I've named, only the late Mark Morrisroe, whose work was both more modest in scale and more diffuse, is not so easily accessible, although a number of his images are reproduced in the recent *Boston School* catalogue; a Polaroid-ish shot with the text "Dismal Boston Skyline – Mark Morrisroe c. 86 1/12" scrawled haphazardly below, is on the cover (Fig. 11.3).

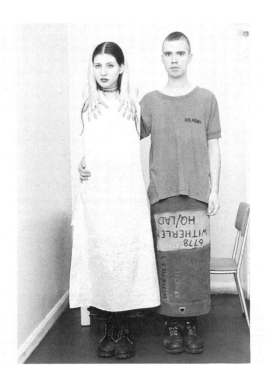

Fig. 11.2 Wolfgang Tillmans, *Suzanne & Lutz, White Dress, Army Shirt*, 1993. Courtesy Andrea Rosen Gallery, New York

Fig. 11.3 Mark Morrisroe, *Dismal Boston Skyline*, 1986. Courtesy Pat Hearn Gallery, New York

Oddly, that caption says it all: that if you were young and sensitive and looking out the window of your small cramped miserable apartment, at that truly dismal skyline, in 1986, in Boston, one of the most miserable cities in the world, you too might want to take drugs and act out and long for escape by any means possible. At least I would. This kind of nondescript little image stops me cold, stops me from launching the kind of dismissive critique it would be only too easy to make. And the image is really "nothing special," just an average skyline shot of a downtown on a sort of overcast day, a little too dark, pretty banal. It could be a postcard reject, or an amateur shot – almost anyone's. It's that very ordinariness that makes it work: that the image *could* have been anyone's, that you might have taken that image if you'd been there then, feeling like that. Operating precariously on the amorphous boundary between "art" and vernacular uses of photography, Morrisroe's work allows viewers to project themselves and their own pasts into the image while also insisting on its specificity as a document of *his* life, not ours.

That's one way this work works, when it does work: a possibly banal image, or even a gruesome one, that triggers a flood of memory, a spark of recognition, and a sense that something private and precious has been disclosed to you. It's precisely the fragility of this private disclosure that gets trampled by the rampant consumerism of the coffee-table book and the museum catalogue. By its very definition as a private, haphazard, accidental meaning, a *punctum* isn't a *punctum* if it's the same for everyone; then it's the *studium*: the coded, public, official meaning.[3] Part of the pleasure this work offers is to allow the *viewer* to feel like an "insider," an intimate, partaking in an experience that is neither public nor official. When the same images are reproduced too many times, in too many places, and are liked *in the same way* by too many people, this intimacy is inevitably compromised. If we all feel the same sentimental rush before the same image, it ceases to be poignant, and instead becomes trite, coded, formulaic: an index of bland liberal humanism rather than acute social difference. And few things are more repellent than a programmed sense of "intimacy" or a regulated experience of "accident."

Perversely, one of the things that initially drew me to writing on Goldin's work was the claim, by countless writers, that her work is "not voyeuristic," that "there is no voyeurism in these images," and so on. Accompanying these claims was the constant affirmation of Goldin's status as insider, participant and survivor of the worlds that she records, often supported by quoting from statements by the artist, as in her introduction to *The Ballad of Sexual Dependency*: "There is a popular notion that this photographer is by nature a voyeur, the last one to be invited to the party. But I'm not crashing; this is my party. This is my family, my friends."[4] To prop up this persistent naturalization of the photographic activity, and further repress the mediation of the technological apparatus, the camera is refigured as a bodily extension, of human sight, of touch: "Taking a picture of someone is like caressing them." As Goldin states:

People in the pictures say my camera is as much a part of being with me as any other aspect of knowing me. It's as if my hand were a camera. If it were possible, I'd want no mechanism between me and the moment of photographing. The camera is as much a part of my everyday life as talking or eating or sex. The instance of photographing, instead of creating distance, is a moment of clarity and emotional connection for me.[5]

Why the persistent need, on the part of artist and viewers, to disavow the voyeurism which is so patently and obviously present in these images? Clearly, it is not just Goldin's voyeurism, but our own, which is pervasively disavowed in such claims. Presented under the guise of an "intimate" relationship between artist and subject, these images relegitimize the codes and conventions of social documentary, presumably by ridding them of their problematic enmeshment

with histories of social surveillance and coercion. Such blind faith in authorial self-understanding and intention, however, ignores the extraordinary power of the photographic language employed: a language with a history and an inscribed structure of power relations that cannot be easily evaded by the spontaneous performance before the lens.

If museum curators, critics, and the art world as a whole rush to embrace Goldin's apparent naivety – "Nan is so honest, there's no screen of theory between her and her work"[6] – it is in part because her enthusiastic willingness to naturalize the photographic transaction allows us to ignore everything we know about the history of photography. It's not so much Goldin's tendency to repress certain historically problematic legacies or to present herself in public as "naive" that troubles me (I have no doubt that she is quite intelligently acute about her practice) but the idea that this somehow "permits" an entire art establishment (which is anything *but* naive) to systematically repress the past twenty years' critical and artistic work investigating such transactions.[7]

As critics and artists such as Martha Rosler, Allan Sekula, and others have long insisted, documentary photography has always been premised on the transgressive pleasures of looking either down the social scale (Strand, Stieglitz, *et al.*) or, more rarely, up (Weegee). If earlier American social documentary practices, such as those of Lewis Hine and the Farm Security Administration, legitimized this pervasive looking at the lives of the poor and disempowered by doing so in the name of reformist social philanthropy or government aid, postwar photography takes the *camera itself* as a license to look. This "New York School" work of Diane Arbus, Richard Avedon, and others derives, critics have argued, from the *failure* of the overtly reformist projects of the 1930s, producing a postwar photographic practice in which (in Benjamin Buchloh's words) "the masochistic identification with the victim" takes over.

For better or worse, such fantasied identifications, and the relentless social voyeurism they authorize, historically open up an entire range of potential new photographic subjects, inadvertently creating the conditions for the relatively new practices of "insider" documentary photography which emerged in the 1960s and 1970s. After all, with photography, one is always in the realm of surveillance, and we really *do* want to look. In the work of subcultural photographers such as Clark and Goldin, the claim to inside-ness, to belonging to the group which is being surveilled, seems to have two principal functions: it allows us greater access, and, as insiders, the photographers' voyeurism authorizes our own.

Given its problematic roots in projects of social surveillance and overt exoticism, the ongoing "ethics" of subcultural documentary demands that the transaction between artist and subject be represented as an *exchange*. For the photograph which is taken, something must be given to the subjects in return: the photographer must endeavor to provide political or reformist help, confer "truth," "dignity," or "humanity" upon the subjects, or at the very least, give them a print. The very relentlessness with which the literature surrounding this work informs us of such "gifts" is perhaps a very good indication of just how queasy such transactions can be – even when subject and photographer are "friends," intimates, or share the same social milieu.

Paradoxically, in the current moment, in which liberal myths of benevolent social "help" have long ceased to be credible, what is most valuably offered by the photographer is simply "recognition." In a recent profile, Goldin recounts how "A TV crew in Paris asked my friend Gotscho, 'What's it like to be photographed by Nan? Don't you feel like you're being imposed upon in your private moments?' And he said, 'No, I feel I'm more myself when Nan's looking at me than I ever am in the rest of my life.'"[8] It's as if, in our current lives of fragile identity and purely privatized experience of social power (I can't change the world, but I can change my hair

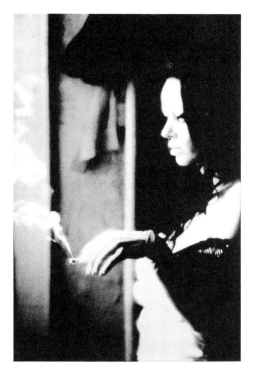

Fig. 11.4 Jack Pierson, *Et Maintenant?*, 1993–94. Courtesy the artist and
Luhring-Augustine Gallery, New York

color), our very existence as subjects must be constantly confirmed by the gaze of others. We've
all encountered this exchange in the gaze of a lover or intimate. But what does it mean for such
moments of recognition to be monumentalized into images, photographs that are no longer
consigned to the photo album or dresser drawer but publicly disseminated through mass
reproduction or museum exhibition?

It is in comparison with the superficially similar work of Jack Pierson that Goldin's relative
conformity to the conventions of liberal social documentary emerges most tellingly. By
presenting his images as pure appearance, pure image, Pierson refuses the illusion of
transparency promised by social documentary, and with it, the expectation that one can learn
something about others through photography. A viewer can read the images as "gay," but
one learns little or nothing about the subjects. If, in Pierson's work, the overall aesthetic effect
is the object, we realize that, in Goldin's photographs, the image is utterly dependent on the
caption, on the identity of the subject (hence the endless and heavy-handed wall texts featured
in her Whitney retrospective). Whereas Goldin's work continues to make a claim on
"benevolent" liberal understanding – playing to an art-world version of Madame de Staël's
"tout comprendre, c'est tout pardonner" (to understand all is to forgive all) – Pierson asks for
neither comprehension nor moral pardon: removing anything overtly "political," no claims are
being staked.

Thus, while frequently grouped with the work of Goldin and other "Boston School"
photographers, Pierson's project may actually be closer to the quotational practices of artists like
Richard Prince. Although Pierson doesn't *literally* rephotograph existing images, he takes his
"own" photographs which somehow uncannily echo or resemble pre-existing cultural
documents and motifs. In so doing, he clearly understands photography as fully semioticized,

fully coded, and knowingly uses it to recirculate certain motifs, not to hold these myths up for scrutiny, but to re-open them for sentimental investment by artist and viewer alike:

My work has the ability to be a specific reference and also an available one. It can become part of someone else's story, because it's oblique and kind of empty stylistically . . . I've geared my work toward getting people to think in that way, toward having romantic allusions that they could take and run with. By presenting certain language clues in my work, people will write the rest of the story, because there's a collective knowledge of cliches and stereotypes that operates.[9]

Given this account, which itself uncannily resembles the logic embedded in advertising images, it should come as no surprise to learn that Pierson was initially trained in graphic design, rather than photography. It accounts for his extraordinary attention to form and presentation, and his use of photographs as tools for total effect rather than as an end in themselves. (We should know, for instance, that Pierson routinely crops his prints to evoke the vertical look of the snapshot, or the horizontal frame of cinema.) The legitimating values of subcultural documentary – "immediacy," "honesty," "intimacy," and the like – are understood as effects of photographic codes, rather than as spontaneous intersubjective performances communicated neutrally via the photograph.

Thus, unlike Goldin's work, there is no real sociological content here, no illusion of transparency, no appeal to liberal humanist understanding. Instead, it operates as sheer sensibility. It's not hard to grasp Pierson's relation to Morrisroe's project, which also functions on the level of sensibility, sentimentality, and the poignant. If all three artists share a tendency towards highly self-conscious self-fashioning, both Morrisroe and Pierson go outside the boundaries of photography proper, extending the exploration of subjectivity and self-portraiture to found materials and text. Self-consciously playing on existing genres and images, both Pierson's and Morrisroe's works continually reveal how subjectivity itself is propped up on an amalgam of desired images: ideal images which we may strive towards, yet to which we feel perpetually inadequate. As Pierson's gridded "self-portrait" (1993), collaged from pages of a James Dean fanzine, attests, we have all seen these images before, yet they still have a certain power to move us, to elicit fantasy and identification (Fig. 11.5).

There is no small irony, then, in the claims of some who support the "Boston School," that this work represents a welcome return of documentary and portrait photography in all their sincerity, transparency, and capacity to function as a "window onto the world," particularly one representing marginalized subjects and subcultures. For if Goldin willingly upholds these beliefs as somehow still possible in late twentieth-century culture, what viewers and critics consistently find "disappointing" and "contrived" about Pierson's work is its inherent construction as a prop for the viewer's fantasies and fantasized identifications, and its implicit address to the viewer's own narcissism and self-recognition. As Pierson states:

You can draw certain language clues and get anybody to believe anything. And I'm a narcissist, and I understand the mechanisms of language and visual clues. I can create a persona from them. Easily . . . Everybody is a narcissist. That's why people can respond to my work.[10]

Such overt recognition of projective content could not be further from the discourse on Goldin's work, yet many of the same mechanisms are in play. What in Goldin's work is still presented as chance documentary effect (however uncredibly so at this point) is fully stylized and controlled in Pierson's avowedly aestheticized practice. As a gradual but inescapable aesthetic

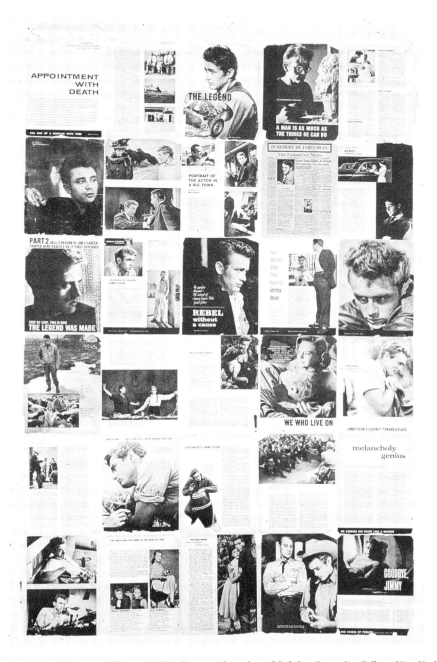

Fig. 11.5 Jack Pierson, *Self-portrait*, 1993. Courtesy the artist and Luhring-Augustine Gallery, New York

codification deprives us of the *punctum* as accidental detail, it may be through this kind of narcissistic identification, this moment of self-recognition in the image, that viewers are offered the experience of constructing an uncoded private meaning in the public coded world of the photograph.

Paradoxically, the emotional response and pathos Goldin's images can at times elicit may depend precisely on her capacity to disavow these processes, while nonetheless engaging them. Sumptuous and sometimes astonishingly beautiful, Pierson's images are not quite what I would describe as "moving": we witness a sense of longing, but whatever pathos seeps in remains resolutely outside the frame. For in the end, nothing could be more different than how Goldin's and Pierson's images "speak of" AIDS. What is explicitly imaged in Goldin's photographs – the deaths of friends, the gradual succumbing to disease – is completely invisible as a subject in Pierson's work, yet nonetheless strongly present as an emotional undertow. Death, poverty, and intense deprivation remain off-frame as precisely that which makes the everyday "banal" pleasures depicted in Pierson's book *Angel Youth* (1992) – pretty boys, flowers, sun-drenched meals with friends – feel so rare and poignant (Fig. 11.6).

However indirect, Pierson's insistent refusal to image death and disease implicitly challenges Goldin's increasingly monumentalizing efforts to image death and suffering. If, in the series of images of Cookie Mueller, AIDS enters the scene as a happenstance tragedy, by the time Goldin photographs her friend Gotscho dying, AIDS has become both the subject and the narrative. In an especially telling five-panel vertical series (1993) (Fig. 11.7), we follow Gotscho from health and vitality to disease and then death. While some viewers clearly find this sequence deeply moving, it struck me as pat and formulaic. Unlike the Mueller images, which present idiosyncratic moments from the life and death of a distinct individual, the later series monumentalizes Gotscho's death as heroic, exemplary, and fully spectacularized.

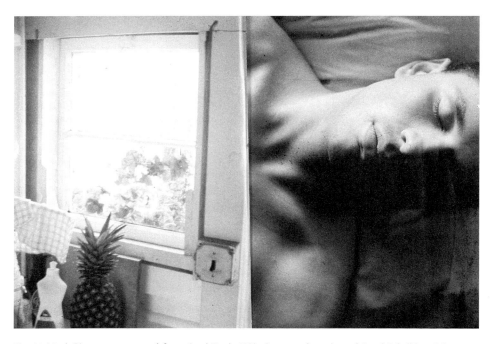

Fig. 11.6 Jack Pierson, page spread from *Angel Youth*, 1992. Courtesy the artist and Aurel Scheibler, Cologne

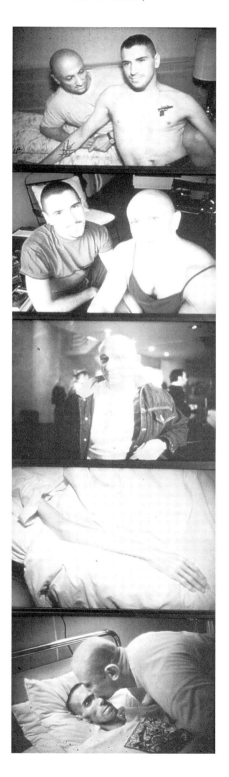

Fig. 11.7 Nan Goldin, *Gilles and Gotscho*, 1992–93. Courtesy Matthew Marks Gallery, New York

A key photograph, occurring late in Morrisroe's work (*Untitled*, 1988), depicts a grainy yellow sky with an out-of-focus silhouetted seagull hovering (Fig. 11.8). It too "speaks of" AIDS, of a life lived against its constant presence, but nothing could be further from the explicitness of the documentary image. By insisting on the importance of that which remains outside representation, the work provides a compelling challenge to the documentary tendency towards total specularization. An experience is offered, but it remains mute, ineffable. You're only given a little access, but maybe that's an antidote to being given too much.

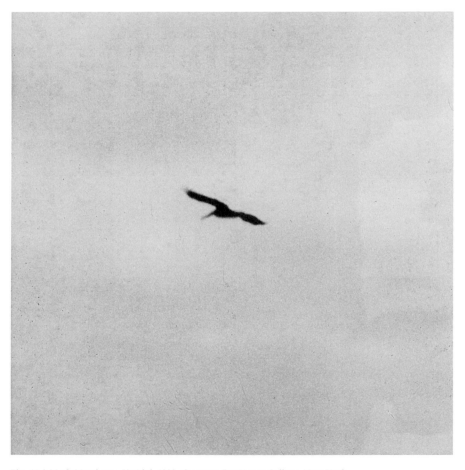

Fig. 11.8 Mark Morrisroe, *Untitled*, 1988. Courtesy Pat Hearn Gallery, New York

aesthetics of "intimacy"

notes

My thanks to Diane Bonder, Pat Hearn, Matias Viegener, Simon Watson, and others for discussing this work with me, and to Deborah Bright for her endless patience and good will. The views expressed are of course my own.

1 See José Esteban Muñoz's essay in this volume.
2 Hence the peculiar perversity of Billingham's project, in which the look of present-day hip fashion photography, itself loosely derived from work by Clark, Goldin, and Pierson, is refashioned once more as a language for realist social documentary.
3 These classic terms come from Roland Barthes's *Camera Lucida*, in which he defines the *punctum* as that which can interrupt the stable, homogenous level of the *studium*: "In this habitually unitary space, occasionally (but alas all too rarely) a 'detail' attracts me" (p. 42). "The detail which interests me is not, or at least not strictly, intentional, and probably must not be so; it occurs in the field of the photographed thing like a supplement that is at once inevitable and delightful" (p. 47).
4 Nan Goldin, introduction to *The Ballad of Sexual Dependency*, New York, Aperture, 1986, p. 6.
5 Ibid. Almost identical statements could be culled from the Larry Clark literature, except that Clark, of course, entirely disavows the erotic dimension of photographic activity that Goldin so insistently affirms.
6 Whitney curator Elizabeth Sussman, as quoted in A. M. Homes, "The Intimate Eye," *Elle*, October 1996, p. 108. The quote continues: "To me, that proclaims a very specific moment, a shift out of the '80s, where there seemed to be an element of cynicism. Her art has never been about cynicism." Whether there is any element of cynicism in the Whitney's choice of the newly commercially successful Goldin as a subject for a mid-career retrospective – the first living female artist to receive one in almost four years – is, apparently, a question we shouldn't consider asking.
7 For instance, in a review of Mark Morrisroe's work, the art critic Peter Schjeldahl claims: "The Bostonians reacted authentically to a situation dominated, in '80s art culture, by theoretical prattle of 'postmodernism' and brittle pictorial mediating of, you know, mediated media mediations. Rather than brainily distance signs of signs and images of images, they sought bedrock in ferociously honed exposure of their first person, bodily, sex-saturated, fantasy-realizing, determinedly reckless experience." "Beantown Babylon," *Village Voice*, 9 April 1996, p. 81. Thus, a return to a prior model of photographic practice (a model of autobiographic self-display with roots well into the early twentieth century) is posed as the "authentic" in order to allow the critic to deny, it would seem, the very historicity of photographic images. One doubts that these artists, who were highly aware of their own photographic precedents, would be so naive.
8 Goldin, from A. M. Homes, "The Intimate Eye," p. 108.
9 Jack Pierson, quoted in Veralyn Behenna, "Jack Pierson: Little Triumphs of the Real," *Flash Art*, April 1994, pp. 88–90.
10 Ibid.

215

mark a. reid

postnegritude reappropriation and the black male nude
the photography of rotimi fani-kayode

Robert Mapplethorpe's nude portraits of black males have enjoyed wide distribution, attracted critical attention, and even precipitated federal legislation. As early as 1982, Mapplethorpe's photographs were shown at the Harlem Exhibition Space, a gallery in New York City's African American community,[1] and they have had many national and international shows since. The exhibition of Mapplethorpe's homoerotic photographs in federally funded museums in the United States in the late 1980s led to new federal appropriations legislation, requiring artists who were given National Endowment for the Arts fellowships to sign an affidavit assuring Congress that the funds would not be used to produce, promote, or disseminate "obscene" or "indecent" materials.

In this essay, however, I would like to discuss Mapplethorpe's work only as it relates to the black male nude photography of Rotimi Fani-Kayode, a Nigerian-born and western-educated artist whose photographs are rarely exhibited in art galleries outside of England (and even there they have met with resistance, as one London gallery refused to exhibit Rotimi's portraits, claiming that they merely imitated Mapplethorpe's). In discussing Rotimi's work, I want first to indicate how western critics – and, through their lack of interest in black gay art, the black British and African American communities – have permitted Mapplethorpe's work to enjoy uncontested space in defining black male nude photography in the West. Second, I would like to explore the psychological and social tension between bourgeois commonplaces and eruptions of post-negritude funk in the photographic act of revisualizing black masculinity. Rotimi's marginal position within black art, and his photographic construction of naked black men, are instances of a postnegritude womanist eruption.[2] His mythopoetic images hail the disjunction of hegemonic forms of representing the black body in western art.

Rotimi's photography articulates a racial/sexual politics of identity. His artistic vision is politically racial and homosexual, and he negotiates and/or resists the psychological, social, and

cultural pressures that would subordinate his black gay subjectivity. In "Being Gay: Politics, Identity, Pleasure," Joseph Bristow writes:

First, gay male identity . . . has always conceived of itself within a sexual politics; that is, within a mutually informing transaction between those two words – a sexualization of politics and a politicization of sex. And second, to be "gay" is not to subscribe to some existential essence. It is instead . . . a strategic identification to express demands in a western world that constantly wants to rid itself of homosexual representation.[3]

Correspondingly, Rotimi's African gay subjectivity invokes a racial politics that resists eurocentric demands to rid itself of African retentions. Rotimi's politicization of his own black gay subjectivity infuses his work with a dialogic quality, one that is similarly present in the doubly resistant discourses of black womanist art (see pages 310 and 311).

Elsewhere, I have defined black womanism as "a form of resistance to a raceless feminism and a phallocentric pan-Africanism."[4] Rotimi's creativity shares a womanist sensibility and explores, through his use of Yoruba mythology, a multitude of visual assertions of blackness. His politicization of race, sexuality, and ethnicity are instances of "postnegritude" – that is, "any moment when members of the black community, through their literature, art and politics, recognize that black culture 'is concretely, an open-ended, creative dialogue of subcultures, of insiders and outsiders, of diverse factions.'"[5]

rotimi is to mapplethorpe as thomas is to dovana

In her analysis of Mapplethorpe's *Thomas and Dovana*, Ingrid Sischy argues that the photograph re-enacts America's racial fears and fantasies. She describes how the image evokes American popularized versions of the sexual economy of the master/slave relationship:

In 1988 something seems very urgent to me. It has to do with memory, and with freedom. So I chose to emphasize in this essay that part of his work which is a record of our civil battles, and an expression of our civil rights . . . One picture by Mapplethorpe, "Thomas and Dovana," epitomizes this. It is of a couple dancing. The man is black; he is naked. The woman is white, she wears a white evening dress, white gloves. She is arched in a melodramatic pose, and he supports her. The picture is a twist, a tie of images that summon "Gone With The Wind," "Mandingo," and fashion all in one, and the knot that holds it together is very different from anything we might expect. It is opposite of the tradition of burying; it is part of the tradition of showing and thereby knowing.[6]

If Mapplethorpe's vision encompasses the fears and desires of the West, how then do Rotimi's images evoke (or resist) similar fears and desires held by the colonial subject? To answer this question, I want to discuss the postnegritude tension between identifying with authorized marginality (as in Mapplethorpe's work) and empowering a resistant art practice. Implicit in my interpretation of Rotimi's work is a critique of the "showing and knowing" creative tradition. Authorial intent never insures against "burying" forms of reception since viewers tend to rely on certain master formulas to decode the unclothed black body. It is the tension between burying the past, discovering its presence, and consciously selecting the appropriate reception formula that creates the critical silence surrounding Rotimi's portraits of black men.

217

Mapplethorpe's work reflects his preoccupation with dramatizing the racist (homo)sexual fantasies held by the neocolonial mind. But his work does little to expose the tension between receptive forms of resistance and negotiation. Mapplethorpe's images are devoid of any ethnicity and it is significant that there is no corollary interest in Rotimi's Yoruba-inflected black nudes. The critical silence surrounding Rotimi's work manifests the West's primordial erasure of Africa in the history of world art, much like the severing of Negroid noses from Egyptian sphinxes. Rotimi's vision is one example of a postnegritude dilemma in which certain forms of black cultural resistance share visual and psychic space with colonial discourses on "The Hottentot Venus" and postcolonial photographic images of "The Hottentot Adonis."

nursed at the bosom of multiple forms of blackness

Oluwarotimi Adebiyi Wahab Fani-Kayode was born in Lagos, Nigeria, in 1955. His *oriki*, or praise name, is Omo Oliife Abure Omo Ade'de Owo Remo, which means "Child of Ife, heir to the crown wealth of the family of the Akire." His family hails from Ife, the spiritual center of the Yoruba people, and served as keepers of the shrine of Yoruba deities and as priests of Ife.

Rotimi's father, Chief Remi Fani-Kayode, was leader of the opposition bloc in the Nigerian Parliament in 1960, and by 1964, was Deputy Prime Minister of the Western State, one of the three administrative regions of the British colony of Nigeria. The 1966 military coup ousted him from this position, and the family emigrated to England as political refugees. There, Rotimi attended primary and secondary school, while his father acquired the title of "Balogun of Ife," a traditional Yoruba title of "warrior." (This status has relevance solely to the Yoruba ethnic group and has little effect on Nigeria's political administration.) Chief Remi Fani-Kayode's two social positions made the Fani-Kayodes an aristocratic, post-independence Nigerian family.

Rotimi attended British schools until 1976, when he traveled to the United States to study economics and fine art at Georgetown University. His parents had agreed to finance his undergraduate and graduate education on the condition that he major in economics while he studied art. Earning a Bachelor's degree in 1980, he pursued a Master of Fine Arts degree in photography at the Pratt Institute in Brooklyn. After receiving his degree in 1983, he returned to England, where he lived and worked until his death from AIDS in 1989.

While at Pratt, Rotimi experimented with color photography and developed a style employing Yoruba folk images. His early photographic works are surrealistic color portraits of black men in Yoruba attire. Alex Hirst, a British photographer–film-maker and co-founder of the art journal *Square Peg*, notes that Rotimi's imagery "came out of his African experience and his physical separation from Africa. His work is more influenced by Africa than by his experience in the West. Rotimi felt that he had been cheated of his Yoruba culture since he and his family were forced into political exile."[7] Rotimi was an expatriate Nigerian yearning for his cultural past, but he recognized that he was also marginalized by a cultural past that refused his gay presence.

Rotimi chose not to exhibit his photographs in Nigeria or in other parts of Africa, fearing this might harm his family's social status and lower the political and religious esteem in which the Fani-Kayode patriarch was held. He felt that Nigerians would interpret his photographs as representations of the Fani-Kayode family rather than as his personal vision of black male sexuality. As Rotimi himself said:

As for Africa itself, if I ever manage to get an exhibition in say Lagos, I suspect riots would break out. I would certainly be charged with being a purveyor of corrupt and decadent Western values. However, sometimes I think that if I took my work into the rural areas, where life is still

vigorously in touch with itself and its roots, the reception might be more constructive. Perhaps they would recognize my smallpox Gods, my transsexual priests, my images of desirable Black men in a state of sexual frenzy, or the tranquility of communion with the spirit world. Perhaps they have far less fear of encountering the darkest of Africa's dark secrets by which some of us seek to gain access to the soul.[8]

Rotimi's decision not to exhibit his nudes in Nigeria manifests his complicity in respecting a status quo which denied his homosexual selfhood, as well as its artistic expression. If one considers how problematic it is for a gay photographer to inherit the title of "Balogun of Ife," then one arrives at the postnegritude moment when a patriarchal and heterosexist tradition fragments. Resistance is a complex and slippery action which can be nullified by hegemonic social and psychic forces. Illustratively, Rotimi complied with the hegemonic forces of heterosexism and Yoruba tradition and thereby denied his sexuality to his Nigerian public while exploring it under the agency of western art photography. His decision exemplifies a postnegritude process of "double talk" which is laden with contradictions and gaps in consciousness.

As other doubly exiled artists, Rotimi reconciled the fact of his separation from Africa by narrating the rupture: "On three counts I am an outsider: in matters of sexuality; in terms of geographical and cultural dislocation; and in the sense of not having become the sort of respectably married professional my parents might have hoped for."[9] Rotimi's confessional narrative is visualized through his nude photographs of black men. Each photograph expresses his attempts to reconcile the first two forms of exile he experienced – that of his Yoruba self from Nigeria, and that of his black gay self from an expatriate Nigerian community in England. Rotimi's photographs permit a sort of imaginary memory in which his gay identity converges within contested spaces of post-independent Africa, which has politically and psychologically suffered fragmentation. Instances similar to Rotimi's predicament force Africans and African diaspora peoples to reassess their past and reformulate the constitutional elements of blackness. Scholar Teshome H. Gabriel finds that "Our memory is always subject to change depending on several factors. To some, memory is an impediment, something to be forgotten. But the power of memory is such that in struggling to forget . . . one [is] in fact reinforcing the very power to recall"[10].

Rotimi's decision to exhibit his male nudes exclusively in western metropolises such as New York and London is at once an act of self-denial and self-affirmation. He denies his homoerotic art in Africa but celebrates it in countries where his black and gay identities make him doubly an outcast. In this sense, he is similar to earlier African American and Afro-Caribbean expatriates such as Josephine Baker, Sidney Bechet, Richard Wright, Chester Himes, James Baldwin, and Frantz Fanon, black exiles who discovered and recreated their racial identities through fictive memories which, paradoxically, garnered recognition in western capitals and cultural marketplaces.

Because Rotimi's work escapes recognition in Nigeria, his photographs are living spirits in search of their Yoruba roots – imagined and real. His black male nudes dramatize the uncertainty of where his Nigerian self ends and where his exiled western self begins. It is not Rotimi's fault that his photographs are incomplete fragments warring for some sense of wholeness in which a diasporic Yoruba culture celebrates and affirms black male sexuality in all its forms. He and his resistance are determined by a postnegritude dilemma in which blacks bury certain elements of their oppression while reaffirming other aspects. Rotimi's photographs alter traditional Yoruba perceptions about an inheritor of the Balogun title as well as the sociopolitical and familial image of the Nigerian Deputy Prime Minister of the Western State.

Figs 12.1–12.3 Rotimi Fani-Kayode, photographs, n.d. Courtesy of the Estate of Rotimi Fani-Kayode and Autograph, London

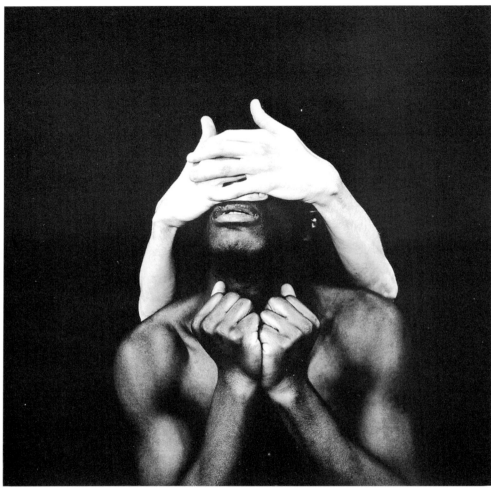

Fig. 12.1
Untitled

the hottentot black (fe)male body in visual art

A narrow interpretation of Rotimi's photography would reduce his work and vision to a singular African or Yoruba or gay aesthetic. I believe his work presents many forms of black male sexuality and articulates a dialogical tension between historical affirmations of racial, ethnic, and sexual pride, and discourses which would deny such utterances. One must recognize that the colonial experience mutually affects the social and psychic constitution of the West. Consequently, Rotimi's photographs are imbued with an eroticized blackness which speaks both to Africa and the West. His images question the dehumanizing gaze which objectifies the black body as unruly and warranting discipline and excision.

 Unlike Mapplethorpe's portraits, which often focus voyeuristically on black male genitals, Rotimi's photographs emphasize the centrality of the total black male form rather than its physical

castrations. The excessive dismembering of the black body is evident in the extreme close-ups of black penises in many of the photographs in Mapplethorpe's *Black Book* (1986), as well as in Leni Riefenstahl's *The Last of the Nuba* (1974).[11] According to Rotimi:

Some Western photographers have shown that they can desire Black males (albeit rather neurotically). But the exploitative mythologising of Black virility on behalf of the homosexual bourgeoisie is ultimately no different from the vulgar objectification of Africa which we know at one extreme from the work of Leni Riefenstahl and, at the other, from the "victim" images which appear constantly in the media.[12]

The images in these books reveal, through the act of showing, racial fantasies masked under the guise of anthropology and fine art. They bury the social history of racial lynching and castration while indirectly recasting it in socially acceptable forms. Correspondingly, the genitals of the black female have been equally objectified across a range of modern cultural discourses in the West, including in works of art such as Pablo Picasso's *Olympia* (1901); on the Paris cabaret stage where Josephine Baker performed her "banana dance" in the 1920s; and in the numerous medical and scientific ruminations on "the Hottentot Venus," Saartje Baartman, whose genitals were literally excised after death by French anatomist Georges Cuvier and preserved in formaldehyde. The story of the Hottentot Venus illustrates how the colonialist speculum (both a mirror and gynecological examining tool) physically and psychologically segregated the genitals of African women from those of their white western counterparts, Victorian ladies. It was the black vagina – and, correspondingly, the black penis – that defined colonized sexuality as primitive and excessive. Sander Gilman describes J. J. Virey and his "scientific" discourse on this as follows:

the author of the study of race standard in the early nineteenth century [who] also contributed a major essay (the only one on a specific racial group) to the widely cited *Dictionnaire des sciences medicales . . .* (1819). In this essay, Virey summarized his (and his contemporaries') views on the sexual nature of black females in terms of acceptable medical discourse. According to him, their "voluptuousness" is "developed to a degree of lascivity unknown in our climate, for their sexual organs are much more developed than those of whites.[13]

Just as Mapplethorpe and Rotimi use the conventions of western art photography, Virey appropriated an "acceptable" form to extrapolate his extra-scientific discussion of the psychology of black women based on the physiognomy of their sex organs. When Mapplethorpe selectively frames well-endowed black glans, he visualizes a "Hottentot Adonis," and references the "voluptuousness" discourse of Virey. It is also possible to read Mapplethorpe's black men as a critical reflection on such racist fantasies in the minds of white (wo)mankind. Rotimi's work, while not as ambiguous in intent, may also enliven Virey's colonial discourse on the Hottentot woman – and, by implication, the Hottentot man – as the epitome of sexual lasciviousness, and may stress the relation between physiology and physiognomy. Oddly and tellingly, the speculum, a mirror instrument, was used to expose the interior cavities of various black women who were collectively called "the Hottentot Venus."[14] The nude images of both Mapplethorpe and Rotimi similarly mirror the interior psychic workings of the white western imagination, providing very different frames for "the Hottentot Adonis."

reception, dialogism, and complicity

Rotimi's nudes distance both the colonialist gaze and Mapplethorpe's white suburban fantasies. True,
Rotimi's photographs do not escape the already-existing Hottentot histories of primitive black
sexuality, nor do they avoid his Nigerian past. All artists are born into histories which determine
how others perceive their work. Yet, Rotimi acknowledges both the force of western history and
his ability to rediscover and revalidate his Yoruba past:

The history of Africa and of the Black race has been constantly distorted. Even in Africa, my
education was in English in Christian schools, as though the language and culture of my own
people, the Yoruba, were inadequate or in some way unsuitable . . . In exploring Yoruba history
and civilization, I have rediscovered and revalidated areas of my experience and understanding of
the world. I see parallels now between my own work and that of the Osogbo artists in
Yorubaland who themselves have resisted the cultural subversions of neo-colonialism and who
celebrate the rich, secret world of our ancestors.[15]

His photographs celebrate a complex black body that has been bombarded by the excisions of
the past. Rotimi articulates this in saying: "It is now time for us to reappropriate such images and
to transform them ritualistically into images of our own creation. For me, this involves an
imaginative investigation of Blackness, maleness, and sexuality, rather than more straightforward
reportage."[16] In his reappropriation of "acceptable" master discourses, Rotimi exorcizes colonialist
fantasies through the creation of alternative myths.

Theoretical discourses on postcolonial/postnegritude subjectivity must acknowledge that the
continuation of the Civil Rights movement and the development of a multiracial feminism
require the recognition of a polyvalent subjectivity that embraces fissures, gaps, and cyclical
setbacks. This realization enables the creation of intermittent spaces to reconstitute both self and
society. It permits irreverent eruptions, like Rotimi's photographs, to represent and interpret the
interstices of race, ethnicity, gender, and sexuality which are all aspects of black subjectivity.

In reading Rotimi's photographs, one must pursue a cultural criticism which articulates gaps
and fissures. This form of open-ended reading permits free zones of discourse and denies
monolithic and hegemonic closures that create binary oppositions of "us versus them," East versus
West, gay versus straight, and black versus white. As Trinh T. Minh-ha asserts, "no system
functions in isolation. No First World exists independently from the Third World; there is a
Third World in every First World and vice-versa."[17] Additionally, this denial of systemic closure
tends to reject critical theories which complacently accept the inevitability of a demoralized and
overdetermined socioeconomic present as the singular effect of postmodernity when the
postmodern also encompasses "a social category – a dominant yet diverse set of structural and
institutional processes wherein certain sensibilities, styles, and outlooks are understood as reactions
and responses to new societal conditions and historical circumstances."[18] One can neither deny
the heterogeneity of psychic forms of reception nor romantically ignore the fact that
sociohistorical experiences overdetermine the receptive processes of encoding and decoding
images of naked black bodies.

The refusal of one London art gallery to show Rotimi's work because, according to these
arbiters of British culture, it merely imitated Mapplethorpe, reflects the overdetermined nature of
hegemonic modes of reception. Equally overdetermined (in a very colonialist way) is the view
held by certain blacks that Rotimi's photographs represent European decadence. Contrary to
Mapplethorpe's work, which speaks to and denies European colonial fantasies, Rotimi's work, as

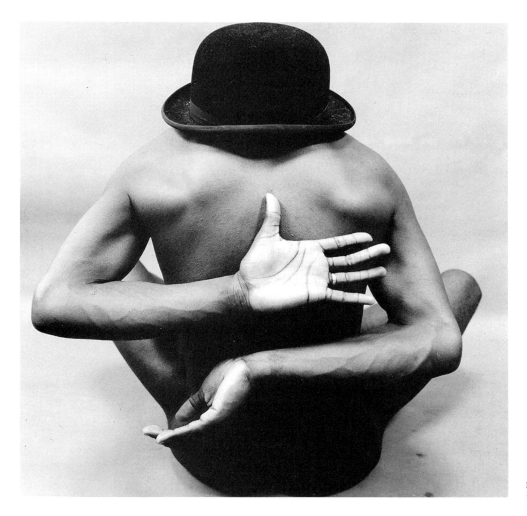

Fig. 12.2
Untitled

well as his social predicament, is an eruption of postnegritude funk. Rotimi Fani-Kayode, inheritor of the title "Balogun of Ife," lived on three continents. Mapplethorpe's experience was limited to his Catholic suburban upbringing and the gay multicultural bohemia of downtown Manhattan.

Rotimi was aware of western art and the fetishization of the black body. But his black males are framed as whole bodies, often adorned with clothing or props signaling his hybrid Nigerian/gay/British colonial identities (Figs 11.2, 11.3). Although Rotimi and Mapplethorpe are both gay photographers who explore black male sexuality, Rotimi is not obsessed with close-ups of the black penis. He resists Mapplethorpe's ambiguous vision of the black male as (un)threatening and (un)worthy of artistic and juridical beheading, in all of its legal and extra-legal forms. One need only review Mapplethorpe's photograph *Man in a Polyester Suit* (1980) to appreciate the point. Conversely, Rotimi de-emphasizes the very parts of the black body that Mapplethorpe and other white males have scientifically scrutinized, legally censored, and eradicated in lynching. Stuart Hall finds that:

Mapplethorpe's handling of the black male figure is always hovering on the brink of voyeurism (when it is not actually collapsing into it) and his truncation of the black body always amplifies its fetishistic effect, objectifying black sexuality. Fani-Kayode "subjectifies" the black male, and black sexuality, claiming it, without making it an object of contemplation and at the same time without "personifying it."[19]

we live in glass houses built on the same excrement

I want to acknowledge the fact that Mapplethorpe's vision is reflective not of his individual agency, but of a cultural and social experience which includes encounters with both black and white men. As expressed earlier, the master's discourse is mutually shared by the colonizer and the colonized. In a 1986 article entitled "True Confessions," and in its 1991 revised form, "Looking for Trouble," Kobena Mercer notes that certain black gays are titillated by Mapplethorpe's fetishistic images of black men and that therefore, black gay reception is implicated in a colonialist fantasy. According to Mercer, the photographs

encourage the viewer to examine his or her own implication in the fantasies that the images arouse. Once I acknowledge my own implication in the image reservoir as a gay subject, as a desiring subject for whom the aestheticized object of the look represents an object choice already there in my own fantasies, then I am forced to confront the unwelcome fact that as a spectator I actually inhabit the same position in fantasy of mastery which I said earlier was that of the hegemonic white male subject![20]

In addition, Mercer discovers a sort of liberal humanistic function in Mapplethorpe's use of the nude black body within the context of western art history. Having retracted his previous critique of Mapplethorpe's objectification of black men and black sexuality as a product of white male hegemony, he writes:

Previously, I argued that the fixative function of the stereotype played the decisive role in reproducing colonial fantasy: now, however, in relation to Mapplethorpe's authorial identity as an explicitly gay artist (located, like other gay artists, on the margins of mainstream art-world institutions), it becomes possible, and necessary, to reverse that view and recognize the way in which his aesthetic strategy begins to subvert the hierarchy of the cultural codes that separate the pure and noble values of the fine art nude from the filthy and degraded form of the commonplace racist stereotype.[21]

Mercer's reassessment of Mapplethorpe permits him to allude to the symbiotic relationship between fine art and ordinary racism. In a similar vein, I want to reassess how the surplus of critical attention accorded to Mapplethorpe's aesthetic strategy of subverting western fine art promotes the deficit of critical attention directed at Rotimi's aesthetic strategy. Surely, Rotimi's camera-eye subverts the hierarchy of the cultural codes that separate "the pure and noble values of the fine art nude" from commonplace racism. But Rotimi's work also avoids the shortcomings that Stuart Hall finds in the subversive strategy of Mapplethorpe, namely, its voyeurism and fetishization of black male sexuality.

In their co-authored 1986 version of the article that appeared in the British photography journal, *Ten.8*, Mercer and black gay film-maker Isaac Julien wrote:

Mapplethorpe appropriates the conventions of porn's racialised codes of representation and by abstracting its stereotypes into "art" he makes racism's phantasms of desire respectable . . . In pictures like *Man in a Polyester Suit*, the dialectics of fear and fascination in colonial fantasy are reinscribed by the centrality of the black man's "monstrous" phallus. The black subject is objectified into Otherness as the size of his penis symbolises a threat to the secure identity of the white male ego.[22]

During the same year that Mercer wrote "Imaging the Black Man's Sex" (1987), he borrowed from Michel Foucault's essay "What Is an Author" (1979) to discuss the overdetermined nature of hegemonic forms of reception. He correctly argues that Mapplethorpe's black male nudes reflect the socio-psychic image of black male sexuality regardless of the racial, sexual, and gender identity of the viewer. Mercer writes that the male nudes

facilitate the public projection of certain sexual and racial fantasies about the black male body. Whatever his personal motivation or artistic pretensions, Mapplethorpe's camera-eye opens an eye onto the fetishistic structure of stereotypical representations of black men which circulate across a range of surfaces, from pornography to sports, newspapers and advertising, cinema and television.[23]

In returning to Mercer's most recent Mapplethorpe study, "Looking for Trouble" (1991), one discovers the surplus that a capitalistic system creates when objects are in high demand. The scholar and the system of academic publishing permit the recirculation of an insightful reflection and, paradoxically, reveal the complicity of left criticism in this capitalistic process.

Unfortunately – and not to dismiss the importance of Mercer's analysis – the essay and its recycled forms do little to reveal how black male (straight and queer) artists are disempowered by the popularity and currency of critical essays about Mapplethorpe's black men. Is it possible to redirect this surplus of critical attention to this white artist's reflection of colonial desires and fears? How have certain academics and art critics participated in their own erasure while situating themselves in neocolonialist double-talking positions?

Taking a different interpretive direction, one could discuss the political import of Mercer's re-evaluation of Mapplethorpe's black male nudes. Such a discussion might reveal that certain well-meaning leftist intellectuals, of all sexual and racial stripes, are constrained by the very eurocentric nature of most western academic discourses. Are progressive academics not equally guilty (and I share some of this guilt) in "the circulation of colonial fantasy" when they limit their readings to the colonizer's products, rather than interpreting the oppositional fantasies of the colonized?

I implicitly support Mercer's use of Foucault to emphasize the shared nature of colonial readings and would further suggest the usefulness of the Bakhtinian notion of heteroglossia as multiple forms of reception which permit alternative readings. Mercer understands this "in-between" aspect of image reception:

Although they reproduce the syntax of common-sense racism, the inscribed or preferred meanings of these images are not fixed; they can, at times, be prised apart into alternative readings when different experiences are brought to bear on their interpretation . . . black readers may reappropriate pleasures which over-turn signs of otherness into signs of identity.[24]

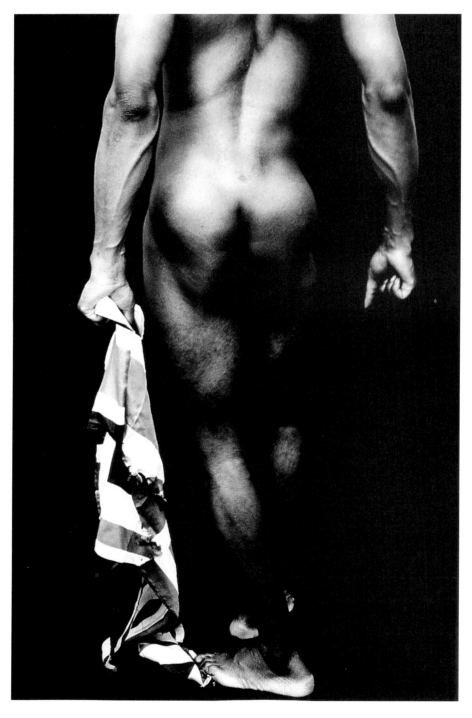

Fig. 12.3
Union Jack

However, I find it more effective to analyze the dilemma facing a black gay photographer whose nude portraits do not enjoy the surplus of attention that greets Mapplethorpe's black nudes. Syntactically, Rotimi Fani-Kayode's black male nudes rarely ever reflect a visual complicity with colonial fantasies. Yet, Rotimi's intentions cannot avoid receptions which psychologically reappropriate his reappropriation to generate a return to the initial primitive and lusty forms of spectatorship.

There exists no guarantee that Rotimi's work is, or ever will be, solely appreciated by connoisseurs and collectors of gay art. Though he worked mostly with black gay models, Rotimi's nudes are not essential articulations of a "blackened" homoerotic desire. His photographs speak to pan-African interests in Yoruba folk culture; they celebrate the black body as fully human and whole. They reflect the multivocal discourse of postnegritude and, in a Bakhtinian sense, a trans-linguistic eroticism which, as Robert Stam describes,

would speak of sexual heteroglossia, i.e. the many-languagedness of sexual pleasure and practice, what Helene Cixous calls the "thousands of tongues" of eroticism. An erotic trans-linguistics would look for "dialogism" on every level – interpersonal, intra-textual, intertextual, inter-spectatorial – and combat an array of monologisms – the monologism of patriarchy, of heterosexism, or puritanism. Its emphasis would be not on unilateral desire but rather on what Bakhtin would call the "in-between" of erotic locution.[25]

Rotimi provides African place "in-between" the classical Greek nude and the African warrior. He leaves his multiracial, multi-sexual, multi-gendered, and multi-ethnic audience with an imaginative, illusive, and slippery sensuality that frames his nudes. Such slippery and illusive qualities are not always available to artists who, like Mapplethorpe, attempt to deal with the epic narrative of black sexuality by showing it in the colonial speculum. While Mapplethorpe's black nudes focus on the phallic threat of black manhood as erotic and dangerous to the western mind, Fani-Kayode's black nudes emphasize the humanity of the total black body as sensual and significant.

notes

I would like to thank Reece Auguiste, Alex Hirst, Lola Young, Lina Gopaul, and John Akomfrah, who helped me obtain the necessary information to write this essay. I would also like to thank the University of Florida's Division of Sponsored Research for awarding me a 1991 summer grant. An earlier version of this essay appeared in *Wide Angle*, vol. 14, no. 2, April 1992.

1 Richard Marshall, ed., *Robert Mapplethorpe*, New York and Boston, Bulfinch Press, 1988, pp. 208–10.
2 I first used the term "postnegritude" when I presented "The Black Middle-Class Hero as a Refiguration of PostNegritude Otherness" at the 1988 Modern Language Association Convention in New Orleans. Postnegritude acts constitute any effort to challenge hegemonies of power through such processes as critical analysis, social action, and creative art. The term "womanist" was coined by Alice Walker in her collection of essays, *In Search of Our Mothers' Gardens: Womanist Prose* (1983). I use the term to describe a non-essentialist, non-biologically fixed, and non-homophobic black feminist political philosophy which provides a foundation for the theoretical aspects of various postnegritude processes.
3 Joseph Bristow, "Being Gay: Politics, Identity, Pleasure," *New Formations*, no. 9, Winter 1989, p. 61.
4 Mark A. Reid, *Redefining Black Film*, Berkeley, University of California Press, 1993, p. 111.
5 Ibid., p. 113.
6 Marshall, *Robert Mapplethorpe*, p. 88.

7 Alex Hirst, in an interview with the author, London, England, 27 June 1991.

8 Rotimi Fani-Kayode, "Traces of Ecstasy," Ten.8, no. 28, 1988, p. 42.

9 Ibid., p. 36.

10 Teshome H. Gabriel, "Theses on Memory and Identity: In Search of the Origin of the River Nile," *Emergence*, no. 1, Fall 1989, p. 134.

11 Robert Mapplethorpe, *Black Book*, New York, St Martin's Press, 1986. Leni Riefenstahl, *The Last of the Nuba*, New York, Harper & Row, 1974.

12 Fani-Kayode, "Traces of Ecstasy," p. 39.

13 Sander L. Gilman, "Black Bodies, White Bodies: Toward an Iconography of Female Sexuality in Late Nineteenth-century Art, Medicine, and Literature," *Critical Inquiry*, no. 12, Autumn 1985, pp. 212–13.

14 Ibid., p. 213.

15 Fani-Kayode, "Traces of Ecstasy," p. 41.

16 Ibid., p. 39.

17 Trinh T. Minh-ha, "Of Other Peoples: Beyond the 'Salvage' Paradigm," in Hal Foster, ed., *Discourses Contemporary Culture* 1, Seattle, Bay Press, 1987, p. 138.

18 Cornel West, "Black Culture and Postmodernism," in Barbara Kruger and Phil Mariani, eds, *Remaking History: Discussions in Contemporary Culture* 4, Seattle, Bay Press, 1989, p. 89.

19 Stuart Hall, in the brochure, *A Retrospective: Rotimi Fani-Kayode, Photographer (1955–1989)*, London, The Black-Art Gallery, 1991.

20 Kobena Mercer, "Looking For Trouble," *Transition* 51, 1991, p. 191.

21 Ibid., p. 192.

22 Kobena Mercer and Isaac Julien, "True Confessions," *Ten.8*, no. 22, 1989, p. 5.

23 Kobena Mercer, "Imaging the Black Man's Sex," in Pat Holland, Jo Spence, and Simon Watney, eds, *Photography/Politics Two*, London, Comedia/Methuen, 1987. A revised version of this essay appeared in the British anthology *Male Order: Unwrapping Masculinity*, eds Rowena Chapman and Jonathan Rutherford, London, Lawrence & Wishart, 1989, p. 141, 143.

24 Mercer and Julien, "True Confessions," p. 5.

25 Robert Stam, "Bakhtin, Eroticism and the Cinema: Strategies for the Critique and Trans-valuation of Pornography," *CineAction!*, Fall 1987, p. 20.

 ason says he is one hot fuck, dude. Primo beefy body. He makes me laugh. Jason says he wants me to drive to another city up the coast to meet him and teach him a lesson. He doesn't know that all the buildings in the city he lives in echo his digital perfection. He knows I do not, that my own flesh does not mirror his. But Jason doesn't know what I can do.

Jason lifts weights over his head. He stopped shooting steroids a few weeks ago. He's deflating now, but not so quickly that his flesh does not feel buoyant in my hands.

You look like a fucking Greek statue.

-- Take off your clothes.

He obliges. I sit back on the leather couch and watch. His striptease is careless but his physique is intentional. I want to tell him: You look like a fucking Greek statue. A behemoth. A building. A picture in a magazine. A code travelling in space. But I refrain. Jason's eyes are wide open. Waiting for his lesson. They are so wide I could step into them. From out of my leather coat I produce a pair of my girlfriend's underwear. Slim. An almost imperceptible swath of silk and lace. -- Put these on.

Paul Pfeiffer and Lawrence Chua, *Where The Stains Begin*, 1996, digital document, variable dimensions. Courtesy the artists

-- I Ain't no...

--- Fuck

𝔄 behemoth. 𝔄 building.

sexuality dude.

A picture in a magazine.

That ain't what this is about.

A code travelling in space.

I **stand to leave. He lowers his head.**
Takes the panties from my hand. Slips them on over an impossibly huge behind. If there is a lesson to learn Jason, it will be repeated over the course of many encounters. It's a lesson that he doesn't know as much as he thought about the spaces we live in, where they end and his body begins. It's a lesson about his own architecture. A building that opens to other buildings, losing its paranoid borders. -- What does it smell like? I pull my fingers out of his mouth and run a vibrator under his nose. My hands don't wait for an answer. They return to his flesh, pushing at where the stains begin. The machine hums at him. My guiding hand feels it caress an inside he wants to deny. I feel it pulsing against the membrane of my skin. Do you think these organs have a sexuality, dude? I'm a part of you now. His eyes are closed, his mouth open. He looks so peaceful he might be asleep. I hesitate to wake him, but I want to tell him that we're here. We've made it all this way without referring back to tables of surplus value or power structures that aren't already in the rules of the game. The machine is a part of him now. It's a part of me. Its language is already a part of his language, a low incantation of pleasure. I begin the slow process of marking his skin with bruises. Kicking in the vascular facade on which Jason has worked so hard. Kicking it in so that we might both discover just what makes our bodies shine.

232

paul b. franklin

orienting the asian male body in the photography of yasumasa morimura

[The body] is a most peculiar "thing," for it is never quite reducible to being merely a thing; nor does it ever quite manage to rise above the status of thing . . . Bodies are not inert; they function interactively and productively. They act and react. They generate what is new, surprising, unpredictable.

<div align="right">Elizabeth Grosz, Volatile Bodies</div>

To love oneself is the beginning of a life-long romance.
<div align="right">Oscar Wilde, "Phrases and Philosophies for the Use of the Young"</div>

Best known in the West for his photographic recreations of artistic masterpieces by the likes of Brueghel, Rembrandt, Velázquez, Manet and the Pre-Raphaelites, the Japanese artist Yasumasa Morimura (b. 1951) visualizes the peculiar "thingness" of the body described by Grosz. However, the body upon which he focuses – his body – is new, surprising and unpredictable, not merely because of its corporeality but also because of the quixotic and querulous race and gender of that corporeality. In his photographic work, Morimura fashions and refashions his body, often by way of computer imaging, assuming the racial, sexual, and gender identities of the characters present in the original artworks. Based on reproductions scavenged from art textbooks and magazines, his photographs are informed by the modern artistic traditions of appropriation and montage. In fact, most western critics discuss Morimura's work in these all-too-familiar terms.

While accurate, such analyses occlude the rich and unsettling questions of gender, race, and sexuality posed by Morimura's *oeuvre*. Furthermore, such explications fail to account for his recent work in which he bypasses high art altogether and adopts the personae of western pop divas like Marilyn Monroe, Audrey Hepburn, Marlene Dietrich, Elizabeth Taylor, Madonna and Michael Jackson. Taken together, the Old Master paintings and pop culture personalities which Morimura

paul b. franklin

Figs 13.1–13.7 Yasumasa Morimura, color photographs. Courtesy the artist and Luhring-Augustine Gallery. New York

Fig. 13.1 *Portrait (Nine Faces)*, 1989

appropriates constitute a canon in their own right – a canon of camp classics, all of which lend themselves to fruitfully queer readings.

Morimura's acumen with the camera and computer suggest that he possesses an artistic hand and eye on a par with those of many Old Masters. In discussing *Portrait (Nine Faces)* (Fig. 13.1), his large-scale computer-assisted reinvention of Rembrandt's *The Anatomy Lesson of Dr Nicholaes Tulp*, Morimura asserts: "I express Rembrandt's theme better than he did . . . I am sure he [the viewer] will say my work is better."[1] Playfully arrogant, he casts himself as Rembrandt's heir. In this stage production, Morimura, like Sarah Bernhardt, plays all the parts, giving narcissism – that psychic "malady" allegedly synonymous with male homosexuality in the West – a dimension beyond even Freud's wildest dreams. As a modern homosexual, Morimura indulges in a narcissistic fantasy of metalepsis, a dream of historical reversal, in which he and camp become the subject of Rembrandt's baroque original. Camp, like baroque art, thrives on the incongruity between form and content, emphasizing gesture and the style of presentation as expressive ends in and of themselves. In *Portrait (Nine Faces)*, Morimura as Dr Tulp is caught in this act. With his wrist flexed and fingers fluttering, the elegantly dressed doctor expounds upon the relationship between art and anatomy, reciting a script written for him by Oscar Wilde: "What Art really reveals to us is Nature's lack of design, her curious crudities, her extraordinary monotony . . . Art is our spirited protest, our gallant attempt to teach Nature her proper place."[2] Morimura's artfully executed anatomy lessons put nature in its place by denaturalizing the corporeal limits of his queer body.

234

Anatomy lessons. Playing doctor. My sister and I did it every afternoon when we should have been napping. No stethoscope or scalpel necessary; our adroit little hands worked perfectly. Cavorting behind her unlocked bedroom door in glorious nakedness, we shared our prepubescent bodies with each other, fascinated by their similarities – an anatomy lesson someone failed to give us. I was one year older, about seven, but my sister was much the wiser. She taught me how to sit on the floor with my legs spread far apart and how to put one leg behind my head without ruffling my hair. In her pink bedroom, my sister taught me to be in my body, to relish rather than to fear its nakedness or its boyness. Such memories of my body and its possibilities well up inside me anew each time I behold the aplomb and splendor with which Morimura unfurls his breathtaking physique. "Nothing should reveal the body but the body," Wilde contended. In so kindly showing me his, Morimura caresses the contours of my own.

One of Morimura's most entrancing anatomy lessons also unfolds in the bedroom. *Portrait (Twin)* (Fig. 13.2) is a photographic re-enactment of Manet's *Olympia*. In this lush color image, Morimura transforms himself into both the white female prostitute and her African maidservant. As Olympia, he exposes his lithe naked body on a gold and silver lamé kimono for the client–viewer's visual inspection. To counterbalance the racial slippage of Olympia's body from white to yellow, Morimura lightens her hair from red to platinum blonde, the penultimate signifier of western femininity. These tresses, however, are those of a cheap tawdry wig worn by a lower-class prostitute or a messy drag queen. In the supporting role of the full-figured African maidservant, Morimura stands in the background in blackface, holding a bouquet of plastic flowers.

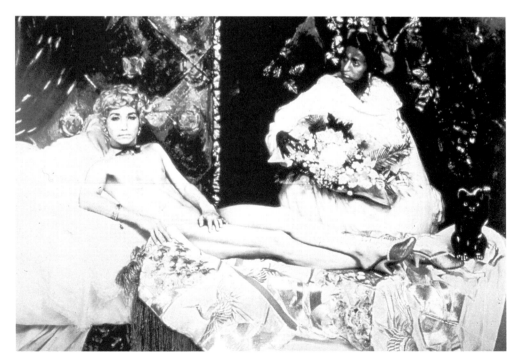

Fig. 13.2 *Portrait (Twin)*, 1988

In this nearly life-size print, Morimura toys with the arbitrary social markers of race, equating them with shades of theatrical make-up and hair dye. This is not to make light of the lived realities of racial difference. While race may be a social construct, a metaphor, a misnomer and a fiction, its citing and sighting, in the words of Hortense Spillers, rely on "a kind of hieroglyphics of the flesh."[3] In fact, Morimura pictures race as an arbitrary trope of difference only when it is *other* than his own, when it is separable from his indelibly Asian body. Just as make-up runs and smudges and hair dyes fade, so too do the presumably "natural" boundaries between "the races." *Maquillage* is miscegenation.

The racial crossings in *Portrait (Twin)* are amplified further by a variety of concomitant gender crossings. The heavily painted face, jewelry, wig and slippers donned by Morimura as Olympia are those of a female prostitute. The mien of this naked body, however, proves to be much more difficult to fix. Its svelte muscularity suggests a certain masculinity. On the other hand, the prominent nipples and pectoral muscles (which cast provocative shadows), the almost complete absence of body hair, the decorously placed left hand, and the figure's petite stature suggest a certain femininity. The literal and metaphoric position of Asian male bodies in the extended middle ground between the poles of white masculinity and femininity reinscribes their location between the racial poles of blackness and whiteness in the racist western imagination. Such a (mis)recognition of Asian masculinity makes Morimura a natural contender for those roles in western art traditionally played by women – of all colors.

Even though Morimura accentuates his ambiguous gender in *Portrait (Twin)*, he never masks his true color in order to pass as anything other than Other. He remains undeniably "yellow" – a cowardly, simpering, effete, queer man–boy. This double crossing of gender and race – the double displacement of his own body – highlights the ambiguous relationship between Olympia and her (re)incarnation as the African maidservant. Freely translating *Olympia* from paint to print, from West to East, and from female to male, Morimura irrevocably transforms Manet's original canvas and "outs" both Olympia and her African maidservant in the process. *Portrait (Twin)* is a queer palimpsest that documents not only a history of inversion but history *as* inversion – gender, racial and sexual inversion. Introducing such inversions as the very substance of *Olympia*, Morimura buttresses Wilde's claim that "The one duty we owe to history is to re-write it."[4]

Manet painted *Olympia* at a historical moment when female sexuality and race were pressing topics of scientific and social debate throughout Europe. Central to most of these discussions were the bodies of African women, particularly those of the Hottentots. Many European scientists and moral reformers believed such "primitive" women symbolized the atavism of female sexuality in general, irrespective of race. The uncivilized and perverse bodies of African women allegedly displayed the morphological markers of their depraved sexual appetites, including hypertrophic labia and nymphae (commonly known as the "Hottentot Apron"), wide hips, excessive weight, enlarged buttocks (steatopygia), and an excessively large clitoris. In nineteenth-century France, these same physiological signs of sexual degeneracy were also attributed to white female prostitutes. Traditionally consigned to the lower echelons of the class hierarchy, white female prostitutes were classified as a hybridized subspecies of the hypersexualized African Hottentot. In turn, African women were believed to be natural prostitutes. Implicit in this circular logic and writ large throughout much of the nineteenth-century discourse on race and prostitution is the supposition that the whiteness of female prostitutes functioned as a rather paltry disguise for their "true" identities as African women. In such narratives, Olympia, like her African maidservant, was also a slave, not only a slave to her primitive passions but an indentured servant in the institution of white slavery.[5]

The perception of the white female prostitute as an African Hottentot – a beast from the jungle – surfaced in many of the distressed critical responses to Manet's *Olympia* when it was first publicly exhibited in 1865. One critic proclaimed that Olympia was "a sort of female gorilla," while another described her as "a sort of monkey."[6] Gustave Courbet characterized Olympia as "the Queen of Spades stepping out of her bath."[7] The litany of misogynistic racial slurs hurled at Manet's nude culminated with Victor Fournel's categorization of her as a "Hottentot Venus."[8]

If Olympia's degenerate morphology suggested a racial affiliation with her African maidservant, so too did her gender and sexuality. Nineteenth-century French medical and popular discourse expounded upon the alarming pervasiveness of tribadism (the historical antecedent to lesbianism) among both white female prostitutes and African women. With their allegedly hypertrophic clitorises and overly masculine secondary sexual characteristics – ranging from raucous voices to beards – white female prostitutes, like their African sisters, possessed a seemingly natural predisposition to such unnatural sexual behavior.[9]

The somewhat mythic equivalence between white female prostitution and tribadism in nineteenth-century France also overshadows the history of Manet's *Olympia*. Several of the invectives lodged against the painting by salon critics resonate closely with those attributed to tribades and other overly virile female prostitutes by contemporary scientific and social commentators. Various critics excoriated Olympia for being "masculinized," "boyish," and "androgynous." One writer likened her to the "Bearded Lady" while others accused her of not being female at all, a charge commonly brought against tribadic prostitutes who were tellingly termed *femmes-hommes*.[10] These sensationalist claims indicate that certain critics understood *Olympia* to be part of the nineteenth-century French artistic tradition in which male artists represented "lesbianism" (or their heterosexual fantasies of it) by depicting together two racially distinct women or two white women with dark and light bodily features.[11] Allegations of Olympia's lesbianism probably derived in part from rumors that Victorine Meurent, the model for Olympia, was herself a lesbian, a speculation recently confirmed by archival evidence.[12]

A few particularly overwrought male critics went so far as to localize their fantasies and phobias regarding Olympia's putative lesbianism in her flagrantly placed left hand which, in their eyes, drew undue attention to her sex and sexuality. Perhaps these men concentrated so ardently on this limb out of fear of what they imagined lay beneath it. Olympia's flexed hand figured her as already in possession of a phallus *vis-à-vis* her enlarged clitoris, thus identifying her as both a lesbian prostitute and a Hottentot. The excited black pussycat at Olympia's feet metonymically signifies this monstrous primitive organ, an organ which also lies veiled beneath the billowing dress of her African maidservant. In opening up Olympia's anatomy to such close scrutiny, Manet's critics displayed the telltale symptoms, not of castration anxiety, but of pussy envy.

Pussy envy! As a pint-sized queer boy with seven sisters, I certainly experienced an inoperable case of it. How could I have escaped its warm welcoming embrace? After all, my mother and sisters repeatedly rescued me from the clutches of the neighborhood bullies who crowned me their "pussy boy." Afraid for my life, I prayed to God, begging him to give me what I seemed to lack on my girlish body. I was convinced that such a gift would enable me to escape permanently the horrors of boyhood. After getting out of the bath, I often would stand naked in front of the mirror and pull my little peepee between my legs, casually posing in the hope of convincing the mirror on the wall that I had the makings and the markings of a fairly fair girl. A cuttingly queer case, indeed.

While Morimura's strategically placed left hand hints at the pussy power of Olympia and her African maidservant, it also gestures toward the phenomena of masculine lack and the lack of masculinity historically assigned in the West to Asian male bodies of any and every orientation.

Under the racialized regime of white masculinity, Asian men often fall desperately short; they, like photographs, are pitiful imitations of an original. Furthermore, those Asian men who display a masculine potency appear, to western eyes, to be overacting and thus are more laughable than intimidating. The film-maker Richard Fung pointedly delineates this double bind:

Asian men have been consigned to one of two categories: the egghead/wimp or . . . the kung fu master/ninja/samurai. He is sometimes dangerous, sometimes friendly, but almost always characterized by a desexualized Zen asceticism . . . [T]he Asian man is defined by a striking absence down there. And if Asian men have no sexuality, how can we have homosexuality?[13]

Morimura plays with occidental stereotypes of Asian masculinity by playing into them. The painted fingers of his bejeweled left hand in *Portrait (Twin)* function as a feminine phallus, standing in for his absent member. With a campy wink and a nudge, he suggests that five members are better than one, especially when that one is not one worth having in the first place owing to its presumably diminutive size and lack of tumescence. The placement of his hand also testifies to the central place of masculine lack in contemporary Japanese culture where government censorship requires that pubic hair and genitals of any kind be blotted out in everything from pornographic magazines and foreign films to comic books and high art photography.[14] As the coquettish Olympia, Morimura proudly shows off his jewelry but cautiously refuses to display his family jewels.

The western stereotypes of Asian masculinity reflected in *Portrait (Twin)* are analogous to those historically ascribed to male homosexuals. In 1864, for example, Léo Lespès, under the suggestive drag pseudonym "Olympia," wrote an article for *Le Figaro* in which he proposed a homology between effeminate male homosexuals and monkeys. The article begins, naturally, in the Museum of Natural History – the *locus classicus* of taxonomy:

To complete our discussion of the collection of the Museum of Natural History, let us discuss a new kind of masculinity which has sprung up in the past few years . . . In examining this type of degenerate who calls himself a "man," we should establish a comparison between *ouistitis*, which are monkeys, and these so-called men.[15]

This puny, nervous, capricious "*homme femelle*," who coats his face with rice powder and cold creams, lounges languidly around his boudoir gazing at himself in his many mirrors, "compar[ing] the whiteness and delicacy of his hand to those of a woman."[16] Lespès's classification of effeminate male homosexuals as *ouistitis* was not accidental. The smallest species of monkey, *ouistitis* are known for their long nails, vibrantly colored manes and irritable dispositions. The male is much more fastidious about his appearance than the female and both spend most of their time sleeping. When they "speak," their faint voices fluctuate between a hiss and a chirp. In appearance, behavior and personality the male *ouistitis* is the princess of the primates, the Mary of the monkeys – well-coiffured, narcissistic, petite, bitchy, listless and, of course, lisping, like any queen of the forest worth her pedigree.

Lespès also likened *ouistitis* to female prostitutes, both of whom, in his opinion, adored exotic things. In the typical *ouistitis*'s apartment, "The shelves are cluttered with *chinoiseries* . . . Everything there breathes of the prostitute."[17] The orientalist abode of the *ouistitis* was assumed to be his natural habitat precisely because the Orient – whether the Far East, Middle East, Indian subcontinent, or North Africa – was presumed to be the home of homosexuality in the nineteenth-century colonialist imagination. During this epoch, the Orient was a museum of distinctly unnatural histories. Indigenous to these exotic lands, the *ouistitis* signified not only male homosexuality but also the male homosexual as Oriental.

In his 1994 *Psychoborg* series, Morimura conjures up a modern version of Lespès's Museum of Natural History by recording himself as pop icon Michael Jackson, whose African and African American forebears were situated in racist nineteenth-century evolutionary discourse as direct descendants of apes. *Psychoborg 8* shows Morimura as Jackson, chained to his chimpanzee cousin and alter-ego, Bubbles (Fig. 13.3). Like the *ouistitis*, Jackson/Morimura sports a well-coiffured mane and long nails, dons a bright red coat and the black spiked heels of a dominatrix or drag queen and displays an expression of arch bitchiness. As the youngest member of the Jackson Five, Michael Jackson had mimed his older brothers on stage. In superstar adulthood, repeated plastic surgery and a chronic skin condition enabled him to imitate the gender of his early idol, Diana Ross, and mirror the race of his mentor–mother, Elizabeth Taylor.

While the coupling of Bubbles and Jackson in *Psychoborg 8* points to the racist stereotype of blacks as jungle primates, it also addresses the phenomenon of Asians who pass as white. In the United States, such individuals are referred to as "bananas" by other Asian Americans; that is to say, "yellow" on the outside but "white" on the inside.[18] The phallic yet fruity metaphor of the banana interpolates Morimura's and Jackson's passings in all their guises. Monkey business, indeed.

"To monkey" means "to mimic." Monkeys mimic humans. Monkeys are often all-too-human in their mastery of humanity. Drag queens mimic women. Drag queens are often all-too-feminine in their mastery of femininity. Monkeys mimicking humans. Drag queens mimicking women. Drag queens as monkeys. Morimura as Olympia. Morimura as the African maidservant. Morimura as Michael Jackson. Such outlandish substitutions strike me as quite believable. As a child, it never took much imagination on my part to believe that I – a scrawny, chirping, gyrating, sissy boy – could mimic Curious George, could be Curious

Fig. 13.3 *Psychoborg 8, 1994*

George. After all, it was through the adventures of this brave little monkey that I learned not to be afraid of things that were bigger than me, including my queerness.

The social and sexual affinities between female prostitutes and male homosexuals articulated by Lespès and his contemporaries have an even longer history in Japan, a history intimated in *Portrait (Twin)*. Kabuki, a transvestic Japanese theatrical genre, developed in the early seventeenth century and quickly became the domain of female prostitutes. Performed on stages constructed in or near brothels, *yujo kabuki* (prostitutes' kabuki) consisted of burlesque skits in which many of the women performers cross-dressed. Rivalries among samurai over the affections of these actress–prostitutes led the government to ban women from the kabuki stage in 1629. In their stead, young male actors appeared.[19]

Barring women from the stage, however, did little to curb the problem of prostitution in kabuki theater. Not surprisingly, the shift to *wakashu kabuki* (youths' kabuki), with cross-dressed boys performing the women's roles, led to an increase in male homosexual prostitution. In a further attempt to preserve social morality, the municipal authorities began to censor the content and production of kabuki performances. Such efforts, however, proved futile. In 1648, the government outlawed male homosexual prostitution altogether, and completely closed kabuki theaters in 1652.[20]

Under pressure from theater owners, the government reopened the theaters in 1653 on the condition that all female parts be played by adult men. In *yaro kabuki* (men's kabuki), boys under fourteen no longer were allowed to wear women's clothes or hairstyles. Out of these reforms, the art of the *on'nagata* (female impersonator), the mainstay of classic kabuki, developed and flourished. Prostitution by male kabuki actors, however, continued unabated until the late nineteenth century when the government elevated these performers to the status of legitimate artists. In so doing, they hoped to disassociate permanently this national art form from its sordid origins in Japan's pleasure quarters. Framing *Portrait (Twin)* within the legitimate legacy of Manet, Morimura coyly recuperates this illegitimate history of kabuki.

Morimura utilizes similar tactics to an equally provocative end in his 1988 photographic homage to Manet's *Fife Player* (Figs 13.4, 13.5, 13.7). In this triptych, he brazenly yet humorously scrutinizes the masculine lack from which Asian male bodies chronically suffer in both straight and queer western canons of visual representation; they are too short, hairless, delicate and deferential to be those of truly manly men. Morimura interrogates the racist foundations of this gender norm by juxtaposing them with that of masculine plenitude, a presumably congenital gender "ailment" in black males.

Portrait (Boy I) (Fig. 13.4) portrays Morimura dressed as the young French soldier from the Imperial Guard whom Manet employed as the model for his painting. The slightly oversized French military uniform that Morimura wears fully conceals his adult Japanese body and thereby fully congeals his gender as that of a white boy. Morimura, however, disrupts this comfortable continuity by applying thick, creamy, yellow-gold make-up to his face in order to underscore his asianness. His re-racination suggests that, in their nascent masculinity, white boys are not unlike Asian men, at least in the eyes of most white westerners.

The equivalence of Asian men and children forms the basis of the larger western stereotypes of the so-called "Asian community" as the model minority and Asians themselves as ideal lovers. White America, for example, has granted Asians the privileged status of "honorary white people" precisely because they act as well-behaved children; they are law-abiding, dutiful, quiet, passive and respectful. These same qualities inform many heterosexual white male fantasies regarding Asian women whose reputed submissiveness is considered the essence of conjugal bliss. Furthermore, the Arcadian image of the pretty, effeminate, sexually passive, Asian man–boy rules

Fig. 13.4 *Portrait (Boy I)*, 1988 Fig 13.5 *Portrait (Boy II)*, 1988

supreme in the erotic imaginations of many white gay men. "Rice queens" – white men who predominantly desire sexual contact with Asian men – occupy a distinct domain within American and European gay subcultures and support a veritable cottage industry of bars and pornography. In mainstream gay pornography, Asian men, when they appear at all, typically are cast as the obedient houseboy, the queer Cho-Cho-San who graciously bends over to satisfy his white master's sexual whims. According to Fung, such scenarios "privilege the [white] penis while always assigning the Asian the role of bottom: Asian and Anus are conflated."[21]

In *Portrait (Boy II)* (Fig. 13.5) Morimura literally is caught with his pants down. His slender Asian body appears to lack the necessary girth to support such manly regimental trousers. As in *Portrait (Twin)*, Morimura's penis – a penis traditionally assumed to be too small to be worth looking at anyway – is obscured by a hand. This exotic limb, a cast of his own hand rendered in "blackface," calls into question the anatomical correctness of his already perversely racialized body. In its placement, upward thrust, and gold fingernails, the hand performs as an improved and priceless copy of Morimura's concealed Asian penis. This colored copy is, in fact, an original – the big black cock, the *sine qua non* of male sexual potency. In both gay and straight white culture, the gigantic black cock is constitutive of black male identity itself, an identity which is not one but rather a fantasmatic synecdoche.

Such a substitution suggests that Morimura, like many gay men, suffers from penis envy. Freud's classic and much disputed description of this stage in the psychic development of little white girls resonates uncannily with the racist stereotype of Asian male lack:

They notice the penis of a brother or playmate, strikingly visible and of large proportions, at once recognize it as the superior counterpart to their own small and inconspicuous organ, and from that time forward fall a victim to envy for the penis.[22]

In the western racist imagination, Asian men not only resemble little white boys in their arrested physical development but also little white girls in their arrested psychological development. Ventriloquizing Freud, Morimura postures himself as the daughter in the family romance of art history who compensates for her feminine lack by fantasizing about presenting a gift to her father–master in the form of a child, a symbolic and psychic extension of his penis: "[My] art works were created for the *daughter* whose *father* is Art History. Or, to put it another way, these art works were created by *me*, as the daughter, for that *father*."[23] *Daughter of Art History, Princess B*, a recreation of Velázquez's portrait of the Infanta Margarita of Spain in which Morimura impersonates the eight-year-old princess, presents Asian masculinity as always already infantile femininity (Fig. 13.6).

Fig 13.6 *Daughter of Art History, Princess B*, 1990

The big black phallus that protrudes from between Morimura's legs in *Portrait (Boy II)* does not fully compensate for his ostensible biological and psychological inferiority. Such a phallic stand-in cannot stand up for or by itself. It is a hollow cast, empty of any real sexual or symbolic power because it has been detached from a black male body, for which it putatively stands, and has been fashioned from Morimura's own Asian hand. This painted feminine cast confirms the epistemological impossibility, in the West, of both the Asian penis and the Asian phallus.

While *Portrait (Boy II)* sketches the differences between Asian and black masculinities within white culture, *Portrait (Boy III)* (Fig. 13.7) pictures their affinities. Here, Morimura reveals his black side by exposing his backside. His blackness, however, is actually blackface (or, more accurately, "blackass"), a theatrical facade betrayed by his yellow Asian hand in the upper right. Just as nineteenth-century French medical and social thinkers treated African Hottentots and white female prostitutes as "sisters" in their racial and sexual morphologies, contemporary white western culture positions Asian and black men as "brothers" in their similarly emasculated status as boys, the former inside the house as domestic servants and the latter outside in the fields as slaves. Bedecked in his soldierly regalia, Morimura acknowledges that the military makes men out of boys while slavery and sexual servitude make boys out of men.

The white master's hand props up the black man–boy in *Portrait (Boy III)*, holding him in his place, a hand which actually is Morimura's in the guise of an hysterical or impassioned white woman. Such a threatening feminine phallus iterates the domineering and castrating femininity of women which so appeals to camp aficionados and drag queens. More specifically, this rigid hand, with its garishly polished nails, calls to mind the image of the hypersexual, white, southern belle who toys with black men, coquettishly inviting sexual violation while disavowing her role in its

Fig 13.7 *Portrait (Boy III)*, 1988

staging. As a black slave, Morimura fights against such entrapment by maintaining an air of cool detachment. Even with his pants around his ankles, he marches along dutifully serenading his mistress in order to save his hide from possible lynching.

While the white hand between Morimura's legs may signify that of a drag queen or southern belle, it may also embody the allegedly misdirected and misplaced erotic impulses of gay men in general, irrespective of other differences. In the misogynistic and homophobic imagination, male homosexuals are divisible into two seemingly discrete camps – drag queens and butch leathermen. The *Portrait (Boy)* series, however, insinuates that these two caricatures literally go hand-in-hand. In their coupling, the drag queen and butch leatherman offer a critique of heterosexuality like that described by Judith Butler: "the parodic or imitative effect of any gay identities works neither to copy nor to emulate heterosexuality, but rather, to expose heterosexuality as an incessant and *panicked* imitation of its naturalized idealization."[24]

Leather queens, like drag queens, dress up and adopt various personae. On the theatrical stage set of s/m sex, gay leathermen role-play so artfully that individual body parts assume roles traditionally assigned to other body parts. *Portrait (Boy III)* refers to one such gripping moment in the *mise en scène* of s/m sex, that of fist fucking, where one man's hand literally performs as his penis. The sexual type-casting of the black male as the "bottom" and the white male as the "top" in Morimura's s/m spectacle typifies the common misnomer that gay sadomasochism uncritically reinscribes the power differential of master and slave.

The scenarios of dominance and submission depicted by Morimura also are informed by the central place these elements occupy in modern Japanese culture. Often described as mild-mannered, orderly, disciplined people, many Japanese harbor a fascination for violence, especially sexual violence. Japanese popular culture is flooded with s/m imagery, particularly comic books, which are notoriously hard-core in content. The portrait of the straight-laced, middle-aged, Japanese businessman who casually engages in such reading on the subway to and from work has become legendary. Morimura's deadpan expression and seeming obliviousness throughout the *Portrait (Boy)* series echo such a paradox.

Hands hold many of Morimura's photographs together, formally and symbolically. Hands hold Rembrandt, Manet, Michael Jackson, Velázquez and Morimura together – thematically, sexually, racially and erotically. Old Masters and pop divas hold Morimura's hand as he turns the pages of western culture. Pedagogy as pederasty. Photography as flirtation. In the words of Roland Barthes, "the Photographer's [*sic*] organ is not his eye . . . but his finger" – his touch, his hand, his cock.[25] In much of Morimura's work, hands play the part of other body parts just as they play themselves. While his hands are often stand-ins for absent members, they occasionally clutch these members, like a flower or a flute. For men, masturbation is much like playing the flute, and "flute" in Japanese (*shakuhachi*) euphemistically refers to the penis. In the *Portrait (Boy)* series, Morimura displaces the mechanics and mechanism of masturbation upward, equating this act with the photographic process itself. In both instances, the speed and dexterity of one's hands determine the quality of the results.

From the stunning visual characteristics and technical sophistication of Morimura's photographs, one might presume that modern photography, like kabuki, is a Japanese art form. Such an assumption is reinforced constantly in the West by the steady stream of Japanese tourists through our cities and towns, most of whom appear to brandish their cameras unabashedly, like gaudy pieces of expensive jewelry. Traveling in packs, the Japanese ostensibly snap pictures of everything and anything that comes their way. Morimura caricatures this western stereotype in his ironic remake of Brueghel's *The Parable of the Blind* (1568), appropriately retitled *Blinded By the Light* – the light of a flashbulb (Fig. 13.8).

As synonymous as the camera and photography have become with Japan, neither are indigenous to the island country. Rather, they are both western inventions. Japan, however, rose to prominence in the modern photography market after the Second World War as a result of the technological advances in camera equipment and photochemical processing achieved by companies like Canon, Minolta, Nikon, Olympus, and Pentax. Western critics often explain and explain away the dominance of Japan in this marketplace as the result of its copycat trade tactics rather than as a consequence of its scientific and business savvy.[26] Interestingly, the renegade tactics of appropriation and adaptation which Japan supposedly employs in the business world also define a queer camp aesthetic which, as Susan Sontag notes, "transcends the nausea of the replica" by investing its cheapness and banality with a unique and mysterious aura of its own.[27] Morimura's dazzling mastery of these techniques as well as his facility with the camera and deftness at the computer console all confirm that modern photography is as much a queer domain as it is a Japanese one. He explains: "East meets West in my work, but I haven't made an attempt to merge the two worlds . . . photographs, I think, are neither Japanese nor western. They represent my feeling that I exist in between the two worlds."[28]

The hybrid position of photography in the in-between – a decidedly queer position – makes it a fitting medium through which to interrogate the hegemonies of whiteness and heterosexuality in the West. For example, the classic genres of color and black-and-white photography literalize the age-old notion whereby racial difference is determinable based on skin color. The process of photographic reproduction, however, repudiates this epidermal conception of race. Traditionally, a photographic print is created by shooting light through a negative. As a result, the lightest areas on a positive print appear darkest on the negative and vice versa. With this in mind, one might conceive of the photochemical process itself as racialized; it relies on a kind of "miscegenation" whereby white begets black and black begets white. Furthermore, since photographic light meters are calibrated to middle grey, individuals with skin tones between black and white – like Morimura – are ideal photographic subjects.

Fig 13.8 *Blinded by the Light*, 1991

245

In repeatedly capturing his likeness both on film and on the computer screen, Morimura embraces visual production as homosexual reproduction. His luxuriously tantalizing mechanical creations picture homosexuality as the replication of the self and/as the Other. In his hands, photography becomes the "homo" – Greek for "same" – in homosexuality; it is, as Walter Benjamin noted, "the most revolutionary means of reproduction," a reproduction revolutionary in its delivery of sameness through difference instead of through progeny.[29] According to Barthes, "a sort of umbilical cord links the body of the photographed thing to my gaze: light, though impalpable, is here a carnal medium, a skin I share with anyone who has been photographed."[30] Photography, as Morimura's *oeuvre* exemplifies, is, indeed, a queer-cut case of narcissistic homosexuality.

notes

I would like to thank Bridgit Goodbody, Norman Bryson, Karen Silberstein and Natalie Kampen for their advice and encouragement on various drafts of this essay. I am particularly indebted to Ann Pellegrini for the many rich and challenging discussions we have had over the years concerning many of the themes herein.

1 Beryl J. Wright, *Options 44: Yasumasa Morimura*, Chicago, Museum of Contemporary Art, 1991, n.p.

2 Oscar Wilde, "The Decay of Lying" (1889), in *The Complete Works of Oscar Wilde*, Glasgow, Harper Collins, 1994, p. 1071.

3 Hortense J. Spillers, "Mama's Baby, Papa's Maybe: An American Grammar Book," *Diacritics*, vol. 17, no. 2, Summer 1987, p. 67.

4 Wilde, "The Critic as Artist" (1890), in *The Complete Works of Oscar Wilde*, p. 1121.

5 In my gloss on the intricate and complex nineteenth-century French discourse of race and sexuality as they relate to African women and white female prostitutes, I have drawn on the following sources: Alain Corbin, *Women for Hire: Prostitution and Sexuality in France after 1850*, trans. Alan Sheridan, Cambridge, Mass., Harvard University Press, 1990; Alexandre-Jean-Baptiste Parent-Duchâtelet, *De la prostitution dans la ville de Paris*, vols 1–2, Paris, J.-B. Baillière, 1836; Sander Gilman, *Difference and Pathology: Stereotypes of Sexuality, Race, and Madness*, Ithaca, Cornell University Press, 1985.

6 T. J. Clark, *The Painting of Modern Life: Paris in the Art of Manet and His Followers*, Princeton University Press, 1984, p. 94.

7 Theodore Reff, *Manet, Olympia*, New York, Viking Press, 1977, p. 30.

8 Clark, *Painting of Modern Life*, p. 289.

9 Corbin, *Women for Hire*, pp. 430–1; Gilman, *Difference and Pathology*, p. 89; Parent-Duchâtelet, *De la Prostitution*, vol. 1, pp. 170–1; Louis Fiaux, *Les maisons de tolérance*, Paris, Georges Carré, 1896, pp. 135, 146–7.

10 Clark, *Painting of Modern Life*, pp. 98, 132; Félix Carlier, *Les deux prostitutions, 1860–1870*, Paris, E. Dentu, 1887, p. 62.

11 Linda Nochlin, "The Imaginary Orient," *Art in America*, vol. 71, no. 5, May 1983, p. 126.

12 Eunice Lipton, *Alias Olympia: A Woman's Search for Manet's Notorious Model & Her Own Desire*, New York, Charles Scribner and Sons, 1992, pp. 65–70.

13 Richard Fung, "Looking for My Penis: The Eroticized Asian in Gay Video Porn," in Bad Object-Choices, eds, *How Do I Look?: Queer Film and Video*, Seattle, Bay Press, 1991, p. 148.

14 Nicolas Bornoff, *Pink Samurai: The Pursuit and Politics of Sex in Japan*, London, Grafton Books, 1991, pp. 400–7.

15 "Olympia" [Léo Lespès], "Muséum d'histoire naturelle: les Ouistitis," *Le Figaro*, no. 959, 24 April 1864, p. 4. I thank Nancy Locke for bringing this article to my attention and for identifying Lespès as its author. I also thank Brian Martin for his translation.

16 Ibid., p. 4.

17 Ibid., p. 4.

18 Margo Machida, "Seeing 'Yellow': Asians and the American Mirror," in *The Decade Show: Frameworks of Identity in the 1980s*, New York, The New Museum of Contemporary Art, 1990, p. 118.

19 Donald H. Shively, "The Social Environment of Tokugawa Kabuki," in James R. Brandon, William P. Malm and David Shively, eds, *Studies in Kabuki: Its Acting, Music, and Historical Context*, Honolulu, University of Hawaii Press, 1978, pp. 5–7.

20 Ibid., p. 9.

21 Fung, "Looking for My Penis," p. 153.

22 Sigmund Freud, "Some Psychical Consequences of the Anatomical Distinction Between the Sexes" (1925), in *The Standard Edition of the Complete Psychological Works of Sigmund Freud*, trans. and ed. James Strachey, vol. 19, London, The Hogarth Press, 1961, p. 252.

23 *Images in Transition: Photographic Representation in the Eighties*, Kyoto, National Museum of Modern Art, 1990, p. 80. Emphasis in the original.

24 Judith Butler, "Imitations and Gender Insubordination," in Diana Fuss, ed., *Inside/Out: Lesbian Theories, Gay Theories*, New York, Routledge, 1991, p. 23. Emphasis in the original.

25 Roland Barthes, *Camera Lucida: Reflections on Photography*, trans. Richard Howard, New York, Hill and Wang, 1981, p. 15.

26 Joseph J. Tobin, "Introduction: Domesticating the West," in Joseph J. Tobin, ed., *Re-made in Japan: Everyday Life and the Consumer Taste in a Changing Society*, New Haven, Yale University Press, 1992, p. 3.

27 Susan Sontag, "Notes on Camp," in *A Sontag Reader*, Harmondsworth, Penguin Books, 1983, p. 116.

28 Carol Lufty, "Morimura: Photographer of Colliding Cultures," *International Herald Tribune*, 2 March 1990, p. 147.

29 Walter Benjamin, "The Work of Art in the Age of Mechanical Reproduction," in *Illuminations*, trans. Harry Zohn, New York, Schocken Books, 1969, p. 224.

30 Barthes, *Camera Lucida*, p. 81.

lyle ashton harris and thomas allen harris

black widow
a conversation

introduction

On 8 August 1994, photographer Lyle Ashton Harris and film-maker/performance artist Thomas Allen
 Harris got together for several hours in Lyle's apartment in Silverlake to have a dialogue about
 what inspired *Brotherhood, Crossroads, Etcetera*, their collaborative 20 × 24 in. Polaroid series. What
 follows are excerpts from the dialogue they began that day and continued over the next three
 years.
 The previous winter, Lyle invited Thomas to collaborate on a photographic project that would
 be a meditation on a famous photographic portrait of Huey Newton, the Black Panthers' minister
 of information. What emerged from their collaboration were four images: a triptych titled
 Brotherhood, Crossroads, Etcetera, and a fourth image, *Untitled (Orisha Studies)*. These photographs
 are collaborative documents that draw from both artists' long histories of engagement with the
 intersection of performance, masquerade, and familial relations.
 In the *Brotherhood* triptych (Fig. 14.1 and page 312), the artists explore and interrogate the
 psychic dimensions of archetypal narratives and images of fraternal relationships. The first image,
 evoking the Pieta or classical imagery of the Greek heroes Achilles and Patroclus, portrays Lyle
 compassionately embracing and supporting his fallen brother. The center image of the triptych,
 the kiss of death (evoking the primal scene of Cain's treachery toward his brother Abel), shows
 the brothers exchanging a passionate kiss as Thomas presses a gun into Lyle's chest. The third and
 final image evokes the heroic image of fraternal warriors (Jacques-Louis David's *Oath of the
 Horatii*, the myth of the Spartans), with the brothers locked in a tight embrace, turning their
 weapons and their fierce gazes outward, toward the viewer/outsider.
 Untitled (Orisha Studies) (page 312) expands on the Harrises' investigation of African
 cosmologies by invoking and engaging the mythology of the sacred twins who, with the guardian

Figs 14.1–14.4 Lyle Ashton Harris in collaboration with Thomas Allen Harris, *Brotherhood, Crossroads, Etcetera*, unique Polaroid Triptych, 1994. Courtesy the artists and Jack Tilton Gallery, New York

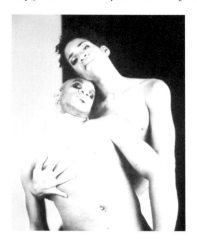 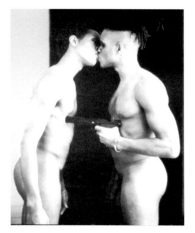 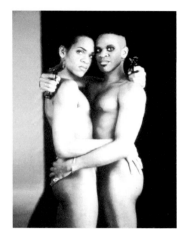

of the crossroads, facilitate movement among spaces of the imaginary, the symbolic, and the real. The photograph depicts two deities of the Yoruba pantheon: Oshun, goddess of beauty and sexuality, who is represented in both her feminine and masculine forms, and Eshu, the divine trickster, who squats between Oshun's two gendered embodiments.

the conversation

Lyle: *Brotherhood, Crossroads, Etcetera* are iconographic representations which also draw from our lived experiences as brothers. Given the work that we've done individually and collectively over the past several years – interrogating as well as re-imagining ourselves – it is important to disclose that these three images embody aspects of our relationship. Yet at the same time it would be dangerous to suggest that this triptych represents the essence of who we are. These photographs reek of symbolism, but I don't mind invoking autobiography.

Thomas: Miss Thing! You love autobiography and so do I. Just look at our respective projects: *The Secret Life of A Snow Queen* (1990), *Heaven, Earth & Hell* (1993), *The Good Life* (1994), and *Vintage: Families of Value* (1995). All of these engage autobiography as a liberatory strategy. Historically, the black literary tradition of autobiography as self-creation and self-fashioning has been a necessary and radical act. The first novels written by Africans in this country were autobiographical texts. In *Bearing Witness*, Henry Louis Gates writes:

Of the various genres that comprise the African-American literary tradition, none has played a role as central as has black autobiography. For hundreds of black authors, the most important written statement that they could make seems to have been the publication of their life stories. Through autobiography, these writers could at once shape a public "self" in language, and protest the degradation of their ethnic group by the multiple forms of American racism. The ultimate form of protest, certainly, was to register in print the existence of a "black self" that had transcended the limitations and restrictions that racism had placed on the personal development of the black individual.[1]

249

As visual artists, we are opening up the form of autobiography by moving beyond the need to assert our humanity to a hostile, yet powerful, Caucasian public. Through the use of performance and fantasy, we are invoking multiple subjectivities within the realm of blackness to address and create our collective selves. In this way, I think we are transforming the notion of autobiography.

Lyle: These images are transgressive in their relationship to the pantheon of African American visual culture. They disregard bourgeois notions of propriety and morality and that has undoubtedly been important in combating hideous representations of blackness in American popular culture. There is a quality of generosity captured in these photos – an offering, a sacrifice. I feel that we have been vulnerable in sharing our ambivalent feelings of desire, envy, fear and loss towards each other. We are proclaiming: "I've given my life and my blood and my brother is giving his – what are you giving?" That's the question. It's about an extreme, a royal, sacrifice.

Thomas: I love that – royal sacrifice. It's completely generous and radical. I remember moments in the past when we've lamented the fact that there are so few written documents of our family's history. Yet we are fortunate to have such a rich visual archive which has inspired several of our projects. Our grandfather, Albert Sidney Johnson, shot thousands of Ektachrome slides, many reels of super-8 film, as well as videotape. Inheritors of his legacy, we have embraced this work, filling in the spaces of silence. Our work expands on the notion of autobiography by articulating the many voices, subjectivities and desires that erupt within the collective body. We are claiming a queer space in the public and private discourse around the black middle-class family. This autobiographical project that Albert Sidney Johnson began was brilliantly illuminated in *The Good Life* and in *Vintage: Families of Value*, projects which brought images of our family from the private domain into the public sphere.

Furthermore, it is interesting to think about the relationship between the depiction of fraternity in *Brotherhood, Crossroads, Etcetera*, and how sibling relations are portrayed in Judeo-Christian narratives. There is this emphasis on competition. For example, the second most significant human relationship described in Genesis is that between Cain and the brother he murders, Abel:

And the Lord said unto Cain, Where is Abel thy brother? And he said, I know not: Am I my brother's keeper? And [the Lord] said, what hast thou done? The voice of thy brother's blood crieth unto me from the ground. And now art thou cursed from the earth, which hath opened her mouth to receive thy brother's blood from thy hand.

Genesis 4: 9–11

This allegory, as well as in the betrayal narrative of Joseph and his brothers, tells of the deadly envy, fear, and repressed sexual desires of the older brother toward the younger one. Gaining the approval of God/the father is a ubiquitous motif as well.

Lyle: It is fighting for, and gaining the approval of Mother as well. Over the past few years I've been actively engaging and processing my feelings around Daddy's absence, and how this set up a mechanism in which you and I were competing for Mother's attention. I remember being "the good one," always trying to be rewarded, whether for good grades or for being a good mamma's boy. At the same time, I would always transgress – stealing from Mother's pocketbook, verbally challenging Grandpa, and, in my late teens, bringing trade to the house. It was as if I was trying to fill a wound, a sense of emptiness, a hole that still lingers with me today. There was a perception that there was limited attention to be had, and it always had to be negotiated.

I can remember when I discovered that we had an older brother. That Albert, the youngest son of Mommy's eldest sister was actually our half-brother. I found this out by snooping, as I often did. This information remained a secret between mother and I, until you found out fifteen years later. This contractual notion of love is something that I have only recently been able to begin moving through.

Thomas: And I was the consummate good son – Mommy's eldest and dearest. On the surface I did all the right things; I was responsible, got good grades, and took care of my younger brother. But underneath I was still reeling from the encounter with our father's painful and tortured repression. He left home before you could fully experience it. But you got a taste in the many ways I tortured you – disrupting your games or ritually eating up your chocolate bunnies every Easter. Even now, the evilness of those acts makes me laugh, though I must confess you got your licks in too, honey!

Lyle: Your earlier biblical references bring to mind our own upbringing in Bethel AME (African Methodist Episcopal) Church in Harlem during the 1960s and 1970s. Even though our parents didn't go to church, it was our grandparents – Grandma, who was head of the Missionary Society and Sunday School, and Grandpa, who was church treasurer and unofficial documentarian – who made sure we were at church every Sunday. This experience exposed us to a deep sense of the sacred, the power of prayer, and the importance of communion and ritual.

Thomas: Because of our grandparents' status and commitment to Bethel, we were little princes. It was their presence that made the church a safe space for us. Somehow we didn't feel the pressure to hide ourselves in any way. There was no need to monitor our performance. There was no threat of being called "faggot," as there was in school or in the neighborhood. There were also gay men in the church who did not have to hide themselves which contributed to the sense that the church was a safe space.

It was during the early years of going to church, right after our parents separated and Daddy left home for good, that we began our weekend rituals of doing drag. Each weekend we would spend hours reconstructing ourselves. We would stuff Ma's bras with tissue paper, create fake hair with towels and turtleneck sweaters, and complete our outfits with Mommy's fabulous early-1970s pant-suits and African garb. Then we would be ready to take off on an action-packed fantasy adventure that transformed our hallway in the Bronx. It would all take place in the hallway upstairs between the bathroom and Mommy's closet. These fantasies always involved our imaginary boyfriends, Johnny and Billy, and were structured around some kind of violence – either we were fighting our boyfriends or some gang that was trying to attack us.

When I think back to my childhood, I understand the importance of those weekend adventures for keeping our sanity amid all the pressures to conform to certain modes of behavior and gender protocol, as well as the threat of violence that accompanied this pressure. Our "evenings out" remind me of Bakhtin's theories of carnival in that we played with the arbitrariness of the "normal" modes of behavior and beliefs around gender and race that we were experiencing as adolescents. It was also during this time in the early 1970s that many African Americans were pursuing their connection to Africa, including the exploration of African religious practice. So as we were reconstructing our public (African) selves, we were simultaneously creating our private (queer) worlds. Both were seminal experiences of play and performance.

251

Lyle: I remember one humiliating time when mother got tired of seeing me with crazy nails and abruptly asked me in front of Lee, our stepfather, "what is this?" I was mortified. It was odd, too, because clearly she had seen me wearing those fake nails before, but, this time, she chose to let me know about it in front of her man. Nonetheless, it is wonderful to have you bring up these memories for it allows me to recover the joys and excitement of being together as young boys and provides a way beyond just remembering our childhood as a site of repression, trauma, and obligation.

Memories that I am particularly fond of are the ritualistic performances we and our cousins would do at family gatherings – Kwanza, Christmas, birthdays – or at one of the several annual parties mother would give. An essential part of the evening included a performance by us kids before we went to bed and they were always orchestrated by our cousin Peggy. She was a couple of years older and had worked as a professional child singer, performing for many years in her father's Trinidadian band. Without a doubt, Peggy opened up so many spaces for us. She was probably one of the first to really mirror and affirm my awkward sensitivity, my pleasure in narcissism, and my outlandish naive queerness. She was my hero.

Thomas: I remember that at one of those parties which featured mother's ground nut stew, you, Peggy and I made our own stew upstairs. It consisted of urine, shit, and spit that was spiced up with whatever we could find to toss in. We presented it to the party as our performance. I think we got into a lot of trouble that time! It's interesting that twenty or so years later, we came together from our respective art practices and lives to perform again; to begin our new project, *Alchemy*.

conceptual background to *Brotherhood, Crossroads, Etcetera*

Lyle: The red, black, green velvet backdrop we use in *Brotherhood* references Marcus Garvey's UNIA (Universal Negro Improvement Association) tri-color flag. Red standing for . . .

Thomas: Blood.

Lyle: Green, for the wealth of land, and black, for the African race. This icon dates from the 1920s when it was accepted by Marcus Garvey as the official colors for the Negro race. As we know, this icon has been taken up at different points since, specifically by the Black Power movement in the late 1960s.

Thomas: I remember learning about Marcus Garvey as a child through African history comic books and the race books in Grandpa's library. Twenty-five years later, the late Marlon Riggs appropriated this UNIA icon in his video, *Anthem* (1991). In a moment of ecclesiastical hybridization, Riggs cross-fertilizes the UNIA flag with the gay liberation symbol, the pink triangle, and an image of two black men sharing a passionate kiss. This representation simultaneously ruptured queer nationalism and black nationalism. Would you say that you are employing the black nationalist symbol in a similar way to Marlon?

Lyle: I began using the UNIA flag in 1993 when I discovered this tri-colored icon combined with the word "AFRO" on a bumper sticker I bought in Compton. I rephotographed the sticker and blew it up to a six-by-four-foot mural. I overlaid it with a quotation from Alice Walker from her controversial *New York Times* op ed piece that you faxed to me where she critiqued David Hilliard's account of the Black Panthers:

These men loved, admired and were sometimes in love with each other. They were confused by this. Who at the time, after all, except perhaps James Baldwin, could teach them that love is the revolutionary emotion, particularly because it cannot be limited, cannot be controlled.[2]

> This piece was in a larger installation, *Victory Parade*, that I was commissioned to create as part of the 1993 42nd Street Art Project organized by Creative Time in New York. As black queer cultural producers, we are celebrating the liberatory potential of this black nationalist icon by expanding the notion of who may lay claim to it. We are stretching it, giving it elasticity by articulating the need for the primacy of compassion in the lives of people of African descent.

Thomas: Historically, there has been a danger, a violence, for black people who have engaged in this expansiveness. For example, we witnessed the communal ostracizing of Michelle Wallace in the 1970s after she published her seminal book, *Black Macho and the Myth of the Superwoman*. We witnessed the ouster of civil rights leader Bayard Rustin when, after he organized the 1963 March on Washington, J. Edgar Hoover's FBI threatened to leak to the press that he was a homosexual. Somehow these feminist and queer black cultural producers are positioned as a threat to blackness or, to be more explicit, to black nationalism. I'm talking about when black nationalism is used to promote a notion of purity around blackness. But it's an exclusionary purity that is more about accessing and establishing a mythic patriarchal power – a "purity" that celebrates violence at the expense of compassion and intimacy.

Lyle: The themes invoked in *Brotherhood* speak to the ambivalence around violence, betrayal, and abjection that is part of our collective legacy as African Americans. These images graphically mirror the violence and self destruction that constitute our contemporary experience. I often question if it is easier to reject or destroy those like yourself – someone who mirrors your shared history of lynching, terror, and the historical trauma experienced by the collective black body – rather than to love them. It is curious that within our communities there is much consternation around the endangered black male, around the representation of black-on-black violence in film, music, and other cultural forms. Yet black people play a part in the production of this primal filmic horror of black-on-black violence. We continue to buy and sell these goods that American mainstream patriarchy is only too happy to profit from. And who is held accountable? Any critique of this consumption really pisses people off because it trespasses on the sacred domain of black popular culture, on the very seductive spectacle of unyielding masculinity. At its core, *Brotherhood* speaks to the twinning of black homophilia, to quote Paul Gilroy, and black-on-black violence.

Thomas: The gun is a metaphor for the historical violence that we are perpetrating on ourselves. The kiss symbolically penetrates the surface to reveal illicit homosocial desire.

Lyle: Exactly.

Thomas: When you first approached me about doing a photograph of us as African warriors, I was intrigued. As an experimental film-maker, I was interested in the narrative potential of this project. We had just come out of counseling together and I think we were primed for this journey. I was interested in exploring issues around masculinity *vis-à-vis* our histories as brothers and the contradictions of compassion and violence, of betrayal and death, and of loss and mourning – as well as our personal contradictions.

253

Lyle: I love these images because they are reflections of our imperfect selves caught in the act of looking. One senses that the beauty and depth depicted in this *mise en scène* comes out of deep emotional and psychic work. At the social register, it's about pollution – not simply in the sense of airing dirty laundry – but as a critique of holiness, of purity.

Thomas: I think this is a good place to discuss the first image, the "Pieta."

Lyle: I am holding you up. You are in repose, leaning back against me with your eyes closed. My eyes are slightly open, meeting the viewer's gaze. You could be dead, you could be sleeping – it could mean a lot of things.

Thomas: When we were making these images in the Polaroid studio with the assistance of Renée Cox, there was a silent or complicit communication between us. We both agreed that perhaps it would be more interesting for me to be the one who is mourned, given our individual relationship and HIV status at the time.

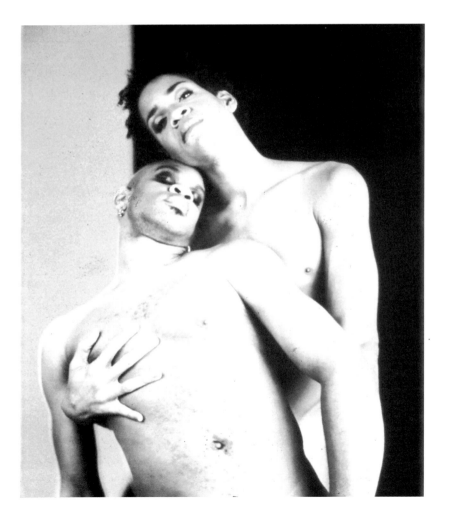

Lyle: It is about mourning and comes out of my own ambivalence around illness and death.

Thomas: Mourning within one's self. It's not necessarily the specific mourning of one's brother or sister. It's about a mourning of a past, a mourning of a present, a mourning of a future. Mourning as a perverse celebration of life. And time.

Lyle: To quote Iké Udé, these images are about being "future perfect." They critique the notion of progress. They move beyond just clinging to a utopian idea that we shall overcome at some future time. Instead, they speak to the need for an immediate political, aesthetic, and psychic intervention; providing a new framework in which to refashion the body and mind. It is about expanding our horizons by working with the possibilities of pain and pleasure, trauma and excess.

Thomas: The photographs stand at the crossroads. They stand between the before and the after while confronting the horror and beauty of life. In a way, it's like splitting apart and being reconstituted; coming back together.

Lyle: These images are significant in the context of cultural representation. If you read the photographs too literally – that these are two *brothers* – it obscures the larger idea of black-on-black violence as well as the resulting psychic violence which is endemic to the culture at large. Such a reading compromises our ability to talk about how we are conditioned to kill that which we love and that which mirrors us – ourselves.

On the other hand, if one reads it as brothers you have the added narrative of the incest taboo. I am reminded of our delight and curiosity over Coco Fusco's comment that the second image of *Brotherhood*, the kiss of death, made her feel very moralistic when she first encountered it. I remember that we wondered whether it was the kiss or the gun that brought this on.

Thomas: Or the representation of both of us together. For instance, my pointing the gun into your body brings to mind memories of how my own internalized homophobia during adolescence kept me from seeing you. It was during those difficult years that our communication diminished.

Lyle: Oddly enough, through this graphic depiction of violence, I feel that we were able to exorcise – to work through – a destructive envy and competition that arose from within as well as from without. I am sure that we can both recall the experience of having people compare us; for example, saying that "you are more talented than your brother," or "your brother is too wild . . ." – whatever. *Brotherhood* claims our ambivalence on our own terms.

Thomas: Furthermore, in the West there is a resistance to seeing two black men connecting; we are more accustomed to black-on-black violence and the disposable black body.

Lyle: A West African friend recently pointed out that it was only when he came to the United States from Nigeria that he realized he could not hold another man's hand on the street because that would have certain homoerotic connotations and, consequently, violent repercussions. Whereas in certain African cultures, joyous physical contact between men is acceptable. The photographs critique black nationalism and diasporic black culture for their acculturated prohibitions of same-sex desire.

Thomas: Though we do not want to mythologize a purity, or indulge in nostalgia around our version of the mythic utopia of Africa, we did experience quite a rupture when we returned from living in Tanzania. And you and I still experience this when we are in public, whether it's walking down the street, riding on public transportation, or whatever. We encounter violence because we are two men holding hands: two men, two brothers, who hold hands, who have intimacy together. It's about the prohibition against men sharing intimacy with each other, regardless of their race or sexual orientation.

Lyle: Exactly. Intimacy. I'm not talking about a woman licking another woman's cunt, or a man sucking another man's dick. I don't give a fuck what you do, that's your business. Keep it to yourself. But what it discloses is the extent to which black nationalism is invested in the law of the white father – and especially the law of the white father's dick, or the law of the white mother's pussy, or whatever. In black nationalists' assertions that homosexuality is a white man's disease, they are buying into the myth that somehow black men – or African men – can't be with each other in intimate ways.

Thomas: If we think about life as being creative expression, then violence can be defined as a curtailment of that expression. I mean, thinking about Daddy for instance, you and I have both spoken about Daddy killing us. I remember him saying – almost as an endearment – "I'll kill you, boy." In part, his utterance can be viewed quite literally (especially from the point of view of a child), although it has a much more significant meaning if read metaphorically.

Lyle: I remember having dreams of Daddy killing me at the opening of my show, *The Good Life*. The scenario was that he would arrive and shoot me in front of everyone, including Mommy. I now understand that this is a projection on my part. Yet how was it that our father came to embody, to signify, all of this fear and uncertainty? I think it is important to point out that, while growing up, it was clearly communicated throughout our family that the husbands of our grandfather's three daughters clearly fucked up; that they did not appreciate their women. Furthermore, Grandpa's relentless critiquing of the ways black men fuck up clearly fucked up my relationships with black men, including my relationship to myself. It is something that I'm working on, yet the stain remains. It was as if the three daughters could do no wrong. Believe me, it's a hard act to live up to.

Thomas: Honey, we produced these photographs in a twenty-minute session. We were right there. It was hell. Because, in a certain sense, it was the two warriors, the guards, the Titans, who approached and bowed to each other; meeting and actually acknowledging their own ambivalences – their pleasures in each other, their love, as well as their hatred for each other. They laid down their swords, in a certain sense. Let's talk about the third photograph, the warriors. In a sense, it was about the making of an offering to each other. It's post-exorcism; we are keeping the evil spirits at bay.

Lyle: These images are very open and raw. They represent aspects of all relationships which are not given space to be acknowledged in our very dualistically structured society.

Thomas: *Brotherhood, Crossroads, Etcetera* presents a moment of reckoning. Our twinned images speak about sameness and difference. The triptych presents at least three different pathways to resolution.

Lyle: While *Brotherhood, Crossroads, Etcetera* is our first official collaboration, we've been collaborating since we were kids. It is important to acknowledge the degree to which the performative and a certain amount of shared imaginary space has led to a type of twinning as embodied in our nonverbal communication, and to a certain paralleling of our projects – the intersection of two narratives at the crossroads. This brings us to the *Orisha Studies*, a second meeting place (see page 312). Here we use the performative to access historical past and future tenses to create another kind of language. The image of twins reappears, but in a distinctly non-western guise. In discussing the African roots of Haitian Vodou, Marilyn Houlberg writes:

The Sacred Twins or Marasa are often depicted as three rather than two because twins represent abundant life, and triplets signal surpassing abundance. [Twins] are associated with transitional places such as thresholds and their magical powers are so strong that they can protect all at that most mystically dangerous place – the crossroads . . . They are the ones who have the power to open the spiritual road.[3]

257

Thomas: The *Orisha Studies* came out of my work with African cosmologies that I began in my videotape, *Heaven, Earth & Hell*. That's when I began to explore the role and function of Elegba, the Yoruba trickster deity and the divine clown in Native American cultures. I was interested in Elegba because he was the deity of change, of transformation, and of individuals' control over their fate. As guardian of the crossroads, he is the first deity to be approached in any ritual or spiritual ceremony.

Elegba, the trickster, can lead one down the road to success or death. Because of this, he was the deity who most terrified the Europeans who saw him as the devil. Using this deity allowed me a certain artistic freedom. I wanted to extend that freedom to you and Peggy in this piece (see page 310). Both you and Peggy represented the deity Oshun, the personification of beauty and sexuality, seduction and love, who is symbolized by the gold color and whose manifestation plays with notions of twinning and femininity. The *Orisha Studies* can be seen as a companion to *Brotherhood, Crossroads, Etcetera*. Both projects draw from our histories as well as from our engagement with performance as a transformational and creative experience. Both come out of the African diasporic experience.

Lyle: To quote Chester Higgins in his book *Feeling the Spirit: Searching the World for the People of Africa*: "We are Africans not because we are born in Africa, but because Africa is born in us. Look around you and behold us in our greatness."

Thomas: In a way, *Orisha Studies* imagines a post-race position in that it is about a certain death of blackness. But how does this project signal a post-race position? By removing the visual sign of color as signifier of "race" and connecting it to an African diasporic mythology. This continues our respective projects of exploding blackness. We came to *Orisha Studies* to be reborn. That rebirth also signals the end of blackness. Again, how is this accomplished? The *Orisha Studies* take identity to another place. This identity shift is reflected in the symbolic use of color in the backdrop of both projects. The black nationalistic field of *Brotherhood* has given way to the deeper womb interior of *Orisha Studies*.

Lyle: To quote Frantz Fanon, "In the world through which I travel I'm endlessly recreating myself." The *Orisha* project is about moving on.

Thomas: Creating new selves. This is actually what our work has been engaged with all along, but here we do it in a different syntax. As African Americans embracing our diasporic identity, we are poised to liberate ourselves from the primacy of archaic race codes. I think that we're at a place now where people are actually making a transition in identity from black or African American to a more expansive identity politics. There is much to be gained from an exchange among Africans living in Brazil, the Caribbean, Africa, and Europe in all of their varied manifestations. People are divesting themselves of racial binaries, black versus white. Moving in this direction, we begin to claim the entire spectrum of identity including the fullness of our various ethnicities. When we were growing up, to speak of one's Native American or European ancestry meant that you undervalued your Africanness. But now, Africanness is the essence of our humanity. I think the *Orisha Studies* positions death as a kind of ritual to get us to another place. But, at the same time, there is all this black death.

Lyle: And it's also – bringing it back home – about my being HIV positive. More specifically, it was around this time five years ago when I found out I was HIV positive – I feel all that is coming up. I need to get my will together, for example, and I have a copy that I want to go over with you as my executor. All that type of stuff. Not that it's goodbye or anything, as you say, I'm young and healthy but it is about a letting go.

I think I've suffered a lot – we both have. We've taken our abuse in different ways; we've had our different trajectories. Sometimes, when I shake my hair, I feel really good about myself. It's funny because people claim I've been closeted about my HIV status and I think I've been quite open. But I feel like it's just one aspect of a whole lot of stuff I have to deal with. Not that I don't have a lot to deal with as a black gay man in this society, but it's less about "poor me" and more about moving on. I feel that if I was to die soon, you must go on, get things done, take care of Mommy. I don't think I'm leaving right now, but I do get the sense that my body is aging. I actually feel good about it. I feel like – if I die tomorrow, I've done . . .

Thomas: You've accomplished a lot in your life. You've touched many people and produced incredible bodies of work.

Lyle: And I feel really good about myself. I feel like there are very few people who know me like you do and it's been a privilege to have that kind of intimacy and rigor.

Thomas: It's very interesting because we talk about psychic space and psychic stuff. I heard you this morning. I don't know why I'm using these words like Momma because I did feel like your mother this morning. You called out once and I said, "What's happening?" And you called out a second time and I just jumped out of bed with Chris. I wanted to get my drawers [laughing] because for some reason I had this feeling even before you called me the first time. I had actually awakened in bed with fear in the pit of my stomach and I woke up Chris and said, "Chris, I have this feeling." Chris, how did you experience what happened?

Chris: Well, you woke up and there was this pain in your eyes and you started to cry. And I just held you. I didn't know what it was, even. I couldn't really hear what you said. You said something about dreaming something disturbing, but I couldn't make out the rest of it because you sort of choked on your words. But I wanted to reassure you of my presence. I didn't know what to say; I just held you. Not very long afterwards, I heard Lyle call out to you.

Thomas: So we have this – there is this psychic connection. This thing exists. We talk about psychic space; it's a very real space we're talking about. And just calling everybody "Momma," for me, it brings up all this intuitive stuff that mothers have – celebrating that kind of stuff. Because I felt very much like a nurturer when I was with you. It felt good because I had a chance to process my stuff earlier with Chris and then you (Lyle) woke up and we processed together. When you told me about your nightmare, I didn't need to tell you I had a scary dream, too, because I was able to be there. We were able to be there for each other.

Lyle: We are also more open to taking emotional risks. I had this dream of my grandfather's death and I was calling him on the telephone. I felt emotional and I had the phone in my hand the whole time during the dream – I was calling out. I felt like I could reach out and call because that's transgression also, transgressing the fear of calling out in times of need. At this point in my life, that's about edge, about risk. It's completely fierce in its anti-oxidant properties, you know what I'm saying? [laughter]

Thomas: It's true. You don't feel backed up at all. I've never mentioned this to you but you were talking about how you were thinking about your death. I now see how it comes out in different ways if I don't process what happens between us and how I feel about it. I remember getting sick in the spring of 1994. A student of mine came to me and said, "Don't try to process your brother's illness. You have to be there for him and be strong and don't try to absorb his illness." She said that a voice had come to her when she was meditating and told her to tell me this. This whole idea of the relationship among the spiritual, the psychic and the physical is something we have to begin to allow for, just as we deconstruct those "primitive/civilized" binaries.

Our work talks about metaphor, about autobiography, but it's also talking about the force of love and how a kiss can be as strong as a bullet coming out of a fucking gun. For Grandpa and Nana, a prayer could be as strong as any kind of action. We're thinking about death as the summation of one thing and the beginning of something else – not only our individual deaths and the lessons we learn – but metaphorically: the different "deaths" we experience such as the death of childhood, of adolescence.

Lyle: The death of the father.

Thomas: The death of the father. And the metaphorical rebirth.

Lyle: We have experienced the death of the father. We have had to let him go symbolically, as opposed

to engaging in his fantasies of us – his fantasized projection of us as children or, on the other hand, as his parents. Our experiences of the "death of the father" have been very different. I guess I used to feel that if Mommy ever died, I could not live without her. I don't have those feelings any more. I've let go. My fears of risking my relationship with you hark back to my relationship to our father. To be able to articulate ambivalences, or to question, or even to relate to the family, you risk not having anyone.

Thomas: It was so intense to leave the therapy session owning our feelings, sometimes not even speaking to each other. Because of family pressures, it was always, "Make up! Make up! Be nice! Don't disturb the peace!" But it was a risk worth taking

Lyle: Indeed! It was a risk worth taking, and the arresting visual power of the *Brotherhood* triptych speaks to this. Furthermore, with *Alchemy*, our current project, we are building on our lifetime investment in collaboration. In this work, we are expanding on the concept of twinning, the family, and redemption by using the mythology of the sacred twins to bring forth our new world order through primarily visual means.

Twins Song[4]

Bobo, father of twins, has passed away.
Bobo died and left the twins in the Vodou temple.
Some say to Bobo, "in whose hands
 have you left the twins?"
"Don't worry, father, we are strong enough.
"When you were alive, we were the big chiefs.
"We had all the power and we led the way for you.
"We use the sweet smell of magic to fight
 against evil spirits."

Marasa Ginen are never afraid of anyone.
When Guinea twins make a magical medicine for you,
 you can even sleep in the crossroads.
Nothing can happen to either you or your children.

Marasa eat during the ceremony, then hide behind the door;
Then they come out and say they haven't eaten.
They hide behind the door on purpose,
They know they are so important that they can cause
 the ceremony to be done all over again.

"We are the Marasa and we never just
 play around with people.
"We are dangerous!
"So don't worry, Bobo, our father,
"We control our own fate,
"We control everything!"

notes

The authors would like to thank Christopher Kuhrt for transcription and initial editing of this document.

1 Henry Louis Gates, Jr, *Bearing Witness: Selections from African American Autobiography in the Twentieth Century*, New York, Pantheon Books, 1991.

2 Alice Walker, "Black Panthers or Black Punks?" *New York Times*, 5 May 1993, p. A23.

3 Marilyn Houlberg, "Magique Marasa: The Ritual Cosmos of Twins and Other Sacred Children," in Donald J. Consentino, ed., *Sacred Arts of Haitian Vodou*, UCLA Fowler Museum of Cultural History, Regents of the University of California, 1995.

4 Loose translation from Creole of "Magique Marasa," by Haitian singer Papa Wawa, 1993. Ibid.

alisa solomon

not just a passing fancy
notes on butch

I didn't realize, when I decided to talk about butchness, that I was creating a serious conundrum for myself, one that would not have arisen if I simply were writing "Notes on Butch" for publication.[1] The fact that I'd have to stand up, delivering – perhaps one can even say, performing – this paper, magnified a mundane question into a theoretical and practical dilemma: What was I going to wear? Given my themes – the way butchness both reveals gender as performance and reveals the limits of the theatrical metaphor – I knew that whatever I pulled out of my closet would be a costume; that is, it would be read as having some direct relation to what I had to say. My garments could substantiate my points, call my authority into question, assert my authenticity.

Would I wear a suit and tie as prideful affirmation of my own butchness – or as compensation for my lack of it? Loop a string of dimestore pearls through that tie to suggest, through mixing iconography, that such identities are provisional? Would I just not think about it and don my everyday academic garb – slacks and a blazer – which in this context might appear more butch than usual? Or, perhaps, in this context, appear less butch than usual, and seem like a cop-out, a shameful refusal to knot that tie or snap on those cuff links? Maybe I'd wear a little black dress with fishnets and pumps, just to keep things provocatively confusing (though I'd have to borrow the entire get-up and practice walking in advance so I wouldn't trip over my high heels on my way to the podium).

Obviously, like actors, who have multiple ways of interpreting a particular moment in a play, I had to make a single choice, and doing so, it seemed, meant doing away with the possibility of expressing every option open to me. But luckily, since I could write my own script, I could have it both ways: of course I made a choice, which by now is not only self-evident but also extremely self-conscious. (Stirrup pants, a unisex button-down shirt, a blazer, a flowery necktie, wingtips.) At the same time, I could call attention to my choice as a way of suggesting that what you see isn't always everything you might get. It's a point worth stating because it's one that's made both by butchness and by a particular kind of theatricality.

I want to look at what butchness and that kind of theatricality have in common and what kind of theater metaphor works best for describing butchness, and by extension, all manifestations of gender presentation. Finally, I want to look at what happens when this already theatrical image is put on a stage.

In considering butchness as performance, it's important to emphasize that I'm addressing butchness as a style of self-presentation, as a way of asserting or displaying oneself – one's lesbian self – in 1990s America. I won't be focusing on butchness as a sexual identity or as a sexual practice (though these can certainly be related to butch presentation – even if they aren't necessarily related by cause and effect, and sometimes have no relation at all). I won't be discussing the historical functions of butch roles; their manifestations in other cultures; the vast differences between, say, 1950s American working-class bar butches and 1920s elegant Left Bank salon butches; or the psychoanalytic meaning of butch representation. (There is a growing body of literature that takes up these subjects and others, for example: Leslie Feinberg's novel, *Stone Butch Blues*; Elizabeth Lapovsky Kennedy and Madeline Davis's sociological study, *Boots of Leather, Slippers of Gold: The History of a Lesbian Community*; Joan Nestle's steamy anthology, *The Persistent Desire: A Femme–Butch Reader*; Sue-Ellen Case's essay, "Toward a Butch–Femme Aesthetic" in *Making a Spectacle*; Teresa De Lauretis's essay "Film and the Visible" in *How Do I Look?*) Instead, I'm interested specifically in how different theories of acting – based on Brecht, Boal, and contemporary performance art – might be used to understand the power of the butch image.

It was, after all, through theater that I first understood how butchness helps reveal the performativity of gender – though that's not how I would have articulated the insight at the time. As a stagestruck adolescent, it was clear to me that I was something of a gender outlaw. I understood this because it was so obvious to me that I couldn't hope to get a lead in a school play any more than I could expect to make the cheerleading squad or be elected homecoming queen. I saw that only certain kinds of girls could play the certain kinds of dramatic parts available to girls. And, with my jock swagger and not quite budding breasts, I certainly wasn't one of those girls. (Recognizing the limits of these dramatic parts awakened my feminist consciousness, too.) Luckily, I didn't much care that I didn't fit that mold. I was far happier to play on the field hockey and softball teams, and to labor as a backstage techie, which allowed me to clip a tape measure on my belt, tie a crescent wrench to my jeans, and wear workboots to school. (This was junior high as baby butch heaven!)

Watching rehearsals day after day of some Huck Finn play or another, I saw adolescent life repeating itself: girls practiced giggling with each other, gawking at boys, and gagging themselves; boys practiced impressing each other, impressing girls, and impressing themselves. At first I took the impossibility of my being cast in the play to mean that there was no part for me in the real-life order of the boy–girl universe, either. (Funny how that didn't upset me too much.) But as I studied theater more intently, I came to a more startling revelation: that I *could* be cast in one of those girl parts if only I learned to act well enough. I figured this out just around the time that female schoolmates started putting on mascara and holding back in class. I decided I could never be that good an actor.

Butchness is the sometimes conscious, sometimes intuitive, refusal to play a part in the heterosexist binary (which doesn't mean that butches never have male lovers). Often referred to as a kind of role-playing, butchness can more accurately be described as the denunciation of a given role. There are "hardcore" butches and "Saturday night" butches; "stone" butches and "soft" butches; butches who so define themselves because they are turned on by turning on femmes; and butches who fall for other butches. There are butches who pass as men; butches who opt for female-to-male hormonal and surgical transsexualism; butches who turn femme; and butches who

Figs 15.1–15.3, 15.5 Deborah Bright, *Dream Girls*, 1990. Courtesy the artist

Fig 15.1

never even think about being butch. The most useful way of defining butch, Gayle Rubin suggests, is "as a category of lesbian gender that is constituted through the deployment and manipulation of masculine gender codes and symbols";[2] in other words, dykes with such objects or attributes as motorcycles, cummerbunds, wingtips, money, pronounced biceps, extreme chivalry. Straight women with such objects or attributes are just straight women with motorcycles, cummerbunds, biceps, etcetera. The difference is audience. Butches present their butchness for women – whether femmes, other butches, themselves, or all three. Some declare their desire through their appearance; some self-consciously participate in codes that, at least under certain social conditions, make lesbians visible to each other; some would say they're simply expressing outwardly who they inwardly know themselves to be. In any case, those motorcycles, biceps, and so on are layered with meaning by the lesbian butch. For her, they are not only objects and attributes, but signs.

Like gender in general, butchness is learned behavior that feels natural – but learning it is often self-conscious. Fifties butches often tell of being tutored by older butches in everything from how to buy a suit to how to behave in bed. In a campy exaggeration of that tradition, Peggy Shaw, a member of the Split Britches company, offered free Butch Lessons one weekend afternoon at the WOW Cafe, the predominantly lesbian woman's theater in New York's lower east side. She gave tips on such butch basics as lighting your date's cigarette, cruising, and choosing a tie.

Adopting and often transforming traits traditionally associated with men, butches threaten masculinity more than they imitate it; they colonize it. Making aggression or toughness or chivalry or rebelliousness their histrionic own, butches reveal the arbitrariness with which traits are said to belong to men. Rather than copying some "original" image of masculinity, butches point to the embarrassing fact that there is no such thing; masculinity is an artifice no matter who performs it. It's for this reason that butches are often victims of the worst lesbian-bashing. Certainly femme or any non-butch lesbians enrage straight men by preferring women lovers; femmes confound straight assumptions about sexuality, and that's enraging. But butches confound assumptions about gender, and that is even more enraging, for it challenges straight men's frantically assembled certainty about their sexuality and power.

This dynamic is clearest in the most macho and most homosocial world of the military, where women – regardless of their sexuality – are often considered man-hating dykes because they remove themselves from the category of sexual object by virtue of their uniforms, physical ability, and, yes, often their lesbianism. Of course not all women in the military are butches or even lesbians (though, like farm women, they can confuse even the most seasoned dyke). But they all illustrate how any woman encroaching on male privilege and presentation will be punished. A common remark from male recruits when a colleague's girlfriend visits the base is: "How nice to have a real woman around here." And when military men just can't stand it any more that the women around them every day are not there for the men's entertainment and pleasure, there's always a Tailhook to set things – shall I say? – straight.[3]

The extent to which bashers are incensed by butches, for blurring the lines between male and female genders, is most apparent in their violent promises to restore butches to their "proper" role. Typical butch-bashing begins with a rhetorical question: "Are you a man or a woman?" This is followed with the threat to answer: "We'll show *you*." One day, a man walking past me on upper Broadway after I'd gotten a particularly severe haircut strode right up into my face and barked: "Hey, whadda you? A boy or a girl?" To which the only appropriate reply seemed to be: "Hey, whadda *you*? A shmuck or an asshole?"

Being butch isn't simply to flunk basic gender training; it's to scoff at the whole curriculum. And in doing so, it reveals the artificiality of that entire system. If a butch can construct her appearance in a way that seems totally authentic and internally consistent to her, then isn't that what all people are doing when it comes to gender presentation? In other words, if one woman can flout the expected or "normal" appearance and behavior of women, doesn't that mean anyone can flout such expectations? Doesn't that mean that gender is performance?

Of course it is a kind of performance, but gender isn't *merely* performance. We may self-consciously choose our clothing for effect, but few people wake up each morning and decide which gender to put on for the day. It's too simple to say that gender is *all* role-playing, even in the sense that Erving Goffman has developed in his theory of social interaction. For Goffman seems to forget that there's no self that pre-exists our roles, or that the roles we play are not separate from us, as they are, say, for a conventional actor. If the analogy to an actor is to be at all useful in this context, then we can't invoke the naturalistic, Stanislavskian actor who develops her role, performs it, and leaves it behind when she steps off the stage. Rather, we have to think about the actor of the experimental theater from the 1970s on – the actor who tries not to make a distinction between herself and her role, whose role, in fact, is not a dramatic character, but her own self as framed by the time and task she has on stage – the sort of actor, in other words, now known as a performance artist.

It's not easy to draw a line between authenticity and artificiality when looking at this type of performer. Her "real self" (and I'll leave the defining of that to philosophers and psychoanalysts)

Fig. 15.2

is not hidden or put in abeyance by a part she's playing; it is the persona that stays with her as she dances, tells a story, utters insensible words, moves about. And yet this persona is to some extent crafted for presentation – at the same time as it is constituted by that presentation. In other words, how do you tell the performer from the performance?

Gender, certainly, is a performance more like this than like the performance of an actor playing, say, Hedda Gabler. It's not a role that is easily discarded, or even easily taken on, though it is heavily regulated. It accrues gradually, yet does not attach itself to some blank, some actor cast in a play she's not yet read; it comes into being by virtue of being performed. Judith Butler has been clarifying this point in various essays and in her book *Gender Trouble*. She writes: "gender is not a performance that a prior subject elects to do, but gender is *performative* in the sense that it constitutes as an effect the very subject it appears to express."[4] Elsewhere she argues, "gender cannot be understood as a *role* which either expresses or disguises an interior 'self,' whether that 'self' is conceived as sexed or not. As performance which is performative, gender is an 'act,' broadly construed, which constructs the social fiction of its own psychological interiority."[5]

Butches point to that fiction in a special way, which can be understood, I think, by looking at some other performance models. This isn't to say that butches feel any less "real" in their gender presentations than people who follow the rules. I offer myself as an example: I'm not, for the sake of making a political point, acting as though I can't wear a dress and heels comfortably – I really can't! I'd feel, and look, like I was in drag – and I'm not even at all that butch. To say that butchness is consciously constructed at times is not to say that it can be easily thrown off, or that it's as simple as putting on a leather jacket and boots. (Though a leather jacket and boots can go a long way.) But because it operates outside of what Butler calls the "regulatory fiction" of gender, it reveals that regulatory fiction for what it is. Butchness reminds its audience of what it is not.

Which is another way of saying that butchness, if not by intention, at least in effect, is epic acting.

Brecht defined epic acting this way (well, not quite this way – I'm changing his pronouns):

When [an actor] appears on stage, besides what she actually is doing she will at all essential points discover, specify, imply what she is not doing; that is, she will act in such a way that the alternative emerges as clearly as possible, that her acting allows the other possibilities to be inferred and only represents one of the possible variants . . . Whatever she doesn't do must be contained and conserved in what she does.[6]

Brecht also said that the epic actor must show her character "in quotations" and suggested that a good way for an actor to practice epic acting was by playing the opposite sex.

The purpose of this acting style, of course, is to make the familiar strange, to reveal social conventions that have become invisible or "natural" and to show how they have been artificially constructed. Elin Diamond has written persuasively of the implications this theatrical theory can have for feminist representation in the theater – even though the particular social conventions Brecht was interested in didn't include gender, much less its particularly oppressive hold on women.

Still, it seems to me that the butch doesn't adopt masculinity, as most stereotypes would have it, but puts quotation marks around it. (A very different process from the parodying of femininity that drag queens perform. Susan Sontag said that camp puts quotation marks around things, too – but she uses the image in a different way than Brecht. In camp, quotation marks punctuate parody; in epic theater, irony.) Thus, the butch reveals the conventions of masculinity while at the same time her self-presentation allows the possibility of femininity – the role she is refusing – to be inferred. That's why she is so intolerable: at once the butch demonstrates the choice she's refusing and claims the ground she can't have.

This is the tempting contradiction that the *v-effekt* of her epic acting reveals. And it's what makes her sexy. The butch's eroticism comes not from her looking like a man, but from her not being one – that is, from her transgression, from the disruption so wittily captured in Deborah Bright's photographs. Of course, once a butch steps over the invisible line into passing for male, her acting is no longer epic. The ironic quotation marks are replaced with earnestness; the alternative is no longer implied.

Historically, there are numerous examples of women who passed for male in order to travel safely, find work, live with the women they loved, get through the day without being beaten up. This type of transvestism is what Marjorie Garber disparagingly calls, in her compendium of cross-dressing, *Vested Interests*, the "progress narrative" – cross-dressing for success. She resents this use of transvestism as "an instrumental strategy rather than an erotic pleasure and play space" for failing to recognize the transvestite as the "figure that disrupts." But why is Garber's abstraction the privileged way of disrupting? Doesn't it count when a woman disrupts her own oppression by dressing as a man?

Garber prefers to see the transvestite as the grand signifier of boundary crossing, that which creates and reflects what she calls a "category crisis." The transvestite, she argues, shakes up our conventional notions of male and female, and unsettles other categories, such as nationality, race, and religion, by "put[ting] in question identities previously conceived as stable, unchallengeable, grounded, and 'known.'"[7]

The butch, I believe, unsettles these categories more successfully than the transvestite – if, that is, the transvestite is passing successfully. For if s/he is passing successfully, what is being trans-ed? To accomplish the disruption Garber insists on, transvestites must allow their beholders a moment

to catch themselves in a recognition, a moment of being struck with the realization: "She's really a man!" or "He's really a woman!" It's Wittgenstein's old duck–rabbit trick: we must notice ourselves seeing-as. Which, again, is exactly what Brecht asks us to do in the theater.

The acting model which best describes this kind of passing is Brazilian director Augusto Boal's idea of invisible theater, described in his book *Theater of the Oppressed*. Influenced by Paolo Freire, who used theater techniques to teach literacy and community empowerment, Boal developed a series of guerrilla theater exercises and tactics for intervening in public life. Invisible theater is "the presentation of a scene in an environment other than the theater, before people who are not spectators . . . During the spectacle, these people must not have the slightest idea that it is a 'spectacle' for this would make them spectators."[8] What Boal had in mind was the creation of some kind of ruckus or confrontation in which the undercover actors would demonstrate some lesson to the unwitting spectators, and perhaps draw them into the action. The actors, in other words, would function as catalysts to some event and discussion that would set people thinking in new ways about, say, the distribution of wealth.

Fig. 15.3

The passing butch can do this, if that is her intention – though a butch passing to keep a job or stay alive may have more pressing things on her mind. But it is in Boal's sense of invisible theater that I understood my single experience of passing for male.

A year or two ago, I was one of a dozen women who attended a workshop titled "Drag King for a Day" (which had been advertised in the issue of *Movement Research* magazine that got the NEA's knickers in a twist). John Armstrong, a preoperative female-to-male transsexual, meticulously colored strips of fake hair to match our own, and then pasted the fuzz above our lips, on our chins, or along our jawlines. He showed us how to flatten our breasts by wrapping Ace bandages around and around our torsos (my Jogbra did the trick). We loosened our belts a notch to make our waistlines fall, slicked back our hair, put on vests. I clinched the transformation by knotting my necktie on the first try. We giggled at each other and ourselves in the mirror. Some of us stuffed socks into our pants.

Performance artist Diane Torr – now "Danny," with a thick moustache and a dark suit – led us in movement exercises. We swaggered, we slumped, we took up space. We dropped our voices into our diaphragms, and talked in slow, measured tones – as if, Torr coached, "you know you have thousands of years of philosophy behind every word and people are bound to listen." We grunted, we grumbled, and we practiced not smiling. Passing for male, said Torr, "is an exercise in repression."

I ventured out on to Lexington Avenue in the blazing light of the afternoon sun, terrified that I'd be discovered. The spirit gum itched like crazy under my brand new moustache; I didn't dare wipe the sweat that trickled down my cheek for fear of smudging off my five-o'clock shadow. But in no time I hit my stride – a lumbering, loping, masculine stride. I wasn't halfway down the block before the self-consciousness slipped away.

Not just the self-consciousness of being in disguise, but the everyday self-consciousness that all women carry in the street, the self-consciousness of being on display. Now, as I sauntered along in my heavy shoes and butch black jacket, no one looked. I walked right past men hanging out on corners, men strolling by, men lingering in doorways. They didn't even see me. For once, my shoulders didn't tense in anticipation of some "hey-baby" lewdness. I had become invisible.

The ad had promised "the adventure of a lifetime." But what was most remarkable about being dressed as a man for twelve hours was how *un*remarkable it felt. I'd expected the frisson of putting one over on the guys, the thrill of catching a glimpse of male privilege and power, the eroticism of maintaining a secret in public, the eeriness of feeling that I'd "become" my brother (whom I resemble even without a moustache). All those emotions were stirred. But what I felt most was ease and comfort.

It was so easy to pass, in fact, that I almost took the subway home at two in the morning, until I remembered that I was still five foot two inches and 115 pounds, and that men, too, get mugged. The cabdriver asked me what I thought about those Mets.

The dozen of us from the workshop spent the evening together, first going for drinks and dancing at a queer bar frequented by transvestites. (That's where I screwed up my courage to go to the men's room, swaggered safely into a stall, pulled down my pants, and watched my crotch-stuffing, wadded-up, red cotton sweatsock leap out, roll under the door, and land by a urinal. So much for the phallus as signifier.) I spent a happy couple of hours, learning to boogie to Motown without swiveling my hips.

Later, we headed downtown to a lesbian bar where lots of gay boys hang out to prove how cool they are. By then, a lot of our group had tired of their itchy whiskers, had yanked them off and gone cruising for girls, but I was in for the long haul. I sat at the bar quaffing a Rolling Rock and chatting with gay guys as they came along. Like one of Boal's undercover actors using

invisible theater, I asked them why they'd come to this bar – a discussion they'd never have had if I'd asked them as a woman. Why, when there were more than fifty gay men's bars in New York, had they decided to come to one of two lesbian bars, since they clearly weren't there to shmooze with the women? Most responded as if the question had never occurred to them, but I prodded, and they began to think things over, weigh their words, wonder aloud why they had come. Some said they *had* come to shmooze with the women, and were disappointed that more weren't interested in socializing with *them*; others said they appreciated the relief of being away from the heavy cruising of men's bars. But one of the guys who told me that was also the one who asked me if we might get together later. It was time to draw the curtain on my invisible theater by revealing myself. "Why do *you* come here?" he asked me. I stroked my moustache, and answered matter-of-factly: "I'm a lesbian."

What happens to the highly theatrical activities of butchness, gender, and passing, though, when they are put into the theatrical frame, when they are made the subject of drama? I've already mentioned Peggy Shaw, the big butch Split Britches actor who is every feminist critic's favorite example. The company's major works have been written about amply – not only because the group tours to colleges across the country, but because their work so neatly demonstrates, and sometimes even refers to, principles of contemporary queer and performance theory. I want briefly to talk about a piece they performed for one night last summer at Dixon Place, the downtown performance space where new work is developed and tested. I don't recall whether the piece even had a name; there certainly wasn't any program.

The short performance was created by Shaw and her partner of more than a decade, on stage and off, Lois Weaver. For years, Shaw and Weaver have staged, celebrated, parodied, and reversed butch–femme identities in autobiographical cabaret (*Anniversary Waltz*, in which Shaw imagines herself as James Dean, and Weaver depicts herself, upon her coming out, as Katherine Hepburn waiting for her female Spencer Tracy to sweep in); fractured fairy tales (*Beauty and the Beast*, with Deb Margolin, which offered a metaphoric fable for Shaw and Weaver's butch–femme roles); and non-linear, multilayered drama (Holly Hughes's *Dress Suits to Hire*, in which Shaw, until then always the heavy butch, sang torch songs in evening gowns, her shoulders massing beneath spaghetti straps, her calves like steel rods stuck in stilettos). Their explorations went in exciting new directions when they joined forces with the London drag troupe, Bloolips, to create *Belle Reprieve*, a four-part invention on *A Streetcar Named Desire* that bent, twisted, and exploded gender with its four-way conundrums: Was the scene between Blanche (played by drag queen *extraordinaire* Betty Bourne) and Stanley (played by Shaw) a lesbian love scene? A straight seduction? A gay male one? Same questions for scenes between Stanley and Stella (Weaver), or Blanche and Mitch (Bloolips veteran Precious Pearl, a man) – and so on. During the run of the show, Shaw raked in adoring fan mail from gay men.

The piece at Dixon Place was a kind of scaling down, a chance for Shaw and Weaver to get used to working alone again, as well as a chance for them to incorporate some of the themes they'd developed in *Belle Reprieve* and make them work even when there weren't any men – or drag queens – in the show with them.

The result was a complex and poignant examination of butch–femme taken to its extremes. Weaver and Shaw had long played with these roles; indeed, they traded them briefly in *Anniversary Waltz*, a compendium of skits celebrating their tenth anniversary. This exchange, and the celebration of their relationship – though heavily camped up – led to accusations by one lesbian critic after another that they'd produced an "assimiliationist" work, and denuded "butch–femme" of its sexual content by reducing it to a set of costumes. I couldn't disagree more strongly. I found the show both charming and liberatory.

Fig. 15.4 Eva Weiss, *Lois Weaver and Peggy Shaw*, n.d. Courtesy the artist

The Dixon Place piece begins with Weaver coming on stage naked in all her buxom bleached-blondeness, and calmly welcoming the audience. She then performs a striptease to the "Take It All Off" song – but strips her femme clothing on, one little piece at a time: stockings, black *bustier*, strapless dress (which a spectator is recruited to zip up). The brilliance of the strip is that the more Weaver puts on, the sexier she becomes.

Shaw follows with a monologue, adapted from *Belle Reprieve*:

I was born this way. I didn't learn it at theater school. I was born butch. I'm so queer I don't even have to talk about it. It speaks for itself. It's not funny. Being butch isn't funny. Don't panic. I fall to pieces in the night. I'm just thousands of parts of other people all mashed into my body. I'm not an original person. I take all these pieces, snatch them off the floor before they get swept under the bed, and manufacture myself. When I'm saying I fall to pieces, I'm saying Marlon Brando was not there for me. James Dean failed to come through. Where was Susan Hayward

when I needed her? And how come Rita Hayworth was nowhere to be found? I fall to pieces at the drop of a hat. Take your pick of which piece you want and when I pull myself back together again I'll think of you. I'll think of you and what you want me to be.

In both solo turns, the roles are established as a layered system of signs, created by the piling-on of pieces from popular culture, from the dominant heterosexist world. Weaver's soft nakedness and Shaw's declaration, "I was born this way," assert a biological femme and butch essentialism, which are immediately distanced and commented upon by the pieces that make their costumes – whether stockings and *bustier*, or gestures and mannerisms borrowed from Brando or Hayworth. Butch and femme are not just the costume, but they're nothing without the costume.

And that's not all. Weaver and Shaw dance together and almost immediately another butch – an even butcher butch, Leslie Feinberg (though Shaw would kill me if she heard me call someone a butcher butch) – cuts in to dance with Shaw. The two glide awkwardly yet tenderly around the floor, stumbling as each tries to lead the other, as they talk about their discomfort: "What if someone sees us dancing together? They might think I'm a femme!" The line is hilarious in its implausibility, yet absolutely honest, and heart-breaking, in its expression of panic. The anxiety is palpable, like a junior high prom. Shaw and Feinberg fumble and trip, searching for the way to make their smooth moves smooth. The scene is intensely erotic.

The exchange is complex in another way: Shaw, a seasoned performer whose street and stage life are largely blurred, represents herself on stage as a butch whose butchness is self-conscious, but no less real for being self-conscious; that is, it's Brechtian. Feinberg, long-time activist, author of the novel I mentioned, and pre-Stonewall bar butch, sways across the stage without the mediation of any self-conscious performance frame. The simple fact of the stage provides one distancing frame, of course, but that irony is not as thick or as nuanced as the ironies surrounding Shaw. The contrast, never remarked upon, raises impossible questions: Which is the more desirable butch – more desirable to have, more desirable to be like, or both? Which is the "realer" butch? This, of course, is the question vexing the performers, but at a totally different level than for us. For them, at least as characters in a script, the question is ontological; for them as performers whose real lives are enmeshed in their performance, the question is existential; for us, the audience, the question is social, sexual, political, aesthetic.

Because it subverts male privilege, butchness can be the most dangerous queer image – and that's exactly why it is increasingly invisible even as gays and lesbians find ourselves in the news for good or ill. And that's why when it does appear, it's tamed, even commodified. Though proportionally three times as many women as men are kicked out of the military for being homosexual, lesbians are never mentioned when the generals get hysterical over the prospect of gay guys in the shower (if they're so afraid of a few fags, I wonder, what business do these brass have protecting America, much less democracy?). And butches are increasingly absent in the ever more pleading efforts of some gay activists to prove that we are just like straights. Think of the front-page photo in the *New York Times* the day domestic partnerships were introduced to New York City: Wow! A lesbian couple on the cover of the *Times* – both of them in little black dresses and pearls. Or we think of the we're-just-like-you rhetoric around the March on Washington. Butches are left out of the picture.

In the 1990s, as a recent *New York* magazine cover story ecstatically explained, lesbians are looking sharp. And thus we overcome the myth of the "mannish" lesbian, banishing, in one ironic swoop, both butches and the lesbian-feminist flannel crunchies of the 1970s, who themselves once drove butches out of the lesbian community.

Fig. 15.5

The effect of our being so fashionable is the de-dyking of butchness. While butchness vanishes from mainstream images of lesbians, a *faux* butchness – its parameters carefully delineated – is all over the straight world. Model Brooke Shields poses in baseball cap and five o'clock shadow under the title "Pretty Butch" for the cover of a New York fashion mag. Straight female college students wear splashy neckties purchased from men's shops.

In part this occurs because women, at least in the corporate world – or, more accurately, fashion designers of clothing for those in the corporate world – have acknowledged women's relative liberation by tailoring their power suits after men's traditional business attire – making sure, of course, there's still a slit at the thigh, or a flounce at the neck, or best of all, a little cleavage peeping through. Still, Radclyffe Hall could almost walk down Wall Street in her famous duds today without much notice – except that her shoes might give her away. (When it comes to physical labor, women's attire has almost always, of necessity, been the same as men's.)

But of course, this is only costume. Butchness, like any full performance, involves stance, gesture, movement, vocal intonation, and, most important, intention. And there's no danger that the intention will ever be appropriated.

notes

1 This essay was developed from a speech delivered at Rutgers University in April 1993. It was first published in *Theater*, vol. 24, no. 2, 1993. A revised version appears in Alisa Solomon, *Re-Dressing the Canon: Essays on Theatre and Gender*, London and New York, Routledge, 1997.

2 Gayle Rubin, "Of Catamites and Kings: Reflections on Butch, Gender, and Boundaries," in Joan Nestle, ed., *The Persistent Desire: A Butch–Femme Reader*, Boston, Alyson, 1992, p. 467.

3 The "Tailhook" scandal broke in the early 1990s when a female officer brought charges against the US Navy for gang sexual assault by partying aircraft-carrier pilots who had gathered for their annual "Tailhook" convention.

4 Judith Butler, "Imitation and Gender Instubordination," in Diana Fuss, ed., *Inside/Out: Lesbian Theories, Gay Theories*, New York, Routledge, 1991, p. 24.

5 Judith Butler, "Performative Acts and Gender Constitution: An Essay in Phenomenology and Feminist Theory," in Sue-Ellen Case, ed., *Performing Feminisms: Feminist Critical Theory and Theatre*, Baltimore, Johns Hopkins, 1990, p. 279.

6 Bertolt Brecht, *Brecht on Theatre: The Development of an Aesthetic*, trans. John Willet, New York, Hill and Wang, 1964.

7 Marjorie Garber, *Vested Interests: Cross-Dressing and Cultural Anxiety*, New York, Routledge, 1992, p. 70.

8 Augusto Boal, *Theater of the Oppressed*, New York, Urizen, 1979, p. 144.

chapter sixteen
elizabeth stephens

looking-class heroes
dykes on bikes cruising calendar girls

Dykes on bikes are bad, flashy, and loud. They are as sexy as the sound of straight pipes on a Harley. These dykes are viewed as special outlaws among lesbian communities – from vanilla anti-porn lesbians to the leather and pierced crowd. Calendar girls, on the other hand, are only slightly naughty in their voluptuous silence. Their images exist to sell tools, motorcycles, and other objects of blue-collar masculine commerce. Pin-up girls on calendars have largely disappeared because they came to be viewed as a public insult to women. But why is an artist with an advanced degree, who makes her living as a university professor, interested in revisiting and working with these clichés of female sexuality?

I'm a biker myself. I had a Harley long before I ever thought of becoming a teacher. As a biker, I became involved with other dykes who ride. My participation in biker culture is bifurcated; I am both an insider and an outsider. I'm inside because of my family's class history, my regional background, my love of motorcycles, and my status as a butch who adores femmes. Yet I'm outside because of my position as a middle-class professor and professional artist. Inside/outside is an uncomfortable position to occupy – a constant push and pull between my personal and public lives. I avoid mentioning my biker world to my academic colleagues because I know that being a biker will not enhance my climb up the academic ladder. Nor do I discuss my art and academic worlds with my biker buddies because these subjects seem so far removed from the thrill of the road, and, where there is class difference, it might alienate us from each other. In the biker photographs I've made for my own pleasure, I often use camp humor to ease my discomfort in straddling these two worlds. Camp gives me a strategy to avoid simply exploiting an already over-exploited class, merely by virtue of being queer. The photographs allow me to reclaim my working-class roots. They also allow me to disrupt my middle-class identity, a status which fills me with ambivalence.

Pat, I wanted you the minute I saw your picture on another woman's desk. I needed my own photo of you so that I could study your butchness at will. You've ridden your Softail miles and it shows in the familiar way

276

you straddle it. Your chrome always sparkles and the flames on your tank are perfectly painted. Do you lavish the same kind of attention on your femmes as you give your bike? Your leather jacket, chaps, and boots are slightly but beautifully worn. They protect you from the road, the heat of your straight pipes, and from the rake of long fingernails. Your dreamy, dangerous look of relaxed desire beckons an unseen passenger to join you if they dare. I could bet that you've never been on the back of your bike. You drive or you don't go at all. I've never been on the back of my bike either. In spite of our class difference, we share a common language of motorcycles and butchness: common tongues.[1] But your look tempts me to mount that bitch pad behind you. You're the top dyke daddy that I want to be and want to be had by.

Fig. 16.1 Pat

Figs 16.1, 16.2, 16.7, 16.9, 16.10 Elizabeth Stephens, photographs, 1994–97. Courtesy the artist

elizabeth stephens

In my fantasy photographs, I long for a time that I imagine was less complicated than the present. I am aware that my desires reflect that particular post-Second-World-War era when the spectacle of outlaw biker culture embodied in the Hell's Angels was both romanticized and popularized in movies such as *The Wild One*, *Rebel Without a Cause*, and, later, *Easy Rider*. This was a time when things were easier economically, at least for white men in gray flannel suits. Working-class white men did not share the same entitlements or cultural power as their more affluent and educated counterparts. Instead, their sense of power resided in the more localized arena of the family and neighborhood and was measured against the lesser status of women, fags, blacks, and immigrants. Their adopted macho swagger was, in part, compensation for a lack of real economic power and freedom.

As a butch who frequently identifies with males more than with females, I romanticize and covet the power that straight white men wield in our society. I am especially drawn to the macho swagger, not because I want to take out my lack of real social and economic power on other groups, but because I understand how bravado and anger can be both a response to and a useful tool for dealing with oppression. In my butch biker fantasies, I momentarily forget about the misogyny, homophobia, race, and class supremacy on which this power is built.[2] I recreate places of power and desire, places that have never fully existed for dykes, gay men, women, or people of color. I am looking for and trying to create dyke working-class heroes (and heroines). Dykes need strong feisty heroes as much as anyone else. I am seeking and constructing spaces that mirror my desires. I wrest my heroes from the pages of tool calendars, cheesecake imagery, biker magazines and camp; rescuing them from the leers of horny straight guys and riding away with them on the back of my bike.

I'm a butch, I guess. At least that is what the femmes tell me. And I do like to be treated with all due butch respect. My Harley is my public pedestal. It is both a way to get around and a way to be seen around. It is my throne from which I can display my mastery of the physical, mechanical, and sensual world to other butches and to the femmes who want to mount and ride that world. The bike is the ultimate form of drag for a butch who wishes to be seen as a top on the streets if not necessarily between the sheets. I like to look at other butches, to study how they do their butchness. And of course I love to look at femmes. In the photographs, some are femme tops while others are femme bottoms posing as butch tops and still others are femmes posing as themselves. In my fantasy photographs, I place them on the bike, pedestal them, and watch them pose for my camera. What better way for me to learn not only how to perfect my butch swagger, but how to catch a femme's eye as well.

Tanya, you seem so statuesque astride my Sportster. As your breast melds into the mirror, your case-hardened muscles complement the engine block below. I want you to stay that way forever, to be my sculpture machine. The look on your face seems both frightened and determined not to reveal your fear. You have the look of someone who has gotten lost in the wrong part of town and wants to leave in a hurry. Your vulnerability excites me. I want to both protect you and take advantage of you. The restraint of your majestic pose makes me feel like an exquisite masochistic sadist. I imagine that I can do anything I want to you in your virtual immobility. My tongue could start by polishing your boot and then snake up your leg to the soft inside of your thigh. I could rip out the crotch of your teddy with my teeth to take full advantage of your well-oiled gears. I imagine what it would be like to be burned by your exhaust pipe, too hot to touch and yet so beautifully polished, so irresistible. There are two types of bikers: the ones who have gone down and the ones who are going to go down. I would go down on you any day of the week.

I am a hybrid in terms of class. I grew up in a family that had been working-class for generations but had risen to the managerial middle class by the time I was born. Nevertheless, the

Fig 16.2 Tanya

family stories I heard as a child proudly memorialized our working-class history. I was told over and over again about how my grandfather, father, and uncles started their machine shop during the Great Depression, scavenging scrap metal from which to fabricate parts. As the stories were told, I imagined being in the family snapshots, standing around the truck with my grandfather and his sons, all of us dirty from handling oily gears and coal bits. These images of the men in my family, taken before I was born, always appealed to me more than the later pictures of them in their suits and ties. Their hands had grown soft and they didn't get dirty any more. My middle-class political consciousness forces me to constantly question my attraction to the working-class look. But then my family's stories return to both confirm and confuse my sense of belonging to any particular class. It takes more than a generation to forget where you've come from. I was never allowed to forget that the privileges that I enjoyed were built on sweat equity. My ambivalence towards my middle-class status has to do with the fact that, although my hands may not have to get dirty, my memory has never been very clean.

As a kid, I often tagged along with my father to his machine shop. While he was doing paperwork in the office, I roamed the aisles of machine parts, rode the chain hoist, or watched the

Figs 16.3–16.6, 16.8, 16.11. Pin-up pages from tool calendars, 1990s. Courtesy the author

Fig. 16.3

Fig. 16.4

machinists at their benches. I'm not sure when I first noticed the calendar pin-up girls that shared the walls of the shop alongside signs warning "Safety First!" or "Caution! Eye Protection Required." But I was fascinated and turned on by those girls for reasons that I could not imagine then. The calendars themselves were often soiled by the machinists' greasy hands which turned the pages each month or revisited a favorite model. But I could tell that the girls who posed were oiled, gleaming, and hot. The tools that they brandished had never been used. These girls seemed to have a secret and I wanted to know what it was. Why else would they be smiling so invitingly at the tools they displayed? And why did they always wear bathing suits, or less? I knew that they were from another universe, and that it was way more exotic than the polyester-clad world I lived in. These alien women must have been very important because they were the keepers of time. Somehow I sensed that they were for men's eyes only, but that taboo made them all the more irresistible.

Once, I was caught intently studying a pin-up girl. Even though I protested that I was just trying to see what day of the week it was, I was quickly hustled out of the shop and into my father's office. I never received a very clear explanation about what I had done wrong. But afterwards, my attraction to these images embarrassed me. I knew that I couldn't show my full appreciation for, curiosity about, or attraction to them to anyone. My desire both humiliated and excited me. I wanted to look at those women and, in my adolescent confused fashion, take them as my own. I wanted them to aim their dewy eyes at me. I wanted to be held and caressed like the virgin tools that they lavished their attention on. If the machinists were around, I averted my eyes and pretended that I didn't see *their* calendar girls. I resented this. But surreptitiously, I bonded with those machinists over their pictures of nearly naked women clutching a Snap On tool or caressing a case of ball bearings. I coveted that masculine space with its prerogatives and entitlements to look and possess, even if only in fantasy. I wanted the power and freedom to enjoy my own glossy babe-of-the-month.

RIDGID pipe stands offer a full range of heavy duty adjustable pipe stands in varying styles with capacities from $1/8$" to 36". These stands are especially suited for use with threading machines, roll groovers and similar equipment.

Product: RIDGID Model HC-450 Hole Cutting Tool

Model: Gaelle Comparat — Photographed at Pacific Palisades, California, by Peter Gowland.

Fig. 16.5

Fig. 16.6

Fig. 16.7 Tanya & Kitten

Your eye in the mirror of the bike could be looking anywhere. Are you looking at yourself to make sure that every hair is in place? Are you gazing at Kitten in the larger-than-life promo poster for Titillation? *Does the anticipation of her dress falling excite you as much as it excites me? Mounted on the bike in front of the poster, you advertise that you too are a sexual outlaw and open to the possibilities that this affords. I would love to explore some of those possibilities with you. But your back is turned to me and you are teasing me with your one-eyed gaze. I should throw you on your back and make you moan, open-mouthed, like the other woman in the poster. As you look at me in the mirror, I want you to be imagining this also. Look at me while I photograph you, try to violate my stage direction. Your eye signals that I can have you. Your eye makes me do whatever you want me to.*

In my imagined world of butch privilege, I long for a time when I can look freely at explicit images that give me sexual pleasure. My education has made my looking complicated and contradictory. Feminism and other critical theories have colored my relationship to images and their meanings. My attraction to mass-produced images of tool calendars, biker-magazine motorcycle chicks, or images in *Playboy* does not exactly conform to the expectations they are intended to serve. I'm not interested in producing images which manipulate the viewer into consuming certain products or ideas. Neither am I interested in producing images that try to speak universally of working-class dyke desire. I am primarily interested in realizing my own particular erotic fantasies. I enjoy "objectifying" someone else who appreciates being looked at with desire as much as I do.[3]

Some would say that mass-media and pornographic images of women always objectify them and thereby disempower them. I understand the conditions that have fostered this belief, but I also know porn stars, strippers, and actresses who are not forced to participate in their profession but choose it as an alternative to other options. They pose because they can make more money, more quickly, than they could as a retail clerk, secretary, or as an educated artist. Some even enjoy their work and take pride in their performance. I am also aware of the growing body of sexually explicit work produced by and for lesbians. I enjoy a lot of it and am grateful it exists.

Fig. 16.8

But I rarely find an image that has that particular blend of elements that excites me to rhapsody. This is the reason that I am returning to my memories of those calendar girls. There was something about their all–American mix of seduction and repression that both melted me and made me want to take them on a wild ride.

I think of making photographs as a performance, a visual construction site. My first photographic project was an extension of my sculptural practice. I created a fantasy photo shoot with New York porn celebrity Annie Sprinkle, using my Harley as a machine pedestal on which she posed as a biker chick while I pretended to photograph her. I exhibited the resulting photographs (taken by two other photographers), along with the bike. The process of setting up a shoot and interacting with my models is a private scene that will have a wider audience later. I can act out my butch–bottom fantasies with my femme tops or other butches, but ultimately I am the top butch as the photographer. I decide what the camera sees, and then what gets shown. I get a vicarious thrill from inspecting the costumes my models bring with them in order to play out their own biker and biker-chick fantasies. It brings out the best of the voyeur and exhibitionist in us all. My fantasy allows my models and me to claim a space that we might not ordinarily occupy. The photographs afford us a chance to remake and queer that space, if only for the click of the shutter.

Olivia, you rich little slut, what are you doing driving your Jaguar out here in the middle of the night? I should rip off your fur just to see how little you have on underneath. You think I'm your personal grease

Fig. 16.9 Olivia

monkey, that I'll check under your hood to test how wet your silk panties are. I'd be happy to check you out but you want more than a simple tune-up, you want a full service job. As I adjust your belts you make it clear that you want the tension tighter. As I check your pressure, you say pump it up; you say that you can hardly feel anything. I thought that you didn't know much about mechanics, but you know what you want and you make me work hard to give it to you. If I apply too much pressure, I'm in trouble. But what you don't know is that I like trouble. I'm a wily Br'er Rabbit who will test your tolerances to their full capacity in order to get what I deserve. I want to take you for a ride, my Venus in Furs. You never could resist the vibration of my twin-headed double stroke engine between your legs. The air burns your face, your breasts burn my back, you have to hold on for dear life. Wrap that fur coat around us both as we break all speed limits.

Photographing is as much about the thrill of having the power to get women to pose for and with me as it is about producing the final images. Everyone is acting out both my and their own erotic fantasies embedded in the outlaw look of biker culture. The shoots themselves are erotically charged, which can even make working in a cold damp studio a pleasure. As with porn stars and actresses, we all know that these pictures have little to do with any reality outside the performance of a very specific and subjective desire. My brand of desire is both serious and serious fun: serious, in that it intertwines class appropriation, gender play, and sexual preference in order to represent a certain range of my fantasies; serious fun in that I know that I am fabricating a pictorial fantasy that turns me on. It is difficult to find the right combination of exposure, subtlety, and play that adequately represents what I am trying to express. There are times when I feel that this work is a fool's errand, given the social and political times in which we live. But then I regain my butch swagger and continue to pursue my belief in the importance of imaging desires that this society would prefer to erase. Dorothy Allison articulates this quandary well in her essay "A Question of Class":

What I know for sure is that class, gender, sexual preference, and prejudice; racial, ethnic, and religious – form an intricate lattice that restricts and shapes our lives, and that hatred is not a simple act. Claiming your identity in the cauldron of hatred and resistance to hatred is infinitely complicated, and worse, almost unexplainable.[4]

This work is made primarily with a lesbian audience in mind but I am comfortable showing the photographs to a wide range of viewers. Recently, I showed a contact sheet of this work to a machinist friend. His hearty appreciation of the images pleased me. After all, I first discovered the impact that an image could have in a straight male working-class machine shop. Subsequently, I have been strongly influenced by both straight and gay male porn. The lesbian sexual content of my work has both titillated and offended straight viewers, but then it has also offended some lesbians. Exhibiting the work in a mainstream galley – assuming they would even show it in the first place – presents the challenge of engaging people who do not necessarily go to an art gallery expecting to see lesbian erotica. These viewers generally do not have the knowledge or experience to easily or accurately decode such images. But if they are open and willing to try, I am willing to try to explain what I'm doing.

Lesbian and gay venues attract a more prepared audience, but this is no guarantee that the work will be viewed without objection. I was once accused of "being a man" by an outraged lesbian feminist who felt that the work I exhibited "objectified" women. This happened in the 1990s in a respected and cosmopolitan university gallery and underscores the unpredictable nature of any individual's response to a given body of work.

Fig. 16.10 Sasha

Sasha, you wouldn't really bring that wrench down on the bike, would you? There's nothing I could do to stop you because I'm too busy trying to focus on your stance against the camera and to work with your utter lack of respect for my directions. You are truly the dom that your costumes mark you, and you are bringing me to my knees. You know how your black stockings held by garters, your leather panties and bustier always make me weak. Your shoes alone could inspire me to be your footrest. You call the shots and you won't stop playing until you are finished. If your desires are denied even the slightest bit, you are quick to get even. Sasha, you might be my perfect tool girl after all. You could be the patron saint of any woman who has been exploited or of any woman who has not been an object of desire. I have always wanted revenge for each time I've had to avert my eyes from what I desired to see. You could avenge my unhappily imposed repression. As you swing that big wrench around I both cower and cheer for the possibilities this scene suggests. But maybe you should put it down for a minute. Come over here and let's plot our revenge together.

I am appropriating working-class imagery to make art while living in a society which still generally doesn't want to confront difference. I love biker culture: the bike, the leather, the butch–femme play, and the butch bonding over how the bike is or isn't running. But I especially love the sense of freedom and sexual power that participating in this world affords me. I long to exercise that power in the arena of making and freely enjoying images that reflect my desires. My photographs of dykes on bikes and calendar girls give me the opportunity to create this world, if only in fantasy. But without fantasy to help us negotiate the bigoted and violent world in which

Fig. 16.11

we live, our invisibility would be unbearable. This is, in part, the importance of my work and that of other artists, writers, and cultural producers who are queering the cultural landscape with images that explore sexual territories. In the meantime, I'm going to keep riding my Harley and cruising for the calendar girl of my dreams.

notes

I would like to thank both the Academic Senate and the Arts Division of the University of California, Santa Cruz, for grants that have supported this project. I would also like to thank the women who posed for me in my drafty studio, as well as those who read and re-read this text. I would especially like to thank E. G. Crichton who not only read several versions of this article and provided useful suggestions, but also discussed the photographs with me.

1 Barbara Joans, "'Dykes on Bikes' Meets Ladies of Harley," in W. Leap, ed., *Beyond the Lavender Lexicon*, New York, Gordon and Breach, 1995. Joans has written several anthropological studies about women bikers, both queer and straight. I borrowed the idea of the common language of bikers from a draft of her essay.

2 I do not address racial differences in this paper because my biker fantasies are specifically informed by the milieu of my white rural West Virginia childhood and adolescence in the 1960s and 1970s, and the prevailing belief that bikers are a white-trash phenomenon. This is not to say that dykes of color do not participate in biker culture, they do; they just don't inhabit these particular fantasies of mine.

3 The word "objectify" has been used by anti-porn feminists to provoke a knee-jerk response to any sexualized representations of women's bodies. Consensual participation in the making of sexual images by and for women implies a very different agenda from the coerced victimization of women that anti-porn feminists' use of the term connotes.

4 Dorothy Allison, *Skin, Talking About Sex, Class and Literature*, Ithaca, Firebrand Books, 1995, p. 23.

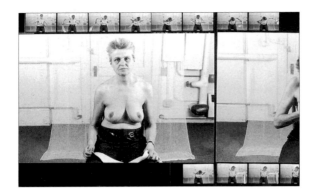

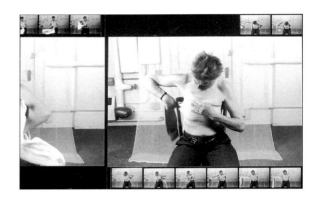

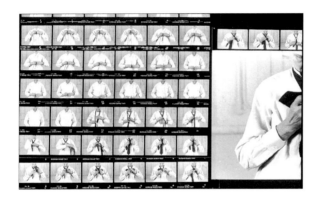

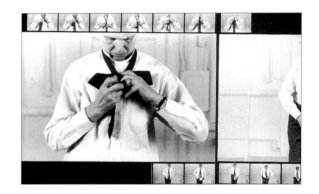

Linn Underhill, *Drag Piece*, 1996, 10 silver gelatin prints mounted on panels, 16 × 20 in. each. Courtesy the artist

catherine lord

looking for my museum

She usually sat in the bouncer's stool, in the exact corner of the bar where she could spot trouble before it came through the door or erupted inside. She made her beer last, like a woman who couldn't afford not to take care of herself, like a woman who had had to learn how to drink alone. She talked to no one except Pat the bartender, gray-haired and small and every inch a femme, or to the old-timers, the women who wafted in with their great blond bouffants and blouses with necklines and ruffles and cleavage, trailed by their mates in plumage at once more modest and far more dangerous, dark pants, white shirts, short hair.

It took a few visits, in fact, to know she was a woman, not just some guy who needed to see dykes to get it up and was allowed to stay because the women knew that he'd call the cops if they tried to throw him out. The first time we came through the door she stared at us for as long as she needed, legs apart, one elbow on the bar, cigarette stuck in her mouth. She didn't bother even to nod. She gave us a good look, without dropping her eyes, without showing want or apology. She wore, as she always did, heavy blue work pants with a knife-edged crease, steel-toed black work shoes, perfectly polished, a pressed denim shirt, top button open, sleeves neatly rolled to a wide cuff above the elbow. Always, a pack of cigarettes in the pocket. Always Camels. Never, even in the bitter winters of upstate New York, a cap, a scarf, or a sweater. The most she would concede, when there was no other way, was a short wool jacket that zipped up the front. Nothing that would disguise the uniform. Nothing that would endanger the perfect ducktail. Nothing that would permit something as ordinary as the raw force of nature to erode the body she had constructed.

The bar had been there since the 1950s, built near factories and working-class row houses that would be demolished to make way for a turnpike in the relentless 1960s. Progress beached the Riverview on an alley that dead-ended into massive concrete pylons instead of letting someone slip home the back way. By the time we walked through the door, hand in hand, in the late 1970s, river and view had long gone. Inside, no one had bothered to keep up with the times. Pat the bartender and owner lived in the apartment above. She kept the front room downstairs for the jukebox and the bar, so that the regulars could hitch up their stools and have a quiet chat. The

back room was for the younger crowd, for playing pool, for dancing, for touching in safety out of sight of the street, for looking. Across the back wall floated a 1960s hippie painting, a white-skinned woman with flowing black tresses and crimson lips, a monstrous paint-by-numbers Ophelia, unbeatified mother of all casualties of love, a silent reproach to those of us still looking for our own kind, stubbornly chasing heartbreak.

We went there because in the 1970s lesbians like me – white, middle-class, college-educated – went to places called lesbian bars. It was folk wisdom (perhaps the goddess actually had decreed it) that every respectably sized city had a lesbian bar. Besides our beds, there was nowhere else but a lesbian bar for a lesbian to go and be a lesbian, to be known as a lesbian, nowhere else to know herself as a lesbian. Without the guidance of queer theory, I had accepted this cultural imperative. My first lesbian bar, in another big northeastern city, was a downtown businessmen's joint by day that turned into a highly profitable women's bar by night. They paid off the cops so that after the straight people fled to the suburbs, they could pack the rooms with young women, making desire and betrayal as thick as the smoke in the air.

When we had time to kill on our way to sex, or when sex wasn't an immediate possibility, or when we needed a good line to get sex, we talked lesbian shop talk, gossiping about who was and who wasn't, trading information about the few books written for us, or the songs sung for us, or the one or two films in which we could see ourselves. Blissfully uninterested in our mothers, our grandmothers, or any abstraction from genealogy into history, we made it up as we went along, inventing ourselves as lesbians in order to create the ground upon which we needed to stand. Though we couldn't have said so, our lesbian bodies were making lesbian culture by filling the only space we had that permitted us to desire each other in public, that allowed us to make a public of each other.

To recognize each other, to be sure of each other, to test each other, we took care to look more or less exactly like each other. We dressed so as to reject a femininity imposed by the patriarchy while policing ourselves for any inadvertent lapses into masculinity, balancing with difficulty on the thin line by which we believed we could separate sex from gender so that we could have sex without gender. In practice, this meant a studiedly unstudied costume of turtlenecks, open shirts (white, denim, or plaid), the full range of jeans from pegs to bells, the full range of shoes so long as nothing had a heel, no lipstick, and no jewelry but womyn-signifier jewelry. Worry about being a sexual object was epidemic. We spurned power trips, inequality, and domination. Barricades formed by wavy drawings of labia, behind which even thinking about penetration was suspect, were a hazard of our lives. More likely we were worried about being sexual subjects. Most likely we worried about being mistaken for the girls our mothers warned us about, which is to say the butch–femme couples who repelled our mothers, or so they would have insisted had we only known to ask.

Why you were interested in a woman who dressed anything like me, or thought anything like me, I only understood years later, when you showed me a book you had loved for a long time. A series of photographs by an American artist traveling in Greece with a few of his friends, the book intercut landscape and architectural fragments with snapshots of young American intellectuals producing for the benefit of Europeans a look of lean, casual, tailored, sensible elegance that was virtually identical for male and female. That was my look, you explained, an American girl in Europe in the 1950s, bestowing on me a past I had neither lived nor seen nor dreamed of until the moment you wanted me to see in myself, to take for myself, an understated mannishness that, unimaginable as a costume for a young French girl of good middle-class family, was naturally your secret desire. Your gender of choice was American. (No matter, when I bought a copy of the book for myself years later, that it had actually been published in the 1930s. No matter, when I

looked at it carefully, that it actually contained only a few photographs of the artist and his ambiguously eroticized friends. No matter that not having been born American, the image could never be a natural fit for me, either as gender or as nation.)

Much of this we couldn't put into words when we needed them, since we barely spoke each other's language. (You had had a Miss as a teacher, and I a Mademoiselle, but as children we couldn't have foretold that their lessons might have been useful to our pleasure.) You were a young French *femme*, a term that had nothing to do with the femme I supposed you must be, suspected you of being, wanted you to be: lipstick, perfume, jewelry, short skirts, heels and all. Unable to conduct extended conversations with each other no matter how much we loved each other, we spent a great deal of time in bed. No matter what we did and discovered there, you were, to my amusement and despair, reluctant to admit the existence of lesbians except, for some reason, as a possibility among librarians, with whom you had a few improbable flings. You were suspicious of a term that would ghettoize you, as you put it, dismissive of a political strategy that used visibility as a tool to build identity. As *femme*/femme, you insisted on choice in appearances.

I spent a lot of time in the back room of the Riv, sitting at the chipped formica tables, drinking, playing pool, making out, watching Marion, watching you. I had never been so close to a woman like you. I had never been so close to a woman like Marion. We watched her intently, as if she came from another species. She watched us back, knowing we came from another species. We stalked each other patiently and delicately across a divide none of us had a word to name, much less a language to describe, in a territory where none of us would find her native language useful.

Marion stayed on after the other old timers had drifted away, giving up their bar to us 1970s dykes, after Pat had gotten sick and passed the Riv on to a younger woman who was more in touch with the times. After Marion was the only one left we could ask her a fraction of what we really wanted to know, and she could begin to show us how to play pool, perhaps because she needed a decent partner, perhaps because it amused her to watch us reinvent an erotic script she knew by heart. During the days she worked as a forklift operator in the same factory that had employed her for thirty years. She was the best they had. She was a man. No one had ever figured it out, or given it away. Except for the union, she stayed out of politics, stayed out of trouble, minded her business. She'd had her share of good times, her share of women, plenty of women. Some of them had made her a home, and she had defended them, made love to them, supported them. What with one thing and another, though, nothing had worked out like she'd planned. No one had made it through with her, so she went back to the Riv. It wasn't home, but it was the only place left to be the butch she was, even amongst women who couldn't see or want or own up to wanting what she was.

Now that I'm in another city, now that Marion must be dead or beyond caring, now that I no longer drink, now that the two of us have memorized every inch of the bodies of other women, no matter how much we loved each other, I can safely map my desire on to her history, turn her absent body into my museum, my shrine, my school, into my home, my church, my country.

She was a great big butch, a big soft beautiful butch, a real stone butch. Her face and neck and forearms and hands were brown flushed pink in heat. The rest of her body, which never saw the sun, was a white so fragile that you could see the blue veins through the skin. Her breasts hung down, her nipples a dark purplish pink, exactly the color of her cunt. Even in the morning, her skin never entirely relinquished the marks made by the wide cotton strap she wrapped round and round herself to hold her breasts flat. Her belly was soft and big and hung in rolls. Like a man's, her hips were small, her legs thin. She was one of those women who hadn't much hair on her

body, except for her pubic hair, which was entirely gray. Her hands and feet, small for the rest of her, seemed at odds with the hard muscles of her arms and shoulders and the tendons that stood out in her neck. Undressed or dressed, she inhabited her body in the same way, performing the smallest action with the careful precision of an athlete, or a lover, who knows it will be more beautiful if no motion is wasted, claiming with certainty the right to part whatever was in her way, to occupy any territory it pleased her to claim. She took her pleasure in controlling by looking, by staying silent, in giving abandon by never dropping her eyes. She was impossible to touch.

Now that I can map her history on to my desire, now that it's too late, I know that every atom of her body had been irrevocably altered by a litany beyond my imagining – police beatings, rape, evictions, firings without notice or explanation, medical abuse, endless small stupid everyday humilations – and, though she was always too much of a gentleman to blame them, abandonment by women who couldn't bear to wake up outcast every morning of their lives. I learned the long way round, not by listening to Marion, who understood the value of silence, who would have seen no reason to relive her pain for a woman who would not comfort her with her body, the only way it could possibly have counted. I learned to map her, body and soul, by means she would have mocked, the books and the libraries, the careful collections that gave me the stories of those like her and those who wished her dead.

Only now that we are lost to each other, all three of us, could I make you a monument in the history I want to give to you, that I want you to give to me, that I want to take from you. Only now could I build you a museum, a museum I would surround by a moat. Inside the walls, we could savor the memory we know we must have of a resistance so deep and wild it could never be vanquished by anything as ordinary as contempt or violence or laughter. In my struggle, I want you to be a heroine, a revolutionary, a *guerrillère*, a woman warrior, an amazon. In my struggle, I want to know your body. Now I could want your body. Now I can say that they ought to name the town after you, or the street, or at least the bar, which had closed when I went back to look.

293

portfolio

introduction

This second selection of photographs, much like the first, presents an array of works that unravel fixed assumptions about gender through their collective emphasis on its constructedness, inflected and given shape by other differences such as ethnicity, race, sexual difference, and class. The direct appropriation and subversion of masculine privilege implicit in the act of photographing and art-making, and in the canonical histories of art, characterize the works of three artists: Chuck Samuels, Rita Hammond, and Deborah Kass. All deploy modes of cross-dressing in their self portraits as photographic impostors, calling upon the given familiarity of their canonical referents to accomplish their effect. **Chuck Samuels**'s series of pastiches of famous photographs of nude women by male modernist art photographers, including the notoriously libidinal Edward Weston and surrealist fashion photographer Paul Outerbridge, are brilliant in their exact replication of detail. The substitution of Samuels's own body for those of the women transforms this white male (who happens to be straight) into the erotic object of an implicit male gaze. Far from being a simplistic "Sadie Hawkins Day" gender switch, Samuels's photographs expose the consistent heterosexist underpinnings of elite culture and taste as he vamps and camps through official photo history. Even better, he overtly homosexualizes those master photographers whose signature styles remain carefully preserved.

 Rita Hammond takes a related tack, inhabiting the space of the male master while simultaneously impersonating his male subjects. Hammond's self-portraits as the mime Charles Debureau (photographed by Adrien Tournachon), the dancer Nijinksy (as portrayed by Franz Kline), and as Max Beckmann (in his self-portrait as a sailor), are doubly queer – both in their original references to coded male homosexual personae (mime, ballet dancer, sailor) and in this septuagenarian lesbian artist's personal reclamation of and reinvestment in these male homo-identities for herself. **Deborah Kass** seems to seamlessly inhabit the queer body of Andy Warhol as originally photographed by Chris Makos, wearing jeans and a plaid tie and vamping in lipstick and a platinum blond wig. Mocking an art-celebrity industry in thrall to male genius, Kass colonizes with barbed feminist wit "America's most celebrated homosexual artist," who was himself the quintessential appropriationist and star-machine *meister*.

The late **Mark Morrisroe**, whose work is discussed in David Joselit's essay, also references Warholian camping in works such as *Sweet Raspberry/Spanish Madonna* where the artist cross-dresses as a Latin diva-hustler – a role he could almost appear to be performing for one of Andy's Factory films (with Lou Reed's "Take a Walk on the Wild Side" as the sound-track). His angular face powdered a ghostly white, sensuous mouth a red gash, and eyes darkly smoldering beneath their liner and mascara, the former hustler-turned-artist puts himself back on the street, this time as an aging queen in pearls, letting his jacket fall seductively from his shoulder in some *noir* pick-up scene.

Tammy Rae Carland's large color photographs reference pop cultural icons of criminal and transgressive female sexuality: denizens of the hard-time lesbian underworld of female criminals in numerous B-movies and pulp novels, and those horror-flick monster-girls whose bodily excesses play on the castration fantasies of the adolescent boys who are the primary market for such films. As with much of Carland's other work, these images retrieve and pay homage to these lusty outlaw gals who are defiantly and irredeemably bad to the bone. **Kaucyila Brooke**'s large color photo comic-strip *Tit for Twat: Madam and Eve in the Garden* also corrals characters from popular entertainment, this time talk-show hosts Oprah, Donahue, Sally, and Geraldo who narrate and provide commentary on a radically revised version of the biblical creation story, the founding myth of Judeo-Christian heterosexuality. A voluptuous black Eve discovers a tattooed white butch "Madam" in a primordial desert Eden while the chatty talk-show hosts thrust their phallic microphones at the protagonists, narrating the action for the audience.

Andrew Kim also uses humor and popular culture references in giant color close-ups of his mouth, his painted red lips pursed into rosebuds, flower petals, and pulsating carmine sphincters. Kim labels his libidinous orifices with punning references to racist stereotypes of Asian effeminacy and gay sex practices. **Hanh Thi Pham** creates large photo-installation works which passionately confront the difficult and contradictory intersections of nationality, religion, and gender and her own struggles with sexism and ethnic difference as an immigrant Vietnamese dyke artist who grounds her life and practice within her tightly knit expatriate community.

In his digital photographic series *Trespass II (The Kitchen)*, **Sunil Gupta** also draws on imagery from his hybrid identity histories. Icons from the South Asian mughal tradition of courtly miniature painting are juxtaposed with domestic snapshots and advertisements for food and gay sex. The kitchen – the locus of food preparation, sex, and conversation – is presented in Gupta's work as a site of struggle between South Asian and European cultural identities and of his own shared love with two different white men. **Laura Aguilar** graphically expresses the oppressive weight of her cross-cultural identity in her triptych *Three Eagles Flying*. Bracketed by images of the US and Mexican national flags, Aguilar photographs herself naked, her hands bound to her ample body by a heavy rope that also encircles her neck. Girding her lower torso is the US flag and covering her head like an executioner's hood is the Mexican flag, its eagle emblem superimposed on her face like a stamp. Aguilar's body is monumental in its fecund womanliness, but is trapped and immobilized by conflicting national identities and allegiances.

The late **Rotimi Fani-Kayode**, whose work is the subject of Mark Reid's essay in this volume, was also caught between two worlds: his heritage as heir to a Nigerian tribal dynasty in exile in the colonial mother country, and his identity as a man who desired other men, including European men. Unlike Aguilar, Rotimi did not express these conflicting cultural identities as irreconcilable and immobilizing dualistic forces, but sought a "third way," integrating them within his own body in a dynamic and strategic dialectic. In photographs such as *Bronze Head* and *The Golden Phallus*, Rotimi brings together trans-cultural and trans-historical references from African myth and ancestral ritual and contemporary western gay porn in a defiant celebration, in

the age of HIV, of alchemical desire "sporting golden condoms." **Terrence Facey**, another London-based photographer, was born of mixed racial parentage and raised in an orphanage. As an adult, Facey made a pilgrimage to his father's homeland, Jamaica, to rediscover his cultural roots and has since spent much time in the Caribbean. His art photography explores diverse issues affecting people of mixed African heritage living in Britain, in particular issues of cultural representation and interracial sexuality.

The photography of **Lyle Ashton Harris** is well known in the US for its prolific and flamboyant expressions of queer desire inscribed across black bodies and their heritages of sexual fetishization by white racist culture. In their edited conversation in this volume, "Black Widow," Lyle and his brother Thomas discuss their collaboration on their photographic triptych, *Brotherhood, Crossroads, Etcetera*, and *Untitled (Orisha Studies)*, shown here. For Lyle and Thomas, these staged photographs engage psychic and social questions around the erotics of fraternal relations within the context of the middle-class black family, mythic icons of Black Power and their heterosexist subtexts, and archetypal heroic representations of mortality and erotic desire across cultures and historical boundaries.

In a series of photographic billboards created for site-specific installations in New York, Los Angeles, and Munich, the late **Felix Gonzalez-Torres** also grappled with the challenge – in a hyper-materialistic age – of expressing the profound spiritual and emotional impact of HIV's potent mix of death and desire. Presiding over subway platforms, suburban subdivisions and inner-city neighborhoods, Gonzalez-Torres's spare black-and-white billboards showing a lone bird soaring against a lowering sky, a pair of nestled pillows on rumpled sheets, and the ghosted form of a figure moving through space demand a reverential and meditative response. Eschewing easy sentiment, Gonzales-Torres's images hallow the mundane landscapes of daily life.

Finally, **Stephen Andrews** and **Tomàs Gaspar** celebrate the tactile and tangible pleasures and desires of male bodies, even in the midst of an epidemic. Andrews overtly references HIV in his series of photocopied images of details of men's bodies and lovemaking transferred on to latex. The photocopies have the grainy offset look of details from old magazine porn, a graphic anonymity undercut by the painterly qualities of the brushed yellow latex and the addition of hand-drawn graphics such as the simulated biker tattoo, "Snakepit." Gaspar, who has produced a moving bilingual and multiracial AIDS primer for children, *Ginger's Book*, has been making art photographs of erotic play among "friends, sex-buddies or non-professional models." Raised in a strict Latin/Asian evangelical home and having experienced first-hand the shaming and punishing regime of "Christian family values," Gaspar sees his images as a celebratory and healing antidote to social bigotry and intolerance, as well as a tender memorial to those who have left us.

Chuck Samuels (with Sylvia Poirier), *After Weston*, 1991, silver gelatin print, 9¾ × 7½ in. Courtesy of the artist

Chuck Samuels (with Cheryl Simon), *After Outerbridge*, 1990, simulated carbrotype, 10 × 9⅝ in. Courtesy of the artist

Rita Hammond, *As the mime Debureau*, 1994, silver gelatin print, 14.75 × 11.25 in. Courtesy of the artist

Rita Hammond, *As Nijinsky*, 1991, silver gelatin print, 10 × 9 in. Courtesy of the artist

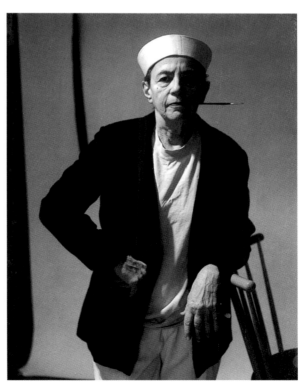

Rita Hammond, *As Max Beckmann*, 1996, unique Polaroid, 4⁷/₁₆ × 3½ in. Courtesy of the artist

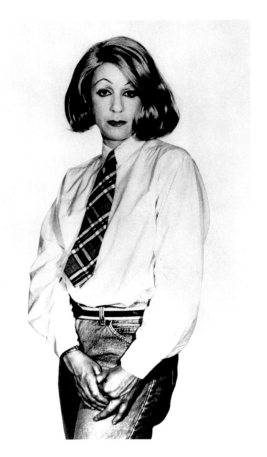

Deborah Kass, *Altered Image #2*, 1994–95, silver gelatin print, 60 × 40 in. Courtesy of the artist

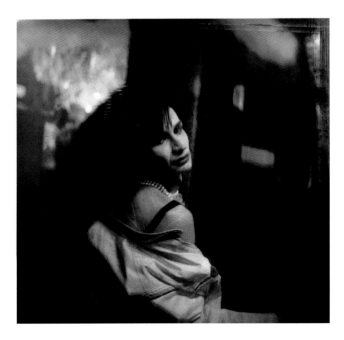

Mark Morrisroe, *Sweet Raspberry/Spanish Madonna*, 1986, color photograph, 16 × 20 in. Courtesy Pat Hearn Gallery

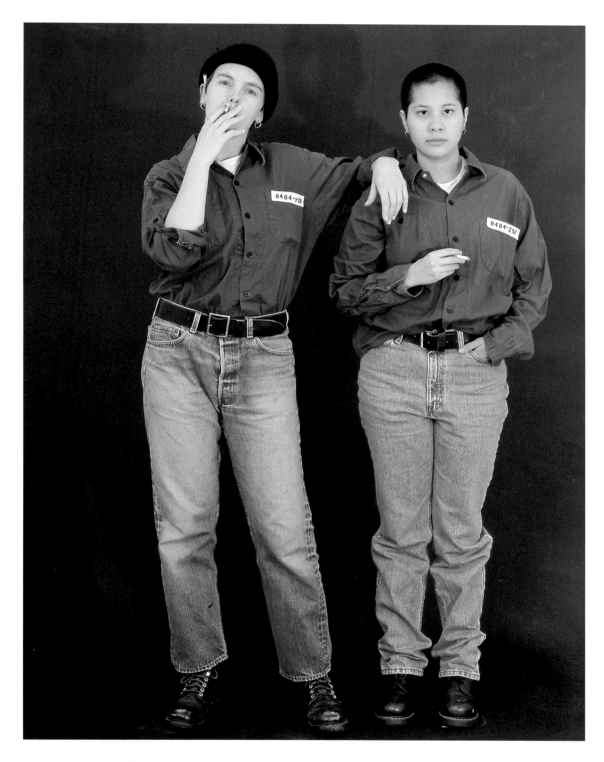

Tammy Rae Carland, *Cell 69*, 1994, chromogenic photograph, 24 × 20 in. Courtesy of the artist

305

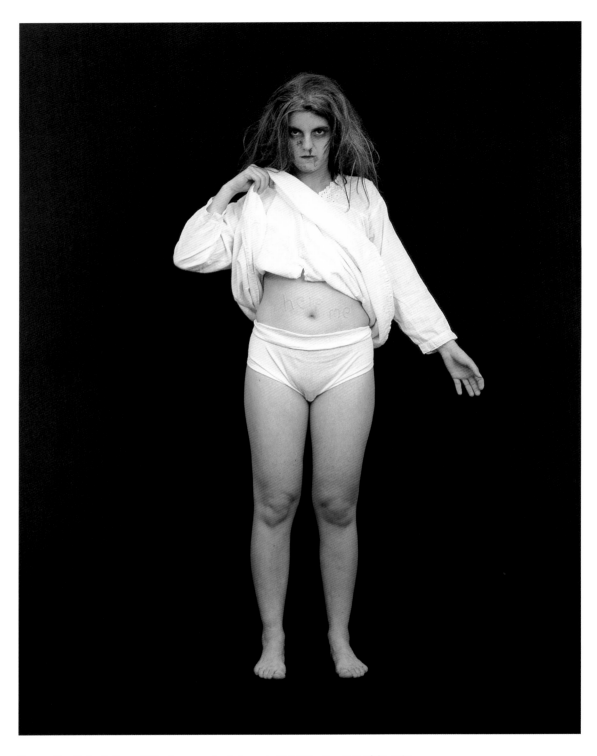

Tammy Rae Carland, *Regan*, 1994, chromogenic photograph, 60 × 30 in. Courtesy of the artist

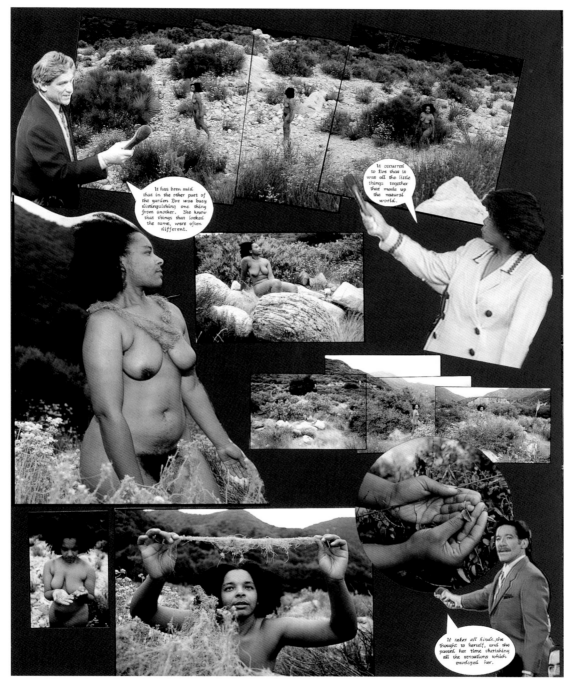

Kaucyila Brooke, *Tit for Twat: Madam and Eve in the Garden*, 1993–96, photomontage, panel 4 of 7, 40 × 32 in. Courtesy of the artist

307

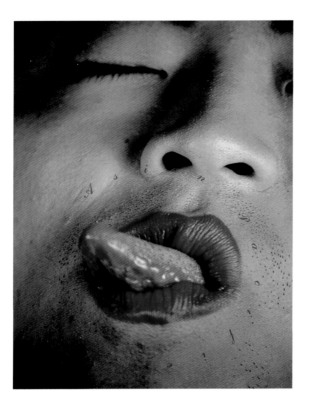

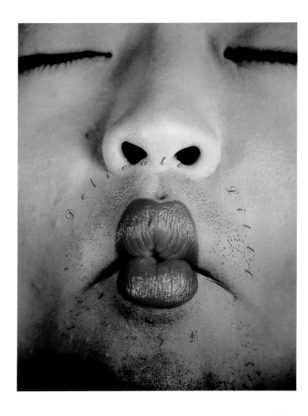

Andrew Kim, *The Asian Pacific Rim*, 1993, color duraflex, 40 × 30 in. Courtesy of the artist

Andrew Kim, *Delicate Little Flower*, 1993, color duraflex, 40 × 30 in. Courtesy of the artist

Hanh Thi Pham, *Number 9, Expatriate Consciousness (Không là người)*. 1991–92, Type R print, 40 × 30 in. Courtesy of the artist

Sunil Gupta, "Untitled" from series *Trespass II*, 1993, chromogenic prints from digital files, 100 × 75 cm.
Courtesy of the artist

309

Rotimi Fani-Kayode, *The Golden Phallus*,
c. 1989, Cibachrome print, 60 × 60 cm.
Courtesy the estate of Rotimi Fani-Kayode
and Autograph, London

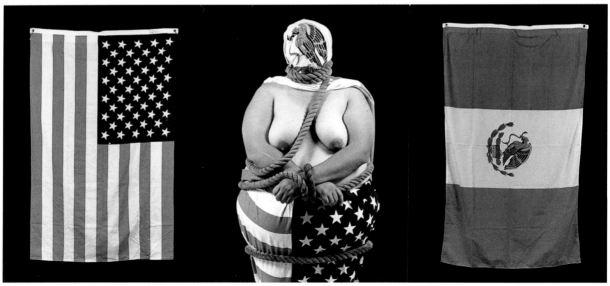

Laura Aguilar, *Three Eagles Flying*, 1990, silver gelatin print triptych, 24 × 60 in. Courtesy of the artist

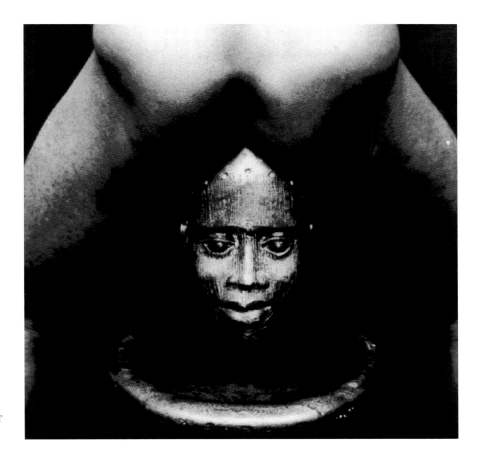

Rotimi Fani-Kayode, *Bronze
Head*. c. 1987, silver gelatin
print. Courtesy of the estate of
Rotimi Fani-Kayode and
Autograph, London

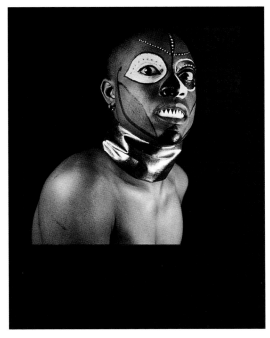

Terrence Facey, "Untitled" from *False Face Society* series, 1994, lith process on
silver gelatin print, 20 × 24 in. (image size 12 × 12 in.). Courtesy of the artist

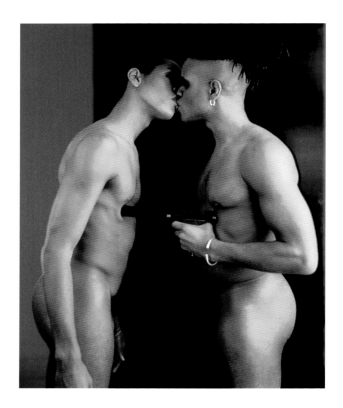

Lyle Ashton Harris with Thomas Allen Harris,
Brotherhood, Crossroads, Etcetera, 1994, unique Polaroid,
24 × 20 in. Courtesy of the artists and Jack Tilton
Gallery, New York

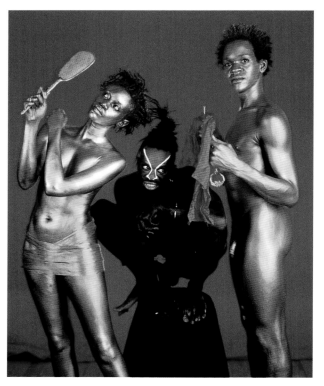

Lyle Ashton Harris with Thomas Allen Harris, *Untitled
(Orisha Studies)*, 1994, unique Polaroid, 24 × 20 in.
Courtesy of the artists and Jack Tilton Gallery, New
York

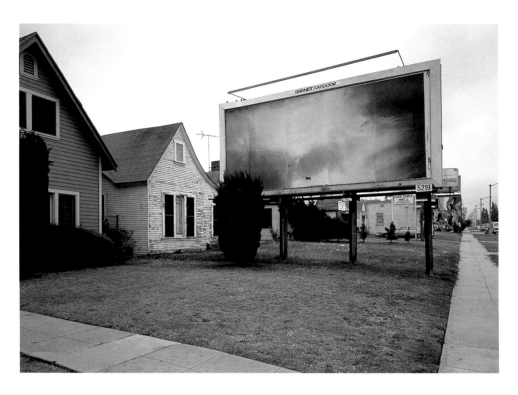

Felix Gonzalez-Torres, *Untitled (Strange Bird)*, 1993, billboard, variable dimensions. As installed for *Traveling*, Museum of Contemporary Art, Los Angeles. Photographer: Alex Slade. Courtesy Andrea Rosen Gallery, New York

Felix Gonzalez-Torres, *Untitled*, 1992, billboard, variable dimensions. As installed for *Felix Gonzalez-Torres/Roni Horn*, Sammlung Goetz, Munich. Location No. 1, U-Bahn Marienplatz, Munich. Photographer: Philipp Schonborn. Courtesy Andrea Rosen Gallery, New York

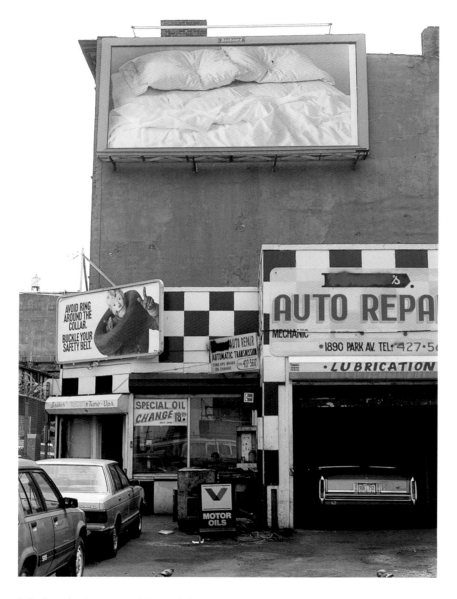

Felix Gonzalez-Torres, *Untitled*, 1991, billboard, variable dimensions. As installed for *Projects 34: Felix Gonzalez-Torres*, Museum of Modern Art, New York. Location No. 10, Park Avenue at East 129th St. Photographer: Peter Muscato. Courtesy Andrea Rosen Gallery, New York

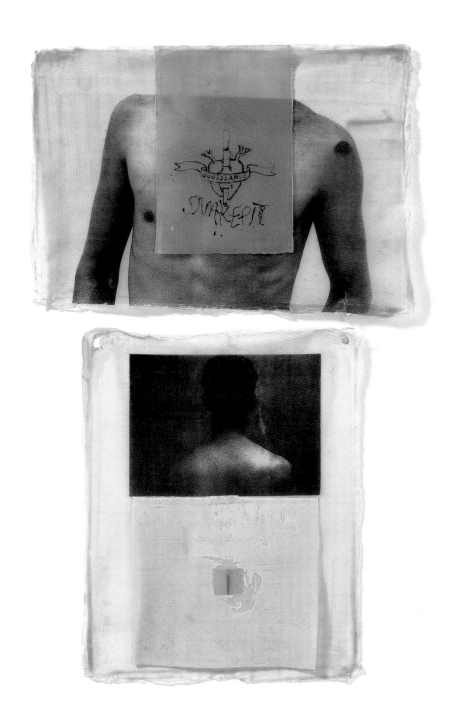

Stephen Andrews, Untitled works from *SAFE* series, 1992, photocopies with ink on latex rubber, each approximately 10 × 14 in. Courtesy of the artist

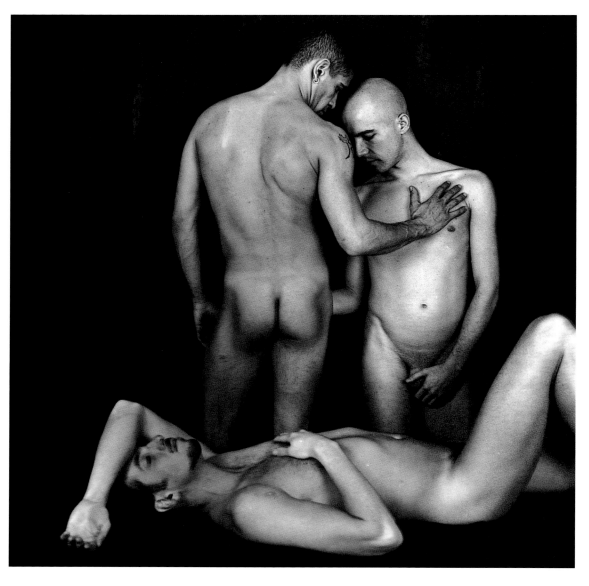

Tomàs Gaspar, "Trio" from series *The Sensual Male*, 1993, silver gelatin print, 16 × 20 in. Courtesy of the artist and MBM Gallery, New York

calculated exposures in risky conditions

linda dittmar

the straight goods
lesbian chic and identity capital on a not-so-queer planet[1]

"And what did the former governess die of? – of so much respectability?"

Henry James, *The Turn of the Screw*

While "lesbian chic" is neither the oxymoron it may have seemed in the 1960s and 1970s nor the hot
journalistic item it became in the early 1990s, the questions it raises concerning the social
construction of glamour, gender, and sexuality within late capitalism remain safely tucked away. I
was reminded of this fact yet again recently when, in the course of purchasing male haberdashery
for my female lover, I was told by a stylish female salesclerk that "women, unlike men, don't
cross-dress. When they wear a suit and tie it's just chic." While the salesclerk was obviously trying
to normalize my purchase as chic rather than queer, she should have known better. After all, she
was employed in one of those Western theme boutiques which could have been the Costume
Department for the film *Midnight Cowboy* (1968). Selling cross-over merchandise, and doing so in
Boston's most exclusive shopping area, where gay antique and art dealers, florists, waiters,
hairdressers, and salesclerks in designer emporia enact the dialectics of gender on a daily basis, she
needed to do little more than glance out of her plate glass window to witness the vibrant fluidities
of gendered attire.

What interests me about this very ordinary episode is the fact that it underscores a pervasive
will to be blind, and that it does so after the notion of a specifically *lesbian* style has actually
surfaced into public discourse as a mode of being that can be named and admired. Though
advertising has been disseminating lesbian-inflected fashion photographs for over a decade, during
a few jaunty months spanning 1993–94 the concept actually got a name: "lesbian chic." Freshly
packaged as a media discovery, and put into circulation through images of female cross-dressing
and same-sex bonding in a variety of media, the fanfare promised to make lesbian presence visible.
But the hype turned out to be short-lived, and was quickly absorbed into heterosexual norms.
"Lesbian chic" reverted to plain "chic," with the "L" word erased and forgotten.[2] This erasure is

easy to effect in fashion photography, where trend-setting fuels consumption and is a bellwether of social values and political economy.

Seen in these terms, the coining of "lesbian chic" responds to a felt need by designers, advertisers, journalists, entertainers, and some working in the sex industry to neutralize an assertive new woman they saw entering the public sphere. The allure of this woman's masculinized power seemed to be in the air, demanding that she be incorporated back into heteronormativity precisely because she was not amenable to it. Imbued with virile dynamism, her newly defined elegance entered public discourse coasting on the paradox of assertiveness within traditional notions of femininity. It invoked lesbian codes (notably those of quasi-cross-dressing and female bonding), but it also remained available to heterosexual readings along the lines of corporate "power" dressing and cosmopolitan sophistication (spiced with hints of fetish dressing). Rendered both queer and "safe," this new chic at once allowed heterosexuals the *frisson* of bisexual and lesbian desire, and opened up for lesbians – notably middle-class and upwardly mobile white lesbians – a hospitable new space for self-definition whose "safety" was predicated on wealth as well as gay/straight indeterminacy.

Fashion photography is, of course, an important medium for instilling values and propagating lifestyles. As a codifying discourse that normalizes the "look" of a given season, fashion establishes the lines, palettes, and even postures that set trends for the consumption of clothing, accessories, cosmetics, and related products. Deeply invested in wealth, power, narcissism, and self-indulgence, the photographic rendition of such products taps the belief that lifestyle gives one access to exceptional well-being. The fact that fashion's norms are unattainable to most women – that the cost of designer clothes is extravagantly prohibitive, that the designs shown are often unwearable in everyday circumstances, and that the lifestyles projected are unrealistically high-maintenance – does not dim its appeal. Popularly disseminated fashion photography was never meant to be merely documentary. Rather, its use of carefully posed models and meticulously planned settings to display its wares aims at constructing fantasies of female pleasure and desire. In this rarefied context, clothes acquire a shamanistic function; they construct fantasies which invite the wearer to cross the imagined lines separating pleasure from utility, essence from its masquerade, and the extraordinary from the quotidian.[3]

Crucial to fashion photography's ability to proffer this invitation is its material presence, where sophisticated manipulations of the apparatus and luxurious presentation support narrative content. From Baron de Meyer to Man Ray, Horst, and Richard Avedon, the use of light, color, filters, lenses, film stock, camera angles, proximities, framing, and cropping foregrounds the artist's genius and elevates the depicted item to the status of art. Stressing the cost of image-making, fashion photography's high production values endow its products with a special aura. The photographs' dramatically large scale and the lustrous, thick, and perfumed magazine paper on which they are printed, further reinforce this message. Not only do these photographs contain narratives that incite desire and invite reverie (en route to consumption), but they mediate these narratives through a luxurious production which pays homage to wealth and class privilege. While the narratives invite viewers to join an affluent coterie of discriminating consumers who supposedly find happiness in acquiring certain commodities, the sensual appeal and sheer costliness of the material text proffer a similar invitation.

It is within this melding of fashion to wealth that the concept of "lesbian chic" needs to be considered. Represented in fashion photography as slim, tall, and a sharp dresser, the new sophisticate to whom the label "lesbian" was attached invoked the boardroom, the penthouse, the editorial office, and the expensive after-hours club. Photographed as she is about to leap on to a moving Manhattan bus in her man-styled DKNY coat, wearing an expensive leather jacket as she

straddles a motorbike, absorbing the sun at a sidewalk café in her carelessly worn man-tailored suit and designer eyeglasses, off to cocktails in her Ralph Lauren velvet blazer and satin tie, sheathed in Gianni Versace black leather and lycra as she and her bustiered companion enjoy a night on the town, or walking her dog in Central Park in an Armani suit, she is a woman of taste who has money and power. Goodbye denim and flannel; hello suits and leather.[4]

This newly confident lesbian has also found welcome in congratulatory journalistic reportage. On 10 May 1993, *New York* magazine granted her a cover story titled "LESBIAN CHIC: *The Bold, Brave New World of Gay Women.*" *Newsweek* quickly responded with its own cover story on 21 June: "LESBIANS: Coming Out Strong. What Are the Limits of Tolerance?" A month later *Vogue* magazine followed suit with an article it safely left off the cover and coyly titled, "SEXUAL POLITICS: goodbye to the last taboo." A subtitle explains what this ingeniously evasive title means: "Not long ago, you couldn't say the word *lesbian* on television. Now everybody's gay-girl crazy." By November of that year, *Cosmopolitan* caught the fever, too. Though "Check Out These SUPER HUNKS" and "HOW TO MAKE YOUR MAN BETTER in BED" are in bolder and larger type than "A Matter of Pride: Being a Gay Woman in the 90's," *Cosmo* did manage to give "gay" women cover space and an article to match. *Esquire*'s subsequent article about "do me" feminism (February 1994) set an uneasy tone as it revisited feminism twenty-one years after a previous Special Issue. Addressing a primarily male audience, its large print heading, "Goddess, riot grrrl, philosopher-queen, lipstick lesbian, warrior, tattooed love child, sack artist, leader of men," replaces the "gentler" feminist of yore with a range of gay/straight viragos who land *Esquire* in a quandary: being lesbian is hip, being powerful is scary.

Finding something to repackage as "news" is journalism's stock in trade, of course. Once gay men gained a modicum of visibility in the post-Stonewall era of gay-lib militancy and ostensible sexual tolerance (at least among certain urban and urbane milieus), it was time for a newly discovered lesbian chic to become the newest news on the block. Erased were centuries of lesbian sartorial display, including records of the beautifully tailored attire of "mannish" butches and cross-dressers – of writer and artists like Natalie Barney, Romaine Brooks, Radclyffe Hall, Djuna Barnes, Colette, or Dorothy Arzner, and of performers like Marlene Dietrich, Gladys Bentley, or Stormé Delareverie.[5] Unmentioned was a history of well-heeled lesbians leading glamorous and often publicly successful lives in the capitals and country retreats of the western world and its colonies. Gone also were centuries where lesbians – indeed, many more lesbians than the privileged few named above – simply blended into the general population as ordinary women (or men, when passing), without availing themselves of the pleasure of publicly defying convention and problematizing their identity.

But while the newly discovered chic is not new at all, its repackaging as novelty is important precisely because it counters the much less prosperous "look" which was tacitly assumed to be the lesbian norm, a "look" which barely entered public record because of its refusal to be assimilated into middle-class respectability. The decidedly un-chic lesbian stereotype of the late 1960s and 1970s articulated both second-wave feminism's separatist anti-sex-object stance and a rejection of consumerism which feminists of all sexual orientations shared with New Left activists and their counterculture cohorts. These women's denim overalls and work boots invoked an androgynous working-class identity apart from the older butch-femme bar culture which preceded it. Augmented by the functional wholesomeness of Birkenstock sandals, the ethnic flair of Latin American textiles, and T-shirts proudly displaying political slogans, lesbian attire shared a rhetoric with others on the "left." Neither parodic nor campy, this anti-chic hybridity acknowledged interrelations of class struggle, decolonization, and what has since come to be known as "identity politics." Steeped in the romance of oppositional militancy, these clothes were citing Cuba,

China, Latin America, the PLO, the Vietnam War, the Civil Rights movement, Chicano solidarity, Native American rights, Black Nationalism, and more as a link between lesbian and other subaltern struggles.[6]

In contradistinction to this outlaw history, *New York*, *Newsweek*, *Cosmopolitan*, and *Vogue* turn to recent films and corporate broadcast programming with explicit lesbian content and provide readers with a long roll-call of successful women who came out with considerable panache. The spotlight is on celebrity: entertainment artists such as Ellen DeGeneres, k. d. lang, and Sandra Bernhard (not to mention the ubiquitous bisexual Madonna); tennis superstar Martina Navratilova; comediennes Kate Clinton and Lea DeLaria; writers Dorothy Allison and Rita Mae Brown; and such public figures as Roberta Achtenberg and Patricia Ireland. Listed also are publishers, political editors, executives, entrepreneurs, artists, intellectuals, professionals, and top-level activists. Even the *Esquire* essay, which mainly concerned the power wielded by heterosexual "do me" feminists, similarly queered its roll-call. Only the names are slightly different, with Camille Paglia, Pat Califia, Susie Bright, and the editor of *Future Sex* magazine, Lisa Palac, giving the article a more *outré* slant.

New York's description of an evening at the upscale Henrietta Hudson bar (formerly the Cubbyhole)[7] is squeaky clean by white middle-class standards. "These are the faces of a new generation of women – women who have transformed the lesbian image," the copy tells us. Here Brooks Brothers cozily miscegenates with leather, "tawny skin" with blonde, an expensive designer suit with a BOYCOTT COLORADO T-shirt, and cropped slicked-back platinum hair with a pair of matching diamond engagement rings. At the door, a shaven-headed female bouncer looks "like an *out-of-shape* kung fu instructor," we are reassured (emphasis mine). A sense of sophisticated well-being pervades the reportage. The poor, the old, the polyester-clad, the frumpy, the hum-drum, or the person of color with no special achievement to her name, barely figure. There is no mention of a rather different scene at the Clit Club, just a few blocks away. There is no mention of the lesbian outlaw, be she passing, transgendered, or transsexual. What Joan Nestle represents beyond being "author and co-founder of the Lesbian Herstory Archives" stays out of the picture, as do the raunchier aspects of Annie Sprinkle's persona beyond her being a "former porn star."

With this clean bill of health in hand, the mainstream media can salute lesbians safely. Passing references to the Lesbian Avengers, *On Our Backs*, or Annie Sprinkle's G-spot add a dash of badness but are quickly assimilated into the general air of respectability, allowing readers to give those recently-turned-chic lesbians a hearty homecoming welcome. In a rush of liberal expansiveness, the early 1990s media construction of a prosperous and largely white lesbian worthiness endowed a certain minority of dykes with civic visibility as partners in the project of underwriting American power. After all, these were the early Clinton years, when the future of gays in the military could still be interpreted as promising, as was the outlook for domestic partnerships and gay marriages. Politically moderate Americans have not yet forgotten the homophobic excesses of the 1992 Republican Convention, linked, as all could see, to anti-woman and anti-minority bigotry. With some politicians "out" in office, with the AIDS epidemic crawling towards containment within the middle-class gay community (though it was worsening for drug users, sex workers, people of color, women and children), and with feminism beamed from the White House via Hillary Rodham Clinton, the media's experiment of inserting a gay and lesbian presence into the mainstream of American life made sense.

It also made sense economically, as several cultural critics have argued. Certainly decades of feminist, gay, and lesbian activism began bearing fruit by the 1980s, but, as Danae Clark notes in an essay that antedates the lesbian chic hype, there has also been a concomitant rise in lesbians'

income and class standing.[8] This information, gleaned from a survey by *OUT/LOOK*, echoed *The Advocate*'s previous reporting of a longer and even more dramatic prosperity in the gay male market, and a subsequent *New York Times Magazine* article (1982) which reported top advertisers' courting that newly identified niche. The emphasis on lesbian success and acceptability evident in the *New York*, *Newsweek*, *Vogue*, *Cosmopolitan*, and even the *Esquire* articles of 1993–94 coasts on this history and speaks to it. Indeed, Clark's analysis of the targeting of a lesbian market has since been reconfirmed by *The Wall Street Journal* ("More Marketers Aiming Ads at Lesbians," May 1995), and is now supported by further research.[9]

This identification of a lesbian market has been both an opportunity and a challenge for fashion designers and promoters who have to choose whether to "closet" or "out" lesbian sartorial insignia. Aiming to have it both ways, they at once banked on the fact that femmes and "lipstick dykes" can be misrecognized as straight and found ways to absorb butches into normative female dress and lifestyle. That smart, co-ordinated look called "chic" is a concept defined by class, not sexual orientation. Its main task is to encode power and give women a commanding presence at the crossroads of femininity and wealth.[10] Like so many other cultural products which sustain our economy and safeguard dominant ideology, the sartorial design and photography that constitute the "lesbian chic" phenomenon absorb lesbians into heterosexuality even as they invite straight women to tour lesbian terrains. They construct a genre of masculinized female power and then proceed to feminize the image and undercut its power.

At issue is not just patriarchal supremacy but upper-class hegemony. The effort to neutralize lesbian presence, including its politically subversive welcoming of diverse voices and masquerades, protects upscale markets as exclusionary, embedding the notion of "chic" in racist, patriarchal, and homophobic norms. Consider, for instance, the Ralph Lauren advertisement I mention above (*Harper's Bazaar*, September 1996) (Fig. 18.1), where the expense implied by the model's deliberately exposed cufflink supplements other props of cross-dressing – her velvet jacket, satin tie, and large satin pocket handkerchief – to signal wealth and white masculine privilege. In this image, male tailoring and haberdashery promote redundant consumption while rendering invisible the labor of the tailor, the laundry worker, the miner, and the jeweler who make such opulence possible. At the same time, the image also undercuts the masculinity it supposedly promotes, for its model's hair, face, body language, and dress encode the mix of competence, defensiveness, and vulnerability Diane Keaton popularized in the film *Annie Hall* (1978). The jacket, tie, pocket handkerchief, and cufflinks would place this woman in the masculine domain, except that their sensuous, slippery, glossy rendition are too feminine, too excessive, to claim the status of masculine attire.

Each element in this glossy photograph initiates certain narratives and suppresses others in the process of constructing for viewers fields of desire. As an image meant for mainstream consumption in venues such as *Harper's Bazaar*, it has to reach heterosexual consumers, and wealthy ones at that. Its strategy is, then, necessarily ambivalent. The idea is at once to queer the image and reclaim it for conventional notions of feminine vulnerability and sensuality. In short, while cross-dressing invokes a specifically butch kind of chic in this image, other details suppress this suggestion. No doubt this model will look as smashing at Henrietta Hudson's as she would at a straight cocktail party on Park Avenue, but is she or isn't she a dyke? As the image at once elicits and fends off an array of narratives, it establishes an undefined field of desire which allows for diversely gendered spectatorial pleasures and points of identification, but commits itself to none.

A Gucci ad published in the same magazine issue, this one of a couple, makes use of similar indeterminacy (Fig. 18.2). We see two people dressed in matching, apparently unisex clothes:

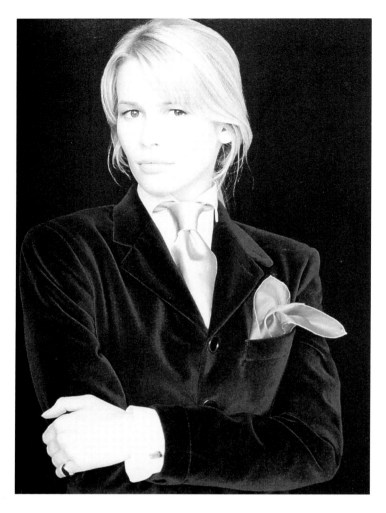

Fig. 18.1 Ralph Lauren. *Harper's Bazaar*, **September 1996**

black pin-striped pants, black shirts, rectangular cufflinks. One model loops a finger through the strap of a small portfolio-like pouch and wears a matching double-breasted, wide-lapelled jacket draped over the shoulders. This person seems to be a woman: she is shorter and slimmer than her companion, her neck is daintier, her waist is higher, her cufflink is slightly less elongated, and she has a ponytail and wears lipstick, albeit pale. Her companion seems to be male: his torso is larger, his hand is thicker, his waistline is lower. Though none of this guarantees either person's identity as "woman" or "man," in our semiotics they do suggest a binary gender arrangement, making the image available for heterosexual desire. The photograph shows the two heads inclining towards each other, cropped at nose level, lips almost touching, but not quite. Each body slightly thrusts its hips forward, one slightly turned to the left, the other to the right, with hands hanging down, bodies barely touching. This invocation of desire restrained within a performance of proximities and barriers, sameness and difference, and echoed in the metrics of pinstripes, recalls the tango – a tension-filled dance that performs reciprocity as the rhythmic interplay of desire and restraint. In this image the overall effect of such reiterative display is at once to establish heterosexuality and qualify it as a medium for desire.

Fig. 18.2 Gucci. *Harper's Bazaar*, September 1996

These two images are prototypes of myriad others which have been appearing in upscale newspapers and magazines since the mid-1980s. Their gist is always the same: masculinized attire invokes fantasies of dynamic, autonomous women, even as details feminize their images and compromise this masculinity. Often the images simultaneously float and submerge the women's subcultural signifiers of the unruly. Gucci develops his Latin/Tango theme in a series of advertisements. Ralph Lauren has a sultry cowgirl series which shows a tousle-haired blonde in chaps and an unbuttoned shirt carrying a profusion of harness straps and chains. Gianni Versace relegates his wild-haired dominatrix to heterosexual fantasy: with her metal belt, tight black catsuit, and spiky heels, she plants her feet on two kneeling men. Escada feminizes a butch model by draping a long beaded necklace around her neck and clamping a delicate little watch to the wrist extending from a blazer decorated with military-like brass buttons and braids.

Such systems of checks and balances are essential to the reciprocities of incitement and restraint in which the fashion industry is so deeply invested. The idea of mingling innocence with

experience, chastity with desire, exposure with barriers to sight and touch, allure with its prohibition, has always played a major part in defining fashion as a discourse of desire as well as a discourse of class, age, occupation, ethnicity, and other filiations. However, since the late 1960s, when the pantsuit first emerged, when denim took the world by storm, and when feminists and now queers turned out to be earners and consumers to be reckoned with, such checks and balances added queerness to the mix. With fashion defined by padded shoulders, broad lapels, and pinstriped fabrics, a masculinized elegance for more than a tiny minority of female cross-dressers has been paying homage to corporate opportunities. On its face, this sartorial "language" evolved out of what was understood to be heterosexual women's dress-for-success career and leisure wear. But looked at more closely, the particular turn it took (e.g. away from the skirted "power suit") worked to queer fashion in its citations of 1940s man-tailored suits (made over, during those days of austerity, from clothes left behind by men gone to the front) as well as the masculinities encoded in nautical blazers, dress uniforms, tuxedos, grunge, and, for more casual occasions, jumpsuits, camouflage gear, and riding and cowboy attire.

These icons of male empowerment did not occur in a historical void, and they did not surface all at once. Each was a discourse engaged in constellations of contemporary issues. Indeed, the corporate phase of masculinized fashion – what is mainly meant by "lesbian chic" – is just a more recent arrival on the performative map of self-definitions. Evolving in the wake of the Civil Rights and anti-war movements in the USA, the French "May Revolution" of 1968, and new left and feminist activism both here and abroad, women's incursion into male attire did not start as a "fashion statement." Instead, feminist and leftist dress codes of the 1960s and 1970s were politically motivated. They challenged existing hegemonies, encoded solidarity with various revolutionary movements, and countered mainstream politics with models derived from the liberation struggles of Cuba, Vietnam, China, Africa, and Central America, as well as Selma, Watts, and Wounded Knee.

It was no accident that the film *Missing* (1982) marks the beginning of Pinochet's right-wing dictatorship in Chile with an episode which has a militia thug slicing off a woman's pants at mid-calf as she waits for the bus after work. "Don't let me ever catch you wearing pants again," the man threatens, condensing into one menacing act debates which were occupying the fashion houses, too, at the time. The question for anybody invested in maintaining the status quo of gender relations was how to do so in face of vigorous bourgeois feminism and, furthermore, at a time when women were aligning themselves with other progressive movements determined to overthrow capitalism and racism along with male supremacy. During Pinochet's coup in 1973, this concern was not limited to the blood-stained streets of Santiago. While pants and pantsuits were becoming acceptable as non-recreational clothing in the West, in the early 1970s women in pants were still refused admission to better restaurants and proscribed from more conservative work sites such as banks and law offices.

That the fashion establishment continued to lampoon the masculinization of women's fashion well into the 1980s, by which time pants had become commonplace in both high and low fashion, reiterates this anxiety. In January 1985, *Vogue* showed a clown-like model in an oversized man-style suit by Chanel, splaying her legs awkwardly. Running counter to the image, the text emphasized "the small elements of charm . . . the *softness* [not so!], the attention to *detail* [not visible], the *attitude* [clumsy], . . . the *charming* [ridiculous] addition of a *small* navy and red pinstriped wool vest [obscured by jumbo tie and an absurdly long necklace]" (emphasis mine). A month later, *Vogue* ran a Gaultier ad that showed a clownish gingham-clad model whose male and female halves were sutured with a zigzag running vertically from head to toe. In February 1987, *Harper's Bazaar* ran a "Manstyle For Women" series which urged women to "Wear his clothes

your way" by showing a disheveled woman in a crushed felt hat hamming it up in a man's shirt and boldly striped pants, both several sizes too big. With her belt barely keeping her pants on and the shirt mis-buttoned, power is definitely not on the agenda. Even as the text invites women to enter the masculine domain, the parodic image is punitive, warning against such impropriety. Readers are obviously not to take such clothing for a serious fashion option.

This is the broad appeal, heterosexual as well as queer, of the *Annie Hall* look, even if its playfulness is laced with pessimism, as evidenced more explicitly in Jeanne Moreau's passing for a working-class young man in an earlier cult film, *Jules and Jim* (1961). This is also the appeal of the nostalgic look of *Fried Green Tomatoes* (1991), which invokes pubescent innocence as a nostalgic throwback to a prelapsarian pastoral past. While these films' renditions of cross-dressing relish female emancipation, they also register the powerlessness which dogs their "liberated" protagonists.[11] A recent instance of this strategy's success in neutralizing the emancipatory potential of a lesbian coding of fashion is a *New York Times Magazine* article titled, "The Power Suit and Other Fictions" (25 March 1997). Its eleven photographs undermine "power" suiting by the design and presentation of each ensemble. While the article addresses this sartorial disempowerment as an effect of women's lack of real (i.e. executive) power, it also notes that, "the idea, put out by Miuccia Prada, that jackets and trousers amount to cross-dressing is laughable. And as the most important trendsetter in fashion, and an intellectual woman, she should be embarrassed to have suggested the idea." Ironically, Prada's model is the only one in the lot whose suit belongs on a hanger in Brooks Brothers' men's department.

But even as some fashion photographs ridicule the wish to wear "his" clothes or sentimentalize it as pubescent innocence, other treatments neutralize lesbian subtexts through yet another strategy. Showing women together in sultry, eroticized ways, they use the image's narrative content to problematize same-sex relations. In an ad titled "parallele" (Fig. 18.3), Ungaro shows a woman crouching at the feet of another, holding her companion's leg in an intimate pose of subservience while looking off camera as if caught in a forbidden act (*Bazaar*, September 1989). Both women are wearing identical breast-binding wraparound tops, pants, and earrings, with the standing woman half-seated on an upholstered Chippendale stool, leaning backwards with her arms spread languidly against polished mahogany antiques. The image echoes Versace's 1987 dominatrix (above), except that Ungaro promotes his clothes through a narrative of same-sex desire enacted with mutual abandon against the mellow luxury of upper-class privilege. Here reigns aristocratic good taste, in contrast with Versace's ferocious woman literally stepping on the two men at her feet. This melding of luxury, languor, dominance, and desire taps the same fantasies which made *The Hunger* (1983) such a cult film and recurs across an array of recent top-of-the-line fashion photographs.

Showing women together has long been a staple in fashion displays, for groupings allow designers to exhibit the same or complementary clothes from different angles, in various states of motion, and in different color combinations. Whether these informational renditions narrativize the homosocial group as chummy or invoke the runway as a site of individual display, they organize space so as to render a given "look" cohesive. However now, with the filtration of queer sensibilities into an array of social discourses, shared space is also the staging ground for narrativizing potentially eroticized encounters. While reiterating treatments of clothes, hairstyles, make-up, accessories, gestures, and moods establish the cohesion of a given "look," the narrative content of such photographs stresses reciprocities. The dramas they enact for viewers concern bonding and autonomy, with the camera focusing on ways the women's bodies "speak" to one another across terrains of pleasure and desire. At the same time, the images are yet again staged to qualify lesbian possibilities. Ungaro's crouching woman looks as if caught in a guilty act;

Fig. 18.3 Ungaro. *Harper's Bazaar*, September 1996

Valentino's sultry models turn away from their companions; and a Versace punky pair have arms entwined but bodies addressing the camera, not each other. As these various models assume their *contrapposto* positions, with each turning both towards and away from her companion, they do so in settings enveloped by moody penumbra and subtly laced with misgivings. Not only do these images include signifiers of heterosexual femininity, but they qualify the likelihood of a happy lesbian outcome.

With so much ambivalence and so many qualifications, ultimately the question posed is, Who is a "lesbian" in the first place? Is a strong-featured, short-haired woman, who assumes masculine body-language and wears man-style clothes and only minimal make-up, a lesbian? A Chanel model appearing in the same *New York Times Magazine* issue which questioned cross-dressing (25 March 1997) fits this description. Butch but classy, attractive yet solitary, her blazer feminized by its decidedly un-masculine red and white plaid, she encodes a lesbian scenario as possible but not certain. Shown staring intently at something which remains outside the frame, her narrative is opaque. Here is a visual rendition of Adrienne Rich's "lesbian continuum," in a manner of speaking.[12] Obviously, the cost of a Chanel outfit, the expense of a glossy full-page advertisement in the *New York Times Magazine*, and the lifestyle signal a different socioeconomic planet than the one Rich and most of her readers inhabit. But the diffusion of identities and desires this advertisement utilizes echos Rich's idea that women journey back and forth across the lesbian/heterosexual divide.

Diana Fuss's essay, "Fashion and the Homospectatorial Look," picks up this thread from a psychoanalytic perspective. Her analysis of ways in which the viewing of fashion photography destabilizes gender identities devolves on mechanisms of identification and disavowal, plenitude and loss, as they get inflected through the spectatorial relations fashion photography sets up for its audiences. Key here is the idea that "the lesbian-looks coded by fashion photography radically de-essentialize conventional notions of the identity of the viewing subject."[13] That is, the photograph constructs for viewers flexible subject positions within gender identification, and is thus capable of homosexualizing spectatorship. This view shares Rich's liberatory attraction to the possibilities of journeying back and forth across the lesbian/heterosexual divide. When we meld these two radically different and yet complementary theories of gender flexibility (Rich's and Fuss's) with the materialist perspective I have been bringing to bear on "lesbian chic" in this essay, we can see how this fashion trend and marketing strategy exploit the multiplicity and instability of our desires and self-constructions. They literally bank on the indeterminacies of our identification as spectators. After all, when we gaze at the Chanel model, do we want to *be* her, to *have* her, or just to *own* her wardrobe?

The consumerist appropriations of sexual and gender indeterminacy which Fuss brings to light are hardly the use Rich would have had in mind for her "lesbian continuum." Above all, Rich's concept stands as a political intervention. However, as Gayle Rubin notes, while Rich's blurring of differences urges us to envision utopian inclusiveness, it also makes women vulnerable to exploitation, as both Fuss's and my own analysis of the effects of gender indeterminacy in fashion photography suggest.[14] Indeed, the myth of inclusiveness constructed by this photography, including its de-essentializing of identities, can occur only because the images suppress the very socioeconomic and ideological differences which keep women apart. After all, these images promote fantasies of high-end consumption and of lifestyles available only to a tiny fraction of their audience. Furthermore, they encourage us to forget that consumption responds to calculated manipulations, that it is only tenuously related to free will, and that this is all the more the case when the consumption is of luxury items which are reified for their symbolic rather than their material use value.

In keeping with its consumerist function, fashion photography's construction and appropriation of "lesbian chic" at once foreground a qualified soft butch image (femmes get absorbed into nondescript femininity) and recast it as corporate "power" dressing. These images can seem liberal in their openness to difference, except that they go on to treat youthful upper-middle-class whiteness as the norm for our well-being. Lesbian identities and agendas get swallowed by masquerades performing other scripts: dressing for success, dressing for freedom, dressing as an idle joke. It is chic to be punk, it is fun to be bad, and it is good politics to hang out with your girlfriends. Consideration of what these images might say to or about lesbians, or indeed of how one even defines a lesbian in the first place, is resolutely avoided. Often we do not even get the reciprocated gaze, eroticized proximities, and directions of energy which Chris Straayer identifies as marking "the hypothetical lesbian" in films like *Entre Nous* (1983) or *Fried Green Tomatoes*.[15]

It is interesting to consider this avoidance in light of Jean Genet's micro-introduction to his play, *The Blacks*: "One evening an actor asked me to write a play for an all-black cast. But what exactly is a black? First of all, what's his color?"[16] A black, a dyke, a lesbian, a queer . . . That we puzzle over the essence of a lesbian, or a queer, or a black person has to do with much more than marketing. As Benetton's cynical exploitation of genetic and cultural diversities has been demonstrating for some years now, and as Calvin Klein is increasingly doing (e.g. when invoking abject images of addiction and disease as fashion statements in his "to be . . . or not to be . . . just be" series, *Vanity Fair*, September 1996), marketing and consumption are arenas for reinstituting existing hegemonies and inequities. They engage us in supposedly personal discourses which have us perceiving, categorizing, and articulating desires, but, as Richard K. Cornwall argues, these discourses are never personal. They are socially constitutive, in that they segment humanity and enforce social stratification.[17]

It stands to reason, then, that mainstream fashion magazines would be interested in catering to queers only *sub rosa*, in heterosexual drag.[18] Lesbians are a market, up to a point, but the emergence of "lesbian chic" has more to do with heterosexual merchandising than with the discovery of a lucrative lesbian market niche. The high fashion photography we find in *Bazaar*, *Vogue*, and their companion journals allows straight women to make excursions – safe excursions! – into a vaguely suggested and emphatically qualified lesbian terrain, while it admits dykes into the land of wealth and privilege on a "don't ask, don't tell" ticket. Such goals cohere with Danae Clark's analysis of "gay window advertising," which invites queer readings without ever precluding heterosexual ones.

"Gayness" remains in the eye of the beholder: gays and lesbians can read into an ad certain subtextual elements that correspond to experiences with or representations of gay/lesbian subculture. If heterosexual consumers do not notice these subtexts or subcultural codes, then advertisers are able to reach the homosexual market along with the heterosexual market without ever revealing their aim.[19]

These queer subtexts inject into straight photography a polymorphous sexual suggestiveness that is alluring precisely because of its unresolvability.

Ultimately, the job of such images is not only to sell clothes, but to establish a "look" – a palette, a line, a drape, and an attitude – geared to selling ideas. These ideas may not be reducible to "heterosexism," "patriarchy," or "capitalism," but they are deeply complicit in those regimes. That fashion photography communicates them diffusely and contradictorily partly reflects the fact that its images address contested issues, and partly performs the function of obfuscating existing

power relations. Such mystification is cobbled across whole magazine issues as well as within a given photograph or a "spread" of images. Seemingly cohesive, it rests on radical inconsistencies, for the images necessarily absorb and reflect back to their audiences contemporary debates. Seen in this light, "lesbian chic" is highly politicized. It frees women's limbs and torsos for dynamic movements; it lets women's bodies display their power and their clothes perform the authority which our society traditionally reserves only for men; and it acknowledges the possibility of passion among women. But it also has designers, photographers, editors, copy writers, and retailers go out of their way to qualify these messages. It lets them bracket the masculinized "look," recasting it as ultimately female/feminine, occasionally as "camp," and most likely as heterosexual or bisexual, even if not definitively so. Truly identity-defining drag, along with transgendered and transsexual codings, is out of bounds. Heterosexuality is reinstated, with all its master narratives secured in place.

What ultimately stands out most clearly about this ostensibly lesbian "look" is its enthusiasm for an executive model of "well being" which has more to do with careers, caste, race, and class than with sexual identity. Here is, then, the "do me" feminism about whose sexual identity *Esquire* equivocated in 1994. The dyke has metamorphosed into a career woman even as the "powerful" woman hints, and only hints, at the dyke. Lesbians' complex relations to love, desire, agency, and dignity have gotten absorbed into the corporate/managerial model which has become, at least for the moment, a legitimate sphere of female aspiration within late capitalism. Here and there a photograph will make space for lesbian identification, but in a context which will tuck that possibility back into the folds of the normative. Such qualified lesbian iconography is rare to begin with and, when it does occur, it is crowded by images and written text which reinstate traditional notions of femininity. Even at the height of "lesbian chic" hype in 1993–94, female queer presence in fashion advertising was kept firmly in check. We find it interpolated among ruffles, florals, and high heels; next to articles on how to be a better lover for "him"; amidst gossip that never normalizes queerness; and interspersed with those ads for makeup, perfume, and lingerie which never make it to the pages of lesbian-targeted magazines. That is, beyond the semiotics of a given image, at issue are also ways in which both the scarcity of such images and their placement, quite apart from their content, further qualify the notion that female queerness might be a viable option.

Reeling my way through microfilms of the *New York Times* dating back to years when *Newsweek*, *New York* magazine, *Vanity Fair*, *Cosmopolitan*, and *Vogue* trumpeted their discovery of "lesbian chic," I was struck by how few of the *Times'* images did, in fact, speak to this mystique, let alone to reality. Furthermore, leafing through mainstream fashion magazines, I was also struck by the extent to which their images are still implicated in racist exoticism. Though I can only touch on the relation between heterosexual femininity and racism here, I cannot let it go by without registering the harem clothing, the gypsy attire, the tribal African fantasies, the Carmen Miranda derivations, the Southeast Asian nostalgia, the African slave trade citations, and the vaguely Hawaiian and Polynesian get-ups which vie for our attention with the energy, vigor, and qualified virility of dashing models in masculine attire. Even if we accept the suggestion that the lesbian image is an entrepreneurial construct, not a dyke, the hedging of her power within supposedly feminine fantasies of colonialist subjugation and "primitive" sensuality diminishes her agency and, even more perniciously, allows for the continuing exploitation of the very women who "man" the global assembly line producing the clothes worn by our chic putative lesbian and her less chic sisters.

Thus, while the relative prosperity of an educated gay and lesbian elite is making the idea of "lesbian chic" a viable proposition for affluent and middle-class consumers, and while this

Fig. 18.4 Kelly Linvil, Jenny Shimizu, supermodel, *Curve*,
September 1996. Courtesy of the artist

development is further sustained by the queer visibility made possible by grassroots post-Stonewall queer activism, both the products and the processes by which they are produced and marketed end up implicated in a range of repressions and exploitations. The facade may be liberatory, but the effects are conservative. Instead of our moving towards a horizon where a flexible understanding of gender would be inextricable from other commitments to social justice, we have a new chic "look" that locks us back into old problems. The very blurring of gay/straight boundaries which frees one to explore liminal sites of self-definitions and uncharted fields of desire becomes harnessed to the goal of marketing as it taps and reinstates traditional values.

In this regard, it is useful to consider briefly what happens in queer media, for on its face, dyke-defined well-being follows a different path. Fashion and advertising photography in magazines like *Curve* (formerly *Deneuve*), *Girlfriends*, *Out*, or the now defunct *On Our Backs* and *OUT/LOOK* does not equate power with top level careers, and it shows no trace of the ridicule and little of the *noir* moodiness which can seep into the "lesbian" subtexts of magazines like *Vogue* or *Bazaar*. Queer magazines emphasize positive images. They show us dykes at play and in pleasure: in their backyards, on vacation, relaxing with friends on the hood of a car, joined in an intimate embrace, leaning on a motorbike, holding hands poolside, playing ball, or staging sexual fantasies with an array of fetish, s/m, and/or butch–femme accessories. As we turn the pages, we move from one feel-good article to the next, pausing along the way to enjoy ads for lesbian travel, lesbian resorts, lesbian erotica and sexual products, lesbian books and CDs, commitment rings, T-shirts, vitamins, oils, Pride memorabilia, and a range of alcoholic options. The models' "look" is spontaneous, as though assembled with less regard for the spectator than for the activity ahead. Informal, confident, and energy-filled, it mixes and matches scenarios of adolescent play, athletic well-being, and "adult" fantasies. It is also, significantly, a middle-class "look," white, respectable, and just about suburban. Imagining an idealized but not improbable lesbian territory, the images integrate dykes into the fantasy of a wholesome all-American normalcy.

Even high fashion photography stresses this wholesomeness in lesbian magazines. In a spread titled "Paris, mon amour!" (January/February 1996)[20] *Curve* poses two adolescent models, intimately introduced to us as "Julia" and "Rebecca," in vignettes which record fragments of a narrative that spans eight pages of misty, grainy, atmospheric photographs printed in sepia and black and white. The models pose informally, as if unaware of the spying camera or indifferently tolerating its intrusion, dressed in simple designer day-wear which invokes schoolgirl attire. The images and text which accompany these baby dykes unfold a story of young love. With a shot of "Julia" just about sucking her thumb as she gives "A Parting Glance," and another of "Julia's Seduction" showing her awkwardly pigeon-toed in her Mary Janes but also wearing a very skimpy black slip-dress by Valentino, all lace and thin slippery fabric, this spread rewrites the venerable boarding-school romance for jet-age dreamers.

But the same issue of *Curve* also includes a sample portfolio from *Nothing But The Girl; The Blatant Lesbian Image*:[21] women in fishnet stockings, raised skirts, and fetish shoes; women in leather, tattoos, and pseudo military/police/nautical insignia; women with shaven heads; in long leather gloves and nipples showing through mesh; in bow-tie, tuxedo, top hat, and partly bared breasts; or assuming the muscle-bound swagger of bulldaggers looking menacingly "bad." An earlier *Curve* issue (September 1996) includes an article about former mechanic, now Calvin Klein super-model, Jenny Shimizu. She is shown wearing plenty of metal and sporting an open, shirtless leather vest which reveals a pierced belly-button and a large bicep tattoo of a woman astride a giant phallic wrench (Fig. 18.4). This issue also has a hip-hop spread titled "Girlz in the Hood," showing husky young butches of color dressed in baggy street styles, rough-housing in an urban

Fig. 18.5 Dina Alfano *Girlz in the Hood. Curve,* **September 1996. Courtesy of the artist**

playground (Fig. 18.5). Showing off their athletic prowess, the women suggest the robust yet supposedly affordable (Levis but also DKNY and Tommy Hilfiger?) joys of inner-city camaraderie. With the models addressing the camera frontally and slightly from above, and with both the Shimizu and the Girlz series awash with clean primary and neutral colors, the effect is direct and vigorous.

This mix is typical. We find it also in the January/February 1997 issue of *Girlfriends*, which has a biker as its pin-up "Girlfriend of the Month," two sultry entries about the recently released film *Bound* (1996), an article on "Glamour Dyke Makeovers," and the "Hollywoodn't" portfolio of steamy, moody, simulated 1940s *film noir* stills which use African American models in butch–femme drag. Though *Out* magazine's April 1997 "Huge Fashion Package!" includes three high-fashion photographs of a female model posed on the subway, looking deathly pale and fashionably anorectic in stark designer suiting, the overall feel of this issue (and this includes its low production values) is fairly humdrum. Other than these three high-end images, this "Huge Fashion Package!" gives women little more than perfectly ordinary polo shirts, slacks, and shorts, supplemented by an article on women surfers. Arguably the most sexy ad in the issue is by Calvin

Klein. It shows a lithe androgynous couple in a passionate embrace, except that upon closer inspection one of them turns out to be a boy. In fact, the physiognomy of young people is ideally suited for such ambivalent, transgendered, and even potentially transsexual renditions, and they allow advertisers to have their cake and eat it, too, in more ways than one. Unlike frankly heterosexual ads which forgo audience-specific discourse, these play a complex role in their appeal to diverse consumer passions.[22]

By and large, the images appearing in magazines targeted to lesbian readers are indifferent to the corporate chic of mainstream magazines. Their lesbian holds a more modest class position and has less buying power. Existing outside even the margins of the upscale markets addressed by Armani or Scada, her consumption patterns and lifestyle are assumed to be simple. She vacations, kayaks, swims, reads poetry, listens to spiritually healing tapes, attends women's events, wears "Pride" T-shirts, drinks vodka, uses credit cards that benefit good causes, and plays a mean game of tennis, but she does not have facials or polish her nails, she does not wear perfume or expensive lingerie (except for "femme" stuff, which is not expensive), she rarely uses high-quality leather accessories other than fetish or s/m paraphernalia, and she does not seem to own jewelry made of any metal more precious than alloy and silver. Though this is no longer the flannel-shirted and Birkenstocked stereotype, this lesbian is a middle-class person of modest means and limited aspirations. Liberal, self-sufficient, fit, vigorous, and community minded, she is the nice girl next door.

Such marketing assumes that lesbians have less money than heterosexual women, are less invested in the masquerade of gender maneuvering, and are less likely to equate upward class mobility with personal worth. If anything, it casts them as a decent but rather dull lot! But despite these differences between what high-fashion photography passes off as lesbian chic and what queer magazines pass off as reality, the ideological tenor of these two trajectories is not that different. Both discourses predicate happiness on consumption, and both situate that consumption in idealized bodies and mythologized narratives. Though lesbian images are down-to-earth while high-end advertising is flamboyant both in its discourse and in the extravagant buying frenzy it promotes, the thrust of all of these images, queer or straight, is to draw consumers into fantasies of a better life mediated by acquisition, and to do so while assuring consumers of happiness in an unchanged world.

While the construction of a "better life" differs radically across heterosexual and queer audiences, in some ways these constructions are not so dissimilar. This is especially evident in all these magazines' suppression of racial politics, even though women of color are now making modest inroads into this all-white territory. It is especially true of Asian models whose light skin, "good" hair, boyish figures, "model minority" status, and international capital backing make them honorary whites, in contrast with models of African ancestry and others bearing socially marginalized codings such as Hispanic and Native Americans. Though some women of marginalized background blend in, and though we do have black super-models such as Naomi Campbell promoting top-quality products, women of darker color, non-western physiognomy, or more African features appear only rarely in fashion photography, lesbian or straight. When acknowledged, the Other is exoticized: *Vogue* and its counterparts continue to give us the tigress, slave, tribal woman, and other myths of the primitive, while *Curve* and its companions give us the ghetto kid, queen of the blues, and the bulldagger menace. Occurring at the crossroads of sexual, racial, and class marginality, *Curve*'s images signal greater agency and power than their straight counterparts, but their power is undermined by the narrow range of their options. Ultimately even queer fashion photography, such as it is, posits whiteness as a norm for women.[23] This lesbian whiteness may merely invoke the modest pleasures of a backyard frisbee game or a brief

Key West winter escape, but its monochromes and Kodachromes nonetheless spin a tale of a better life which is based on white privilege and spare change.

Not surprisingly, for all its good-girl-next-door stance, this notion of a better life does include flirtations with the taboo of being "bad." At work are transgressive needs which all women share, straight or queer. These needs exist at the cusp of gender definitions, responding to the restrictions of childhood and the severe constraints of straight female adolescence and adulthood. Straight fashion photography, which has traditionally registered such impulses in narratives of sexual excess and images of the exotic Other, now uses the quasi-butch lesbian to stage "badness" for heterosexual consumption. Its renditions of qualified cross-dressing, thwarted same-sex longing, and plunging necklines that play on ambiguity and voyeurism in their exposure of chests and suppression of breasts, construct for straight women safe fields of queer desire, containing the very impulses they have unleashed. Lesbian "badness," which has a more complex oppositional function and consequently plays across a much wider register, also ends up being contained. "Julia"'s dress may be about to slip off her shoulders, but ultimately "Julia" is still a knock-kneed kid. The "Girlz in the Hood" are merely dykes having healthy physical fun: their clothes are clean, their skin color is light, and even the inner-city playground is tidy and litter-free. Whatever may be disquieting or unacceptable in their narrative occurs contextually, outside the image, freeing the image itself to remain embedded in a discourse of wholesomeness. Even the Shimizu story, for all its tits, leather, metal, tattoos, and body-piercing, projects a delicate and exceptionally *soignée* look, reassuringly enhanced by the high production values of expert studio photography.

The photographic practice which best articulates lesbian transgression occurs at the fringes of the respectability lesbian magazines aim to construct. It finds its most vital expression in a range of homosocial and erotic images that take their inspiration from fashion photography (and pornography!) but exist in counterpoint to it. This "art" photography probes the relation between essences and masquerades and challenges the appropriation of appearance and its enlistment in the service of vested economic and political interests. It interrogates the performative nature of self-presentation and the conceptual dilemmas which renditions of self-presentation create for spectators within the deconstructed terrain of gender identities. Compressing the idioms of portrait and fashion photography are photographers such as Catherine Opie but also, in a different way, Della Grace, Jill Posener, and Grace Lau, who appropriate the canon and conventions of gender representation for oppositional agendas. Their images incite reverie and desire, irony and impossible dreams, as they engage with the mystique of portraiture. Following a related trajectory, *Curve* magazine's *film noir* series meshes nostalgia for sultry Hollywood iconography with fantasies of elegant *demi-monde* cross-dressing, spiced with racial funk. There is something sadder and sweeter about these retro images, as their atmospheric murkiness removes them from the direct display and direct address of most fashion photography. But it is especially images like those collected in *Nothing But the Girl* or, before that, *Stolen Glances* and *Love Bites*,[24] that unleash the repressed transgressions which are so determinedly qualified in heterosexual venues. These have little affinity with mainstream fashion photography. Their address is radical, not consumerist, and has more in common with Valerie Solanas, Pat Califia, Joan Nestle, Dorothy Allison, and Hothead Paisan, than it does with the good taste defining Jenny Shimizu's portraits.

While these outlaw images merit extended discussion in their own right, attention to their affinity with fashion photography invites us to reconsider the nature of beauty, the semiotics of *mise en scène*, and the meaning of propriety and normalcy within fashion photography. Seen through the lens of such outlaw photographic practices, the extent to which mainstream fashion photography (lesbian or straight) sutures viewers into myths and purchases which sustain the status quo becomes particularly clear. Lesbian magazines accomplish this by preaching moderation, and

straight women's magazines do so by blinding us with stardust. Yet for all this concerted effort to contain outlaw desires, neither the fashion industry nor its photographic images want to suppress fully the passions which make "badness" strain against the boundaries of the "respectable" and "well behaved." Ultimately, the bodily discourse of attire cannot be cleansed of its impulse towards unruly signification. Whether we are considering cufflinks or neckties, leather or lace, suspender belts or spaghetti straps slipping off a bare shoulder, texture, color, or line, extravagant high fashion photography shares with both its subdued lesbian counterpart and its unruly fellow-travelers a deep appreciation for the shamanistic aura of clothes, including the freeing and pleasuring resonance of transgression.

This shamanistic aura emanates from the fact that attire, like all discourses, disseminates effects which have a range of material as well as intangible consequences. It concerns the ability of fashion and its images to touch identities and transform realities. Awareness of this talismanic aspect of sartorial representation, worn or imaged, informs the intensity of any fashion discourse which challenges the "normal." We can see this, for example, in the mix of joy and recoil facing the performative extravagances of cross-dressing, masquerades, fetish attire, butch–femme role-playing, or vampire narratives, including the debates which flare up periodically around s/m practices, fetish eroticism, and pornography.[25] At stake are identity-forming rituals and performative aspirations that extend from the barely acknowledged recesses of the psyche and the private consumption of erotica to public display. In this respect the far right's hostility to Gay Pride's carnivalesque antics is not off base, for clothes are indeed a political as well as personal praxis. Their talismanic power may speak to private needs, but once asserted collectively and publicly, they acquire the force of political discourse. They construct communities and legitimize modes of being.

Considering that the greatest harm done by fashion photography in both queer and straight venues occurs through its numbness to local and global injustice, this power to construct and legitimize communities is indeed significant. It is significant because fashion photography has been an indefatigable conveyor of classist and racist frameworks for envisioning our social options. While queer magazines include images and texts that attempt to be more inclusive than their upscale straight counterparts, they still suppress the awareness that difference may register injustice. Ultimately, neither the corporate "lesbian" nor the "Girlz in the Hood" live up to the liberatory agendas they claim to put forth. Queer magazines reassure their readers about their ostensibly legitimate and wholesome place within North American society, while straight magazines give women promissory notes of class power spiced with same-sex dalliance which it does not allow to come to fruition. Setting up idealized contexts for consumption, the photographic renditions which deliver these promissory notes turn personal needs into tropes which market straight goods to a primarily straight world. They help consumers mediate fields of desire, but they do so within a system of use and exchange that diverts the progressive potential of lesbian visibility away from political thinking.[26]

In short, fashion photography's "lesbian" has become a mere repository for the hegemonic values which sustain the social and economic stratifications of late capitalism. Starved for her image and eager for our own validation, we scour each photograph for the subtle details that may tell our lesbian, bisexual, and otherwise queer stories – in the play of eye contact, bodily proximities, haircuts, the strength of a chin, or a self-sufficient posture – but we are taught to do so without noticing that she inhabits those territories where the greatest economic injustices take place. Lesbians and other women who love women enjoy seeing their likeness reflected in handsome models who project confidence, intelligence, and good looks, but we do so at a cost to truth and to our collective, interdependent political well-being. Ultimately the images we are

taught to accept are compromised; they promise benefits which society will not deliver. The delusions and obfuscations that reach us through the iconography of "lesbian chic" are all too familiar, even if laced with fresh twists of unresolved ambivalence about what could have been but isn't there. Not quite. Not yet.

notes

1 The title cites Michael Warner, ed., *Fear of a Queer Planet: Queer Politics and Social Theory*, Minneapolis, University of Minnesota Press, 1993. I want to thank Leslie Anglin for her insightful assistance in researching this project and Deborah Bright for her unfailing editorial acumen and loving support at all times.

2 The terms "lesbian," "dyke," "queer," and "woman" prove increasingly elusive the more one ponders them. They are all sites of the trouble Judith Butler unpacks in "Imitation and Gender Insubordination," in Diana Fuss, ed., *Inside/Out: Lesbian Theories, Gay Theories*, New York, Routledge, 1991, p. 14. In this essay these terms provide only rough distinctions: I use "lesbian" in its conventional, essentialist sense; "dyke" as "lesbian" in its more contemporary and militant garb; "queer" as signaling indeterminacy; and "woman" as a biology-based definition of identity. (Ditto "bisexual," "heterosexual," and "feminine," and "masculine.")

3 Ellen Leopold's criticism of fashion history's top–down privileging of haute couture is well taken. My own discussion assumes a trickle down from high fashion to its ready-to-wear derivations. See "The Manufacture of the Fashion system," in Juliet Ash and Elizabeth Wilson, *Chic Thrills*, Berkeley, University of California Press, 1992, pp. 101–17.

4 I name here designers, not photographers, partly because not all images are credited, but also to stress fashion photography's ties to consumption, not art.

5 See Jane Gaines, "Dorothy Arzner's Trousers," *Jump Cut*, no. 37, pp. 88–98.

6 Cartoonist Alison Bechdel captures these anti-fashion fashion statements with historical precision in *Dykes To Watch Out For* and its sequels.

7 Michelle Parkerson's documentary film, *Stormé: The Lady of the Jewel Box* (1987) records Stormé Delareverie working as a bouncer at the Cubbyhole before this makeover.

8 Danae Clark, "Commodity Lesbianism," *Camera Obscura*, no. 25/26, 1991, pp. 180–201.

9 Amy Gluckman and Betsy Reed, "The Gay Marketing Moment," pp. 3–9, and Dan Baker, "A History in Ads: The Growth of the Gay and Lesbian Market," pp. 11–20, both in *Homo Economics: Capitalism, Community, and Lesbian and Gay Life*, New York and London, Routledge, 1997.

10 Considered in terms of Marjorie Garber's *Vested Interests: Cross-Dressing and Cultural Anxiety*, New York and London, Routledge, 1992, lesbian chic may tease and question binary sex and gender distinctions without overflowing their boundaries.

11 Fred Davis, *Fashion, Culture, and Identity*, Chicago, University of Chicago Press, 1992, p. 42. Especially relevant here is his reading of irony, exaggeration, and contradiction in fashion as blunting cross-gender representation.

12 Adrienne Rich, "Compulsory Heterosexuality and Lesbian Existence," *Signs, A Journal of Women in Culture and Society*, vol. 5 no. 4, 1980, pp. 631–60.

13 Diana Fuss, "Fashion and the Homospectatorial Look," *Critical Inquiry*, vol. 18, no. 1, Summer 1992, pp. 713–37.

14 Gayle Rubin, "Sexual Traffic" (interview with Judith Butler), *Differences: More Gender Trouble: Feminism Meets Queer Theory*, vol. 6, Summer–Fall 1994, pp. 74–7.

15 Chris Straayer, "The Hypothetical Lesbian Heroine in Narrative Film," in *Deviant Eyes, Deviant Bodies: Sexual Re-orientations in Film and Video*, New York, Columbia University Press, 1996, pp. 9–22.

16 Jean Genet, *The Blacks*, New York: Grove Press, 1960.

17 In "Queer Political Economy: The Social Articulation of Desire," *Homo Economics*, pp. 89–122, Cornwall

theorizes ways in which discourse segments society, invoking William Burroughs's view that "languages are viruses, spreading from culture to culture . . . as a market-driven phenomenon" (p. 110). Henry A. Giroux, "Benetton's 'World without Borders': Buying Social Change," *The Subversive Imagination: Artists, Society, and Social Responsibility*, Carol Becker, ed., New York, Routledge, 1994, pp. 187–207. Roland Barthes's *The Fashion System*, Berkeley: University of California Press, 1983, is an extended study of the semiotics of attire.

18 Cf. *Details* magazine's ostensibly straight use of "boy" models to market straight fashion or Steven Meisel's use of adolescent boys for *L'Uomo Vogue*, reprinted in Camilla Nickerson and Neville Wakefield, eds, *Fashion: Photography of the Nineties*, New York, Scalo, 1996.

19 Danae Clark, "Commodity Lesbianism," p. 183.

20 Citing the New Wave film, *Hiroshima, Mon Amour!* (1959), references Paris, politically transgressive love, and atmospheric nostalgia.

21 Susie Bright and Jill Posener, eds, *Nothing But the Girl: The Blatant Lesbian Image*, New York, Freedom Editions; London, Wellington House, 1996.

22 Exposed chests have become just about *de rigueur* in the nineties, while breasts are vanishing from view. Cf. the use of boy-like girls in photographs by Corinne Day, Juergen Teller, Nobuyoshi Araki, and Paolo Roversi, published in *Fashion: Photography of the Nineties*.

23 The use of the black stud in male iconography takes a different trajectory.

24 Tessa Boffin and Jean Fraser, eds, *Stolen Glances: Lesbians Take Photographs*, London, Pandora, 1991, and Della Grace, *Love Bites*, London, GMP Publishers, 1991.

25 See Lisa Duggan, "The Anguished Cry of an 80s Fem: 'I Want to be a Drag Queen,'" *OUT/LOOK*, vol. 1, no 1, Spring 1988, pp. 62–5, and Arlene Stein, "All Dressed Up, But No Place to Go? Style Wars and the New Lesbianism," *OUT/LOOK*, vol. 1, no. 4, Winter 1989, pp. 34–42. See also Anne McClintock, "The Return of Female Fetishism and the Fiction of the Phallus," *New Formations: A Journal of Culture/Theory/Politics*, no. 9, Spring 1993, pp. 1–21. McClintock argues that "fem fet" permeates the fashion and cosmetics industries, asserting female agency as it "dislodges the centrality of the 'phallus,' [and parades] instead the presence and legitimacy of a multiplicity of pleasures, needs, and contradictions" (p. 2). Gayle Rubin comments: "I do not see how one can talk about fetishism, or sadomasochism, without thinking about the production of rubber, the techniques and gear used for controlling and riding horses, . . . the history of silk stockings, . . . or the allure of motorcycles and the elusive liberties of leaving the city for the open road" ("Sexual Traffic," pp. 78–9). See also Diana Fuss's discussion of the codependency of fashion, fetishism, photography, and femininity as suggesting that within the regime of fashion photography femininity itself is an accessory ("Fashion and the Spectatorial Look," p. 97).

26 In "Queer Visibility and Commodity Culture," *Cultural Critique*, no. 29, Winter 1994–95, pp. 31–76, Rosemary Hennessy cautions against taking queer visibility for an end in itself. She argues that "visibility" (and "lesbian chic" alongside it) can turn into false consciousness, just as the view that sexuality is a discourse tempts us to overlook its historically determined material investments in social institutions. See also Jane Gaines's emphasis on history, materialism, and ideology in her "Introduction: Fabricating the Female Body," in *Fabrications: Costume and the Female Body*, Los Angeles, American Film Institute, 1990, pp. 1–27.

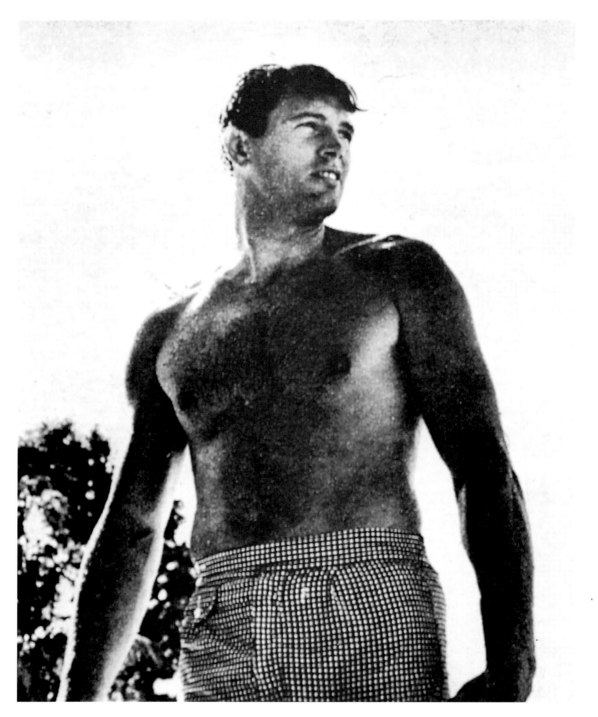

Fig. 19.1 Rock Hudson, *Movieland*, February 1955

chapter nineteen
richard meyer

rock hudson's body

the star body

Rock Hudson's was a body to fill, even to overflow, the enlarging film screen of the 1950s. In response to the new competition of television, Hollywood touted and technologically reinvented the spectacular size of its image.[1] Rock Hudson's body, featured in five cinemascope productions, seemed writ in particularly large-screen proportion. At six foot four inches and 200 pounds, Hudson was physically the largest male star of the day and his strapping physique was emphasized, even pumped up, by his films and fan magazine photographs (Fig. 19.1). The 1956 film *Giant*, for example, was promoted as a "big story of big things and big feelings."[2] In it, Hudson, as (big) rancher Bick Benedict, iconized both the state of Texas and the film's own delirious grandeur: "Rock Hudson is gigantic, relaxed, rocklike indeed, and right for the part,"[3] exclaimed *Newsweek*'s reviewer at the time.

According to an article in the 1957 *McCalls* magazine entitled, "Why Women are in Love with Rock Hudson," the executives at Universal Studios decided that in all Hudson films "there would be at least one scene in which [Rock] overflows a normal sized doorway,"[4] as though to demonstrate that the scale of everyday life was too diminutive for the Hudson body. This motif of Rock outstripping or barely fitting into the frame appeared not only in his films but in his publicity photographs as well. The March 1954 *Photoplay*, for example, offered Hudson's body as one so expansive that it must crouch to fit into the visual field of nature (Fig. 19.2). *Photoplay*'s 1958 image (Fig. 19.3) seems equally insufficient in its effort to contain the star's bending body, which is once again portrayed in quiet communion with the outdoors. As these images suggest, Hudson's body was often set within a natural surround – even the patently inauthentic name, gleaned respectively from the Rock of Gibraltar and the Hudson River,[5] was meant to locate the actor in (and as) an expansive landscape of the masculine.

In his publicity images, Hudson was often photographed from below so as to increase the already prodigious proportions of his body. Consider, for example, a photograph of Hudson

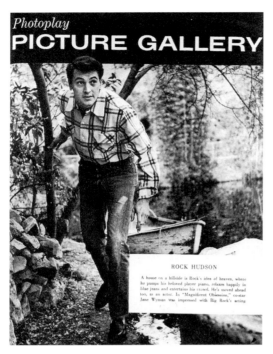

Fig. 19.2 "Photoplay Picture Gallery," *Photoplay*, March 1954

Fig. 19.3 *Photoplay*, February 1958

which was published in the October 1953 *Photoplay*. The image is part of a larger spread called "Meet the Champs" (Fig. 19.4) which presented twelve beefcake stars, each with the ("vital") measurements of his height, weight, chest, and waist. Hudson, the largest champ on display, is also the only one favored by a full-length, color portrait. In contrast to the close-up or three-quarter length shots of Marlon Brando, Kirk Douglas, Ricardo Montalban and the rest, Hudson's full-length, low-angle photograph marks (and in a sense makes) the unique scale of his body. So too does the accompanying text which asserts that "Rock towers over even such lanky stars as Jimmy Stewart" and "Rugged Rock 6' 5", 190, 44", 32" has an appetite to match his size so he resorts to swimming, riding, tennis, and golf to stay in shape. And an eye-pleasing shape it is . . . "[6] Notice that *Photoplay* has added an extra inch to Hudson's height, something that happened with some frequency in the fanzine reporting on him, as though his size were so impressive as to be expandable.

The insistence on Hudson's stupendous proportions was meant, I think, to secure his manhood as similarly well-endowed. In the 1959 bedroom farce *Pillow Talk*, for example, a savvy, size-conscious Thelma Ritter warns the less knowledgeable Doris Day that "six foot six inches of opportunity doesn't come by every day. When you see it grab it!"[7] Ritter's snappy line suggests that the size of Hudson's body is to be measured as phallus. Here again, the imagined size of Hudson's body is expanded – now to six foot six inches – beyond the somatic limits of his anatomy.

Yet for all its emphatic bigness, Hudson's (out-)size did not harden his screen persona into the 1950s machismo of a Marlon Brando or even the rough readiness of a Kirk Douglas or a Robert Stack. What distinguished Hudson from the other male stars of his day was not just the fact (and

fantasy) of his largeness, but the way he tempered that big body with a measure of safety, of "gentle giant" reassurance.[8]

Hudson's quieter masculinity may be traced, at least in part, to his roles in the domestic melodramas or "women's films" of Douglas Sirk. As Mary Ann Doane has observed, the "women's film"

offers some resistance to an analysis which stresses the "to-be-looked-at-ness" of the woman, her objectification as spectacle according to the masculine structures of the gaze . . . [It enacts] a deflection of scopophiliac energy in other directions, away from the female body.[9]

In Sirk's melodramas, one of the "other directions" in which scopophilic energy is pointed is towards Rock Hudson's body. As the object of a desiring, *implicitly female* gaze, Hudson's masculinity is at once less aggressive and more eroticized than that of the conventional male hero of Hollywood film.

Ironically, Hudson had himself embodied such heroic characters before appearing in Sirk's melodramas. In the early 1950s, as a newly signed contract player for Universal, Hudson was featured in a series of frankly macho films – westerns, sports, and war pictures with titles like *Gun Fury* (1951), *The Iron Man* (1953), and *Taza, Son of Cochise* (1954). Important for our purposes is the fact that these films enjoyed only limited success and that Hudson's shift toward domestic melodrama, beginning with his role in Sirk's *Magnificent Obsession* (1954), marked the start of his major stardom and top box office status.[10] The softening of Rock Hudson's masculinity as he switched from action films to melodramas – from "men's movies" to "women's films" – registered in his publicity photographs as well. Initially domineering (e.g. Fig. 19.4), Hudson's

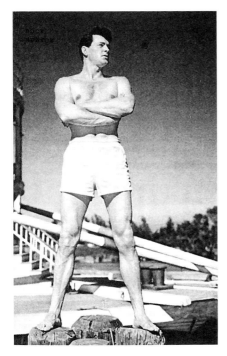

Fig. 19.4 "Meet the Champs," *Photoplay*, October 1953

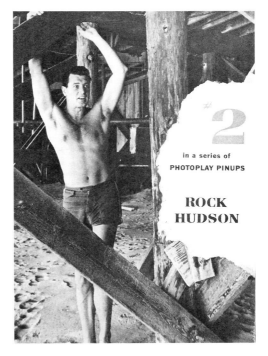

Fig. 19.5 "Photoplay Pinups – Number Two – Rock Hudson: How Far Is a Star?" *Photoplay*, July 1959

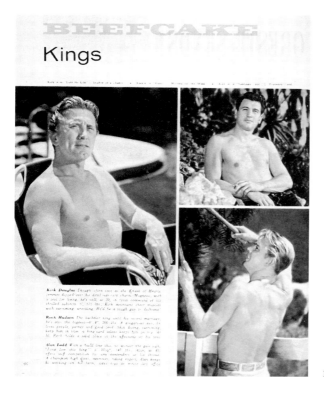

Fig. 19.6 "Beefcake Kings," *Photoplay*, **June 1956**

body was gradually seen to slacken its stance (Fig. 19.5), to relax or lie recumbent, to more comfortably invite the look of its (now female) viewer.

Within the context of Hudson's relaxed masculinity, I'd like to consider a 1956 *Photoplay* spread called "Beefcake Kings" (Fig. 19.6): On the upper left of the layout, squinting while remaining seated, Kirk Douglas looks resolutely past the camera. To the bottom right, Alan Ladd concentrates on pruning a backyard tree, seemingly unaware of the camera which catches his flexing deltoids in *medias res*. Both Douglas and Ladd exemplify what Richard Dyer has called the instability of the male pin-up, "the contradiction between the fact of being looked at and the model's attempt to deny it."[11] This denial usually takes the form of the male model either ignoring the camera as though unaware of its presence (as does the butch Alan Ladd) or acknowledging its gaze with a sort of phallic defiance, a looking past or through its vision (as might be argued for Kirk Douglas). Douglas and Ladd – all tense expression and improbable posture – stage their masculinity as hostile to the stilling gaze of the camera.

But Rock Hudson, the third in this triumvirate of beefcake royalty, submits rather more readily to the camera, anticipating, even inviting its objectification. Hudson's frontal orientation and comfortable, *contrapposto* stance acknowledge the fact of self-presentation. And with his upward glance and slight smile, he doesn't so much defy the camera as ethereally gaze beyond it. In contrast to Kirk Douglas's strained pool-side sitting and Alan Ladd's backyard pruning, Rock Hudson seems to be doing nothing except posing. Uniquely among these beefcake kings, Hudson could accommodate the intrinsic passivity of the pin-up stance, could visibly acquiesce to his position of "to-be-looked-at-ness."[12]

Part of the appeal of Hudson's body, then, was that it seemed somewhat immobile, available as

an object of erotic delectation but without the threat of male action. At a cultural moment when young women were reminded of their "duty" to rebuff the erotic advances of their male companions,[13] Rock Hudson provided a less threatening, less sexual model of masculinity: "Unlike Rudolph Valentino, who was the sex-boat of his day, Rock Hudson is not the lover type. He has sex appeal but the older fans want to mother him, young girls want to marry him, and men want to emulate him . . . He gives the appearance of great solidity."[14] Consider the split between sex and domesticity here (it's the 1957 *Photoplay*), as Rock is aligned with marriage, mothering, and male identification and opposed to any fantasy – the lover, the sex-boat – of heterosexual exchange. That his strapping male body should house this sort of (desexed) safety was promoted as the foundational reason "Why Women Are In Love with Rock Hudson": "Through the magic of Rock Hudson's eyes and size, combined with his unaffected friendliness . . . he makes women feel they can count on him."[15] *McCalls* will work the trope of Hudson's reliability especially hard, repeatedly emphasizing his quiet compliance to the desires of a largely female audience: "Rock is never cast as the heavy in the movies, never appears drunk, and never, never makes a pass at a girl. His fans wouldn't stand for it."[16] Hudson offered not only the visual pleasure of his physical form, his open-faced good looks and unparalleled large proportions, but also the promise to control that big body, the promise not to pounce. And, as the 1958 *Look* magazine suggests, Hudson's promise of self-restraint extended not just to his romantic relations on screen but to the very surface of his star body:

In the past few years too many stars have been sensitive and spooky like Jimmy Dean; the public got tired of decay. So now here's Rock Hudson. He's wholesome. He doesn't perspire. He has no pimples. He smells of milk. His whole appeal is cleanliness and respectability. This boy is pure.[17]

Jimmy Dean's method actor angst and performative volatility (Fig. 19.7) are figured as implicitly physical decay, to be set against Hudson's wholesomeness, which is here imagined as a kind of somatic wholeness. Rock Hudson's star body will not break out or emit fluids; cleansed of pimples, pores, and perspiration, it serves as the consummate safe sex-object.[18]

Fig 19.7 Publicity still, James Dean in *Giant*, reprinted in Jean-Loup Bourget, *James Dean* (Paris: H. Veyrier, 1983)

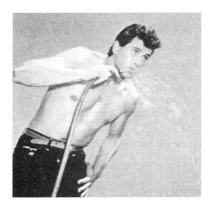

Fig. 19.8 Publicity photograph of Rock Hudson, 1952, reproduced in "The Long Goodbye: Rock Hudson: 1925–1980," *People*, 9 June 1986

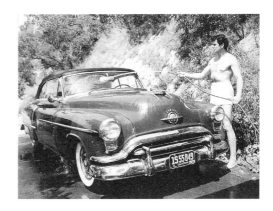

Fig. 19.9 Publicity photograph of Rock Hudson, 1952, reproduced in "Rock Hudson: On Camera and Off," *People*, 12 August 1985

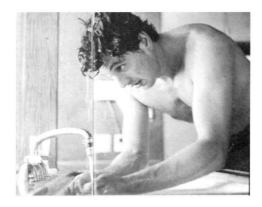

Fig. 19.10 "Are Actors Sissies?" *Photoplay*, February 1953

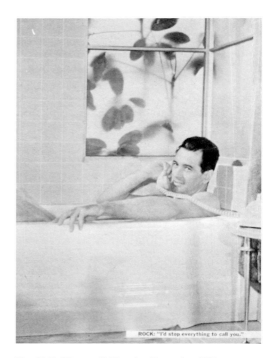

Fig. 19.11 "Pin-ups," *Photoplay*, December 1959

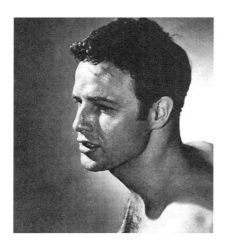

Fig. 19.12 Marlon Brando, "Hollywood's New Sex Boat," *Photoplay*, July 1952

Several of Hudson's fanzine photographs seem to play off this fantasy of sanitization (Figs 19.8–11), washing his car in 1952, washing his hair or drinking from a spewing hose in 1953, relaxing in a bathtub in 1959 – the fictions imagined in these beefcake shots are themselves ones of cleansing or purification. As opposed to the method actor body of "spooky" James Dean or "grubby"[19] Marlon Brando (Fig. 19.12), Rock Hudson's body did not sweat or secrete emotion. Hudson's represented fluids were those which had come from outside the body to cleanse it, rather than his own bodily fluids which had leaked and were soiling the surface. There were no layers of conflicted identity to be recovered beneath the serene surface of the starbody, no reason for it to break out into a sweat.

Hudson's unflagging hygiene registered not only in the cleanliness of his fanzine photography but in the consummate health of the characters he played on-screen, particularly in the Sirk melodramas of the mid-1950s. During the course of these films, Hudson's body remains beautifully unmarked by the diegesis while the female characters combat any number of psychic and physical dysfunctions – blindness in *Magnificent Obsession*, migraine headaches and community ostracism in *All that Heaven Allows*, sexual insatiability in *Written on the Wind*.[20] Hence the paradoxical relation of the implied female spectator of the Sirk melodrama to Rock Hudson's body: while she could see and freeze Hudson's body in erotic delectation, her visual power was contested insofar as she identified with the look of the ailing female protagonist. "In film's addressed to women," Doane writes, "spectatorial pleasure is often indissociable from pain."[21]

Of all Hudson melodramas, *Magnificent Obsession* is perhaps most pointed in the way it maneuvers both female spectatorial pleasure and (punitive) female pain around the pivot of Rock Hudson's body. In that film, the erotic spectacle of beefy Bob Merrick (Hudson) is repeatedly mediated through the desiring "look" of Helen Phillips (Jane Wyman). But because Helen is blind throughout most of the film (Figs 19.13–15), the spectator identifying with her – the spectator gazing at Merrick "through" Helen's eyes – draws a conflicted pleasure at best. And the spectatorial economy of Helen's "blind desire" for Bob Merrick is further complicated by the fact that it is his eroticized body which ultimately administers the cure for her blindness: After the three foremost experts on ophthalmology declare no hope for Helen's case (Fig. 19.16), Merrick resumes his lapsed medical studies, becomes a neurosurgeon, and, at film's end, performs an

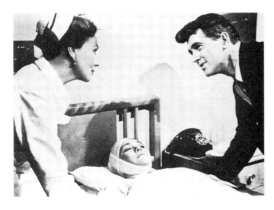

Fig. 19.13 Publicity still from *Magnificent Obsession* (dir. Douglas Sirk, 1954, Universal), reproduced in *Sirk on Sirk: Interviews with Jon Halliday* (London: British Film Institute, 1971)

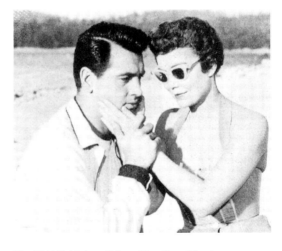

Fig. 19.14 Publicity still from *Magnificent Obsession*, reproduced in "Rock Hudson: On Camera and Off"

347

Fig. 19.16 Publicity still from *Magnificent Obsession*, reproduced in *Sirk on Sirk*

Fig. 19.15 Publicity still from *Magnificent Obsession*, reproduced in Jean–Louis Bourget, *Douglas Sirk* (Paris: Edilig, 1984)

Fig. 19.17 Publicity still from *Magnificent Obsession*

experimental procedure which simultaneously saves Helen's life and restores her sight. The film's most explicit specularization of Rock Hudson's body occurs just before the sight-saving operation: a sustained half-length shot catches a shirtless Dr Merrick as he scrubs for surgery (Fig. 19.17). Even as Helen lies blind and comatose on the operating-room table, *Magnificent Obsession* takes time out to objectify Rock Hudson's body, "to freeze the flow of action in a moment of erotic contemplation."[22] It is as though the film can venture such an intense eroticization of Merrick's body because Helen is at her most disabled point yet, her vision at its most impaired. And even after Dr Merrick's strapping male body revives Helen to fully sentient womanhood, the camera does not take up her desiring gaze. Helen will see ("tomorrow," Merrick tells her in

post-op) but the viewer will not see through her *functional* gaze, will not identify with her restored vision or spectatorial pleasure.

Where *Magnificent Obsession* manages the spectacle of Rock Hudson's body by blinding its female protagonist, Sirk's 1956 melodrama *Written on the Wind* diagnoses female desire for Hudson as a symptom of nymphomania (Fig. 19.18). In that film, millionairess Marylee Hadley (Dorothy Malone) overproduces her libido because Mitch Wayne (Hudson), the only man she truly wants, will not reciprocate her desire: "Marylee . . . couldn't have Mitch, so she sought love when and where she could get it."[23] Because the film frames Marylee's active pursuit of Mitch as psychosexual pathology, Mitch's inert heterosexuality in the face of that pursuit is seen as necessary and normative.[24] As in *Magnificent Obsession*, the dysfunction and desire of the female character are here opposed to the immobile, immaculate masculinity of Rock Hudson. "In melodrama, it's of advantage to have one immovable character against which you can put your more split ones," said Sirk, referring to Hudson's function within his films.[25] Pushing the point a bit further, I would argue that it was Rock Hudson's very "immovability" which fractured his female companion into sickness and desire, which, in effect, "split" her into the subject of melodrama.

The utter immobility of Hudson's characters came to frustrate the actor, however, and, when *Written on the Wind* was being cast, he campaigned for the part of volatile, violently alcoholic Kyle Hadley – Marylee's brother and Mitch Wayne's best friend.[26] The role, and eventually an academy award nomination for it, went to Robert Stack while Rock was cast as geologist (!) Mitch Wayne. Barely veiling his resentment at the bland-boy typing, Hudson would accurately say of his performance in the film, "As usual, I am so pure I am impossible."[27]

Fig. 19.18 Publicity still from *Written on the Wind* (dir. Douglas Sirk, 1956, Universal), reproduced in Michael Stern, *Douglas Sirk* (Boston: Twayne Publishers, 1979)

In defense of the casting decision, one Dave Lipton, then head of Universal Studios publicity declared, "Rock's fans won't accept his doing anything shoddy . . . They like him because he's what they want their daughters to marry, or their children's father to be, or their childhood sweetheart. If we let him break out of that character, they'd howl."[28] Once again, we hear a male narration of the heterosexual (and implicitly female) fan's power to keep Hudson grounded in his wholesome image. This *rhetoric* of determinant female desire – "they'd howl," "they wouldn't stand for it," "they won't accept anything shoddy" – was produced by a male-dominated publicity network to contain Hudson within his sanitized masculinity.[29] And when, as in the casting for *Written on the Wind*, Hudson attempted to transgress the boundary of that masculinity, the Hollywood rhetoric of "what women want" functioned to reinscribe him within it.

The indenture of Rock Hudson to the *purported* desires of his female fans reached a predictable extreme over the issue of marital status. In 1955, as a still unwed Hudson neared the age of thirty, the press exhorted him to marry. The title of a *Life* cover story, "The Simple Life of a Busy Bachelor: Rock Hudson Gets Rich Alone," implied Hudson's duty to share his newfound wealth with a wife while the story inside reported that:

since 1949 movie fan clubs and fan magazines have parlayed a $75-a-week ex-truck driver named Roy Fitzgerald into a $3,000-a-week movie hero named Rock Hudson . . . But now they are beginning to grumble. Their complaints, expressed in fan magazine articles, range from a shrill "Scared of Marriage?" to a more understanding "Don't Rush Rock." Fans are urging 29-year-old Hudson to get married – or explain why not.[30]

A tabloid publication called *Movie/TV Secrets* baited the bachelor star rather more overtly: "He is handsome, personable, intelligent, and a top-salaried actor – what's wrong with Rock where the fair sex is concerned, we ask?"[31] Adding considerable urgency to Hudson's "marriage question" was the fact that the tauntings of *Life* and *Movie/TV Secrets* were on the verge of becoming yet more explicit. According to several accounts, *Confidential*, a contemporary tabloid which billed itself as a publication which would "tell the facts and name the names," was threatening in 1955 to run an exposé on Hudson's homosexuality.[32]

And so, in November of that same year, Rock Hudson married Phyllis Gates, a woman formerly employed as the secretary of Hudson's agent, Henry Willson. Although descriptions of the relationship between Hudson and Gates vary, it is clear that Willson, an openly gay man within Hollywood circles, masterminded both the match and the wedding, making certain that photographers would be on hand to record such seemingly intimate moments as the couple in their wedding-night hotel room, the drinking of champagne on the conjugal bed(s), and the sharing of joy, long-distance, with the bride's mother (Fig. 19.19).[33] What lay behind this picture of nuptial bliss, then, was not only the explicit threat of homosexual exposure but Henry Willson's (gay) knowledge of how to construct an ideal heterosexuality for, and in, photographic representation.

But why should Hudson's marriage have served as a foolproof defense against the tabloid threat of "outing"? Even after the wedding, might not *Confidential* have published an exposé on Hudson's *former* life as a homosexual, or on the Hudson–Gates marriage as a sham? Apparently not, as no such threat is mentioned following the nuptial moment. It is as though the images of Hudson's wedding and married home-life (Fig. 19.20), working in conjunction with the domestic iconography of his films (Fig. 19.21), signified a heterosexuality powerful enough to defuse any threat of homosexual exposure.

Fig. 19.19 Publicity photograph (Universal International), Rock Hudson's wedding to Phyllis Gates, 1955, reproduced in "The Master of Illusion," *People*, 9 June 1986

Fig. 19.20 Publicity photograph of Rock Hudson and Phyllis Gates, c. 1956, reproduced in Sara Davidson and Rock Hudson, *Rock Hudson: His Story* (New York: Avon, 1986)

Fig. 19.21 Publicity still from *All that Heaven Allows* (dir. Douglas Sirk, 1956, Universal)

While the desire for Rock Hudson's marriage may have been orchestrated through the fictions of his films and fanzine stories, it was answerable in the contracts and rituals of his lived experience. Because there was no cultural space available for Hudson to "explain why not," his homosexual body was forced to enact the premier ritual of heterosexual identity. As Michel Foucault has famously observed, "the body . . . is directly involved in a political field, power relations have an immediate hold upon it; they invest it, torture it, force it to carry out tasks, to perform ceremonies, to emit signs."[34] In 1955, Rock Hudson's marriage was sufficient to secure and emit the sign "heterosexuality." Though the marriage would last less than three years, the sign would remain publicly affixed to Hudson's body for the following three decades.

the anti-body

The star has no right to be sick or even to appear out of sorts.
 Jean Marais, preface to *Comment devenir vedette de cinéma?*[35]

Consider a publicity still from the mid-1950s (Fig. 19.22). Its fictive scenario suggests the characteristics of Rock Hudson's body which I have offered as definitive. The strapping star, nearly overflowing the door-jam is called to the phone during a shower. Photographed from below so as to loom yet larger, Hudson embodies the codes of both hygiene and domesticity, both cleanliness and heterosocial communication. Now compare a news photograph from the summer of 1985 (Fig. 19.23), the moment of the public disclosure that Hudson was ill as a result of AIDS. Both photographs were published in a single layout (with the news photograph markedly larger than the publicity still) in the September 1985 *Life* magazine. The caption they shared reported that

AIDS was given a face everyone could recognize when it was announced that Rock Hudson, 59, was suffering from the disease. The quintessential 1950s leading man . . . had looked ill when he appeared with Doris Day in July at a press conference.[36]

Implicit in the notion that Hudson gave "AIDS a face everyone could recognize" is the unrecognizability, and in a sense, the unreality of the twelve thousand faces and bodies already diagnosed with AIDS in the United States by 1985, and the six thousand faces and bodies already dead from it. Because those were primarily the bodies of non-celebrity gay men and intravenous drug users, they were either ignored by the media or constructed as radically other from the body of the Reader. Their death and dysfunction were not to be "recognized."

But is even Rock Hudson's illness recognizable in this before and after format, and, if so, what have we have been asked to recognize it as? The caption offers Hudson's as a familiar and universalized "face of AIDS," but the familiar face is the one attached to the hygienic body in the publicity still. Far from being asked to identify with Hudson's ailing body, the Reader is meant to view it as the contrast and contamination of his star body, to view it as Rock Hudson's "anti-body":[37] "Tinged with the stigma of illness that dramatically destroys the body, what was usually absent from representation becomes spectacularly and consistently visible."[38] What was absent from prior images of Rock Hudson's body but what is now meant be visible – to be visibly leaking out – is his homosexuality. Within the economy of *Life*'s before and after circuit, the after-image, the AIDS image, not only figures the physical signs of illness but proffers those signs

352

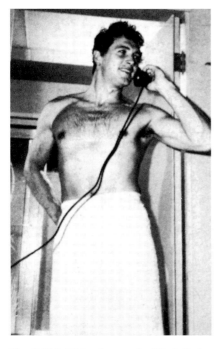

Fig. 19.23 Rock Hudson, 1985, "Faces"

Fig. 19.22 Publicity photograph of Rock Hudson,
c. 1955, reproduced in "Faces," *Life*, September
1985

as the evidence and horrific opening of Hudson's closet. And what *Life* signified pictorially, *Time* would plainly state:

To moviegoers of the 1950s and 60s no star better represented the old-fashioned American virtues than Rock Hudson . . . [but] last week as Hudson lay gravely ill with AIDS in a Paris hospital, it became clear that throughout those years the all-American boy had another life, kept secret from the public: he was almost certainly homosexual.[39]

In this scenario, homosexuality supplants HIV as the origin and etiology of Rock Hudson's illness. Closeted through all the years of his celebrity, Rock Hudson's secret finally registers, Dorian-Gray-like, on the surface of his body. The physical repercussions of AIDS are here imbued with a heavy (and heavily homophobic) symbolism such that Hudson's moribund body becomes both signifier and symptom of his "almost certain" homosexuality.[40]

As I suggest above, Rock Hudson epitomized a particularly sanitized version of hetero-masculinity in American popular culture of the 1950s and early 1960s. Because this image elided not just Hudson's homosexuality but the very fluids and functioning of sex itself, an extreme excess of signification obtained in 1985 to his AIDS body. Rock Hudson, once deeply overdetermined in his hygiene, became commensurably overdetermined in his sickness: "The faceless disease now has a face. But it is not the ruggedly handsome face of *Giant* or *Magnificent Obsession* or even *Pillow Talk* that will be Rock Hudson's greatest legacy. Instead, that legacy will be the gaunt, haggard face of those poignant last days."[41] Here again, the spectacular contrast of Hudson's two bodies – before/after, well/ill, 1950s/1980s, and, implicitly hetero-/homosexual – provides the central trope for the conceptualization of his AIDS.

richard meyer

The body/anti-body binary produced around Rock Hudson's illness may be usefully compared to the media's handling of the second episode in which a national celebrity was revealed to have contracted AIDS – the 1987 death of Liberace. Consider, for example, the covers which *People* magazine respectively devoted to each star's illness (Figs 19.24–25). Published shortly after the July 1985 announcement of Hudson's illness but before his death that October, the Hudson cover features a contemporary image into which we are meant to read the visual evidence of AIDS. Image and text together signify that the "other life of Rock Hudson," his until-now-covert homosexuality, has produced this, his ailing and "other" body. By contrast, the Liberace cover presents a familiarly flamboyant image of the star with the superimposed dates of his birth and (AIDS-related) death. Because Liberace, who became a star at roughly the same time as Hudson, was already situated outside the popular codes of heterosexual masculinity, *People* did not construct from his AIDS the kind of "other life" apparently required for Hudson. For *People*, Liberace's illness is iconized well enough by his already – and indeed flamingly – deviant image of masculinity. Hudson's illness, by contrast, must be produced as the very picture of his "fall" from ideal masculinity.

The tone of betrayal which underwrote many of the commentaries on Hudson's AIDS – though not on Liberace's – reflects an intensely fantasmatic investment in Hudson's particular image of heteronormative masculinity. Theater critic Frank Rich, for example, speaking as (and for) a heterosexual audience, would write in *Esquire* magazine:

Does Hudson's skill at playing a heterosexual mean that he was a brilliant actor, or was just the way he really was, without acting at all? I suspect that most Americans believed that Hudson, who seemed so natural on screen, was playing himself, which means that in the summer of 1985 we

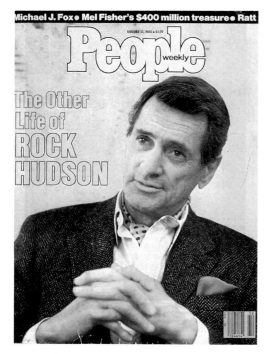

Fig. 19.24 "The Other Life of Rock Hudson," *People*, 12 August 1985

Fig. 19.25 "Liberace 1919–1987," *People*, 16 February 1987

had to accept the fact that many of our fundamental, conventional images of heterosexuality were instilled in us (and not for the first time) by a homosexual . . . everything that happened on screen was a lie, with the real content embedded in code.[42]

Homosexual panic here issues ("and not for the first time") from Rock Hudson's enactment of what was, for Rich, a most convincing, even an instructional masculinity. No matter that Hudson's screen image was, as the star himself noted, "impossible" in its purity; Rich holds him accountable to it, to some imagined transparency of it.

In a similar if even more startling response to Rock Hudson's AIDS, the popular sex therapist Ruth Westheimer told *Playboy* magazine, "I feel sad for all the thousands of women who fantasized about being in [Hudson's] arms, who now have to realize that he never really cared about them."[43] Because he has been revealed as homosexual through a spectacle of illness, Hudson is said to betray the projective fantasies of his heterosexual spectator, here a female one. Rather than scrutinizing the extreme over-investment of these spectators in Rock Hudson's star body, Westheimer blames Hudson for not reciprocating their desire.

As Simon Watney has pointed out,

Rock Hudson's death . . . offered journalists an opportunity for particularly vicious revenge on a man whom they had casually taken to embody their own patriarchal and misogynistic values for more than three decades. To begin with we should note the practical impossibility of Hudson's "coming out" as gay in the American film industry of the 1950's . . . given the intensely homophobic atmosphere of McCarthyite values in Hollywood.[44]

Watney inserts what Rich, Westheimer, and nearly all of the other mainstream commentators on Hudson's illness erase, namely the historical impossibility of any publicly homosexual identity for Hudson in the 1950s. In dehistoricizing Hudson's homosexuality, Rich, Westheimer, *et al.* suggest the actor's closet as a matter of personal agency and thus of deception. ("The Master of Illusion" and "The Hunk Who Lived a Lie" were among the titles of other articles on Hudson's illness.) With Watney, we should recall that Hudson's closet was not an effect of individual choice but of homophobia and compulsory heterosexuality, systems of surveillance enforced with particular ferocity in 1950s America.[45]

And yet, when we consider the specific image of masculinity which Hudson embodied in the 1950s, we have proper cause to wonder precisely what kind of sexuality he was offering his film viewer. Recall the fanzine hype: "Rock Hudson is not the lover type" . . . "his whole appeal is cleanliness and respectability" . . . "he smells of milk" . . . "he never, never makes a pass at a girl." Rock Hudson was a star fantasmatically defused of active (hetero)sexual desire, a man to marry or to mother but not to fuck. I would suggest that Hudson's homosexuality – however disavowed by Hollywood, by the film viewer, or by Hudson himself – registered in his star image, in the sexual immobility of his masculinity, in the way that women really *could* count on him to maintain his erotic distance. Many of those who orchestrated Hudson's stardom were aware of his homosexuality – certainly his agent, probably his directors, photographers, and fanzine journalists and of course, Hudson himself.[46] It seems likely that the framing of Hudson's hunky but deheterosexualized masculinity worked off this knowledge, responded to it, *used* it as source and building block.

How then do we explain the heterosexual desire for Rock Hudson's body, the fact that he was the male star "men wanted to emulate" and "thousands of women" fantasized about embracing? Hudson promised straight women a space of sexual safety – he would acquiesce to domesticity without insisting on male domination. And Hudson's less typical heterosexual male viewers

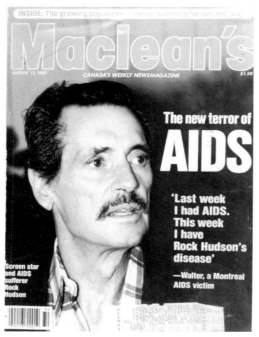

Fig. 19.26 "The New Terror of AIDS," *Maclean's*, 12 August 1985

(Frank Rich, for one) were no doubt relieved to find a role model which did not require the exhaustive work of machismo to "measure up" to its masculinity. In Rock Hudson, then, a strapping gay male body closeted its explicit desire for other men while retaining its erotic neutrality towards women, thereby providing a sexual "safe place" for both sides of his heterosexual audience.[47] As D. A. Miller points out, the closet (and I would suggest Rock Hudson's closet in particular) might best be understood as "a homophobic, heterosexual *desire* for homosexuality, and not merely a homophobic, heterosexual *place* for it."[48] There were things that heterosexual culture wanted from Rock Hudson's body (a safe date was one) but only under the proviso that the homosexuality underwriting those things remain unspoken and precisely unspeakable.

In the summer of 1985, when Rock Hudson's homosexuality was finally spoken by the popular media, it was as the "New Terror of AIDS" (Fig. 19.26). By rights, that headline should have been reserved for a death count of six thousand Americans and the lethal indifference of a Reagan Administration faced with those deaths. Instead, it described the collapse of a particular fantasy of male containment and sexual safety – a fantasy once attached to Rock Hudson's body, a fantasy once embodied by Rock Hudson's closet.

notes

1 Such innovations of the 1950s as cinemascope, panavision, and Warnercolor sought to exploit those elements of film – the larger scale of the image, the intensity of the color – which the "small screen" of television could not match. On this issue, see Robert Carr and R. M. Hayes, *Wide Screen Movies: A History and Filmography of Wide Gauge Filmmaking*, Jefferson, NC, McFarland & Co., 1988, and William Kuhns, *Movies in America*, Dayton, Ohio, Pflaum/Standard, 1972, p. 189.

2 Advertisement for *Giant* in *Photoplay*, December 1956, pp. 6–7.

3 "Young Dean's Legacy," *Newsweek*, 22 October 1956, p. 112.

4 Joe Hyams, "Why Women Are In Love With Rock Hudson," *McCalls*, February 1957, p. 52.

5 According to, among others, *Variety*, "Rock Hudson, Hollywood Star for Three Decades, Dies at 59," 9 October 1985, p. 42. Hudson's agent, Henry Willson, who created the star-name, offers this recollection of its coining: "I picked Rock because of the Rock of Gibraltar – big and rugged. Also, there was only one other Hudson in pictures – Rochelle – and she worked infrequently. The name sounded right, because he was six-foot-four and handsome, but awkward and rather shy." Quoted in Whitney Stone, *Stars and Star Handlers: The Business of Show*, Santa Monica, Round Table Publishing, 1985, p. 206.

6 Hildegarde Johnson, "Meet the Champs," *Photoplay*, October 1953, p. 43.

7 Unpublished manuscript of *Pillow Talk* (author's possession), screenplay by Stanley Shapiro and Maurice Richlin, p. 66.

8 I borrow the term "gentle giant" from Simon Watney, whose brief but extremely insightful discussion of Hudson in *Policing Desire* is unique for its address to Hudson's alternative image of 1950s masculinity: "Hudson's starring roles in films such as *Written on the Wind*, *Magnificent Obsession*, and especially *All that Heaven Allows*, construct him as a figure quite removed from mainstream 1950s masculinity, as represented by Victor Mature and Clark Gable. On the contrary, Hudson's film persona frequently presented him as a sensitive figure, a gentle giant aligned with nature rather than masculine culture." *Policing Desire: Pornography, AIDS, and the Media*, Minneapolis, University of Minnesota Press, 1987, p. 88. The references to Mature and Gable are slightly anachronistic to 1950s culture and may be replaced by, for example, Gary Cooper (the top box office draw of 1952) and John Wayne (number one for 1953).

9 Mary Ann Doane, *The Desire to Desire: The Woman's Film of the 1940s*, Bloomington, Indiana University Press, 1987, p. 16. Doane's is the definitive analysis of the structures of spectatorship in the "woman's film" and my reading of Sirk's melodrama, and much of the circulation of Rock Hudson's body within it, is deeply indebted to her work. See also Christine Gledhill, ed., *Home Is Where the Heart Is: Studies in Melodrama and the Woman's Film*, London, British Film Institute, 1987.

10 According to *Variety*'s annual list of "Boxoffice [*sic*] Champs," *Magnificent Obsession* earned $5 million in its first year of release, making it the seventh most successful film of 1954 (as well as Hudson's most popular film, by a wide margin, to that date). See "1954 Boxoffice Champs," *Variety*, 5 January 1955, p. 7. Following *Magnificent Obsession*, Hudson grew progressively more popular until, in 1957, he was voted the top box office attraction in America by the *Motion Picture Herald* poll of exhibitors. See Martin Quigley, Jr and Richard Gerner, *Films in America, 1929–1969*, New York, Golden Press, 1970, p. 266, and Roy Pickard, *The Hollywood Studios*, London, F. Muller, 1978, p. 46.

11 Richard Dyer, "Don't Look Now," *Screen*, vol. 23, nos 3–4, September/October 1982, p. 66.

12 The erotic specularization of Rock Hudson's body poses a problematic which Laura Mulvey's classic division of spectatorial labor along gender lines ("woman as image, man as bearer of the look") cannot accommodate. See Laura Mulvey, "Visual Pleasure and Narrative Cinema," in *Visual and Other Pleasures*, Bloomington, University of Indiana Press, 1989, pp. 14–26. For a helpful response to some of the elisions of Mulvey's argument, see Steve Neale, "Masculinity as Spectacle," *Screen*, vol. 24, no. 6, November/December 1983, pp. 2–16.

13 See, for one example, the 1950s "educational films" on dating and "social hygiene" included in the 1989 documentary, *Heavy Petting* (Fossil Films). These educational films – with such titles as "How Much Affection?" "Dating Do's and Don'ts," and "How to Say No" – instruct young women to restrain (politely) their male companions while admonishing young men to restrain themselves.

14 Joe Hyams, "The Rock Hudson Story," *Photoplay*, February 1957, p. 90.

15 Hyams, "Why Women Are In Love With Rock Hudson."

16 Ibid., p. 85.

17 Eleanor Harris, "Rock Hudson, Why He's Number 1," *Look*, 18 March 1958, p. 48.

18 The opposition set up by the article – Rock Hudson's health vs James Dean's decay – was no doubt informed by the fact that Dean had died in an automobile crash just over two years before. At the time of the crash, Dean was on location in Texas shooting *Giant*, a film in which he played Jett Rink, the rival of Rock Hudson's Bick Benedict.

19 See Hedda Hopper, "Hollywood's New Sex Boat," *Photoplay*, July 1952, p. 62. "He's no rose – a grubby Peter Pan, some call him. But in any group of women, the name Marlon Brando acts like a flash fire . . . 'Marlon Brando? He's exciting.' 'Marlon Brando! He's coarse, he's vulgar,' 'Marlon Brando, he's male! High time someone like him came along . . . '"

20 Although Hudson's characters do not suffer physical dysfunction or long-term disease in Sirk's melodramas, they do have severe accidents (Bob Merrick's motorboat flip in *Magnificent Obsession*, Ron Kirby's cliffside fall in *All That Heaven Allows*). These accidents are not, however, the central predicament of the melodramatic plot so much as its initial "motor" (in *Magnificent Obsession*) or its closure (in *All That Heaven Allows*). Moreover, Hudson's characters miraculously recover from these accidents and are not visibly disfigured by them. Unlike the long-suffering female protagonists in Sirk's melodrama, Rock Hudson is seemingly immune from permanent damage or serious disease.

21 Doane, *The Desire*, p. 16.

22 I am paraphrasing Mulvey here, although against the (gendered) grain of her argument: "The presence of woman is an indispensable element of spectacle in normal narrative film, yet her visual presence tends to work against the development of story-line, to freeze the flow of action in moments of erotic contemplation." Mulvey, "Visual Pleasure," p. 19.

23 Advertisement for *Written on the Wind*, *Variety*, 24 October 1956, p. 21.

24 For more on the character of Marylee Hadley and her relation to the larger psychosexual economy of *Written on the Wind*, see Christopher Orr, "Closure and Containment: Marylee Hadley in *Written on the Wind*," *Wide Angle*, vol. 4, no. 2, 1980, pp. 29–35.

25 Quoted in Michael Stern, *Douglas Sirk*, Boston, Twayne Publishers, 1979, pp. 135–6.

26 Jimmy Hicks, "Rock Hudson: The Film Actor as Romantic Hero," *Films in Review*, vol. 26, no. 5, May 1975, p. 276.

27 Hyams, "Why Women Are In Love With Rock Hudson," p. 85.

28 Quoted in Hicks, "Rock Hudson," p. 276.

29 Consider that Hudson's agent, directors, publicity photographers, and even the authors of some of his fanzine articles (including "Why Women Are In Love With Rock Hudson") were men.

30 "The Simple Life of a Busy Bachelor: Rock Hudson Gets Rich Alone," *Life*, 3 October 1955, pp. 129–32.

31 *Movie/TV Secrets* (undated clipping, purchased by the author at *The Magazine*, San Francisco, September 1989). Although the clipping is undated, I am confident that it is roughly contemporary with the *Life* piece cited above since it includes a reproduction of a fan letter addressed to Hudson on which a May 1955 postmark is visible.

32 See, for example, "AIDS Strikes a Star," *Newsweek*, 5 August 1985, p. 69; "Rock: A Courageous Disclosure," *Time*, 5 August 1985, pp. 51–2; "Rock Hudson: On Camera and Off," *People*, 12 August 1985, pp. 34–41; "Rock Hudson: Hollywood Star for Three Decades, Dies at 59," *Variety*, 9 October 1985, p. 42; "The Double Life of an AIDS Victim," *Time*, 14 October 1985, p. 106; Jerry Oppenheimer and Jack Viteck, *Idol: Rock Hudson, The True Story of an American Film Hero*, New York, Villard Books, 1986, p. 55, and Sara Davidson and Rock Hudson, *Rock Hudson: His Story*, New York, Avon, 1986, p. 93.

33 Phyllis Gates, Rock Hudson's former wife, has recently attested to their relationship as a romantic and (rather) sexually active one in *My Husband Rock Hudson: The Real Story of Rock Hudson's Marriage to Phyllis Gates*, New York, Jove Books, 1987, 1989. Other accounts (including most of those in the note above) claim the marriage as pure Hollywood cover, as Rock Hudson's heterosexual "beard." All the accounts agree,

however, on the determinant importance of Henry Willson in setting up the marriage and on the fact that the union was exploited to secure Hudson's heterosexuality in the face of threatened homosexual exposure.

34 Michel Foucault, *Discipline and Punish: The Birth of the Prison*, trans. Alan Sheridan, New York, Vintage Books, 1979, p. 25.

35 Guy Gentilhomme, preface by Jean Marais, *Comment devenir vedette de cinéma?*, cited in Edgar Morin, *The Stars*, trans. Richard Howard, New York, Grove Press, 1960, pp. 44–5.

36 *Life*, September 1985, p. 63.

37 My particular use of the term "anti-body" is borrowed from Timothy Landers's excellent essay, "Bodies and Anti-bodies: A Crisis in Representation," *The Independent*, vol. 11, no. 1, January/February 1988, pp. 18–24, reprinted in Cynthia Schneider and Brian Wallis, eds, *Global Television*, New York and Cambridge, Mass., Wedge Press and MIT Press, 1988, pp. 281–99. Landers writes: "Commercial media representations in general are informed by a variation on the normal/abnormal paradigm – one better suited to a visual medium: that of Bodies/Anti-Bodies. The Body – white, middle-class, and heterosexual – is constructed in contrast to the Other, the Anti-Body (frequently absent from representation) – blacks, gay men, lesbians, workers, foreigners, in short, the whole range of groups that threaten straight, white, middle-class values . . . Applied to the subject of AIDS, oppositions revolve around the nexus of health. The Body is, above all, healthy. The Anti-Body becomes, specifically, gay, black, Latino, the IV drug user, the prostitute, in other words, sick" (p. 19).

38 Ibid., p. 19.

39 "Rock: A Courageous Disclosure," p. 51.

40 This economy of blame, apparent in the initial reporting of Hudson's illness, was most blatantly enacted in the 1990 ABC television docudrama *Rock Hudson* when a moribund Rock (played by Thomas Ian Griffith) makes the following "confession": "I spent my whole life keeping everything inside, denying everything, and now everybody knows anyway. You know what's so damn funny, all the time I kept pretending that I wasn't gay, I kept on thinking I was the perfect man, the perfect star; [that] if it ever came out that I was gay it would kill me. And look, it has." For an insightful discussion of the film, see Mark Gevisser, "Rock in a Hard Place," *Outweek*, 28 January 1990, pp. 58–9.

41 Neil Miller, "Personally," *Boston Phoenix*, 8 October 1985, p. 2 (Lifestyle Section).

42 Frank Rich, "The Gay Decades," *Esquire*, November 1987, p. 99.

43 Cited in Oppenheimer and Viteck, *Idol*, p. 175.

44 Watney, *Policing Desire*, p. 88.

45 On the cultural terrorism facing lesbians and gay men in 1950s America, see John D'Emilio, "The Homosexual Menace: The Politics of Sexuality in Cold War America," in Kathy Peiss and Christina Simmons with Robert A. Padgug, eds, *Passion and Power: Sexuality and History*, Philadelphia, Temple University Press, 1989; John Gerassi, *The Boys of Boise: Furor, Vice and Folly in an American City*, New York, Macmillan, 1966; and Jonathan Katz, *Gay American History: Lesbians and Gay Men in the USA: A Documentary*, New York, Thomas Crowell, 1976.

46 Hudson's homosexuality was apparently an open secret within Hollywood circles. See, for example, "The Double Life of an AIDS Victim," p. 106, and "Rock Hudson: On Camera and Off," pp. 35–41. According to the latter, for example, "Behind the doors of Universal, where he was a contract player, 'we all knew Rock was gay, but it never made any difference to us,' says actress Mamie Van Doren, who went on studio-arranged dates with Hudson" (p. 36). The extent of the knowledge of Hudson's homosexuality outside Hollywood is a complex issue which remains unresolved by this essay. At the very least, one can say that the media reports of Hudson's illness elided whatever public knowledge (or hunch or rumor) existed about his homosexuality so as to pathologize more dramatically his closeted homosexuality as disease(d).

47 The issue of the (historical) gay viewer's response to Rock Hudson's star body must remain, at least for the time being, an open question. One would very much like to determine, for example, whether the defused

heterosexuality of Hudson's masculinity held resonance for gay viewers, and particularly gay men, in its contemporary moment. Yet because of the enforced muting of gay voices during the 1950s, it is extremely difficult to mount a convincing reading of a gay male reception of Rock Hudson's stardom.

48 D. A. Miller, "Anal Rope," in Diana Fuss, ed., *Inside/Out: Lesbian Theories, Gay Theories*, New York and London, Routledge, 1991, p. 132.

Nina Levitt, *Think Nothing of It (Dorothy Arzner and Joan Crawford)*, 1990, monochrome color photographs, 30 × 40 in. each.
Courtesy the artist

363

365

erica rand

the passionate activist and the political camera

There's a tale in the *Brownie Scout Handbook* about a proto-Brownie, Mary, whose grandmother suggests that Mary can appease her father's anger about having to do all the chores (there is no mother to be found and grandma is too old) by consulting the Wise Old Owl about how to find "brownies": helpful chore-doing creatures who work for love but never for pay. The owl directs Mary to go to the pond during a full moon, turn around three times, and chant: "Twist me and turn me and show me the elf / I looked in the water and saw _____." If she looks down, she will then see a brownie and figure out how to complete the rhyme. Mary does this, expecting to see someone else; luckily for her father, she sees herself instead. The reader might well expect her to see the moral, too, which is hardly subtle. But Mary remains clueless and has to return to the owl for debriefing.[1]

 This founding legend performs the neat trick of teaching girls that, even if it's fun to get together apart from males in Brownie troops, the real reward comes from giving one's labor to men for free. (A similar logic underlay my troop leader's explanation for why Brownies wore ties: not, apparently, for butchlet appeal, but so that we'd know how to tie them for our fathers, brothers, and husbands.) It also registers, I think, three key elements in play today when people struggle over how to use pictures in queer-rights struggles: (1) the idea that people can be persuaded of the picture-makers' case if they can be made to see themselves when they expect to see aliens ("I thought those people were different but really they look just like me" or "I thought I was the only one but now I see that I'm not"); (2) the bit of magical thinking involved in the hope that one can effect a sudden transformation by merely saying "look here"; and, simultaneously, (3) the recognition that "look here" is no magic spell, hence the need for a text-making spin master to coax out the hoped-for interpretive work. What's different is not just the cast of characters or the trade-in of a pond for pictures, but also the battle over who should play each part and the uncertainty of the outcome. The Brownie story raises no question about whether it's the father who should benefit most, the Wise Old Owl who should call the shots, or Mary (not, for instance, her brother Tommy) who should seek the brownie and find herself. Nor do we doubt that Mary will be turned around eventually. Today, everyone is fighting over who

should be the father, the owl, and Mary, partly because no formula to date has worked as well as the owl's.

In this essay, I discuss the picture fights of two activist groups I was involved with in the early 1990s: the ACT UP/Portland Maine Pissed Off Dyke Cell and Women's Health Action Crew (PODCell/WHAC), which worked on projects devoted to pro-sex dyke visibility and health issues; and Equal Protection Lewiston (EPL), which fought to pass and then uphold in referendum a 1993 Lewiston, Maine, city ordinance that banned discrimination on the basis of sexual orientation in housing, public accommodations, credit, and employment. (We won the ordinance but lost the vote to uphold.) Both are groups in which the major representational struggles ostensibly centered on the Mary problem. Who should be Mary? How can we represent her to herself for her own benefit and ours? Who gets to decide all of this? Each group's dominant stance on these questions and on the representation of sexuality typifies those taken by groups of its kind. PODCell/WHAC, like many radical anti-assimilationist, direct-action groups, wanted to address and represent queers (in this case dykes in particular) as sexual beings plus. EPL, like many referendum-focused groups, took an assimilationist, hide-the-sex approach. Straight people were Mary, and Mary was "just like us," a strategy that entailed taking sex, along with visible style markers of sexual orientation, out of the picture.

I state at the outset that my own allegiance lies with the representational and political positions taken by PODCell/WHAC. In fact, I functioned on EPL's steering committee as the community's direct-action representative, though eventually I resigned, after ten months, over political disagreements. Yet my purpose here is not to enshrine the first group and trash the second. To enshrine the first would be to discount the extent to which we failed miserably: we produced little and fizzled out. To trash the second would be to ignore the well-intentioned work of many people who struggled in good faith to combat prejudice. Instead, I use my interpretation of what happened in these groups to address three issues: the place and practice of representational theory in activism; the relation of theory to practice both within and between academic and activist arenas; and the sexual messiness of queer pictures and politics, which intrudes, it seems, whether you brandish or banish it in your representational output. I argue that while each group's history can illuminate fruitful approaches to the Mary problem, a shift in focus, more than an attempt to solve it, is in order.

PODCell/WHAC met weekly for about eighteen months in 1992 and 1993. Its core membership of eight white women was relatively diverse in age (early twenties to mid-forties), geographic origin (urban, rural, suburban; Maine, California, Chicago, Albany, Connecticut), economic background (poor to monied), and current economic status (poor to comfortable). The group's long name resulted from a relative diversity in political/sexual identification: "PODCell" was the dyke caucus of ACT UP/Portland; some dykes on the "WHAC" side, for separatist or other reasons, did not want to be considered part of ACT UP. Corresponding, but only partly, both to this division and to age divisions, was a division between dykes who identified across genders as "queer" and dykes who saw their primary allegiance with other women.

We had important similarities, too. Most of us were cultural producers by trade or avocation: photographers, craft-makers, an art student, a computer graphics expert, and a college art history teacher (me). We all wanted to make and circulate sexy pro-(safer)-sex images and to avoid promoting the equation "sexy=young urban dyke chic." Because "free speech," currently, is hardly free in terms of either money or permissible content,[2] we all considered it legitimate to use illegal means to get our pictures out, such as appropriating resources from corporate employers, wheatpasting flyers (a felony in Portland), and breaking Portland's anti-obscenity laws. We agreed

on an ambitious list of projects that we'd complete if we could muster the resources: a safer-sex "porn" video project, a dyke sex survey, and a wheatpasting series.

We had a productive first few months. We wrote and distributed a draft of a sex survey and got a write-up in the local semi-alternative paper, the *Casco Bay Weekly*, that resulted in a generous offer of video funds. We had fruitful if sometimes frustrating discussions about how images worked, much of which concerned the Mary problem. Part of our project was to promote dyke visibility to dykes: we are everywhere, and everywhere as sexual, political beings. How, then, could we get dykes to see themselves in our pictures? Could we, for instance, even use the term "dyke" in word-and-image pieces without alienating women who identify as lesbians but dislike the term "dyke"? (What readers might be disidentifying with me here for using "dyke" rather than "lesbian" as a generic shorthand term because of my own preferences in connotation?[3])

This issue of address was also important given our intention to promote HIV education and safer sex practices among dykes in the context of a general tendency to underestimate risk of HIV transmission between women and to dykes in other ways – a tendency due partly to CDC definitions for both "lesbian" and AIDS-related illnesses, and partly to dominant habits of using criteria of identity (gay man) rather than acts (oral sex without latex during menstruation) to assess risk overall. How could we get dyke viewers to think "this is (about) me"? Which representations would likely attract or deter such identification? Which might be generally considered sexy or unappealing? How many people were turned on or off to, say, bondage? On what levels were information and persuasion most effectively conveyed? We repeated here many of the discussion topics well described by Cindy Patton in "Safe Sex and the Pornographic Vernacular" concerning strategies of showing and telling.[4] Was conspicuous and sexy use of latex necessary or sufficient? (How) could written or spoken information be introduced without detracting from the product's sexiness and preventing a viewer from getting into it – or, in Brownie terms, from turning herself into Mary (I am or want to be these women)?

These discussions, in which we resolved little, nonetheless involved collaborative thinking more than conflict. Other topics, however, generated intense conflict and, over time, virtually immobilized us. Our biggest disagreement concerned where to circulate sexually explicit material. Our primary target audience, we agreed, was dykes. But what about men seeing the material? Some wanted to deter men from seeing what we produced. They suggested, for instance, that a video should carry a label such as "for dykes only" or "for women only," and that wheatpasting flyers, which would surely have a coed audience, should be less explicit. Others disagreed for one or more of the following reasons. (1) We wanted to publicize dyke sexual visibility to a big audience, including men. (2) We thought we could produce images for this broad audience that challenged the dominant "we're waiting for you, o male viewer, to complete our picture" formula of heterosexual porn. (3) We didn't care enough about men appropriating or masturbating to our pictures to work around this, especially if there were women who would thereby lose access to the material; getting to female passers-by mattered more than avoiding male passers-by. With regard to the video, some of us also worried that many women would be turned away by the implicit separatism of a "for women only" label either because of anti-separatism or because of a suspicion that separatists were less fun.

These disagreements made it almost impossible to produce sex pictures collectively, and we disagreed also about alternatives. One woman, for instance, wanted to show positive images of dykes with guns, claiming the right to self-protection. Others couldn't sanction this. Finally, we did a single wheatpasting project, using two different flyers that we posted around Portland. One, promoting women's health, was completely textual: a white text on a black background that read,

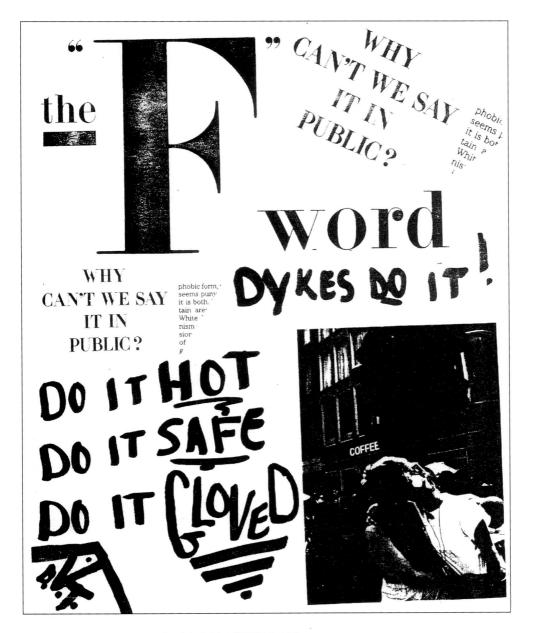

Fig. 20.1 Wheatpasting flyer, produced by PODCell/WHAC, 1993

"Check your breasts / Check your pussy / Do it Now / Don't be wussy." The other (Fig. 20.1), with a shadowy picture of two women kissing, had a dyke-sex visibility and safer-sex message promoted again primarily through the text: "the "F" word, why can't we say it in public? Dykes *do* it! Do it *hot*. Do it *safe*. Do it *gloved*." Soon after, however, the group disbanded.

369

Why? Certainly, our demise came partly from unresolved struggles over how to turn as many dykes as possible into Mary and whether to work actively against having men get to be Mary's father or the Owl – against, that is, having men benefit from or give meaning to our representational products. But it would be wrong to attribute too much to our failure to resolve representational dilemmas. For one thing, we *were* able to act without solution or agreement. The poster in Fig. 20.1 represents a successful compromise: the picture denotes sexual activity without being "graphic" enough to seem actively to court male voyeurism. We could have constructed countless others. We also established an agree-to-disagree strategy for other wheatpastings; people who objected strongly to particular wheatpastings simply would not participate in putting them up.

But it was much more than representational standstills that made meetings wearing. Talking sex, like having sex, is fraught with potential difficulties in that it entails personal and interpersonal decisions about self-disclosure, confidentiality, and trust. While our sex talk was often fun and arousing, it was just as often discomforting, especially because sex among us was not just a matter of theory and pictures but of lived experience: the group included current lovers, soon-to-be former lovers, people with shared ex-lovers outside the group, big crushes, etc. In addition to the questions on the table, others arose, sometimes arousing, sometimes disturbing, usually unarticulated: You get off on what? Is she flirting with me? Is she flirting with my girlfriend? Why did she tell everyone that she thinks *x* is sexy because now everyone will think/know she does it with me? Do I want the whole group (or so-and-so in particular) to know that I think *x* is sexy?

All this talk about representation generated other tensions as well. It turned out, for instance, that some people considered the two of us with degrees from prestigious institutions, and, in my case, a fancy educational job, to be "the smarter ones." They sometimes felt intimidated if they didn't understand what one of us said. When I didn't make sense, some people interpreted this as their failure to get it, rather than my failure to communicate or ill-formulated ideas. I should have anticipated or noticed this but I didn't, probably because I had a big investment in the fantasy that PODCell/WHAC was a place where I didn't have to be "the professor," ignoring the obvious point that roles depend at least as much on how people perceive one as on how one wants to be perceived.

In short, these discussions could make participants feel bad, insecure, or threatened for many reasons, and their duration alone became frustrating. No one had much free time: some worked full time and went to school, others worked several jobs, one worked full time and also edited a queer newspaper, and most of us had other activist commitments. So talk time cut into action time. Lots of talk meant no action, and lots of talk about sex pictures shoved other items off the group's agenda, such as the dyke and women's health issues besides HIV that had motivated some dykes to participate in the first place. Add to all this those inevitable little aggravations – including for us a conflict between the compulsively punctual and the chronically late – and it is clear why the perceived payoff of these meetings decreased over time.

These problems are less lofty, to be sure, than dilemmas of representational theory, and may seem as well less worthy of historical record and critical analysis. But my point is precisely that these are, perhaps, the big issues, although I do not present my tale of our demise as a paradigm for what any such group will face. Some PODCell/WHAC problems were specific to the particular people involved and our geographical location. Portland, Maine, has a small population and thus fewer potential new members who might have brought new dynamics to the group or at least more labor power. It's not that there are hordes of radical activists in big cities, but at least the pool of potential recruits is larger. In many large cities, too, police lack the time, desire, and

community pressure to get rid of wheatpastings. One important representational problem in those areas, then, involves how to create pictures and graphics that will stand out among others. In Portland, where police have fewer crime distractions and there is a strong public anti-"defacement" ethos, almost any wheatpasting graphic stands out; as a result, wheatpastings done at midnight are often gone the next morning. Devising other strategies to get our messages out to passers-by would have needed to be one of our central projects had the group kept going. Other PODCell/WHAC difficulties, however, are less specific to the context of Portland. I suggest some more broadly applicable conclusions after a discussion of a very different group, centered 35 miles north, in which related problems arose: Equal Protection Lewiston (EPL).

If PODCell/WHAC members disagreed about the Mary issues, our views looked remarkably similar from the standpoint of the Mary debate as it evolved in the more mainstream EPL. In EPL, the Mary problem appeared repeatedly in various guises. Indeed, the whole existence of EPL might be attributed to one person's conviction that he had solved it. The anti-discrimination ordinance that later was put to a public referendum had been proposed by the man then serving as Lewiston police chief, Laurent (Larry) Gilbert, out of an admirable desire to enable queers to report hate crimes without fear of reprisal. Having himself been converted from the "special rights" to the "equal rights" position, Gilbert believed that if such an ordinance were brought to referendum (a virtual certainty) other Lewistonians could be convinced, too. In Mary terms, Gilbert thought that he was the model Mary – especially since he was a typical Lewistonian in ethnicity, a Franco-American of French Canadian descent. Although other people at preliminary meetings, particularly queer activists, argued that converting voters on this topic would not be so easy, Gilbert carried the day, and the ordinance was passed and then challenged.

EPL's subsequent fights over campaign strategy also engaged the Mary problem. EPL hired Al Caron, the paid political consultant for a similar campaign in 1992 for Equal Protection Portland (EPP), where we won (although, I would argue, in spite of his campaign strategy). Caron had run the campaign in Portland exactly on the principle that voters would "Vote No" against overturning the ordinance if you could get them to say, "that's me." To this end, EPP used many sympathetic heterosexual spokespeople, and presented homosexuals, when it did so, as "people just like you," i.e. heterosexuals. EPP's slogan, which became ours, was "no discrimination." It was designed to signal that the issue was not really gay rights but discrimination in general, so that a "no" vote would not imply endorsement of gay rights or practices. In Lewiston, this strategy acquired an additional local justification. Many Franco-Americans had experienced discrimination in employment, education, housing, and many other contexts; the term "French" is still used sometimes as an ethnic slur here. The argument went that if the campaign portrayed the "no voter" as a person against discrimination and the beneficiary of a "no" vote as a victim of discrimination, Franco-Americans might see themselves in both pictures, regardless of their views on homosexuality.

The anti-discrimination, straight-people-are-Mary plan won enough supporters in EPL to get approval, despite, however, strong opposition from some steering committee members, including me, and from people in the organization at large. Some of us thought that Portland had been won in spite of, rather than because of, the "no discrimination" strategy – an argument that activist Suzanne Pharr made in her assessment of a similar campaign in Oregon[5] – and that it simply wouldn't work. Targeted voters would know it was a "gay rights" issue no matter what we called it and might also conclude that, by downplaying the sexuality issues, we had something to hide. We wanted a more honest approach. Such an approach, many of us also believed, required not only a different media "message," but a shift in focus from a big media campaign to door-to-door canvassing, so that our neighbors would meet us and see who we were.

Also, we wanted to reach potential Marys who *were* queer. Lewiston's queer population was barely visible. People who had grown up in the area, even recently, remembered how difficult it had been to come out here, and we all lived with the daily dangers and demoralization that result from having too few visible allies. We wanted to make queers and queer rights valid and visible as part of this process and to use the campaign as an opportunity to educate our neighbors. We also considered such education a necessary prerequisite for ensuring the long-term success of the ordinance. Just as rape laws don't work if judges and juries still believe that women mean "yes" when they say "no," our ordinance wouldn't be enforceable if people still thought gays were outsiders and child molesters. For all of these reasons, we wanted to take on – rather than evade – the issue of gay rights, and to showcase out queer people as well as straight or "straight-acting" supporters.

Besides challenging the overall strategy, opponents also took issue with some specific EPL proposals for executing the campaign plan, proposals that trashed our dignity and worked against our long-term goals. Caron wanted our campaign literature to state: "This ordinance does not endorse (or does not approve) homosexuality." We considered this homophobic. Other fights involved proposed visuals, including spectacles, staged television coverage, and photographs. When EPL participated in the Maine State Parade, Gilbert, Caron and others wanted to ask marchers to wear an EPL T-shirt, to solicit especially participation by "normal" heterosexual family units, and to tell gay participants not to act gay. Not surprisingly, many people, predominantly queers, voiced resistance: "I'm not going to tell someone she can't hold hands with her girlfriend"; "I was told to hide for most of my life, and I will hide no more."

The official campaign, however, allocated only one place for queer visibility: a "victims press conference" where gays and lesbians told about being victims of violence. We wanted gays to be visible other than as "victims." Similarly, we didn't want to privilege "just like you" people to an extent that encouraged prejudice against non-mainstream queers or made assimilation to mainstream "lifestyles" a criterion for rights, tolerance, or praise. We deserve rights because we are human, mainstream or not, and we wanted rights and respect for everyone, from bankers to drag queens.[6]

Why did so much contention revolve around the visuals? Photo-ops, media consultants, and television bytes have become so dominant in the political scene that such a question may seem rhetorical, but it should not be considered so. Their taken-for-grantedness is part of the problem, for it prevents many activists both from questioning the use of media as a primary tool and from addressing particular visuals at work. In EPL, our debates were greatly structured by one specific visual product: *The Gay Agenda*, an anti-queer video with the single vague credit line, "© 1992, *The Report*," that was widely circulated by the religious right, particularly by Donald Wildmon's organization, the American Family Association. Many EPL members screened the video just before the City Council vote on the ordinance after it was forwarded to us by one of the city councilors, each of whom had received copies from the local anti-ordinance group All Catholics for Truth. The video begins with footage from the 1991 protest after California governor Pete Wilson vetoed a state anti-discrimination bill, edited to emphasize window-breaking, and includes footage from gay pride parades, edited to emphasize nudity, leather, and signs with words like "fuck." The narrator explains that groups like ACT UP and Queer Nation are at the vanguard of a movement to "force" the "approval" of homosexuality, and the video enlists "experts," mostly white men, who promote as fact the homophobic disinformation that has now become standard fare in mailings, meetings, and subsequent videos: about eating feces as a predominant practice; about queer responsibility for the spread of AIDS; about gays' high-income status, desire to recruit, and pedophilia; and about homosexuality as a curable condition.

As even the topics of the EPL arguments that I discussed above should indicate, *The Gay Agenda* affected EPL's participants and strategies. Those anxious to control clothing and demeanor at the Maine State Parade had in mind the pride parade footage, which, for some, was the only pride parade documentation they had encountered; even if they claimed to believe that the tape gave a distorted view, they revealed a fear that, without rules, queers would appear in leather thongs and nipple rings at anything designated "parade." The very idea of participating in the parade was partly motivated by a desire to present parade images alternative to the *Agenda* footage, which some described as the standard view of gays. The idea of limiting gay visibility to a "victim" conference also had the two *Agenda*-related goals of counterimaging and of preventing cameras from getting in front of gay people who weren't under strictly scripted control.

Overall, the *Agenda* contributed to EPL's sense of urgency to fight pictures with pictures and served as the anti-model for many EPL strategies. Against *Agenda* footage suggesting violence and sex out of control, EPL designed images that were products and intended designators of hypercontrol. Against *Agenda* presentation of gays as abnormal and alien, EPL was all the more determined to designate "normal" and "just like us," or, even safer, to leave queers out of the picture altogether. EPL did not always explicitly label these strategies as counter-*Agenda*, and the *Agenda* was hardly the only source of the images EPL wanted to oppose. The tape's effectiveness must be attributed partly to its ability to tap into already present mental images, fears, and prejudices – not only in viewers sympathetic to the tape's message but in hostile viewers as well.

In discussing *Gay Rights, Special Rights*, the more sophisticated anti-queer video produced by the religious right one year later, Ioannis Mookas makes several points that also apply to *The Gay Agenda*. Mookas suggests that while activists have rightly fought the video by publicizing its falsities, this strategy is insufficient because "to anchor one's criticism of it in truth claims is in some sense to miss the point that, to a large extent, the video operates best in the cognitive realms outside of logic." Among the effects resistant to argumentation that Mookas delineates are the persistence in homophobic material of the image of gays as child molesters, despite well-publicized evidence that the predominant majority of child molesters are heterosexual men. He also notes the "psychic toll taken by homophobic propaganda upon lesbians and gay men," even upon those armed with counter-evidence and critical viewing skills, that comes from "the cumulative force of having virtually every awful thing straight society has ever said about us – 'sick,' 'guilty,' 'worthless,' 'doomed' – amalgamated into one terrific wallop."[7] Mookas also addresses the video's contribution to painful, emotionally charged battles among civil-rights activists about marginalized subcultures, battles that also occurred within EPL against the phantasm of the pervert raised by *The Gay Agenda*: mainstream, assimilation-identified gays and lesbians on the committee were among those most upset by the *Agenda*'s use of drag queens, Queer Nation rioters, and leatherfolk to represent gays and lesbians in general, the most determined to guarantee a different public picture, and the most angry at those of us who embodied or advocated the presence of the margin.

Agenda-based arguments erupted periodically throughout steering committee meetings – including one largely digressive fight that occurred when a steering committee member suddenly announced that "those women without shirts" were a disgrace – and our fights over the Mary problem lasted throughout the campaign. As in PODCell/WHAC, these disputes raised more questions than those ostensibly up for debate. Issues that simmered underground in PODCell/WHAC surfaced immediately in EPL. We had a fixed deadline – election day – and massive amounts of work to do. In PODCell/WHAC, lengthy debates meant talk instead of action; in EPL, they simply meant more hours. EPL's two thorniest issues – the Mary problem and organizational structure (broad-based coalition activism vs top–down administrative hierarchy)

– were frustrating, and often described by some EPL members as abstract, philosophical, and a luxury we couldn't afford; we don't have time to remake society, let's just *act*.

The frequently articulated opposition between talk and action was amplified, I think, because a Bates College student and I protested frequently against the Mary plan, top–down hierarchy, and tabling the arguments. Given typical town/gown income disparities in Lewiston, we could easily be charged with dwelling in the realm of luxury and philosophy, although the Steering Committee did not divide neatly by class positions on these issues. My strongest non-Bates allies were poor; many professional-class people stood against me. Nonetheless, the Bates affiliation, along with the perceived opposition between talk and action, marked my side of the debate as the monied one. I'm sure, too, that despite my deliberate avoidance of theory-speak, my own habits of speaking remained alien and difficult to many, contributing to the class antipathies that did not actually structure our political oppositions, but certainly affected the development, perception, and description of them. For instance, a number of my unmonied allies described having to get over an initial mistrust of me in order to see that we did share common political ground. This cross-class common ground was subsequently rendered invisible when those same elements of mistrust were used by others to discredit my positions as being abstract, out of touch, gown vs town, and attributable to a class status that allowed for nonessentials.

These are matters about which academics who do political work in their communities need to be vigilant: how our language and institutional affiliations may signal elite economic status (accurately or not), hindering both the forging and representation of alliances across economic differences. Another source of marginalization that many Bates people encountered in EPL is also one that academically affiliated activists face frequently: we were transplants, or "from away" in Maine-speak. As such, we were hurt by EPL's "that's me" voter strategy, which both magnified and gained strength from an insider/outsider opposition in the campaign discourse. EPLers usually blamed our foes for forcing us to make use of this opposition. Local homophobes, we heard repeatedly in EPL, were convinced that a huge national gay conspiracy was trying to force homosexuality on them, so we had to keep outsiders invisible in order to avoid fueling this belief. But even within EPL, outsiders were suspect, leading to misrepresentations of both insiders and outsiders. For instance, although people often remembered steering-committee battles as bitter disputes between me and the police chief, outsider vs insider, many born-and-bred Lewistonians sided with me. And people often forgot that many native Lewistonians wore the signs designating "outsider," like green hair. Outsiders were just not so easily pinpointed.

Neither, it turned out, were insiders, leading to at least one fiasco. Because the primary criteria for "insider" seemed to be "Franco-American" and "not queer-looking," EPL made Gilbert a central spokesperson. This was a gross miscalculation. After a mid-day law-enforcement press conference was reported in the local newspaper (Fig. 20.2),[8] our opponents charged that Gilbert should not have been working for EPL on city time and, quite rightly, that having a police chief press residents to vote a certain way amounted to coercion. In this context, Gilbert was not seen as primarily a Franco-American Lewistonian.

Our dismal loss at the polls in November, by more than a two-to-one margin, suggests that other strategies at work in the carefully crafted media presentation – visual spectacles, speeches, broadsides, and photographs – didn't convince Lewistonians that they were "just like us." These strategies included an increasing attempt to eliminate visual evidence of difference or deviance. By September, the campaign primarily staged events for television and newspaper coverage that would most likely yield pictures of prominent local people standing at podiums as opposed to events such as rallies in which the cast of characters, their dress, and behavior could not be strictly controlled. Thus, EPL no longer sponsored public actions like the EPL contingent at the Maine

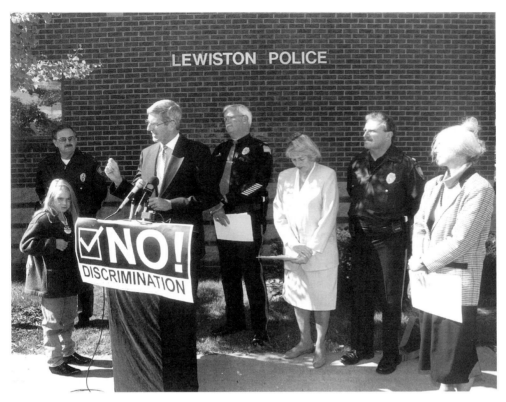

Fig. 20.2 Press photograph accompanying an article on EPL's "law-enforcement press conference" in the local newspaper. The podium bears EPL's official slogan and logo. Note the lack of clues that a gay issue is involved, and some subtle hints about the apparent heterosexuality of the participants, such as boy/girl alternation. Photograph Russ Dillingham, courtesy Lewiston/Auburn *Sun-Journal*

State Parade and, even after the vote, had spokespeople condemn a post-defeat protest as a product of radicals and outsiders, even though many EPLers of diverse political opinion participated (Fig. 20.3). Among other visuals used during the campaign were headshots of community supporters in one mailing that, in format, prevented any contextual reference that might have marked the spokespeople as gay or lesbian (Fig. 20.4). The campaign's most widely distributed piece, a broadside distributed door-to-door, solved the problem of controlling visuals simply by omitting them. Apparently, however, "just like us" could not be achieved either by presenting controlled images or omitting potentially disruptive images.

But was it EPL's Mary strategy or the inadequate execution of it that failed? One could argue that the mistake with Gilbert lay primarily in trying to represent "community leader" and "average Lewistonian" at the same time – in failing to see that Gilbert's position of power and class status overshadowed the Franco surname. The campaign failed on many levels to engage class issues, even after our (nationally aided) local opposition publicized the bogus allegation that the average annual gay income was $55,000.[9] Greater attention to the terms of the debate as they were being shaped outside our office might have enabled EPL to generate "that's me" pictures and texts.

One project by a split-off group may support such a conclusion. The group was composed of local activists who were dissatisfied with EPL's closet campaign, including a number with

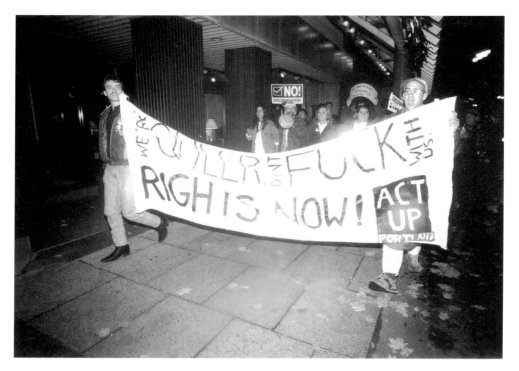

Fig. 20.3 Demonstration in Lewiston on 3 November 1993 to protest the results of the previous day's vote. The ACT UP banner, which had been used in earlier demonstrations, had caused great conflict within EPL, due to the use of *fuck*. Although I defended the banner, two negative effects are worth noting. First, with regard to issues of coalition-building and attention to vernaculars, widespread local hostility to the use of the term meant that the banner was displayed at a high cost in good will. (Conversely, *fuck* was effective as a mark of speaking the vernacular of some unaddressed locals, particularly youth.) Second, *fuck* ensured that the banner would never appear in local media coverage, which censors "obscenity." Thus, ACT UP, ironically, contributed to its own erasure from the scene by making this banner its most prominent visual. Courtesy Phyllis Grabar Jensen

ACT-UP/Portland affiliation, and some people from the New York Lesbian Avengers who provided back-up support for the projects.[10] We designed a flyer for canvassing one of the poor neighborhoods that EPL staff had written off on the ridiculous theory that "those people" don't vote. The flyer used a "that's me" approach to address economic issues:

The ordinance guarantees gays and lesbians the SAME rights that all Americans should have. It means we can't lose our jobs or our homes for being gay. AND JUST LIKE YOU, we can't afford to lose our jobs, our homes, or be scared to walk the streets. Gays and lesbians in Lewiston have the same economic problems as everyone else. We should all be asking why there are no jobs. The opposition is trying to divert your attention from the real problems facing Lewiston – jobs, housing, our schools, our lives.

Voter counts indicated that in the area that the split-off group canvassed with this material the "no" votes were higher than projected.

We might conclude from this small success that EPL did well to try to construct a reflecting pond for Mary, but failed to provide the right one. Yet an alternate interpretation of the Mary issue might also explain this small success: the key here was not in the "just like you" appeal of the literature, but in taking the literature door-to-door. By talking to residents, canvassers gave them a chance to see that queers and their supporters were not necessarily just like them but OK

Religious & Community Leaders Say– Discrimination Is *Always* Wrong.

"We acknowledge that there is internal disagreement in our religious communities about the moral status of homosexuality... but there is no disagreement among our member religious traditions that gay and lesbian persons ought to be treated fairly and justly in civil matters."

Lewiston-Auburn Interfaith Clergy Association

Left to right: Mark Greenleaf Schlotterbeck, pastor, Friends of the Savior Mennonite Church; Rev. Johanna Nichols, First Universalist Church Unitarian Universalist; Rabbi Douglas D. Weber, Temple Shalom; William M. Baxter, rector Trinity Episcopal Church; Rev. David Wood, United Baptist Church.

Photo: Russ Dillingham

Laurent Gilbert, Sr.
Lewiston Police Chief
Before I got involved with the Lewiston Police Department's Hate/Bias Crimes Task Force, I thought that we all enjoy the same, basic protections. I found that I was very wrong.

Michael E. Carpenter
Maine Attorney General
There is no statewide law prohibiting discrimination based on sexual orientation. As a result, victims of hate crimes fear coming forward to report their experiences.

Kathy Urban
Nurse Practitioner, Lewiston
I believe in equal rights for all members of our community, regardless of their sexual orientation. People should not be discouraged from seeking medical help, because they fear discrimination.

Trudi Chase, M.D.
Physician, Lewiston
In my practice, I've seen much discrimination against homosexuals. All discrimination is wrong.

Paul Cote Sr., Esq.
Lewiston Attorney
As an attorney and former municipal court judge, I'm familiar with the laws about discrimination. There is no state or federal law, or provision of the Constitution, which protects homosexuals against discrimination in housing, employment, credit and public accommodation. That's why I will be voting "NO" in the referendum seeking to overturn the Lewiston anti-discrimination ordinance.

The Law Does *Not* Protect Everyone Equally.

Rev. Johanna Nichols
Unitarian Universalist Church, Auburn
I know from listening to the members of my congregation that there is discrimination against homosexuals in this area. One person was denied a mortgage by a Lewiston bank. Another was afraid to claim health benefits for fear of losing a job with a Lewiston company. Another fears losing a teaching position.

Geneva Kirk, *Retired Lewiston Teacher*
I support the anti-discrimination ordinance. When people such as police chiefs and district attorneys endorse the ordinance, I believe they know the necessity, and the serious problems of discrimination faced by some individuals in our community.

Eloise L. Moreau
Service Provider to the Elderly, Lewiston
I am voting "NO" because I believe that it is of great importance that Lewiston voters send the message loud and clear that discrimination does not have a place in our community.

On November 2, Vote "NO" Against Discrimination.

Because it's *always* wrong.

Fig. 20.4 Interior of a 3-fold mailing put out by EPL, October 1993. The texts respond to opponents' contentions of insufficient evidence of discrimination and extant protection. In response to concern by some steering committee members about queer invisibility in the campaign, it was resolved that this mailing should include testimony from at least one person who would self-identify in the text as gay or lesbian. In production, however, staff people used the refusal of the first potential spokesperson whom they approached as an excuse to drop this feature.

anyway. It is this second interpretation which I find persuasive and which is backed up by other cases where person-to-person contact swayed votes, such as the 1978 Briggs initiative in California and the 1994 Idaho referendum. But I don't find in it a theoretical solution to the Mary problem that can be applied in any activist context. What follows are six conclusions I have drawn from what happened in EPL and PODCell/WHAC that will influence what I advocate for in the future:

1. *Representational work must be situation-based; that is, oriented to specific issues and locations.* In both PODCell/WHAC and EPL, we spent too much time trying to answer questions about how representations work in general. In fact, Caron sold EPP and EPL on the one-message media strategy partly on the grounds that he had used it to defeat a referendum to widen the Maine Turnpike. His opponents argued that you cannot merely transfer what worked for the turnpike to the matter of gay rights because images of queers touch people in personal, sometimes disturbing, ways – ways that images of a three-lane highway simply do not. Many people in Lewiston doubted whether a plan that had worked in Portland, the state's "liberal" town, would work in Lewiston, a more conservative working-class town with a different set of political traditions and ethnic base, and expressed these concerns. Why, then, did things proceed as they did? One answer to this question leads me to my next point.

2. *Representational theorizing and strategizing is everybody's business.* This is not to say that people need to start theorizing. Everybody is already, to borrow academy slang, "doing theory." As I confirmed doing research on Barbie, from eight-year-olds to elders, people always generate theories about how cultural products work, based partly on their own experience.[11] But in EPL, people often viewed theorizing as the trade of academics and political consultants. Some expertise was also accorded to people with political power and social status, such as the police chief and the mayor. But none of us had the resources from which to draw situation-based theoretical conclusions on our own. I had a lot of experience with queer-issue activism but had moved to Lewiston only in 1990. The consultants, police chief, and mayor – the people who pushed the original ordinance forward – had no experience living as queers and were so new to queer-issue activism that the latter two were shocked to get hate mail when their support for the ordinance became known.

 At least as integral to decision-making should have been the supposed non-experts – those queers who had lived in this town for a long time and were well acquainted with the images of queers circulating in the heads of their neighbors. Certainly, a degree in cultural studies or prior campaign work are useful tools to bring into new political contexts. They remain largely ineffectual, however, unless the provisional conclusions we draw from them undergo broad-based analysis about whether they hold in the given situation.

3. *We must create contexts for more broad-based theorizing and strategizing,* and recognize that this requires very hard work. It requires, too, professional theorists, like consultants and academics, getting over ourselves – so that we neither presume that we have all the representational expertise nor encourage others to conclude that we do – and vigilant attention about impediments to broad-based theorizing. The different dynamics in my two groups, and the different perceptions of me in them, suggests how complicated, situation-specific, and variable these impediments are. PODCell/WHAC was resolutely anti-hierarchical and "pro-theory" in the sense that questions about how representations worked were considered appropriate collective work; my job, however, enhanced my credibility. In EPL, where my job hindered my credibility, fewer people thought of theory work as appropriate collective labor. Many came to embrace a hierarchical model, based partly on a broad distrust, fueled by our consultant, both of the decision-making ability of the people who had elected us to represent them and of their own judgments when those contradicted our consultant's advice. Despite these differences, however, both groups were affected by class and education issues that, I suspect, often arise elsewhere; activist groups are hardly the only cases where many people mistrust or disrespect their own brainwork. These issues need close attention.

4. *The merit or truth value of particular representational theories is sometimes beside the point.* What if it were true that we could have controlled the image bank in voter's heads and won the election by camouflaging queers and queer issues under the term "discrimination"? We shouldn't have been doing it anyway. These strategies prevent outreach to struggling queers who need to find allies and draw resources away from grassroots coalition activism. As I indicated above, opponents of the big closet media campaign did marshal representational countertheories. We argued for an out, door-to-door, multi-issue campaign partly on the grounds that we couldn't control the image bank or interpretive context by our output or by output addressed impersonally to the public at large. Our arguments about what works, I believe, were theoretically sound. But the issue is hardly just "what works." We need to address economic issues, whether our opponents throw them into the mix or not, because without addressing economic and class issues, the only "gay rights" you can win are rights for queers with money. If you don't have rent money, it matters little that a landlord can't evict you for being queer. We also needed to be doing coalition activism and grassroots organizing because we all need to be working to achieve social and economic justice for all oppressed peoples and to increase our numbers; we need to generate multi-issue activists, not just single-ballot votes.

Coalition activism and grassroots organizing preclude a one-message media campaign, by definition and in practice. You can't spend most of your money on commercials and still fund field organizers. You can't print up bumper stickers first and talk later. You need to find out what local people want them to say (if they want them at all) or whether people can risk having their cars vandalized (if they have cars at all). You can't plan anything until you know about people's work, money, and safety; about the risks they want to take, the issues they want to advance, and the skills they want to share or learn. These vary from neighborhood to neighborhood, block to block, person to person. From this kind of work, alliances are produced that remain after the immediate project is over. The single-message media campaign, even if the message works in the short run, yields a limited payoff. (Thus, even if we could find a slogan as spectacularly successful as "gay rights are special rights," limited resources should be allotted to deploying it.)

5. *We need to deal with how extraordinarily messy and complicated sex, sexuality, and the interpretation of them really are.* In Lewiston, the campaign tried to tell people, "you might not approve of homosexuality, but you don't need to think about it right now." This approach didn't work, partly because we couldn't squash discomforting pictures already in people's heads, whether they got them from right-wing videos like *The Gay Agenda*, from experiences (real, fantasized, vicarious), or from elsewhere. Several PODCell/WHAC disasters as well as slowly corrosive discomforts arose from our failure to address intergroup and personal sex matters. In EPL, too, silences worked subtle effects. One heterosexual steering-committee member, who greatly favored the closet/discrimination approach, commented after attending a benefit at a gay bar that he was surprised and impressed by how well-mannered he found the regulars. How could his prior expectation not have affected his contribution to policy-making?

I don't present this point about sexual messiness as new information. I assume that many readers can share similar stories about how personal and interpersonal sex dynamics among group members complicated or even wrecked political projects: triangles, break-ups, internalized homophobia, and the like are common problems. But they are also among those matters that rarely get acknowledged, discussed, or recorded when we pass on information, experience, and insight. Certainly, we have lots of insightful theoretical work about sexual identity and the subjects/objects of representation. But we can't transfer it into working groups without factoring

in the actual sexual practices, fantasies, feelings, and interactions among the individuals in those groups – a provisionality for which, in turn, academic theorizing needs to account.

6. Finally, and as a consequence of the first five points, *we need to reconceive the purpose, method, and value of addressing the Mary problem.* There's nothing wrong with trying to turn people around with pictures or sometimes aiming for a "that's me" response. But the Mary problem can never be solved for good because the people who create and look at our pictures vary from one pond site to another. One can't know much about how images will fly before they are put out, and ongoing ethical and political issues – which matter as much as short-term efficacy – vary too. Thus, questions concerning who should be Mary and how to construct the neighborhood pond need to share priority with provisional picture-testing at every stage of the project. Furthermore, attention must be paid to whether apparently workable solutions preserve human dignity and serve long-term multi-issue social, political, and economic goals. Because we need to keep and generate activists and because representational strategies need to be based on the insights of many people, we need to think about conditions that prevent or encourage collective participation at the time, and to circulate those discussions in written and oral narrative later. What makes people come to, stay in, talk during, and walk away from political work?

I took the Brownie story with which I began from the 1993 edition of the *Brownie Scout Handbook*. I end by suggesting that the 1963 version actually has more to offer. In the earlier version, before *Handbook* editors made Mary generic, Mary had a geographical location (the north of England), a dialect (children are called "bairns"), and a particular class/economic place (her father was a tailor). The work she does, once transformed, includes work suited to the needs of this particular situation: "'And look,'" Dad says, "'A brownie has even found my scissors!'" This specificity can stand, I think, for the attention to the local needs, vernaculars, and casts of characters that must figure in both theory work and the transformation of provisional theories based on past experiences into situation-specific practices.

Missing from the new version, too, is a special Brownie pleasure described in 1963. Whenever the moon is full, the owl explains, Brownies hear the call to the Brownie Ring "deep in the woods": "Round and round and round about, / Turn about and in and out. / Come into the Brownie Ring, / Ready for most anything!" Now, I don't want to overstate the sexual undertones or pleasure component suggested by this rhyme. "Turn about and in and out" hardly corresponds to "Push, push, in the bush," and, according to the story, the Brownie Ring serves primarily to teach helper skills. It's where the tailor's daughters "learned to do so much." (This is before the *Handbook* switched Mary's sibling from Betty to Tommy in order, I presume, to suggest – half-heartedly, since only girls become Brownies – that boys should do chores too.) Yet there is something about the girls, "ready for most anything," who sneak out without the father's knowledge to join the other Brownies under the full moon that betokens to me the passionate activist, although with passion located much more subtextually than I would like to see.

Queer activists, like Brownies of all ages and like all the Marys we try to lure to our ponds, are sexual beings, and bring our sexual selves into our rings. Queer activism is both the impetus and the occasion for addressing sexual practices, even when we name the primary subject "civil rights," and even more than we often acknowledge when sex is officially on the agenda. This is, I suggest, simultaneously one of the most thoroughly theorized matters in cultural studies and one of the most frequently disregarded.

postscript

After our defeat at the polls in 1993, even many people who had supported EPL's official campaign plan, with its closeting of queers and queer issues and its emphasis on reflecting straight Mary in the representational pond, concluded that the campaign had erred. We should, they conceded (although without explicitly crediting those of us who had been arguing for queer visibility all along), have "put a human face" on the issue of gay rights. Several people also acknowledged that they hadn't known the Lewiston community as well as they thought that they had. These reassessments suggested that the loss in Lewiston might eventually generate new strategies, if subsequent referendum fights should arise, that gave more priority to education, community-based organizing, and queer visibility.

However, this was not to be. In 1995, Maine faced another anti-queer referendum, this time a statewide measure designed to repeal Portland's anti-discrimination ordinance and to make it impossible to pass protections in the future.[12] Despite some promising early signs that community-based organizing would figure prominently in the campaign plan of the state's primary "vote no" organization, which came to be called Maine Won't Discriminate (MWD), the opposite happened. Many of the people who supported out, direct-action, door-to-door organizing were pushed out during MWD's formation process. Others left, voluntarily or otherwise, as regional chapters were stripped of their semi-autonomy and checkbooks; as the organization moved to shrink its steering committee to six (of whom three were Portland-area lawyers, thus omitting even the pretense of broad-based coalition organizing); as the campaign's official messages increasingly refused to address the queer issues that were at the base of the referendum.

One mailing from MWD (Figs 20.5, 20.6) illustrates the overall approach of the campaign. An expensive, full-color, five-fold flier on glossy paper trumpets the banner headline: "People you trust . . . " Surrounding it are four headshots of white middle-aged people who are socially

Figs 20.5, 20.6 Mailing produced for Maine Won't Discriminate, Autumn 1995

Fig. 20.5

381

Question 1 is opposed by:

Bangor Area United Methodist Clergy
Maine Council of Churches
Bangor Theological Seminary Faculty
Roman Catholic Diocese
Jewish Community Council
Episcopal Diocese of Maine

Betty Lameyer Gilmore
Rector, Trinity Episcopal
President, Greater Portland
Interfaith Council

Discrimination

Question 1 was designed for one reason: to target gay men and lesbians for discrimination. But the sad fact is, Question 1 is so flawed and poorly written that it'll hurt veterans, hunters, whistleblowers and people on workers' compensation in the process.

But Question 1 doesn't stop there. Now it's being reported that Question 1 could strip away some of the rights enjoyed by senior citizens in nursing homes and low income families in low income housing.*

It seems everyday we find out something new about the damage Question 1 will do to our way of life here in Maine. If it passes, **Question 1 will discriminate**...the only question is...will you and your family be next? Please vote "no" on Question 1.

(*Source: Bangor Daily News, 10/18/95.)

Fig. 20.6

contextualized only by clothing that suggests status and mainstream respectability. As one unfolds the document, a photograph of Maine's landscape emerges on the inside, with Maine's signature rocky coast and lighthouse, until the final panel completes the opening sentence: "The people you trust . . . Don't trust Question 1." The outside panels each reproduce one portrait photograph from the cover, this time identifying the individual and her/his affiliation, along with a list of institutions and prominent individuals who oppose Question 1 and a statement about why one should vote no.

The text in Fig. 20.6 repeats EPL's strategy of directing attention away from queer issues to make "you" the primary target. The first sentence, "Question 1 was designed for one reason: to target gay men and lesbians for discrimination," from which the text quickly moves to identify other potential victims such as veterans, hunters, and senior citizens, represents one of two brief mentions of queer issues in the entire flier. Another panel, entitled "Less Freedom," advocates local control of decision-making (a short-sighted strategy given the intention to bring a state gay-rights bill before the legislature several months later). This frequent campaign message, appearing also in television ads and campaign literature, was often phrased by describing Question One as the ominous work of outsiders, thus shamelessly promoting xenophobia and, by extension, fueling its component partners, racism, anti-Semitism, and anti-immigrant hostility.

This mailing typifies MWD's output in its minimal attention to queer issues, which stands out even more here given the use of almost half the space, which might have been used to address such matters, for a landscape photograph. MWD used virtually none of the funds it raised, over

$1,200,000, to challenge the homo-hatred that generated the referendum. MWD leaders admitted as much at a statewide meeting that took place several weeks after the election, when attendees raised the issues of silence on queer matters and "outsider" bashing, as well as other issues. Rural organizers protested that the official campaign "messages" had been designed primarily to address Portland. Some activists expressed anger at the portion of funds used for television ads and mass mailings, with the consequent lack of funds for local organizing. To all these complaints, MWD leaders responded that they had to do what polling and research dictated, which required accommodating rather than challenging homophobia, targeting regions with the most voters, and bombarding people with messages that, supposedly, "worked" at the polls, even if those messages had unfortunate implications.

We did win (narrowly) on election day, but with little long-term gain and at a cost succinctly summarized in the comments of an organizer from thinly populated Aristook County in Northern Maine. He said that his chapter members had not been included in decision-making, had been handed literature that didn't address local issues, and then had been abandoned to live with the danger of having come out in a hostile environment during the campaign without the resources needed to educate neighbors or to generate allies.

His comments suggest the urgency of rethinking campaign strategies, and the role of picture-making within them. I have argued in this essay that activist picture-making cannot be based on the Mary model of putting numerous people (studied, at most, through polling) in front of images designed to reflect or transform them through one act of looking. Viewers are too complicated to predict from afar, and a focus on the Mary problem often obscures other representational issues, sidesteps ethical matters, and ignores the work that builds coalitions and sustains activism. Given the religious right's increased use of referenda to attack queers, affirmative action, and US residents who are not US citizens, which will continue to suck up our time and money, it is crucial to think seriously about how visuals might figure in political projects before we turn over money and faith to those pollsters, mass mailings, and television ads that have become staples of political work.[13]

notes

Thanks to all the people in PODCELL/WHAC, especially Ana R. Kissed, Annette Dragon, and Bee Bell, and to many EPL members, particularly Anne Perron, Ray Gagnon, Kevin Gagnon, and Don Plourde, who dedicated his last years to a righteous fight for queer rights and queer dignity in his home town of Lewiston, and was the greatest ally that a girl "from away" could possibly dream of having.

1 *Brownie Scout Handbook*, Girl Scouts of the United States of America, 1993, pp. 17–21.

2 Access to many venues for communicating anything to large numbers of people, such as newpaper space, television time, or mass mailings, depends on having resources including money and connections. Access to venues for communicating pro-homosex messages, among many others, is additionally limited by censors.

3 I was queried during editing about whether "dyke" was apt to use here as a catch-all term. I retain it because I think that no term will please everyone nor alienate no one – not even "lesbian," which some associate with the monied and the mainstream. Thus, I had to either include a string of terms every time I wanted to designate women who identify as lesbians, dykes, gay women, queers, etc., or choose one term to use as shorthand. For convenience, terseness, and flow of text, I chose to do the latter, and, to be honest, picked the term I prefer.

4 In Bad Object-Choices, eds, *How Do I Look*, Seattle, Bay Press, 1991, pp. 36–8.

5 Marla Erlien, "Up Against Hate: Lessons from Oregon's Measure Nine Campaign, an Interview with Suzanne Pharr," *Gay Community News*, April 1993, pp. 3, 11.

6 See Donna Minkowitz, "Trial by Science: In the Fight Over Amendment 2, Biology is Back – and Gay Allies are Claiming it," *Village Voice*, 30 November 1993, pp. 27–9. In discussing the revival of nineteenth-century medical misinformation by lawyers arguing on "our" side for overturning Colorado's anti-queer amendment, Minkowitz similarly urges vigilance about marshalling images of queers that may work in the short-term but have bad long-term effects. She points out, too, that part of this ill-conceived strategy must be attributed to the Colorado Legal Initiatives Project's decision to bypass assistance from groups with extensive litigating experience on queer issues, like the Lambda Legal Defense Fund, out of a desire to look mainstream and to avoid front-lining "outsiders." I discuss EPL's "outsider" problems below.

7 Ioannis Mookas, "Faultlines: Homophobic Innovation in *Gay Rights, Special Rights, Afterimage*", vol. 22, no. 7/8, February/March 1995, pp. 17–18.

8 Barbara Proko, "Anti-discrimination Ordinance Winning Some Official Support," *Lewiston/Auburn Sun-Journal*, 6 October 1993, p. 11.

9 This allegation was presented orally in press conferences and interviews, and through brochures distributed door to door. Although local anti-gay activists often described themselves as underfunded locally based activists struggling against a national monied gay conspiracy, the brochures they distributed evidenced the national monied base of their own support. One brochure of visible high-production quality was produced by the high-budget, Washington-DC based Family Research Council. Another had a low-budget production and local-talent look, although the text had clearly come from outside sources since broadsides distributed in Colorado, and Florida, and Oregon have the same "myths" and "facts" chart slightly adapted in each case so that they appear to be homegrown.

10 In Sarah Schulman's *My American History: Lesbian and Gay Life During the Reagan/Bush Years*, New York, Routledge, 1994, pp. 313–19, Schulman incorrectly implies that the Avengers brought anti-closet, direct-action activism to Lewiston, and designed such projects as the one described below. In fact, the Avengers' productive involvement began with their recognition that such activism already existed in the area and their decision to leave EPL and offer back-up support for projects designed by local activists who were similarly disenfranchised from the mainstream organization. While the history of the Avengers' involvement in Lewiston raises important issues that bear on the matters discussed in this essay, the topic requires a longer treatment than can be provided here.

11 I address this matter in my book *Barbie's Queer Accessories*, Durham, Duke University Press, 1995.

12 This was the referendum's intent although homosexuality is never mentioned in the text of the ballot question: "Do you favor the changes in Maine law limiting protected classifications, in future state and local laws, to race, color, sex, physical or mental disability, religion, age, ancestry, national origin, familial status and marital status, and repealing existing laws which expand those classifications as proposed by citizen petition?" Carolyn Cosby, of the right-wing organization Concerned Maine Families, which had been vocal during previous referenda fights, was the primary initiator of the petition drive. By all accounts, the question was functionally illegible to virtually all voters. This added complexity to political activism on both sides, which was further complicated by the need to explain why, despite habitual associations of a stop sign with "no," it was a "yes" vote that signalled allegiance with the slogan "Stop Special Rights."

13 *Editor's note.* In May 1997, the Maine Legislature passed a "gay-rights" bill, barring discrimination in housing, public accommodation, employment and credit, which was signed into law by a sympathetic Governor. The religious right organized a petition drive and in a statewide referendum in February 1998, voters rescinded the law by a narrow vote of 52 percent to 48 percent.

mary patten

the thrill is gone

an act up post-mortem (confessions of a former aids activist)

After we kick the shit out of this disease, I intend to be alive to kick the shit out of this system, so that this will never happen again.

> Vito Russo, Health and Human Services Rally, Washington, DC, October 1989

There was always a hole when someone died. It was always in the middle of people.

> Rebecca Brown, *Gifts of the Body*[1]

Spread out before me is an eclectic group of images: newspaper clippings, photographs of street demonstrations, leaflets, posters, stickers, and other ephemera, and informal snapshots taken after meetings and marches, at parties, benefits, and bars. All were produced by ACT UP/Chicago, its ad hoc collectives, anonymous offshoots, and individual members, over a period of five years (1987–91), the most vibrant ones of ACT UP/Chicago's history.

In studying these photographs, these self-defined "radical queer" representations, I revisit ACT UP's attempts to counter the mainstream culture's images and discourse about AIDS and queer life, as well as those of established lesbian and gay organizations that claimed to represent the entire movement. I am also painfully aware of the limits of this resistance, and the extent to which ACT UP's imagery and street style have become assimilated and absorbed within a larger context of the commodification of "queerness," a now-exhausted "lesbian chic," and the professionalization of the AIDS movement. In these pages, I will concentrate on the images deployed by ACT UP/Chicago in order to re-read and interpret a history which I experienced from the inside and which I helped shape. And since most documentary materials and critical writings about ACT UP's cultural production to date have centered on Gran Fury and other

highly visible New York-based activist art collectives, I am also interested in expanding the frame of the dialogue beyond the boundaries of Manhattan.

As my eyes drift over these photographs, I realize the near-impossibility of carrying out a distanced discourse about these images. Although most are (or were at one time) very public documents, they also function for me as a kind of family album, a visual diary of my experiences in ACT UP. While once occupying other, more public, and heterogeneous spaces, these pictures are now both the subject of my arguments here and the object of my own biased and fragmented view. And while they trigger memories of real events from a specific activist history, these images have also circulated over time through numerous channels, past my own desiring gaze, and have now attained the status of myth.

I cannot look at these photographs without a huge sense of loss, reliving the grief for friends who have died, and missing others who are no longer in my life. I mourn the disappearance of an imagined community of passionate friends, lovers, cohorts, and comrades[2] which, despite its problems, frustrations, and contradictions, embodied for me a common struggle against the state, corporate America, and a prevailing culture of homo- and sex-phobia, racism, ignorance, and fear. As a "body" taken together, these photographs represent this loss for me, while still functioning as objects of desire for an unrealized utopian vision. I confess that I (and probably others) have invested these pictures with the power to radically transform vision, points of view, individual and collective consciousness, if not the world.[3] Repositories of personal and collective memory, documents and "evidence," these pictures, and the actions they represent, have already produced a range of impacts and effects on queer cultures and subcultures, on political theories and movements for social change. But to what extent did our images intervene in culture, in prevailing regimes of meaning? To what extent did they change the world? Perhaps ultimately the "worlds" most permanently altered were our own; often, our images functioned as much as anything else to create a shared political and cultural community.

I'm staring at the poster above my desk (Fig. 21.1) *recently sent to me by Laura Whitehorn, a friend serving a twenty-year sentence in a federal women's prison in California. The poster was sent to Laura by Elisabeth Goerg, a lesbian activist involved with international political prisoner support work in Germany. The text on the poster "demands freedom for all women and lesbian political prisoners" – including many names from the Puerto Rican independence movement, the Native American/First Nations movement, and the New Afrikan/Black nationalist struggle in the USA – and for "Euro-amerikan, Irish, and women who attacked, killed, or hurt their rapists and abusers." The German and English-translated text, including poems by Laura and by Susan Rosenberg, another US political prisoner, addresses a highly politicized audience of German lesbians for whom the struggle to free political prisoners is not perceived as fringe, strange, or extreme. Unlike in the USA, the names of current and former women political prisoners such as Ulrike Meinhof, Irmgard Moller, and Hanna Krabbe, who were incarcerated for actions against the German state, are well-known.*

There are layers of ironies here. One political vision, now "past" – represented by radical street dykes seizing public space to fight for women with AIDS – is employed in the service of another: freedom for political prisoners and an end to racism. I know too much about "what's happened" outside the frame of this photograph; I'm too conscious of the gulf between the "real" and the imaginary. A group of German lesbians celebrate Susan and Laura as heroes and role models, but these two women are virtually invisible to many AIDS and queer activists in the USA, despite the fact that, along with other political prisoners, they have helped initiate ground-breaking peer-run AIDS education and counseling programs in the Federal women's prisons where they've been incarcerated. The poster bridges several lost utopias. It speaks to two distinct griefs: the invisibility

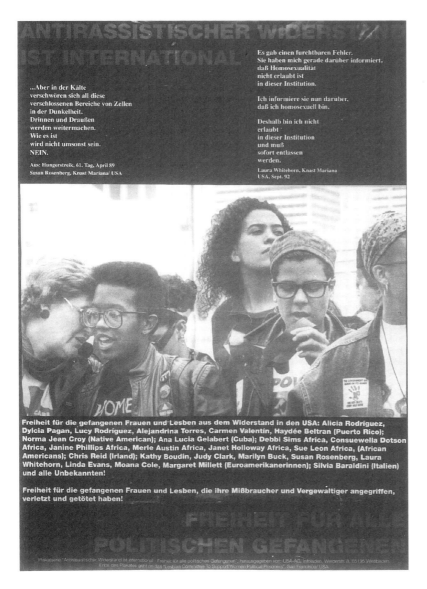

Fig. 21.1 *AntiRassistischer Widerstand 1st International – Freiheit Für Alle Politischen Gefangenen*, poster by USA-AG Support Committee for Mumia Abu-Jamal, Wiesbaden, Germany, 1995. Photograph Jane Cleland, poster courtesy Elisabeth Goerg

of women in prison and the loss of a radical culture I associate with my friends who are incarcerated, as well as the loss of the kind of militant queer culture which I identify with ACT UP.

But what is most striking to me about the poster is the appropriation of this image. It is from a photograph by Jane Cleland which circulated in the US lesbian and gay press for a brief moment in the early 1990s, showing a small group of women crowded together at a demonstration. I know this photograph well. The women in the picture were my friends; the site is the Sixth International AIDS Conference in San Francisco in 1990, where months of work by a national

ACT UP Women's Caucus culminated in a collective civil disobedience action and our subsequent arrests.

There is a funny reversal at work here in the appropriation of a graphic from ACT UP, the queen bee of media appropriation, by German dyke activists who have displaced this image on to the struggle to end racism and free political prisoners. For some, the fact that this image was lifted from a women's AIDS action might engender a more cynical response, given the left's persistent habit of "stealing" images from spontaneous mass struggles, identifying with exciting, popular surges of collective anger and political rage at any given moment, only to project them as reflections of its own, often problematic, agendas. Perhaps because I've been a part of both of these "movements," I have no problem with this kind of appropriation. But when the mainstream media or a slick queer mag steals "my" images in order to market products and parties during the 25th Anniversary of Stonewall, my blood boils. I am not pictured in the photo on the poster, I did not shoot it, yet I claim ownership. I was "there," in an indexical sense, but, more fundamentally, I claim authority because of my investment in this representation.

But rather than debate who properly or authentically "owns" such an image (a questionable enterprise in itself), I'd like to consider why this image appealed to the German lesbians for their poster campaign, long after it had exhausted its ability to excite and incite in its community of origin. A true "multi-culti" portrait, utopian in its diversity, as well as a gritty, street-level precursor of lesbian chic, its desirability lies in its success in projecting our own (preferred) self-image. For the dykes in this photograph, *just like us*, the accoutrements of buttons, stickers, and leather jackets were not just a fashion statement but key elements of a uniform in a self-defined political and culture war over health policy, corporate greed, mis-education, and media lies.

These women are powerful, determined, sexy. As they strategize, chant, whisper in each other's ears, they suggest the continuous and intensive networking that happens at these street actions. Who knows? Perhaps they are listening to a statement from HIV-positive women prisoners/political prisoners.

The photograph has been reproduced in black and white. But my memory of that day fills in the shocking pink of the graffiti-style letters screaming WOMEN UNITE!! on the ACT UP/San Francisco Women's Caucus T-shirts. Four of the women are clearly visible: two are women of color; one is in her forties. Their "Silence = Death" buttons, "Power Breakfast" T-shirts, and bloody palm-print stickers mark them as ACT UP dykes. They are wearing the emblems of late 1980s and early 1990s grassroots rough-and-ready queer chic: black leather jackets, heavy-rimmed glasses, fade hairstyles and bandannas. Because of my familiarity with this image, because I was *there*, this narrative begs to be extended outside the frame. One of the women in the photograph is film-maker Rose Troche, director of *Go Fish*, and an old ACT UP/Chicago cohort. My friend Laura has no idea about this. For her, it's just an image: a fabulous picture of politically right-on dykes who happen to be AIDS activists.

What has become of lesbians in the AIDS movement? What of ACT UP, for that matter? The slow and sometimes barely noticeable death of many ACT UP chapters in the past few years in the USA has been attributed to the usual litany: too many people have died, too many people have burned out, too many people got tired of the arguments and the political divisions. The constant pressures to produce better and more militant actions and campaigns in absurdly inverse proportion to waning media attention, along with the persistence of governmental inaction, corporate greed, and homophobic and racist social attitudes, took a huge toll. And of course, the success of the organized right wing, in tilting the entire political landscape in the USA and in building a base for their gay-bashing, civil-rights-smashing agenda, cannot be minimized.

Many former AIDS activists have opted to work "on the inside," to develop careers as service providers, public health workers, lobbyists, and AIDS bureaucrats. Many women inside ACT UP, some of the most visible and articulate dykes among them, and many people of color (whose contributions and voices far outstripped their actual numbers in the organization) became increasingly embattled with factions of (mostly) white professional gay men whose politics were narrow, class-bound, and steeped in privilege. The "face of AIDS" was changing. The impact of the epidemic on communities of color, women, and poor people was met by ignorance and disregard by some activists who didn't factor in the realities of racism, homelessness, the drug plague, and the needs of women and lesbians at risk for AIDS and HIV in their political world view. When the promise of building a significant coalition with people of color, health-care reform activists, women's groups, and advocates for the poor began to evaporate, many women left the ranks of ACT UP to help form WHAM! (Women's Health Action Mobilization), WAC (Women's Action Coalition), and the Lesbian Avengers. Some took a break from the relentless pace and pressures of full-time AIDS activism, went to graduate school, threw ourselves into art-making, or were swept up into the world of "new queer cinema." By the early 1990s, "AIDS art," queer theory, and even lesbians (for a brief moment) became fashionable.

This messy, impossible coalition – not only of different communities, identities, and ideologies, but also of different subcultural styles, performances, and languages – couldn't last long. Yet despite ACT UP's limitations, there is still much rich material waiting to be excavated, studied, and theorized from ACT UP's successes, failures, and overall contributions to queer politics and to contemporary radical political practice in the USA. ACT UP combined the red fists of radical 1970s feminism and the New Left with the flaming lips of neo-punk, postmodern, pro-sex queer politics. Sisterhood was indeed powerful, but red now stood for lips, bodies, and lust as well as anger and rebellion; fists connoted not only street militancy, but sex acts (Fig. 21.2).[4] A new kind of lesbian visibility emerged in the 1980s, reflecting our complexities and differences while connecting younger dykes with the sexual histories and cultures of older women and gay men. Paradoxically, the AIDS movement was crucial in this process, creating an umbrella for militant, in-your-face lesbian and gay activism and powerful erotic alternatives to the sex-and-death equations of the right wing.

A friend remembers: "Those were the days when we would go into Suzie B's (a since-closed dyke bar), and we knew everybody (and everyone knew us)." The connective tissue between our "private" and our "public" lives – between the ways we did political work and organizing, had sex, played, theorized, and mourned – was strong, elastic, sometimes barely noticeable. These days, both of us grieve the loss of our girl-gang; our recognizable public identities and desires.

At its best, ACT UP combined the often ungratifying, difficult, and unglamorous struggles around the "bread and butter" issues of the AIDS movement with the celebration of a new post-Stonewall street style. We liked "talking dirty" in our slogans and public speech ("All over the USA, butt-fucking, clit-licking every day"). For us, "in your face" meant not just confrontation, but blatant inversions of "private" into "public" – making face, sit on my face, giving head, off with their heads, sexism rears its unprotected head.[5] All those who were marginalized in the "gay community" – drag queens, leatherfolk, sex workers, butches and femmes, and gender-fuckers – celebrated in the street circuses that were our marches and demonstrations.

ACT UP did not always acknowledge our predecessors – in fact, some of us needed constant reminders that direct action, street theater, and media genius were not "invented" by us. ACT UP inherited much from the women's liberation movement, the Civil Rights and Black Power movements, and radical student movements – all of which succeeded, for a brief moment, in

Fig. 21.2 "We are here to affirm our love and our lust for one another . . . " – unknown lesbian, 1987 March on Washington, during civil disobedience at the Supreme Court. Photographer unknown, taken in downtown Chicago, c. 1989. Courtesy the author

subverting business-as-usual, deploying the rhetoric of personal transformation as well as social revolution, visualizing a literal "turning inside out" in their demonstrations, media spectacles, and struggles for power. Like the feminist health movement's grassroots health research and collective do-it-yourself gynecological exams (which made the speculum "user-friendly" years before Annie Sprinkle's performances), South African freedom fighters' transformations of public funerals into political protests against apartheid, the Black Panther Party's public demonstrations of armed self-defense, or Abbie Hoffman and the Yippies' levitation of the Pentagon – ACT UP, too, created a theater of our bodies in the public sphere. We, too, intended to smear the dichotomies between

"private" and "public" life – this time, between sexuality and politics, our "social" demands and our "individual" desires.

Many have written eloquently of how ACT UP, along with the growing, resurgent gay/ lesbian/bisexual/transgender movement, turned the streets of Washington, DC, and countless other cities and towns into spaces for people with AIDS and radical queer activism.[6] However temporary, this figural and literal transformation of normalized heterosexual space demonstrated to us and the broader culture some of the possibilities of what "queer life" might look like. Here, we simultaneously performed our mourning rituals – the NAMES quilt, our die-ins, and ultimately, political funerals – in concert with militant, creative direct actions, raucous, campy chants ("Your gloves don't match your shoes, they'll see it on the news"), and sexy, goofy kiss-ins. Many of us wanted not only the "bread" of treatment and access to care but the "roses" of social transformation, too. ACT UP's unique contribution lay not so much in the explosion of private acts and images into public space, nor even in the sheer inventiveness and media-smarts of so many actions, but in the performance of queer identities and desires, including our profound grief and anger – at once political and remedial, and intensely private and unanswerable – on a public stage.

freedom beds and death beds

In 1986, the US Supreme Court's landmark *Bowers* v. *Hardwick* decision (the infamous "sodomy ruling") left a frightening image permanently engraved into the minds and imaginations of queers all over this country. The police raid of a bedroom shared by two gay men in Georgia, and the branding of their sexual acts as "crimes" was sanctioned by the highest court in the land. In subsequent years, a main prop used by ACT UP chapters everywhere was the image of a bed. Sometimes a virtual bedroom signified a site of state surveillance and repression and the location of heterosexual "normalcy"; when multiplied, beds connoted sites of government regulation or neglect (acute-care beds in hospital wards, the minuscule numbers of beds in shelters for homeless people with AIDS).[7]

In response to initiatives in the Illinois state legislature to pass mandatory HIV testing laws and other right-wing legislation, ACT UP/Chicago created a "freedom bed" street theater, a simultaneous celebration and protest against our status as sexual outlaws. A "rogues' gallery" of "enemies" – including the Pope, a bible-thumping bigot, and a local right-wing politician – surrounded the (literal) bed where a lesbian three-way was in progress. The freedom bed became a regular motif with an ever-changing cast of characters and scripts, and was rolled out during benefits at local bars to the delight of ourselves and "our queer public."

These images alternated with those of ACT UP's die-ins where, on cue, anywhere from ten to one hundred activists would drop to the ground together in sprawled silence, our prone bodies then outlined in chalk by others (Fig. 21.3). In these tableaux, the street became a metaphoric death-bed, and the tracings left behind marked the site as a scene of murder, a visual testament to the bodies that were in fact disappearing.[8] One also recalls earlier protests marking the 1945 US bombings of Hiroshima and Nagasaki, where chalk outlines were used to represent ghostly irradiated images, the sole remains of thousands of dead human beings.

In April 1990, ACT UP/Chicago hosted the National AIDS Actions for Healthcare, which had been organized by ACT UP chapters nationally under the umbrella of ACT-NOW (AIDS Coalition to Network, Organize and Win). Our actions included a twenty-four-hour teach-in and vigil at Cook County Hospital, rallies, and a day-long march which threaded through downtown Chicago, targeting the insurance industry, the American Medical Association, and city and county public health offices through civil disobedience. The culmination of the day-long

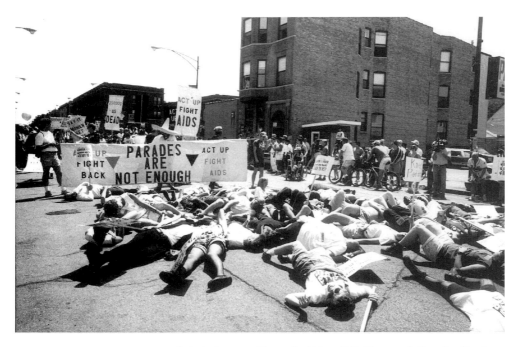

Fig. 21.3 ACT UP and Queer Nation die–in during gay pride parade, 28 June 1992. Photograph Genyphyr Novak

protests was the ad hoc National Women's Caucus Action, where we used beds as a literal direct action tool. We semi-secretly dragged fifteen mattresses, representing the number of empty beds of Cook County Hospital's AIDS ward (which until that point, owing to cynical bureaucratic mismanagement, was barred to women) through the streets and alleys of downtown Chicago. Chanting "AIDS is a disaster, women die faster" and "Women are dying to get in," lovers, friends, comrades and fuck-buddies, butches and femmes, older women and teenagers, sat on the mattresses, using them and our bodies to block busy midday traffic in front of City Hall (Fig. 21.4).

In 1990, only a handful of HIV-positive women in the city of Chicago were willing and able to speak publicly, Betty Jean Pejko and Novella Dudley among them. Although none of the members of the Women's Caucus who were arrested was known to be HIV positive at the time, we put on hospital gowns and seized these mattresses in solidarity with women with AIDS. In assuming these identities and representations, our intention was not to speak *for* women rendered "invisible and voiceless," but to create a visual homology of our identification and solidarity with women with AIDS, not unlike Argentinian protestors who "became" *desaparecidos* by wearing white death-masks at demonstrations in the 1970s and 1980s. Two national caucuses – of people of color and people with immune system disorders (PISD) – joined the action, creating crucial diversions which allowed the women to prolong the blockade. This was a pivotal moment of mutual solidarity in the AIDS movement among women, people of color, and people diagnosed with HIV/AIDS and chronic fatigue syndrome, at a demonstration which powerfully focused our demands in the context of a national healthcare agenda. Our mass blockade and arrests sparked an immediate debate about AIDS, women, and city policies, and, in an unusually swift demonstration of the effectiveness of civil disobedience and direct action, Cook County's AIDS ward was opened to women the very next day.

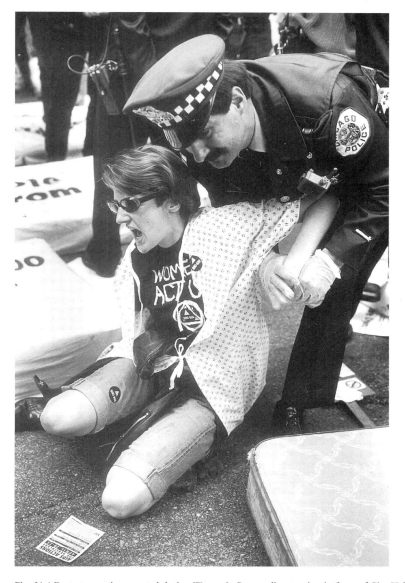

Fig. 21.4 Protester getting arrested during Women's Caucus direct action in front of City Hall, Chicago, April 1990. Photograph Genyphyr Novak

the women's caucus billboards

Many of ACT UP/Chicago's agit-prop campaigns, such as the 1988 "Target CTA (Chicago Transit Authority)" campaign, a project initially conceived by the late Daniel Sotomayor, employed direct address to viewers to make visible what was invisible, denied, obscured, or sensationalized in the culture. These included visual and textual representations of people with HIV/AIDS, and frank, non-judgmental information about risk factors and safer sex education.

393

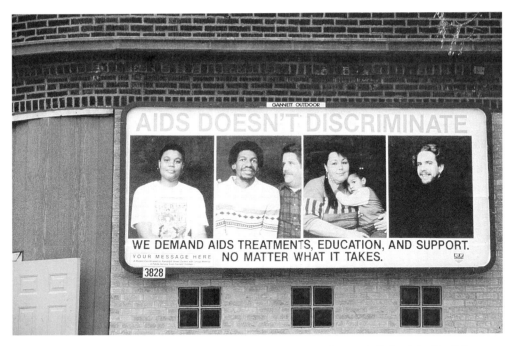

Fig. 21.5 "AIDS DOESN'T DISCRIMINATE," Billboard, Chicago, 1990. Photograph Shelley Schneider Bello

In 1989 and 1990, Randolph Street Gallery, a major alternative art space in Chicago, and Group Material, a New York-based artists' collaborative, organized a public art project titled "Your Message Here." Forty design concepts, solicited from a large pool of artists, educators, and community groups, were selected for billboards at sites in working-class urban neighborhoods where a billboard company had donated advertising space. After a brainstorming and design process involving the entire Women's Caucus, we submitted a batch of proposals, three of which were chosen to be part of the project. "AIDS DOESN'T DISCRIMINATE" (Fig. 21.5) used HIV/AIDS activists, their children, and lovers as "models" to represent a range of "faces of AIDS," with the additional message: "We demand AIDS treatments, education and support . . . No matter what it takes." "talk about it" (Fig. 21.6) featured a series of floating portraits of teenagers from two different working-class neighborhoods in Chicago: West Town, a primarily Puerto Rican community, and Uptown, one of the poorest but also most integrated communities in the city. The figures are surrounded by words like "sex," "AIDS," "drugs," and "racism," while the main text simply encourages open dialogue about these and other issues affecting young people. While "talk about it" gained some currency in that sector of the art world sympathetic to community-based projects, there was little follow-up research and analysis as to the reception of the designs in the neighborhoods where they were displayed.

Occasionally, Women's Caucus propaganda did not even directly address AIDS. The third billboard, "COME OUT, COME OUT, COME OUT," a lesbian visibility project, was an example of this (Fig. 21.7). The process of making this billboard, and its public display for three months on a street-corner of Chicago, was a key marker in lesbian community-building here. The various shoots, first in a bar and later at photographer Shelley Schneider Bello's house, the numbers of dykes involved in the project, the gossip about who posed, who made the final cut and who didn't, became the stuff of urban dyke legend.

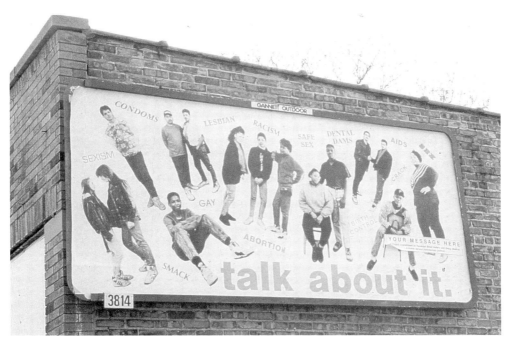

Fig. 21.6 "talk about it," Billboard, Chicago, 1990. Photograph Shelley Schneider Bello

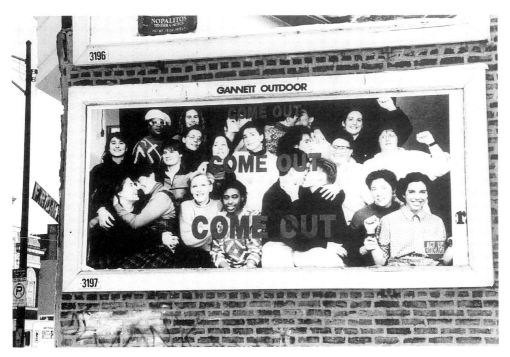

Fig. 21.7 "COME OUT, COME OUT, COME OUT," Billboard, Chicago, 1990. Photograph Shelley Schneider Bello

the "power breakfast" t-shirt, or, "where's the latex??"

I'm looking at several photographs: one (Fig. 21.8) is from a Gay Pride march where women I've never met are wearing a funny, sexy T-shirt I helped design. Another is a snapshot of me and my ex-lover at a women's martial arts camp, wearing the same shirts. I remember an evening seven years ago when, during one of the countless continuing discussions among lesbians in ACT UP about the "men problem," Jeanne Kracher and I began to draw ideas for a T-shirt on a restaurant napkin. We were frustrated and pissed off at men in ACT UP who didn't "get it" – who were clueless about the problem of lesbian invisibility, inside the group and out. We were perhaps even more nauseated by the mainstream lesbian and gay community's impersonation of "corporate speak" in their outreach efforts. (IMPACT, the local gay lobbying organization, had just organized the first of several "power breakfasts" between professional dykes and elected representatives.) We sketched a woman going down on another woman, sandwiched between the words "Power Breakfast" printed in large italicized bold gothic type, à la Barbara Kruger. We then approached the rest of the Women's Caucus with our idea and they agreed to adopt the project. Although the image, a medium shot of two women in a bedroom, was not an "in-your-face" representation of dripping cunts and tongues, it did provoke some negative reactions, notably from a group of Bay Area women who objected to it as pornography and "degrading to women." But mostly, in Chicago and elsewhere, women we knew and met loved the design, though some confessed they would never wear the shirt outside their bedrooms.

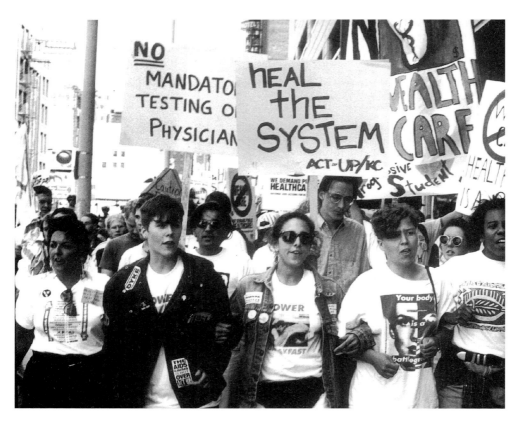

Fig. 21.8 Women wearing "Power Breakfast" T-shirt marching during AMA demo, June 1991. Photograph Genyphyr Novak

When the Caucus brought the proposal to the floor of ACT UP, a floor-fight broke out. Some of our male comrades argued that the design didn't promote safe sex because "there was no dental dam visible" and because it didn't provide any instructional or admonishing text. But because the Women's Caucus had been distributing safer-sex and AIDS educational information for several years at women's events and lesbian bars – the only group to do so at the time – and had produced several pieces of informative propaganda directed to lesbians, we won the debate. A context already existed, we argued, because in the eyes of the larger queer "community" our politics were inseparable from a strong advocacy of safer-sex practices. Because of our history of sensitivity to different communities' needs in understanding and negotiating risk, it would have been hard for anyone to perceive "Power Breakfast" as bearing an anti-safe-sex message.

This story provides an interesting case of how some men in ACT UP attempted to advocate a dogmatically prescriptive approach to safer-sex education and, at the same time, quash a project promoting a joyous, in-your-face piece of agit-prop done by dykes, for dykes, and for anyone else who wanted to come along. The biggest irony is not that the "Power Breakfast" T-shirt became so popular among gay men (its production just preceded the massive gender-fuck mis-wearings of "big fag/big dyke" shirts by proud boys and girls all over the USA), but that it became ACT UP/Chicago's best selling T, year after year, despite the controversy and objections by some men in the group.

The Women's Caucus was unanimous in its support (and shared hilarity) over this T-shirt. Several years before, we could never reach consensus on imagery and photographic representations for a planned poster campaign addressing issues of HIV risk and safer-sex guidelines for lesbians and bisexual women. What had stymied us was not so much the huge debate about what constituted "safe behavior" and how to represent it, but what constituted "appropriate" and "effective" imagery for our propaganda. The debate was roughly drawn between those who argued that we should find a unifying, non-threatening image – for example, two women kissing – that "everyone" in our target audience could relate to, and others who felt that we needed to represent a range of activities, such as fisting and s/m play, to make visible and sexy the differences in sexual practices and histories among lesbians.

All of us agreed that, in fighting against the practice by the government and the media of categorizing *groups* rather than *behaviors* as indicators of risk for HIV transmission, we did not necessarily want to advocate a dogmatic position that all lesbians should *always* practice safe sex. But in order to have any meaningful exchanges about HIV/AIDS risk factors for lesbians, we had to confront the silences that still persisted in many lesbian communities around certain taboos: the occurrence of sex with men, gay or straight; injection drug use; s/m and "rough sex." Some women worried that the entire discussion would threaten the relatively recent openness in lesbian communities about sex and desire – talking about it, having it, celebrating it. Others felt that in representing the diversity of lesbian desire, some images would appear too scary or too "fringe" for many women who, in not "seeing" themselves, would then exempt themselves from the propaganda's address.

Unable to resolve any of these issues at the time, we abandoned the poster. In 1991, we designed a T-shirt in part as a "corrective" to the fact that "Power Breakfast" was not intended as an educational tool, but rather as a pointed and sexy joke about lesbian invisibility. This new design featured two bare-breasted women kissing at a dinner table, and was inscribed with safer-sex information on the back. It was successful in combining educational information, sexy imagery, and humor to deal with representations of lesbians and AIDS. Perhaps because it was a much gentler piece of agit-prop, it was nowhere nearly as successful as its predecessor in creating visibility for the group or as a marketing tool.

the problem of "visibility" and the paradox of act up's success

But perhaps we need to examine more closely and critically our notions of "visibility," a key political buzzword used by lesbian/gay/bisexual/transgendered (LGBT) communities.[9] I would argue that its constant invocation flattens the complexities of our own necessary analyses and critiques. "Visibility" is posed as an inherent undifferentiated good – even necessity – whether we're debating our participation in the political process, examining images/representations of queers or homosexuality in the media and popular culture, or "discovering" and "reclaiming" literary or historic figures from the closets of the past. Only if we are collectively visible, the argument goes – as people with AIDS, as lesbians and gay men, as radical queer activists – will we have power and be regarded as a force to be reckoned with in the larger culture.

Obviously I am not at all interested in romanticizing what we have come to define as "the closet." The existence of visible, vibrant, and diverse queer cultures is crucial – a matter of survival for thousands who struggle against isolation, internalized oppression, self-hatred and despair, as well as socially sanctioned homophobia, anti-gay violence, and hatred. But a re-examination of the mythologies and icons we have created for ourselves is needed in order to recognize that visibility carries a price.

Many have understood for a long time that our "increased queer visibility" has been an indispensable ingredient in our transformation into a market – or series of markets – and that the power of "our" queer subcultures has been enervated and at least partly subverted by this absorption.[10] Leather, drag, piercings and tattoos, the hustler pose, butch–femme and gender transgressions no longer signify as markers of rebellious subcultures with rich complex narratives. Rather, they have become individual identity ornaments promising the fulfillment of our desires, purveyed at the point of purchase. I may hate the commodification of "my images," not only by Calvin Klein, the Gap, *Newsweek* and *Vanity Fair*, but also (and perhaps, even more so) by slick queer rags like *The Advocate*, *OUT*, *Genre*, *Girlfriends*, and *Curve* (Fig. 21.9).

But this is the inevitable, ironic by-product of our very effectiveness and impact on a consumer capitalist culture. This is not unique to ACT UP or to queer culture, of course: one need only look at the iconization of Malcolm X. However, when this product identification and consumption is perceived as identical with politics, we are in trouble – for example, when the mere presence of a red ribbon is seen as a marker of "AIDS awareness," or the buying and wearing of red ribbon jewelry and rainbow flags at gay bookstores is constituted as a political act (Fig. 21.10).

This is not to argue that ACT UP's images have become indistinguishable from those used in CK ads. ACT UP's representations are clearly linked to the struggles from which they spring, providing the sometimes invisible mortar in a community-building process: such bonds are dissociated, simulated, or just plain irrelevant in the advertising arena. And in a violently heteronormative society, where queers of all kinds live, look, and desire in a scarcity economy of "positive queer images," it would be wrong-headed to argue against the pleasures, multiple readings, and values afforded by the "visibility" of lesbian and gay characters on television programs, the significance of "coming out" by celebrities and culture heroes, or gender-bending play in the pages of major magazines.[11] But we need to acknowledge that our heightened visibility – even on our "own" rebellious, seemingly autonomous terms – has hastened the absorption of "queered" representations into the mainstream. Making visible our "otherness" is not just a defiant celebration of ourselves and our difference, but has also led to an inevitable reification: new categories and signs are now available in the marketplace of style, swallowed whole and re-fashioned for the voyeuristic spectacle of the media and the larger body politic. Perhaps this is

REV UP THE REVOLUTION

J une 26. Gay Pride. Stonewall Night. And you're headed for the Roxy, New York's premier gay disco. You'll dance on the largest disco dance floor in Manhattan, rock to a phenomenal $50,000 sound system and state-of-the-art lighting system. Go-go boys galore, drag queens, and a riotous blast of the city's nightclub scene. MC Kathy Najimy of *Sister Act* will introduce the best dance acts in the world, including live performances by gay legend Jimmy Somerville, house rockers C+C Music Factory, dance diva Ultra Nate, the supersonic Shannon, and hot, hot Uncanny Alliance ("I Got My Education"). C+C masterminds Robert Clivillés and David Cole will DJ the walls down. You'll be able to say you were there for **The Revolution…**

Sunday June 26 The Stonewall Revolution, The Roxy. Event #17

STONEWALL NIGHT

DIFFA and BC/EFA salute the lesbian and gay community's response to AIDS

OUT IN NEW YORK '94 **11**

Fig. 21.9 "Rev Up the Revolution," page from special supplement of *OUT* magazine promoting Stonewall anniversary celebration, 1994

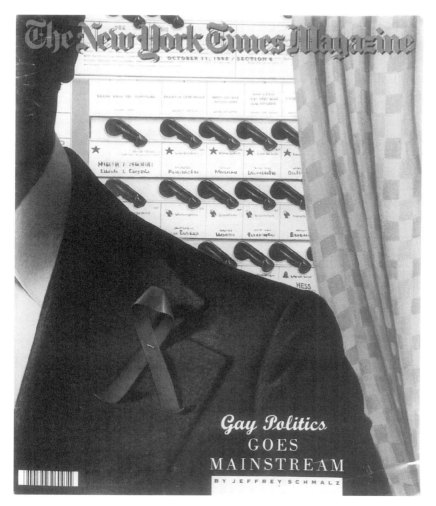

Fig. 21.10 "Gay Politics Goes Mainstream." *New York Times Magazine* cover story, 11 October 1992

why I confess a strong attraction to the marginal, hidden, and private visual cultures of personal snapshots, photo albums, and poster collections.

For years, my friend Debbie had what can only be described as an altar in her bedroom – composed of flyers, buttons, stickers, Polaroids, newsclippings and ephemera related to ACT UP. And whether it's Joan Nestle's narratives of sex in public restrooms in the 1950s, Audre Lorde's accounts of private parties of black women in New York of the same period (Zami), *Leslie Feinberg's* bildungsroman *of a young gender-queer in* Stone Butch Blues, *or my own friends' allusions and unspoken stories about their clandestine lives, I am immensely propelled by these accounts and the "underground" sites they describe, coded for me as outlaw, subversive, and therefore "free." Here, I find the real pleasures of difference: we are not the same as you – we don't want to be absorbed. Despite the pain.*

ACT UP's very success in seizing the public space of spectacle in the media to articulate, and indeed reframe, the debate and crisis about AIDS contained within it some of the very

contradictions that contributed to the demoralization of the movement. Despite our sophisticated manipulation of the broader culture's media through our direct actions, street theater, and counter-information, we neither fully anticipated the "public's" eventual lack of interest in us and in the AIDS crisis, nor the ease with which our theater, our images, and our political subculture would get absorbed as "queer style." If we weren't covered by the media, our actions were seen, at least partially, as failures. If we weren't news, we were inconsequential; worse, for the majority of Americans, we didn't exist. For many in the AIDS movement, the battle against the epidemic was identical with the production of lesbian, gay, and queer identities. The shifting of the epidemic to more and more poor people, communities of color, intravenous drug users, and women necessitated that the fight against AIDS become simultaneously a fight against racism, homelessness, the drug plague, the prison system, and the collapsing social safety net in the USA. None of these potential battlegrounds is particularly media-genic; in fact, all are almost hopelessly, routinely endemic to and deeply entwined with the structures of capitalist society.[12]

our bodies, our lives on the line

I'm looking at a picture of demonstrators (Fig. 21.11). *It's 1990. They are holding placards bearing the text: "Wealth Care" slashed by the universal "stop" sign. The most visible among them is a group of men breaking through a police line. This image is physical, forceful . . . ACT UP has the initiative,*

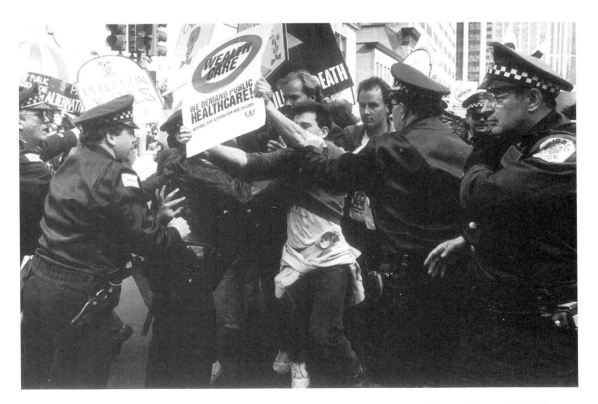

Fig. 21.11 Protesters struggle to break through a police line at the National AIDS Actions for Healthcare, Chicago, April 1990. Photograph Linda Miller

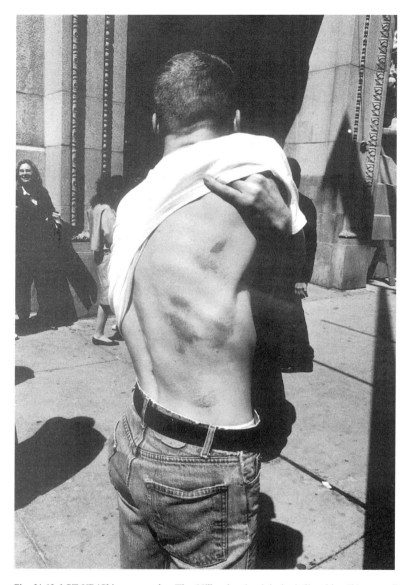

Fig. 21.12 ACT UP/Chicago member Tim Miller showing injuries inflicted by Chicago police at AMA demonstration, Chicago, June 1991. Photograph Linda Miller

aggressively fighting for our political space in the street. Besides anger, there is energy and optimism in these young bodies.

I have in front of me another image: of a police officer with gloved hands smashing my friend Tim's head down on a barricade, while another grabs his exposed neck. The site was ACT UP's demonstration against the AMA (American Medical Association) in 1991. This was a turning point for ACT UP/Chicago, for it was here, during a marked escalation of police brutality, that demonstrators were beaten, hospitalized, and traumatized (Fig. 21.12). More injuries were sustained here than ever before in our brief experience. Perhaps, more significantly, we suffered

collective psychic damage; many people were effectively freaked out. This was the point, after all: we were up against the limits of our own power and effectiveness.

The AMA demonstration was, like all such experiences, a potentially educational one. There were many in the AIDS movement who had been buffered all their lives from the overt aggression of the state by protective layers of class, skin color, or maleness, for whom the brutality encountered was new and unprecedented. For some, these primary experiences were links to a new kind of consciousness about the systematic police brutality endured and fought by African Americans, Mexicans, other people of color, and poor people for centuries.

And while some people moved from this experience with greater awareness, seriousness, and sense of solidarity, others were hurt, frightened, and afraid. Despite our press conferences, counter-information, and lawsuits,[13] the calculated brutality by the police – much of it soft-tissue injuries which, though less visible than head-crackings and blood wounds, took longer to heal – the violence we encountered had a chilling effect on our ranks. At the same time, police infiltration, "dirty tricks," and spying on AIDS activist groups increased across the country, along with anti-gay violence.

Less than ten years into the epidemic, the literal disappearance of so many – all those who had joined the horribly escalating numbers of the dead – began to collapse into the erasure of our images in the media. We dropped out of sight. This produced another hole in our midst, another empty space: we were literally being chalked out. At this point, the "politics of desperation" began to assert itself, in the literal name of a series of actions in New York City in January 1991 ("The Days of Desperation"), and most profoundly in a series of proposed political funerals where activists planned to dump the actual remains of fallen comrades on the steps of our enemies.

I don't want to reinvoke here the kind of hyperbolic rhetoric and imagery sometimes associated with ACT UP: for example, when accusations of "genocide" risked levelling all other plagues and holocausts, past and present. But we did see ourselves as partisans in a war over AIDS: a war of bodies, policies, and representations. Contingents of PWAs (People with AIDS) wore bloody head-bandages as uniforms in our demonstrations. All of us had sustained losses; many of us were living casualties. In the early 1990s, activists began to talk anonymously or clandestinely about armed self-defense against queer-bashings, and ideas of kamikaze suicide missions floated about. A hard, cynical edge that had always been a part of ACT UP's politics became more evident: for example, when the NAMES Project's AIDS quilt was vaunted as an alternative to militant activism, an angry PWA retorted, "I wish someone would just burn that stupid blanket."

During this period, a number of ad-hoc agit-prop offshoots emerged in Chicago, as in ACT UP chapters elsewhere. Anonymous and independent of the larger group, these collectives produced swift, biting graphic statements with a minimum of intervention. Even in an organization known for its provocative politics and style, some sentiments were seen as too inflammatory and too rude to pass group consensus. This graphic activism, much of it extreme, reflected a new level of frustration and anger by many PWAs and activists in general.[14]

Some of these projects sought to attack the transformation of every resistant gesture into a consumable object or image, and to bitterly mock the "progress" signalled by the representation of our identities and struggles in mass culture (Fig. 21.13). Here, our cynicism and despair – born of reckoning with our losses, and the bitterness that our dreams were unrealizable – and a deep anger at those within our own ranks who wanted no part of that vision, but only to belong to the "American family," began to define our work and our worldview.

mary patten

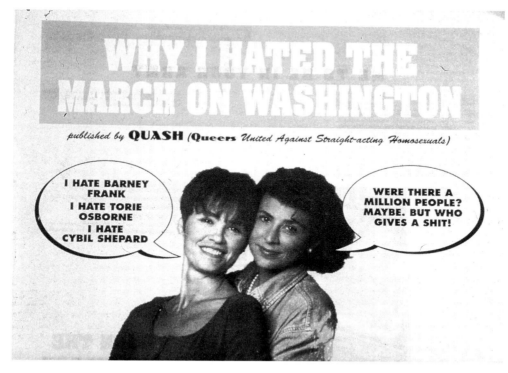

Fig. 21.13 Detail from anonymous broadside by QUASH (Queers United Against Straight-acting Homosexuals), Chicago, 1993

In what seems more like a pause than a closing, I feel obliged to recite two parallel and conflicting litanies:

- Today, the images of ACT UP that have circulated within the culture have attained almost iconic status, especially in parts of the art world and academia.
- There are no pictures of ACT UP or militant direct actions in either the mainstream or gay media any more. The public is sick to death of AIDS.
- At the 1996 International AIDS Conference in Vancouver, according to queer columnist Rex Wockner, the co-optation of ACT UP became complete when the pre-orchestrated protests became a normalized part of the agenda.
- The display of the NAMES Project quilt in October 1996, in Washington, DC, was flanked by booths from major pharmaceutical companies promoting the latest AIDS drugs.
- With the exception of a relatively small number of close friends, most of my reunions with old ACT UP cohorts occur at the inevitable funerals and memorial services, or sometimes at academic conferences and gallery openings.

Meanwhile, Laura Whitehorn, Susan Rosenberg, Kathy Boudin, Judith Clark, Linda Evans, Marilyn Buck, Silvia Baraldini, and many other women continue to work in peer-run HIV/AIDS programs, facilitating support networks, bereavement groups, and AIDS walkathons inside prisons. There are no pictures of these activities.

404

Against the odds, ACT UP chapters still exist and work hard in New York, Philadelphia, the Bay Area, and internationally. For years after ACT UP/Chicago had become a shell of its former self, the Prison Issues Committee continued their research and coalition with prisoners with AIDS, former prisoners, and prisoners' rights groups to educate and fight for the demands of HIV positive people in prison. The Coalition for Positive Sexuality and other groups like ACT UP/New York's YELL (Youth Education Life Line) – whether part of ACT UP's structure or not – are engaged in serious grassroots organizing and safer-sex and risk-reduction education among high schoolers, gang kids, and street youth. Women activists have worked tirelessly to persuade officials from the Department of Health and Human Services, the National Institutes of Health and the Centers for Disease Control that lesbians and bisexual women deserve and need specific, targeted prevention programs and HIV/AIDS services.

More and more differences among and between queers have been addressed, and many groups have sprung up to address the relationship of "queerness" to national, ethnic, and gender identities. Many activists have found other channels, such as community-based media projects, for their activism. Some have stepped back to write. None of this can be ignored or erased. There are no images, no billboards, no stickers or buttons, and relatively scarce column inches devoted to these stories and shifts. I need to remind myself that despite these "disappearances," our work continues in different forms. I do not want us to make the same mistake again: once the "center" of a vibrant, militant community has collapsed, to become incapable of seeing or understanding the struggles and changes that, although invisible or marginalized, keep pushing under the surface and through the cracks of the political landscape.

notes

Special thanks to everyone who gave me helpful comments and criticisms during the development of this essay: Kate Black, Jeff Edwards, Darrell Moore, Erica Rand, Laura Whitehorn, and especially Debbie Gould for her numerous readings and critiques. Thanks to Deborah Bright for her patience and support, and to Christine Holmlund for the initial suggestion. I am grateful to the photographers Genyphyr Novak, Shelley Schneider Bello, Linda Miller, and Jane Cleland, who generously allowed their images to be reproduced in this essay. I am also indebted to the body of critical work by AIDS activists and queer theorists, and the passionate and compassionate art and literature that has risen from our communities like a phoenix out of this crisis. Above all, I am grateful to all my fellow-activists, the living and the dead, who shared in the culture of ACT UP, and who always made a difference.

1 Rebecca Brown, *Gifts of the Body*, New York: Harper-Collins, 1994.

2 Benedict Anderson is the contemporary historian who theorized the concept of "imagined communities" in his book of the same name, *Imagined Communities*, London, Verso, 1983.

3 For an indispensable document and analysis of ACT UP/New York's propaganda, and a crucial book examining the role of pictures in politics, see Douglas Crimp and Adam Rolston's *AIDS Demo/Graphics*, Seattle, Bay Press, 1990. "One day in the future, when a far more complete history will be written, we hope ACT UP will have been just an episode – the episode compelled by the AIDS crisis – in the formation of a new mass movement for radical democratic change" (p. 22).

4 The shifting of signs from red fists to red lips was a metaphor for the transformation of lesbian identities popularized by Susie Bright, writer and former editor of the dyke porn magazine *On Our Backs*.

5 This is the banner text in a particularly (in)famous Gran Fury poster.

6 Douglas Crimp and Adam Rolston, *AIDS Demo/Graphics*. See also Crimp's "Mourning and Militancy" in *October*, no. 51, MIT Press, Winter 1989.

7 More recently, a contingent of AIDS activists in the 1995 New York City Gay Pride Parade used a bed in a raunchy, sexy street theater in response to a "safe sex police" alliance between some gay and AIDS activists and the New York City Department of Health, which advocated a crackdown against bath-houses.

8 See Josh Gamson's "Silence, Death, and the Invisible Enemy: AIDS Activism and Social Movement 'Newness,'" *Social Problems*, vol. 36, no. 4, October 1989.

9 Related to this discussion are numerous theoretical critiques of vision and visuality as over-privileged sites of knowledge and meaning production. See, for example, Joan W. Scott's "Experience," in Judith Butler and Joan W. Scott, eds, *Feminists Theorize the Political*, London, Routledge, 1992, pp. 22–40.

10 Two particularly good considerations of the commodification of queer culture can be found in Danae Clark's "Commodity Lesbianism," in Henry Abelove, Michèle Aina Barale, and David Halperin, eds, *The Lesbian and Gay Studies Reader*, New York and London, Routledge, 1993, and in Rosemary Hennessy's "Queer Visibility in Commodity Culture," *Cultural Critique*, no. 29, Winter 1994–95.

11 For a helpful discussion of these issues, see Jan Zita Grover's "Framing the Questions: Positive Imaging and Scarcity in Lesbian Photographs," pp. 184–90, in Tessa Boffin and Jean Fraser, eds, *Stolen Glances*, London, Pandora Press, 1991.

12 Douglas Crimp describes the shift in the US government's management of the AIDS crisis since the Bush administration as "the normalization of AIDS," even as the devastating impact on affected communities continues: "AIDS is no longer an emergency. It's just a permanent disaster." See "Right On, Girlfriend!" in Michael Warner, ed., *Fear of a Queer Planet*, Minneapolis, University of Minnesota Press, 1993, pp. 304–5. In 1996, a cruelly ironic turn of events is evidenced by the gap between the optimistic rhetoric heralding the new protease-inhibitor drugs, with the promise of "ending the AIDS epidemic as we know it," and the exorbitant cost of these drugs, placing them beyond the reach of the vast majority of people with HIV/AIDS.

13 In 1995, injured demonstrators finally reached a settlement in a lawsuit against the Chicago police.

14 Various semi-clandestine graphics groups which were offshoots of ACT UP/Chicago included CHILL, RAGU (Romanian Art Guerrilla Unit), and QUASH (Queers United Against Straight-Acting Homosexuals). Artists like Robert Blanchon, working independently of ACT UP, also produced anonymous activist ephemera during this period. Examples of this kind of work abounded in other ACT UP chapters, too – for example, the broadsides "I Hate Straights" (which appeared in 1990 and became the de facto manifesto for Queer Nation), and "I Hate Gay Men" and "Burn the Red Ribbon," both by Anonymous Queers.

catherine lord

the family jewels

It was a solid Midwestern family, German with a whiff of French, Protestant, the sort of family that had lived in the same ungainly house for a hundred and fifty years, ringing it as necessary with other houses so that the sons, too, and their wives, could look out over the same wide river at the end of every placid day. It was a family engineered to outlast areas of potential structural collapse – the philandering grandfather, for example, dad the drunk, a few mestizos, the Catholics, the aunt who liked to fuck, even a Jew – by deftly redrawing the floorplan so as to erase the space occupied by these skeletons with tricks of perspective, subtly calculated distortions in the rendering of joists and walls, by allowing woodwork and wallpaper and, when all else failed, yet another piece of heavy furniture to envelop, to smother, to flesh over any nasty piece of grit with something that cost money and would last. It was a family that made a virtue of necessity, enduring by making pearls in precisely those spots rubbed raw by some small hard mote of pain.

It was a family obstinately true to the tradition it had inflicted on itself. The story told to each generation was that the founder, my great-great-great-great-great and then some grandfather, had survived a massacre in the old country because his nurse hid him in a barrel until it was all over. That's how history works: some small boy lifts the lid on pools of blood, and then revenges himself on children who don't believe he existed and don't deserve to inherit his rage. In my day, it was a family that stayed together mainly because the house had enough room to accommodate anyone who needed a door to shut in someone else's face. Dad got the basement, Mother got the kitchen, Grandma got the best bedroom, my little brother got the attic, my sister got the abandoned servants' rooms, and I, child of the tropics landlocked in the interior of a great continent, captured the back bathroom with the tub. I drowned as much of my adolescence as I could in that tub, reading books and smoking the Kents I pinched from my grandmother's closet. For years, that tub was the nearest I would ever get to the blue blue sea of the islands I had left behind. The other rooms, the more public rooms – the living room, the drawing room, the dining room, the sewing room, the den – these were social deserts. More accurately, in a family held together only by the process of its secretions, they were quicksand. People might speak to

each other in such rooms. Someone might want something. Someone might walk in the back door, always unlocked, and say what they saw, or ask the obvious.

In such a family, it made sense to display the photographs in the room with the most doors, the room with a 360-degree view of whatever might threaten on the horizon, the room guests always walked through to somewhere else, the room where no one had to talk because the TV was there and could always be turned on in an interpersonal emergency. There they sat, the family, my family, in their silver frames, arranged in a fixed but indecipherable order on a polished mahogany table: Bob in his captain's uniform, Suzanne with her baby, my cousin Robin with a big fish, the three of us when we were little, Mimi and her poodle, and then the marriages, Bob and Betty, Frederic and Nina, Aldo and Dolores, Hans and Alice, but not Marie and Robert senior, for they'd been divorced, or Mimi and any of her husbands, for that in a nutshell was the problem, or Marge and Tex or any of her children, for she had made a bad marriage, or, when the matter came up years later, my sister and her husband, because his skin was too dark for that table. Dead center in the middle of them all was young Alice in the immaculately pressed uniform of the Women's Army Corps, short hair, her cap at an ever so slightly rakish angle, strong jaw tilted up, eyes looking off at the photographer's raised hand, and a smile as wide and open and slow as the sun beating down on the river. She was more handsome by far than my father in his uniform, confident, fuller in the face, bigger in the shoulders – not that anyone ever ventured near the dangerous ground of physiognomy. Alice was the biggest secret of them all, buried by placing her out in the open for all to see, so demonstrating that there was nothing to hide about this young woman, radiant in her solitude amongst brides and grooms and babies, the only man in the family.

Alice and my own private sea got me through until I could leave home. Her picture was there, under the lamp on the table next to the television, a silent witness to possibilities I hadn't yet imagined, an ally when I needed relief from any of the families that inhabited that room – not just my own but the broadcast invasion of perfect white Americans with straight white teeth who had enough money and loved each other, the Junes and the Wards and the Dicks and the Marys in their immaculate modern houses with their immaculate modern furniture, ever solicitous of the children, always boys, ever attentive to each other as they lay talking in their pajamas in their twin beds with the one reading lamp in the middle, even though there was never a book in sight. Of all the family on the table next to the television, the light fell most strongly on Alice's face, the one face I wanted to see coming through the door at the end of a long day of work, sober, steady on her feet, ready with a kiss for her pretty wife and a smile for the tumble of kids' problems. I knew she would at least sit on the edge of that twin bed to exchange sweet nothings.

The photographs in the room with the most doors were by no means the only photographs in the house. There were caches everywhere. Crammed into a small cabinet in the drawing room were the pictures deemed unworthy of display, grandparents and great grandparents, the various unsuccessful suitors whose names had been forgotten, the babies dead of summer fever, the albums of cabinet cards and tintypes, and the pictures of those who either didn't photograph well or photographed all too well. In that cabinet were buried the remnants of my grandmother's marriage – the albums of Robert and Marie, their courtship, their wedding, their trips, as well as a few large photographs that still bore the impression of frames now being put to a better use.

In the upstairs bedroom, under the glass covering the top of my father's bureau, were the snapshots of the man he wished he'd never lost - barechested in the Texas oil fields, gaunt outside a barracks in North Africa, bronzed in a sailboat off Barbados. There, too, was the picture of Gus and Robbie and my parents picnicking in their bathing suits in the shade of a coconut palm. My

mother's wavy, abundant auburn hair is disheveled. Caught by the camera just in the act of licking her lips, her tongue, searching for a speck invisible to the camera, is the center of the photograph – formally, erotically, in perpetuity. My father could not be parted from this snapshot. He kept it in the center of the bureau. He carried a small copy of it in his wallet all his life. On the bureau as well, scattered among the snapshots of groups of strangers, were three or four of his old girlfriends, the marriages he'd refused, or so he said.

He kept no photographs of his children. These were in my mother's domain, safe under the glass top of her bureau. She preserved every school photograph ever taken of the three of us, nubby black and white prints of children with bad haircuts turning into larger color pictures of teenagers forcing a smile. She kept there also, right next to a small photograph of her wedding, a picture of her father in a short-sleeved white shirt, open at the neck, poring over his daily newspaper with a magnifying glass. My grandfather devoted every long morning of his retirement to this ritual, reading the newspaper from front to back, fighting failing vision to police acts of treason against the empire collapsing around him. In a leather frame, on that same bureau, my mother kept the snapshot of herself as a girl, a plump little child with curly hair, holding an umbrella above her head and pouting. It is the only evidence I have that she was ever ordinary, ever anything but a slim, beautiful, laughing woman who made heads turn when she entered a room.

On the floor below, in my grandmother's room, were the photographs that sustained her. On her dressing table, where she sat to fuss over her thinning hair, were the photographs of her children, toddlers, then teenagers, and then the young man and woman who left home for college. On her bureau, the one I now use, she arranged the other photographs she had brought home after her divorce, the ones she would be sure to see every morning as she looked out over the river. These were all women, the dozen or so friends of her finishing school years and her young married life. In the fashion of the 1920s, these Olives and Louises and Dorothys and Margarets had exacted mercy in the crispness with which they were recorded, hands clasped demurely in their laps, sitting like spaniels in their unwavering solemn gaze at the camera. "What's it like to be old?" I once asked her. "All your friends die," she replied. Though she would often exclaim in sadness when she opened the morning mail, she never put away those photographs.

Alice would visit once a year, almost always with the woman from Boston she'd met in the army and with whom she'd bought a house back east after the war, in the late 1940s, an old farmhouse they would fix up and make their own and cherish for the rest of their lives. Mary, short and plump, all graying fluff, pastel drip-dry outfits, smiles and garrulous chat, would sweep into the house, greeting and pinching and squeezing and hugging, leaving my long-faced family bobbing and nodding in her wake, like children's toys momentarily set in motion by a gust of wind they could best weather by riding it out until it was all over and they could pretend it had never happened, containing Mary's determined, futile generosity by reverting to a silence so profound that it never failed to deaden the ring of her Irish brogue. Alice would bring up the rear, flashing an occasional shy smile, watching the flurry of Mary's entrance with a look of affectionate wonder that never diminished, no matter how often she observed the performance. Broad-shouldered, her straight, thin, brown hair cut as short as was decent, dressed in slacks and a plaid shirt, no jewelry save a large watch, Alice was absolutely untroubled by the fact that she displaced far more of the atmosphere she moved through than any woman was supposed to. Everything about her was big: her laugh, her voice, the muscles of her arms, the line of her jaw, her smile. "Alice is as strong as a man," my mother would say, admiringly. To my fastidious teenage mind, Alice was an awkwardness, my shame, as irresistible as she was embarrassing. Try as

I might, I could never quite effect a reconciliation between the figure I'd imagined striding across an airfield or effortlessly swinging herself up into the cockpit of a bomber and this strapping middle-aged woman whose body, larger than life, seemed to carry within it the memory of a small boy whose cowlicks, recently wetted down and combed flat, would spring back up the instant she was left to her own devices.

Alice and Mary always got the bedroom with the double bed. No one ever gave this fact significance by saying a word about it, thus rendering their sleeping arrangements literally unmemorable. It would take me years, in fact, to remark on the achievement represented by this room assignment, and years more to register what I'd so often heard in passing, that it was Alice herself, after the war, who had bought the double bed as a gift to the house.

Alice and Mary were always together. Though they would part temporarily to enter the universe of gender – Mary to talk to the women, Alice to watch golf with the men, or Mary to help in the kitchen, and Alice to fix the lawnmower with my father – they were nonetheless a cell indivisible by even the closest of gazes, a prime number in the calculations of my family. They existed in a charmed circle, melded together without space between the words of their names, so that the set of syllables aliceandmary, heard together without pause or hesitation, became a word fundamental to the language of my family. It was as difficult to imagine breaking up aliceandmary to examine its separate components as it was to imagine cutting apart the photograph of any of the heterosexual couples whose smiles of proprietary pride in each other adorned that mahogany table. It was more than difficult: it was utterly impossible. A bob-and-betty, or a frederic-and-nina, after all, could easily be forced apart by a surge of the exact desire said to hold them magically together. Aliceandmary, however, who could be coupled only in hearing, only as an inevitable phrase on the tongues of people who would never permit them to be seen together on that table, were all the more indivisible for my family's failure of imagination. Denied the possession of desire, they had no reason ever to separate.

Later, when I was in college, I would visit Alice and Mary every now and again in their farmhouse. Mary would fuss, asking about school, and boyfriends, and family, telling me how proud of me she was. Alice and I would walk the land, looking at the pond, the barn, the old stone walls. When we came indoors, she would mix old-fashioneds while Mary cooked. They knew every wide plank and stone of the house. Alice was especially proud of the chimney, the backbone of the house, which went up from the foundation through the second floor, a stone mass that virtually filled the crude basement and gradually decreased in size as it rose, with fireplaces and ovens and warmers opening in a spiral around its circumference. Everything in the house had shifted to contain the bulk that made the house itself inhabitable. On the ground floor the rooms were crowded, slightly out of true, angled on their internal walls. The stairs varied width and height to accommodate the idiosyncrasies of the stones as they wound up around the chimney. Only on the second floor did the chimney diminish to a size that allowed proportion to be restored.

Alice and Mary kept separate bedrooms. Alice's was almost monastic, of course, a single bed neatly covered with a dark blanket, her bureau, bird prints, a few photographs of her parents, and little else. Mary's room was another story. A crucifix hung over the large four-poster, which had a bedside table and reading lamps on either side. There were piles of books, and, everywhere, pictures of relatives and their children, interspersed with snapshots of Alice and Mary on their various trips, smiling comrades, the one with a friendly arm across the shoulder of the other, taken by strangers, or one of them caught in a moment of familiar wonder or ease, taken by the other. When I came to stay they went to their separate bedrooms, as if they did so every night, and put me on a cot in Alice's study. Alice would come in to say goodnight, and to talk quietly for a

moment or two, asking how my mother was, really, now that my father was dead. "You have such soft hair," she told me once. "Don't ever change it."

With each woman I took as a lover, the language I used to describe Alice shifted, from "my aunt who lives with her friend," to "my aunt who might be a lesbian," to "my aunt the lesbian," to "my dyke aunt," to "my aunt the butch." The less we saw of each other, as I moved farther and farther away, the more closely I learned to picture Alice through the bodies and desires and memories of the women I wanted. I had no photograph of her to hold me in check. My lovers gave Alice shape, and gave that shape solidity, gradually forcing the architecture of my family to yield, allowing me to glimpse the woman I needed to see through the movement of the very surfaces used to camouflage her.

Mary died two months after she'd retired, before she and Alice could begin the big trip they'd been planning all their lives. I struggled to invent words of compassion for someone who had given her life to a love no one would speak, a love so remote and quiet that I wondered if it had also become lost to Alice herself. I settled, finally, on a code I hoped Alice could read. "I am so sorry to hear about Mary. I think I understand what a loss it must be after all the years you were together. I'm coming to realize how much it meant to me to have the two of you nearby. I wish we saw more of each other."

Alice, true to my family, never replied. Instead, she sent me a Christmas card a few years later. I sent one back. This is now our habit. She tells me about the farmhouse, the pond, and the trips she takes with her sister. I complain about work, in a vague sort of way, and tell her about my trips, defaulting to the lesbian "we" to convey my pleasure. "We loved _____ ," I say. "We'd wanted to go for so long. We hiked and hiked. The birds were everywhere, and the forest was full of orchids."

I have no photograph of Alice. The photograph I memorized has long since disappeared. I have no idea how to photograph the woman I know to be true, tall, her thin gray hair cut very short, her face lined and brown, an old woman in baggy pants and a plaid wool shirt, a red and black shirt, a small boy with a cowlick going on eighty.

select bibliography

Allison, Dorothy, *Skin: Talking About Sex, Class and Literature*. Ithaca, Firebrand Books, 1994.

Apter, Emily and William Pietz, eds, *Fetishism as Cultural Discourse*. Ithaca, Cornell University Press, 1993.

Armstrong, Carol, "The Reflexive and Possessive View: Thoughts on Kertesz, Brandt, and the Photographic Nude," *Representations*, no. 25, Winter 1989, pp. 57–69.

Armstrong, David, *The Silver Cord*. New York, Zurich and Berlin, Scalo, 1997.

Armstrong, David and Nan Goldin, *A Double Life*. New York, Zurich and Berlin, Scalo, 1994.

Art Journal, "Censorship I," Barbara Hoffman and Robert Storrs, eds, vol. 50, no. 3, Fall 1991.

Art Journal, "Censorship II," Barbara Hoffman and Robert Storrs, eds, vol. 50, no. 4, Winter 1991.

Bad Object–Choices, eds, *How Do I Look? Queer Film and Video*. Seattle, Bay Press, 1991.

Baker, Houston, *Modernism and the Harlem Renaissance*. University of Chicago Press, 1993.

Bailey, David A., "Photographic Animateur: The Photographs of Rotimi Fani-Kayode in Relation to Black Photographic Practice," *Third Text*, no. 13, Winter 1990–91, pp. 57–62.

Barrie, Dennis, "The Scene of the Crime," *Art Journal*, vol. 50, no. 3, Fall 1991.

Barthes, Roland, *Camera Lucida*. New York, Hill and Wang, 1981.

Barthes, Roland, *The Fashion System*, Berkeley, University of California Press, 1983.

Bartlett, Neil, *Who Was That Man? A Present for Mr Oscar Wilde*. London, Serpent's Tail, 1985.

Beam, Joseph, *In The Life: A Black Gay Anthology*. Boston, Alyson Press, 1986.

Beaton, Cecil, *Cecil Beaton's New York*. Philadelphia and New York, Lippincott, 1938.

Benjamin, Walter, "One Way Street," in Peter Demetz, ed., *Reflections: Essays, Aphorisms, Autobiographical Writings*. New York, Schocken Books, 1986.

Benstock, Shari, *Women of the Left Bank: Paris, 1900–1940*. Austin, University of Texas, 1986.

Berger, John, *Ways of Seeing*. Harmondsworth, Penguin, 1972.

Berger, Maurice, *Ciphers of Identity* (exhibition catalogue). New York, DAP in association with Fine Arts Gallery, University of Maryland, Baltimore, 1993.

Bergman, David, *Gaiety Transfigured: Gay Self-Representation in American Literature*. Madison, University of Wisconsin Press, 1991.

Berlant, Lauren and Elizabeth Freeman, "Queer Nationality," in Michael Warner, ed., *Fear of a Queer Planet*. Minneapolis, The University of Minnesota Press, 1993.

Berlant, Lauren and Michael Warner, "What Does Queer Theory Teach Us about *X*?" *PMLA*, May 1995.

Berry, Chris, *A Bit on the Side*, Sydney, emPress, 1994.

Bersani, Leo, "Is the Rectum a Grave?" in Douglas Crimp, ed., *AIDS: Cultural Analysis, Cultural Activism*. Cambridge, Mass., MIT Press, 1988.

Bhabha, Homi, *The Location of Culture*. London and New York, Routledge, 1994.

Biren, Joan E. (JEB), *Eye to Eye: Portraits of Lesbians*. Washington, DC, Glad Hag Press, 1979.

Blinderman, Barry, ed., *David Wojnarowicz: Tongues of Flame*. Normal, University Galleries of Illinois State University, 1990.

"Bodies of Excess," *Ten.8*, vol. 2, no. 1, Spring 1991.

"Body In Question," *Aperture*, no. 121, Fall 1990.

Boffin, Tessa and Jean Fraser, eds, *Stolen Glances: Lesbians Take Photographs*. London, Pandora, 1991.

Boffin, Tessa and Sunil Gupta, eds, *Ecstatic Antibodies: Resisting AIDS Mythology*. London, Rivers Oram Press, 1990.

Bogdan, Robert, *Freak Show: Presenting Human Oddities for Amusement and Profit*. Chicago, University of Chicago Press, 1988.

Bolton, Richard, ed., *The Contest of Meaning: Critical Histories of Photography*. Cambridge, Mass., The MIT Press, 1987.

Bolton, Richard, ed., *Culture Wars: Documents from the Recent Controversies in the Arts*. New York, The New Press, 1992.

Bornoff, Nicolas, *Pink Samurai: The Pursuit and Politics of Sex in Japan*. London, Grafton Books, 1991.

Brassaï, *The Secret Paris of the 30's*, trans. Richard Miller London, Thames and Hudson, 1976.

Bright, Deborah, ed., "Sex Wars: Photography on the Frontlines," *exposure*, vol. 29, nos 2/3, 1994.

Bright, Deborah, "Exposing Family Values: Sexual Dissent and Family Photography," in Chris Scoates, ed., *Family Matters: Lesbian and Gay Photographs of Family Life* (exhibition catalogue). The Atlanta College of Art Gallery, 1995.

Bright, Deborah, "Mirrors and Window Shoppers: Lesbians, Photography and the Politics of Visibility," in Carol Squiers, ed., *The Critical Image: Essays on Contemporary Photography* (revised edition) Seattle, Bay Press, 1998.

Bright, Susie and Jill Posener, eds, *Nothing But The Girl: The Blatant Lesbian Image*. New York, Freedom Editions, London, Wellington House, 1996.

Bronski, Michael, *Culture Clash: The Making of Gay Sensibility*. Boston, South End Press, 1984.

Brown, Beverly, "A Feminist Interest in Pornography – Some Modest Proposals," *m/f*, vol. 5/6, no. 5, 1981, pp. 5–18.

Bryson, Norman, "Morimura: Three Readings," *Art + Text*, no. 52, 1995, p. 74.

Budd, Michael Anton, *The Sculpture Machine: Physical Culture and Body Politics in the Age of Empire*. London and New York, Macmillan and New York University Press, 1996.

Burana, Lily, Roxxie and Linnea Due, eds, *Dagger: On Butch Women*. Pittsburgh and San Francisco, Cleis Press, 1994.

Burgin, Victor, ed., *Thinking Photography*. London, Macmillan, 1982.

Burstyn, Varda, *Women Against Censorship*. Toronto, Douglas & McIntyre Ltd, 1985.

Butler, Judith, "The Force of Fantasy: Feminism, Mapplethorpe, and Discursive Excess," *differences: A Journal of Feminist Cultural Studies*, vol. 2, no. 2, 1990, pp. 105–25.

Butler, Judith, *Gender Trouble: Feminism and the Subversion of Identity*. New York and London, Routledge, 1990.

Butler, Judith, *Bodies That Matter: On the Discursive Limits of Sex*. New York and London, Routledge, 1993.

Butler, Judith and Joan W. Scott, eds, *Feminists Theorize the Political*. New York and London, Routledge, 1992.

Buurman, Gon, *Poseuses: Vrouwenportretten/Portraits of Women*. Amsterdam, Schorer Foundation/Uitgeverij An Dekker, 1987.

Califia, Pat, *Public Sex: The Culture of Radical Sex*. Pittsburgh, Cleis Press, 1994.

Campbell, Mary Schmidt *et al*, *Harlem Renaissance: Art of Black America*. New York, Abrams, 1987.

Carmen, Gail, Weeba, and Tamara, "Becoming Visible: Black Lesbian Discussions," in *Feminist Review*, eds, *Sexuality: A Reader*. London, Virago Press, 1987.

Case, Sue-Ellen, "Towards a Butch–Femme Aesthetic," *Discourse: Journal for Theoretical Studies in Media and Culture*, vol. 11, no. 1, 1988–89, pp. 55–73.

Chauncey, George, *Gay New York: Gender, Urban Culture, and the Making of the Gay Male World, 1890–1940*. New York, Basic Books, 1994.

Chester, Mark I., *Diary of a Thought Criminal*. Liberty, TN, RFD Press, 1996.

Chua, Lawrence, "I Didn't Mean To Turn You On," *Art + Text*, no. 53, 1996, pp. 37–9.

Clark, Danae, "Commodity Lesbianism," *Camera Obscura*, no. 25/26, 1991, ppp. 180–201.

Clark, Larry, *Tulsa*. New York, Lustrum Press, 1971.

Clark, Larry, *Teenage Lust*. New York, Larry Clark, 1983.

Clifford, James, "On Orientalism," *The Predicament of Culture*. Cambridge, MA, Harvard University Press, 1988.

Cohen, Ed, *Talk on the Wilde Side: Toward a Genealogy of a Discourse on Male Sexualities*. New York and London, Routledge, 1993.

Connell, R. W., "Democracies of Pleasure: Thoughts on the Goals of Radical Sexual Politics," in Linda Nicholson and Steven Seidman, eds, *Social Postmodernism: Beyond Identity Politics*. Cambridge University Press, 1995.

Cooper, Emmanuel, *The Sexual Perspective: Homosexuality and Art in the Last 100 Years in the West*. London and New York, Routledge, 1994.

Cooper, Emmanuel, *Fully Exposed, The Male Nude in Photography*. London and New York, Routledge, 1995.

Crimp, Douglas, *AIDS: Cultural Analysis, Cultural Activism*. Cambridge, Mass., MIT Press, 1988.

Crimp, Douglas, "The Boys in My Bedroom," *Art in America*, February 1990, pp. 47–9.

Crimp, Douglas, "Portraits of People with AIDS," in Cary Nelson *et al.*, eds, *Cultural Studies Now and In The Future*. New York and London, Routledge, 1991.

Crimp, Douglas with Adam Rolston, *AIDS Demo/Graphics*. Seattle, Bay Press, 1990.

Crompton, Louis, *Byron and Greek Love: Homophobia in 19th Century England*. Berkeley, University of California Press, 1985.

Crump, James, ed., *George Platt Lynes: Photographs from the Kinsey Institute*. Boston, Bulfinch Press, 1993.

Crump, James, "The Kinsey Institute Archive: A Toxonomy of Erotic Photography," *History of Photography*, vol. 18, no. 1, Spring 1994, pp. 1–12.

Davis, Keith F., *The Passionate Observer, Photographs by Carl Van Vechten*. Kansas City, MO, Hallmark Cards, 1993.

Davis, Melody, *The Male Nude in Contemporary Photography*. Philadelphia, Temple University Press, 1991.

Davis, Whitney, "HomoVision: A Reading of Freud's 'Fetishism,'" *Genders*, no. 15, Winter 1992, pp. 86–118.

D'Emilio, John, *Sexual Politics, Sexual Communities: The Making of a Homosexual Minority in the United States, 1940–1970*. University of Chicago Press, 1983.

D'Emilio, John and Estelle B. Freedman, *Intimate Matters: A History of Sexuality in America*. New York, Harper & Row, 1988.

De Lauretis, Teresa, *Technologies of Gender*. Bloomington, Indiana University Press, 1987.

De Lauretis, Teresa, "Sexual Indifference and Lesbian Representation," *Theatre Journal*, vol. 40, no. 2, May 1988, pp. 155–77.

De Lauretis, Teresa, *The Practice of Love: Lesbian Sexuality and Perverse Desire*. Bloomington, Indiana University Press, 1994.

Deitcher, David, "Gran Fury," in Russell Ferguson *et al.*, eds, *Discourses: Conversations in Postmodern Art and Culture*. New York, The New Museum of Contemporary Art, 1990.

Deitcher, David, "The Gay Agenda," *Art in America*, vol. 82, no. 4, April 1994, pp. 27–35.

Deitcher, David, ed., *The Question of Equality: Lesbian and Gay Politics in America Since Stonewall*. New York, Scribner, 1995.

Deitcher, David, "Death and the Marketplace," *frieze*, no. 29, July–August 1996, pp. 40–5.

Delacoste, Frederique and Priscilla Alexander, eds, *Sex Work: Writings by Women in the Sex Industry*. Pittsburgh, Cleis Press, 1987.

Dellamora, Richard, *Masculine Desire: The Sexual Politics of Victorian Aestheticism*. Chapel Hill, University of North Carolina Press, 1990.

Dennis, Kelly, "Ethno-Pornography: Veiling the Dark Continent," *History of Photography*, vol. 18, no. 1, Spring 1994, pp. 22–9.

differences, vol. 3, no. 2, Summer 1991, special issue, "Queer Theory: Lesbian and Gay Sexualities."

differences, vol. 6, nos 2/3, Summer–Fall 1994, special issue, "More Gender Trouble: Feminism Meets Queer Theory."

Doane, Mary Ann, "Film and the Masquerade – Theorising the Female Spectator," *Screen*, vol. 23, nos 3/4, September/October 1982.

Doane, Mary Ann, *The Desire to Desire: The Woman's Film of the 1940s*. Bloomington, Indiana University Press, 1987.

Doyle, Jennifer, Jonathan Flatley and José Muñoz, eds, *Pop Out: Queer Warhol*. Durham, Duke University Press, 1996.

Duberman, Martin, *About Time: Exploring the Gay Past*. New York, Meridian Books, 1991.

Duberman, Martin Bauml, Martha Vicinus, and George Chauncey, Jr, eds, *Hidden From History: Reclaiming the Gay and Lesbian Past*. New York, New American Library, 1989.

Duggan, Lisa and Nan D. Hunter, *Sex Wars: Sexual Dissent and Political Culture*. New York and London, Routledge, 1995.

Dworkin, Andrea, *Pornography: Men Possessing Women*. New York, Seal Press, 1981.

Dyer, Richard, ed., *Gays and Film*. London, British Film Institute, 1977, 1980; revised edition New York, Zoetrope, 1984.

Dyer, Richard, "Don't Look Now: The Male Pin-Up," *Screen*, vol. 23, September/October 1982, pp. 61–72.

Dyer, Richard, *Now You See It: Studies on Lesbian and Gay Film.* New York and London, Routledge, 1990.

Edwards, Elizabeth, ed., *Anthropology and Photography.* New Haven, Yale University Press, 1992.

Edwards, Susan, "Pretty Babies: Art, Erotica or Kiddie Porn?" *History of Photography*, vol. 18, no. 1, Spring 1994, pp. 38–46.

Ellenzweig, Allen, "Picturing the Homoerotic," *Out/Look*, no. 7, Winter 1990.

Ellenzweig, Allen, *The Homoerotic Photograph: Male Images from Durieu/Delacroix to Mapplethorpe,* New York, Columbia University Press, 1992.

Ellis, John, "Photography/Pornography/Art/Pornography," *Screen*, vol. 21, no. 1, 1980, pp. 81–108.

Ellis, Kate, *et al.* (FACT Book Committee), *Caught Looking: Feminism, Pornography & Censorship.* Caught Looking Inc., 1986. East Haven, Long River Books, 1992.

Ewing, William A., *The Body: Photographs of the Human Form.* San Francisco, Chronicle Books, 1994.

Ewing, William A., *The Photographic Art of Hoyningen-Huene.* London, Thames and Hudson, 1986.

Faderman, Lillian, *Surpassing the Love of Men: Romantic Friendship and Love Between Women from the Renaissance to the Present.* New York, William Morrow, 1981.

Faderman, Lillian, *Odd Girls and Twilight Lovers: A History of Lesbian Life in Twentieth-century America.* New York, Columbia University Press, 1991.

Fani-Kayode, Rotimi, *Black Male/White Male.* London, GMP Publishers, 1988.

Fani-Kayode, Rotimi & Alex Hirst, Photographs. Jean Loup Pivan and Mark Sealy, eds. London, Autograph: The Association of Black Photographers, and Paris, Revue Noire, 1997.

Feinberg, Leslie, *Stone Butch Blues.* Ithaca, Firebrand Books, 1993.

Ferguson, Russell, *et al.*, eds, *Discourses: Conversations in Postmodern Art and Culture.* Cambridge, Mass., MIT Press, 1990.

Ferguson, Russell, *et al.*, eds, *Out There: Marginalization and Contemporary Cultures.* Cambridge, Mass., MIT Press, 1990.

Fernie, Lynne, *Sight Specific: Lesbians and Representation.* Toronto, A Space, 1988.

Flynt, Robert, *Compound Fracture*, Altadena, CA, Twin Palms Publishers, 1996.

Foster, Alistair, *Behold the Man: The Male Nude in Photography* (exhibition catalogue). Edinburgh, Stills Gallery, 1988.

Foster, Hal, *Recodings: Art, Spectacle, Cultural Politics.* Seattle, Bay Press, 1985.

Foucault, Michel, *The History of Sexuality, Vol. 1: An Introduction.* Trans. Robert Hurley, New York, Random House, 1980.

Foucault, Michel, "Friendship as a Way of Life," in Sylvère Lotringer, ed., *Foucault Live: Collected Interviews, 1961–1984*, trans. John Johnston. New York, Semiotext(e), 1996.

Freud, Sigmund, "On Fetishism" (1927), in *The Standard Edition of the Complete Psychological Works of Sigmund Freud.* James Strachey (trans. and ed.), vol. 21, London, The Hogarth Press, 1953–74, pp. 147–57.

Freud, Sigmund, *Three Essays on the Theory of Sexuality* (1905), vol. 7 of *The Standard Edition,* trans. James Strachey, pp. 3–122. London, The Hogarth Press, 1953.

Fung, Richard, "Burdens of Representation, Burdens of Responsibility," in Maurice Berger, Brian Wallis, Simon Watson, eds, *Constructing Masculinity.* New York and London, Routledge, 1995.

Fung, Richard, "Looking for My Penis: The Eroticized Asian in Gay Video Porn," in Bad Object-Choices, eds, *How Do I Look?* Seattle, Bay Press, 1991.

Fuss, Diana, *Essentially Speaking: Feminism, Nature and Difference*. New York and London, Routledge, 1989.

Fuss, Diana, ed., *Inside/Out: Lesbian Theories, Gay Theories*. New York and London, Routledge, 1991.

Fuss, Diana, "Fashion and the Homospectatorial Look," *Critical Inquiry*, vol. 18, no. 1, Summer 1992, pp. 713–37.

Fuss, Diana, *Identification Papers*. New York and London, Routledge, 1995.

Gaines, Jane, "Dorothy Arzner's Trousers," *Jump Cut*, no. 37, pp. 88–98.

Gaines, Jane, *Fabrications: Costume and the Female Body*. Los Angeles, American Film Institute, 1990.

Gallop, Jane, "The Pleasures of the Phototext," *Afterimage*, vol. 12, no. 9, April 1985, pp. 16–18.

Gamson, Josh, "Silence, Death, and the Invisible Enemy: AIDS Activism and Social Movement 'Newness,'" *Social Problems*, vol. 36, no. 4, October 1989.

Gangitano, Lia, ed., *Boston School*. Boston, The Institute of Contemporary Art, 1996.

Garber, Eric, "'Tain't Nobody's Bizness: Homosexuality in Harlem in the 1920s," *The Advocate*, no. 13, May 1982.

Garber, Eric, "A Spectacle in Color: The Lesbian and Gay Subculture of Jazz Age Harlem," in Martin Bauml Duberman, Martha Vicinus, and George Chauncey, Jr, eds, *Hidden from History: Reclaiming the Gay and Lesbian Past*. New York, New American Library, 1989.

Garber, Marjorie, *Vested Interests: Cross-Dressing and Cultural Anxiety*, no. New York and London, Routledge, 1992.

Gardiner, James, *A Class Apart: The Private Pictures of Montague Glover*. London, Serpent's Tail, 1992.

Gates, Henry Louis Jr, "The Black Man's Burden," in Gina Dent, ed., *Black Popular Culture: A Project by Michelle Wallace*. Seattle, Bay Press, 1992.

Genet, Jean, *The Blacks*, New York, Grove Press, 1960.

Gever, Martha, "Neurotic Erotic: Debating Art and Pornography," *Afterimage*, vol. 10, nos. 1–2, Summer 1982, p. 5.

Gever, Martha, John Greyson, Pratibha Parmar, eds, *Queer Looks: Perspectives on Lesbian and Gay Film and Video*. New York, Routledge, 1993.

Gever, Martha and Nathalie Magnan, "The Same Difference: On Lesbian Representation," *exposure*, vol. 24, no. 2, 1986, pp. 27–35.

Gibson, Pamela Church and Roma Gibson, *Dirty Looks: Women, Pornography, Power*. London, British Film Institute, 1993.

Gilman, Sander L., *Difference and Pathology: Stereotypes of Sexuality, Race, and Madness*. Ithaca, Cornell University Press, 1985.

Giroux, Henry, "Benetton's 'World without Borders': Buying Social Change," in Carol Becker, ed., *The Subversive Imagination: Artists, Society, and Social Responsibility*. New York, Routledge, 1994, pp. 187–207.

Gluckman, Amy and Betsy Reed, eds, *Homo Economics, Capitalism, Community, and Lesbian and Gay Life*, New York and London, Routledge, 1997.

Golden, Thelma, ed., *Black Male: Representations of Masculinity in Contemporary American Art*. New York, Whitney Museum of American Art, 1994.

Goldin, Nan, *The Ballad of Sexual Dependency*. New York, Aperture, 1986.

Goldin, Nan, *The Other Side*. New York, Scalo Publishers, 1993.

Goldin, Nan, *I'll Be Your Mirror*. New York, Whitney Museum of American Art, 1996.

Goldsby, Jackie, "What It Means to be Colored Me," *Out/Look*, no. 9, Summer 1990, pp. 8–17.

Goldstein, Richard, "The Culture War Is Over! We Won! (For Now)," *Village Voice*, 19 November 1996, pp. 51–5.

Goldstein, Richard, "The Taboo Artist: Andres Serrano Goes for the XXX," *Village Voice*, 11 March 1997, pp. 50–1.

Grace, Della, *Love Bites*. London: GMP Publishers, 1991.

Grosz, Elizabeth A., "Lesbian Fetishism?" *differences: A Journal of Feminist Cultural Studies*, vol. 3, no. 2, Summer 1991, pp. 39–54.

Grosz, Elizabeth A., *Volatile Bodies: Toward a Corporeal Feminism*. Bloomington, Indiana University Press, 1994.

Grover, Jan Zita, "Dykes in Context: Some Problems in Minority Representation," in Richard Bolton, ed., *The Contest of Meaning: Critical Histories of Photography*. Cambridge, Mass., MIT Press, 1987.

Grover, Jan Zita, guest curator, *AIDS: The Artist's Response*. Columbus, The Ohio State University, 1989.

Grover, Jan Zita, "Framing the Questions: Positive Imaging and Scarcity in Lesbian Photographs," in Tessa Boffin and Jean Fraser, eds, *Stolen Glances: Lesbians Take Photographs*. London, Pandora, 1991.

Grover, Jan Zita, *North Enough: AIDS and Other Clear-Cuts*, Minnesota, Greywolf Press, 1997.

Gumpert, Lynn, "Glamour Girls," *Art in America*, vol. 84, no. 7, July 1996.

Gupta, Sunil, *An Economy of Signs*. London, Rivers Oram Press, 1990.

Gupta, Sunil, "Desire and Black Men," *Ten.8*, no. 2, Spring 1992, pp. 80–85.

Gupta, Sunil, ed., *Disrupted Borders*. London, Rivers Oram Press, 1993.

Halberstam, Judith, "F2M: The Making of Female Masculinity," in Laura Doan, ed., *The Lesbian Postmodern*. New York, Columbia University Press, 1994.

Hall, Stuart, *Minimal Selves*. ICA Document 6. London, Institute of Contemporary Art, 1988.

Hall, Stuart, "Pluralism, Race, and Class in Caribbean Society," *Race and Class in Post-Colonial Societies*. Paris, UNESCO, 1977, pp. 150–82.

Hall, Stuart, "The Whites of Their Eyes: Racist Ideologies and the Media," in Manuel Alvarado and John O. Thompson, eds, *The Media Reader*. London: BFI Publishing, 1990, pp. 7–23.

Harris, Lyle Ashton, "Drag Racing," *Rrose is a Rrose is a Rrose: Gender Performance in Photography* (exhibition catalogue), Jennifer Blessing, curator. New York, Solomon R. Guggenheim Foundation, 1997.

Heins, Marjorie, *Sex, Sin and Blasphemy: A Guide to America's Censorship Wars*. New York, The New Press, 1993.

Hemphill, Essex and Joseph Beam, *Brother to Brother: New Writings by Black Gay Men*. Boston, Alyson Publications, 1992.

Hennessy, Rosemary, "Queer Visibility in Commodity Culture," *Cultural Critique*, no. 29, Winter 1994–95.

Heresies 12, The Sex Issue. New York, The Heresies Collective Inc., 1981.

hooks, bell, "Reflections on Homophobia and Black Communities," *Out/Look*, vol. 1, no. 2, Summer 1988, pp. 22–5.

hooks, bell, *Black Looks: Race and Representation*. Boston, South End Press, 1992.

Horne, Peter and Regina Lewis, eds, *Outlooks: Lesbian and Gay Sexualities and Visual Cultures*. London and New York, Routledge, 1996.

Huggins, Nathan Irvin, *Harlem Renaissance*. London, Oxford University Press, 1971.

Hujar, Peter, *Peter Hujar*. New York, Grey Art Gallery and Study Center, New York University, 1990.

Joans, Barbara, "'Dykes on Bikes' Meet Ladies of Harley," in W. Leap, ed., *Beyond the Lavendar Lexicon*, New York, Gordon and Breach, 1995.

Jones, Kellie, *Interrogating Identity* (exhibition catalogue). New York, Grey Art Gallery and Study Center, New York University, 1991.

Katz, Jonathan Ned, ed., *Gay American History: Lesbians and Gay Men in the USA*. New York, Thomas Crowell, 1976.

Katz, Jonathan Ned, *The Invention of Heterosexuality*. New York, Dutton Books, 1995.

Kelley, Mike, "Larry Clark: In Youth Is Pleasure," *Flash Art*, vol. 25, no. 164, May/June 1992.

Kellner, Bruce, *Carl Van Vechten and the Irreverent Decades*. Norman, University of Oklahoma Press, 1968.

Kellner, Bruce, ed., *Letters of Carl Van Vechten*. New Haven and London, Yale University Press, 1987.

Kenny, Lorraine, "What's Love Got To Do With It," *Afterimage*, May 1987, pp. 8–9.

Kirschenbaum, Baruch D., "Private Parts and Public Considerations," *exposure*, vol. 22, no. 3, Fall 1984.

Kiss & Tell, *Drawing the Line: Lesbian Sexual Politics on the Wall* (postcard book). Vancouver, Press Gang Publishers, 1991.

Kiss & Tell (Persimmon Blackbridge, Lizard Jones, Susan Stewart), *Her Tongue on My Theory*. Vancouver, Press Gang Publishers, 1994.

Kotz, Liz, "The Body You Want: Liz Kotz Interviews Judith Butler," *Artforum*, November 1992, pp. 82–9.

Kotz, Liz, "Erotics of the Image," *Art Papers*, November/December 1994, pp. 16–20.

Kotz, Liz, "Beyond the Pleasure Principle," *Lusitania* , no. 6, 1994, pp. 125–36.

Krauss, Rosalind, "Nightwalkers," *Art Journal*, Spring 1981.

Krauss, Rosalind and Jane Livingston, *L'Amour Fou: Photography and Surrealism*. New York, Abbeville Press, 1985.

Lacan, Jacques, *The Four Fundamental Concepts of Psychoanalysis*. Jacques–Alain Miller (ed), trans. by Alan Sheridan, New York, W.W. Norton & Co., 1978.

Laqueur, Thomas, *Making Sex: Body and Gender from the Greeks to Freud*. Cambridge, Mass., Harvard University Press, 1990.

Landers, Timothy, "Bodies and Anti-bodies: A Crisis in Representation," *The Independent*, vol. 11, no. 1, 1988, pp. 18–24.

Lau, Grace, "Confessions of a Complete Scopophiliac," in Pamela Church Gibson and Roma Gibson, eds, *Dirty Looks: Women, Pornography and Power*. London, British Film Institute, 1993.

Lehman, Peter, *Running Scared: Masculinity and the Representation of the Male Body*. Philadelphia, Temple University Press, 1993.

Leong, Russell, ed., *Asian American Sexualities: Dimensions of the Gay & Lesbian Experience*. New York and London, Routledge, 1996.

Leopold, Ellen, "The Manufacture of the Fashion System," in Juliet Ash and Elizabeth Wilson, eds, *Chic Thrills*, Berkeley, University of California, 1992.

Lewes, Kenneth, *The Psychoanalytic Theory of Male Homosexuality*. New York, Simon and Schuster, 1988.

Lewis, David Levering, *When Harlem was in Vogue*, New York, Oxford University Press, 1981.

Lipton, Eunice, *Alias Olympia: A Woman's Search for Manet's Notorious Model & Her Own Desire*. New York, Charles Scribner and Sons, 1992.

List, Herbert, *junge männer*, Altadena, CA, Twin Palms Publishers, 1988.

Lord, Catherine, "Queering the Deal," *Pervert* (exhibition catalogue). Irvine, The Art Gallery, University of California, 1995.

Lord, Catherine, "This is Not a Fairy Tale: A Middle-aged Female Pervert (White) in the Era of Multiculturalism," in Diane Neumaier, ed., *Reframings: New American Feminist Photographies*. Philadelphia, Temple University Press, 1996.

Lord, Catherine and Millie Wilson, "Something Borrowed," in *Longing and Belonging: From the Faraway Nearby* (exhibition catalogue), essays by Dick Hebdidge, Lucy Lippard, Bruce Ferguson, *et al*. Site Santa Fe, 1995.

Lorde, Audre, *Sister Outsider*. Trumansburg, New York, Crossing Press, 1984.

Lott, Eric, *Love and Theft: Blackface Minstrelsy and the American Working Class*. New York, Oxford University Press, 1993.

Lufty, Carol, "Morimura: Photographer of Colliding Cultures," *International Herald Tribune*, 2 March 1990.

Machida, Margo, "Seeing 'Yellow': Asians and the American Mirror,'" in *The Decade Show: Frameworks of Identity in the 1980s*. New York, The New Museum of Contemporary Art, 1990.

Machida, Margo, *Asia/America*. New York, Asia House, 1994.

Mapplethorpe, Robert, *The Black Book*. Munich, Schirmer-Mosel and New York, St Martin's Press, 1986.

Mapplethorpe, Robert, *The Perfect Moment*. Philadelphia, Institute of Contemporary Art, 1989.

Robert Mapplethorpe: Early Works, 1970–74. New York, Robert Miller Gallery, 1991.

Maricevic, Vivienne, *Male To Female* (text by Vicki Goldberg), Zurich, Edition Stemmle, 1995.

Marks, Laura U., "Minor Infractions: Child Pornography and the Legislation of Morality," *Afterimage*, vol. 18, no. 4, November 1990.

Marshall, Richard, ed., *Robert Mapplethorpe*. New York and Boston, Bulfinch Press, 1988.

McClintock, Anne, *Imperial Leather: Race, Gender and Sexuality in the Colonial Contest*. London and New York, Routledge, 1995.

McClintock, Anne, "The Return of Female Fetishism and the Fiction of the Phallus," *New Formations: A Journal of Culture/Theory/Politics*, no. 9, Spring 1993, pp. 1–21.

Mellor, David, ed., *Cecil Beaton, a Retrospective*. Boston, Little Brown, 1986.

Mercer, Kobena, "Imaging the Black Man's Sex," in Pat Holland, Jo Spence, and Simon Watney, eds, *Photography/Politics Two*. London, Comedia/Methuen, 1987.

Mercer, Kobena, "Skinhead Sex Thing: Racial Difference and the Homoerotic Imaginary," in Bad Object-Choices, eds, *How Do I Look? Queer Film and Video*. Seattle: Bay Press, 1991.

Mercer, Kobena, "Dark & Lovely: Notes on Black Gay Image-Making," *Ten.8*, no. 2, Spring 1991, pp. 78–85.

Mercer, Kobena, *Welcome to the Jungle: New Positions in Black Cultural Studies*. New York and London, Routledge, 1994.

Mercer, Kobena and Isaac Julien, "True Confessions," in Thelma Golden, ed., *Black Male: Representations of Masculinity in Contemporary Art*, New York, The Whitney Museum of American Art, 1994, p. 194.

Meskimmon, Marsha, *The Art of Reflection: Women Artists' Self-Portraiture in the Twentieth Century*. London, Scarlet Press, 1996.

Metken, Günter, *Herbert List, Photographs, 1930–1970*. New York, Rizzoli, 1981.

Metz, Christian "Photography and Fetish," *October* 34, Fall 1985, pp. 81–90.

Meyer, Richard, "Robert Mapplethorpe and the Discipline of Photography," in Henry Abelove *et al*., eds, *The Lesbian and Gay Studies Reader*. New York and London, Routledge, 1993.

Minh-ha, Trinh T., "Of Other Peoples: Beyond the 'Salvage' Paradigm," in Hal Foster, ed., *Discourses in Contemporary Culture*. Seattle, Bay Press, 1987.

Minkowitz, Donna, "Trial by Science: In the Fight Over Amendment 2, Biology is Back – and Gay Allies are Claiming It," *Village Voice*, 30 November 1993, pp. 27–9.

Mookas, Ioannis, "Faultlines: Homophobic Innovation in *Gay Rights, Special Rights*," *Afterimage*, vol. 22, no. 7/8, February/March 1995.

Moore, Catriona, *Indecent Exposures: Twenty Years of Australian Feminist Photography*. St Leonards, Allen & Unwin, 1991.

Moraga, Cherrie and Gloria Anzaldua, eds, *This Bridge Called My Back: Writings by Radical Women of Color*. New York, Kitchen Table Women of Color Press, 1981.

Morgan, Stuart, "Open Secrets: Identity, Persona and Cecil Beaton," in David Mellor, ed., *Cecil Beaton: A Retrospective*, Boston, Little Brown, 1986, pp. 116–17.

Mulvey, Laura, "Magnificent Obsession," *Parachute*, March/April/May 1986, pp. 6–12.

Mulvey, Laura, "Visual Pleasure and Narrative Cinema," in *Visual and Other Pleasures*. Bloomington, Indiana University Press, 1989, pp. 14–26.

Muñoz, José Esteban, *Disidentifications: Race, Sex and Visual Culture*. Minneapolis, University of Minnesota, 1998.

Navarro, Ray and Catherine Saalfield, "Not Just Black and White: AIDS, Media and People of Color," *The Independent*, vol. 12, no. 6, 1989, pp. 18–23.

Neale, Steve, "Masculinity as Spectacle," *Screen*, vol. 24, no. 6, November/December 1983, pp. 2–16.

Nederveen Pieterse, Jan, *White on Black: Images of African and Blacks in Western Popular Culture*. New Haven, Yale University Press, 1992.

Nestle, Joan, *A Restricted Country*. Ithaca, Firebrand Books, 1987.

Nestle, Joan, ed., *The Persistent Desire: A Femme–Butch Reader*. Boston, Alyson Publications, 1992.

Neumaier, Diane, ed., *Reframings: New American Feminist Photographies*. Philadelphia, Temple University Press, 1996.

Newton, Esther, *Mother Camp: Female Impersonators in America*. University of Chicago Press, 1972.

Nicholson, Linda and Steven Seidman, eds, *Social Postmodernism: Beyond Identity Politics*. Cambridge University Press, 1994.

Nickerson, Camilla and Neville Wakefield, eds, *Fashion: Photography of the Nineties*. New York, Zurich, Berlin, Scalo, 1996.

Nixon, Nicholas, *People with AIDS*. Boston, David R. Godine, 1991.

O'Neal, Hank, *Berenice Abbott: American Photographer*. New York, McGraw-Hill, 1982.

Owens, Craig, "Photography *en abyme*," *October*, no. 5, Summer 1978, pp. 73–88.

Patton, Cindy, "The Cum Shot: Three Takes on Lesbian and Gay Sexuality," *Out/Look*, vol. 1, no. 3, Fall 1988, pp. 72–7.

Patton, Cindy, "Hegemony and Orgasm – Or, the Instability of Heterosexual Pornography," *Screen*, vol. 30, nos 1–2, Winter/Spring 1989, pp. 100–12.

Peiss, Kathy and Christina Simmons, eds, *Passion and Power: Sexuality in History*. Philadelphia, Temple University Press, 1989.

Peraldi, Francois, ed., "Polysexuality," *Semiotext(e)*, no. 10, 1981, 1995.

Pfeifer, Marcuse, *The Male Nude in Photography*. New York, Pfeifer Gallery, 1979.

Pheterson, Gail, *A Vindication of the Rights of Whores*. Seattle, Seal Press, 1989.

Pierre Molinier, with essays by Wayne Baerwaldt, Scott Watson, and Peter Gorsen. Winnipeg, Plug-In Editions, 1993.

Pierson, Jack, *All of a Sudden*. New York, PowerHouse Books/Thea Westreich, n.d.

Pierson, Jack, "[Mark Morrisroe]," *Artforum*, vol. 32, no. 5, January 1994.

Pierson, Jack, *The Lonely Life*. Frankfurter Kunstverein and Edition Stemmle, 1997.

Pohlman, Ulrich, *Wilhelm von Gloeden: Sehnsucht nach Arkadiea*. Berlin, Nishen Verlag, 1987.

Rabinowitz, Paula, *They Must Be Represented: The Politics of Documentary*. New York, W. W. Norton, 1994.

Rand, Erica, *Barbie's Queer Accessories*. Durham, Duke University Press, 1995.

Reid, Mark A., *Redefining Black Film*, Berkeley, University of California Press, 1993.

Reid, Mark A., *PostNegritude Visual and Literary Culture*. Albany, SUNY Press, 1997.

Rich, Frank, "The Gay Decades," *Esquire*, November 1987, p. 99.

Ritts, Herb, *Pictures*. Altadena, CA, Twin Palms Publishers, 1988.

Ritts, Herb, *Herb Ritts: Work*. Boston, Bulfinch Press (Little, Brown), 1996.

Riviere, Joan, "Womanliness as Masquerade," in Hendrick M. Ruietenbeck, ed., *Psychoanalysis and Female Sexuality*. New Haven, College and University Press, 1966.

Rodgerson, G. and Elizabeth Wilson, eds, *Pornography and Feminism: The Case Against Censorship*. London, Lawrence and Wishart, 1991.

Roditi, Edouard, "The Homophobia of André Breton," *Christopher Street*, no. 113, July 1987, pp. 17–24.

Roof, Judith, *A Lure of Knowledge: Lesbian Sexuality and Theory*. New York, Columbia University Press, 1991.

Rotimi Fani-Kayode, Photographer (1955–1989). London, The Black-Art Gallery, 1991.

Rotundo, Anthony, "Romantic Friendship: Male Intimacy and Middle-Class Youth in the Northern United States, 1800–1900," *Journal of Social History*, 1989.

Rrose is a Rrose is a Rrose: Gender Performance in Photography (exhibition catalogue), Jennifer Blessing, curator. New York, The Solomon R. Guggenheim Foundation, 1997.

Rubin, Gayle, "The Traffic in Women: Notes on the 'Political Economy' of Sex," in Rayna R. Reiter, ed., *Toward an Anthropology of Women*. New York, Monthly Review Press, 1975.

Rubin, Gayle, "Thinking Sex: Notes for a Radical Theory of the Politics of Sexuality," in Carole S. Vance, ed., *Pleasure and Danger: Exploring Female Sexuality*. Boston, Routledge, Kegan and Paul, 1984.

Rubin, Gayle, "Of Catamites and Kings: Reflections on Butch, Gender, and Boundaries," in Joan Nestle, ed., *The Persistent Desire: A Butch–Femme Reader*. Boston, Alyson, 1992.

Russo, Vito, *The Celluloid Closet: Homosexuality in the Movies*. New York, Harper and Row, 1981, 1987.

Said, Edward, *Orientalism*. New York, Vintage Books, 1979.

SAMOIS, *Coming To Power: Writings and Graphics on Lesbian S/M*. Boston, Alyson Publications, 1981.

Saunders, Joel, ed., *Stud: Architectures of Masculinity*. New York, Princeton Architectural Press, 1996.

Schulman, Sarah, *My American History: Lesbian and Gay Life During the Reagan/Bush Years*. New York, Routledge, 1994.

Schwabsky, Barry, "Irresponsible Images: The Photographs of Mark Morrisroe," *Print Collector's Newsletter*. May/June 1994.

Scoates, Christopher, curator, *A Family Affair: Gay and Lesbian Issues of Domestic Life* (exhibition catalogue). Atlanta College of Art Gallery, 1995.

Sedgwick, Eve Kosofsky, *Between Men: English Literature and Male Homosocial Desire*. New York, Columbia University Press, 1985.

Sedgwick, Eve Kosofsky, "Epistemology of the Closet," in Henry Abelove *et al.*, eds, *The Lesbian and Gay Studies Reader*. New York and London, Routledge, 1993.

Sedgwick, Eve Kosofsky, *Tendencies*. Durham, Duke University Press, 1993.

Sedgwick, Eve Kosofsky, "Gosh, Boy George, You Must Be Awfully Secure in Your Masculinity!" in Maurice Berger, *et al.*, eds, *Constructing Masculinity*. New York and London, Routledge, 1995.

Severa, Joan, *Dressed for the Photographer: Ordinary Americans & Fashion, 1840–1900*. Ohio, Kent State University Press, 1995.

Sinclair, Nicholas, *The Chameleon Body: Photographs of Contemporary Fetishism*. London, Lund Humphries Ltd, 1996.

Smalls, James, *Exclave, Negre, Noir: The Black Presence in French Art from 1789 to 1870*. Berkeley, University of California Press, forthcoming.

Smith, Barbara, "Homophobia: Why Bring It Up?" in Henry Abelove *et al.*, eds, *The Lesbian and Gay Studies Reader*. New York and London, Routledge, 1993.

Smith, Todd D., "Gay Male Pornography and the East: Re-orienting the Orient," *History of Photography*, vol. 18, no. 1, Spring 1994, pp. 13–21.

Smith-Rosenberg, Caroll, "The Female World of Love and Ritual: Relations Between Women in Nineteenth-Century America," in *Disorderly Conduct: Visions of Gender in Victorian America*. New York, Alfred A. Knopf, 1985.

Smyth, Cherry, *Damn Fine Art: By New Lesbian Artists*. London, Cassell, 1996.

Snitow, Ann, Christine Stansell and Sharon Thompson, eds, *Powers of Desire: The Politics of Sexuality*. New York, Monthly Review Press, 1977.

Sobieszek, Robert A., *Ports of Entry: William S. Burroughs and the Arts*. Los Angeles County Museum of Art and New York, Thames and Hudson, 1996.

Sokolowski, Thomas W., "Iconophobics Anonymous (the Human Body, pornography and Homosexuality)," *Artforum*, vol. 28, Summer 1990, pp. 114–19.

Solomon, Alisa, *Redressing the Canon: Essays on Theater and Gender*. New York and London, Routledge, 1997.

Solomon-Godeau, Abigail, "Reconsidering Erotic Photography: Notes for a Project of Historic Salvage," *Journal: A Contemporary Arts Magazine*, vol. 47, no. 5, Spring 1987, pp. 50–8.

Solomon-Godeau, Abigail, *Mistaken Identities* (exhibition catalog.) Santa Barbara, University Art Museum, 1993.

Sontag, Susan, "Notes on Camp," *A Sontag Reader*, Harmondsworth, Penguin Books, 1983.

Sontag, Susan, *On Photography*, New York, Doubleday Anchor, 1989.

Spence, Jo, *Cultural Sniping: The Art of Transgression*. London and New York, Routledge, 1995.

Stein, Arlene, ed., *Sisters, Sexperts, Queers: Beyond the Lesbian Nation*. New York, Plume, 1993.

Stewart, Jeffrey C., "Black Modernism and White Patronage," *The International Review of African American Art*, vol. 11, no. 3, 1994, pp. 43–6.

Straayer, Chris, *Deviant Eyes, Deviant Bodies: Sexual Re-orientation in Film and Video*. New York, Columbia University Press, 1996.

Strossen, Nadine, *Defending Pornography: Free Speech, Sex and the Fight for Women's Rights*. New York, Scribner, 1995.

Sullivan, Constance, *Nude Photographs: 1850–1980*. New York, Harper, 1980.

Taormina: Wilhelm von Gloeden (intro. Roland Barthes). Altadena, CA, Twelvetrees Press, 1990.

Terry, Jennifer, "Theorizing Deviant Historiography," *differences: A Journal of Feminist Cultural Studies*, vol. 5, no. 2, Summer 1991, pp. 55–74.

Theweleit, Klaus, *Male Fantasies, Volume One: Women, Floods, Bodies, History*, trans. Stephen Conway, with Erica Carter and Chris Turner. Minneapolis, University of Minnesota Press, 1987.

Torgovnick, Marianna, *Gone Primitive: Savage Intellects, Modern Lives*, Chicago, University of Chicago Press, 1990.

Trebay, Guy, "Camera Obscura," *Village Voice*, 15 October 1996, p. 16.

Vance, Carole S., ed., *Pleasure and Danger: Exploring Female Sexuality*. Boston, Routledge and Kegan Paul, 1984.

Vance, Carole S., "The War on Culture," *Art in America*, September 1989, pp. 39–43.

Vance, Carole S., "Misunderstanding Obscenity," *Art in America*, May 1990, pp. 49–52.

Vance, Carole S., "Feminist Fundamentalism – Women Against Images," *Art in America*, September 1993, pp. 35–9.

Voinquel, Raymond, *Photographies 1930–1988*. Paris, Nathan Image, 1988.

Wallace, Michelle, "Afterword: 'Why Are There No Great Black Artists?' The Problem of Visuality in African–American Culture," in Gina Dent, ed., *Black Popular Culture: A Project by Michelle Wallace*. Seattle, Bay Press, 1992.

Wallis, Brian, ed., *Art After Modernism: Rethinking Representation*. Boston, David Godine, 1984.

Warner, Michael, ed., *Fear of a Queer Planet: Queer Politics and Social Theory*. Minneapolis: Univesity of Minnesota Press, 1993.

Watney, Simon, *Policing Desire: Pornography, AIDS, and the Media*. Minneapolis, University of Minnesota Press, 1987.

Watney, Simon, "Photography and AIDS," in Carol Squiers, ed., *The Critical Image: Essays on Contemporary Photography*. Seattle, Bay Press, 1990.

Watney, Simon, *Practices of Freedom: Selected Writings on HIV/AIDS*. Durham, Duke University Press, 1994.

Waugh, Thomas, *Hard To Imagine: Gay Male Eroticism in Photography and Film from their Beginnings to Stonewall*. New York, Columbia University Press, 1996.

Weber, Bruce, *Bruce Weber* (intro. William Burroughs). Tokyo, Treville Co. Ltd, 1991.

Weeks, Jeffrey, *Coming Out: Homosexual Politics in Britain from the Nineteenth Century to the Present*. London and New York, Quartet Books Ltd, 1977.

Weeks, Jeffrey, *Sex, Politics and Society: The Regulation of Sexuality Since 1800*. London, Longman, 1981.

Weeks, Jeffrey, *Sexuality and Its Discontents: Meanings, Myths and Modern Sexualities*. London, Routledge & Kegan Paul, 1985.

Weiermair, Peter, ed., *The Hidden Image: Photographs of the Male Nude in the Nineteenth and Twentieth Centuries*. Cambridge, Mass., MIT Press, 1987.

Weiermair, Peter, ed., *George Platt Lynes*. Berlin, Bruno Gmünder Verlag, 1989.

Weil, Brian, *Every 17 Seconds: A Global Perspective on the AIDS Crisis* (intro. Simon Watney). New York, Aperture, 1992.

Weinberg, Jonathan, "'Boy Crazy,' Carl Van Vechten's Queer Collection," *The Yale Journal of Criticism*, vol. 7, no. 2, 1994, pp. 25–49.

"We're Here: The Gay and Lesbian Presence in Art," co-edited by Flavia Rando and Jonathan Weinberg, *Art Journal*, vol. 55, no. 4, Winter 1996.

White, Edmund, *Black Males: Robert Mapplethorpe*. Amsterdam, Galerie Jurka, 1980.

Williams, Anne, "Re-viewing the Look: Photography and the Female Gaze," *Ten.8*, vol. 25, 1987, pp. 4–11.

Williams, Linda, *Hard Core: Power, Pleasure and the Frenzy of the Visible*. Berkeley, University of California Press, 1989.

Wilson, Judith, "What Are We Doing Here? Cultural Difference in Photographic Theory and Practice," *SF Camerawork Quarterly*, no. 17, Fall 1990, pp. 27–30.

Wilson, Sarah, "Femininities – Masquerades," in *Rrose is a Rrose is a Rrose: Gender Performance in Photography* (exhibition catalogue), Jennifer Blessing, curator. New York, Solomon R. Guggenheim Foundation, 1997.

Wittig, Monique, *The Straight Mind and Other Essays*, Boston, Beacon Press, 1992.

Wojnarowicz, David, *Brush Fires in the Social Landscape*. New York, Aperture, 1994.

Woody, Jack, *George Platt Lynes, Photographs, 1931–1955*. Pasadena, Twelvetrees Press, 1981.

Woody, Jack, *Collaboration: The Photographs of Paul Cadmus, Margaret French and Jared French*. Santa Fe, Twelvetrees Press, 1992.

Wright, Beryl J., *Options 44: Yasumasa Morimura*. Chicago, Museum of Contemporary Art, 1991.

Ziolkowski, Joe, *Walking the Line*. Berlin, Bruno Gmünder Verlag, 1992.

index

Note: *Italicized* page numbers indicate halftone reproductions in the text; ***bold italics*** indicate works in the color portfolio sections.